THE
ARTISTS DIRECTORY

HEATHER WADDELL
AND RICHARD LAYZELL

Published by
ART GUIDE PUBLICATIONS
A & C BLACK
35 Bedford Row
London WC1R 4JH
Tel: 01 242 0946

ACKNOWLEDGEMENTS

We would like to thank the following contributing editors: Adrian Barr-Smith, Robert Coward, Muriel Wilson, Keith Patrick, Roland Miller, Max Wykes-Joyce, Graham Paton and Renée Harris of the Public Art Development Trust.

We would also like to acknowledge all the galleries, art centres, art colleges, studios, artists' groups, overseas art organisations, regional arts associations, the British Council Fine Art department and countless others who gave up time to help us with all the necessary information, especially all the artists who wrote to us with specific addresses of the suppliers that they use throught the UK.

Thanks also to the Arts Council of Great Britain, the Scottish Arts Council, Welsh Arts Council, the Arts Council of Northern Ireland and the Regional Arts Associations.

Abbreviations

A.B.G.B.	= Arts Council of Great Britain
R.A.A.	= Regional Arts Associations
C.V.	= curriculum vitae
s.a.e.	= stamped addressed envelope
D.A.C.S.	= Design and Artists Copyright Societ

British Library Cataloguing Publication Data
Waddell, Heather, The Artists Directory: a handbook to the contemporary British art world 3rd edition
1. Great Britain—Arts—Directories
1. Title II. Layzell, Richard
700'.25'41

ISBN 0-7136-3039-6
First edition 1982 Second edition 1985
Reprinted 1986
Third edition 1988

Printed in Great Britain by
Hollen Street Press Ltd at Slough

CONTENTS

PHOTOGRAPHS

Cover photograph: Clare Palmier and Phil von Bettman Hollweg in performance..........
The authors: Richard Layzell (Caroline Forbes) and Heather Waddell (Nancy Durrell McKenna)......
Keith Patrick and Martin Lilley of Cable Street Studios, London E1....................
Mike von Joel of Artline magazine at his Line Art Gallery, London SW18. (Heather Waddell).....
Graham Paton at the Paton Gallery, Covent Garden (Heather Waddell)...............
ASB Marketing Gallery, Bruton Street, London W1..
Baschet sculpture at the Barbican Arts Centre, London (Heather Waddell)..............
Olivier Raab paintings at Cadogan Contemporary Art Gallery, London SW3..............
'The Road' 1988, Lance Smith (Fabian Carlsson Gallery).
Installation at the Institute of Contemporary Arts, London (Heather Waddell).
Jonathan Waller painting at the Paton Gallery, Covent Garden, London (Heather Waddell)........
The Photographers Gallery, 5 & 8 Great Newport Street, Covent Garden, London (Heather Waddell).........
Martin Fuller painting (Austin Desmond Fine Art).....................................
Woodhorn Church Museum, Ashington..
Cartwright Hall, Bradford..
Towneley Hall, Burnley..
Darlington Arts Centre (Keith Pattison). ...
St. Paul's Gallery, Leeds. ...
Walker Art Gallery, Liverpool (John Mills)..
Calouste Gulbenkian Gallery, Newcastle on Tyne.
Rochdale Art Gallery. ...
Horse's Tails, Lois Williams (Rochdale Art Gallery).
Artists in residence, Sophie Ryder and Christopher Campbell at Yorkshire Sculpture Park. .
Helen Chadwick, artist in residence, 1986 at Birmingham Art Gallery and Museum........
Margate Library Gallery..
Nine Portuguese Painters at John Hansard Gallery, Southampton.
Library Gallery, University of Surrey..
The Royal Photographic Society, Bath..
Off Centre Gallery, Bedminster..
3D Gallery, Bristol. ..
Prema Art Centre, Dursley...
Krszyztof Wodiczko projection at the Guildhall, Derry, Northern Ireland...............
Davis Gallery, Gerald Davis in foreground, Dublin, Eire...................................
Charles Cullen with his mixed media on brown paper, part of the In Dublin series.
The Solomon Gallery, Dublin (John Donat). Exhibition in the foreground.
Aberdeen Art Gallery, Scotland..
City Art Centre, Edinburgh (Antonia Reeve). ..
The Travelling Gallery, Scottish Arts Council (Antonia Reeve)........................
The Scottish Gallery, Edinburgh (Antonia Reeve)..
Studio—The Drawing Room, The Mackintosh House (Hunterian Art Gallery).
Chapter Arts Centre (Steve Benbow). ...
Mostyn Art Gallery new craft and design shop (Martin Collins).
Attic Gallery, Swansea...
Winsor and Newton, paint production at a factory.
Art Supplier (Fiona Dunlop). ...
Keiko Hasegawa, Raku bottle, Oxford Gallery..
Space Studios and AIR Gallery offices, London EC1. (Heather Waddell.
Artist's studio (Heather Waddell)...
Basil Beattie print, Curwen Gallery, London W1...
2nd year film students at work on 'State of Siege', Polytechnic Central London (J. Hunningher).
Richard Lawrence with 'Reeling Woman' (Wimbledon Art School at Cannizaro Park.)
Textiles Workshop, Northbrook. ...

artists newsletter publications

■ **Artists Newsletter**

The most comprehensive and up to the minute listing for practising artists, craftspeople and photographers of awards, placements, exhibition opportunities, arts fairs, craft fairs, new galleries, open exhibitions, competitions, film/video opportunities, jobs, studios, training, conferences and other events and opportunities in the UK and abroad. Also news coverage of current events and issues and articles on the practice and support of the visual arts.

1 Year (12 issues) subscription inc p&p £9.50

■ **Making Ways**

The only book written by practising artists for practising artists covering exhibiting, packing and transporting artwork, residencies, commissions, teaching, community action, publicity, photographing artwork, studios, funding, sponsorship, working abroad, employment status and tax, trading status, insurance, contracts, copyright, health and safety, training, codes of practice . . . fully indexed and cross-referenced with full bibliographies placed in the relevant sections. *Making Ways* is designed to be *used* rather than read.

A5 · 360 pages · £7.95 plus £1 p&p.

■ **Directory of Exhibition Spaces 2nd Edition -** Available late Autumn

A comprehensive listing of exhibition spaces in the UK covering public galleries, private galleries, libraries, community centres, theatres . . . giving all available information on each space. Ask for details and special pre-publication price

A5 · 360 pages approximately.

■ **Organising Your Own Exhibition**

A guide to all aspects of doing it yourself . . . packing, framing, transport, publicity, openings, insurance, funding Published by Acme.

A5 · 100 pages · £3.00 plus 50p p&p.

■ **Mural Manual 2nd Edition**

Looks at all aspects of contemporary mural practise . . . history, design, environment, people, materials, money, planning permission, maintenance. Jointly published with Greenwich Mural Workshop, (and also available from them).

A4 · 22 pages · colour illustrations · £3.50 inc p&p.

ORDER FORM

❏ Subscription to *Artists Newsletter* @ £9.50 inc p&p
❏ *Making Ways* @ £7.95 plus £1.00 p&p
❏ *Organising Your Own Exhibition* @ £3.00 plus 50p p&p
❏ *Mural Manual 2nd Edition* @ £3.50 inc p&p

Name: _____

Address: _____

_____ Post Code _____

Please send all orders to Publications Department (AG), Artic Producers, PO Box 23, Sunderland, SR1 1EJ.

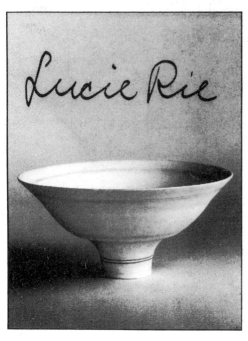

FOREWORD

We hope that this Artist's Handbook will provide a comprehensive art directory for British and overseas artists, gallery directors, art organisations and the general public interested in buying and seeing original artwork. It is an almost impossible task to cover the whole of Britain adequately for all sections and we apologise if your particular area is not adequately represented. Please do write with additional information over the next two years so that we can bear this in mind for updating purposes. We have specifically avoided a London bias as much as possible so that the whole of Britain is included.

The idea of an artist's handbook arose when we realised, through our daily involvement with artists and the art world, that there was no comprehensive British artists' handbook available and that we both often carried lists of useful information around which could be distributed and made use of by other artists.

We hope that artists will find the handbook an essential directory for use both within Britain and before travelling overseas. We would also like to think that we have pehaps helped members of the public to consider buying original artwork for the first time or at least widen their knowledge about the practical world of art.

The new third edition has been completely revised and the gallery section has many additions throughout the UK. There are new articles by Graham Paton of the Paton Gallery and Roland Miller, new photographs and updated information in each section. New articles on Performance Art and Starting on your Own have also been included.

HEATHER WADDELL AND RICHARD LAYZELL

Richard Layzell is a performance and video artist. He recently gave a series of performances at the Tate Gallery, sponsored by the Patrons of New Art. He has also performed at the Gate Theatre, Oval House and other venues nationally and internationally.

He teaches Fine Art at Wimbledon School of Art, lives in North London and has an eight year old son, Owen.

Heather Waddell is a freelance art journalist and photographer. She is also the author of the London Art and Artists Guide and created the Art Guide series in 1981. There are now art guides to London, Paris, New York, Amsterdam, Berlin, Australia and soon Glasgow and Madrid.

She is London correspondent for Vie des Arts and has written for Artnews USA, Artline, Art and Australia, the Glasgow Herald (1980–84), Artists Newsletter, The Artist, Art New Zealand, the Evening Standard and the Times Educational Supplement. Her photographs have been published in the British Journal of Photography, LAM magazine and in various books and on postcards.

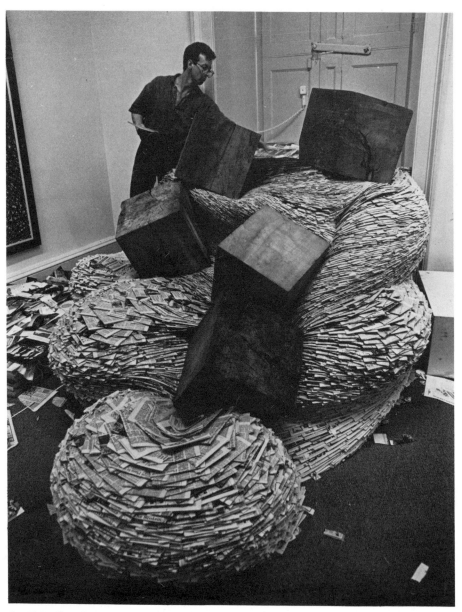

*David Mach with his Sculpture at the Scottish
National Gallery of Modern Art (Antonia Reeve)*

Chapter 1
THE ART WORLD

APPLYING FOR AN EXHIBITION

Try to find out which galleries might be interested in your work, what kind of work they normally exhibit and their particular procedure for applications. The gallery guide that follows does not include comprehensive details for every gallery, but is as thorough as we were able to make it.

Documentation: This is more important than many artists realise because it's very often the only work that is seen, and studio visits or a personal meeting are frequently based on it. It's advisable to present your documentation, whether it's in the form of slides, photographs, a book or written proposal, as clearly, concisely and thoroughly as you can. It might help to think of the person viewing your slides as an outsider who does not know you or your work and try to present the information so that he or she can gain a clear idea of your previous work and what you would like to exhibit. Interesting *presentation*, in whatever form, can make a considerable contribution to how your work communicates itself in the form of documentation. What may seem obvious to you may not be so to somebody else. It is also essential to enclose a curriculum vitae or some sort of biography about yourself. Always enclose an sae, or details for return of slides and check the gallery address first!

PREPARATION BEFORE AN EXHIBITION

This is really to help artists who are not in the fortunate position to be holding an exhibition at a gallery that is going to do all the printing of invitations, posters and general press contact. Since many artists show work at alternative venues such as art schools, rented galleries etc. we hope that the following information will be of some help to them.

Private view invitation: If you are holding a private view for friends and buyers, press and other contacts then a card should be sent out *at least two weeks before the opening date* and should clearly state *the time, date, place and name of the artist and the exhibition.* A photograph is desirable, but not essential, and clarity of information is the most important factor. Printing costs vary according to the printer, from £40–£1000 (if you use colour) for 500 to 1000 invitations. If you do the artwork yourself it saves money but if you hate lettering then a more professional end product is desirable.

Press lunch: For small exhibitions this is unnecessary but, if you can afford it and can guarantee members of the press turning up, go ahead with drink and provide simple eats. Remember that the press can't resist a drink or two now and again! Invitations to a press lunch can be either on a separate card or the same one as the private view invitation and should be sent out, once more, *at least two weeks before the show opens.*

Wine for the opening: Unless you are feeling very flush see if a local wine dealer will give you wine on a sale or return basis or ask if they will consider a reduction. For example, if your show has any connections with a country that produces wine, then approach a wine shipper from that country direct. Glasses should be clean and are usually borrowed from the wine trader on the basis that you pay for any breakages.

Poster: Desirable for publicity but not essential. Black and white posters can be made cheaply, if you find the right printer. They should be clear and simple with the *time of opening for gallery visitors, place, address, dates of the show and any additional information, name of the artist and exhibition* and a clear photograph if possible. These should be *posted two weeks before the opening* to galleries, museums and any other outlets that might entice the public to the exhibition, for example shops, notice boards at art schools and so on.

Press release: If possible a press release should be sent to the various art critics and journalists on newspapers, magazines, radio, TV and local papers stating exactly *what the show is about* with *dates, time of openings and the name of the artist* and *the exhibition.* Don't make the press release too long as journalists get bored reading too much irrelevant information. If possible also send a 10″ × 8″ *black and*

white photograph to newspapers that you think might consider printing a photography if they review it or list the exhibition. Remember that, even if you don't get a review, most art magazines, photographic magazines and some newspapers list exhibitions. For example, in London, listings for visual art would go to *Time Out, Galleries, Artline, City Limits, Arts Review, Art Monthly, British Journal of Photography* (for photo exhibitions), *The Guardian* (on Saturday), *The Independent* and *The Standard.* Out of London visual arts listings are found in local newspapers and *The Guardian, Arts Review, BJ, The Artist* and some women's magazines. If you want to cover the whole of the UK and you can obtain a good colour transparency which is unusual enough send it to the colour supplements *The Sunday Times, The Observer* and *The Sunday Telegraph)* six weeks before the show opens and include a press release. Don't forget a *contact address* and *phone number for further information* at the end.

Exhibition card: Sometimes a separate card is sent with no private view invitation, to the press and to people that one does not want to add to the private view list due to shortage of space. This should have *clear information and a photograph* on it. Alternatively a card can be stamped with the private view details to save money and included or not as you wish.

Catalogue: For those who can afford the cost, it is well worth producing a small catalogue. This can be sold at Dillons Arts shop, the ICA or other art bookshops after the show is over. Most catalogues are sent to art critics and select mailing-list people. The price of producing one is therefore extremely high. Colour is the main expense so using black and white can be a good alternative. Always avoid a very cheap catalogue—it's probably better to do without and save for the next exhibition when you can afford one. Check with several printers for prices as they vary enormously. Make sure they are reliable as well , to save upset and delays. Ask local galleries for names of good printers locally and then visit them in person to see if they will do small jobs.

Private view night: When the press arrive it is advisable to have black and white photographs ready if they intend to write a review or mention the show. Artists often forget about this. Journalists like to have work made easy for them and the editor might ask for a photo but not have a spare photographer to send along that evening.

Whatever happens do not get depressed if the press do not come to the opening. They may prefer to come along during the week when they can see the work without hordes of artists clamouring for a mention. If, after following all this advice, nothing is mentioned, then it certainly isn't for want of trying or planning. It's probably just that there are too many exhibitions on at the same time or perhaps your particular exhibition was not different or unusual enough. Remember that the press thrives on new and varied news items. It bears no reflection on your work, only on the level of readership of the paper.

Remember that *listings* should always be put first in case reviews are not forthcoming, and information should be sent *separately* if you also intend to mail the art critic or journalist as listings will invariably be dealt with by a different person.

Local radio is also a useful source of publicity. Contact the arts section to see if they will mention the exhibition on an arts programme for the week.

Below is a list of newspapers and art magazines that cover art exhibitions and art events. See the section on art magazines for other specialist publications. It's worthwhile phoning them to see if they'd be interested in coming along. Wherever you live in the UK find the name of the art critic on your local paper and inform him or her, as mentioned above, at least two weeks before the show opens.

ART REVIEWS

Most national and local newspapers, as well as art magazines, publish reviews of current exhibitions weekly, or monthly. Some of these papers and magazines are listed below together with the art critics who write for them on a regular basis. As many of them write freelance it is also advisable to give them advance notice as they make take time to receive the information.

Newspapers and general magazines

Daily Express, 121/128 Fleet Street, London EC4P 4JT. Tel. 01-353 8000. (John Walsh).

Daily Mail, Carmelite House, Carmelite Street, London EC4. Tel. 01-353 6000. (Corina Honan/ entertainment).

Daily Mirror, 33 Holborn Circus, London EC1P 1DQ. Tel. 01-353 0246. (News editor).

The Daily Telegraph, South Quay Plaza, 181 Marsh Wall, Isle of Dogs, London E14 9SR. Tel. 01-538 5000. (Richard Dorment).

Sunday Telegraph, South Quay Plaza, 181 Marsh Wall, Isle of Dogs, London E14 9SR. Tel. 01-538 5000. (Michael Shepherd).

Financial Times, Bracken House, Cannon Street, London EC4P 4BY. Tel. 01-248 8000. (William Packer).

The Guardian, 119 Faringdon Road, London EC1. Tel. 01-278 2332. (to be appointed).

The **Observer**, Chelsea Bridge House, Queenstown Road, London SW8 4NN. Tel. 01-627 0700. (William Feaver).

The **Observer Colour Magazine**, (Chelsea Bridge House, Queenstown Road, London SW8 4NN. Tel. 01-627 0700.

The **Times**, 1 Pennington Street, London E1 9XN. Tel. 01-481 4100. (John Russell-Taylor).

The **Sunday Times** and the **Sunday Times Magazine**, 1 Pennington Street, London E1 9XN. Tel. 01-481 4100. (Marina Vaizey—Sunday Times) (John McEwen—Magazine).

The **Times Educational Supplement**, Priory House, St Johns Lane, London E1. Tel. 01-253 3000. (Michael Church).

International Herald Tribune, 103 Kingsway, London WC1. Tel. 01-242 5173. (Max Wykes-Joyce).

The **Standard**, 118 Fleet Street, London EC4. Tel. 01-353 8000. (Brian Sewell).

The **Glasgow Herald**, 195 Albion Street, Glasgow G1 1QP. Tel. 041-552 6255. (Clare Henry, Alice Bain).

The **Scotsman**, 24 North Bridge, Edinburgh EH1 1QG. Tel. 031-225 2468.

The **Illustrated London News**, 4 Bloomsbury Square, London WC1A 2RL. Tel. 01-404 4300. (Edward Lucie-Smith).

New Statesman Magazine, 10 Great Turnstile Street, London WC1V 7HJ. Tel. 01-405 8471. (John Spurling).

The **Spectator**, 56 Doughty Street, London WC1N 2LL. Tel. 01-405 1706. (Giles Auty).

Time Out, Tower House, Southampton Street, London WC2. Tel. 01-836 4411. (Sarah Kent).

Vogue, Vogue House, Hanover Square, London W1R 0AD. Tel. 01-499 9080. (William Feaver).

City Limits, 8–15, Aylesbury Street, London EC1. Tel. 01-250 1299. (Mark Currah).

The **Independent**, 40 City Road, London EC1Y 2DB. Tel. 01-253 1222. (Andrew Graham-Dixon).

Television and Radio

BBC Radio, Portland Place, London W1A 1AA. Tel. 01-580 4468. (Future events unit send 12 copies of press release well in advance).

Kaleidoscope, (arts programme) **Woman's Hour, Today** (interviews).

BBC TV, TV Centre, Wood Lane, London W12 7RJ. Tel. 01-743 8000.

Arena, Leslie Megahey, **The Lively Arts**, **General Arts features** (Christopher Martin).

Breakfast Time, Lime Grove, London W12 7RJ. (art interviews possibly.

London Weekend Television, Kent House, Upper Ground, London SE1. Tel. 01-261 3434.

Thames TV, 316 Euston Road, London NW1 3BB. (Arts: Francis Coleman).

Capital Radio, Euston Tower, Euston Road, London NW1. Tel. 01-388 1288. Art Beat, News Interviews.

LBC, PO Box 261, Gough Square, London EC4P 4LP. Tel. 01-353 1010. (art news).

TV Am, Breakfast TV Centre, Hawley Crescent, London NW1 8EF. Tel. 01-267 5483. Regionally there are various local radio stations and independent television is divided into **Scottish TV** based in Glasgow, **Grampian** (Aberdeen), **Yorkshire TV**, **TV South West**, **Central** and **Southern**.

Channel 4, 60 Charlotte Street, London WC1. Tel. 01-631 444. (Michael Kustow).

ART MAGAZINES

Alba, Talbot Rice Art Centre, University of Edinburgh, Old College, South Bridge, Edinburgh EH8 9YL. A new quarterly magazine started 1987 to comment upon the state of contemporary visual arts within Scotland and internationally. £4.00 subscription per annum. Editor: Peter Hill.

AND, Journal of Art and Art Education, 10 Swanfield Street, London E2 7DS. Tel. 01-739 7380. Subscriptions UK £4.50 Europe £10.00.

Apollo, 22 Davies Street, London W1Y 1LH. Tel. 01-629 3061. Editor: Denys Sutton. Glossy monthly publication with articles about art and antiques for collectors. £3.00 per issue or £48.00 Annual subscription UK Overseas £52.00.

Art and Design, Academy Editions, 7/8 Holland Street, London W8 4NA. Tel. 01-402 2141. £35.00 per annum UK $75.00 USA. 6 double issues covering subjects such as 'Sculpture Today' and 'The New Modernism'. Also publishers of **Architectual Design** £45.00 UK.

The **Artist**, 102 High Street, Tenterden, Kent. Tel. 05806 3673. £1.00 monthly annual subscription £12.00. Art magazine for amateur artists with useful tips on painting.

Art Monthly, 36 Great Russell Street, London WC1. Tel. 01-580 4168. Editors: Peter Townsend and Jack Wendler. 10 issues per annum. Magazine with news, reviews, criticism interviews, monthly artlaw column and correspondence from artists, dealers, gallery directors and historians. £1.20 UK sub £12.00 outside UK £15.00 outside Europe $40.00.

Arts Alert, Greater London Arts Association, 9 White Lion Street, London N1. Editors: Barry Jackson. Free magazine covering London arts news.

Artscribe, 41 North Road, London N7 9DP. Tel. 01-609 2339/2029. Editor: Stuart Morgan. Lively art magazine with lengthy interviews and reviews of contemporary painting, sculpture, performance and other art events. £1.50 Annual subscription £12.50 UK Europe £26.50 Overseas £40.00.

Artists Newsletter, PO Box 23, Sunderland SR1 1EJ. Tel. 091-567 3589. Editors: Sue Jones and Richard Padwick. Published by Artic Producers with the aid of a grant from Regional Arts Associations.

Useful magazine listing suppliers, awards, exhibitions, every useful piece of information that they can glean from organisations that will help artists. £8.50 sub per annum Institutions £15.00 Overseas £25.00.

The Artists and Illustrators Magazine, 6 Blundell Street, London N7 9BH. £1.25 per copy or £15.00 per annum subscription. Artnews, Buyers Guide and practical projects. For amateurs and professionals.

Art Line, 3 Garratt Lane, London SW18. Tel. 01-870 0427. Annual sub £15.00 USA $50.00 £1.50 per issue. Lively art news magazine with newsy approach to features, gossip, reviews, art world interviews. Run by Mike von Joel. Reports from Paris, Milan, New York, Berlin and large Scottish section. UK listings for exhibitions.

Arts Alive, Merseyside Arts free magazine. Tel. 051-709 0671.

Artseen, 25 Charterhouse Works, 7 Eltringham Street, London SW18 1TD. Tel. 01-877 0233. Editor: John Kemp, Newish art magazine. Features, listings.

Arts in Action, Arts Council's free bulletin.

Arts Express, 43 Camden Lock, London NW1 8AF. Tel. 01-267 0972/3/4. £13.00 Annual sub Overseas £39.00 Arts and art education coverage, jobs, workshops and more.

Artwork, School Road, Gartocharn, Alexandria G83 Scotland. Free newspaper guide to the arts and crafts in Scotland. Also available for £4.50 for 12 issues.

Arts North, Northern Arts, 10 Osborne Terrace, Newcastle on Tyne. Tel. 0632 816334. Editor: Tim Brassell. Guide to arts events in the north of England with interviews, articles etc. Free.

Arts Review, 69 Faroe Road, London W14 0EL. Tel. 01-603 7530 or 8533. Editor: Graham Hughes. Fortnightly magazine with listings of London and regional art exhibitions, art reviews and news. £1.80 Annual subscription £35.00 Overseas £43.00 USA $54.00 Airmail. They also publish *Arts Review Yearbook* £11.00 annually.

Atlas, The Woolley dale Press, 44 Bromwood Road, London SW11 6HT. £2.95 per issue or $6.00 Add $4.00 airmail if required. An artists magazine run by Jake Tilson.

Audio Arts, 6 Briarwood Road, London SW4. Tel. 01-720 9129. Editor: William Furlong. Quarterly publication on audio cassettes with slides. Covers performances, events, documentation of work by known UK artists.

Bazaar, South Asian Arts Forum Diorama Arts, 18 Park Square, East London NW1 4DT. Tel. 01-935 9183. £1.50 per copy. £5.00 for 4 issues. Quarterly South Asian Arts magazine.

Mike von Joel of Artline magazine at his Line Art gallery London SW18

Block, Middlesex Polytechnic Art History Department, Cat Hill, Cockfosters, East Barnet, Herts. Tel. 440 7431 ext 224. Articles on performance, art historical research, exhibitions. £3.50 Annual sub £4.00 Overseas.

British Journal of Photography, 28 Great James Street, London WC1. Tel. 01-404 4202. Editor: Geoffrey Crawley. Established weekly photographic magazine with photo news, reviews and articles. Fortnightly photo exhibition listings.

Burlington Magazine, 10–16 Elm Street, London WC1A 2B4. Tel. 430 0481. Editor. Monthly art journal for art historians, directors, curators and private collectors. Annual subscription £82.00.

Blueprint, 26 Cramer Street, London WC2. Subs to BKT, Dowgate Works, Tonbridge, Kent TN8 2TS. Lively newish architectural magazine printed in large format like the American Skyline. Essential for anyone interested in British contemporary architecture. Editor: Deyan Sudjic.

Camera, Bretton Court, Peterborough. Tel. 0773 264666. Editor: Richard Hopkins. Articles on equipment and portfolios in colour and black and white of work by UK photographers. 95p Annual sub £12.50. *Practical Photography* also at this address.

Camerawork, Half Moon, 119 Roman Road, London E2. Tel. 01-980 6256. Photo paper/magazine with emphasis on photography as a medium for social change. Documentation of social photography and useful technical information.

Circa, 22 Lombard Street, Belfast BT1 1RD. Tel. 0232 230375. UK £15.00 $36.00 USA £1.50 per issue. Irish art magazine.

Crafts, 12 Waterloo Place, London SW1. Tel. 01-839 6306. Editor: Martina Margetts. Published every two months with news and reviews articles and book news.

Craftwork, SDA Rosebery House, Haymarket Terrace, Edinburgh EH12 5EZ. £1.50 per copy or £5.00 Annual subscription. Scottish Crafts magazine subsidised by the Scottish Development Agency. Colourful.

Creative Camera, Battersea Arts Centre, Lavender Hill, London SW11. Portfolios of photographs by known and unknown photographers.

Design, 28 Haymarket, London SW1. Tel. 01-839 8000. Editor. Monthly publication for designers, design students to design managers. Covers graphics, textiles, interior and product design. £1.50 Annual sub £16.00. Available at the Design Centre bookshop along with other design magazines.

The Face, Old Laundry Buildings, Moxon Street, London, W1. Occasional art feature articles. Fashionable magazine covering rock, fashion and lively events. Large circulation by art magazine standards. Anthony Fawcett covers their art articles. Editor: Nick Logan.

Feminist Art News, £17.50 for 10 issues. 34 Sandford Road, Birmingham B13 9BS. A magazine by women artists for women artists.

Flash Art, UK distribution. P.I.P. Tel. 01-388 4060. £4.00 per issue and Annual subs £25.00 Covers international art reviews, art feature articles keeping a tab on art movements internationally in Europe, USA, Britain and Australasia. Glossy, colour photographs.

FMR, magazine, 16 Royal Arcade (Old Bond Street), London W1X 3HB. Tel. 01-499 8363. Subscriptions £42.00 $66.00 per annum. Luxury glossy art magazine. Full colour, no expense spared.

Galleries, magazine, 54 Uxbridge Road, London W12. Tel. 01-740 7020. Monthly gallery listings for London and the South/South West of England with features and index of artist/specialist area listings at the back. £12.00 per annum.

Modern Painters, Central Books, 14 Leather Market, London SE1 3ER. Tel. 01-407 5447. Subscriptions £14.00 UK $30.00 USA. Editor: Peter Fuller. A new glossy quarterly. Editorial address: 10 Barley Mow Passage W4 4PH. Tel. 01-994 6477.

Performance Magazine, 61 Hackney Road, London E2.Tel. 01-739 1577. 90p per copy annual sub £6.50 institutions £11.00. Performance and art related events in the UK and internationally.

Print Out, Bells Court, Pilgrim Street, Newcastle on Tyne NE1 6RH. Annual sub £4.00 for 3 issues. Photographic magazine covering individual photographers portfolios.

RA Magazine, Royal Academy, Burlington House, London W1. Tel. 01-439 7438. Free to the 48,000 Friends of the Royal Academy. Editor: Nick Tite.

Studio International, 4th Floor, Southampton Street, London WC2. Tel. 01-379 6005. Glossy art magazine covering international art events and art reviews in detail. £5.00 or £20.00 per annum sub $45.00.

Scottish Arts Review, Kelvingrove Art Gallery and Museums, Glasgow. Tel. 041-334 1134. Editor: Patricia Bascom. Published twice a year with articles on art and art history. £1.00 or free to members of the Gallery and Museums Association in Glasgow. Colourphotos.

Undercut, c/o London Film makers Cooperative, 42 Gloucester Avenue, London NW1. Tel. 01-586 4806. Subs £6.00 UK and £10.00 abroad.

Variant, 76 Carlisle Street, Glasgow G21. £1.00 plus 40p p&p per issue. Scottish arts magazine with interviews, exhibition listings and art articles.

South East Arts magazine, 10 Mount Ephraim, Tunbridge Wells, Kent TN4 8AS. Tel. 0892-41666. Free arts magazine covering the South East Arts area. £3.00 for monthly mailing of Arts Desk.

Watercolours and Drawings, London House, 271–3 King Street, London W6. Tel. 01-741 8011. £1.00 per issue £6.00 annual subscription £9.00 Overseas. International magazine for the collector of watercolours and drawings published quarterly.

Zoom, 2 Rue Faubourg Poissonière, 10 eme Paris, France. Tel. 523 3981. Excellent glossy photo magazine and occasional visual arts events—international.

Most art and photography magazines can be obtained at local arts centres, galleries and specialist art bookshops and occasionally at WH Smiths if circulation is over 10,000/15,000.

ART BOOKSHOPS

London

The Art Book Company, 18 Endell Street, London WC2. Tel. 01-836 7907. Books on design history, graphics, advertising, cinema history and photography.

Dillons Arts Shop, 8 Long Acre, London WC2. Tel. 01-836 1359. Open: Mon–Sat 10 a.m.–7.45 p.m. Good selection of art books, art magazines, photography books, general books, art postcards, artist's books and much more.

Arts Bibliographic, 37 Great Russell Street, London WC1B 3PP. Tel. 01-636 5320. Good selection of art books; also mail order service.

Compendium Books, 234 Camden High Street, London NW1. Tel. 01-485 8944 or 01-267 1525.

Ian Shipley (Books) Ltd., 70 Charing Cross Road, London. Tel. 01-836 4872. Specialist art booksellers.

St George's Gallery Bookshop, 8 Due Street, St James, London SW1. Tel. 01-930 0935. Good selection of art books, especially historical.

London Art Bookshop, 7–8 Holland Street, London W8. Tel. 01-937 6996. Good selection of most art books.

Design Centre Bookshop, 28 Haymarket, London SW1. Tel. 01-839 8000.

Peter Stockham Ltd., 16 Cecil Court, London WC2. Tel. 01-836 8661. Secondhand art books.

Creative Camera, Battersea Arts Centre, Lavender Hill, London SW11. Art Bookshop and large mail order business for photographers and artists.

Triangle Bookshop, 36 Bedford Square, London WC1. Tel. 01-631 1381. Art and arhitectural books. Open: 10 a.m.– 6 p.m.

Nigel Greenwood Inc. Ltd. Books, 4 New Burlington Street, London W1. Tel. 01-434 3797/8. Publishes a list of books for sale. Good selection of art and artist's books.

Camden Arts Centre Shop, Arkwright Road, London NW3 6OG. Tel. 01-435 2643/5224. Joint venture with Atlantis to give North West London a major art materials and art bookshop outlet. Open: 9.30 a.m.–7.00 p.m. Monday–Thursday. Sunday 2 a.m.–6 p.m.

Dillons, 1 Malet Street, London WC1. Tel. 01-636 1577. Excellent art section.

ICA Bookshop, ICA, The Mall, London SW1. Tel. 01-930 0493. Selection of books, catalogues, magazines for visual arts, performance, photography, video and general literature books. Bookshop within an art centre context.

W. & G. Foyle Ltd., (Art Department), 119 Charing Cross Road, London WC2. Tel. 01-437 5660. Large selection of art books and art related subjects.

A. Zwemmer Ltd., 24 Litchfield Street, London WC2. Tel. 01-836 4710. Art bookshop with large selection of books on art, architecture and art related subjects.

Many small galleries sell art magazines and small art books and artist's postcards. Royal Academy AIR, ICA, Photographers gallery. Camden Arts Centre and the Serpentine fall into this category, as do Whitechapel, Riverside Studios and Edward Totah gallery.

Royal Academy Bookshop, Royal Academy, Burlington House, London W1. Tel. 01-439 7438. Art books, art materials, postcards etc.

Tate Gallery Bookshop, Tate Gallery, Millbank, London SW1. Large bookshop with postcards, calendars, art books and art slides. Open gallery hours. Reductions for Friends of the Tate.

Photographers Gallery, 8 Great Newport Street, London WC2. Tel. 01-240 5511. Larger bookshop now that the gallery has expanded. Good selection of photographic magazines, photography books and other art related books.

Crafts Council, 8 Waterloo Place, London SW1. Tel. 01-930 4811. Craft, art books and magazines.

Serpentine Gallery Bookshop, Kensington Gardens, London W2. Tel. 01-402 6075. Arts Council books, catalogues and art magazines.

Contemporary Applied Arts, 43 Earlham Street, London WC2. Tel. 01-836 6993. Bookshop downstairs stocking craft books and magazines.

Falkiner Fine Papers, 76 Southampton Row, London WC1. Tel. 01-831 1151. Bookshop.

Waterstones, 191-195 Kensington High Street, London W8. Tel. 01-937 8432/3. Good art department. 99–101 Old Brompton Road, London SW1. Tel. 01-581 8522/3. 121-125 Charing Cross Road, London WC2. Tel. 01-434 4291/2. Also Hampstead now and branches in Bath and Edinburgh.

Elsewhere in the UK

Many arts centres, galleries and other centres for artists sell art magazines and small art books. A very incomplete list of art bookshops is given below. Most major bookshops in British cities have an art section.

Third Eye Bookshop, Third Eye Centre, 350 Sauchiehall Street, Glasgow. Tel. 041-332 7521. Good selection of art magazines and art books.

City Art Centre, 14 Market Street, Edinburgh. Catalogues and art books.

The Public House Bookshop, 21 Little Preston Street, Brighton. Tel. 0273 28357. Bookshop; also performance and poetry events.

Oriel Bookshop, 53 Charles Street, Cardiff, Wales. Tel. Cardiff 395548.

Newlyn Orion Art Gallery Bookshop, Penzance, Cornwall. Tel. 0736 3715.

Ceolfrith Bookshop, Northern Centre for Contemporary Art, 27 Stockton Road, Sunderland. Tel. 091-514 1214.

Arnolfini Bookshop, Narrow Quay, Bristol. Tel. 0272 299191.

South Hill Park Arts Centre, Bracknell, Berkshire. Art books, postcards and craftwork.

South West Arts, 23 Southernhay, Exeter, Devon. Tel. 0392 38924. Bookshop for art poetry, fiction and art catalogues.

Newcastle Bookshop, 1 The Side, Newcastle on Tyne NE1. Tel. 0632 615380. Both new and secondhand art books.

Side Gallery, 9 The Side, Newcastle on Tyne NE1 3JE. Photographic books and magazines.

Museum of Modern Art Bookshop, 30 Pembroke Street, Oxford. Books, magazines, postcards and copious space to look at them.

Ikon Gallery Bookshop, 58/72 John Bright Street, Birmingham B1 1BN. Tel. 021-643 0708.

Corner House Bookshop, 70 Oxford Street, Manchester M1 5NH. Tel. 061-228 7621. Lively bookshop in an arts centre.

ON BEING AN ART CRITIC

To gallery owners, managers and directors who claim they do not see critics often enough; and to disappointed exhibitors who have either been reviewed favourably or altogether unnoticed, the art critic appears a layabout or parasite, only to be glimpsed at the plush galleries being served smoked salmon and caviare canapes at their press/private views. A mite more knowledge of the critic's lot would, I suggest, lead to less obloquy on all sides.

As London art critic for the global daily, the *International Herald Tribune*, with a vast sophisticated and cosmopolitan readership, for which I write 50 columns a year; exhibitions reviewer for the monthly *Art and Artists*, with a more specifically art-orientated readership; and occasional writer reviewer, often historically, ceramically or Orientally specialist, for other papers and magazines, I have to make it my business carefully to look at as many exhibitions as possible.

To date (I write these notes on a bright November morning, aboard a train heading for the West Country, there to do a round of rural galleries) I have this year received invitations to view 1583 exhibitions. Of that total, I last night went to my 359th of the year, the first show in England of a young Russian-born sculptor now living and working in Sweden. Of those 359 my editors have afforded me space—a generous and untypical allowance it must be said—to review just over 200.

Even so, however, the trials of the art critic are just beginning. Music critics, for example, are allowed, indeed encouraged, to specialise—in opera, ballet, the classics, jazz, folk or pop; not so the art critic. He, or she—for 3 of every 8 members of the British section of AICA (the International Association of Art Critics) are women—is expected by his/her readership to have a detailed knowledge of every art and craft, not matter how exotic or esoteric.

In the past few weeks I have written what I believe and hope to be knowledgeable and informative pieces on Japanese *Netsuke, inro* and lacquer; ceramic panels illustrating turn-of-the-century motor races in Europe; the work of a Polish portraitist about to exhibit in Florida and California; the London showing of an Art Nouveau collection in the permanent collection of the University of East Anglia; a catalogue introduction for an Italo-Welsh painter mounting a major retrospective in Switzerland; major articles on George Stubbs, the Danish Golden Age, Dutch 17th-Century Genre Painting, the Thyssen Collection, and Anglo-Saxon manuscripts; contemporary book illustration; Matisse; Chinese porcelains; Varga, the centrefold pinup painter for *Esquire*; and the Scots-Irish master Sir John Lavery.

When, despite such activities, activities typical of British art critics, I am once more taken to task by artist or gallery keeper, I console myself by enquiring how many among them have been accorded a spontaneous tribute in the form of a book of essays and illustrations to mark his 60th birthday, as was Dr. Paul Hodin. The Committee of Honour for the tribute included, among artists Dame Barbara Hepworth, Henry Moore, Bernard Leach and Oskar Kokoschka; among historians and critics Dr. Argan, Professor of Art History in the University of Rome, the German critic Franz Roh, the Czech critic Vladimir Vanek, and the doyen of English critics, Sir Herbert Read. Among contributors to the book were the sculptors Emilio Greco, Giacometti, Manzu and Marini; the composers Prialux Rainer and Elizabeth Lutyens; the

poet Michael Hamburger; the Italian man of letters and historian Mario Praz; and the philosopher Lancelot Law Whyte.

The book appeared in 1965. Twenty years later Paul Hodin is still practising his profession as a critic—delivering a course of art history lectures in the University of Vienna, and working on studies of the sculptor Dame Elizabeth Frink and the Austrian mannerist painter Franz Luby. If artist and gallery keeper are honest they must admit that such critical activities are essential to the future well-being of the visual arts in Britain.

MAX WYKES-JOYCE
GALLERIES—AN ALTERNATIVE VIEW FROM THE EAST END

The cynic would perhaps describe the commerical gallery system as a closed shop, although, personally, I know many otherwise optimistic spirits who hold the same view. In reality, of course, for the majority of artists the galleries are an irrelevance in the career stakes, simply because the number of artists far outweighs the capacity of galleries to show them.

My experience at Art School was that the crass commercialism of selling was treated with mock disdain and seldom mentioned. The successful artist was always a remote figure. If fame and fortune came to anyone too close to home, it was obviously ill-deserved, a fickle whim of fate, or, the ultimate reserve in put-downs, the old boy network. It was never anything to do with native talent. It's hard to imagine Da Vinci or Michelangelo's first successes so begrudgingly acknowledged by their contemporaries, although, as an historical footnote, they were.

Genius is rare. At best, each decade produces one or two, the market leaders, in whose wake every other artistic product follows. If that sounds cynical, remember that any gallery is first and foremost a commercial proposition, trying to sell its wares in a difficult and highly competitive market. True genius being in short supply, the price tag is more likely to reflect the packaging—the cost of promotion and of maintaining the gallery and its staff—than any qualitative distinction between one work of art and another. The cherished belief that the top commercial galleries effectively filter out the available talent is, for a variety of reasons, little more than wishful thinking. Ultimately, the only criteria for judging how an artist will survive the rigours of time, is time itself. What the galleries do hold an exclusive charter over, of course, is status, although it would clearly be rash to confuse status with quality. The discriminating spectator, whether a critic, collector or interested bystander, is no more disadvantaged than the gallery owner, who indeed is forced b contract (if not loyalty) to commit him or herself to a relatively small stable of hopefuls.

Having dismissed the prejudice that a handful of galleries hold the monopoly over talent, the spectator, whatever his starting point, is really left to his own devices. My advice is simple, although, particularly in London, the variety of galleries and the work they show can be bewildering. Overlooking the sometimes frosty gaze of the receptionist and the reverent stillness common to both churches and galleries, do make use of the facilities and become familiar with the range of work individual galleries are involved in. When a particular artist interests you, talk with the gallery staff (they may have other work by the artist which is not on public view). On average a gallery changes exhibitions once a month. If you like the direction taken by a gallery, ask to be put on the private view invitation list. Most views are attended by the artist, so take the opportunity to talk about the work (any compliment is a good opening line). Do remember that the artist is probably feeling very anxious at the opening of an exhibition. Defensively, many appear to oversell themselves, but then, if the artist doesn't have complete faith in the work, no-one else will. Finally, if you are seriously interested in the work of a particular artist, a visit to the studio might be arranged, which is perhaps the most rewarding and enjoyable way of seeing art.

By far the majority of artists are not associated with a particular gallery, although this should never be seen as an outright reflection on the quality of their work. Many can be contacted at private views, as the smell of blood and the promise of free wine acts like a magnet within the artistic fraternity. Most artists will endeavour to exhibit at the smaller galleries (often on a pay-your-own-way basis) at least once a year, so always ask if they have a show coming up. Many work in the various studio blocks (see *Studios*) where often annual open studio exhibitions are held. This is an excellent opportunity for seeing the artist and work together, but it relies on the visitor taking a little more initiative, as lack of finance generally restricts publicity and the studio many only be open to the public for a few days each year. A hidden advantage is that here you are not paying for the expensive packaging that is inevitable when gallery overheads, often astronomical, have to be considered.

The problem of creating more exposure for artists in this position is one of great personal interest; several years ago Martin Lilley and I launched an approach to the problem under the name of Albion Contemporary Arts. Our main aim was to bring together a large number of young, London-based artists under one umbrella and to create exhibition opportunities and alternative approaches to public exposure. I wouldn't claim this was a serious challenge to the established gallery system, but clearly there is room for alternative viewpoints and we have been instrumental in organising numerous exhibitions, both in this country and abroad. There is also a need to steer the public through the labyrinth of London's artistic underground, and here we act as guide and bearer for both individual and corporate collectors. At the time of writing, we have recently opened a new studio block at Cable Street in London's East End

where we are able to house over fifty artists. Although a far cry from the plate glass and fitted carpets of the West End Galleries, it is hoped that Cable Street Studios, in addition to its obvious function, will provide a further meeting point between artists and their public.
KEITH PATRICK
Cable Street Studios
566 Cable Street, London E1

Keith Patrick and Martin Lilley of Cable Street Studios, London E1

THE RISE AND RISE OF NEW BRITISH PAINTING

Back in 1981 it may have seemed just a bit Quixotic to open a gallery in London, to back a new generation of British painters in a market as conservative in taste as that of the UK. It's one thing to sell Old Masters, 19th century French painting, and British art before 1950; quite another to campaign for newcomers straight out of the postgraduate schools. The visual arts have never been the backbone of English culture as they were, for instance, in 17th century Holland where pictures were bought and sold as commonly as books and periodicals in Britain today. The English have long been resistant to the art of their time— especially innovative art (though Charles I did buy an early Rembrandt self-portrait).

This traditionally wary attitude to the new contrasts sharply with practice in the US where a good collection of modern art can be a passport to social success: where museums of contemporary art are as much part of the social fabric as the great civic orchestras. The mammoth appetite for 20th century art of a Charles or Doris Saatchi is a rare phenomenon in the UK

Against this background, my feelings when opening the Paton Gallery in Covent Garden in 1981 were decidedly mixed. It was clear, on the one hand, that 'painting' was coming back; that the 'anti-painting' of 70's Minimalism and Conceptualism was being overtaken by a new generation that took to paint and figuration with a talent and conviction that must lead to a high international profile for British painting, not known since the 'Pop' artists of the 60s—Hockney, Blake, Kitaj and the rest.

My faith in the future was real enough. But doubts nagged. Who was going to buy the work of these unknown painters from the London postgraduate colleges around the early 80's? Would the critics take notice? The best advice at the time came from 'The Times' critic who said 'the best way to establish a gallery's reputation is by mounting good quality exhibitions regularly, but remember that a gallery is like a bookshop: it takes time for people to realise you're there'.

And so it was. It took some years to establish a core of collectors who would buy on a regular basis; further years to gain recognition as a platform for some of the best painters of the new generation. When

21

the Metropolitan Museum of Art in New York began to buy paintings from the gallery for its 20th century collection, there was a distinct sense of 'having arrived'; it was also confirmation at the highest level that new British painting was going to be a force, internationally, in the late 20th century and beyond, a point underlined by the trans-Atlantic success of the so-called New Glasgow Painters whose key figures—Steven Campbell and Adrian Wiszniewski—were being collected avidly by US museums and collectors.

What has seemed to me, at any rate, a veritable Niagara of talent pouring out of the UK art schools over the last year or so has given the media much food for thought—and hype. Glossy monthlies feature the latest rising 'star'; TV cameras prowl young studios and lives. The notion spreads that British painting is in the ascendancy, that its purchase—at least in the early stages—is fun: and relatively inexpensive (see the splendid success of the annual Contemporary Art Society's market).

Even the major West End galleries now include a representative or two of the young new painters amongst the Picassos, Expressionists, Bacons and other modern masters they purvey to the world.

1988 could see advance into the US heartlands—literally, since the Cincinnati Contemporary Art Center will be touring an exhibition: 'NEW BRITISH PAINTING' (26 painters under 45, five from the Paton gallery) through the mid-West, thus alerting American collectors to the fact that there is life beyond Julian Schnabel and his (expensive) kind.

As the word gets about that the British David is about to attack the international Goliaths of international painting (preceded, that is, by the cohorts of new British sculpture: Bill Woodrow, Richard Deacon and the rest), a welcome spin-off has been the rapid growth of new galleries in London itself, both around Notting Hill and the City fringes, all winnowing through the latest crop of graduates for the future heroes of British painting and sculpture.

'Form' studying gets more intensive each year. It is common for the degree show of an evident 'high flyer' to sell out, with galleries vying for the artist, not only at the Glasgow School of Art with its aura these days of international glamour, but also at London's Royal College of Art.

The pioneering galleries of the early '80s must look upon all this activity in some wonderment (mission work it was in those early unsung days); and also with some degree of satisfaction that the consequences of early risk are now breasting a tide that extends from London to the US at the very least. And this is only the beginning: great promise, though, is one thing; the next phase as young artists come to maturity will decide who really **are** the lions of new British painting. There is a tendency on the part of many London reviewers to measure against ideological yardsticks—talents are celebrated often according to the degree to which they illustrate current international 'fashions'.

This is a pity since strong painters abound who work within a traditional British sensibility yet are thoroughly alert to the achievements of Modernism. It is a cliché that history so often reverses contemporary judgements in such matters; what is not at issue, however, is that never before has British painting been so various, gifted and likely to seize its share of the world stage. I myself am glad to have had the opportunity to participate keenly in such memorable times.
GRAHAM PATON
Paton gallery, Covent Garden, London WC2.

Graham Paton at the Paton Gallery, Covent Garden

Chapter 2
THE GALLERIES

LONDON

London Art and Artists Guide (editor Heather Waddell), also published by Art Guide Publications, has more information on some 600 galleries. Price £5.95.

THE ACTORS INSTITUTE GALLERY, 137 Goswell Road, London EC1. Tel. 01-251 8178. Gallery space on the fifth floor within the institute. Height 9ft width 50ft Policy to show paintings, drawings, designs, photos, textiles of first time exhibitors and or serious young artists. Hanging free per month £120 (1987). No commission taken. Director Ms Naomi Longman. Tel. 01- 582 5383.

ACTUALITIES, 152 Narrow Street, London E14. Tel. 01-515 6036. Opening: Thurs–Sun 1–7 and by appointment. Contemporary art and avant garde events.

AI MEI GALLERY, 205 Royal College Street, London NW1. Tel. 01-267 4597. Opening: Tues–Fri and Sun 3–6. Contact: Nancy Kuo, Guy Davis. Applications: They specialise in Oriental Art but other arts and crafts are also considered. Exhibition: The gallery is an art centre, its activities include; lectures/demonstration on Chinese calligraphy, painting, paper-cut, puppets, flower arrangement, cookery, also art classes, poetry reading etc. Artists showing regularly are Nancy Kuo and some leading artists of China. Space: Front gallery 15m rear gallery 10m.

AIR GALLERY, 6 & 8 Rosebery Avenue, London EC1. Tel. 01-278 7751. Opening: Mon–Fri 10.30–6, late evenings Tues and Thurs till 8. Contact: Sara Selwood. Applications: It is advisable for artists to acquaint themselves with the work handled by the gallery and the spaces available, before making an application. Application forms sent on request. Proposals should be specifically designed for the Air Gallery. Exhibitions: Artists who do not exhibit on a regular basis elsewhere and who have not had a recent major exhibition in London. Painting, sculpture and allied activities—music, dance, poetry, film, performance and video. Regional artists are encouraged to apply, as well as London-based. Space: 2000 sq. ft, on 2 floors, with approx. 200 linear ft of wall space, spotlighting and natural light. Basement has been converted into a performance space. There are usually two one-person shows running at the same time. Air Gallery is a service provided by

AIR and SPACE (Arts Services Grants Ltd) a registered charity which provides various services to visual artists, including a slide collection and studio space.

ALBERMARLE GALLERY, 18 Albermarle Street, London W1. Tel. 01-493 7968/491 1153. Large West End gallery space with exhibitions by major international artists. Opening: Mon–Fri 10–5.30, Sat 11–1.

ALDGATE BARRS GALLERY, Aldgate Barrs Shopping Centre, The Sedgwick Centre, Whitechapel High Street, London E1 8DX. Tel. 01-481 5344. Variety of exhibitions that have included collaboration with Artlease and Hardware Gallery. Young contemporary artists.

ALEXANDER ROUSSOS GALLERY, 22 Princes Street, London W1R 7RG. Tel. 01-493 1480. Director: Alexander Roussos. Gallery hours Tues–Sat 10–6. A lively new gallery that has shown work by Keith Haring as well as work by young international artists. Underground Oxford Circus.

ALWIN, 9–10 Grafton Street, London W1X 4DA. Tel. 01-499 0314. Opening: Mon–Fri 10–6, Sat 10–1. Exhibitions: 12 one-person shows per year, mainly sculpture.

AMALGAM ART LTD., 3 Barnes High Street, London SW13. Tel. 01-878 1279. Opening: Tues–Sat 10–1, 2.15–6. Contact: T A M Boon, A F Boon. Applications: Professional artists can apply but avoid Nov/Dec. Exhibitions: Specialises in contemporary ceramics, prints and studio glass. Shows English art and crafts. Space: one floor 15ft × 30ft.

AMWELL GALLERY, 31 Amwell Street, London EC1R 1VN. Tel. 01-837 7756. Opening: Varies with each exhibition. Contact: Elizabeth Dunbar/ Jane Blackstock. Applications: Professional artists can apply at any time. Exhibitions: One-man exhibitions, specialise in young, local painters, print makers, jewellers. Informal gallery that takes a very small commission on sales. Artists staff their own exhibitions. Space: one floor.

ANATOL ORIENT, Art of the Twentieth Century, 318 Portobello Road, London W10 5RU. Tel. 01-969 4119. Director Anatol Orient.

Ceramic exhibitions only. Lively gallery in the Portobello Road area. Participates in the Portobello Contemporary Art Fair annually in April. Now called **Michaelson & Orient.**

ANDERSON O'DAY, 255 Portobello Road, London W11. Tel. 01-221 7592. Opening: Tues–Sat 10–5.30. Contact: Prue O'Day. Applications: Considered at any time of the year. Exhibitions: Painting, prints, sculpture & drawings. Their exhibition programme covers a variety of exciting artists such as Mario Rossi. Space: one floor. Participates in the Portobello Art Fair in April. The artists whom they publish regularly include Ackroyd, Neiland, Wilkinson, Tinsley, Smallman, Orr, Fassolas at 5 St. Quintin Avenue, London W10. Tel. 01-969 8085. Contact: Don Anderson.

ANNELY JUDA FINE ART, 11 Tottenham Mews (off Tottenham Street), London W1. Tel. 01-637 5517/8. Opening: Mon–Fri 10–6, Sat 10–1 or by appointment. Contact: Mrs Annely Juda and David Juda. Applications: Professional artists can apply but at present they are fully committed for the next 3 years. Exhibitions: 20th century art including: Alan Green, Nigel Hall, Peter Kalkhof, Michael Kenny, Edwina Leapman, Michaeledes, Alan Reynolds, Christo, Al Held, and Russian Constructivism and Suprematism. Space: 3 rooms on 2 floors. Each room—13ft x 15ft approx.

ANTA, 46 Crispin Street, Spitalfields Market, London E1. Tel. 01-247 1634. Opening: Mon–Fri 10–6 and by appointment. Avant garde exhibitions.

ANTHONY REYNOLDS, 37 Cowper Street, London EC2. Tel. 01-608 1516. Director: Anthony Reynolds. Avant Garde Gallery. Gallery artists include Amikam Toren, Tim Head. Opening: Tues–Sun 11–6.

ARCHITECTURAL ASSOCIATION, 34 Bedford Square, London WC1. Tel. 01-636 0974. Opening: Mon–Fri 10–7, Sat 10–1.30. Occasional art and architectural exhibitions. Also Triangle Bookshop for art and architectural books.

ARGENTA GALLERY, 82 Fulham Road, London SW3. Tel. 01-584 3119. Opening: Mon–Sat 9.30–5.30. Exhibitions: Jewellery by about 30 younger designer/craftsmen.

ART FOR OFFICES, 15 Dock Street, London E1. Tel. 01-481 1337. Contact: Andrew Hutchinson and Peter Harris. Artists can submit 35mm slides of work and if suitable these will be shown to architects, designers and business clients. Gallery by appointment only. Prints, painting, sculpture, photography.

ART HOUSE, 213 South Lambeth Road, London SW8. Tel. 01-735 2192. Represents John Bellany and other contemporary artists. By appointment only or about advertised exhibition. Also Outsider Archive based on the 1979 Hayward gallery exhibition. "The Outsiders".

ARTISTS REGISTER, 110 Kingsgate Road, London NW6. Tel. 01-328 7878. Opening: 10–5 Weekdays. Contact: P. Sims, C. Cook, M. Rieser, A. Forbes. Applications: Open to applications any

time of the year. Exhibitions: Shows contemporary work including: Bennett, Butler, Cook, Forbes, Margrave, Mcgowan, Riese, Sims. Space: Gallery walls measuring 20ft × 8ft, ceiling 60ft × 10ft. Mezzanine adjoins ground floor.

ARTISTS REGISTER. Now run by Sue Williams gallery 320 Portobello Road, London W10. Tel. 01-960 6123. Work by some of the 65 members is on show here.

ARTLINE, 141–143 Kingston Road, London SW19 1LJ. Tel. 01-543 3755. A small gallery within a contemporary art interiors organisation. Not to be confused with Artline magazine which has its own gallery **Line Art.**

ARTSPACE, 84 St. Peter's Street, London N1. Tel. 01-359 7002. Lively contemporary paintings and drawings. Opening: Tues–Sat 2–7.

ASB GALLERY, 28 Bruton Street, London W1. Tel. 01-491 1333. Branches also in Switzerland and Germany. Major international artists. Opening: Mon–Fri 10–5.30 or by appointment.

ASSOCIATION OF ILLUSTRATORS GALLERY, 1 Colville Place, off Charlotte Street, London W1. Tel. 01-636 4100. Applications open to illustrators. Exhibitions of work by the members also; Chloe Cheese, Sue Coe, David Gentleman, Gerald Scarfe, Sarah Midda, Paul Hogarth and others. Opening: Mon–Fri 10–6.

ATMOSPHERE, 175 Muswell Hill, Broadway, London N10. Tel. 01-722 6058. Opening: Mon–Fri 10–6. Contact: Ian Freedman. Applications: By invitation only. Exhibitions: Major British craftsmen—jewellers, glass-blowers, potters, print-makers, weavers etc. Space: 2 floors 44ft × 27ft and 19ft × 27ft. Contemporary work only.

AUSTIN DESMOND have opened a new gallery in Pied Bull Yard, 15A Bloomsbury Square, London WC1. Telephone 01 242 4443 Directors John Austin William Desmond. Looking for new contemporary painters. Martin Fuller and 20th century British art.

BARBICAN ART GALLERY, Silk Street, London EC2. Tel. 01-638 4141 ext. 306/346. Art gallery curator John Hoole. Opening: Tues–Sat 11–7 (gallery hours changeable), Sunday and Bank Holidays 12–6. Closed Mondays. The Arts Centre has been much in the news since it opened in 1982. It houses The Royal Shakespeare Company, the London Symphony Orchestra, Barbican Library, three cinemas, one gallery (level 8), one exhibition space (level 5), the Waterside Cafe, the Cut Above restaurant, a conservatory, conference centre, thousands of yards of corridor and space to get lost in. There are many surprises including beautiful woodwork in the auditorium, an exciting series of murals by Gillian Wise-Ciobotaru with mirrors and in pastel colours on your way down to Cinema and an open air space in which to sit down and rest your weary feet. The gallery on level 8 has major exhibitions of historical interest often with parallel exhibitions of more contemporary interest. Further downstairs (on level 5) there is foyer and concourse space where artists can apply for exhibitions. Indian contemporary art, Canadian tapestry

have both been shown here and illustrations from books have also been shown in the foyer. Contact the Planning Dept. for details about both spaces. Ne fee charged but exhibitors have to pay for any expenses or security costs. Excellent access to the public.

BEDFORD HILL gallery, 50 Bedford Hill, London SW2. Tel. 01-675 5446. Opening: Mon–Fri 1–7, Sat 10–7. Contemporary recent paintings.

BENJAMIN RHODES, 4 New Burlington Place, London W1X 1SB. Tel. 01-434 1768/9. Directors: Benjamin Rhodes and Carol Kroch-Rhodes. Gallery artists are David Ben Zadok, Tricia Gillman, Eileen Cooper. Exciting gallery artists on show in a large two floor gallery space near Cork Street and Regent Street.

BEN URI ART GALLERY, 21 Dean Street, London W1. Tel. 01-437 2852. Opening: Mon–Thurs 10–5. Contact: A. Katz. Applications: Artists can apply for exhibitions. Exhibitions: Specialises in Jewish artists or Jewish themes by artists of any denomination. Space: one fllor, 50ft × 32ft approx. (walls).

BERKELEY SQUARE GALLERY, (see CCA Galleries), 23A Bruton Street, London W1. Tel.

01-493 7939. Director: Peter Osborne. Contemporary painting, sculpture and prints.

ANNE BERTHOUD GALLERY, 10 Clifford Street, London W1 9JY. Tel. 01-437 1645. Contact: Anne Berthoud. Opening: Mon–Fri 11–6, Sat 11–2 and by appointment. Exhibitions: Contemporary art; gallery artists include: John Elliot, Robert Mason, Victor Newsome and Michael Upton.

BIRCH AND CONRAN FINE ARTS, 40 Dean Street, London W1. Tel. 01-434 1246. Opening: Mon–Fri 11–6. Directors: James Birch and Sebastian Conran. Lively contemporary art and sometimes ceramics and other art forms. Underground Piccadilly Circus.

BLACK AND WHITES GALLERY, 50–52 Monmouth Street, London WC2. Tel. 01-836 4109. Photography gallery.

THE BLACK-ART GALLERY, 225 Seven Sisters Road, London N4 2DA. Tel. 01-263 1918. Exhibits work in all media by Afrikan-Caribbean artists.

BLACKHEATH GALLERY, 34 Tranquil Vale, London SE3. Tel. 01-852 1802. Opening: Mon, Tues, Wed, Fri, Sat 10–6. Contact: J. V. Corless. Exhibitions: Contemporary paintings, prints and sculptures.

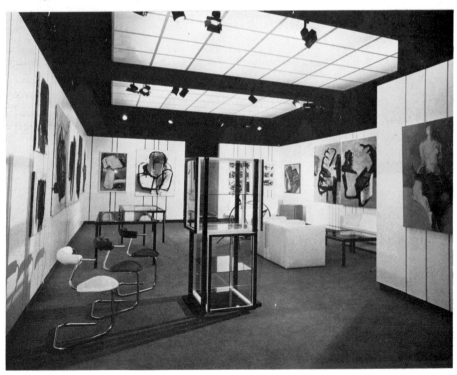

ASB Marketing Gallery, Bruton Street, London W1

BLOND FINE ART, Unit 10, Canalside Studios, 2–4 Orsman Road, London N1. Tel. 01-739 4383. 20th century British Art. By appointment.

BOILERHOUSE, The Conran Foundation, Butlers Wharf Business Centre, 45 Curlew Street, London SE1 2ND. Tel. 01-403 6933. The new Boilerhouse building will open in the future here rather than at its old home at th V&A Museum in Kensington. There will be major design related exhibitions and events and the building should be worth visiting on its own merits.

BOOKSHOP GALLERY, 4 Perrins Lane, Hampstead, London NW3 1QY. Tel. 01-794 2775. Opening: Tues–Sat 10–6, Sun 12–6. Contact: Leigh Middleton, Gail Goodwin. Exhibitions: Contemporary art, graphics, painting, sculpture, ceramics, frequent one-person shows.

BOOKWORKS, No. 3 Arch Green Dragon Court, Borough Market, London SW1. Tel. 01-378 6799. Opening: Wed–Sat 10–6. Exhibitions to focus interest on the book in contemporary art.

BOUNDARY GALLERY, 98 Boundary Road, London NW8. Tel. 01-624 1126. Opening: Tues–Sat 11–6. Near the Saatchi collection in NW8 and holds lively painting exhibitions of both historical and contemporary work. Jacob Epstein and young Scottish women painters, Australian painters are past exhibitions. Underground St. Johns Wood.

BROWSE & DARBY LTD., 19 Cork Street, London W1. Tel. 01-734 7984. Opening: Mon–Fri 10–5.30. Exhibitions: 20th century and contemporary painting and sculpture.

BUSINESS ART GALLERIES, 34 Windmill Street, London W1. Tel. 01-323 4700. Opening: Mon–Fri 10–6, Sat 11–5. Contact: Stephen Reiss. Applications: Artists need not make an appointment to show their work to the Director, but they must remove their work on the same day, after it has been viewed. Exhibitions: Contemporary British painters and printmakers recruited from the Royal Academy, Curwen and other sources. Set up in 1978 by the Royal Academy mainly to offer a comprehensive art service to businesses, but members of the public are welcome at the new gallery premises. Now in new premises.

Martin Fuller painting (Austin Desmond Fine Art)

26

BUSINESS DESIGN CENTRE, Upper Street, Islington Green, London N1. Holds a variety of art related events, including work on display by several galleries such as Leinster, Blond, and private dealers such as Chantal Scherrer to attract corporate and business buying of contemporary art.

CADOGAN CONTEMPORARY ART, 108 Draycott Avenue London SW3. Tel. 01-581 5451. Director: Christopher Burness. Opening: Mon–Fri 10–7, Sat 10–5. Lively colourful exhibitions of work by young professional artists both British and international. Well worth visiting as they have held shows of work by contemporary Chinese and Japanese Art.

CAFE GALLERY, By the Pool, Southwark Park, London SE16. Tel. 01-232 2170. Opening: 10–5, seven days a week. Has shown very lively work by local and London painters as well as other art related events.

CAHILL AND GREBLER, 65 Dalling Road, London W6 0JD. Tel. 01-741 3298. Directors: David Cahill and Gillian Grebler. Opening: Mon–Sat 9–6, Sun 11–3. Contemporary Art gallery with exhibitions and installations by UK and international artists. Interested in work by contemporary artists. Underground Hammersmith/Ravenscourt Park.

CAMDEN ARTS CENTRE, Arkwright Road, London NW3 6DG. Tel. 01-435 2643/5224. Opening: Mon–Thurs, Sat 11–6; Fri 11–8; Sun 2–6. Contact: Zuleika Dobson. Exhibitions: Contemporary art, photography and crafts, some historical shows. Space: Two large galleries, a foyer and a coffee bar used for small photographic shows. Garden space used for sculpture shows in the summer. Part of an educational centre offering courses in art and crafts.

CANADA HOUSE CULTURAL CENTRE, Canada House, Trafalgar Square, London SW1. Tel. 01-629 9492 ext 246. Opening: Mon–Fri 9.30–5. Contact: Michael Regan. Exhibitions: Monthly shows of Canadian art, mostly contemporary, also a cinema and autitorium for recitals + performances.

CARLILE GALLERY, 341 Goswell Road, London EC1. Tel. 01-837 1639. Opening: Tues–Sat 11–6. Lively contemporary art gallery. Has shown installations as well as painting and sculpture.

CCA GALLERIES, 8 Dover Street, London W1. Tel. 01-499 6701. Dover Street concentrates on the gallery's new print editions (100 a year). **Berkeley Square Galleries**, (CCA) 23A Bruton Street, London, W1. Tel. 01-493 7939. Director:

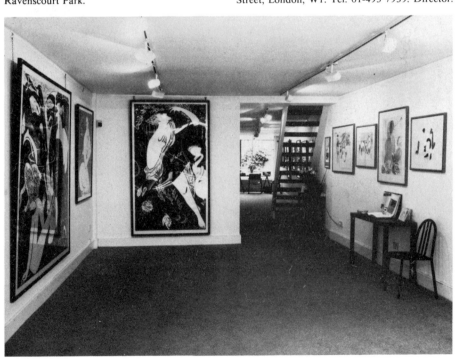

Olivier Raab paintings, Cadogan Contemporary Art, London SW3

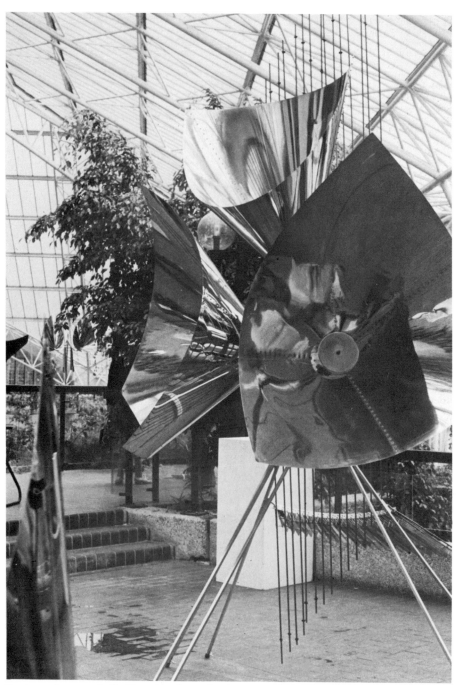

Baschet sculpture at the Barbican Arts Centre London

Peter Osborne. These new galleries will concentrate on contemporary painting, sculpture and master prints.

CENTAUR GALLERY, 82 Highgate High Street, London N6. Tel. 01-340 0087. Opening: Mon–Sat 11–6. Contact: Jan and Ddinah Wieliczko. Exhibitions: Contemporary painting and sculpture.

CENTRAL SPACE GALLERY, 23–29 Faroe Road, London W14 0EL. Painting, prints, drawings by professional artists. Opening: Mon–Sat 10–6. Sundays by appointment.

CENTRE 181, 181 King Street, London W6. Tel. 01-741 3696. Opening: Mon–Fri 10.30–5.30, Sat 11–2. Contact: Liz Taunt. Applications: Open to London artists to apply at any time. Exhibitions: One-man shows by young, London based, professional artists, monthly. Space: One floor, 30ft × 10ft.

CHALK FARM GALLERY, 20 Chalk Farm Road, London NW1. Tel. 01-267 3300. Temporary exhibitions in the first floor gallery and large selection of limited edition prints downstairs. Framing service and art card shop. Opening: Tues–Sun 10–5.30. Underground Chalk Farm/ Camden Town.

CHAPMAN GALLERY, 31 Lower Richmond Road, London SW15. Opening: Tues–Sat 11–7 or by appointment. Specialises in known British artists who have not received adequate recognition. Martin Fuller's work can be seen here as well as other established British artists. Underground Putney Bridge.

CHENIL GALLERY, 183 Kings Road, Chelsea, London SW3. Tel. 01-352 4689. Opening: Mon–Sat 10–6. Applications: Would like to hear from young professional artists interested in exhibiting, send s.a.e. for details. Exhibitions: Paintings, prints, photography, crafts, sculpture. Four open exhibitions are held annually.

CHISENHALE GALLERY, 64–84 Chisenhale Road, Bow, London E3 5EZ. Tel. 01-981 4518. Opening: Wed–Sat 12–6. Co-ordinator: Emma Dexter. Large Gallery space within a studio context. Chisenhale also has dance, performance and other live events.

CHRISTOPHER HULL GALLERY, 17 Motcomb Street, London SW1. Tel. 01-235 0500. Director: Christopher Hull. Lively contemporary art exhibitions.

CITY ARTISTS ASSOCIATION, 75–79 East Road, N1. Tel. 01-253 2068. Artist run gallery. Contact Richard Trench and George Foster.

CLAUS RUNKEL FINE ART, 97 Cambridge Street, London SW1V 4PY. Director: Claus Runkel. Specialises in 20th century paintings, drawings and sculpture. Has shown work by the innovative sculptor Will Maclean.

COCKPIT GALLERY HOLBORN, Cockpit Arts Workshop Annexe, Drama and Tape Centre, Princeton Street, London WC1. Opening: Mon–Fri 10–8. Contact: Alan Tomkins, Exhibitions Organiser. Applications: Photographers can apply for exhibitions. Exhibitions: They promote and show exhibitions (usually by groups) on contemporary culture e.g. style, youth, race, politics etc. Space: Main gallery 40ft × 20ft. Small gallery 40ft × 10ft. All walls 8ft high.

THE CONCOURSE GALLERY, The Polytechnic of Central London, 35 Marylebone Road, London NW1.

CONNAUGHT BROWN, 2 Albermarle Street, London W1. Tel. 01-408 0362. Recent contemporary British art, and European Post Impressionism. Opening: Mon–Fri 9.30–6, Sat 10–12.30. Underground Green Park.

CONTEMPORARY APPLIED ARTS, 43 Earlham Street, London WC2H 9LD. Tel. 01-836 6993. Opening: Mon–Fri 10–5, Sat 10–4. Director: Karen Elder. Exhibitions: Contemporary crafts, mostly British, sometimes international exhibitions e.g. Finnish glass. A major venue for crafts in a bright, spacious gallery.

CRAFTS COUNCIL GALLERY, 12 Waterloo Place, London SW1. Tel. 01-930 4811. Opening: Tues–Sun 10–5. Contact: Ralph Turner. Exhibitions: Contemporary British crafts and some from overseas. Slide register of work by British craftsmen and women—the public can use this to look at work or buy an illustrated catalogue. Also excellent craft bookshop.

CRAFTSMEN POTTERS ASSOCIATION, William Blake House, Marshall Street, London W1 1FD. Tel. 01-437 7605. Opening: Mon–Fri 10–5.30, Sat 10.30–5.00. Contact: David Canter and Stephen Brayne. Applications: Selection committee meets 4 times a year. Exhibitions: About 6 major exhibitions a year and there is always a large selection of both functional and decorative, contemporary ceramics. They specialise in artists from the United Kingdom. There are 165 full members of CPA who show regularly. Space: 1 floor.

CREASER, 316 Portobello Road, London W11. Tel. 01-960 4928. Director: Debbie Woods. Contemporary art. Lively exhibitions. Opening: Tues–Sat 10-30–5.30. Underground Ladbroke Grove.

CREATIVE IMAGE, 17a Bulstrode Street, London W1M 5FQ. Tel. 01-487 3308. Contemporary art.

CRUCIAL GALLERY, 204 Kensington Park Road, London W11. Tel. 01-229 1940. Directors: Kitty and Josh Bowler. Exciting environmental, unusual exhibitions. Open to applications but artists must make an appointment first.

CURWEN GALLERY, 4 Windmill Street, off Charlotte Street, London W1P 1HF. Tel. 01-636 1459. Opening: Mon–Fri 10–5.30, Sat 10.30–1. Founded 1965. Director: Jane Hindley. Monthly exhibitions of Contemporary British Art specialising in abstract and semi-abstract paintings, constructions and works on paper. Artists include: Basil Beattie, Christopher Corr, Natalie Dower, Dan Fern, Jonathan Gibbs, Gill Hewitt, Kent Jones, Thirza Kotzen, David Leverett, Lino Mannocci, Steve Matteson, Martin McGinn, Russell

Mills, Yuko Shiraishi, Harry Thubron, Ian Walton. Contemporary prints including Frink, Hepworth, Moore.

DAVID KER FINE ART, 85 Bourne Street, London SW1. Tel. 01-730 3523/8365. Opening: Mon–Fri 9.30–6.30. Director: David Ker. 20th century paintings, drawings and prints.

DIORAMA GALLERY, 18 Park Square East, London NW1. Tel. 01-487 2896. Lively young artists, often unknown names.

DISCREETLY BIZARRE GALLERY, 166 New Cavendish Street, London W1. Tel. 01-631 3140. Opening: Tues–Sat 12–7.30. Contemporary art exhibitions including Malcolm Poynter amongst other lesser known names.

ANTHONY D'OFFAY, 9 Dering Street, New Bond Street, London W1. Tel. 01-629 1578. 23 Dering Street, London W1. Tel. 01-499 4695. Opening: Mon–Fri 10–5.30, Sat 10–1. Contact: Anthony d'Offay. Exhibitions: 20th century British art, including Bell, Burra, Epstein, Wyndham Lewis, John Nash, Roberts, Spencer and Wadsworth. Also contemporary British, European and American experimental art, including Gilbert and George, Joseph Beuys, Lawrence Weiner and Boyd Webb.

DRIAN GALLERIES, 7 Porchester Place, London W2 2BT. Tel. 01-723 9473. Opening: Mon–Fri 10–5, Sat 10–1. Contact: Halima Nalecz. Applications: Professional artists can apply. Exhibitions: Contemporary painting, mostly with figurative references— Alkazzi Lacasse, Portway, Spears, Tate, Zack etc.

5 DRYDEN STREET GALLERY, 5 Dryden Street, Covent Garden, London WC2E 9NW. Tel. 01-240 2430. Opening: Mon–Sat 9–6. Applications: Application forms can be obtained from the gallery. These should be sent back with slides of work to the selection panel. Exhibitions: Gallery run on a non-profit making bases, 10% commission on sales. Exhibitions organised on a self-help basis, gallery was set up to show a wide variety of work. They want to provide opportunities for lesser-known artists to show their work. Exhibitions held every fortnight. Mostly smaller works. Space: One floor and staircase area, spotlights, some screens, providing, in total about 100 linear feet of wall space.

EBURY GALLERY, 89 Ebury Street, London SW1. Tel. 01-730 3341/7806. Contemporary artwork by young British artists.

EDITIONS ALECTO, 27 Kelso Place, London W8. Tel. 01-937 6611. Opening: Mon–Fri 10–5.30, Sat by appointment. Exhibitions: Contemporary prints. Studios and workshops attached providing etching, screenprinting and lithography facilities.

ELECTRUM GALLERY, 21 South Molton Street, London W1. Tel. 01-629 6325. Opening: Mon–Fri 10–6, Sat 10–1. Contact: Barbara Cartlidge. Applications: Not open to artists to apply. Exhibitions: Contemporary jewellery only. Artists showing regularly include: Wendy Ramshaw, David Watkins, Gerda Flockinger, Martin Page,

Roger Morris, Babetto, Paul Preston, Nelé, Lisa Kodré. Space: 2 floors.

ENGLAND & CO., 14 Needham Road, London W11. Tel. 01-221 0417. Opening: Tues–Sat 11–6. 20th century British art.

ROGER EVANS, 46 Frostic Walk, London E1 5LT. Tel. 01-377 9438/9426. Opening: By appointment only. Contact: Roger Evans. Applications: Printmakers resident in the UK only. Exhibitions arranged through galleries in the UK and abroad. Artists who exhibit include: Ana Maria Pacheco, Vinicio Horta, Maung Tin Aye, Richard Blaney, Kent Jones, Marcus Rees Roberts. They deal in twentieth century art and also act as agents to artists. Special emphasis on the work of professional younger artists, mainly printmakers. An investment service is provided for collectors.

EXPOSURE, 715 Fulham Road, London SW6. Tel. 01-736 9581. Opening: Mon, Tues, Fri 10–6, Wed, Thurs 10–7.30, Sat 10–5. New photographic gallery specialising in reportage photos.

FABIAN CARLSSON GALLERY, 160 New Bond Street, London W1. Tel. 01-409 0619. Opening: Mon–Fri 10–6, Sat 10–1. Directors: Fabian and Eugenia Carlsson, Clive Adams. Top lively international artists and also contemporary British artists include: Lance Smith, Hughie O'Donoghue, Andy Goldsworthy and others. Colourful, dynamic exhibitions.

FELIKS TOPOLSKI, The Arches, beneath Hungerford Bridge, London SE1. Opening: evenings Mon–Sat only. A series of murals from 12 to 20ft high and 600ft long. Permanent exhibition well worth visiting by this well-known artist.

FISCHER FINE ART, 30 King Street, St James's, London SW1. Tel. 01-839 3942. Opening: Mon–Fri 10–5.30, Sat 10–12.30. Contact: W. F. Fischer. Exhibitions: German Expressionism, Russian Constructivism and Suprematism, Vienna School, Bauhaus and various 20th century and contemporary British artists. Australian artists Arthur Boyd and Brett Whiteley.

MARGARET FISHER, 2 Lambolle Road, London NW3. Tel. 01-794 4247. Opening: Mon–Fri 2–6, Sat 11–3. Applications: Professional artists can apply, but they should phone for an appointment. Contact: Margaret Fisher. Exhibitions: Modern English artists but they specialise in Austrian art and have shown the work of Hundertwasser and Kokoschka. Space: 1 floor.

FLAXMAN GALLERY, 3 Lever Street, London EC1V 3QU. Tel. 01-253 9515. Directors: Francesca Piovano and Edward Purkiss. Opening: Tues–Sun 11–6. 2000sq ft in a converted Victoria workshop. On the fringes of the City this relatively new gallery holds exhibitions of contemporary paintings and sculpture from the UK and abroad. Also art related performances and events. Artists include: Wendy Hodge, Tim Maguire, Chris Najman, Luoise Vercoe, David Cook and Aurora B.

ANGELA FLOWERS GALLERY, 11/12 Tottenham Mews, off Tottenham Street, London W1P 9PJ. Tel. 01-637 3089. Opening: Mon–Fri

10.30–5.30, Sat 10.30–12.30. Contact: Angela Flowers, Matthew Flowers. Exhibitions: Gallery artists are Boyd and Evans, Lucy Jones, Nicola Hicks, Neil Jeffries, Tom Phillips, David Hepher, Derek Hirst, Patrick Hughes, John Loker, Amanda Faulkner. Also new HACKNEY gallery *Flowers East*

FOTOGALERIE, 48 Hill Rise, Richmond, Surrey. Tel. 01-940 9143. Exhibitions: photography.

FRANCIS GRAHAM-DIXON GALLERY, 17–18 Great Sutton Street, London WC1. Tel. 01-250 1962. Opening: Tues–Fri 11–6, Sat & Sun 2–6. Lively new contemporary art gallery. Major British contemporary artists.

FRANCIS KYLE, 9 Maddox Street, London W1. Tel. 01-499 6870. Contemporary paintings and illustrative drawings.

FRENCH INSTITUTE, 17 Queensberry Place, London SW7. Tel. 01-589 6211. Opening: 8–6.30. Exhibitions: The work of French artists. Space: 70 metres of wall space on one floor. Known as **Galerie Matisse** now.

GALERIE BASTET, 98 Marylebone High Street, London W1. Tel. 01-486 3609/6968. Bizarre but unusual exhibitions.

GALLERY 111, 111 Highbury Park, London N5. Tel. 01-354 3912. Opening: Tues–Sat 11–6. Contemporary painting.

GALLERY 10, 10 Grosvenor Street, London W1. Tel. 01-491 8103. Opening: Mon–Fri 10–5.30, Sat 10–11. Applications: Professional artists can apply for shows. Exhibitions: Contemporary British artists including: Peter Coker RA, D Hamilton Fraser ARA, Tom Nash, R. T. Cowern RA, R. Buhler RA, Roger De Grey RA, Jean Creedy, Jo Milton, etc. Space: One floor. Director: Anne Marcou.

GALLERY 273, Queen Mary College, Physics Building, Mile End Road, London E1 4NS. Tel. 01-980 4811 ext 373. Opening: Mon–Fri 10–5. Contact: Keith Nickels, John Charap. Applications: Professional artists can apply at any time. Exhibitions: About 6 exhibitions a year in term time. The gallery shows work by young artists, usually small paintings or graphics. No charge is made to artists nor is any commission taken on sales, the intention is to encourage less well-known artists. Space: One floor.

GALLERY 44, 309a New King's Road, London SW6. Tel. 01-736 6887. Opening: Mon–Fri 10–4, Sat 10–2. Contact: Matthew Wallis. Exhibitions: Wide range of contemporary art, from traditional watercolours to abstracts. Aims to promote younger, less well-known artists.

ST GEORGES GALLERY, 11 Church Street, Twickenham. Tel. 01-891 2611. Opening: Tues–Sat 10–6. Contact: T. Osborne, P. A. Osborne. Application: Open to professional artists. Exhibitions: Special interest in local artists and artists of the Wapping group. Locally produced ceramics, pottery and jewellery are also exhibited. Space: One floor 30ft long × 20ft wide.

GIMPEL FILS, 30 Davies Street, London W1Y 1LG. Tel. 01-493 2483. Opening: Mon–Fri 9.30–5.30, Sat 10–1. Contact: René & Peter Gimpel. Applications: Not open to artists to apply. Exhibitions: Contemporary work including; Alan Davie, Adams, Hepworth, Scott, Jenkins. They also exhibit South Arabian antiquities and Eskimo art. Space: 2 floors.

GOETHE INSTITUTE, 50 Princes Gate, London SW7. Tel. 01-581 3344. Opening: Mon–Fri 12–8, Sat 10–7. Exhibitions: Work connected with Germany, contemporary and historical. Space: 50 metres of hanging space.

GRABOWSKI GALLERY TWO, 84 Sloane Avenue, London SW3. Tel. 01-589 1868. Director: Wojciech Grabowski. During the 50s the Grabowski was a well-known gallery for contemporary artists; Hockney and Derek Boshier showed here along with Bridget Riley and others. The new gallery run by Grabowski's son has been completely redesigned. Stefan Knapp's enamel mural outside. Work by young European artists. Also a wine bar with French food. Underground Knightsbridge.

GRAFFITI, c/o Blackman Harvey, 29 Earlham Street, London WC2. Tel. 01-836 1904. Contact: Nancy Patterson, Peter Leigh. Exhibitions: Mostly original prints, some painting and sculpture. Artists shown include: Peter Daglish, Anthony Benjamin, Martin Leman, Julia Atkinson, Noreen Grant, Bob Chaplin, Val Ewens.

GREENWICH PRINTMAKERS ASSOCIATION, 1A The Market, Greenwich, London SE10. Tel. 01-858 2290. Opening: 11–5 daily except for Mon & Thur. Contact: Run by 30 artist-printmakers mainly living in Greenwich. Applications: Show work of the co-operative. Exhibitions: Run on co-operative lines by the printmakers whose aims are to show their work together in Greenwich, to arrange travelling group exhibitions, to buy printmaking materials cheaper in bulk and generally to promote an interest in printmaking in the area. The association is run by a committee of 7 members, elected annually. Selection of 2 new members takes place twice a year. Show mainly etchings, lithographs with some watercolours and drawings. Space: Gallery and local restaurant used as an overflow gallery.

GREENWICH THEATRE ART GALLERY, Greenwich Theatre, Crooms Hill, Greenwich, London SE10. Tel. 01-858 4447/8. Opening: Mon–Sat 10.30–10.15. Contact: Geoffrey Beaghen. Applications: Professional artists can apply. Exhibitions: Contemporary work. Space: 3 floors.

NIGEL GREENWOOD INC LTD., 4 New Burlington Street, London W1. Tel. 01-434 3795. Contact: Nigel Greenwood. Opening: Mon–Fri 10–6, Sat 10.30–1.30. Applications: Artists are free to send in slides. Exhibitions: Gallery artists showing regularly include: Adams, Becher, Bill Beckley, Jane Berthot, Chaimowicz, Rita Donagh, Ger Van Elk, Joel Fisher, Alan Johnston, Christopher Lebrun, Ian McKeever, J. Stezaker, D. Tremlett, Tuttle, J. Walker, and other contemporary artists. Space: One floor.

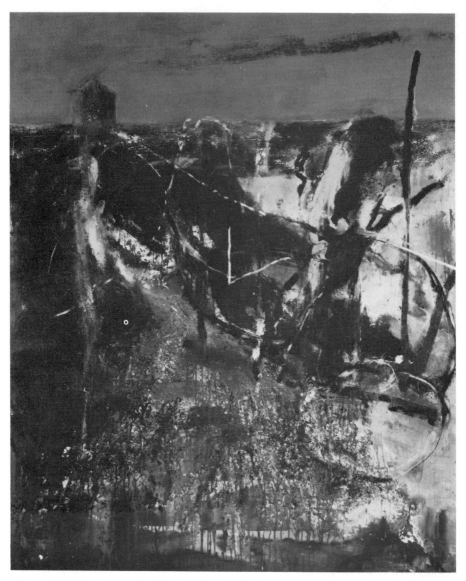

'The Road' 1988, Lance Smith (Fabian Carlsson Gallery)

THE GUILD GALLERY, Fine Art Trade Guild, 192 Ebury Street, London SW1. Opening: Mon–Fri 10–5, Sat 10–1. Work by established British artists.

HAMILTONS GALLERY, 13 Carlos Place, London W1. Tel. 01-499 9493. Photo exhibitions by known names. Fashionable associations.

HARDWARE GALLERY, 277 Hornsey Road, Islington, London N7. Tel. 01-272 9651. Opening: Mon–Fri 1–7, Sat 10–6. Limited edition prints, also a framing service.

HAYWARD GALLERY, Belvedere Road (The South Bank), London SE1 8XZ. Tel. 01-928 3144. Opening: Mon–Thurs 10–8, Fri and Sat 10–6, Sun 12–6. Exhibitions: The Arts Council's major British venue for exhibitions. The shows are mainly contemporary or 20th century, covering all media. Many prestigious international shows have been mounted here or originated by the gallery itself. Retrospective, two-person, mixed thematic and group shows. Applications: By invitation only. Space: A purpose-built new building, with spacious galleries on three levels, no natural light. Two exterior courtyards for sculpture. Part of the South Bank complex, between the Royal Festival Hall and the National Film Theatre. There is a bookstall selling Arts Council catalogues, books and postcards, also a schools mailing list.

HENRY MOORE GALLERY, RCA, Kensington Gore, London SW7. Tel. 01-584 5020 ext 355. Opening: Mon–Fri 10–6. The enormous gallery at the Royal College of Art has been named after Henry Moore. Regular exhibitions of work by established artists and also degree shows and other interesting events and exhibitions. Underground High St, Kensington/South Kensington.

HORIZON GALLERY, 70 Marchmont Street, London WC1N 1AB. Tel. 01-837 1431. Funded by GLAA. Exhibitions of contemporary art.

THE INSTITUTE OF CONTEMPORARY ARTS, Nash House, The Mall, London SW1. Tel. 01-930 3647. Opening: Tues–Sun 12–9. Director: Bill McAlister. Visual Arts/Performance: Iwona Blazwick. Applications: All 3 galleries in the Institute of Contemporary Arts have a scheduled programme of exhibitions. The ICA is not a submissions gallery, but at the same time they are interested to see applications for exhibitions in the form of slides, photographs, or documentation. Exhibitions: Contemporary, including performance and video. Also houses a cinema and theatre besides the 3 galleries and new cinematheque for 8mm and 16mm films and video. Specialist bookshop, bar and restaurant. Space: 3 gallery spaces, so there are usually at least three exhibitions running concurrently. Full membership for mailing list and day membership.

INTAGLIO PRINTMAKER, 323 Goswell Road, London EC1. Tel. 01-278 0641. Opening: Mon–Fri 10–6. Printmakers gallery and also sells printmaking supplies and some art books.

INTERIM ART, 21 Beck Road, London E8. Tel. 01-254 9607. Opening: Wed & Thurs 4–8.30, Sat 12–6. Run by Maureen O. Paley. A gallery devoted to set-theme exhibitions in London's east end near Bethnal Green.

IRAQUI CULTURAL CENTRE, 177 Tottenham Court Road, London W1. Tel. 01-637 5831. Opening: Mon–Sat 10–6. Exhibitions: Contemporary and historical shows of Iraqui art, architecture and ceramics.

JABLONSKI GALLERY, 16 Woodstock Street, London W1. Tel. 01-629 4419. Variety of painting and sculpture exhibitions. Underground Bond Street.

NICOLA JACOBS GALLERY, 9 Cork Street, London W1. Tel. 01-437 3868. Opening: Mon–Fri 10–5.30, Sat 10–1. Contact: Nicola Jacobs. Applications: Not open to applications. Exhibitions: Six one-man shows and six group shows per year. Artists showing include: John Gibbons, Jeff Lowe, John Carter, Shelagh Cluett, Jean Gibson, Jon Groom, Patrick Jones, Ken Kiff, Kim Lim, John McLean, Mali Morris, Peter Rippon, Paul Rosenbloom, Adrian Searle, Colin Smith, Derek Southall, Anthony Whishaw, Gary Wragg. Specializes in British art but has occasional exhibitions from the USA. Space: One floor.

BERNARD JACOBSON LTD., 2a Cork Street, London W1. Tel. 01-439 8355. Opening: Mon–Fri 10–6. Contact: Bernard Jacobson. Exhibitions: Contemporary work, including Ivor Abrahams, Stephen Buckley, Robyn Denny, Michael Heindorff, Howard Hodgkin, Richard Smith, William Tillyer. Space: One floor. They also have galleries in New York and Los Angeles.

GILLIAN JASON GALLERY, 42 Inverness Street, London NW1. Tel. 01-267 4835. Modern British art. Opening: Tues–Sat 10.30–5.30 or by appointment.

J. P. L. FINE ARTS, 24 Davies Street, London W1. Tel. 01-493 2630. Opening: Mon–Fri 10–6 and by appointment. Contact: Christian Neffe. Exhibitions: 20th century masters.

JUDD STREET GALLERY, 99 Judd Street, London WC1. Tel. 01-388 1985. Opening: Mon–Sat 11–7. Contemporary paintings and drawings.

KALEIDOSCOPE, 98 Willesden Lane, London NW6. Tel. 01-624 1343/01-328 5833. Opening: Mon–Sat 9.30–6. Contact: Karl Barrie. Exhibitions: 18th–20th century paintings and prints and contemporary artists. Occasional open shows. New artists are invited to apply.

KAPIL JARIWALA, 50–52 Rivington Street, London EC2. Tel. 01-729 7807. Opening: Tues–Sat 12–6. Mali Morris shows here and other interesting colourful painters. Underground Old Street.

KARSTEN SCHUBERT, 85 Charlotte Street, London W1. Tel. 01-. Opening: Relatively new large gallery on two floors opposite Channel 4's offices. Top contemporary British artists.

KNOEDLER, 22 Cork Street, London W1. Tel. 01-439 1096. Opening: Mon–Fri 10–6. Contact: J. Kasmin. Exhibitions: Contemporary paintings from Britain and USA, also 20th century masters.

FRANCIS KYLE GALLERY, 9 Maddox Street, London W1. Tel. 01-489 6870. Opening: Mon–Fri 10–6, Sat 11–5. Contact: Francis Kyle. Exhibitions: Paintings, watercolours, drawings and limited edition prints by younger British artists. Some leading artists from Europe.

LAMONT GALLERY, 65 Roman Road, Bethnal Green, E2. Tel. 01-981 6332. Opening: Tues–Sat 11–6. Local east London gallery— contemporary art and local historical exhibitions.

LEINSTER CONTEMPORARY ART, 3 Clifford Street, London W1. Tel. 01-437 4534. Contemporary European artists. Directors: Jebbufer & Holger Brasch.

LIGHT FANTASTIC, Gallery of Holography, 48 South Row, The Market, Covent Garden, London WC2. Tel. 01-836 6423. One of Britain's few holography galleries. Entrance fee. Lively experimental work.

LISSON GALLERY, 67 Lisson Street, London NW1 5DA. Tel. 01-724 2739. Opening: Tues–Fri 12–6, Sat 10–1. Contact: Fiona and Nicholas Logsdail. Exhibitions: Conceptual, minimal and other recent developments in visual art from Britain and abroad, including Rober Ackling, Jo Baer, Alan Charlton, Stephen Cox, Dan Graham, John Hilliard, Richard Long, On Kawara, etc.

LOCUS GALLERY, 116 Heath Street, London NW3 1DR. Tel. 01-435 4005. Opening: Mon–Fr 10.30–5.30, Sat 11–5. Other times by appointment. Contact: Gudrun Fazzina. Applications: Considered. Exhibitions: Artists showing regularly include Aldo D'adamo, Rintaro Yagi, Claudia Amari, Enzo Plazzotta. Works exhibited in bronze, marble terracotta. Also artisan marble sculptures, copies of classic works. Specialise in Italian art. Space: 2 floors 5m × 13m approx.

LONDON ECOLOGY CENTRE AND COMMON GROUND, 45 Shelton Street, Covent Garden, London WC2H 9HJ. Tel. 01-379 3109. Common ground is one of six environmental organisations based in the Ecology Centre. Their brief is to promote greater understanding of conservation of nature and the landscape using the arts (all disciplines). The Ecology Centre has a large exhibition space and runs a full time programme of exhibitions. Common Ground also uses this space to mount exhibitions. Andy Goldsworthy has shown his land-related sculpture/photographs here. Underground Covent Garden.

LOUISE HALLETT GALLERY, 27 Junction Mews (off Sale Place), London W2. Tel. 01-724 9865. Opening: Tues–Sat 11–7. Enormous gallery spaces with dynamic paintings and sculptures by young contemporary artists. Lively gallery director Louise Hallett tries to bring young artists work to a wider monied public. Underground Paddington.

THE MALL GALLERIES, 17 Carlton House Terrace, London SW1Y 5BD. Tel. 01-930 6844. Galleries for the Federation of British artists. Regular exhibitions here to show work by members of the various organisations which include artists in watercolour, painting, marine scapes, miniature painters, sculptors and engravers, portrait painters, wildlife artists, pastel artists and other related exhibitions. Underground Charing Cross.

MARLENE ELEINI, First Floor, 14 New Bond Street, London W1. Tel. 01-408 0138. Tues–Fri 10–6, Sat 10–1. Variety of shows ranging from photographs to paintings in this relatively new gallery.

MARLBOROUGH FINE ART 9 (LONDON) LTD., 6 Albermarle Street, London W1. Tel. 01-629 5161. Opening: Mon–Fri 10–5.30, Sat 10–12.30. Exhibitions: 20th century paintings, drawings and sculpture— Auerbach, Bacon Jacklin, Davies, Kitaj, Kokoschka, Moore, Nolan, Pasmore, Piper, Sutherland etc. Graphics at 39 Old Bond Street. Tel. 01-499 2641.

MATT'S GALLERY, 10 Martello Street, London Fields, London E8. Tel. 01-249 3799, 01-263 7548. Opening: 2–8, closed Fri and Mon. Contact: Robin Klassnik. Applications: Ring for an appointment. Exhibitions: Artists showing regularly include: David Troostwyk, Joel Fisher, Jaroslaw Kozlowski, Robin Klassnik, Susan Hiller, Jeff Instone, Mike Porter, Tony Bevan, Tom Claril. Space: One floor, 21ft × 16ft 4" and 14ft × 10ft and 35ft × 16ft.

THE MAYOR GALLERY, 22A Cork Street, London W1X 1HB. Tel. 01-734 3558. Opening: Mon–Fri 10–5.30, Sat 10–1. Contact: James Mayor, Andrew Murray, Anne Vribe-Mosquera. Applications: Not open to applications. Exhibitions: Modern, 20th century, American, British and European paintings, drawings and sculpture. Space: One floor.

MAYOR ROWAN GALLERY, 31A Bruton Place, London W1X 7AB. Tel. 01-499 3011. Directors: David Grob, Alex Gregory Hood, Kay Hatenstein, James Mayor and Andrew Murray. Joint venture between Mayor and Rowan galleries. The Mayor gallery will still be showing work at 22A Cork Street, London W1 as well.

THE MEDIA GALLERY, 10 Museum Street, London WC1. Tel. 01-379 5841. Interested in suggestions for exhibitions within the aims of the gallery. Sponsorship possibilities from companies associated with or benefiting from the communications industry. Mediac International a film and television production company owns and runs the gallery. Exhibitions of photographs, designs which document productions that have been innovative in film and television. Underground Tottenham Court Road.

MINSKY'S GALLERY, 81 Regent's Park Road, London NW1. Tel. 01-586 3533. Opening: Thurs and Fri 11–6, Sat 11–3. Contact: M. & S. Mintz. Exhibitions: Limited edition original prints and works on paper—John Keane, Richard Beer, Peter Daglish, Dick Hart, Richard Walker and others.

MONTPELIER STUDIO, 4 Montpelier Street, London SW1. Tel. 01-584 0667. Opening: Mon–Fr 10–5, Sat 10–1. Contact: Bernice Sandelson and Victor Sandelson. Exhibitions: Artists showing regularly include: J. Emanuel, G. Yeomans, B. Dorf, D. Hazlewood, plus works in stock

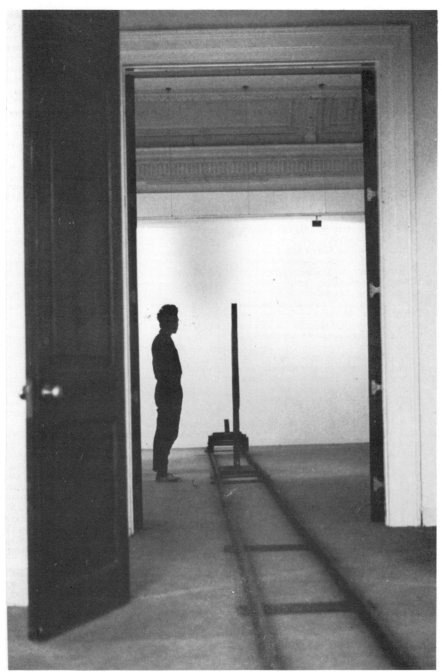

Installation at the Institute of Contemporary Arts, London (Heather Waddell)

by Joseph Herman, Meninski, Duncan Grant, Sir Jacob Epstein, Sir Stanley Spencer, John Piper. Specialise in 20th century British art. Space: Ground floor and basement 8ft high, varying lengths.

MORLEY GALLERY, 61 Westminster Bridge Road, London SE1. Tel. 01-928 8501 ext 30. Opening: 10–9 during college term, 10–6 otherwise. Contact: Adrian Bartlett. Exhibitions: All forms of art and craft are considered. Space: Approx. 150 linear feet on one floor. No exhibiting fees, but artists or societies pay own costs—publicity, private views etc.

MUSEUM OF LONDON, London Wall, London EC2. Tel. 01-600 3699. Opening: Tues–Sat 10–6, Sun 2–6, closed Mondays. Exhibitions connected with London, often photographic.

NATIONAL THEATRE, South Bank, London SE7. Tel. 01-928 2033 ext 381. Opening: Mon–Sat 10–11, closed Sundays. Regular exhibitions of contemporary art. Open to professional artists to apply.

NEW ART CENTRE, 41 Sloane Street, London SW1 9LU. Tel. 01-235 5844. Opening: Mon–Fri 10–6, Sat 10–1. Contact: Madeleine Ponsonby, Michael Servaes. Applications: Artists can apply but heavy future commitments make chances of success slim. Exhibitions: Young and established living British artists. Monthly exhibitions, one-man and mixed stock of both gallery artists and modern British masters. Space: 2 floors. Slim galleries 40ft deep.

THE NEW GALLERY, Hornsey Library, Haringey Park Road, London N8. Applications: Open to applications from contemporary artists. Space: Self-contained gallery adjacent to the library.

NEW SOUTH WALES HOUSE, 66 The Strand, London WC2. Tel. 01-839 6651. Opening: Mon–Fri 9–4. Exhibitions: Work by Australian artists, mostly contemporary, including photography, painting and sculpture.

NEW ZEALAND HOUSE, Mezzanine Gallery, Haymarket, London W1. Tel. 01-930 8422. Exhibitions: The work of artists from New Zealand.

NEW GRAFTON GALLERY, 49 Church Road, Barnes, London SW13. Tel. 01-748 8850. Opening: Tues–Sat 10–5.30. Contact: David and Geraldine Wolfers. Applications: Professional artists can apply at any time of the year. Exhibitions: Contemporary figurative work including: Carel Weight, Ken Howard, Peter Greenham, Christyen Hall, Dick Lee, Joan O'Connerm, Mary Fedden, Clotilde Peploe. Also a portrait centre with examples of portraits by 16 painters and 6 sculptors.

NIGHT GALLERY, 52–4 Kenway Road, London SW5. Tel. 01-373 4227. Exhibitions: Photography. Photography training courses also.

N.P.C. GALLERY, The Poetry Society, 21 Earls Court Square, London SW5. Tel. 01-373 7861. Opening: Mon–Fri 10–5. Contact: John Stathatos. Exhibitions: One-person shows of photography, prints, drawings, graphics and sculpture.

THE OCTOBER GALLERY, 24 Old Gloucester Street, London WC1. Tel. 01-242 7367. Opening:

Tues–Sat 12.30–4.30. Contact: Flash Allen. Applications: Considered. Exhibitions: 12 shows per year, artists from around the world, only contemporary work. Space: One floor. 40ft × 20ft. Also a restaurant and arts events.

PALLAS GALLERY, Rufus Street, London N1. Tel. 01-729 4343. The gallery publishes prints by Norman Ackroyd and other top artists/printmakers.

PARKIN GALLERY, 11 Motcomb Street, London SW1. Tel. 01-235 8144. Director: Michael Parkin. 20th century British art.

PATON GALLERY, 2 Langley Court, Long Acre, London WC2. Tel. 01-379 7854. Director: Graham Paton. Graham Paton is always interested in new ideas from lively professional painters. Exhibitions by invitation or application from British and overseas artists. Top contemporary British painters; Jonathan Waller, Gwen Hardie, Andrew Stahl, John Devane and others.

PENTONVILLE GALLERY, 4 Whitfield Street, London W1. Tel. 01-482 2948. Contact: Geoffrey Evans. Opening: Mon–Fri 11–6, Sat 11–2. Applications: Are welcome bearing in mind content (see exhibitions). Exhibitions: Different one-person shows every 3–4 weeks. Prefer work that has a social and/or political content. The purpose of the gallery is not to show purely decorative or aesthetically 'pure' work. Space: One floor.

PEOPLE'S GALLERY, 73 Prince of Wales Road, London NW5. Tel. 01-267 0433. Artists should contact Margo Reid. 25% commission taken. Gallery also available for hire.

PETERSBURG PRESS, 59a Portobello Road, London W11. Tel. 01-229 0105. Opening: By appointment only, from 10–5. Exhibitions: Publishers of prints by well-known British and international artists. Hockney, Kitaj, Stella, Francesco Clemente, Howard Hodgkin.

PHOTOGRAPHER'S GALLERY LTD., 5 & 8 Great Newport Street, London WC2. Tel. 01-240 5511/2. Opening: Tues–Sat 11–7, Sun 12–6, closed Mondays. Contact: Sue Davies. Applications: Photographers can apply at any time but decisions are made at meetings in early March and early October. Exhibitions: All types of photographic work exhibited, from reportage and advertising to the purely creative. Space: The other space at 5 Great Newport Street includes 2 gallery areas. The old gallery has been re-arranged to make one big space and an enlarged bookshop. The gallery has 3 ground floor spaces and the walls measure 35ft × 30ft, 50ft × 20ft, 40ft one wall only. New facilities include a good-sized, quiet print room; a reference library containing over 3000 books; slide library containing over 5000 slides of prints; enlarged bookshop stocking over 1200 titles and over 400 postcards and international selection of posters, magazines and catalogues. Telephone information centre giving details of exhibitions, photographers, agents etc.

PICCADILLY GALLERY, 16 Cork Street, London W1X 1PF. Tel. 01-629 2875/01-499 4632. Contact: Godfrey Pilington, Eve Pilkington

and Christabel Briggs. Applications: Make an appointment to show work. Exhibitions: Specialise in contemporary British figurative painting, including: Eric Holt, Rosie Lee, Graham Ovenden, Jack Simcock, David Tindle, Peter Unsworth. Space: One floor, 500sq ft.

PICTURE GALLERY, 4 Abercrombie Street, Battersea Park Road, London SW11. Tel. 01-228 6370. Opening: Mon–Sat 11–10, Tues and Thurs 11–6. Contact: Tony and Anne Isseyegh. Applications: Professional artists can apply for an exhibition at any time. Exhibitions: The gallery mainly shows the work of young and contemporary artists in mixed exhibitions with a two-man show every three months. The exhibitions change every month. They show the work of British artists, including: Peter Smith and Libby Raynham. Space: One floor, 2 walls 8ft 6″ × 10ft 6″; 8 strips 3ft 4″ × 10ft 6″; 3 strips 4ft 6″ × 10ft 6″.

PIERS FEETHAM GALLERY, 474 Fulham Road, London SW6. Tel. 01-381 5958. Opening: Mon–Fri 10–1, 2–6, Sat 10–1. Contemporary art.

RICHARD POMEROY GALLERY, Jacob Street Studios, Mill Street (off Jamaica Road), London SE1. Tel. 01-237 6062. Director: Richard Pomeroy. 1500sq ft of exhibiting space to show painting, sculpture and associated arts by artists in the UK and abroad. Situated in the Jacob Street film studio complex the gallery aims to provide flexible and high quality exhibiting opportunities resulting in fresh and controversial shows. Seven studios alongside the gallery also.

JONATHAN POOLE GALLERY, 165 Draycott Avenue, London SW3. Tel. 01-736 1404. Opening: Mon–Fri 10–6, Sat 10–2. Director Jonathan Poole. A small gallery with regular shows of painting, sculpture and drawings. Underground South Kensington.

PORTAL GALLERY LTD., 16A Grafton Street, Bond Street, London W1. Tel. 01-629 3506/01-493 0706. Opening: Mon–Fri 10–5.45, Sat 10–1. Contact: E. Lister, L. Levy, J. Wilder. Applications: Professional artists can apply for shows at any time. Exhibitions: Approximately 40 painters regularly exhibit and they specialise in self-taught (naive) art and figurative fantasy painting. Mainly 20th century British painters. Space: 2 floors.

PORTFOLIO GALLERY, 105 Golborne Road, London W10. Tel. 01-960 3051. Opening: Tues–Sat 10–6. Directors: Jayne Diggory and Gail Marcuson. Lively contemporary photography gallery. Participates in the annual Portobello Contemporary Art Fair. Underground Westbourne Park.

RAAB GALLERY, 29 Chapel Street, Belgravia, London SW1. Tel. 01245 9521. Opening: Mon–Fri 10.30–7, Sat 11–5. Director: Ingrid Raab. This gallery set up relatively recently by Ingrid Raab of Raab Gallery in Berlin. Exciting Berlin artists such as Elvira Bach, Peter Chevalier and also soon young British (including Scottish) artists, some straight out of art school. Well worth visiting. Lively, colourful and international work. Underground Hyde Park Corner.

The Photographer's Gallery, 5 and 8 Great Newport Street, Covent Garden (Heather Waddell)

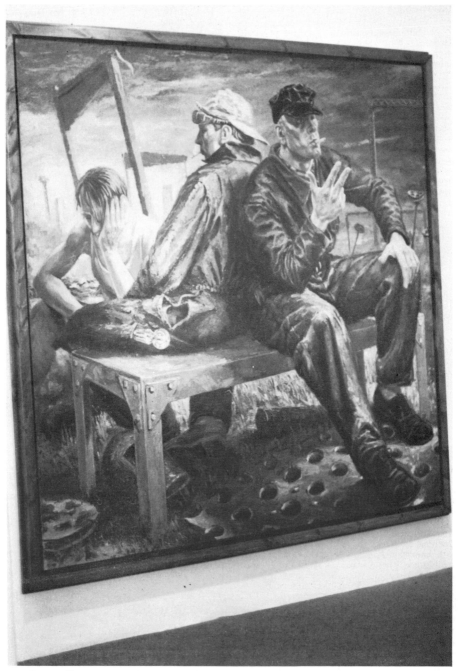

Jonathan Waller painting at the Paton Gallery, Covent Garden, London (Heather Waddell)

RAILINGS GALLERY, 5 New Cavendish Street, London W1M 7RP. Tel. 01-935 1114. Director: Geihle Sander. Small contemporary art gallery.

REBECCA HOSSACK GALLERY, 35 Windmill Street, London W1. Tel. 01-409 3599. Director: Rebecca Hossack. Opening: Mon–Sat 11–7. Contemporary painting. Relatively new gallery.

THE REDFERN GALLERY, 20 Cork Street, London W1. Tel. 01-734 1732. Opening: Mon–Fri 10–5.30, Sat 10–12.30. Contact: Harry Tatlock-Miller, John Synge, Gordon Samuel, Margaret Thornton. Applications: Preferably in the first six months of the year and appointments should be made first. Exhibitions: The gallery changes its exhibitions every month, showing about 7 artists each year. There is usually a print show during Dec/Jan, with a mixed show of gallery artists and others during the summer. Artists showing regularly include: Proktor, Oxtoby, Stevens, Wunderlich, Preece, Kneale. Space: Ground floor, painting and sculpture; basement, graphics.

THE REGENT STREET GALLERY, Polytechnic of Central London, 309 Regent Street, London W1. Tel. 01-580 2020 ext 335. Opening: Mon–Fri 8–8. Contact: Richard Allen. Applications: Apply to Richard Allen, exhibitions consultant to Polytechnic of Central London, for consideration by exhibition committee. Exhibitions: No regular artists, mainly group shows, artists and/or photographers, documentary shows etc. and overseas shows. Space: Concourse Gallery approx 27 metres (screens).

RIVERSIDE STUDIOS, Crisp Road, London W6 9RL. Tel. 01-741 2251. Opening: Mon 11–6, Tues–Sat 11–11, Sun 12noon–10.3.0. Exhibitions: Very wide-ranging, from contemporary painting and sculpture to historical shows, i.e. Munch and pre-Raphaelites. Space: A very recently opened new gallery, converted from workshops and dressing rooms. 150–160 linear feet of wall space, brick and plaster walls, natural and soft artificial lighting no spotlighting, dark-grey concrete floor. The original gallery space in the foyer will still be used for exhibitions (40ft × 12ft high). Performance art has been shown in the theatre space at Riverside, including Dan Graham and Bruce McLean, as well as theatre, music and dance. There is a specialist bookshop on the premises.

ROYAL ACADEMY OF ARTS, Burlington House, Piccadilly, London W1. Tel. 01-734 9052. Opening: daily 10–6. Major London gallery space with important historical and contemporary art exhibitions. The Diploma Galleries upstairs hold exhibitions such as the annual Stowells Trophy Student Exhibition. Annual summer exhibition gives artists a chance to reach a wider public—over 1000 works on display!

ROYAL FESTIVAL HALL, South Bank, London SE1. Tel. 01-928 3002. This year there has been a great increase in exhibitions at Festival Hall with promotion of the facilities, covering a bookshop, restaurant and exhibition spaces. Access to a large public Gerald Scarfe's work was seen by 140,000 people!

SAINT BENET'S GALLERY, Queen Mary College, Mile End Road, London E1. Tel. 01-980 1204. Opening: 9–6 during term. Contact: St Benet's House. Applications: To the Chaplain at the above address. Exhibitions: Paintings and sculpture. Space: A small gallery.

SALAMA-CARO GALLERY, 5/6 Cork Street, London W1X 1PB. Tel. 01-734 9179/01-581 1078/9. Opening: Mon–Fri 10–6, Sat 11–2. Directors: Simon and G Salama-Caro has moved to Cork Street from his successful Brompton gallery in Knightsbridge. The opening show was David Begbie the sculptor but Salama-Caro also shows paintings by British and international artists; Haman, Dieter-Pietsch, Ricardo Crinalli, Jaume Plensa and others.

SALLY HUNTER GALLERY, 2 Motcomb Street, Belgravia, London SW1. Tel. 01-235 0934. Opening: Mon–Fri 10–6. Contact: Sally Hunter. Applications: Considered. Exhibitions: 2 galleries, one showing late 19th and early 20th century paintings, the other showing contemporary paintings and original prints, i.e. Chris Orr, Mick Rooney, Andrew Logan.

SARAH LONG ART INTERNATIONAL, 16 Farm Place, London W8. Tel. 01-221 7430. Art consultancy for corporations. By appointment only.

SEEN, 8 Frederic Mews, London SW1X 8EQ. Tel. 01-245 6131. Opening: Mon–Fri 10–6.30, Sat 10–5. Contact: Jeffrey Sion. Applications: Open application at any time. Exhibitions: Specialise in figurative and representational paintings, drawings and prints. Also print publishers. They deal in contemporary work. Space: 2 floors.

SERPENTINE GALLERY (Arts Council of Great Britain), Kensington Gardens, London W2 3XA. Tel. 01-402 6075. Opening: April–Sept 10–7 daily, other months 10–dusk. Contact: Alister Warman (Director). Applications: Annual open submissions in Autumn for the following summer shows, application forms from gallery. Exhibitions: Only contemporary work from Britain and aborad, including painting, sculpture, prints, drawings and mixed media. Space: 450 linear hanging feet, divided amoungst four large rooms, with plaster walls and high celings. Adjacent outdoor facilities for sculpture and performance. Lively education programme. Admission free.

THE SHOWROOM GALLERY, 44 Bonner Road, London E2. Tel. 01-980 6636. Contact: David Thorp. Opening: Wed–Fri 10–3, Sat & Sun 11–6. Contemporary sculpture, painting and drawings.

SMITH'S GALLERIES, 56 Earlham Street, London WC2. Tel. 01-836 6252. Large space for contemporary art. Used by the contemporary art society for its annual art sale. Available for hire.

THE SOLOMON GALLERY, 10 Dover Street, London W1. Tel. -1499 4701/2. Contemporary European art.

SOUTH BANK CENTRE, Royal Festival Hall, London SE1 8XX. Regular exhibitions to a wide

public of concert goers. Drawings, photographs, painting, sculpture have all been shown here.

SOUTH LONDON ART GALLERY, Peckham Road, London SE5. Tel. 01-703 6120. Opening: Mon–Sat 10–6, Sun 3–6. Contact: K. A. Doughty. Exhibitions: Contemporary art, historical and retrospective shows and local societies. Permanent collection of British paintings and drawings from 1700 onwards.

THE SOUTHWARK COLLEGE GALLERY, Elephant & Castle Shopping Centre, London SE1 6TE. Opening: Normally Mon–Fri 9.30–4.30. This is a new gallery which opened in November 1987. Applications: The programme of exhibitions is in the process of arrangement. The gallery will be used for exhibitions of work by staff and students of the college. But applications from lively professional painters, sculptors and design groups are welcomed. Duration of Exhibitions: Exhibitions will be changed monthly. The gallery will be closed during the summer months and during the Christmas period. Contact: John Lidzey, Southwark College, Albany Road, London SE5. Tel. 01-928 9561 ext 320 or 01-703 2936. Space available: The gallery measures 1500sq ft but a process of flexible screening permits variations of exhibition size. It is also possible to mount two separate exhibitions at the same time. The gallery which enjoys the backing of Southwark College will give artists a good opportunity to show their work in an area which is at the centre of a thriving community of business people, students and local people.

SPECIAL PHOTOGRAPHERS COMPANY, 21 Kensington Park Road, London W11 2EU. Tel. 01-221 3489. Directors: Chris Kewbank and Catherine Turner. Opening: Mon–Sat. 10–6. This dynamic photography gallery sells photographs both to organisations and individuals, acting as agents for the gallery photographers. Involved in the annual Portobello Contemporary Art Fair in April.

THE SQUARE GALLERY, Pond Square, Highgate, London N6. Tel. 01-340 4983. Opening: 11–7, Sat 12–6, closed Mondays. Contemporary art and also Artlease Framing service.

SUE WILLIAMS, 320 Portobello Road, London W10 5RU. Tel. 01-960 6123. Art Ceramics, glass and sculpture by up and coming artists. Sympathetic environment and affordable prices. Register of artists work also.

THACKERAY GALLERY, 18 Thackeray Street, Kensington Square, London W8 5ET. Tel. 01-937 5883. Opening: Tues, Thurs and Fri 10–6, Wed 10–7, Sat 10–5, closed Sun and Mon. Contact: Mrs. Priscilla Anderson. Applications: Open to applications but the gallery is very booked up and is closed in January and August. Exhibitions: Mainly British artists and solely contemporary work including: Nicholas Barnham, Donald Blake, Charles Duranty, James Gunnell, Susan Hawker, Ben Levene, Donald McIntyre, James

Morrison, Alberto Morrocco, Neil Murison, Kyffin Williams, Andy Wood, Brian Yale, Roderick Barrett. Space: Ground floor and basement.

THE SEVENTH FLOOR GALLERY, St Martin's School of Art, 107 Charing Cross Road, London WC2. Tel. 01-437 0611. Contact: Frank Hall, Vice Principal. Recent work by a wide range of emerging and established artists, mostly connected with St Martins: students, graduates, full time and visting staff.

THE TALENT STORE GALLERY, 11 Eccleston Street, London SW1. Tel. 01-730 8117. Opening: Mon–Fri 9.30–5.30. Contact: Jane Penruddock, Berta J. Pinnell. Exhibitons: Shows unknown artists in as many fields as possible, perhaps for the first time.

THE 39 STEPS, 273a Whitechapel Road, London E1. Tel. 01-247 3588. Opening: Mon–Fri 10–7, Sat 11–3. Lively contemporary paintings and drawings.

THEATRE GALLERY, Unicorn Theatre, Great Newport Street, London WC2.

THUMB GALLERY LTD., 38 Lexington Street, London W1. Tel. 01-439 7343. Director: Jill George. Opening: Mon–Fri 10–6, Sat 11–4. Applications: Prefer to see slides before making an appointment to see the work. Exhibitions: The gallery specialises in works on paper by young British artists, prints, drawings and watercolours. Artists showing regularly include: Trevor Allen, Chloe Cheese, Sue Coe, Sue Dunkley, Jeffery Edwards, Andrew Holmes, Anthony Moore, Chris Orr, Richard Walker. New enlarged premises.

TODD GALLERY, 326 Portobello Road, London W10 5RU. Tel. 01-960 6209. Opening: Tues–Fri 11–7, Sat 10.30–4.30. Lively contemporary young artists. Director: Jenny Todd.

EDWARD TOTAH GALLERY, 1st Floor, 13 Old Burlington Street, London W1. Tel. 01-734 0343. Opening: Tues–Sat 11–6. Contact: Edward Totah. Exhibitions: Mostly contemporary painting, prints and sculpture. Application: Artists should contact the director first to arrange for an appointment to show slides and work. Space: Two floors of sizeable well-lit gallery space.

TRICYCLE THEATRE GALLERY, Tricycle Theatre, 269 Kilburn High Road, London NW6. Tel. 01-328 8626. Lively exhibitions.

TRYON GALLERY LTD., 41 Dover Street, London W1. Tel. 01-493 5161. Opening: Mon–Fri 9.30–5.30. Contact: A. D. Tryon, D. E. H. Bigham, B. D. Booth, C. De P. Berry. Applications: Considered at any time. Exhibitions: All artists paint sporting and natural history subjects and include: David Shepherd, Susan Crawford, Rodger McPhail. Space: One floor.

VANESSA DEVEREUX GALLERY, 11 Blenheim Crescent, London W11 2EE. Tel. 01-221 6836. Director: Vanessa Devereux. Opening: Mon–Friday 11–7, Sat 10–1. Artists include: Pete Nevin, Sunil Patel, Fred Pollock, Androrj Klimowski, Andrej Dudinski and others. Small gallery with sympathetic lively atmosphere. The

gallery participates in the annual April Portobello Contemporary Art Fair.

VICTORIA MIRO GALLERY, 21 Cork Street, London W1. Tel. 01-734 5082. Opening: Mon–Sat 10–6. British and European artists: Kate Blacker, Antony Gaimley, Alan Charlton.

VORTEX GALLERIES, 139 Church Street, Stoke Newington, London N16. Tel. 01-254 6516. 1000sq ft, 150ft hanging wall space. Artists can submit slides and c.v. Contact: David Mossman on Irving Kinnersley Artists suppliers, gallery, bookshop and café.

WADDINGTON GALLERIES LTD., 2, 12, 31 and 34 Cork Street, London W1X 1PA. Tel. 01-437 8611. Also at 4 Cork Street (Waddington Graphics). Tel. 01-439 1866. Opening: Mon–Fri 10–5.30, Sat 10–1, Thurs open until 7pm. Contact: Leslie Waddington, A. Bernstein, V. A. Bernstein, A. C. Cristea, E. S. Waddington, D. Cornwall-Jones, A. G. Sprackling. Applications: Do not accept applications. Exhibitions: Contemporary well-known artists including: Peter Blake, Patrick Caulfield, Bernard Cohen, Robyn Denny, Barry Flanagan, Elisabeth Frink, Hamish Fulton, Ivon Hitchens, John Hoyland, David Inshaw, Allen Jones, Kenneth Martin, Michael Moon, Ben Nicholson, Kenneth Noland. Works in stock by: Dubuffet, Matisse, Calder, Picasso, Avery, Dine Dufy, Hayden, Kitaj, Louis, Moore, Morris and many others. Space: One floor in each gallery. No. 5 Cork Street is soon to be a sculpture space and contain an art bookshop.

THE WARWICK ARTS TRUST, 33 Warwick Square, St George's Drive, London SW1. Tel. 01-834 7856. Opening: Mon–Fri 10–5.30, Sat 10–1. Large gallery space. Well worth visiting. Interesting theme exhibitions and individual shows.

WATERMANS ARTS CENTRE, 40 High Street, Brentford, Middlesex TW8 0DS. Tel. 01-847 5651. Box Office: 01-568 1176. Opening: Mon–Fri 12.30–8.30, Sat & Sun 11–9. Contact: Rod Varley, Film and Visual Arts Organizer, Liz Smith, Visual Arts Officer. Applications in the form of slides and C.V. are considered quarterly from artists and photographers working in any medium. The gallery space is 250 linear feet/1000 sq ft. The centre also has a theatre, cinema, foyer areas, restaurant and bar. Underground: Gunnersbury/South Ealing. Bus: 237, 267 and 65.

WESTSIDE GALLERY, 317 Upper Richmond Road West, East Sheen, SW14 8QR. Tel. 01-878 6209. Opening: 9.30–5.30 throughout the week. Contact: Shelagh Gould. Contemporary art and craft. Approximately 7 exhibitions a year showing work by established artists and craftsmen with work by people who are less well known. Regular group shows. Modern, well-lit, on two floors. Situated on the South Circular Road.

WHITECHAPEL GALLERY, Whitechapel High Street, London E1. Tel. 01-377 0107. Opening: Sun–Fri 11–6, closed Sat. Director: Catherine Lampert. Applications: Details for applications to Whitechapel. Open Exhibition, available from gallery. Exhibitions: Contemporary art from this country and abroad. Work by artists living and working in the locality and historical exhibitions which are of particular contemporary or local interest. Duration of shows usually 6–8 weeks. Space: Main gallery—315 linear feet, concrete floor, natural and spot-lighting. Upper gallery—250 linear feet, wooden floor, natural and spot-lighting. The Whitechapel Gallery shows a mixture of prestigious British and International one-person shows i.e. Max Beckmann, Carl Andre, Joel Shapiro, Richard Long. Shows with local, East End, relevance and some mixed shows.

WOODLANDS ART GALLERY, 90 Mycenae Road, Blackheath, London SE3 7SE. Tel. 01-858 4631. Opening: Weekdays 10–7.30, Sat 10–6, Sun 1–6, closed Wed. Contact: H. Davis, Borough Librarian, J. Bunston, Keeper. Applications: Professional artists can apply for shows at any time throughout the year. Exhibitions: Mainly local artists. A continuous series of temporary contemporary art exhibitions each lasting for about a month. Space: Four galleries on the ground floor. 200ft of wall space.

THE WORKSHOP, 83 Lamb's Conduit, London WC1. Tel. 01-242 5335. Opening: Mon–Fri 10.30–5.30, Sat 11.30–1.30. Contact: Mel Calman. Applications: Open to professional artists to apply at any time, the work is seen by Mel Calman. Exhibitions: Shows leading cartoonists, along with Calman. Original artwork of cartoons published in national newspapers and magazines together with Searle lithographs and etchings and illustrations by other well-known living artists. Mainly work by British artists, sometimes American and other nationalities. Space: One floor.

ZAMANA GALLERY, 1 Cromwell Gardens, London SW7. Tel. 01-584 6612/3. Opening: Tues–Sat 10–5.30, Sun 12–5.30, closed Mon. Magnificent building housing 3rd world related and Ismaili art activities. Variety of excellent photographic and art exhibitions. Also a bookshop. Opposite V & A museum.

ZEBRA ONE GALLERY, Perrins Court, Hampstead, London NW3. Tel. 01-794 1281. Opening: Tues–Sat 10–6. Contact: Lee Brews. Application: Professional artists can apply at any time. Exhibitions: Contemporary work, including: Samuel Koskh, Oliveiro Masi, Gill Lawson, Massingham, Le Yaouanc, Hastaire. Space: 2 floors, 24ft × 18ft approx.

ZELLA 9, 2 Park Walk, London SW10. Tel. 01-351 0588. Director: Mozella Gore. Opening: Mon–Sat 10–9. Exhibitions: Prints of all kinds by British and European printmakers. Work of a professional nature can be submitted for sale, contact gallery for details.

NORTHERN ENGLAND

These galleries are listed alphabetically by town.

ASHINGTON
WOODHORN CHURCH MUSEUM, Woodhorn Village, near Ashington, Northumberland. Tel. 0670 81444/817371. Opening: Wed–Sun (and Bank Holiday Mondays), 10–12.30, 1–4. Contact: A. G. White, Wansbeck District Council, Town Hall, Ashington, Northumberland. Exhibitions: Restored Saxon church with exhibition area approx 500sq ft, display panels and wall mounted cases. Throughout the year there is a lively programme of temporary exhibitions changed at monthly intervals. These wide ranging exhibitions—many of national significance—are often supported by workshops, films, talks and demonstrations. There is a craft shop selling quality items produced by Northern craftsmen and a picnic area.

BARNSLEY
COOPER GALLERY, Church Street, Barnsley, South Yorkshire S70 2AH. Tel. 0226 242905. Opening: Tues 1–5.30, Wed–Sun 10–5.30, closed Mon. Contact: Claire Slattery (Curator> Applications: To the Curator, send slides/photographs, C.V. and statement or full details of work and aims. The gallery presents a broad-based programme of historical and contemporary art and craft. Emphasis is placed on themes of social relevance. The programme includes adult and children's education events, workshops, debates and special events eg. performance art and dance workshops. Permanent collections of 19th and 20th century paintings and drawings, and the William Harvey Bequest of Dutch and Flemish art currently on loan to the gallery. Equipment: Video deck and monitor, 16mm film and slide projector. Members of staff include a development worker (crafts). Gallery dimensions 350 running ft approx.

BIRKENHEAD
WILLIAMSON ART GALLERY 7 MUSEUM, Slatey Road, Birkenhead, Merseyside. Tel. 051 6524177. Opening: Mon–Sat 10–5, Sun 2–5, Thurs 10–9. Contact: Mr. D. Hillhouse. Curator. Applications: In writing. Exhibitions: Contemporary, retrospective and historical. Space: Temporary exhibitions in five galleries, hessian covered walls, daylight and artificial light. Permanent collection of 18th–20th century English watercolours, decorative arts, local and maritime history. Temporary exhibitions are geared to local artists and craftsmen as well as nationally known individuals/groups.

Woodhorn Church Museum, Ashington

BLACKBURN

BLACKBURN MUSEUM & ART GALLERY, Museum Street, Blackburn. Tel. 0254 667130. Opening: Tues–Sat 10–5. Contact: The Exhibitions Officer. Applications: In writing with photographs of work, addressed to the Museum & Art Gallery, Museum Street, Blackburn BB1 7AJ. Exhibitions: Work of local interest, work by local artists and photographers, contemporary art. Space: Ground floor, approx 10 × 15 metres, controlled lighting, carpeted floor, pin board walls.
LEWIS TEXTILE MUSEUM, Exchange Street, Blackburn. Tel. 0254 667130. Opening: Tues–Sat 10–5. Contact: The Exhibitions Officer. Applications: In writing with photographs of work, addressed to the Museum & Art Gallery, Museum Street, Blackburn BB1 7AJ. Exhibitions: Work of local interest, work by local artists and photographers, contemporary art. Space: First floor gallery with windows at one end, approx 70ft × 25ft, carpeted floor, pin board walls, spotlighting.

BLACKPOOL

GRUNDY ART GALLERY, Queen Street, Blackpool. Tel. 0253 23977. Opening: Mon–Sat 10–5. Contact: James Burkitt, Curator. Applications: Are welcomed, particulary from artists living in the north west. Send letter with slides. Exhibitions: Professional work of suitable quality and that of local amateurs. Space: Three main gallieries giving about 100 linear feet of wall space each. Hessian wall surfaces, overhead track lighting, polished wood floor. Equipment: Slide projector. The Grundy is the major public funded gallery in the Fylde areas of Blackpool, Fylde and Wyre. It attempts to give space to (1) Its own permanent collection of 19th and 20th century paintings. (2) One-person shows throughout the year. (3) Fylde Arts Ass. promoted exhibitions and travelling exhibitions. (4) Local amateur societies. Most of the one-person shows are by artists based in the NW.

BOLTON

BOLTON MUSEUM AND ART GALLERY, Le Mans Crescent, Bolton, Lancs BS1 1SE. Tel. 0204 22311 ext 2194/2191. Opening: Mon, Tues, Thurs, Fri 9.30–5.30, Sat 10–5, closed Sun and Wed. Contact: David Morris, Senior Keeper of Art. Applications: In writing with biography, slides and photos. Exhibitions: about 20 temporary exhibitions per year, touring shows, historical, contemporary fine and decorative arts, local societies. Space: Two large galleries—160 and 140 running feet, painted woodchip walls, parquet floors, spot and fluorescent lighting, no daylight. Equipment: Slide projectors, tape recorder, display cases, some frames and video recorder. Permanent collections of 17th–20th century fine and applied art.
GREAT HOUSE GALLERY, Rivington, near Bolton, Lancashire. Tel. Horwich 66327 or Horwich 69127. Opening: Daily 2–5 except Mon and Fri. Contact: Mrs Dorothy Almond. Applications:

Write or telephone. Space: It is a 400 year old Tudor building. Gallery size 54ft × 18ft, spot and strip lighting. Promotes the work of modern painters, some sculpture and ceramics.

BOSTON

BLACKFRIARS ARTS CENTRE, Spain Lane, Boston, Lincs PE21 6HP. Tel. 0205 63108. Opening: Mon–Sat 10–11, admission free. Contact: Charles Wilde. Details for applications and dates of selection meetings sent free on request. Exhibitions: Usually 4 weeks, paintings, photography, drawings, prints and crafts. Most costs met by gallery. Space: 30 linear metres. Height of walls and screens vary between 1.8 metres and 2.9 metres. Surfaces, off white chipboard, fixings by screws/mirror plates. Lit by spotlights. UV can be excluded, temperature and humidity cannot be completely controlled. Equipment: Art studio and 2 darkrooms available (black/white photography up to 5″ × 4″ negative format). Video playback facilities (VHS) available. Primarily shows of work of professional artists and touring exhibitions but also amateur work. Touring exhibitions available for hire particularly for small/medium scale venues. Security: ACGB category C/B. Invigilation and video surveillance and overnight alarm system. All risks insurance cover provided. Commission 20% of gross sale price, but work need not be for sale.

BRADFORD

CARTWRIGHT HALL, Lister Park, Bradford BD4 4NS. Tel. 0274 493313. Opening: Tues–Sun 10–5 (Oct–March), 10–6 (April–Oct), closed Mon, except Bank Holidays. Contact: Caroline Krzesinska. Applications: Submit slides/photographs of work with C.V. Exhibitions: Contemporary art programme including one-person, thematic and group shows. Also craft, photography and large historical exhibitions. The programme reflects the multicultural nature of Bradford's population. Equipment: Five galleries of varying size used for temporary exhibitions are modern, well-lit with full audio-visual equipment. There is an active education programme of lectures, workshops and residencies running alongside the exhibition programme. Dance, performance and musical events are promoted throught the building.

BURNLEY

TOWNELEY HALL ART GALLERY & MUSE-UMS, Todmorden Road, Burnley BB11 3RQ. Tel. 0282 24213. Opening: Mon–Fri 10–5, Sun 12–5. Contact: Hubert R. Rigg, Curator. Annual programme of temporary exhibitions Easter–October, covering a wide range of Art and Museum subjects, including one-man and group shows of contemporary regional artists. House dates from 14th century with 16th, 17th and 19th century modifications. Fine entrance hall, furnished period rooms. 19th and 20th century oil paintings and early English watercolours, collections of period furniture, glass, ceramics, militaria

43

etc. Museum of Local Crafts and Industries, Natural History Centre and woodland trails.

BURY

BURY ART GALLERY AND MUSEUM, Moss Street, Bury, Lancs. Tel. 061-705 5879. Opening: Mon–Fri 10–6, Sat 10–5. Contact: C. Billingham, Senior Curator. Applications: Personal contact or by letter. Exhibitions: 19th/20th century permanent collection, travelling shows, local art societies, one-person shows, group shows, 'Artists-in-Residence'. Space: Approx. 250 linear feet of hanging space in two galleries.

DERBY HALL, Market Street, Bury BL9 0BN. Tel. 061-761 7107. Opening: Mon, Wed, Thurs, Fri 10–4, Sat 10–2, Tues and Sun 6.30pm–11. (When an evening performance is on—Arts Centre Venue). Contact: Director—Richard Haswell. Applications: Submit photos and C.V.s to the Director Local (Bury area, Gtr M/cr) but touring shows welcome. Exclusively contemporary art/photographs/posters, etc. but flexible policy, open to interesting offers. Regular/person/group shows. Also craft display cabinets. Spotlighting.

CARLISLE

CARLISLE MUSEUM AND ART GALLERY, Castle Street, Carlisle, Cumbria CA3 8TP. Tel. 0228 34781. Opening: April–Sept Mon–Fri 9-7, Sat 9–5, Sun 2.30–5 (May–Aug incl), Oct–Mar Mon–Sat 9–5. Contact: Laura Hamilton, Arts Assistant. Applications: In writing initially plus slides of recent work. Exhibitions: Contemporary visual art, photography and craft, exhibitions of work selected from the permanent collection, occasional social history exhibitions, art historical shows from external sources. Space: three galleries of approx 120 linear feet each. Gallery walls recently relined in a high density chipboard. Lighting by tracked spotlights. Floors polished hardwood. Daylight excluded in Gallery 2. All galleries recently rewired. Ample power-points throughout. Equipment: Carousel projector. Photographic darkroom. Tape recorders. The policy of the museum is to display and interpret the collections and to exhibit the best of contemporary art, photography and craft, particularly when relating to the region.

CHESTER

AYLING PORTEOUS GALLERY, 33 City Road, Chester CH1 3AE. Tel. 0244 324556. Opening:

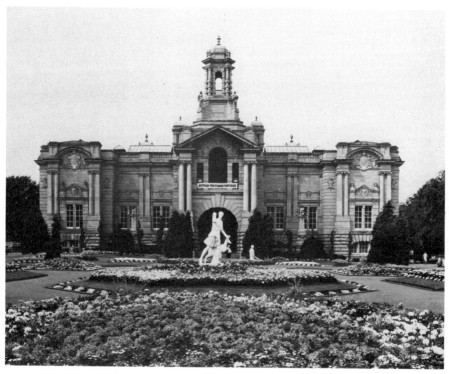

Cartwright Hall, Bradford

44

Daily (excl. Wed & Sun) 10–12.30, 1.30–5. Contact: Mick Ayling. Exhibitions: By invitation only. Send slides or contact the gallery for initial introduction. If exhibition considered, studio visit follows and we proceed from there. Private gallery showing contemporary art.

COCKERMOUTH
CASTLEGATE HOUSE (opposite the Castle), Cockermouth, Cumbria CA13 9HA. Tel. 0900 822149. Opening: Daily except Sun & Thurs 10.30–4.30 (Weds 7) March to mid-Jan (also Feb by appointment). Contact: Chris Wadsworth. Exhibitions: Contemporary paintings, plus some limited edition prints, ceramics, sculpture and glass. Space: One room 260sq ft for gallery artists, and another 320sq ft for one-person and group exhibitions, changing approx monthly. Lit by suspended wall wash lights. A private gallery in a Georgian house occupied by the owner, which retains its original features and a homely atmosphere.

DARLINGTON
THE ARTS CENTRE,Vane Terrace, Darlington, County Durham DL3 7AX. Tel. 0325 483271. Opening: Mon–Wed 9–10.30, Thurs–Sat 9–11. Myles Meehan Gallery (Category B) open Mon–Sat 10–8. Also Glass Corridor specialising in photography exhibitions, Crafts Window and Foyer space. Director: Peter Bevan. Exhibitions Officer: Alison Lloyd. 10 mins walk Town Centre. London 2½ hours British Rail (Kings Cross)/A1 road. Exhibitions of contemporary visual art; painting, sculpture, photography, craft, performance art and videos originated and touring. Encourages participation in the Gallery's activities through workshops, community projects, artists in schools projects and residencies. The Gallery, through its programme of exhibitions is attempting to increase the accessibility of visual arts to a wider audience. Residential accomodation for 30.

DARLINGTON ART GALLERY, Crown Street, Darlington, Co. Durham DL1 1ND. Tel. 0325 462034. Opening: Mon–Fri 10–8, Sat 10–5.30, closed Sunday. Contact: Mrs F. M. Layfield, ALA, District Librarian. Applications: In writing, followed by personal visit with photographs and samples of work. Professionals only. Exhibitions: Temporary exhibitions from various sources which include painting, photography, prints etc. Also annual exhibitions from local art and photographic societies. Works vary from abstract to traditional and local exhibitions have a tendency to be on landscape, genre, wildlife or railway themes. Selections from the permanent collection are shown from time to time. Space:

Towneley Hall, Burnley

Walls—hessian covered panels. Floor— thermo-plastic tiles. Lighting—indirect ceiling. Dimensions— 70ft × 40ft. Approx. 150ft wall run. Display case. Permanent collection of local paintings of the 19th century. Temporary exhibitions are predominantly by local artists, both figurative and abstract.

DONCASTER
DONCASTER METROPOLITAN INSTITUTE OF HIGHER EDUCATION, Church View, Doncaster DN1 1RF. Tel. 0302 22122 (to be changed to 322122 sometime later on in 1988) ext 276. Opening: Mon–Fri 9–5. Contacts: Belinder Pollit, Rob Ward. A space of 38ft × 30ft in the foyer of the Art and Design building, with direct fixing and spotlighting. The gallery shows one-person and group exhibitions in a broad range of art, craft and design areas. We take no commission, and cover insurance while work is on the premises.
DONCASTER MUSEUM & ART GALLERY, Chequer Road, Doncaster DN1 2AE. Tel. 0302 (3)734287. Opening: Weekdays 10–5, Sun 2–5. Contact: T. G. Manby, Curator. Applications: In writing, giving details of subject and content. Exhibitions: Painting, sculpture, ceramics, glass, textiles, wood and metalwork, as well as historical and scientific subjects. Group and one-person shows. Space: First floor of museum, mobile display screen system of 300 linear feet. Floor area

2000sq ft. Adjustable track lighting. Equipment: Slide projectors, tape recorders. Provides a venue for a number of national exhibitions. Permanent collection of fine and applied art.

DUKINFIELD
DUKINFIELD LIBRARY GALLERY, Concord Way, Dukinfield, Cheshire SK16 4DB. Tel. 061-330 3257. Opening: Mon, Tues, Thur 9–7.30, Fri 9–5, Sat 9–12.30. Contact: Arts Officer, Tameside Libraries and Arts Council Offices, Wellington Road, Ashton under Lyne OL6 6DB. Applications: Send slides of recent work or personal visit. Any small scale arts/crafts work considered. Exhibitions: Includes painting, collage, photography, sculpture, drawings, craft work. About 12 exhibitions per year, mostly one-person. Space: Floor area 18t × 28 fully carpeted. Hessian covered panelling on walls, 38ft in length. Lighting, fluorescent and spots. A small gallery presenting a varied programme in a recent building (1984) situated in a shopping mall. Equipment: Slide projector and tape recorder.

DURHAM
THE BOWES MUSEUM, Barnard Castle, Co. Durham DL12 8NP. Tel. 0833 690606. Opening: Mon–Sat 10–5.30, Sun 2–5, closes 5pm, Mar, Apr, Oct; 4pm, Nov–Feb, closed entirely for one week leading up to Christmas, and 1st Jan. Contact:

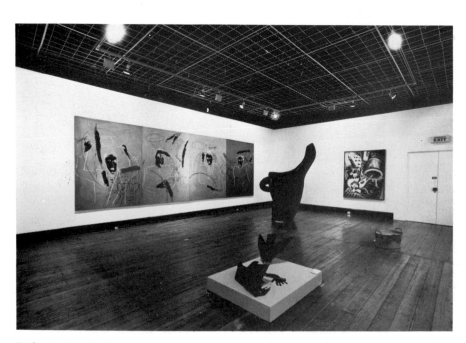

Darlington Arts Centre

Elizabeth Conran, Curator. Permanent collection of European fine and decorative arts, 15th–19th century. Temporary exhibitions.

DLI MUSEUM & ARTS CENTRE, Aykley Heads, Durham DH1 5TU. Tel. Durham 42214. Opening: Tues–Sat 10–5, Sun 2–5, closed Monday except Bank Holidays. Contact: Nerys A. Johnson, Keeper-in-Charge. Applications: In writing enclosing slides/photographs. Exhibitions: All aspects of contemporary visual arts in two or three dimensions. Main emphasis on painting, printing, sculpture and photography. Only very limited facilities for any type of performance art. Space: Gallery 1—18.29m × 9.14m × 2.67m high. Gallery 2—15.24m × 9.14m × 2.67m high. White plaster walls; cork floors; lytespan track in Gallery 2; diffused daylight in Gallery 1. Flexible system of screens and hanging rods. Full security. Equipment: One Steinway Grand Piano. One Kodak Carousel Slide Projector. Two small single frame Hanimex Projectors. One Tanberg two track tape recorder. BASF 9110 tape recorder, VHS video and monitor. Indoor sound system to both galleries and coffee bar. The Arts Centre shares a modern building with the Regimental Museum of the Durham Light Infantry, which means that its exhibitions are seen by a wide range of people, many of whom do not have any specialist knowledge or understanding of art. The broad policy of the Arts Centre therefore, is educational in a very wide sense, with work by living artists included in thematic exhibitions (structure colour, etc.). or into meaningful groupings. These, together with one-person shows are often accompanied by seminars, creative workshops, films and talks which involve the artists with the local community.

ECCLES
MONKS HALL MUSEUM, 42 Wellington Road, Eccles, Lancashire M30 0NP. Tel. 061-789 4372. Opening: Mon–Fri 10–12.30, 1.30–5, Sun 2–5. Contact: Mr. W. M. Leber at Salfrod Art Gallery. Space: Approx. 75ft of hanging space, max. size of work shown is 6ft sq. Fluorescent lighting. Other details, see Salford Art Gallery.

GATESHEAD
SHIPLEY ART GALLERY, Prince Consort Road, Gateshead, Tyne and Wear NE8 4JB. Tel. Tyneside 4771495. Opening: Tues–Fri 10–5.30, Sat 10–4.30, Sun 2–5. Contact: Andrew Greg, Curator. Applications: By letter with slides or good photographs. Exhibitions: Mostly contemporary craft, some art exhibitions. Space: 75m hanging length, track lighting. Equipment: Video and slide equipment. Exhibition programme planned 18–24 months in advance.

HARTLEPOOL
GRAY ART GALLERY AND MUSEUM, Clarence Road, Hartlepool, Cleveland TS24 8BT. Tel. Hartlepool 266522 ext 259. Opening: Mon–Sat 10–5.30, Sun 2–5. Contact: J. O. Mennear, Curator, Mrs E. Law, Keeper of Art. Applications: In

writing to the Curator, or in person to the Keeper of Art. Exhibitions: Local artists, one or two-person exhibitions, artists from other areas, Arts Council exhibitions. Space: Two galleries available for temporary exhibitions—30ft × 20ft and 40ft × 40ft strip and track lighting. Equipment: Slide projector, frames & VHS video. Most exhibitions are biased towards 2-dimensional work.

HEXHAM
MOOTHALL ART GALLERY, Market Place, Hexham, Northumberland. Tel. 0434 604011 for details and bookings. Exhibition space for arts and crafts exhibitions and sales.

THE QUEEN'S HALL ARTS CENTRE, Beaumont Street, Hexham, Northumberland. Tel. 0434 606787. Exhibition area available in the gallery, studio one and stairwell.

HUDDERSFIELD
HUDDERSFIELD ART GALLERY, Kirklees Libraries and Museum Service, Princess Alexandra Walk, Huddersfield, W. Yorks. Tel. 0484 21356. Contact: Robert Hall. Opening: Mon–Fri 10–6, Sat 10–4. Contemporary Art and touring exhibitions

HULL
BEVERLEY ART GALLERY, Champney Road, Beverley, N. Humberside. Tel. 0482 882255. Opening: Mon, Tues, Wed, Fri 9.30–5.30, (closed 12.30–2), Thurs 9.30–12 noon, Sat 9.30–4. Contact Chief Administrative Officer, Beverley Borough Council, The Hall, Lairgate, Beverley. Applications: To Chief Administrative Officer. Exhibitions: Permanent collection and local artists' work only. Some one-person and two-person shows.

FERENS ART GALLERY, Queen Victoria Square, Hull. Tel. 0482 222750. Opening: Mon–Sat 10–5, Sun 2.30–4.30. Contact: Mrs Louise West, Senior Keeper. Applications: By form, available from the gallery. Exhibitions: Permanent collection of old masters, 19th/20th century painting, photography, design, graphics. Temporary exhibitions of contemporary art by local and national artists, both amateur and professional. Space: Two spaces 28ft × 24t and two @ 28ft × 49ft, all inter-connecting. Walls hessian-lined, lighting flourescent, with additional spotlights. New extension opening approx. 1990. Equipment: Slide projectors.

POSTERNGATE GALLERY, 6 Posterngate, Hull. Tel. 0482 222745. Applications: Twice yearly selections in March & November held at the Ferens Gallery. Exhibitions: Contemporary art. Space: One single room ofering 120 linear feet of hanging space, floor sockets, daylight and spotlights. Coffee and shop area. Also a small (50–60 linear feet) exhibition space for photographic work, organised by the Posterngate Photographic Workshop.

ILKLEY

THE HAWKSWORTH GALLERY, 3 Hawksworth Street, Ilkley LS29 9DU. Tel. 0943 603165. Opening: Tues–Sat 10–4, Wed 1.30–4. Contact: Mary Sara, owner. Private gallery showing contemporary work by established and lesser-known artists from the region in month long one-person and group shows. Crafts by local makers shown in August and December. Gallery space: Ground floor rooms of terraced house in town centre with excellent natural and artificial light, plus upstairs varied stock from gallery artists and contemporary prints, in sitting room setting. Also Hawksworth Art Hire—hiring pictures to business and private clients.

JARROW

BEDE GALLERY, Springwell Park, Jarrow, Tyne and Wear NE32 5QA. Tel. 091-489 1807. Opening: Tues–Fri 10–5, Sun 2–5, closed Sat & Mon. Contact: Vincent Rea. Applications: By letter enclosing slides or photographs. All applications go before a management committee for acceptance. Exhibitions: 20th century, contemporary, British and foreign art. Twelve one-person shows are held each year. Space: Gallery 70ft × 30ft × 11ft high, floor carpeted, walls wood. Tracked spotlights to gallery. The gallery is situated in a public park which has been used in the past for performance events. Equipment: Slide projectors, tape recorders and a fully comprehensive art film library on video cassette and monitor. Although beginning, in 1967, in premises used formerly as an underground airaid shelter, the Bede Gallery now has exhibition resources to equal those of any major regional gallery in the country. In addition to showing the work of young experimental artists, it is gallery policy to devote space regularly to new work by established British artists and to provide a venue in the north-east for major shows of international standing. It also maintains close links with the local community by showing local artists and having a permanent collection of local history exhibits. The gallery's excellent film library plays a part in involving children and young people in the gallery's activities.

BEDE MONASTERY MUSEUM, Jarrow Hall, Church Bank, Jarrow, Tyne and Wear NE32 3DY. Tel. 091 489 2106. Opening: Apr–Oct, Tues–Sat 10–5.30, Sun 2.30–5.30. Nov–Mar, Tues–Sat 11–4.30, Sun 2.30–5.30, closed Mon except Bank Holidays. Contact: Mr. J. R. Kilburn. Exhibitions: Local history, photographic and artistic exhibitions, but the emphasis is not on contemporary arts. Space: First floor gallery 14ft × 17ft × 10ft. Track lighting. Equipment: Slide projector, plinths, screens. Jarrow Hall is a site-museum for St. Paul's Church, Jarrow, nationally famous as the home of the Venerable Bede. Temporary exhibition programme serves two purposes: (1) To provide a changing display producing regional interest in the museum generally. (2) Specialist exhibitions of an archaelogical or historical nature relating to the monastic site and its cultural significance.

KEELE

UNIVERSITY OF KEELE, Keele, Staffs ST5 5BG. Tel. 0782 621111. Opening: 9–9 every day of the week. Contact: Mrs. A. Drakakis-Smith. Applications: By letter. Exhibitions: Paintings, prints, sculpture, craft, photography etc. One-person and group shows. There are three possible areas: A purpose built gallery properly lit and secured: a long wall space in the main concourse of the Chancellor's Building close to the gallery; and Keele Hall, a smaller hanging space with oak panel walls. There is a student population of around 3000 and a keen artistic hinterland. There is a strong emphasis on local artists but we also encourage artists from other areas to exhibit and so broaden the perspective. The university insures all works displayed on its premises.

KENDAL

ABBOT HALL ART GALLERY, Abbot Hall, Kendal, Cumbria LA9 5AL. Tel. 0539 22464. Opening: Mon–Fri 10.30–5.30, Sat and Sun 2–5. Contact: Miss V. A. J. Slowe, AMA. Applications: By letter to the Gallery Director, with slides/photos etc. Exhibitions: Modern paintings, sculpture, ceramics, crafts, permanent collections. Space: Four galleries about 20ft × 30ft each. Equipment: Slide projectors, tape recorders. Abbot Hall was built in 1759, ground floor has been restored to period decor and contains permanent collection of fine and decorative art of local significance and national importance. Gallery aims to encourage young talent as well as established artists.

BREWERY ARTS CENTRE, Highate, Kendal, Cumbria. Tel. 0539 25133. Photography and warehouse galleries with a variety of interesting local and national exhibitions.

KEIGHLEY

CRAVEN ART GALLERY, Scott Street, Keighley BD21 2SP. Tel. 0535 680388. Opening: Mon–Sat 10.30–4.30. Contact: Eileen Newell. Exhibitions: Changing exhibitions—work by Yorkshire artists, good stock of original works and prints, framing service.

KIRKBY LONSDALE

COACH HOUSE CONTEMPORARY ART, 9 Main Street, Kirkby Lonsdale, via Carnforth, Lancs LA6 2AQ. Tel. 05242 71142. Opening: Mon–Sat 9.30–5. Contact: Ian Higginbotham. Applications: Submit slides/photos of work together with C.V. Exhibitions: Changing shows by gallery artists. Regular one-person and mixed exhibitions. Comprehensive selection of artists' graphics. Exclusively contemporary and 20th century artists. Space: Modern conversion, natural and spotlighting. Commercial gallery committed to the promotion and sale of art into the private

and public sectors. Extensive slide index system for client use.

KNARESBOROUGH
GOLDSBOROUGH GALLERY, 4 York Place, Knaresborough, North Yorkshire. Tel. 0423 865109. Opening: Mon–Sat 10.30–5. Contact: Loïs Pertee. Applications: Submit slides/photographs with C.V. Exhibitions: Thematic mixed paintings/crafts. Contemporary works of well-known and lesser-known artists/craftsmen. Small, well lit area of 450sq ft × 180sq ft.

LANCASTER
THE SCOTT GALLERY, University of Lancaster, Bailrigg, Lancaster LA1 4YU. Tel. 0524 65201 ext 4336.

LEEDS
CITY ART GALLERY, The Headrow, Leeds LS1 3AA. Tel. 0532 462495. Collection of 19th and 20th century paintings and sculpture. Some impressionists. Outstanding British art of the 20th century, and new Henry Moore Sculpture Gallery. Important early English watercolours and print collection. Henry Moore Study Centre, and new wing including watercolour gallery, print room, licensed restaurant, exhibition gallery and art workshop facilities. Disabled access. Wideranging exhibition programme, paintings, sculpture, performance, lectures.
PAVILION PHOTOGRAPHY PROJECT, 235 Woodhouse Lane, Leeds LS2 3AP. Tel. 0532 431749. Opening: Wed–Fri 10–4, Sat 1–4. Contact: Emma Ayling, Sonia Hendrickson, Jude Thomlinson. Exhibitions: The only women's photography centre in Britain, open since 1973. Promotes women's photography through a combined programme of educational and exhibition events and particularly encourages women who do not usually get the opportunity to learn photographic skills. Space: Large, flexible exhibition area which is also used for conferences. Equipment: Darkroom, with wheelchair access and mobile darkroom which is used within the community.
ST PAUL'S GALLERY, Stowe House, 5 Bishopgate Street, Leeds LS1 5DY. Tel. 0532 456421. Opening: Mon–Fri 10–5, Sat 10–4. Contact: James Hamilton. Applications: In writing or by appointment. Exhibitions: Contemporary painting, sculpture, prints, photography and crafts. One-person, theme and group shows. Space: One gallery on the top floor of an office block opposite Leeds City Station. Track lighting and daylight, linoleum floors. Equipment: Small number of frames. The Gallery attempts to strike a balance between work in different styles and media and between well-known and less-established exhibitors. The gallery is part of the Yorkshire Contemporary Art Group. Funded by Yorkshire Arts Association, Leeds City Council, West Yorkshire Grants and the Gulbenkian Foundation.
LEEDS CITY ART GALLERIES, Temple Newsam House, Leeds LS15 0AE. Tel. 0532 647321.

Contact: Christopher Gilbert, Director. Applications: Normally by invitation. Exhibitions: Contemporary painting, sculpture, photography, craft and design work. Space: Temporary exhibition galleries at The City Art Gallery, The Headrow, Leeds 1. Limited space also at Lotherton Hall, Aberford, Leeds.
UNIVERSITY GALLERY, LEEDS, University of Leeds, Leeds LS2 9JT. Tel. 0532 431751 ext 6298. Opening: Term only Mon–Fri 10–5. Contact: The Curator, University Collection and University Gallery. Applications: In writing. Exhibitions: Fine, applied art and photography.

LINCOLN
BISHOP GROSSETESTE COLLEGE GALLERY, Newport, Lincoln LN1 3DY. Tel. 0522 27347. Opening: 9–9. Contact: Dennis Valentine, The Art Centre. Applications: To Exhibitions Officer. Exhibitions: Amost any kind of work which is interesting and of a good standard. Mostly one-person shows. Space: Gallery is also the entrance to a college. About 80 linear feet of hanging space, additional corridor space available for large exhibitions. Tracked spot and flood lights. Exterior spaces available for showing sculpture. Equipment: Audio/visual equipment is freely available. Gallery aims to provide a continuing diverse programme of exhibitions for students and visitors to the college, but is also open to the public. Situated centrally, close to the Cathedral.
USHER GALLERY, Lindum Road, Lincoln LN2 1NN. Tel. 0522 27980. Opening: Weekdays 10–5.30, Sun 2.30–5. Contact: R. H. Wood. Applications: Form available from the gallery. Exhibitions: Historical and contemporary work of regional and national significance in all media. Space: Three temporary exhibition galleries all with controlled spotlighting, neutral wall and floor surfaces, flexible hanging screens. Equipment: Slide projector, plinths, frames, video (U-Matic), showcases. Permanent collection containing a wide variety of fine and applied art, including Dutch (major collection of Peter de Wint), Flemish and Italian paintings, ceramics, metalwork and sculpture. Active temporary exhibitions programme. Lively educational programme mainly in conjunction with temporary exhibitions. Workshops and residencies, sometimes week-long artist-in-residence schemes. Important venue for other arts events i.e. music, lectures, drama groups, performance art.

LIVERPOOL
ACORN GALLERY, Newington, Liverpool L1 4ED. Tel. 051-709 5423. Opening: Mon–Sat 10–5. Contact: Janine Pinion. Applications: Submit slides/C.V. Monthly exhibitions of contemporary art including a display of sculpture, crafts or other 3-dimensional work to complement the main exhibition. Good space for one-person or two-person shows. Occasional group or mixed shows. Small charge made for hire of gallery, all publicity and private view costs provided. Information

packs available. Space: Excellent natural lighting in spacious 1500sq ft Victoria warehouse attic. Also spotlighting, and good display facilities. Well-attended.

BLUECOAT GALLERY, School Lane, Liverpool L1 3BX. Tel. 051 709 5689. Opening: Tues–Sat 10.30–5. Contact: Bryan Biggs. Applications: Submit slides/photographs of work, together with C.V. Exhibitions: Local artists (touring shows sometimes arranged); one-person shows by nationally recognised artists; thematic touring shows; small exhibitions of craftwork, graphics, photography etc.; performance art. Space: Four galleries, 800sq ft, 180sq ft, 300sq ft and 200sq ft. Natural and spotlighting. Equipment: Carousel projector, some frames. Occasional lectures by exhibiting artists and video. Dance and music events are promoted in other parts of the building by the Bluecoat Society of Arts.

HANOVER GALLERIES, 11/13, Hanover Street, Liverpool L1 3DN. Tel. 051 709 3073. Opening: Tues–Sat 10.30–5. Admission free. Details from gallery proprietor. Applications: Submit slides/photographs, with C.V. for Galleries One and Two rental details. The galleries recieve no subsidies or grants from National or Local Arts Councils, but nevertheless do their utmost to encourage young and/or unknown artists, country-wide. We believe that with the opening of the Liverpool Tate Gallery, that the young, at present 'unknowns', may well receive the encouragement they deserve.

LADY LEVER ART GALLERY, (National Museums and Galleries on Merseyside) Port Sunlight Village, Wirral. Tel 051-645 3623. Opening Mon–Sat 10–5, Sun 2–5. Train services to Bebington. An outstanding permanent collection of English 18th century furniture, Chinese porcelain, Wedgwood, and Victorian paintings, formed by the first Viscount Leverhulme (1851–1925). Adm. free. No temporary exhibitions.

SUDLEY ART GALLERY, (National Museums and Galleries on Merseyside) Mossley Hill Road, Liverpool. Tel. 051-724 3245. Opening: Mon–Sat 10–5, Sun 2–5. Train services to Mossley Hill Station. A fascinating collection of 18th and 19th century English paintings formed by Liverpool merchant George Holt, displayed in his house. Historic and contemporary temporary exhibitions, particulary of photography. Contact: Alex Kidon, Walker Art Gallery.

TATE GALLERY LIVERPOOL, Albert Dock, Liverpool L3 4BB. Tel 051-709 3223. Opening: Tues–Sun 11–7, closed Mon. Director: Richard Francis, Curator, Lewis Biggs. Exhibitions programme: Tate Gallery Liverpool is the new gallery of modern art for the North of England. Works on show are drawn from the Tate Gallery's collection and there will be a programme of major exhibitions from this and other collections. There will be thematic surveys of groups of works by artists or movements of significance, and displays linked to events: internationally recognised painting, sculpture, photography; performance, dance, music,

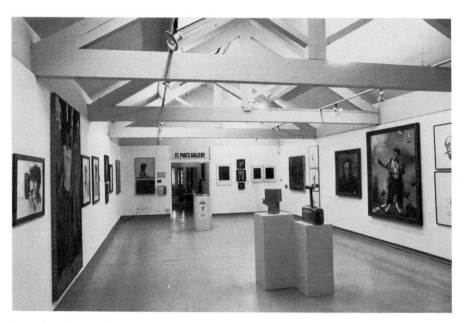

St Paul's Gallery, Leeds

50

film by invitation. The opening displays are Mark Rothko: The Seagram Mural Project; Surrealism (28 May 1988–March 1989); Starlit Waters British Sculpture an International Art 1968–1988 (28 May 1988–4 September 1989). There will also be a major review of British Sculpture from 1908–1988, drawn from the Tate Gallery's collection. This is the first of a series of thematic displays designed as a valuable study source, and will be on display for three years. Tate Gallery Liverpool has a videotheque for showing videos of artists and their work, and a reading room. There is also a classroom available for hire. The education department are developing a full education programme both in and outside of the gallery. Please contact Toby Jackson for further information.

THE UNIVERSITY OF LIVERPOOL ART GALLERY, 3 Abercromby Square, Liverpool L69 3BX. Tel. 051-709 6022 ext 3170. Opening: Mon, Tues, Thurs 12–2, Wed, Fri 12–4. Otherwise by arrangement. Contact: Janice Carpenter. Permanent collection of British art from late 17th century including sculpture, paintings, watercolours, prints, furniture, ceramics, silver and glass.

WALKER ART GALLERY, William Brown Street, Liverpool L3 8EL. Tel. 051-227 5234. Opening: Mon–Sat 10–5, Sun 2–5. Contact: Timothy Stevens. Applications: By letter to the Director. Exhibitions: Work in all media, including painting, graphics, sculpture, video and performance. Mostly group shows. Space: Six galleries— 72ft × 28ft, 71ft × 26ft, 103ft × 35ft and three measuring 35ft × 35ft. Wooden floors, strip and spotlighting, also natural top-lighting. Equipment: Slide projectors, 16mm projector, cassette recorder, a selection of wooden frames in different sizes. The aim is to make available on Merseyside the best cross-section of current art to enlarge on aspects of the permanent collection which includes Old Masters, contemporary British art and the local school of artists, and to provide a forum for the work of painters, especially in the John Moores Liverpool Exhibitions, as well as for more established artists.

MANCHESTER

CASTLEFIELD GALLERY, 5 Campfield Avenue Arcade, off Deansgate, Manchester. Tel. 061-832 8034. Opening: Tues–Sat 10.30–5, Sun 12–4.30. Contemporary painting and sculpture shows, one-person and thematic. National tours initiated. Regular workshops for children plus other events organised in conjunction with exhibition programme. Applications: 12 slides and C.V. Original works of art for sale up to £100. Postcards and magazines for sale.

Walker Art Gallery, Liverpool

CORNERHOUSE, 70 Oxford Street, Manchester M1 5NH. Tel. 061-228 7621. Opening: Tues–Sun 12–8. Contact: Gerald Deslandes, Exhibitions Director. Applications: Submit slides/photographs and C.V. Exhibitions: 3 gallery spaces showing thematic group exhibitions; exhibitons of work by nationally recognised artists; group local shows. Photographs in the bar. Space: Three galleries—150 linear ft/1500sq ft; 150 linear ft/900sq ft; 190 linear ft/2020sq ft. Fluorescent strip and spotlighting; additional daylight through top-lighting in large gallery. Linked to three cinemas, cafe, bar and bookshop; full related education programme. Independent registered charity supported by BFI, NW Arts and Association of Greater Manchester Authorities.

THE CRAFT CENTRE, Royal Exchange Theatre, St. Anns Square, Manchester M27 7DH. Tel. 061-833 9333. Opening: Mon, Tues, Thurs 11–7.30, Wed 11–2.30, Fri 11–8, Sat, 11–4. Contact: Morag Shaw. The Craft Centre, situated in the theatre's magnificent foyer, is one of the Craft Council's 54 galleries selected for quality. The work on display is exclusively contemporary craft work, ranging from jewellery, ceramics and glass to textiles and wood. Regular exhibitions are held, promoting the work of both new and established makers. The Craft Centre has an educational programme.

THE GINNEL GALLERY, Lloyds House, 16 Lloyd Street, Manchester M2 5ND. Tel. 061-833 9037. Opening: Mon–Fri 9.30–5.30, Sat 10–4. Contact: Keith Mottershead. Space: 2800sq ft on one level divided into different areas and lit by spotlights. One-person, mixed and national competitions held throughout the year. Applicants should apply with slides and C.V.

HEATON HALL, Heaton Park, Prestwich, Manchester M25 5SW. Tel. 061-773 1231. Opening: Daily 10–6 (closed Tues), Sun 2–6, 29 Mar–27 Sept. Set in extensive parkland, Heaton Hall has been described as 'the finest house of its period in Lancashire and one of the finest in the country' (Pevsner). Dating from 1772, it was designed in the Neo-classical style by James Wyatt for Sir Thomas Egerton, later Earl of Wilton. The impressive period interiors include fine plasterwork, 18th century furniture and paintings. The unique Pompeiian Room was recently restored and other restoration work can often be viewed in progress. The Music Room houses the original Samuel Green Organ, still in good working order. Regular music recitals are held during the summer months. Changing exhibitions are displayed in the 'Heaton Gallery'. An audio-visual introduction to the history of the Hall and family is shown on request.

HOLDEN GALLERY, Manchester Polytechnic, Grosvenor Building, All Saints MIC, Manchester M15 6BR. Contact: M. Mason.

COLIN JELLICOE GALLERY, 82 Portland Street, Manchester 1. Tel. 061-236 2716. Founded 1963. Directors: Colin Jellicoe and Alan Behar. Contact: Colin Jellicoe, Applications: Open submission. Send slides or photos with an s.a.e. or phone the gallery for an appointment. Exhibitions:

One-person, group and mixed. The gallery deals in figurative and modern drawings, paintings, graphics and sculpture. Main themes exhibited are: Landscape/townscape/traditional and modern figure. New artists shown in mixed shows first. A lively gallery, showing a wide range of work by known and unknown artists.

LANTERN PHOTOGRAPHIC ART GALLERY, 3 Worsley Road, Worsley, Manchester M28 4NN. Enquiries Tel. David Tasker 061-794 1160. Open year round Tues, Fri Sat 1–5.30, Sun 12.30–7. The gallery founded 1984 is exlusively for the promotion of photography as a viable alternative art form and there are no other galleries of its kind in the UK although many like it exist in the USA. A framing service is also available, custom cibachrome printing, and weekend workshops are sometimes undertaken. Apart from a permanent ever changing exhibit of cibachromes and black and white photography by founder photography artist David Tasker and his former photographic students on a range of themes from international, historic to abstract, one gallery is set aside for visiting contributors and new work of a high standard especially if it differs from our own existing exhibits is always welcome. Entrance to the gallery is from a footpath alongside the Bridgewater Canal and the area is of great historical interest being the birthplace of the industrial revolution canal system with the world's longest underground tunnels. The gallery itself dates from before the canals (1725) and is the oldest listed building in Worsley.

MANCHESTER CITY ART GALLERY, Mosley Street, Princess Street, Manchester. Tel. 016-236 9422. Opening: Weekdays 10–6, Sun 2–6.

MEMORIAL ART GALLERY, Central Library, Chorley Road, Swinton, Manchester M27 2AF. Tel. 061-794 7440, 061-794 7440. Opening: Mon, Tues, Wed, Fri 9–7. Contact: Mr. W. M. Leber at Salford Art Gallery. Space: Approx. 100ft of hanging space, fluorescent lighting, chain and hook hanging system. Other details: See Salford Art Gallery.

PORTICO LIBRARY & GALLERY, 57 Mosley Street, (entrance in Charlotte Street), Manchester M2 3HY. Tel. 061-236 6785. Opening: Mon–Fri 9.30–4.30. Admission free. Contact: Exhibitions organiser. Improved gallery area of 120 linear feet of screens plus 4 display cases, floor space for small sculpture, situated under the beautiful restored domed ceiling of one of Manchester's finest Georgian buildings. Spotlighting and daylight. We intend to show a wide variety of arts and crafts of the highest standard, occasional open days in conjunction with shows, local and national artists are welcome to apply in writing enclosing slides and C.V.

TIB LANE GALLERY, 14A Tib Lane (off Cross Street), Manchester 2. Tel. 061-834 6928. Opening: Mon–Fri 11–2, 3–5, Sat 11–1. Contact: Jan Green. Applications: Phone or call to make an appointment. Exhibitions: Mainly figurative, British paintings, drawings and sculpture of this century. Group and one-person. Space: Very

small—one room, semi-basement, wooden walls, carpeted floor, window onto street level, spotlighting on track. Private gallery showing work by well-established artists and those who are lesser or unknown, whose work the owner is enthusiastic about.

WHITWORTH ART GALLERY, University of Manchester, Oxford Road, Manchester M15 6ER. Tel. 061-273 4865. Opening: Mon–Sat 10–5, Thurs 10–9. Contacts: Prof. C. R. Dodwell, Director; Francis W. Hawcroft, Principal Keeper; Julian Tomlin, Exhibitions Officer. Applications: By letter. Exhibitions: Fine and decorative arts of all periods. Apart from the biennial **Whitworth Young Contemporaries**, shows by living artists tend to be one-person. Space: Approx. 600sq metres, divided into two rooms of equal size (interconnecting), plastered walls. Exterior spaces occasionally used for outdoor sculpture exhibitions, one or two-person. Equipment: Slide projectors tape recorders and video equipment can be hired. Extensive permanent collection well worth visiting, with special emphasis on British watercolours, European drawings, textiles, prints and 20th century British art, including contemporary.

MIDDLESBROUGH

CLEVELAND GALLERY, Victoria Road, Middlesbrough, Cleveland. Contact: Mike Hill. Tel. 0642 248155 ext 3375. Opening: Tues–Sat 12–7. 1800sq ft of exhibition space. Open to applications.

MIDDLESBROUGH ART GALLERY, 320 Linthorpe Road, Middlesbrough, Cleveland TS1 4AW. Tel. 0642 247445. Opening: Mon–Sat 10–6. Contact: Vivienne Totty. (Please submit exhibition request in writing). Permanent collection—20th century British art on show through exhibitions. Very active temporary exhibitions programme; local and national artists, short residencies and workshops. Outdoor Sculpture Court, summer and winter shows. Late Victorian house, natural and spotlighting. Part of Middlesbrough Borough Council Museum Service.

NEWCASTLE UPON TYNE

NEWCASTLE ARTS CENTRE, 67–69 Westgate Road, Newcastle upon Tyne NE1 1SG. Tel. 091-261 5618. Opening: Mon–Fri 10–6, Sat 10–7. A major new arts centre in central Newcastle. Contact: Mike Tilley

CALOUSTE GULBENKIAN GALLERY, People's Theatre Arts Group, Stephenson Road, Newcastle upon Tyne NE6 5QF. Tel. 091-265 5020. Openings: 6.30pm–9.30pm during plays and arts group activities. Contact: Trevor Hopkins. Applications: Open to anyone but priority given to local artists. Applications: From groups and organisations are also welcome. Apply by letter to: The Chairman, Calouste Gulbenkian Gallery Committee. Exhibitions: The gallery is part of the arts centre and contains a bar and refreshment area used during shows. Twelve exhibitions a year, each for a fortnight plus a Christmas crafts show. Space: 60ft long continuous wall with direct fixing. Two 15ft side walls. Six hanging boards 6ft × 4ft or extra display. Strip lights and fifty adjustable spotlights. Equipment: Plate glass, secure display cabinet, free standing with adjustable shelves. Set of wooden plinths for display of sculpture. Ten (size A1) and twenty (size A2) picture frames available, no charge for use. The gallery will pay for posters, distribution of these, local publicity, bar staff for openings and invitation cards for opening. All work is fully insured. Commission: 20%. The gallery is part of one of Britain's largest amateur arts groups. All the staff are volunteers and the gallery is run by a committee of people interested in, or working in the arts. The gallery exists on grants from Newcastle City Council and northern arts. It is a popular venue with young artists and craftspeople looking for their first one-person show and is very suitable for large works and sculpture.

HATTON GALLERY, The University, Newcastle upon Tyne. Tel. 091-232 8511. Exhibitions: A wide range of mostly fine art, contemporary and historical. Gallery houses a permanent collection, which includes the only remaining Merzbau by Kurt Schwitters.

LAING ART GALLERY, Higham Place, Newcastle upon Tyne NE1 8AG. Tel. 091-232 7734/091-232 6989. Opening: Tues–Fri 10–5.30, Sat 10–4.30, Sun 2.30–5.30. Contact: Mike Collier, Senior Art Exhibitions Officer. Applications: By letter with minimal back-up information (further information and visual material will be requested if necessary). Exhibitions: Contemporary art in various media, plus historical fine and applied arts, often with northern reference. Space: (available for exhibitions) Two galleries 10m × 15m, painted walls, carpeted floor, track lighting; two galleries 8m × 16m, painted walls, parquet floor, fluorescent lights. Equipment: Sound, video, A/V available and some framing in standard A sizes. Newcastle's most centrally situated and prestigious gallery with a large permanent collection of decorative and fine art (mainly British).

NEWCASTLE CENTRAL LIBRARY, Princess Square, Newcastle upon Tyne. Tel. 091-261 0691. Opening: Mon–Thurs 9.30–8, Fri 9.30–5, Sat 9–5. Contact: David Boyes, Publicity Officer. Application: Application forms sent out by request. Exhibitions: Wide range, including one-person shows. Space: 40ft × 20ft, and large glass case, fluorescent and spotlighting. Equipment: Free standing hanging boards and variable height display blocks. There is an exhibition room at Gosforth Library and apart from these there are 12 libraries which can accommodate small exhibitions. They are used not only by artists but by local community groups etc.

NEWCASTLE MEDIA WORKSHOPS, 67–75 Westgate Road, Newcastle upon Tyne NE1 1SG. Tel. 091-232 2410. Three production workshops, photography, audio, and Projects UK initiate and

respond to a wide range of new and original developments in media practice, presentation, distribution, education and debate through a constantly expanding series of projects. NMW engages with both general and specialised media developments.

LIBRARY ARCHIVE—a constantly growing resource comprising independent video work, new sound and music tapes, photographs and slide packages, and audio-visual documentation material. This resource is a bank of information for both practitioners and researchers promoting topical and relevant debate on cultural, social, political, historical and educational issues.

POLYTECHNIC ART GALLERY, Library Building, The Polytechnic, Sandyford Road, Newcastle upon Tyne. Tel. 091-232 6002. Exhibitions: Mostly contemporary British painting.

SIDE GALLERY, 9 Side, Newcastle upon Tyne NE1 3JE. Tel. 091-232 2208. Opening: Tues–Sun 10–6. Exhibitions: Entirely photography, monthly shows of contemporary and historical. Regular shows of new British work as well as a venue in the north-east for major shows of international standing. Space: 2600sq ft on three floors, natural and spotlighting. There is also a bookshop specialising in film and photography and a small cinema showing mainly non-commercial and independent films.

PROJECTS UK (Newcastle Media Workshops), 67–75 Westgate Road, Newcastle upon Tyne NE1 1SG. Tel 091-261 4527. Contact: Jon Bewley. An 'arts enabling agency' committed to commissioning, presenting and promoting new initiatives in various media, particularly in experimental and time-based mediums.

NORTHWICH
SALT MUSEUM, 162 London Road, Northwich, Cheshire CW9 8AB. Tel. Northwich 41331. Contact: Curator. Exhibitions: Permanent collection of the Cheshire Museum. Temporary exhibitions include pottery, prints and photographs.

OLDHAM
OLDHAM ART GALLERY, Union Street, Oldham OL1 1DN. Tel. 061-678 4653. Opening: Mon, Wed, Thurs, Fri 10–5; Tues 10–1; Sat 10–4. Contact: Trevor Coombs, Keeper of Art for applications. Exhibitions: Contemporary art (regional and national). Historical exhibitions mainly from the gallery's collection of 19th and 20th century paintings. Decorative arts. Contemporary and archive photography shows including commissioned work. Oldham Art Gallery houses north-west arts' photography collection and has its own expanding collection. Currently owns over 600 fine art prints from 1960s and 70s. Small collection of sculpture. Galleries: 3–4 contemporary art; 2 photography; 1–2 for historical collection. Total = 7. Permanent **Exhibitions Officer** for outreach/education events. Workshop area. Light: daylight (restricted) floods and spots in all galleries. Equipment: Slide projectors, video, tape recorders, extensive frame stock, etc.

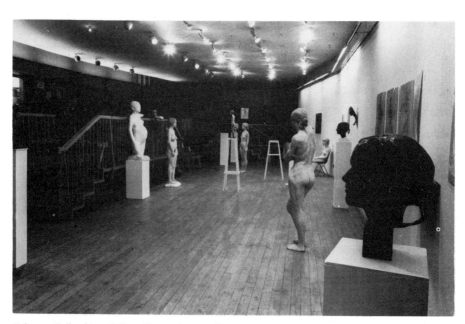

Calouste Gulbenkian Gallery, Newcastle upon Tyne

SADDLEWORTH MUSEUM AND ART GALLERY, High Street, Uppermill, Oldham OL3 6HS. Tel. 04577 4093. Opening: Daily. 'Man and the Landscape' gallery, Victorian Rooms, Weaver's Cottage, Textile History, Victoria Mill woollen manufacturing gallery, Transport gallery, museum shop and Tourist Information Centre. Programme of exhibitions in the art gallery. Schools service, guided parties by arrangement.

PORT SUNLIGHT
LADY LEVER ART GALLERY, Port Sunlight, Wirral L62 5EQ. Tel. 051-645 3623. Opening: Mon–Sat 10-5, Sun 2-5. Contact: Lucy Wood. Permanent collection of British 18th–19th century paintings and sculpture, English 17th–18th century furniture and needleworks, Wedgwood pottery, Chinese porcelain, Greek vases and antique sculpture. No temporary exhibitions at present.

PRESTBURY
ARTIZANA, The Gallery, The Village, Prestbury, Cheshire. Tel. 0625-827582. Opening: Mon–Sat 10.30-6, Sun 2-6. Contact: Ramez Ghazoul. Exhibitions: Exclusively contemporary British crafts; two major and two or three minor annually. Specializing in studio glass, permanent stock also includes ceramics, wood, jewelry, embroidery, sculpture, paintings, etc. by over 200 British craftsmen. Space: Modern, elegant interior in the setting of a listed building within 50 yards of the 13th century St. Peter's Church.

PRESTON
HARRIS MUSEUM & ART GALLERY, Market Square, Preston, Lancs PR1 2PP. Tel. 0772 58248. Opening: Mon–Sat 10-5, closed Sundays & Bank Holidays. Contact: Vivienne Bennett, Museum & Art Officer. Description of shows: Varied programme of temporary exhibitions, mainly contemporary art, in all media. How to apply: Send slides, C.V. and statement. Gallery Spaces: Three galleries are used for temporary exhibitions. Two are 29ft 7", The third is 55ft 3". In addition to showing a wide variety of temporary exhibitions the Harris houses fine collections of British 19th and 20th century paintings and sculptures, costume and decorative art, and local history.
DALLS INMAN GALLERY, 36 Friargate, Preston, Lancs PR1 2AT. Tel. 0772 59670. Opening: Mon–Sat 10-5, closed Thurs. Applications: Occasional shows of contemporary work, always figurative and landscape by local artists. Exhibitions: 18th, 19th and 20th century paintings, some original graphics and craftwork. Space: Old building in the centre of the town on 3 floors. Well lit with fluorescents and spots.
VERNON GALLERY, Building Design Partnership, Vernon Street, Moor Lane, Preston PR1 3PQ. Tel. 0772 59383. Opening: Mon–Fri 9-5.30. Contact: Anne McVittie. Applications: To the Arts Committee of BDP at the above address. Write and include slides, though samples of work may be requested for viewing in some cases. Exhibitions: Works in any medium, including sculpture, from either new or established artists, is shown on a monthly basis. Mixed exhibitions of two or more artists are included in the annual programme. Space: Approx. 50sq metres. Informal layout with generous wall spaces, dividing screens, carpeted flooring and spotlighting. Equipment: Slide projection and sound system available through arrangement with the committee.

ROCHDALE
ROCHDALE ART GALLERY, Esplanade, Rochdale, Lancs OL16 1AQ. Tel. 0706 342154. Opening: Mon–Fri 10-5, Wed 10-1, Sat 10-4. Contact: Arts & Exhibitions Officer, Jill Morgan. Applications: Proposals for projects, installations specifically for the gallery and the community especially welcome. Exhibitions: Contempory work in all media, supporting programme of work by artists based locally/community projects, researched historic exhibitions. Space: Wall space 550 linear feet, floor, wooden block flooring. Light: Track lighting with dimmer facility, overhead natural light, U.V. filtered and blinds. Three interconnecting galleries, one separate gallery. All galleries modernised in 1978/85. Equipment: Carousel slide projectors (2), monitor VHS video recorder, video camera, 35mm sound projector, display cases, frames. The gallery aims to present art in a social context and has a strong commitment to the needs of the local community. The gallery has a policy of support for issue-based contemporary art, particulary the work of women and black artists. A new post of community/education officer is extending the role of the visual arts within the community and taking on more educational work through the gallery. Researched historic exhibitions offer a radical perspective on art history, presented in an accessible way. Exhibitions policy does attract a wider audience and some national attention.

ROTHBURY
COQUETDALE ART GALLERY, Church House, Rothbury, Northumberland. Secretary's Tel. Rothbury 20534. Opening: Easter–Sept Tues–Sat 10.30-12.30, 2-4; Sun 2-4. Contact: Chairman, Paul Lamb. Applications: To the gallery. Exhibitions: No limits set, but most have been on conventional lines—landscapes, portraits wildlife, some crafts. Space: Three average-sized house rooms and one smaller room. Local artists encouraged. The community is small and the gallery depends on summer visitors for interest and support.

ROTHERHAM
ART GALLERY, Brian O'Malley Central Library and Arts Centre, Walker Place, Rotherham S65 1JH. Tel. 0709 2121 ext 3569/3519. Opening: Tues–Fri 10-6, Sat 10-5. Contact: Michael Densley. Applications: Local or locally related artists

55

only, apply direct. Exhibitions: Modern/traditional. Space: Spotlights, hessian-covered walls, floors carpeted, double gallery sapce, about 40ft × 40ft.

ST. HELENS
ST. HELENS MUSEUM AND ART GALLERY, College Street, St. Helens, Merseyside WA10 1TW. Tel. St. Helens 24061 ext 2959. Opening: Mon–Fri 10–5, Sat 10–1. Contact: Curator. Applications: In writing to the Curator—gallery is booked up a year in advance. Exhibitions: Touring shows; annual shows by local societies; one-person photographic and art shows. Space: 1172sq ft, 109 linear feet of hanging space.

SALFORD
SALFORD MUSEUM AND ART GALLERY, Peel Park, Salford, Lancashire M5 4WN. Tel. 061-736 2649/061-737 7692. Opening: Mon–Fri 10–5, Sun 12–5, closed Saturdays, Good Friday, 24–27 Dec, New Year's Day. Contact: Principal Museums Officer, Mr. W. M. Leber. Applications: Normally by letter, enclosing slides (4) and a list of previous exhibitions. Exhibitions: A wide range of fine and applied arts. Space: Two galleries, providing a total of 330ft of hanging space, incandescent and fluorescent lighting. The gallery aims to present contemporary trends in art and encourage the work of artists working in the north. Some of the finest exhibition spaces in the north.

SCARBOROUGH
SCARBOROUGH ART GALLERY, The Crescent, Scarborough. Tel. 0723 374753. Opening: Tues–Sat 10–1, 2–5, Sun 2–5 (summer only). Contact: Josie Montgomery. Permanent collection of paintings from 17th–20th century. Also local collection of 19th century oil and watercolours. Temporary exhibitions programme of contemporary painting, sculpture, craftwork, photography and prints and annual open exhibition—some occasional historical exhibitions. Early Victorian Italianate building with seven galleries, three modernised with new spot and flood lighting. New study space and coffee area. Applications: By letter with slides/photographs.

SCUNTHORPE
SCUNTHORPE BOROUGH MUSEUM & ART GALLERY, Oswald Road, Scunthorpe, South Humberside DN15 7BD. Tel. 0724 843533. Opening: Mon–Sat 10–5, Sun 2–5, Bank Holidays 10–5. Admission free. Contact: Miss P. J. Spencer,

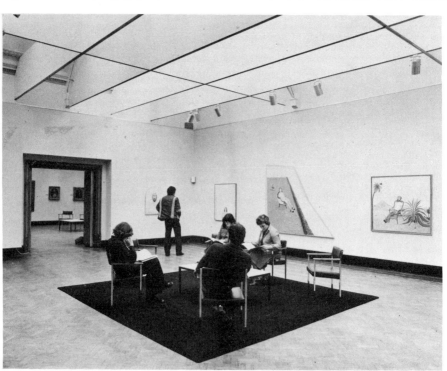

Rochdale Art Gallery

Curator. Applications: In writing (application form and details available from Museum Secretary) enclosing photographs of work. Exhibitions: Amateur and professional. Oils, watercolours, pastels, drawings, prints, sculpture, photography and craft work. Mixed media shows welcomed. 18–20 exhibitions each year. Groups, one-person, two-person, etc., etc. Preference given to artists working within the Lincolnshire and Humberside region. Space: (for temporary exhibitions) Two large galleries and one small space, all on the first floor. Gallery 1. 50ft × 20ft hessian covered blockboard walls. (123ft running length). Artificial light only—diffused ceiling lights and/or tracked spotlights. Gallery 2. 39ft × 20ft artificial light only—tracked spotlights. Pictures mounted on to 4ft deep blockboard panels around walls. (87ft running length). Wall-mounted display cases in gallery (18ft total length). Small Space: 10ft × 20ft (head of stairs and stairwell). Large wall-mounted display case (6ft) and wall-mounted display boards (27ft total length). Equipment: Additional display cases and screens are available for either gallery. Carousel projector and screen. Back projection unit. VHS video display unit in small viewing room off local history gallery.

SHEFFIELD
GRAVES ART GALLERY, Surrey Street, Sheffield S1 1XZ. Tel 0742 734781. Opening: Mon–Sat 10–8, Sun 2–5. Deputy Director of Arts, David Alston. Permanent collections of European Art 16th–20th century. 20th century British paintings, early English watercolours and Oriental artefacts. Continuous temporary exhibition programme.
MAPPIN ART GALLERY, Weston Park, Sheffield S10 2TP. Tel. 0742 726281. Opening: Mon–Sat 10–5, Sun 2–5. Keeper, Michael Tooby. Applications: By letter, enclosing photographs/slides and C.V. Exhibitions: 18th, 19th, 20th century and contemporary fine art and photography. This is shown in the permanent collection as well as in a continuing succession of temporary exhibitions. About 30 shows per year. Space: Total floor area: 8794sq ft polished wooden floors, fluorescent, spot and track lighting. Weston Park is available as an exterior space. There are five galleries. Permanent collection of British art from 1700 to the present. Temporary exhibitions reflect the Sheffield area by showing the work of artists who have links with the district. Dance, music and films are also shown. Programme run in conjunction with Graves and Ruskin galleries and touring exhibitions.
SHEFFIELD UNIVERSITY LIBRARY, The University Library, Western Bank, Sheffield S10 2TN. Tel. 0742 68555 ext 4334. Opening: Mon–Fri 9–9, Sat 9–12noon. Contact: University Librarian. Applications: To Secretary, University of Sheffield Fine Art Society. Exhibitions: Paintings, prints, drawings, small sculpture, crafts.
YORKSHIRE ARTSPACE SOCIETY, Sydney Works, 111 Matilda Street, Sheffield S1 4QF. Tel.

0742 761769. The 2 galleries provide a service not available to either the commercial or municipal galleries within Sheffield i.e. the provision of venues to the young, unknown artist. These galleries receive no public funding and are available for hire. Space: 2 galleries, each 1000sq ft. Equipment: Seating, slide projector. Exhibitions: Paintings, sculpture, prints, drawings, photography, crafts etc.

SKELMERSDALE
LIBRARY ARTS CENTRE, Central Library, Southway, Skelmersdale, West Lancashire WN8 6NL. Tel. Skelmersdale 20312. Opening; Mon–Fri 1–5, Sat 10–1, 2–5. Contact: Eddie Ohren, Arts Co-ordinator. Applications: Submit slides/photographs of work with C.V. Exhibitions: Local artists, (touring shows sometimes arranged), one-person shows by nationally recognised artists, thematic touring shows, small exhibitions of craftwork, graphics, photography, etc. Lectures: Authors, celebrities, informative, educational, nature, local history, travel etc. Theatre, music and poetry performances on a regular basis sometimes accompanied by complimentary workshops. Space: 580sq ft, natural, strip and spotlighting. Equipment: Carousel projector, overhead projector, screens and p.a. system.

SOUTH SHIELDS
SOUTH SHIELDS MUSEUM AND ART GALLERY (Tyne and Wear Museums Service), Ocean Road, South Shields, Tyne and Wear. Tl. Tyneside 4568740. Opening: Tues–Fri 10–5.30, Sat 10–4.30, Sun 2–5. Exhibitions: Variety of art exhibitions including local art shows. Space: 40ft × 30ft, track lighting, no natural light.

SOUTHPORT
ATKINSON ART GALLERY, Lord Street, Southport, Merseyside PR8 1DH. Tel. 0704 33133 ext 2111. Opening: Mon, Tues, Wed, Fri 10–5, Thurs, Sat 10–1. Contact: Stephen P. Forshaw BA (Keeper of Fine Art). Applications: In writing to the Keeper. Exhibitions: Arts Council touring shows and work by local artists. Space: Eight galleries, some of which are used for permanent collection. New lighting and wall surfaces have been installed, part fitted carpets and wood floor. New building development is planned. Equipment: Slide/tape unit.

STOCKTON-ON-TEES
BILLINGHAM ART GALLERY, Queens Way, Billingham, Cleveland. Tel. 0642 555443. Opening: Mon–Sat 9.30–5. Contact: J. P. Warbrook, Curator. Opening submission write to Curator, 76 Norton Road, Stockton-on-Tees, Cleveland. Exhibitions: Group and one-person. Painting, prints, photographs, sculpture and ceramics. Space: Hanging space. Approx. 230ft of fixed linear hanging space but temporary panels also available.

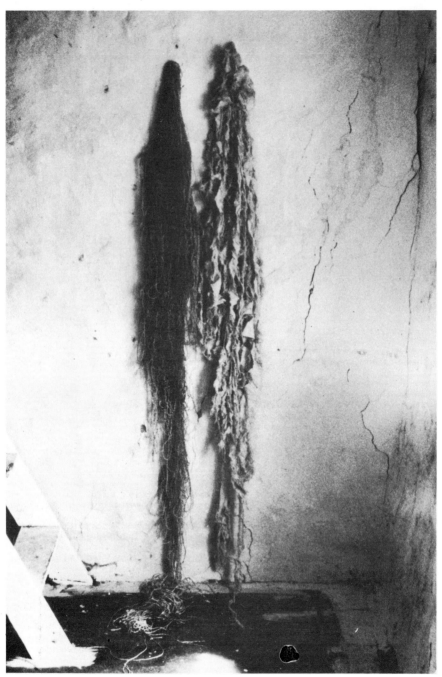

Horse's tails, Lois Williams (Rochdale Art Gallery)

small supply of freestanding cases may be available on request. Spotlights. Equipment: Slide projectors, limited supply of aluminium frames. Aims to show work of national or international significance, with occasional shows by better-known local artists or art groups. Funded by the local authority.

STOCKTON
DOVECOT ARTS CENTRE, Dovecot Street, Stockton, Cleveland. Tel. Stockton 611625/611659. Opening: Tues–Sat 10–5, 7–9.30. Showing mainly work by local artists.
PRESTON HALL MUSEUM, Yarm Road, Stockton, Cleveland. Tel. Stockton 781184. Exhibitions: Wide range, including crafts, fine art and historical. Also working craftsmen in period workshops. Unfortunately no temporary exhibition space available.

SUNDERLAND
NORTHERN CENTRE FOR CONTEMPORARY ART, 17 Grange Terrace, Stockton Road, Sunderland. R2 7DF. Tel. 091 5141214. Opening: Tues–Fri 10–6, Sat 10–4, closed Bank Holidays. Contact: Director, Tony Knipe; Exhibitions Organiser, Susan Priestley; Crafts Organiser, Hazel Nicholson. Applications: In writing with slides/photographs. Exhibitions: Contemporary painting, sculpture, printmaking, drawing, crafts etc. Four galleries, well lit and painted. Gallery 1—125 linear hanging feet, 1000sq ft, floor T & G wood varnished, spotlighting, no daylight. Gallery 2—125 linear hanging feet, 1000sq ft, floor T & G wood varnished, spotlighting, no daylight. Gallery 3—97 linear hanging feet, 550sq ft T & G wood varnished, spotlighting, no daylight. Gallery 4—(craft gallery) 80 linear hanging feet, 550sq feet, floor T & G wood varnished, daylight optional. The Northern Centre for Contemporary art is a public gallery, showing and originating exhibitions. The programme covers significant aspects of contemporary visual arts and crafts and the gallery operates an extensive touring programme throughout the region, Great Britain and abroad. The touring exhibitions range from large scale research projects shown in national galleries, to exhibitions designed specifically for more limited gallery spaces in arts centres, university and polytechnic galleries. Small scale touring exhibitions are on offer to small galleries, libraries and schools etc. The centre has a print workshop, craft sales area and a licensed bar and restaurant. Ceolfrith Press, established in 1970, offers a quality range of art publications.
SUNDERLAND MUSEUM AND ART GALLERY, (Tyne and Wear Museums Service), Borough Road, Sunderland. Tel. 091 5141235. Opening: Tues–Fri 10–5.30, Sat 10–4, Sun 2–5. Contact: Group Museums Officer, N. T. Sinclair MA, FMA. Exhibitions: Work by artists of national or regional importance. Space: 35ft × 63ft natural light excluded, track lighting. Equipment: Projectors and frames.

WAKEFIELD
ELIZABETHAN EXHIBITION GALLERY, Brook Street, Wakefield. Tel. 0924 370211 ext 540. Opening: Mon–Sat 10.30–5, Sun 2.30–5. Contact: Exhibitions Officer. Applications: Submit slides/photographs with C.V. Exhibitions: Varied programme of temporary exhibitions—art, craft, photography, social history, archaeology, science and technology. One-person or group shows by local artists, shows by nationally recognised artists and touring exhibitions. No commission is charged and the gallery will not sell work, though names and addresses of artists are given to potential purchasers. Space: One display gallery 60 × 22 with 132 linear feet of wall space, 10 moveable screens giving a further 160 linear feet (cannot be removed from gallery). A first-floor balcony from small displays/education projects. Occasional displays of performing arts in forecourt.
WAKEFIELD ART GALLERY, Wentworth Terrace, Wakefield WF1 3QW. Tel. 0924 370211 ext 8031. Opening: Mon–Sat 10.30–5, Sun 2.30–5. Contact: Exhibitions Officer. Applications: Submit slides/photographs plus C.V. Exhibitions: Temporary, c. 4–5 p.a. includes: one-person shows, thematic and historical exhibitions, touring exhibitions and shows of applied arts and crafts. Space: Limited but intimate in an attractive late Victorian vicarage. Permanent collection includes mostly 20th century British artists, especially Moore and Hepworth.
THE YORKSHIRE SCULPTURE PARK, Bretton Hall, West Bretton, Wakefield WF4 4LG. Tel. 0924 85302 for information. Opening: 10–6 (or dusk). Activities include: Varied programme of open air exhibitions. Selections from the YSP collection on view throughout the year. Public sculpture workshops. Opportunities to see artists working on site. Educational programmes for school and college groups. The Yorkshire Sculpture Park was founded in 1977 and is now recognised as one of this country's major art resources attracting visitors from all over Britain and abroad. It is set in the beautiful parkland of Bretton Hall. This was originally landscaped in the 18th century and provides a varied setting for the exhibitions, permanently sited sculptures and works on loan. The YSP education and community programmes, sculpture workshops, residencies and exhibitions provide the public with unique opportunities to enjoy and learn about sculpture in the open air.

WARRINGTON
WARRINGTON MUSEUM AND ART GALLERY, Bold Street, Warrington, Cheshire, WA1 1JG. Tel. 0925 30550. Opening: Mon–Fri 10–6, Sat 10–5. Contact: Mrs. C. E. Gray, Keeper of Art. Applications: In writing or by appointment with Keeper of Art. Exhibitions: One-person shows of fine and decorative arts; group exhibitions with variety of work; travelling, photographic and items from permanent collection. Space: Hessian

59

covered panelled walls, with hanging rail. Approx. 200 linear feet of hanging space. Fluorescent lighting and linoleum floor-covering. Equipment: Slide projector and tape recorder. Aims to provide a programme appealing to as many sections of the community as possible. Local artists are encouraged—individually and in groups, also those outside the area.

WASHINGTON
WASHINGTON ARTS CENTRE GALLERY, Washington Arts Centre, Biddick Lane, Fatfield, District 7, Washington, Tyne & Wear. Tel 091 4166440. Opening: Tues–Sat 10–6. Contact: Director of Centre Simon Sherwin. Visual Arts Officer, Elizabeth Carter. Applications: Send biography, C.V., plus photographs/slides. Exhibitions: A varied programme. Space: 59ft × 32ft 9″, with natural wood beams supporting roof. Lighting—spots. Washington Arts Centre promotes the arts in Washington, a new town where no student population or other nucleus of interest exists, providing a venue for any area of art activity to keep the population abreast of current developments. The Arts Centre has a theatre for dance, drama and music performances; however, where relevant, the gallery might present these areas also.

WHITEHAVEN
WHITEHAVEN MUSEUM AND ART GALLERY, Civic Hall, Lowther Street, Whitehaven, Cumbria CA28 7SH. Tel. 0946 67575 ext 307. Opening: Mon–Fri 9–5, Sat 10–4, closed Sundays and Bank Holidays. Contact: Harry Fancy, AMA, Curator. Applications: To the Curator, preference given to local artists. Exhibitions: As diverse as possible, half are on arts/crafts subjects, others museum-oriented. Space: Natural light, spotlights on overhead gantry, textured plasters walls. Equipment: Large quantity of screens, tape/slides facility (carousel projector and tape recorder). 15–20 exhibitions are featured each year, whilst some are travelling shows, most are originated by the museum staff.

WIGAN
THE POWELL GALLERY, The Wiend Centre, Millgate, Wigan. Tel. 0942 828100.

WORKINGTON
CARNEGIE ARTS CENTRE, Finckle Street, Workington, Cumbria. Tel. 2122. Exhibitions: Professional photographic, local photographic and local artists.

YORK
GRAPE LANE GALLERY, 17 Grape Lane, Low Petergate, York YO1 2HU. Tel. 0904 643825. Opening: Mon–Sat 10–5.30. Contact: Oliver Worsley. Applications: Submit slides, photographs together with C.V. Exclusively contemporary art—paintings by nationally recognized artists alongside new artists. Local artists featured. Regular one-person shows and mixed group shows. Comprehensive stock of prints, ceramics and pottery. Framing service offered. Space: Three galleries, well-lit.
IMPRESSIONS GALLERY OF PHOTOGRA-PHY, 17 Colliergate, York. Tel. 0904 54724. Contact: Paul Wombell. Opening: Tues–Sat 10.30–5.30 Exhibitions: Photography. Darkrooms, workshops, and talks. Also shop.
THE STONEGATE GALLERY, 52a Stonegate, York YO1 2AS. Tel. 0904 35141. Opening: Apr–Oct and Dec, Tues–Sat 10.30–5. Contact: Alan Hitchcock RIBA. Monthly exhibitions of pictures by both local and national artists. All mediums, but not prints or photographs. Normally one-person shows but group shows at Christmas. Occasional recitals and lectures.
YORK CITY ART GALLERY, Exhibition Square, York YO1 2EW. Tel. 0904 23839. Opening; Mon–Sat 10–5, Sun 2.30–5, closed 25 and 26 Dec, 1 Jan and Good Friday. Contact: Richard Green, Curator. Applications: In writing, enclosing slides. Exhibitions: A wide range, covering the whole field of western pictorial art—old master and contemporary, local, national and international. Occasionally applied arts. Space: Approx. 250 linear feet of hanging space, blockboard wall surface, track lighting. Exhibitions Square—a paved pedestrian area in front of gallery—could be used, with permission from York City Council. Equipment: Slide projector. Permanent collection of European painting from 1350 to the present, also local topography and modern pottery. Art reference library.

MIDLANDS

BEDFORD
CECIL HIGGINS ART GALLERY & MUSEUM, Castle Close, Bedford. Tel. 0234 211222. Opening: Tues–Fri 12.30–5, Sat 11–5, Sun 2–5, Bank Holiday Mondays 12.30–5. Exhibitions from our extensive collection of watercolours are changed regularly and we have permanent displays of ceramics, glass and lace. The ceramics and glass form one of the most comprehensive collections outside London. The furnished Victorian Mansion provides a fascinating look back into the past. Guided Tours to groups, refreshments if booked

in advance. Children's activities during school holidays, children's quizzes, and facilities for the disabled.

DAN SULLIVAN'S GALLERY, 33 Castle Lane, Bedford MK40 3RP. Tel. Bedford 0234 43783 (answerphone when gallery unattended). Opening: By appointment or as advertised. Contact: D. J. Sullivan. Description: Informal dealership with a regular stock of work by 20–30 artists; occasional shortrun exhibitions. Gallery small, but bright and well situated; artist-run.

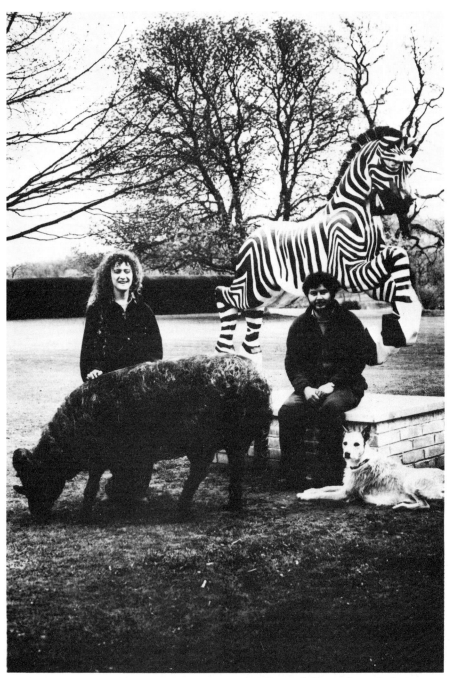

Artists in residence Sophie Ryder and Christopher Campbell at Yorkshire Sculpture Park

BIRMINGHAM

BIRMINGHAM CITY MUSEUM AND ART GALLERY, Chamberlain Square, Birmingham B3 3DH. Tel. 021-235 9944. Opening: Mon–Sat 9.30–5.30, Sun 2–5.30. Contact: Keeper of Fine Art, Richard Locket. Applications: By letter enclosing slides/photos. Exhibitions: Painting, sculpture and graphics of all periods. Usually only 1 or 2 exhibitions of contemporary art per year. Space: 21 × 9.5metres; 55 linear metres hanging space plus screens.

BIRMINGHAM POLYTECHNIC GALLERY, Faculty of Art and Design, Gosta Green, Birmingham. Tel. 021-331 5970 ext 223. Contact: Arthur Hughes.

IKON GALLERY, 58/72 John Bright Street, Birmingham B1 1BN. Tel. 021-643 0708. Opening: Tues–Sat 10–6. Contact: Director, Antonia Payne. Applications: Send slides/photos/documentation. Exhibitions: All media, including 'Third Area', emphasis on contemporary, experimental work, but not exclusively so. About 20 shows per year, which vary widely in scale, mostly one-person shows. Space: A former showroom—very open. Two floors, ground and basement approx. 3000sq ft per floor. Ground: Natural light from high glass room plus halogen lamps. Basement: halogen lamps, floors concrete. Walls are demountable and some are movable in the basement. Equipment: Carousel projector plus pulse-linked cassette player, few frames, other equipment can be borrowed or hired. Criteria are both national and regional. Artists from overseas have produced installations and performances at the gallery.

THE LING GALLERY, Highcroft Hospital, Highcroft Road, Erdington, Birmingham B23 6AX. Contact: Mandy Rogers. Tel. 021 378 2211 ext 4140, Thurs 9–11.30. Opening: Wed–Thurs 10–3. Arrangements for group visits contact Mandy Rogers on above number. This is a new gallery aiming to celebrate the creative work in the hospital and to explore the bridge between 'fine arts' and 'art' made in hospitals or other community settings. We wish future events to include work by professional painters, sculptors and performance artists as well as current work from the art therapy department. We would hope that these events will stimulate interest, understanding and respect for the expression of feeling and imagination as an essential part of human experience. Size: 30ft × 42ft. Hanging space: 20 chipboard screens, each 8ft × 4ft plus 11ft wall space. Other equipment: eight spotlights. We hope to increase lighting facilities and to obtain plinths at some point in the future.

BLAKESLEY

BLAKESLEY GALLERY, The Old Greyhound, The Green, Blakesley, near Towcester, Northants NN12 8RD. Tel. Blakesley 274. Contact: Ann

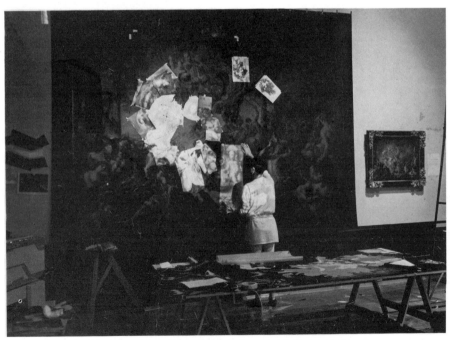

Helen Chadwick, artist in residence, 1986, at Birmingham Art Gallery and Museum

Purser. Applications: By writing or visiting. Exhibitions: Pottery, sculpture, prints, jewellery and paintings. Continuous exhibition of about 30 artists. Space: A converted bar of about 1000sq ft. Walls are stone (white and natural), spotlighting throughout. Exterior space available for showing sculpture. A private gallery showing predominantly fine art. Whilst showing work by some nationally known artists, the development of relative newcomers is also encouraged and the gallery works closely with local art colleges.

COVENTRY

HERBERT ART GALLERY, Jordan Well, Coventry, W. Midlands. Tel. 0203 25555 ext 2662. Opening: Mon–Sat 10–6, Sun 2–5. Contact: Mr. P. Day. Applications: Slides plus letter. Exhibitions: Any contemporary art of sufficient quality. Loan exhibitions, one-person shows, local art, permanent collection. Space: Three galleries available for temporary shows—70ft × 25ft, 52ft × 32ft, 33ft × 32ft, linoleum floors, louvred daylight with blackout, fluorescent and track spotlighting. Equipment: Lecture theatre facilities. Permanent collection of British art. For temporary exhibitions, preference is given to younger artists who show promise.

THE LANCHESTER GALLERY, Lanchester Polytechnic, Gosford Street, Coventry CV1 SR2. Tel. 0203 24166 ext 540/520. The Lanchester Gallery puts on approximately six one-person shows per year, concentrating on the work of young relatively unknown artists. The gallery attempts to meet all exhibition costs, i.e. transport, previews, publicity and insurance. The gallery publishes a catalogue for each exhibition, containing black and white illustrations, biographical details and artist's statement. They also produce and distribute two-colour silk-screened posters and preview invitation cards. A technician's help is available for the hanging and mounting of shows.

MEAD GALLERY, The Arts Centre, University of Warwick, Coventry CV4 7AL. Tel. 0203 523523. Opening (term time): Mon–Fri 12–8, Sat 10–8. Contact: The Curator. Exhibitions: Painting, sculpture, photography and applied arts. Space: 600sq metres of exhibition space usable as a whole or divided into two or three separate galleries; plus a 238sq metre sculpture courtyard with canopied glass roof. The Arts Centre has a wide-ranging programme of theatre, dance, music and film. Tel. Box Office 0203 417417.

DERBY

GREEN LANE GALLERY, 130 Green Lane, Derby. Tel. Derby 368652. Opening: Fri & Sat 10–3.30, 8–11pm; Sun 8–11pm. Contact: Jeffery Tillett. Applications: By letter, with slides. Exhibitions: Contemporary art. Space: Three gallery rooms— ground floor of a Georgian town house, one of which is a wine bar. Private gallery, linked closely with local cummunity arts trust. Annual

craftwork show in December and local (Derbyshire) shows in summer months, at least one show per year for 'young artists'.

DUDLEY

DUDLEY MUSEUM AND ART GALLERY, St. James's Road, Dudley. Tel. 0384 456000 ext 5570/1/3/4. Opening: Mon–Sat 10–5. Contacts: Charles Hajdamach, Roger Dodsworth, Colin Reid. Permanent collections of paintings, sculpture, prints, decorative arts and geology. Temporary exhibitions in three galleries of fine art, sculpture, crafts and photography including many contemporary artists. Three galleries with average of 120 linear feet and 875sq ft lit by strip and spotlights. Applications for exhibitions should include slides/photographs and C.V. Occasional lectures by artists, workshops based on exhibitions, lunchtime music concerts, poetry readings, film shows.

BROADFIELD HOUSE GLASS MUSEUM, Barnett Lane, Kingswinford, West Midlands. Tel. 0384 273011. Opening: Tues–Sun 2–5, Sat 10–1 and Bank Holidays. Contacts: Charles Hajdamach, Roger Dodsworth. Permanent collection of English and Continental 18th, 19th and 20th century glass. Temporary exhibitions of antique glass and modern studio glass. Two glass studios run by Bill Davies (Osiris Studio) and Louis Goodman. Visits by outside groups, lectures, film shows, glass antique roadshow.

HEREFORD

HEREFORD CITY MUSEUMS, Broad Street, Hereford HR4 9AU. Tel. Hereford 268121 ext 207 and 334. Opening: City Museum—Tues, Wed, Fri 10–6, Thurs 10–5. Churchill Gardens—Hatton Gallery Tues–Sat 2–5, Sun (summer) 2–5, open Bank Holiday Monday. Contact: A. E. Sandford, Curator, BA, AMA. Applications: By letter. Exhibitions: Local art groups including schools. Art college student shows. Art Council travelling exhibitions. Single or joint exhibitions. Midland Area Museum Service exhibitions. Craft exhibitions. Permanent collection. Craft Council. Space: Maximum wall space 49 metres also new spaceframe system of 30 metres, display cases. Equipment: Can be borrowed. Aims above all to serve the local community.

KIDDERMINSTER

KIDDERMINSTER ART GALLERY, Market Street, Kidderminster, County of Hereford and Worcester. Tel. 0562 66610. Opening: Daily 11–4, closed Wed, Sun and Bank Holidays. Contact: Michael Dwight, Assistant Curator. Applications: Open submission. Send slides, photographs or examples of work, or phone for appointment. Exhibitions: 2 or 3 group exhibitions per year of contemporary art. Space: 40m of linear hanging space, on grey hessian-covered screens. Fluorescent lighting. Public gallery aiming to serve the local community. Exhibitions often of a local nature, also Arts Council and museum touring

shows. The contemporary art shown should be of an easily accessible kind. Permanent collection, mainly local, also Frank Brangwyn and other print etc.

LEAMINGTON SPA
WARWICK DISTRICT COUNCIL ART GALLERY AND MUSEUM, Avenue Road, Leamington Spa, Warwickshire CV31 3PP. Tel. 0926 26559. Opening: Mon, Tues, Fri and Sat 10-45–12.45 and 2.30–5; Wed 10.45–12.45 only; Thurs 10-45–12.45, 2.30–5 and 6–8; closed Sundays. Applications: By letter. Exhibitions: Oils, watercolours and craftwork. Space: Four areas, the largest is 29ft × 21ft. Fluorescent and spotlighting. Composition block floor, plaster walls. Permanent collection of 20th century paintings, with a few Dutch and Flemish works. Bi-annual exhibition for young people.

LEEK
LEEK ART GALLERY, Nicholson Institute, Leek, Staffs. Tel. 0538 399181.

LEICESTER
THE LEICESTERSHIRE MUSEUM AND ART GALLERY, New Walk, Leicester LE1 6TD. Tel. 0533 554100. Opening: Weekdays 10–5.30, Sun 2–5.30. Contacts: Director, Dr Patrick Boylan; Keeper of Fine Art, Mrs Robin Paisey; Keeper of Decorative Art, Ms Pamela Indes. Applications: By letter. Exhibitions: Contemporary art and crafts from this country and abroad, from major retrospectives to simple one-person or group shows. Space: Approx. 1000sq metres of divisable space, fully air-conditioned, controlled lighting u/v filtered, daylight and spotlighting, carpeted timber floors. Belgrave Hall Gardens can be used for displaying sculpture outside. Equipment: Usual audo-visual equipment available. Permanent collection of British Art (17th–20th century), French Impressionists and German Expressionists.

LICHFIED
ART GALLERY, Lichfield Library, Bird Street, Lichfield, Staffs. Tel. Lichfield 262177. Contact: Principal Area Librarian. Varied exhibitions of art and craft. Large open room with screens around the walls, skylight.

LUDLOW
SILK TOP HAT GALLERY, 4 Quality Square, Ludlow, Shropshire SY8 1AR. Tel. 0584 5363. Opening: Mon–Sat 10–5, closed Thurs. Contact: Jill Howorth. Applications: Submit slides/photographs of work, together with C.V. Exhibitions: Contemporary paintings, prints and sculpture (also stock art materials and cards some published by the gallery). Regular one-person and group shows on top floor, other two floors changing mixed displays.

MALVERN
MALVERN FESTIVAL GALLERY, Vivian Cooke Organisation, Grange Road, Malvern Worcestershire. Tel. 0684 892277. Applications to exhibit are accepted. Aims to encourage young talent as well as established artists. Specialises in showing modern art. Three gallery spaces. Circle, stalls and the foyer have natural lights. All have spotlights. Foyer gallery has a display case.
MALVERN WORKSHOP, 90 Link Top, Malvern. Tel. 0684 68993. Opening: 10–5 daily, Sat 7–till late, closed all day Mon and Tues. Daily newspapers and Sunday newspapers always available on tables. Cafe provides a wide range of vegetarian and some non-vegetarian meals. Exhibitions: Exclusively contemporary art. Contact: Sandra Masterson. Applications: Submit slides/photographs of work together with C.V. A display of ceramics and a wide range of crafts always on show.

MANSFIELD
MANSFIELD MUSEUM & ART GALLERY, Leeming Street, Mansfield, Notts NG18 1NG. Tel. 0623 663088. Opening: Mon–Fri 10–5, Sat 10–1 and 2–5. Contact: Liz Holmes, Curator. Exhibitions: Both local artists and touring exhibitions; varied mediums including craftwork and photography. Very varied small permanent collection including the watercolours of local artist, A. S. Buxton,

MILTON KEYNES
CITY GALLERY ARTS TRUST, The Great Barn, Parklands, Milton Keynes MK14 5DZ. Tel. 0908 606791. Gallery Director: David Wright. Opening: By appointment. Established in 1973 to bring the contemporary visual arts to the living and working environment, and now a charitable trust. Organises projects in Buckinghamshire, Leicestershire, Northamptonshire and parts of Bedfordshire, Hertfordshire and Oxfordshire. Organises exhibitions and sites works in public places, initiates and manages commissions, organises residency schemes and acts in an advisory capacity. The Trust places special emphasis on the process of education and therefore, is involved in projects at all levels from consultancy with the public and the organisation of small touring exhibitions to the initiation of large public commissions.
MILTON KEYNES EXHIBITION GALLERY, 555 Silbury Boulevard, Central Milton Keynes MK9 3HL. Tel. 0908 605536. Opening: Mon–Wed 9.30–6, Thurs & Fri 9.30–8, Sat 10–5. Contact: Peter Laws. Applications: Submit slides/photographs of work, together with C.V. Exhibitions: Local artists; shows by nationall recognised artists; touring shows; local craftsworkers; decorative art; historical shows. Space: One gallery—175sq m; 55m hanging space. Lighting track with flood and spotlighting. Occasional lectures and workshops by visiting artists, films and events

relating to exhibitions. The gallery is part of the Milton Keynes Central Library building.

OLLERTON
RUFFORD CRAFT CENTRE, near Ollerton, Newark, Notts NG22 9DF. Tel. 0623 822944. Opening: Mar–Dec everday 11–5, Jan–Feb weekends only 11–5. Contact: Interpretation/Craft Officer, Peter Dwork. Programme of six major craft exhibitions and three outdoor sculpture shows each year. Comprehensive programme of workshops, demonstrations and residencies that are directly associated with the exhibition programme. Applications: Submit slides/photographs together with C.V. Main gallery—140sq ft. Programme of one-man shows, thematic shows of crafts. Fringe area for flat work only paintings/graphics/photography/textiles 30 linear ft. Sideshow area for flat work only paintings/graphics/photography/textiles 200 linear ft. Rufford is now acknowledged as the premier venue for contemporary crafts in the Midlands. Permanent collection of garden pots and sculpture sited in the formal gardens. The craft centre is a renovated 18th century stable block situated in Rufford Country, the landscape includes meadows, woodlands the Abbey and a lake.

NOTTINGHAM
CASTLE MUSEUM AND ART GALLERY, Nottingham NG1 6EL. Tel. 0602 411881. Opening: Apr–Sept 10–5.45 daily, Oct–Mar 10–4.45 daily. Contact: Michaela Butter. Permanent collection of ceramics, silver, glass, alabaster carvings etc. Two temporary exhibition galleries. Major new contemporary craft shop and bookshop, also gallery space selling work by young regional artists.

NUNEATON
NUNEATON MUSEUM & ART GALLERY, Riversley Park, Nuneaton, Warwickshire CV11 5TU. Opening: Mon–Fri 12–7, Sat & Sun 10–7 (summer); Mon–Fri 12–5, Sat & Sun 10–5 (winter), closed Christmas Day, Boxing Day, New Year's Day, Good Friday. Admission free. Contact: Ann Robson, Curator.

NORTHAMPTON
CENTRAL MUSEUM AND ART GALLERY, Guildhall Road, Northampton NN1 1DP. Tel. 0604 34881 ext 391. General enquiries 0604 39415. Opening: Mon–Sat 10–5, late Thurs evening until 8. Contact: Sheila Stone 34881 ext 391. Exhibitions: Arts and Crafts, both local and touring. Space: One gallery, approx. 82ft × 20ft, natural and spotlighting. Equipment: Lecture theatre, projector and screen, amplifying equipment. Permanent collections: Boot and shoe collection, local archaeology, fine art, both foreign and British, sculpture, ceramics, egyptology.

OMBERSLEY
OMBERSLEY GALLERY, Church Terrace, Ombersley, near Droitwich, Worcs. Tel. 0905 620655. Opening: Feb–Dec Tues–Sat 10–5. Contact: Carole Dalzell, Gallery owner. Applications: Slides/photographs of work plus C.V. Exhibitions: One-person and group shows arranged throughout the year of both national and new artists. Due to space available a variety of work can be displayed mainly: paintings, ceramics, woodwork (including certain furniture), studio glass, jewellery and textiles. Space: Three galleries, 600sq ft, and two 180sq ft, natural colour with spotlighting. Occasional lectures by exhibiting artists.

RUTLAND
GOLDMARK GALLERY, Orange Street, Uppingham, Rutland, Leics. LE15 9SQ. Tel. 0572 821424. Opening: Mon–Sat 9.30–5.30. Exhibitions: Exclusively contemporary art. Regular one-person shows; mixed group shows in between; Ayrton, Graham, Minton, Sutherland; sculpture, paintings, drawings and graphic work. Also English 19th–20th century watercolours and etchings. Framing service.

STAFFORD
STAFFORD ART GALLERY, The Green, Stafford. Tel. 0785 57303. Opening: Tues–Fri 10–5, Sat 10–4. Contact: John Rhodes. Applications: In writing. Exhibitions: Contemporary fine art, craft and photography. Space: Two galleries, 40ft × 20ft and 25ft × 20ft. Floor, carpet. Walls, painted white. Lighting, track spotlights with dimmers. Equipment: Carousel projector synchronised tape. The gallery shows a wide range of work from the visual arts, specialising in contemporary craft. Work by any visual artist is considered. The gallery also runs a shop selected for quality by the Crafts Council.

STOKE-ON-TRENT
FLAXMAN GALLERY, North Staffordshire Polytechnic, College Road, Stoke-on-Trent, Staffs. Tel. 0782 744531 ext 349. Opening: 10–5. Contact: Susan Leeks. Applications: In writing with slides or photographs. Exhibitions: Mostly one-person shows related to the visual arts, although there is also opportunity or showing visual material related to aspects of science and technology. Space: 44ft × 22ft, three walls are made of glass, display surfaces are provided by panels of hessian-covered building board, strip and spotlighting, neutral green carpeted floor. There is an unsupervised grassed area adjacent. Equipment: Slide projectors, tape recorders, frames (aluminium). The aims of the gallery are essentially educational and the work shown is not exclusively fine art. The first concern is that the exhibitions should have relevance to the activities of its known audience—the staff and students of the Polytechnic, where there are degree courses in art and design, science and technology.

STOKE-ON-TRENT CITY MUSEUM AND ART GALLERY, Bethesda Street, Hanley, Stoke-on-Trent ST1 3DE. Tel. 0782 202173. Opening: Mon–Sat 10.30–5, Sun 2–5. Contact: Jennifer

Rennie. Applications: Write enclosing slides/ photos, or make an appointment. Exhibitions: Anything considered in the following categories: a) Major Touring shows; b) Permanent collection exhibitions; c) Home initiated shows of nationally important contemporary art; d) One-person, retrospective and group shows of artists working in the region. Media shown includes: Video, performance, photography as well as painting, sculpture, prints and drawings. The programme aims to balance historical, modern and contemporary work. Space: 214 metres of linear hanging space in two galleries, dimmable lighting on track network, screens available, carpeted floor. 100sq metres of tiled sculpture court, suitable for residencies, performance, installations, large sculpture. Overlooked by balcony. Walls clad with removal white boarding, with tiled floor. Equipment: Slide projector, frames, plinths, video recorder and monitor, cassette player, tape/slide machine. The galleries are some of the most flexible and up-to-date outside London, perhaps best compared to the Ikon Gallery, Birmingham.

STRATFORD UPON AVON
PETER DINGLEY GALLERY, 8 Chapel Street, Stratford upon Avon CV37 3EP. Tel. 0789 205001. Opening: Mon–Sat 9.30–1.30 and 2.30–5.30, early closing Thurs. Contact: Peter Dingley. Applications: Letter: Letter and photographs first, then ring for appointment. The gallery was established in 1966 and specialises in the work of British artist-craftsmen, the work being gathered from all over the country, from both the well-known, and the less so. One-man exhibitions (often the first for the craftsmen concerned) are held in the spring and the autumn, and in the summer there is, in addition to the usual spread of craftwork in general, a display of pieces from a selection of the country's leading artist-potters. Layout: Simple and well lit, in three areas, on one floor.

WALSALL
WALSALL MUSEUM AND ART GALLERY, Lichfield Street, Walsall, West Midlands WS1 1TR. Contact: Jo Digger, Keeper of Fine Art, Tel. Walsall 21244 ext 3124. **The Garman-Ryan Collection.** The nucleus of the collection is a group of sculptures and paintings by Sir Jacob Epstein which forms one of the most representative collections of his work in Britain. Alongside these are works by artists as diverse as Dürer, Rembrandt, Constable, Van Gogh and Picasso. French art of the late 19th century and early 20th century, however, is a particular strength including pictures by Degas, Renoir and Cézanne. **The E. M. Flint Gallery.** A temporary exhibitions gallery.

WOBURN
WOBURN FINE ARTS LIMITED, 12 Market Place, Woburn MK17 9PZ. Tel. 0525 290624. Opening: Weekdays (except Thurs) 2–5.30, Sat

and Sun, 11–1, 2–5.30. Contact: Z. Bieganski. Permanent collection fine quality oils, from 17th century to contemporary. Watercolours, etchings, drawings, bronze and ivory objects d'art. Georgian building on three floors, well lit, easy parking. Exhibitions quarterly.

WOLVERHAMPTON
WOLVERHAMPTON ART GALLERY AND MUSEUM, Lichfield Street, Wolverhampton WV1 1DU. Tel. 0902 312032. Opening: Mon–Sat 10–6. Contact: The Keeper of Fine Arts. Exhibitions: Fine Art, (Painting, sculpture, installations, performance). Applied arts, local and social history. 'Light House' Media Centre programmes film, video, photography. Space: Two at 118m², one at 190m², one at 50m² (all approximate). Fluorescent and spotlights, air-conditioning, no natural light. Equipment: anything within reason obtainable. Normally artists are invited to exhibit, but applications accompanied by slides etc. will be considered with interest. Programme is finalised 12 months ahead.
WOLVERHAMPTON POLYTECHNIC GALLERIES, School of Art & Design, Molineux Street, Wolverhampton WV1 1DT. Tel. 0902 313004. Contact: Exhibitions Curator.

WORCESTER
CITY ART GALLERY, Foregate Street, Worcester WR1 1DT.Tel. 0905 25371. Opening: Mon, Tues, Wed, Fri 9.30–6, Sat 9.30–6, closed Thurs and Sun. Contact: Principal Curator. Applications: In writing, or personal visit, priority given to local artists. Exhibitions: All aspects of contemporary art and crafts, also shows drawn from permanent collection. Space: Artists are welcome to use all or any combination of three galleries. Two are 25ft × 18ft, third is 46ft × 22ft. Wall surface—hessian over matchboard, fluorescent lighting with dimmers and spotlighting. Equipment: Slide projector, tape recorder.
FRAMED, 46 Friar Street, Worcester. Tel. Worcester 28836. Opening: Tues–Sat inc. 10-30–4.30. Contact: David Birtwhistle, Michael Westby. Applications: Submit portfolio or six framed works. Large works are difficult to exhibit. Several hundred framed and unframed prints and paintings on show. All work held is displayed. Exhibitions: Contemporary paintings and original prints. Space: Mediaeval timber framed buildings on three floors, hanging track suspension, carpeted floors, 200–300 paintings all displayed, none held in stock. Tungsten track spotlighting. A private gallery, close to the cathedral, showing a wide range of contemporary work.

WORKSOP
NOTTINGHAMSHIRE COUNTY LIBRARY, Memorial Avenue, Worksop, Notts. Tel. Worksop 472408. Opening: Mon, Tues, Wed and Fri 9.30–7.30, Thurs and Sat 9.30–1. Applications: To the above address. Exhibitions: Local and national. Space: Cork covered walls, picture rails,

about 200 linear feet of hanging space, fluorescent and spotlighting.

EAST ANGLIA

AYLSHAM
RED LION GALLERY, Red Lion Street, Aylsham, Norwich, Norfolk NR11 6ER. Tel. 0263 732115. Opening: Mon–Sat 10–4 or by appointment. Contact: Liz Butler. Permanent exhibition of Norfolk Watercolours by resident artist, Anthony B. Butler. Reproductions of old photographs of Norfolk towns, characters, country views and Broads. Regular exhibitions by East Anglian artist of oils, watercolours, prints, drawings and sculpture. Small and intimate gallery in 19th Century townhouse on main street of small market town.

CAMBRIDGE
BELDESIGN ART GALLERY & DESIGN SHOP, 4 Silver Street, Cambridge CB3 9EL. Tel. 0223 69622. Opening: Mon–Sat 10–6. (Some Sundays, May–Sept, ring to confirm). Contact: Rebecca Wright. This small predominantly well-lit gallery shows exclusively contemporary work with an emphasis on young unknown painters. Predominantly one-person shows due to the size of the gallery but a mixed Christmas show and usually one other during the year. The shop is separate from the gallery and specialises in well designed items usually from small manufacturers and young designers.
CAMBRIDGE DARKROOM, Dales Brewery, Gwydir Street, Cambridge CB1 2LJ. Tel. 0223 350725. Opening: Tues–Sat 12–6, Sun 2–6. Contact: Mark Lumley, Director. Applications: Submit slides/photographs of work, plus C.V. and supporting materials. Exhibitions: Contemporary art photography both national and international, both solo and group. Emphasis on exploring the boundaries between mainstream photography and fine art. Some touring shows produced each year. Strong education programme, with workshops, talks and occasional film showings.
CONSERVATORY GALLERY (and BUSINESS ARTS' rental service), 6 Hills Avenue, Cambridge. Tel. 0223 211311. Normal opening times: Sat 10–5 and 1st Sun in each month 10–5 or by appointment but open every day during special exhibitions and events. Contact: Pamela Barrell. Permanent evolving exhibition of living East Anglian art in modern and traditional styles. Three rooms and hallway in unusual conservatory setting in large Victorian house. Occasional special events such as poetry readings, musical evenings, talks linked to exhibitions.
FITZWILLIAM MUSEUM, CAMBRIDGE, Trumpington Street, Cambridge CB2 1RB. Tel. 0223 332900. Opening: Tues–Sat 10–5, Sun 2.15–5. Contact: Prof. A. M. Jaffé. Applications: By invitation only. Exhibitions: Ancient and modern, eastern and western decorative and fine arts.

GALLERY ON THE CAM, The Floating Art Gallery, near Jesus Lock, Chesterton Road, Cambridge CB3 2AE. Tel. 0223 316901. Opening: Tues–Sat 10–5, Sun 12–5. Contact: Gallery Administrator, Denise Collins. Exhibitions of work by contemporary East Anglian artists in the form of invited three week exhibitions and more open two monthly exhibitions in the Summer and Christmas. Any work suitable for exhibition on a barge will be considered but we do deal mostly with prints and paintings.
KETTLE'S YARD, Castle Street, Cambridge CB3 0AQ. Tel. 0223 352124. Opening: Tues–Sat 12.30–5.30 (late night opening until 7 Thurs), Sun 2–5.30. Permanent collection open 2–4 daily. Contact: Hilary Gresty. Kettle's Yard has a varied programme of circa 7 exhibitions a year, mainly originated by Kettle's Yard, showing modern and contemporary art. The programme is put together circa 18 months in advance with a mixture of one-person and group exhibitions. Recent exhibitions have included work by Mary Kelly, Naum Gabo's monoprinted wood engravings and 'Turning over the Pages, some books in contemporary art' (work by Boltanski, Carrion, Hamilton, Anne and Patrick Poirier, Kiefer etc.). Performance and time based media are also included in the programme. Slide applications are dealt with three times a year, and must be accompanied by return postage. Space: Circa 250 running feet, 1500sq ft, ceiling height ranging from circa 8 to circa 14ft. Kettle's Yard is part of the University of Cambridge, and receives subsidy from Eastern Arts. It is the major centre for contemporary art in the Cambridgeshire region. There is an annual Artist in Residence scheme run in conjunction with the University and the Arts Council. There is an extensive programme of guided tours, lectures, seminars, a children's art club, outreach work and workshops. Throughout the university term there is a weekly series of chamber music concerts by professional musicians.

COGGESHALL
ADAM GALLERY, 7 East Street, Coggeshall, Essex CO6 1SH. Tel. 0376 62803. Opening: Mon–Sat 9–5.30, Sun 2–5.30. Contact: Philip Dye. Exhibitions: Period and contemporary art. Permanent stock of frequently changing fine 19th and early 20th century watercolours and oils. Framing and restoration services.

COLCHESTER
THE MINORIES, 74 High Street, Colchester, Essex CO1 1UE. Tel. 0206 577067. Opening: Tues–Sat 11–5, Sun 2–6, closed Monday. Contact: Liz Rentjes. Applications: In writing, with slides, a

link with the region preferred. Exhibitions: Contemporary fine art and crafts; historical or theme shows of particular relevance to the area; photography; continually changing small shows of crafts and printmakers. Space: The gallery is composed of two Georgian houses, the one retaining the rooms as they were, the other renovated and reconstructed to give three main areas, the largest able to seat 100 persons for concerts. Most rooms are carpeted, with walls covered in timber cladding suitable for screw fixings. Most lighting is Concord track all of which is dimmer controlled. Approx. 500 linear feet hanging space. Equipment: 1 slide projector, Carousel; 6 16" × 20" wooden frames; Twenty five 20" × 30" wooden frames. The Minories was established to provide an exhibiting facility for Colchester primarily, but since then increased public funding has given it a greater responsibility to the whole region, and its policy has expanded to include this. It can take very large exhibitions as well as the work of very local artists; it shows regularly the Colchester Art Society, and the work of local, regional and national crafts-people. Whilst it exists as a 'touring house' for ACGB exhibitions, it tries to initiate as many of its own shows as well.

GREAT YARMOUTH

GREAT YARMOUTH MUSEUMS' GALLERIES, Central Library, Tolhouse Street, Gt. Yarmouth NR30 2SH. Tel. 0493 858900. Opening: Mon–Sat 9.30–5.30, closed Sats 1–2. Contact: Damian Eaton. Applications: By forms available from galleries. Artist should also show examples of work and discuss exhibition with organiser. Exhibitions: Group, one-person and touring exhibitions. Mostly 2-D outwork. Space: Three galleries, 2 × 775sq ft and 112 linear feet, 1 × 560sq ft and 65 linear feet. All artificially lit. Equipment: Various display cases and plinths. Lecture facilities available for talks. Permanent collection mainly local 19th and 20th century oils and watercolours, includes Norwich School pictures, works displayed as part of the exhibition programme. Educational events can be arranged to accompany exhibitions.

IPSWICH

WOLSEY ART GALLERY, Christchurch Mansion, Christchurch Park, Ipswich Museums & Galleries, High Street, Ipswich IP1 3QH. Tel. 0473 213761. Opening; Mon–Sat 10–5, Sun 2.30–4.30, closes at dusk in winter, open Bank Holidays except Good Friday, closed 24, 25th and 26th December. Contact: The Curator. Applications: In writing to the Curator. Limited space available for one-person shows. Exhibitions: Permanent collection and a varied programme. Space: 24m × 8m parque floor. New lighting and air-conditioning system from Spring 1988. Also small upstairs area in the house for small shows.

KING'S LYNN

FERMOY ART GALLERY, Fermoy Centre, King Street, King's Lynn, Norfolk PE30 1HA. Tel. 0553 774725. Opening: Tues–Sat 10–5. Contact: Brion Clinkingbeard. Applications: In writing with examples of work. Exhibitions: All periods, loan, touring, commissioned. Space: 105ft of linear wall space. Walls are fabric-lined, celing spotlights, screens and plinths available. Ample unloading space. Equipment: Slide projector, 16mm projector.

RED BARN GALLERY, Fermoy Centre, King Street, King's Lynn, Norfolk PE30 1HA. Opening Tues–Sat 10–5. All periods, loan, touring, commissioned. Space: 100ft linear wall space, hessian lined, celing spotlights. Screens and plinths available. Gallery available for hire.

LOWESTOFT

SCHOOL OF ART & DESIGN GALLERY, Art Centre, Regent Road, Lowestoft, Suffolk. Tel. 0502 83521 ext 281 or 270. Opening: Mon–Fri 10–4, Sat 10–12, evenings by prior arrangement. Contact: Tony Collins. Regular programme of one-person and group shows. Touring exhibitions arranged and received. No restrictions on media or mode. Attractive, well-lit ground floor gallery, wall-hanging space 540sq ft, floorspace 510sq ft. Studio/lecture facilities available to run exhibition-related workshops. Applications: submit slides/photographs with C.V. The School of Art & Design Gallery is part-funded by Eastern Arts.

NORWICH

CASTLE MUSEUM, Norwich NR1 3JU. Tel. 0603 611277 ext 279. Director: Francis Cheetham OBE BA FMA. Opening: Mon–Sat 10–5, Sun 2–5. Headquarters of the Norfolk Museums Service. The oldest part of the building is the Castle Keep, built between about 1100 and 1140. The museum houses important collections of art (particularly paintings of the Norwich School), ceramics, archaeology, natural history and social history. There is a continuous series of temporary exhibitions throughout the year.

THE COACH HOUSE, Townhouse Road, Old Costessey, Norwich. Tel. 0603 742977. Exhibitions: Modern British paintings, oils and watercolours, some sculpture. Mainly purchased privately. Also British prints 1800–1950.

NORFOLK ARTISTS' GALLERY LTD, 56 St. Benedicts Street, Norwich NR2 4AR. Tel. 0603 760219. Opening: Mon–Sat 11–6, admission free. Admin: Corinne Livingstone, Rachael McLanaghan. Applications: Slides and C.V. Statement (plus sae) about current work to Selection Committee at above address. Exhibitions: One-person, group shows, usually 4 weeks. Contemporary art, with emphasis on local artwork. Equipment: Video. Space: Ground floor 4.76m × 3.57m; Mezzanine 4.57m × 2.82m; 1st floor 3.72m × 4.69m; well-lit. Contact is run by a co-op of Norfolk artists. Aims: To bring (local) contemporary

art to the general public; to develop the educational programme. We also 'exhibit' videos about artists.

NORWICH ARTS CENTRE, Reeves Yard, St. Benedicts Street, Norwich. Tel. 0603 660352. Opening: Mon–Sat 10–6 and evenings. The exhibition space is housed in our Cafe and Gallery area. Totalling 85ft. Items must be displayed under glass and be able to be fixed securely to the walls. Photographic exhibitions are shown on a monthly basis—with a mixed programme of exhibitions touring nationally, commissioned work and photography documenting life in Norfolk and Norwich. Courses and talks and events are held on different aspects of photography, exhibiting photographers are encouraged to visit and talk on their work. The Arts Centre provides a community darkroom, with facilities for 35mm black and white printing and developing. The Arts Centre is also setting up the Norfolk Photographic Archive, to document contemporary Norfolk and Norwich. Through commission, project work and donation we will be building an archive for use as both a picture library, promoting touring photographic exhibitions and to record local life. The Arts Centre promotes a full programme of theatre, mime, dance, jazz, blues and popular music. Where possible events and exhibitions are programmed together.

NORWICH SCHOOL OF ART GALLERY, St. George Street, Norwich NR3 1BB. Tel. 0603 610561 ext 62. Opening: Mon–Sat 10–5, closed during the school holidays. Contact: Lynda Morris. Applications: Send slides/photographs. Exhibitions: Concentrate on aspects of the subjects taught at the school—painting, sculpture, graphic design, print-making and photography. Space: Rectangular 38 × 26ft, with plate glass window facing onto the street, polished wood floor and moveable screens, track lighting. Equipment: Frames, display cases and other equipment can be borrowed from school. One of the principles of the gallery is to encourage students to participate in the origination and organisation of exhibitions, and students are able to work on gallery projects in their second year. Theme exhibitions are organised which are open to contributions from all members of the school, and there are occasional exhibitions of staff work and departmental work. This is, in addition to exhibitions organised by the curator and other members of staff, exhibitions of individual and group of artists and designers and hired exhibitions. We are also interested to show groups of student work for other schools and colleges.

SAINSBURY CENTRE FOR VISUAL ARTS, University of East Anglia, Norwich, Norfolk NR4 7TJ. Tel. 0603 56161. Opening: Tues–Sun inclusive 12–5, closed for Easter and Christmas. Contact: Keeper. Applications: By letter, with C.V. and slides or photographs; there is generally a two year waiting list. Exhibitions: A balance between historical and contemporary exhibitions. About 8, mostly group shows, per year. Space: 400sq metres, screen system hanging, combination of natural and overhead spotlighting. Gallery is surrounded by grassed areas. Equipment: Video equipment and slide projectors. A very large, extraordinary new building, housing a permanent collection of ethnic art and contemporary painting and sculpture, the space for temporary exhibitions is relatively small.

PETERBOROUGH
LADY LODGE ARTS CENTRE, Orton Goldhay, Peterborough. Tel. 0733 237073. Opening: Mon–Sat 9–5. Contact: Christine Redington. Applications: Submit slides/photographs of work with C.V. Exhibitions: Local and regional artists, some touring shows, photography, linked to residencies and workshops where possible. Space: Three galleries—large barn and performance space, bar, and cafe. Arts Centre runs a full programme of arts activities.
PETERBOROUGH MUSEUM AND ART GALLERY, Priestgate, Peterborough PE1 1LF. Tel. 0733 43329. Opening: Tues–Fr 12–5, Sat 10–5 Oct–Apr; Tues–Sat 10–5 May–Sept. Contact: Diana Treacher. The exhibition programme encompasses all of the visual arts. Most exhibitions are initiated by gallery staff but applications from others by slides and accompanying letter are welcome. There is one annual open exhibition for painters working in Britain 'Pace Setters' and details are always announced in the visual arts press. Three galleries are available for temporary exhibitions; two 50ft × 24ft, another 24ft sq. Good top natural lighting in all three galleries, one large gallery also with track.

SAFFRON WALDEN
THE FRY ART GALLERY, Bridge End Gardens, Castle Street, Saffron Walden, Essex. Opening: Sat, Sun 2.30–5.30. Exhibitions: Representatives of the artistic community which flourished in and around the village of Great Bardfield before and after the Second World War, including Edward Bawden, Michael Aldridge, Eric Ravilious and Michael Ayrton. The gallery demonstrates the continuing artistic tradition of north-west Essex by including a number of works by another artists from the area.

WELLS-NEXT-THE-SEA
SACKHOUSE GALLERY, The Wells Centre, Staithe Street, Wells-next-the-Sea, Norfolk NR23 1AN. Tel. 0328 710130. Opening: 10.30–5 except Mon and Thurs (winter), everyday (summer) when exhibition/workshops in progress. Contact: Margaret Melicharova. Regular exhibitions and workshops in crafts and visual arts. Crafts emphasis. Photography feature—own community darkroom on premises. Space: Two galleries (700sq ft downstairs, 500sq ft upstairs) in converted maltings. Natural and spotlighting. Spaces also used for other arts centre activities.

THE SCHOOL HOUSE GALLERY, Wighton, near Wells-next-the-Sea, Norfolk. Tel. Walsingham 457. Director: Diana Cohen. Opening: Daily 2–6.30 including Sat, Sun and Bank Holidays, closed Mon. A small private gallery showing contemporary art. Established and well-known artists as well as promising young artists. Regular mixed exhibitions of oils, watercolours, drawings and limited edition prints. Two or three one-man shows each year. Premises converted from former village school.

SOUTHERN ENGLAND

ASHFORD
ASHFORD LIBRARY GALLERY, Ashford Library, Church Road, Ashford, Kent TN23 1QX. Tel. 0233 620649. Opening: Mon & Tues 9.30–6; Wed 9.30–5; Thurs & Fri 9.30–7; Sat 9–5. Contact: Group Librarian, David Mole. Applications: Submit slides/photographs of work, together with C.V. All purpose exhibition gallery stages a programme which includes exhibitions by groups and individuals, both professional and amateur, national and local. Exhibitions cover a wide range of subjects, notably the visual arts and local history. The gallery has up to 50 linear feet of wall space, which can be used in conjunction with double-sided screens, providing an additional 120 linear hanging feet. Floor space approx. 720sq ft. Lighting by track-mounted spotlights. Programme planned 12–24 months in advance. Nighttime security alarms, but if daytime supervision is required, it must be provided by the exhibitor. Charges: 15% gross of any sales.

BAMPTON
WEST OXFORDSHIRE ARTS ASSOCIATION, Arts Centre, Town Hall, Bampton, Oxon OX8 2JH. Tel. 0993 850137. Opening: Tues, Thurs, Fri, Sat 10.30–1, 2.30–5, Sun 2.30–4.30. Space 30ft × 15ft plus screens.

BASINGSTOKE
CENTRAL STUDIO, Queen Mary's College, Cliddesden Road, Basingstoke, Hants. Tel. Basingstoke 20861. Opening: 9–4 and 7.30–10.30. Exhibition space within Arts Complex (space 60 linear metres). Exhibition range from local artists to Arts Council touring exhibitions. Contact: Paul Tong, Exhibitions Organiser.
WILLIS MUSEUM & ART GALLERY, Old Town Hall, Market Place, Basingstoke, Hampshire. Tel. Basingstoke 465902. Opening: Tues–Sat 10–5, closed Sun, Mon. Contact: Exhibitions Officer, J. D. Stewart. Applications: Supply evidence of work to the Director, Hampshire County Museum Service. Exhibitions: A varied programme of visual arts exhibitions drawn mainly from the Southern Arts region. Flexible screening in large open entrance area fronting on to the busy market place.

BEXHILL ON SEA
BEXHILL MUSEUM, Egerton Road, Bexhill on Sea, East Sussex TN39 3HL. Tel. 0424 211769. Opening: Tues–Fri 10–5, Sat & Sun 2–5. Contact: Stella Bellem, Curator. Displays on local and social history, geology, marine life, archaeology. Comprehensive temporary exhibitions programme, including Fine Art. Space: Three galleries—2088sq ft, 432sq ft, 390sq ft. Natural, strip and spotlighting. Access for disabled. Easy parking.

BLANDFORD
THE HAMBLEDON GALLERY, 42–44 Salisbury Street, Blandford, Dorest. Tel. Blandford 52880. Opening: Mon–Sat 9–5. Contact: Mrs Kitty West, Mrs Wendy Suffield. Applications: By showing work to the gallery. Exhibitions: Mostly well-known British Artists— Moore, Frink, Piper, Sutton etc., some local artists; 8–9 shows per year. Space: Roughly 25sq ft above shop, with self space for pottery and small sculpture. 33⅓% commission on sales.

BLETCHINGLEY
CENTRE GALLERY, Bletchingley Adult Education Centre, Stychens Lane, Bletchingley, Surrey. Tel. Godstone 842115. Opening: Weekdays 9.30–5 General Public, Weekdays 7.30–9.30 Student Members, Weekends by appointment. Contact: Gus. H. Hyatt. Applications: By phone or letter to Gus. H. Hyatt, Head of Art Dept., Tandridge A. E. Institute, Caterham Valley Adult Education Centre, Beechwood Road, Caterham, Surrey. Tel. Caterham 45398. Exhibitions: Paintings, drawings, prints, craftwork, small sculpture, local history, community education. Group and one-person. Space: Approx. 60 linear feet of hanging space, only suitable for fairly small works, spotlights and natural light. Equipment: Slide projectors, overhead projector, 16mm projector, video recorder plus monitor, tape recorders.

BRACKNELL
SOUTH HILL PARK ARTS CENTRE, Bracknell, Berkshire. Tel. 0344 427272. Opening: Mon–Fri 9–12.30, 1.30–5, 7–10; Sat 10–4, 7–10; Sun 1–4. Applications: Initially by letter enclosing C.V. and colour slides or photographs showing recent work. Exhibitions: Contemporary work in all fields—fine art, craft, photography and performance. Permanent collection of outdoor sculpture. Between 20 and 25 exhibitions, one-person and group, per year. Space: Main gallery—30ft square, wooden floor, many windows, track lighting, 75ft of linear wall space. Long gallery—30ft long, windows on one side, carpeted floor, track lighting, 50ft of linear wall space. Staircase area—Extension of main entrance, deep walls,

mostly suitable for large paintings and woven/printed textiles. Smaller wall areas adjacent, suitable for drawings/photographs. About 90 linear feet of wall space. The centre is surrounded by 15 acres of unfenced parkland and is highly suitable for showing sculpture and outdoor performances. Equipment: Most of the Art Centre's facilities can be made available to exhibiting artists. Touring exhibitions of craftwork are organised each year; in August there are outdoor projects related to the permanent collection. Remainder of the programme is divided between more popular shows (e.g. cartoons and kites), work from the local community (e.g. murals from local primary schools), group shows by local younger artists and one-person shows of a more experimental nature by established artists.

BRIGHTON

BRIGHTON ART GALLERY & MUSEUMS, (Royal Pavilion), Church Street, Brighton. Tel. 0273 603005. Opening: Tues–Sat 10–5.45, Sun 2–5. Contact: John Filkin, Exhibitions. Temporary exhibition programme includes Festival exhibition and the annual Sussex Artists and Photographers open event. Permanent displays of Art Nouveau and Art Deco decorative art, the Willett Collection, paintings from 17th to 20th century, etc.

BRIGHTON POLYTECHNIC GALLERY, Faculty of Art and Design, Brighton Polytechnic, Grand Parade, Brighton. Opening: Mon–Fri 9–8. Contact: Julian Freeman. Applications: By letter, enclosing slides/photos and as much information as possible. Exhibitions: Fine and applied art, some crafts, occasionally sculpture and mixed media work, mostly contemporary work. Space: 77ft × 19ft, three large pillars and one wall is windows, looking out on to the street, screens available, concrete floor, spotlighting and daylight. Equipment: Frames, slide projectors and back projection, cassette recorders and video equipment can be obtained from Polytechnic.

BURSTOW GALLERY, Brighton College, Eastern Road, Brighton. Opening: Daily 1–6.

GARDNER CENTRE GALLERY, University of Sussex, Falmer, Brighton, East Sussex BN1 9RA. Tel. 0273 685447. Opening: 10–6, closed Sundays. Contact: Hilary Lane (Visual Arts Organiser). Applications: By letter in the first instance, with supporting material. Exhibitions: One-person shows form a small part of the programme, only 2 or 3 per year; there are small exhibitions by one-person (4 or 5 per year), the rest are group shows. A wide range of work is shown, mostly contemporary, painting, sculpture, mixed media, prints etc. Space: Gallery—White painted plaster walls and an interesting screen system, giving approx. 230 linear feet of wall space, quarry tiled floor, spotlighting and natural light. Foyer—Brick staircase and plaster landing area giving 64 linear feet, rod system for hanging. Sculpture can be shown outside, but work cannot be insured and may be at risk. Equipment: Some standard frames available—20 @ 30″ × 40″, 10 @ 30″ × 20″, 50 @ 15″ × 12″. Projectors, sound equipment etc. can usually be borrowed. The gallery forms part of an arts centre where ballet, dance, classical and contemporary music and theatre are shown. The gallery space itself is an interesting, curved shape with dramatic, high windows looking out onto water and grass.

CANTERBURY

DREW GALLERY, 16 Best Lane, Canterbury, Kent CT1 2JB. Tel. 0227 458759. Opening: Mon, Tues, Wed, Fri, Sat 10–5, closed Thurs & Sun. Contact: Ms. Sandra Drew. Applications: Submit slides/photographs of work together with C.V. Exhibitions: Continuous exhibition programme of contemporary art—the work of well established artists exhibited alongside that of lesser-known and new artists. Comprehensive stock of contemporary graphics. Equipment: Natural and spotlighting. Ground floor Georgian building with courtyard garden. Private non-funded gallery. Major funded exhibitions of sculpture/performance/video organized by Sandra Drew from the Gallery for 'out of gallery' inner city exterior and interior sites. These exhibitions are accompanied by lectures, seminars, workshops and guided tours.

GULBENKIAN THEATRE GALLERY, University of Kent, Canterbury, Kent. Tel. 0227 66822. Opening: Weekday afternoons 2–5.30 and theatre opening times (most evenings). Exhibitions: Transferred from other galleries and some mounted independently. Space: Foyer area of theatre.

JOHN NEVILL GALLERY, 43 St. Peter's Street, Canterbury, Kent. Tel. 0227 65291. Opening: Mon–Sat 10–5. Contact: John Nevill. Exhibitions: Modern paintings, drawings and lithographs. 33% commission on sales, artist pays for printing and postage.

THE HERBERT READ GALLERY, Canterbury College of Art and Design, Kent Institute of Art and Design, New Dover Road, Canterbury CT1 3AN. Opening: Mon–Fri (during the academic year) 10–5. Applications for touring exhibition programme, submit: slides/photographs of work, thematic exhibitions showing aspects of 20c visual arts.

KIAD PUBLIC EXHIBITIONS
Regular touring public exhibitions dealing with 20c visual arts with related events including study days and symposia. Space: Modern, purpose built, 150 linear running feet.

THE ROYAL MUSEUM, High Street, Canterbury, Kent. Tel. 0227 452747. Opening: Mon–Sat 10–5. Contact: Curator. Exhibitions: Wide range—crafts, painting and photography from local and national sources. Space: Main gallery 50ft × 25ft, hanging rail and rods, flexible track lighting. Smaller gallery 20ft × 12ft with screens.

CHICHESTER

CHICHESTER CENTRE OF ARTS LTD., St Andrew's Court, East Street, Chichester, W. Sussex. Tel. 0243 779103. Opening: Evening events—times to suit. Exhibitions—Mainly 10.30–4.30. Contact: Mrs Doris A. Wilson. Applications: Give fullest possible information. Exhibitions: Mainly group shows, covering painting, sculpture, collage and crafts. Space: Size 66ft × 21ft, hanging rails, plaster walls. The building is a converted 13th century church, with good natural lighting, with the addition of fluorescent lighting. Gallery is part of an arts centre whose activities include music, poetry reading and practical workshops.

PALLANT HOUSE GALLERY, 9 North Pallant, Chichester, W. Sussex. Tel. 0243 774557. Contact: David Coke. Space: A new gallery attached to an early 18th century restored house, housing temporary exhibitions in a space 33ft × 27ft, giving 120ft linear space, plus 100 on screens.

CHRISTCHURCH

THE RED HOUSE MUSEUM AND ART GALLERY, Quay Road, Christchurch, Dorset. Tel. Christchurch 482860. Opening: Tues–Sat 10–5, Sun 2–5. Contact: Kenneth Barton, Hampshire County Museum Service, Chilcomb House, Chilcomb Lane, Bar End, Winchester. Applications: Local artists preferred. Exhibitions: All types of two and three dimensional art especially by local artists. Group and one-person shows. Space: 130ft of linear wall space, spotlight and natural light.

CIRENCESTER

THE NICCOL CENTRE, Brewery Court, Cirencester, Glos. 0285 67181. Opening: Mon–Fri 9–5. Sat 10–12.30. Contact: Joe Macrae, exhibitions organiser. Temporary exhibitions programme—twelve per year. Theatre and arts centre with exhibition galleries on two levels. Apply in writing with photographs or call in during opening hours.

CIRENCESTER WORKSHOPS, Brewery Court, Cirencester, Glos. Tel. 0285 61566. Opening: Mon–Sat 10–5.30. Contact: Director. Applications from artists and craftsmen should be addressed to the Deputy Director. Exhibitions: Mostly group shows of craftwork, some art exhibitions. Gallery Space: 42ft × 20ft, good lighting, carpeted floor, white walls. The centre is managed by a Charitable Trust and has as its objective the education of the public in the arts and creative crafts. The Cirencester Workshops comprise: Gallery, craft shop, wholefood restaurant, study room, workshops accommodating 20 independent craftsmen.

COOKHAM

STANLEY SPENCER GALLERY, Kings Hall, High Street, Cookham, Berkshire. Opening: Easter to October daily 10.30–1, 2–6. Nov to Easter, Sat,

Sun, Bank Holidays, 11–1, 2–5. Major collection of Spencer works in the village where he was born and worked.

CRAWLEY

IFIELD BARN THEATRE, Rectory Lane, Ifield, Crawley, W. Sussex. Tel. Crawley 24524. Contact: Mrs A. Allday. The Ifield Barn Theatre has been created from a group of agricultural buildings lying immediately to the north of the 13th century church of St. Margaret, in the Domesday village of Ifield. The buildings consist of a 13th century tithe barn, an ancient granary and a more recent block of stables. It has been provided and is managed entirely through voluntary effort. The programme presented each year includes five plays directed and performed by members of the Society together with professional drama and music recitals. The pleasant, intimate theatre is in a conservation area in beautiful Sussex.

DITCHLING

CHICHESTER HOUSE GALLERY, High Street, Ditchling, Sussex BN6 8SY. Tel. 07918 4167. Opening: Tues, Thurs, Fri & Sat 11–1, 2.30–5; Sun, Mon & Wed by appointment. Contact: John Hunter/Joan Hunter. Applications: By appointment to view the work. Exhibitions: Changing exhibitions throughout the year of paintings in all media by contemporary artists and signed limited editions.

EASTBOURNE

LIBRARY GALLERY, Eastbourne Central Library, Grove Road, Eastbourne, East Sussex BN21 4TL. Tel. 0323 22834. Opening: Mon, Tues, Thurs, Fri 9.30–7, Sat 9.30–5. Contact: Mrs Yvonne O'Neill. Applications: Submit examples of work. Exhibitions: Paintings, prints, photographs, etc. It must be possible to hang exhibits as there is no space for free-standing exhibits. Equipment/Space: We supply the hanging space and suggest potential exhibitors view the gallery before applying.

PREMIER GALLERY, 49 Grove Road, Eastbourne, East Sussex BN21 4TX. Tel. 0323 647892. Opening: Mon–Sat 10–5.30, Wed 10–1. Contact: Dino Mazzoli. Permanent collection of oils and watercolours from the 18th–20th century, with emphasis on Victorian artists; also contemporary art. Specialists in restoration of oils and watercolours. Space: 1800sq ft in two floors.

TOWNER ART GALLERY, High Street, Eastbourne, East Sussex. Tel. 0323 21635/25112. Opening: Mon–Sat 10–5, Sun 2–5, closed Monday Nov–Mar. Contact: Curator. Exhibitions: Wide-ranging programme of historical and contemporary art, some exhibitions drawn from permanent collection of mainly 19th and 20th century British art and some touring shows from other galleries and the Arts Council. Also exhibitions of local professional and amateur societies. Space: 18th century manor house providing ten galleries.

FARNHAM

NEW ASHGATE GALLERY, Wagon Yard, Farnham, Surrey GU9 7JR. Tel. 0252 713208. Opening: 10–1.30, 2.30-5, closed Sun & Mon. Contact: Elfriede Windsor. Applications: Write or call to arrange an interview with director, professional artists only. Exhibitions: Painting, sculpture, prints, ceramics, textiles, jewellery, sculpture and glass by living artists. Mostly 3–4 artists are shown each month, two mixed exhibitions (summer and winter). Space: Two large rooms, three small rooms, white walls, carpet throughout, daylight and spotlights, showcases and plinths. The New Ashgate Gallery is administered by a board of trustees, as a charitable trust. The local authority owns the building and supports the gallery to the extent that a non-commercial rent is charged. The artistic policy is solely decided by the director, Elfriede Windsor, who selects the artists to exhibit. The artists may come from anywhere in the country. Each monthly exhibition comprises the work of two or three painters, a potter, a jeweller and perhaps some other craftsman or woman. The trust buys work from time to time, which is lent to local institutions—hospitals, schools, libraries etc., on indefinite loan. In 1986 the gallery was extended to include the adjoining premises, and now has an additional Craft Gallery and two workshops, currently occupied by two bookbinders and a jeweller.

JOHNSON WAX KILN GALLERY, The Farnham Maltings, Bridge Square, Farnham, Surrey GU9 7QR. Tel. 0252 726234. Opening: Mon–Fri 11.30-5.30, Sat 10–12 (1st Sat of every month 10-4.30). Contact: Susan Bourke. Applications: Apply using application forms provided by the gallery enclosing slides or prints. The gallery is normally hired to exhibitors for two weeks. Exhibitions: Mainly one-person and group exhibitions by local amateur and professional artists, as well as schools and colleges. Work includes paintings, prints, sculpture, ceramics and textiles. Some touring exhibitions. Workshops and talks are held in conjunction with theme exhibitions. Space: The gallery is situated in a large Arts and Community Centre. The overall dimensions are 45ft × 22ft, with natural and artificial lighting.

REDGRAVE THEATRE 'Foyer & Restaurant', The Redgrave Theatre, Brightwells, Farnham, Surrey GU9 7SB. Tel. 0252 727000. Opening: 10–10.30pm except Sun & Mon. Sun 12–2, Mon 10–6. Contact: House Manager. Applications: Write or telephone House Manager. Exhibitions: Tend to be small, due to limited space, all kinds of work have been exhibited. Mostly one-person shows. Space: Plaster walls with spotlights (no floor space available). The gallery aims to provide exhibition space for a wide variety of artists, whilst providing an interesting diversion for the theatre-going public. Exhibitions tend to run for two plays.

WEST SURREY COLLEGE OF ART AND DESIGN, Falkner Road, The Hart, Farnham, Surrey. Tel. 025 13 22441. Opening: During college hours. Contact: Deborah Peake. Applications: Write, enclosing slides/photographs. Exhibitions: Wide range of exhibitions of a high standard—major retrospective and survey exhibitions, also smaller, more frequent displays of contemporary work. Viewed as a teaching aid to students and as an accessible resource for other colleges and the public. Space: Main Exhibition Hall—5000sq ft. Window Gallery (545sq ft) for wide variety of student work and outsiders—information and application forms on request. Equipment: Cinema, lecture theatre, seminar rooms and library with audio-visual material, video recording and play-back, slides, records and tapes.

FOLKESTONE

METROPOLE ARTS CENTRE, The Leas, Folkestone, Kent. Tel. 0303 55070. Contact: Director. Space: 252sq ft of hanging space. There is also a studio for the practice of art and crafts, painting, photography, print-making etc.

LADY SASSOON ROOM, Folkestone Central Library, Grace Hill, Folkestone, Kent CT20 1HD. Tel. Folkestone 850123. Opening: Mon, Tues, Thurs & Fri 9–5.30, Wed 9–1, Sat 9–5. Contact: Ms M. E. E. Ward. Applications: Prospective shows by established artists, photographers, craftsmen etc. Also touring exhibitions and local artists. Exhibition space: 45ft × 30ft and 176 linear feet of hanging space, mainly on screens and wall mounted panels. Spotlighting and natural light. Gallery adjoins a museum of local history and is part of a busy public library.

GILLINGHAM

GAEC GALLERY, Gillingham Adult Education Centre, Green Street, Gillingham, Kent. Tel. 0634 50235. Opening: 9–4, 6–9 weekdays only. Contact: Nicholette Goff. Applications: Submit slides/photographs of work with C.V. Exhibitions: Student shows, young unknowns, local artists, occasionally nationally known artists and touring shows. Wall hanging work only. Gallery in Common Room with 46 linear feet hanging space, lit by natural light and fluorescent tube. Gallery in adjoining lobby with 45 linear feet hanging space lit by fluorescent tube and some spotlights. Spaces can be booked separately or together.

GUILDFORD

GUILDFORD HOUSE GALLERY, 155 High Street, Guildford, Surrey GU1 3AJ. Tel. 0483 50346. (Guildford Borough Council). Opening: Mon–Sat 10.30–4.50 (a few days each month the gallery is closed for staging), please telephone. Contact: Miss Iris Rhodes, Curator. Temporary exhibitions include historical and modern paintings of local and national importance, photography and craftwork. Picture loan scheme. This is a 17th century town house now an art gallery. Original fine carved staircase, plaster ceilings and wrought iron window fittings.

JONLEIGH GALLERY, Wonersh, Surrey GU5 0PF. Tel. 0483 893177. Exhibitions: Contemporary art. A selection and hanging committee, comprising of: The President, Royal Academy, Roger de Grey, Professor Carel Weight, CBE, RA, Leslie Worth, VPRWS. Exhibitions are internationally known and well advertised. The gallery is closed between exhibitions. A telephone call to view stock between exhibitions is welcomed. Gallery Director: J. Hudson-Lyons.

THE REID GALLERY LTD., Milkhouse Gate, High Street, Guildford, Surrey GU1 3HJ. Tel. Guildford 68912. Opening: Tues–Fri 9.30–5.30, Sat 9.30–1, closed during August, and after Christmas for 3 weeks. Contact: Graham and Pamela Reid. Applications: Will always look at any artist's work, and if appropriate, arrange to show it. Exhibitions: 19th and early 20th century watercolours. A 'stable' of contemporary artists (both oils and watercolours) mostly landscapes, some flowers and still lives. Space: One long room downstairs, stairs, landing, and smaller, divided by partitions, room upstairs. Off-white painted walls, red carpet, spotlighting. Dimensions approx. 50ft × 15ft—only about a third of that upstairs for display purposes. Small enclosed paved courtyard in which are shown a couple of pieces of sculpture.

UNIVERSITY OF SURREY, Guildford, Surrey GU2 5XH. Library Gallery, with 70ft of hanging space; 9 exhibitions per year of work by contemporary artists and art schools, touring shows. Talks are featured with some of the exhibitions. Also Teaching Block Gallery wich may be rented by approved artists. Contact: Patricia Grayburn, Arts Administrator. Tel. 0483 509167.

HAILSHAM
MICHELHAM PRIORY, Upper Dicker, Hailsham, East Sussex. Tel. 0323 844224. Opening: 25 Mar–31 Oct. Daily 11–5.30. Contact: Jane Bellam. Exhibitions: Historic 13th–16th century buildings with varied exhibits. Annual in-house temporary art exhibition. Permanent collection of paintings, emphasis on Sussex artists. To view by request, the Sharpe Collection of nearly 400 watercolours and drawings of Sussex Churches (1797–1809) mainly by Henry Petrie, FSA. Paintings by James Lambert of Lewes are exhibited. Three annual temporary art exhibitions in the Tudor Barn. Applications from local artists for future exhibitions in the Barn are invited. A varied programme of events in the grounds.

HARLOW
THE PLAYHOUSE GALLERY, The High, Harlow, Essex. Te. 0279 24391. Contact: Exhibitions Organiser.

HASSOCKS
CHECHESTER HOUSE GALLERY, High Street, Ditchling, Hassocks, West Sussex BN6 8SY. Tel. 07918 4167. Opening: Daily 11–1, 2.30–5 except Sun, Mon & Wed—by appointment only. Contact: Mr and Mrs Hunter. Applications: By letter or

telephone in the first instance. Exhibitions: Original paintings, limited editions, books, crafts etc. Space: Wallspace to hang 150–200 small works, spotlights throughout. Privately funded.

HASTINGS
MUSEUM AND ART GALLERY, John's Place, Cambridge Road, Hastings, East Sussex. Tel. 0424 721202. Opening: Weekdays 10–1, 2–5, Sun 3–5. Curator: Miss Victoria Williams. Exhibitions Officer: Lesley Cornish. Balance of local contemporary artists/loan exhibitions of general interest. Space: One top-lit gallery with total wall area of 122sq ft.

HAVANT
HAVANT MUSEUM AND ART GALLERY, East Street, Havant, Hants. Tel. 0705 451155. Opening: Tues–Sat 10–5. Contact: Curator. Applications: To John Stewart, Hampshire County Museum Service Tel. 0962 66242. Local connections might help. Exhibitions: Local art shows, historical exhibitions, photographic work and local industries, past and present, and touring painting or graphic exhibitions. Sculpture and craft could be shown. Space: Originally a large Victorian room in a private house, it provides about 70 linear feet of wall space. Suspended track lighting, very flexible. Walls panelled up to 7ft in height. Adjoining Havant Arts Centre, the gallery and museum has a permanent collection. Temporary exhibitions include some local origin.

HEMEL HEMPSTEAD
OLD TOWN HALL GALLERY, Old Town Hall Arts Centre, High Street, Hemel Hempstead, Herts. Tel. 0442 42827. Opening: Mon–Sat 10–5. Contact: Robert Adams. Applications: By letter or appointment. Exhibitions: Small shows of paintings or photographs by local or national artists, some touring shows. About 10 one-person shows per year. Space: 385sq ft, hessian-covered chipboard, strip and spotlighting, surrounding a coffee shop and brasserie.

HENLEY-ON-THAMES
BOHUN GALLERY, Station Road, Henley-on-Thames, Oxon. Tel. Henley-on-Thames 6228. Opening: Mon–Sat 10–5.30, Sun 2.30–5, closed Wed. Applications: In writing with slides or photos, or in person with examples of work. Exhibitions: Original work by contemporary artists—paintings, prints, sculpture, ceramics etc. Space: 28ft × 13ft, windows and spotlights. A private gallery established in 1973, has shown the work of: Elizabeth Frink, John Piper, Ivon Hitchens, Patrick Proctor, Peter Blake, but is also interested to show the work of younger artists.

HITCHIN
HITCHIN MUSEUM AND ART GALLERY, Paynes Park, Hitchin, Herts SG5 1EQ. Tel. 0462 34476. Opening: Mon–Sat inclusive 10–5, closed

Sun and Bank Holidays. Contact: Curator. Applications: From artists working in Hertfordshire and the surrounding counties. Apply by letter to the Curator. Exhibitions: Painting, sculpture, ceramics, textiles, photography, mixed media. One-person or group shows. Space: Three interconnecting rooms, cream-painted walls, spotlights and daylight. Equipment: Slide projectors, additional display screens, plinths etc. A public gallery aiming to encourage and promote art and artists in Hertfordshire through a wide but balanced programme of exhibitions in all media. Holds a permanent collection of topographical watercolours, early 20th century etchings and a large photogrpahic archive.

HORSHAM

CHRIST'S HOSPITAL THEATRE, Christ's Hospital, Horsham, W. Sussex RH13 7LW. Tel. 0403 52709. Contact: Duncan Noel-Paton. Opening: Daily 10–1, 3–6 during term time only. Local artists/regular one-person and group shows. Space: Modern on one level/spotlights and natural light.

HOVE

HOVE MUSEUM AND ART GALLERY, 19 New Church Road, Hove, E. Sussex. Tel. 0273 779410. Opening: Mon–Fri 10–5, Sat 10–4.30, Sun (May–Sept) 2–5. Curator: T. Wilcox. Applications: Young artists one-man shows: Painting, prints, sculpture, ceramics. Permanent collection of 18th–20th century painting and decorative art.

ISLE OF WIGHT

QUAY ARTS CENTRE, Sea Street, Newport, Isle of Wight PO30 5BD. Tel. 0983 528825. Opening: Tues–Fri 11–5, Sat 11–4, Sun 2–5. Contact: Ian Bilsborough. Applications: Slides/photographs of work with brief C.V. and letter. Exhibitions: Mainly contemporary group or one-person shows, also touring thematic shows. All media welcomed, but no video facilities. Two galleries, lecture facilities, performance/dance area.

LEATHERHEAD

GALLERY 1, 3 North Street, Leatherhead, Surrey KT22 7AX. Tel. 0372 370072. Contact: Lynne Peake. Exhibitions: A new commercial gallery showing a wide range of contemporary

Library Gallery, University of Surrey

work—painting, sculpture, printmaking and crafts. Keen to encourage fresh artists and crafts peope in all media.
THORNDIKE GALLERY, Thorndike Theatre, Church Street, Leatherhead, Surrey. Tel. Leatherhead 376211. Opening: 10am to end of performance. Contact: Publicity Dept. Applications: By agreeing to the conditions and terms of exhibition. Exhibitions: All kinds of work shown. Mostly one-person shows. Space: The wall is 40ft long by about 8ft deep (usable, lighted area). It faces a bar about the same length, so the floor space available is limited to about 4ft. The wall is white brick and is lit by small spots and floodlights. It is the leading gallery in the area and the policy is to give first chance to local artists.

LETCHWORTH
LETCHWORTH MUSEUM AND ART GALLERY, Broadway, Letchworth, Herts SG6 3PD. Tel. 0462 685647. Opening: 10–5 everday except Sun. Contact: Senior Curator. Applications: In writing, with photographs and C.V. Exhibitions: Work by local and non-local artists, photographic exhibitions, travelling exhibitions, work by local schools. Space: 13mtrs×6mtrs, parquet floor, central lighting track. Equipment: Slide projector, screens, plinths, some frames.

LEWES
THE SOUTHOVER GALLERY, 7 Southover Street, Lewes, E. Sussex. Tel. 079 16 2640. Opening: Tues–Sat 11–1, 2.30–5.30. Contact: Director. Exhibitions: 6 per year of contemporary art, figurative only. Pottery and occasional sculpture.

LUTON
LUTON MUSEUM AND ART GALLERY, Wardown Park, Luton, Beds LU2 7HA. Tel. 0582 36941. Opening: Summer 10.30–5 weekdays, Sun 1.30–6; winter 10–5 weekdays, Sun 1.30–5. Contact: Doreen Fudge. Applications: By letter. Exhibitions: Painting, drawing, prints, photographs etc., mainly figurative. Two open exhibitions each year for artists in Beds, Bucks and Herts. Space: 30ft × 15ft plus 1st floor landing, fluorescent lighting, hessian-covered walls. Open air facilities adjacent. Equipment: Slide projector, video projector.
33 ARTS CENTRE, 33 Guildford Street, Luton. Tel. 0582 419584. Contact: Mike Adcock. An ambitious arts centre which has expanded considerably over the last few years. It includes cinema/theatre, photographic gallery, darkroom, extensive video and film facilities (see Video Workshops section), community arts team and vegetarian cafe. Recommended.

MAIDSTONE
MUSEUM & ART GALLERY, St. Faith's Street, Maidstone, Kent ME14 1LH. Tel. 0622 54497. Opening: Mon–Sat 10–5.30. Recently refurbished art galleries display 17th & 18th century Dutch and Italian oil paintings (including works by Giovanni Panini, Willem Schellincks, Frans Snyders

and the van Steenwycks I & II). Temporary exhibition gallery with changing display of work from the permanent collections alternating with loan exhibitions. Print gallery specialising in the work of Thomas Baxter.
MAIDSTONE LIBRARY GALLERY, St Faith's Street, Maidstone, Kent. Tel. 0622 52344. Opening: Mon–Fri 9.30–7, Sat 9.30–5. Contact: The Exhibitions Organiser. Applications: Submit slides/photographs of work with C.V. Exhibitions: One-person shows by nationally recognised artists, newly emerging artists, touring shows, local artists. Photography, painting, sculpture, ceramics, some live events and talks by artists. Space: 1400sq ft floor space, 110 linear feet hanging space, lit by track-mounted spotlights.

MARGATE
LIBRARY GALLERY, Cecil Square, Margate, Kent CT9 1RE. Tel. 0843 223626. Opening: Mon–Thurs 9.30–6, Fri 9.30–7, Sat 9.30–5. Contact: Hazel Halse. Applications: Submit slides/ photographs of work, together with C.V. Exhibitions: Continuous programme of touring and one-off fine art, craft and photography shows, some with a regional emphasis. Space: Single gallery 120 linear feet, 1100sq ft. Spotlighting and direct fixing to hanging surface.

MARLBOROUGH
PETER PHILLIPS FINE ART GALLERY, 142A High Street, Marlborough, Wiltshire. SN8 1HN. Tel. 0672 53089. Opening: Mon–Sat 9.30–5.30. Contact: Peter Phillips. Permanent collection of 18th–20th century English watercolours and drawings, plus contemporary Wiltshire artists Hugh Ennion, John Hopkins, Leslie Hall-Carpenter, etc.

OXFORD
ASHMOLEAN MUSEUM, Beaumont Street, Oxford. Tel. Oxford 278000. Opening: Weekdays 10–4, Sun 2–4. Exhibitions: Policy is to show at least one exhibition of contemporary art and usually two or three exhibitions of works by 20th century artists every year, together with other more historical exhibitions in the McAlpine Gallery, designed by Brian Henderson, on the first floor of the museum. It has a travertine floor, hessian panelled walls and spotlights. Policy is decided by the Keeper of the Department of Western Art in consulation with the Director. The Keeper should not be approached concerning exhibitions either in person or by telephone, but only in writing.
MUSEUM OF MODERN ART, 30 Pembroke Street, Oxford OX1 1BP. Tel. 0865 722733. Recorded information: 0865 728608. Opening: Tues–Sat 10–6, Sun 2–6. Contact: Director. Applications: In writing, enclosing slides etc. Exhibitions: 20th century visual arts, generally. The accent is on showing contemporary work in the context of historical developments. Some international work is shown. Mostly one-person shows. Some performance and mixed-media work. Space:

There are five separate exhibition areas, which vary in size considerably, the principal gallery having 60 running metres length and walls over 12ft high, walls are mainly brick, painted white. Lighting is tungsten spots, tungsten-halogen floods or large arc lights. Museum is housed in a redesigned and renovated brewery but the industrial architecture is still evident in the feel of the exhibition areas. Equipment: Slide projector, 16mm projector, video monitor, framing facilities. The museum has tried to fill a gap in the British gallery system by organising large one-person shows, the like of which might not normally be seen in the UK, on the Continent and in the USA. It was one of the first organisations of its kind to appoint an education officer and links have been established with local schools and colleges all over the country and Oxord University.

OXFORD GALLERY, 23 High treet, Oxford OX1 4AH. Tel. 0865 242731. Opening: Mon–Sat 10–5. Managing Director: Valerie Stewart. Applications: Submit slides/photographs of work together with C.V. and any relevant information. Exhibitions: Monthly selling exhibitions of craft and fine art by established and emerging talents. Extensive stock of ceramics, glass, jewellery and turned wood by the best British craftsmen. International selection of contemporary prints. Gallery established in 1968. Crafts Council selected list outlet.

POOLE

POOLE ARTS CENTRE, Kingland Road, Poole BH15 1UG. Tel. 0202 670521. Opening: 10–10.30. Contact: Jenny Surridge, Exhibition Organiser. Applications: Telephone, call in, or in writing. Exhibitions: 2D and 3D visual art; crafts; photography; most other forms of art. Spaces: There are three main gallery spaces, each serving a slightly different function: Seldown Gallery and studio: 44ft × 27ft, 12 screens 8ft ⨉ 4ft. Used as a multi-purpose studio for dance, music lectures etc., as well as for exhibitions. It is used mainly for touring, international, national or professional exhibitions. This can be for an individual artist, group of artists, or school or college. Longfleet Gallery: Foyer gallery, very long, narrow space, about 115 linear feet of wallspace in total, divided into fairly short stretches, track lighting. Used mainly to promote individual artists, groups or societies, nominal hire fee. Whitecliff Gallery: Open floor, foyer area. Artists need to provide their own screens or cases, exhibitions need to be self-contained. Equipment: Slide projectors. There is also a picture bank for which all artists are invited to submit 1–3 pieces of work for selection. If selected, the works are then kept for 3 months and exhibited for at least 2 weeks. This system offers the public a permanent, but constantly changing exhibition.

POOLE MUSEUMS SERVICE, The Guildhall Museum, Market Street, Scaplen's Court Museum, High Street, Maritime Museum, The

Margate Library Gallery

Quay, Poole. Tel. 0202 675151 ext 3530/3550. Contact: Kerry Smith. Opening: Mon–Sat 10–5, Sun 2–5. Permanent collection of mainly English work, 19th & 20th century topographical of Poole & Dorset including maps. Works by Henry Lamb, Bernard Gribble, Arthur Bradbury, Leslie Ward. Temporary exhibitions programme.

RAMSGATE
LIBRARY GALLERY, Guildford Lawn, Ramsgate, Kent CT11 9AY. Tel. 0843 593532. Opening: Mon–Wed 9.30–6, Thurs & Sat 9.30–5, Fri 9.30–8. Contact: John Brazier. Applications: Submit slides/photographs of work, together with C.V. Exhibitions: A continuous programme of contemporary and historical touring and one-of fine art, craft and photography exhibitions by established artists. Space: Single gallery 175 linear feet, 1300sq ft. Spotlighting, direct fixing to hanging surface, environmental controls.

READING
THE HEXAGON, Queens Walk, Reading RG1 7UA. Tel. 0734 592397. Opening: Conventionally six days a week 10–to end of evening performance. Contact: Exhibition Co-ordinator. Exhibitions: Include amateur and professional artists and craftsmen, local/national societies, touring exhibitions. No restriction on style, medium, or type of work. Space: Upper and lower foyers plus garden terrace suited to large sculpture.
READING MUSEUM AND ART GALLERY, Blagrave Street, Reading, Berkshire. Tel. 0734 55911 ext 2242 or 2192. Opening: Mon–Fri 10–5.30, Sat 10–5, Sun 2–5. Contact: Eric Stanford. Exhibitions: Local artists, loan exhibitions, touring shows. Space: Linear space of 50 metres plus additional screens.

REDHILL
HARLEQUIN THEATRE, Warwick Quadrant, Redhill, Surrey RH1 1NN. Tel. 0737 773721. Opening: Mon–Sat 10–11, Sun 12–3 (evenings if performance). Contact: The House Manager. Foyer space throughout theatre, and self-contained gallery (The Pilgrims Hall) modern, natural, strip and spotlighting. Temporary exhibition programme. Lively theatre complex.

ROTTINGDEAN
THE GRANGE, Rottingdean, E. Sussex. Tel. and Contact: As for Art Gallery and Museum, Brighton. Tel. 0273 603005. Contact: Exhibitions Officer. Opening: Weekdays 10–6, closed Wed, Sat 10–5, Sun 2–5. Exhibitions: One-person and group shows, travelling shows. Space: 40ft × 15ft.

RYE
RYE ART GALLERY, Stormont Studio, East Street, Rye, E. Sussex. Tel. Rye 223218. Opening: Tues–Sat 10.30–5, Sun 2.30–5. Contact: Eric Money. Exhibitions: Paintings, sculpture, graphics.

EASTON ROOMS, 107, High Street, Rye, E. Sussex. Tel. Rye 222433. Opening: Mon–Sat 10.30–5, Sun 2.30–5. Contact: Martha Money. Exhibitions: Paintings, original prints, designer-crafts by selected artists and craftsmen. Works for sale.

ST. LEONARDS-ON-SEA
PHOTOGALLERY, The Foresters Arms, 2 Shepherd Street, St. Leonards-on-Sea, E. Sussex. Tel. 0424 440140. Opening: Wed–Sun 11–6. Contact: Lesley Cornish. Exhibitions: Best available photography. Maintains portfolios of young photographers. Also organises travelling shows, lectures and workshops.

SALISBURY
SALISBURY ARTS CENTRE, Bedwin Street, Salisbury, Wilts. Tel. 0722 21744. Opening: Tues–Sat 10–5.30. Contact: The Director. Exhibitions: Art, craft, photography and touring shows. Space: Two galleries with 88ft linear and 32ft linear.
SALISBURY LIBRARY, Market Place, Salisbury, Wilts SP1 1BL. Tel. 0722 24145. Mon–Sat 10–5. Contact: Monte Little. Applications: In writing to above address with C.V. information. Local, national and touring exhibitions. Main gallery—113.7 linear feet; Young gallery—49.5 linear feet; Creasey gallery—49.5 linear feet. All with tracked lighting, rod and hook hanging system, screen systems, display cases. Category A security. Creasey collection of contemporary art and Edwin Young collection of 19th century watercolours housed. Excellent one-person or two-person or group facilities. Centrally placed in modernised corn exchange.
ROCHE COURT SCULPTURE GARDEN, Winterslow, near Salisbury, Wilts. Tel. 0980 862204. Run by the New Art Centre in London. Tel. 01-235 5844. Sculptures by Alison Wilding, Barry Flanagan, Stephen Cox, Antony Gormley, Barbara Hepworth and others in an open air setting. Opening every Sat and Sun 11–5 from 16 Apr–end Sept.

SEVENOAKS
THE BANK STREET GALLERY, 3–5 Bank Street, Sevenoaks, Kent TN13 1UW. Tel. 0732 458063. Opening: Tues–Sat 9.30–5.30. Contact: Jane Wallis/Peter Ramsay (owner). Contemporary Art, Limited edition prints. Sculpture, New Gallery. Regular exhibitions. Held in upstairs gallery. Professional artists invited to apply.

SOUTHAMPTON
THE GANTRY, off Blechynden Terrace, Southampton SO1 0GW. Tel. 0703 229319. Opening: Mon–Fri 10–4 and during performances. Contact: Exhibitions Committee. Applications: Slides/photographs of work. Exhibitions: Paintings, drawings, prints, photographs, textiles, some sculpture. Space: Open on one side, 73ft wall hanging area, spotlighting. Possibility of associated activities,

workshops etc. Exhibition area of Community Arts Centre.

THE FIRST GALLERY, 1 Burnham Chase, Bitterne, Southampton SO2 5DG. Tel. 0703 462723. Opening: During temporary exhibition 2–8 daily, including Sun, otherwise by appointment. Exhibitions: Pictures, sculpture, pots. Four temporary exhibitions annually: early spring, one or two-man show; May, patio show emphasis on outdoor garden pots/sculpture; Oct, main show, mixed, sometimes with special feature; Nov/Dec, Xmas show. Deliberate policy of remaining small to retain informal atmosphere. Permanent constantly changing display in friendly private house, accessible to anyone interested to come to look and buy. Expands by initiating occasional national touring exhibitions. Specialist framing, frame and picture conservation service.

THE JOHN HANSARD GALLERY, The University, Southampton. Tel. 0703 559122 ext 2150. Opening: Mon–Sat 10–6. Contact: Julien Robson. Exhibitions: Contemporary fine art, crafts and photography by young and well established artists. Gallery opened 1980.

SOUTHAMPTON ART GALLERY, Civic Centre, Southampton SO9 4XF. Tel. 0703 23855 ext 769. Opening: At present Tues–Sun but this may be changed 1981/82. Contact: Keeper of Art of Assistant Keeper. Applications: Group exhibitions are usually initiated by the gallery, but there is a small space (72 linear feet) for one-person shows, for which applications are invited. To apply, write for an application form. Exhibitions: No particular 'type' of work preferred, programme tends to reflect the taste of the organiser. Space: Large shows—painted walls, cork floor, roof light and spots (1320 linear feet). Small shows—stone walls (beige), stone floor, spotlights. Equipment: Slide projector, other equipment can be negotiated with other departments. There is a permanent collection of historical and contemporary art and the exhibition programme is also shaped to reflect this. There are one or two 'local' amateur shows, but the main policy is to bring work of good quality to the region, not to show local work, except where it is worthy of special attention. There is also a strong emphasis on education in the gallery, which is also reflected in the progamme.

STEVENAGE
STEVENAGE LEISURE CENTRE, Lytton Way, Stevenage, Herts. Tel. Stevenage 316291. Opening: 10–10 everyday. Contact: Arts & Crafts Officer. Applications: Letter followed by appointment. Exhibitions: Basically, non-commercial, fine art, textiles and craft. Space: Large exhibition area plus two foyers, limited security.

STEVENAGE MUSEUM, St. George's Way, Stevenage, Herts SG1 1XX. Tel. 0438 354292. Opening: Mon–Sat 10–5, closed Sun. Admission

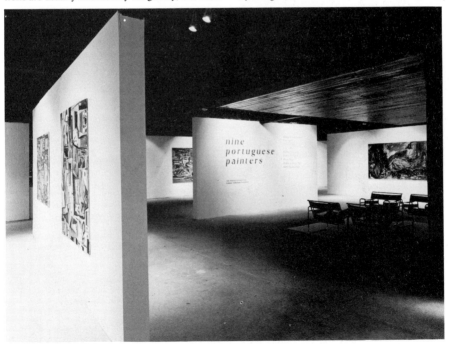

Nine Portuguese Painters at John Hansard Gallery Southampton

free. Contact: Curator, Colin V. Dawes; Designer/ Exhibitions Officer, Nick Jones. Two temporary exhibition areas: Large, 22ft × 20ft, small 16ft × 10ft. Trackspots, showcases (10) 780mm high × 675mm wide × 675mm deep. Some frames also available. Other equipment: VHS, 35mm slide projectors, tape/slide presentation, tape recorders, process camera. The Museum tells the story of the town up to the present day. Temporary exhibitions (20 per year) include art/design, local history, and hired-in exhibitions. Both our temporary exhibition areas have been completely refurbished recently to a high standard, and provde excellent, if somewhat small, facilities. We now also publish a quarterly Museum Bulletin, which is excellent in advertising our exhibitions.

STROOD
STROOD LIBRARY GALLERY, Strood Library, 32 Bryant Road, Strood, Rochester, Kent ME2 3EP. Tel. 0634 727626. Opening: During library hours—Mon–Fri 9–7, Sat 9–5. Contact: Group Librarian (Address above). Applications: In writing with slides or strictly by appointment with samples. Exhibitions: Paintings—all media, ceramics, crafts. Equipment: Glass lockable cabinets, exhibitions screens, projector slide and film facilities. Information: Annual exhibition programme arranged up to 18 months advance. Publicity for events arranged. Childrens' activities, Easter and Summer holidays. Lectures and author visits.

SWINDON
JOLIFFE ARTS STUDIO, Wyvern Theatre Square, Swindon, Wilts SN1 1QT. Tel. 0793 26161 ext 3149. Contact: Alastair Snow. Exhibition facilities in a number of Swindon venues programmed from the Joliffe Studio. The Thamesdown Press, based at the Joliffe Studio prints Artists' catalogues, cards, posters, book-works and other publications. Graphics/reprographics/silkscreen and offset litho. Public art commissions and residencies e.g. murals and sculpture. The Studio also organises hospital art projects, live art/ performance art, street theatre and community art events. There are studio/workshop facilities in sculpture, drawing, painting, photography, film, video, ceramics and jewellery. Further details available on request.
SWINDON MUSEUM AND ART GALLERY, Bath Road, Swindon, Wilts. Tel. 0793 26161 ext 3129. Opening: Mon–Sat 10–6, Sun 2–5. Contact: Robert Dickinson. Exhibitions: Mixed programme of temporary exhibitions often of local interest and permanent collection (mostly 20th century British art). Space: L-shaped gallery of 200 linear feet.

TUNBRIDGE WELLS
MUSEUM AND ART GALLERY, Civic Centre, Mount Pleasant, Tunbridge Wells, Kent. Tel. 0892 26121 ext 171. Opening: Weekdays 10–5.30, Sat

9.30–5. Contact: Exhibitions: Two permanent collections and temporary shows.
TRINITY GALLERY, Trinity Arts Centre, Church Road, Tunbridge Wells, Kent TN1 1JP. Tel 0892 25111. Opening: 10–2.30 and during hours of theatre performances, six days a week, as is the box office (0892 44699). Apply to the Exhibitions Organiser, sending slides to arrive by the first Wednesday of any month. Exhibitions are of contemporary paintings and free-standing work. It is a good space for one-person exhibitions. Works hang on the rod system. The theatre has become one of the most popular venues for touring companies such as National Theatre Studio, ATC, Millstream, Phoenix Dance, etc. It is a versatile performing space suitable for a wide range of entertainment from musical extravaganzas to intimate review, classical and contemporary dance, music of all kinds and as a venue for workshops and lectures. There is good foyer space and a bar and buffet open daily from 10–2, and bar open during theatre performances.

TWICKENHAM
ORLEANS HOUSE GALLERY, Riverside, Twickenham, Middlesex. Tel. 01-892 0221. Opening: Apr–Sept Tues–Sat 1–5.30, Sun 2–5.30; Oct–Mar Tues–Sat 1–4.30, Sun 2–4.30. Exhibitions: Permanent colleciton of paintings and prints. Full programme of temporary exhibitions.

UCKFIELD
THE ASHDOWN GALLERY, 70 Newtown, High Street, Uckfield, Sussex TN22 5DE. Tel. 0825 67180. Opening: Feb–Sept Tues–Sat 10–5; Oct–Dec Mon–Sat 10–5, closed Jan. Contact: Margaret Skeates. Permanent display of selected contemporary applied art— ceramics, studio glass, textiles etc. With supporting sculpture and pictures. 3/4 exhibitions annually showing work of nationally established craftspeople alongside selected lesser-known artists. Mailing list for invitations to private views. Space: Converted pub comprising four interlocking galleries with custom made fittings and display lighting. Selected for quality by Crafts Council and included in list of approved galleries.

UXBRIDGE
HILLINGDON BOROUGH LIBRARIES, High Street, Uxbridge, Middlesex UB8 1JN. Tel. Uxbridge 50600. Opening: Library hours daily Mon–Fri 9.30–8, Sat 9.30–5. Contact: Mrs M. Farley, Arts Liaison Officer. Applications: Apply direct to Mrs M. Farley. Exhibitions: Mostly pictures, only limited facilities for 3-D work. 30–40 exhibitions are mounted each year. Space: Central library (Uxbridge) has a large exhibition area, approx. 60m², linear hanging run approx. 13m. Two branch libraries have meeting/exhibition rooms attached and space is available within the body of other libraries for small exhibitions. Cow Byre Gallery (Annexe to Ruislip Library), suitable 30–40 paintings, 3-D work and small items in

glass cases. The Great Barn at Ruislip is used for larger and more complex exhibitions. Equipment: Slide projectors, rear projection units. Local societies and artists are particularly encouraged.

WAREHAM

PETER HEDLEY GALLERY, 16 South Street, Wareham, Dorset BH20 4LT. Tel. 09295 51777. Opening: Mon–Sat 9.30–5.30. Contact: Peter Hedley. Exhibitions: Frequently changing stock of oil paintings, watercolours, etchings and bronzes, promoting contemporary artists selected throughout the United Kingdom. Framing, restoration and advisory service.

TRINITY ART GALLERY, 32a South Street, Wareham, Dorset BH20 4LU. Tel. 0202 671078 & 09295 6541. Contact: Douglas H. Chaffey. Exhibitions: Changing exhibition of over 600 works from British and European artists. Works are for sale.

WATFORD

WATFORD MUSEUM, 194 High Street, Watford, Herts. Tel. 0923 32297. Opening: Mon–Sat 10–5. Exhibition Organiser, Mary Taylor. Permanent collections of paintings and sculpture. Temporary exhibitions of work by local artists past and present. Craft, sculpture, painting and pottery exhibitions. Demonstrations by artists to members of the public encouraged.

WELWYN GARDEN CITY

DIGSWELL HOUSE GALLERY, Monks Rise, Welwyn Garden City, Herts. Tel. 070 73 21506. Opening: 10–5. Contact: Bill Parkinson. Applications: By letter, plus slides, in the first instance. Exhibitions: Emphasis on artists looking for first main show, particularly those whose work is unlikely to be shown elsewhere. About 10 one and two-person shows are held each year. Space: Regency rooms, three gallery spaces, roughly 30ft × 20ft each, wooden floor in two, stone in third, mainly spotlighting. Extensive lawns, but security risk not good. Equipment: Slide projector and tape recorder. Shows the work of artists from all areas of involvement, including performance, installations and video. Digswell House Arts Centre runs a Fellowship Scheme, providing studio and living accommodation for 16 artists.

WINCHELSEA

THE WINCHELSEA GALLERY, 3 High Street, Winchelsea, East Sussex. Tel. 0797 226363. Opening: Mon–Sat 10–1, 2–5.30, Sun 2–5.30. Contact: Alison Davey. Exhibitions of contemporary paintings prints, crafts and photography. Small private gallery, well lit in centre of historic Cinque Port town. Gallery available for rent to approved artists

wishing to hold their own exhibitions. Regular exhibitions of group and one-man shows of new and established artists.

WINCHESTER

WINCHESTER SCHOOL OF ART EXHIBITION GALLERY, Park Avenue, Winchester, Hampshire. Tel. Winchester 61891. Opening: Normally Mon–Fri 10–6, Sat 9–12. Applications: In writing, with slides, to the Director. Exhibitions: Emphasis on contemporary painting and printmaking, but a wide range of work is shown encompassing art and design. There are between 10 and 15 one-person shows held each year. Space: 1800sq ft, polished timber floor, top natural light. There are also some excellent exterior spaces. Equipment: Most things are available. The gallery aims to bring contemporary work of quality to Winchester, for students and the general public. Dance and music performances are also occasionally held. Director. John Gillett.

WINDSOR

LIVE BRITISH ARTISTS, 67 Victoria Street, Windsor, Berks. Tel. Windsor 54925. Opening: 10–5.30. Contact: E. J. Quaddy. Applications: Phone for appointment. Exhibitions: Continuous exhibition of gallery artists, most of whom paint in oils. Space: Ground floor and lower floor. approx. 16ft×14ft. A small private gallery, aiming to give value for money to the man in the street.

WORTHING

WORTHING MUSEUM AND ART GALLERY, Chapel Road, Worthing, West Sussex BN11 1HD. Tel. 0903 39999 ext 121. (Saturdays 0903 204229). Opening: Mon–Sat 10–6 (Oct–Mar 10–5). Contact: J. F. L. Norwood, Curator. Exhibition programme Feb–Nov. (Fine and applied art, crafts, photography, historical and social themes). Permanent collection of English paintings, 18th–20th centuries; English ceramics and glass; costume and textiles.

TERRACE GALLERY, 7 Liverpool Terrace, Worthing, West Sussex BN11 1TA. Tel. 0903 212926. Opening: Tues–Fri 10.30–4.30, Sat 10.30–1, closed Jan & Aug. Contact: Margrit Avon. Strictly contemporary art and crafts. Crafts Council recommended. Applications: Submit slides/photographs of work and current C.V. About six exhibitions p.a. of paintings, etchings, ceramics, studio glass, wood, textiles, jewellery and sculpture by established artists and newcomers. Comprehensive stock of work by well-known makers. Spacious, modern gallery housed in fine Regency terrace in the centre of town, privately owned.

SOUTH WEST ENGLAND

BATH

BATH INTERNATIONAL FESTIVAL in late May annually includes the **Contemporary Art Fair** where some 40 UK galleries exhibit work at Green Park. Festival address as for **Artsite** below.
ARTSITE GALLERY, 1 Pierrepont Place, Bath, Avon BA1 1JY. Tel. 0225 60394/61659. Opening: Tues–Sun 10.30–7. Contact: Sean F. Kelly. Applications: Submit slides/photographs of work together with C.V. Exhibitions: Contemporary art by national and international artists concentrating on painting, sculpture, installation and craft work. Space: Two well-lit rooms 250sq ft, 200sq ft, also gallery gardens featuring sculpture exhibitions. The gallery organises lectures by exhibiting artists, an educational programme and special events during the Bath International Festival. A unique feature of Artsite is Artplan, an interest free credit scheme for the purchase of works.
BEAUX ARTS GALLERY, York Street, Bath. Tel. 0225 64850. Opening: Mon–Sat 10–5. Collection of work by Epstein, Frint, Green, Nolan, Vaughan. Also contemporary painting, sculpture and pottery.
CCA GALLERIES, 5 George Street, Bath. Tel. 0025 448121. Opening: 9.30–6, closed Sundays. A branch of the London Christies contemporary art galleries. Contemporary art by Chloe Fremantle, Stephen Bartlett, Matthew Spender amongst others.
CLEVELAND BRIDGE GALLERY, 8 Cleveland Place East, Bath. Tel. 0225 447885. Opening: Mon–Sat 10–5. Major 20th century artists; Keigh Vaughan, Mary Fedden, Loury etc.
F STOP PHOTOGRAPHY, 2 Longacre, London Road, Bath. Tel. 0225 316922. A state subsidised gallery and darkroom. Emphasis exhibiting young unknown photographers.
HITCHCOCKS, 10 Chapel Row, off Queens Square, Bath. Tel. 0225 330646. Opening: Mon–Sat 10–5.30. The gallery opened in 1986 on the 2nd floor with a shop below that sells crafts.
HOLBURNE MUSEUM AND CRAFTS STUDY CENTRE, Great Pulteney Street, Bath BA2 4DB. Tel. 0225 66669. Opening: Mon–Sat 11–5, Sun 2.30–6, closed mid Dec–mid Feb. Mondays Nov–Easter. Contact: Barley Roscoe. Permanent collection of decorative and fine art in an 18th century setting. Collection and archive work by 20th century British artist-craftsmen in pottery, textiles, calligraphy, furniture. Study facilities by appointment. Annual programme of temporary exhibitions.
KELSTON FINE ARTS, Kelston Houes, College Road, Lansdown, Bath BA1 5RY. Tel. 0225 24224 anytime. Viewing by appointment. Richard Ewen, oils and watercolours. Contemporary limited edition prints, etchings, lithographs and silkscreens by many artists.

PETER HAYES CONTEMPORARY CERAMICS, 2 Cleveland, Bath. Tel. 0225 66215. Opening: Mon–Sat 10–5. A gallery and studio of ceramics and sculpture.
ROOKSMOOR GALLERY, 31 Brock Street, Bath, Avon BA1 2LN. Tel. 0225 20495. Opening: Mon–Sat 10–5.30, closed in Jan. Contact: Robin Lipsey. Applications: Submit slides/photographs of work together with C.V. 8 exhibitions each year, usually one or two-man shows. Occasional theme exhibitions. For the rest of the year, a mixed show of contemporary paintings, ceramics, original prints and sculpture. No abstract work. Space: Four inter-connecting rooms on two floors, a private gallery.
THE RPS NATIONAL CENTRE OF PHOTOGRAPHY, The Octagon, Milsom Street, Bath. Tel. 0225 62841. Created by the Royal Photographic Society in one of Bath's most noted buildings. The Centre has extensive exhibition galleries and a continually changing and varied programme of both historic and contemporary photographs. There is also a museum of photography which houses some of the world's rarest photographs and, an outstanding collection of early photographic equipment. A programme of films, lectures, talks and workshops is available on a free newsletter. Contact: Carole Sartain for exhibition and event programmes as well as for details about conference facilities. Opening: Mon–Sat 9.30–5.30 (last admission 5.00). Also, library, rare books, equipment and prints from the world famous collection, open by appointment to researchers etc. Contact: Pam Roberts for details Tel. 0225 62841.
SLADEBROOK HOUSE, 222 Englishcombetare, Bath. Tel. 0225 20160. Opening: Mon–Sat 10–6, Sun 2–6. Prints, paintings and other art forms have all been shown here.
ST JAMES'S GALLERY, 9 Margarets Buildings (near the Royal Crescent), Bath BA1 2LP. Tel. 0225 319197. Opening: Mon–Sat 10–5.30. Contact: Ron or Susan Sloman. Applications: Submit slides or photographs. Exhibitions: Mixed shows by British artists, craftspeople and jewellers. Extensive stock of contemporary ceramics always available. A Crafts Council selected gallery.
THURSDAY GALLERY, 2a York Street, Bath. Tel. 0225 66904. Opening: Mon–Sat 9.30–5.30. Director: Dominic Nevill. Regular exhibitions by new and established artists. Paintings, prints, ceramics.
UNDERGROUND GALLERY, 72–74, Walcot Street, Bath, Avon BA1 5BD. Tel. 0225 62546. Opening Tues–Sat 10.30–5 and by appointment. Contact: Rupert Blunt, Dr Sheila Day. Applications: Submit slides/photographs/C.V. with sae. Exhibitions: Contemporary paintings, sculptures and ceramics by established, up and coming and unknown artists particularly from Scotland and Cornwall. Regular one person and mixed shows.

Modernised well-lit cellar gallery in central Bath. Privately owned and managed.

THE YORK STREET GALLERY, 12 York Street, Bath BA1 2LX. Tel. 0225 447399. Opening: Mon–Sat 10.30–5.30, closed month of Jan except Sat. Contact: Judith Bentham-Dinsdale. Interesting comtemporary paintings and ceramics, all media. Always interested in new work. Applicants submit photographs and C.V. initially. Constantly changing display. Exhibitions, two/three weeks four times a year. Exhibitions sent abroad (Canada, USA, Japan). Also hiring scheme and link with a London gallery.

BIDEFORD

BURTON ART GALLERY, Kingsley Road, Bideford, North Devon. Tel. Bideford 6711 ext 275. Opening: Weekdays 10–1, 2–5, Sat 9.45–12.45, closed all day Sun. Contact: Curator, J. Butler. Applications: By obtaining an applications form from TDC (Secretariat Dept), Bridge Buildings, Bideford, North Devon. Exhibitions: Varied, but largely of a local flavour. Space: 60ft × 40ft, screens over permanent exhibits, diffused lighting. A public gallery, with a pemanent collection of paintings, ceramics and furniture.

BRIDGWATER

BRIDGWATER ARTS CENTRE, 11/13 Castle Street, Bridgwater, Somerset TA6 3DD. Tel. Bridgwater 422700. Opening: Tues–Sat 9.30–5,.; Mon–Sat 7–11. Contact: Centre Director. Applications: By letter. Exhibitions: A broad range of arts, crafts and design of historical or contemporary interest, 12 per year. Space: One ground floor room, plus the theatre foyer, lit secure display case approx. 1 metre × 50 centimetres. Both rooms have a picture rail 2.2 metres above the floor giving a total wall length of 75ft lit by daylight, and 20 × 100 watt mirrored spotlights on a track. 20% commission plus vat on sales, minimum charge £32 plus vat. Insurance cover of £5000. Theatre equipment: Full stage lighting, slide projector, 16mm cine projector, Bechstein grand piano, selection of rostra.

BRISTOL

ARNOLFINI GALLERY, 16 Narrow Quay, Bristol BS1 4QA. Tel. 0272 299191. Opening: Tues–Sat 11–8, Sun 2–7. Contact: Gallery Director. Applications: Send documentation by post. Exhibitions: Contemporary developments in visual art. A balance of 2-dimensional, 3-dimensional and time-based work. Ten 'major' and ten smaller shows are held each year, most of these are one-person exhibitions. Space: Two large galleries, each with 170 linear feet of hanging space and an area of about 1700sq ft. Floors are polished wood blocks, no daylight, spots only. There is also an auditorium seating 200 which can be used to show

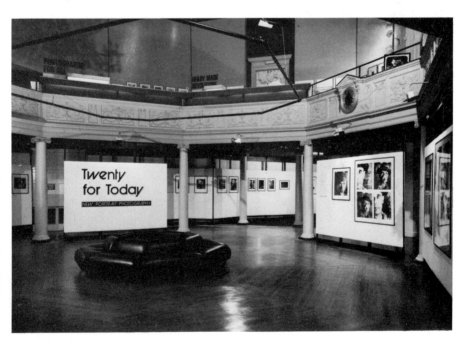

The Royal Photographic Society, Bath

films, music or dance events. Equipment: Most things can be arranged, finance permitting. The largest venue for contemporary work in the south west, the Arnolfini aims to stage exhibitions of a sufficiently high quality to attract the attention of the national and international art world. A programme of discussions, films and lectures is organised, to provide a context for the work. There is also an Artists in schools placement scheme (for the south west) and the gallery acts as artists' agent in finding commissions. There is also a full-time public cinema, a music, dance and theatre programme, cafe, bar and arts bookshop and a video reference library.

BRISTOL CITY ART GALLERY, Queen's Road, Clifton, Bristol BS8 1RL. Tel. 0272 45008. Opening: Mon–Sat 10–5. Contact: The Director. Permanent collection and temporary exhibition programme.

DAVID CROSS GALLERY, 3a Boyces Avenue, Clifton, Bristol BS8 4AA. Tel. 0272 732614. Opening: 9.30–6 Mon–Sat and CONTEMPORARY CELLAR GALLERY, Contact: Chris Billing. Submit photographs and C.V. by post. Representing traditional qualities in British painting especially relating to the West Country, the search for new talent, in conjunction with more established main gallery.

GUILD GALLERY, 68 Park Street, Bristol. Tel. 0272 265548. Opening: Mon–Fri 9.30–5.30, Sat 9.30–5. Contact: John Stops, Gallery Organiser. A large well-lit gallery 36ft × 18ft. A variety of strong cube rostra available for 3-D display in addition to pictures. The gallery is rented and no commission is charged on sales. There is a large well-lit entrance stairwell which is included in the gallery area. Shows last for 3 weeks. Considerable advance booking advisable.

OFF-CENTRE GALLERY (formerly Hard Times Gallery), 13 Cotswold Road, Windmill Hill, Bedminster, Bristol BS3 4NX. Tel. 0272 661782. Contact: Peter Ford and Christine Higgott. Opening; Tues, Wed, Sat 11–6, Thurs Fri 11–9, closed Feb–Mar. Exhibitions: To or three thematic exhibitions and group shows of contemporary original printmaking each year. Also one exhibition of new work by artist owner, Peter Ford. Touring shows sometimes arranged. The gallery features prints by artists from Britain and abroad with special interest in Eastern Europe. The aim is to put printmaking first but some paintings, drawings and 3-D works are also shown. Space: Two rooms, 340sq ft and 204sq ft (galleries are at top of building, up two flights of stairs. Printmaking workshop at street level).

ROYAL WEST OF ENGLAND ACADEMY, Queen's Road, Clifton, Bristol BS8 1PX. Tel. 0272 735129. Opening: 10–5.30 during exhibitions; staff available 9–5 at other times. Contact: Jean McKinney, Academy Secretary. Applications: Write to the Academy Secretary giving full details, and sending slides if possible. The request will be passed on to the exhibitions committee for consideration. Two years notice is normally required. Exhibitions: Drawings, paintings, water colours, sculpture (if not too heavy). Space: All five galleries are extremely well proportioned and all have natural lighting. Walls are hessian covered tongue and groove cladding, painted silver-grey. Floors are highly polished wood strip. Sizes of galleries may by obtained on application to the Academy Secretary. The general policy of the RWA's Council is to keep a steady flow of exhibitions of fine art, but also inluding crafts, quilting, embroidery, e.g. the National Children's Art Exhibition. The RWA is a society of artists and the first consideration is given to its own members and to artists whose work is either known to members of the counsil or whose work has been accepted for an annual exhibition.

3-D GALLERY, 13 Perry Road (Park Row), Bristol BS1 5BG. Tel. 0272 291363. Opening: Mon–Sat 11–5.30, Wed closed 1.30. There is a lively exhibition programme and a varied collection of work on display by a cross-section of the artist represented. Applications: Submit slides/photographs of work together with C.V. for consideration.

WATERSHED MEDIA CENTRE, 1 Canon's Road, Bristol BS1 5TX. Tel. 0272 276444. Gallery Opening: everyday 12–8. Applications to the Photography Co-ordinator. Exhibitions of photography and reprographics; cinema, video and media related issues. Permanent gallery space, also Concourse gallery and work in progress area. Facilities include darkrooms; studio; film, video and sound production and post production; two cinemas; conference area; bar and restaurant.

PATRICIA WELLS GALLERY, Morton House, Lower Morton, Thornbury, Bristol BS12 1RA. Tel. 0454 412288. Opening: Daily 11–1, 2–5. Otherwise by telephone appointment. Contact: Patricia Wells. Exhibitions: Living artists, one-person and mixed shows.

BRUTON
BRUTON GALLERY, High Street, Bruton, Somerset. Tel. 0749 812205. Opening: Mon–Sat 10–5 and by appointment. Contact: Michael and Sandra Le Marchant. European figurative sculpture of the 19th & 20th centuries, including Rodin and Bourdelle. Contemporary European painters, particularly Scottish and French including Philipson, Barrie, Holland, Sacksick. Regular exhibition cards and catalogues available. Also in New York.

CHELTENHAM
CHELTENHAM ART GALLERY & MUSEUMS, Clarence Street, Cheltenham, Gloucestershire GL50 3JT. Tel. 0242 237431. Exhibitions of a temporary nature are held at both the Art Gallery & Museum, Clarence Street, and the Pittville Pump Room Museum. All Correspondence should be sent to the address above. ART GALLERY & MUSEUM. Opening: Mon–Sat 10–5.30, closed Bank Holidays. Exhibitions Officer, Jonathan Benington. Applications: In writing to the above. Exhibitions: Historical and current

subject matter, mostly related to the Arts & Social History, but do not need to be. Permanent collections: Nationally important arts and crafts collection—furniture by Gimson and the Barnsleys, Voysey, Ashbee and Gordon Russell; Hull Grundy gift of arts and crafts metalwork and jewellery. English furniture, ceramics, glass and pewter from the 17th–20th centuries. Oriental ceramics and armour. 17th–20th century British and Continental painting, notably 17th century Dutch. Local history, archaeology, geology and folklife; Edward Wilson, Antarctic explorer. PITTVILLE PUMP ROOM MUSEUM. Opening: 1 Apr–31 Oct Tues–Sun, 10.30–5, closed Good Friday, open Easter, Spring and August Bank Holiday Mondays. 1 Nov–31 Mar Tues–Sat 10.30–5, closed Bank Holidays. Exhibitions Officer: Helen Brown. Applications: In writing to the above. Exhibitions: Historical and current subject matter, specifically related to textiles, costume, jewellery. Permanent collection: Displays of costume, textiles and accessories from the 1760s to the present shown in the context of Cheltenham's history. Graphic displays on the history of Cheltenham from Saxon times to the present day. Hull Grundy gift of jewellery from the late 18th to early 20th centuries.
MANOR HOUSE GALLERY, Manor House, Badgeworth Road, The Reddings, Cheltenham, Glos. Tel. 0452 713953. A private gallery by appointment only. Exclusively 20th century modern British paintings of lesser-known artists between the period 1920–1950. Contact: Geoff Hassell.
YEW TREE GALLERY, Green Lane, Little Witcombe, Gloucestershire GL3 4TX. Tel. 0452 863516. Opening: During exhibitions Tues–Sat 11–5.30, Sun 1.30–5.30, other times by appointment. Privately owned fine art and craft gallery (selected for quality by Crafts Council), holding 4 exhibitions annually, all by living artists. Exhibitions: (between Easter and Christmas) based on themes or titles, e.g. in 1988 1 Apr–15 May 'The Black and White Show'— photographs, wood engravings, ceramics, glass, jewellery, wearable art; 7 Jun–18 Jul 'Two Visions of Landscape'—oils by Oliver Heywood; embroidered paintings by Verina Warren, plus 2 collections of porcelain; 10 Aug–15 Sept 'Fish, Fowl and Water Places'—mixed media. Situated in 17th century farmhouse in village, 5 miles from both Cheltenham and Gloucester, at foot of Birdlip Hill. Brochures on request.

COLYTON
THE MARKET PLACE GALLERY, The Market Place, Colyton, Devon. Tel. Colyton 52918. Opening: 10–1, 2.15–5, closed Wed and Sun. Contact:

Off Centre Gallery, Bedminster

Miss P. Rattray. Applications: In writing, enclosing slides, or by personal visit. Exhibitions: Contemporary art. Mixture of group and one-person shows. Space: Natural light and spotlights. Also framing and art materials departments.

DARTMOUTH
SIMON DREW GALLERY, Foss Street, Dartmouth, Devon TQ6 9DR. Tel. 08043 2832. Opening: Mon–Sat 9–5. Shortened hours in Feb. Permanent collection of contemporary art and craft. Regular exhibitions, usually group shows. Contact: Simon or Caroline Drew.

DORCHESTER
DORSET COUNTY MUSEUM, High West Street, Dorchester, Dorset DT1 1XA. Tel. Dorchester 62735. Opening: Mon–Sat 10–5. Contact: Curator. Applications: To the curator at the beginning of March and beginning of September. Exhibitions: Paintings, photographs, engravings, sculpture and pottery, by contemporary and artists of the past. Mostly mixed exhibitions. Space: About 140 linear feet of wall space, wall 10ft high. Small courtyard for sculpture. Equipment: Display cases, stands for sculpture and screens.

DURSLEY
PREMA, Uley, near Dursley, Glos GL11 5SS. Tel. 0453 860703/860800. Opening: 10–6 weekdays, please phone if you are coming a long way as gallery space also used for performances, workshops, classes etc. Director: Andrew Wood. Gallery space: 44ft × 32ft. Showcase: 12ft × 5ft. Exhibition policy: 10 exhibitions per year in both the showcase and gallery. The showcase is used for small sculptures and craftwork. The gallery is used for paintings, drawings, prints, photography and textiles (no sculptures), 2 or 3 exhibitions per year are hired in, the remainder are organized by Prema. Most of the latter are one-person shows. Applications for exhibition are always welcome from anyone, preferably by written submission with accompanying slides or photographs. Prema is a mixed media arts centre with broadranging performance, workshop, class and exhibition programme throughout the year. Increasingly schools', lectures and educational work are undertaken in conjunction with each exhibition.

EXETER
ROYAL ALBERT MEMORIAL MUSEUM, Queen Street, Exeter EX4 3RX. Tel. Exeter 77888. Opening: Tues–Sat 10–5.30. Contact: Exhibitions Officer. Lively temporary exhibitions programme including Arts Council, Crafts Council and other touring shows. Some self-initiated shows. Application: Ideas for exhibition always considered. Space: 65ft × 29ft white walls, carpeted floors, track spotlighting, air handling

3-D Gallery, Bristol

system. Total area: Permanent collection consists of archaeology, natural history, ethnography, fine and applied art.
SPACEX GALLERY, 45 Preston Street, Exeter, Devon. Tel. 0392 31786. Opening: Tues–Sat 11–5. Contact: Director. Applications: Send colour slides of recent work (approx. 12), curriculum vitae and written statement (not more than 500 words) about the work. Exhibitions: Selected by the gallery committee with a view to presenting a balanced programme of exhibitions throughout the year reflecting the variety of work now being done by contemporary artists, ranging through painting, sculpture, printmaking, film, video, photography, performance etc. A mixture of group and one-person shows. Space: Gallery occupies the ground floor of a converted warehouse, two floors above are artists studios. Walls are white painted brickwork. Even lighting throughout by fluorescent and spotlights. Large arched windows and archways. Large doors make access easy. Local artists and groups are supported, also artists who do not exhibit regularly elsewhere. There are also other activities such as music, poetry, film, drama, dance etc., and talks and discussions.

FALMOUTH
FALMOUTH ARTS CENTRE, Church Street, Falmouth, Cornwall. Tel. Falmouth 314566. Contact: Peter Gilson, Hall Manager. Opening: 9.30–11.30 weekdays.
FALMOUTH ART GALLERY, The Moor, Falmouth, Cornwall TR11 2RT. Tel 0326 313863. Opening: Mon–Fri 10–4.30 (all year round, except between exhibitions). Contact: Curator, Miss Kate Dinn MA. Applications: In writing or in person, include photos of current work. Exhibitions: One/two-person shows of fine art/craft, travelling exhibitions, and subjects of general/local historical interest. Also permanent collection of 19th and early 20th century paintings and prints, including fine maritime section, on display from time to time. Space: Two rooms, display plinths and free-standing panels, strip lighting and track spots. Approx. 60 metres wall space. Wide variety of regularly changed shows.

GLOUCESTER
CITY MUSEUM AND ART GALLERY, Brunswick Road, Gloucester GL1 1HP. Tel. 0452 24131. Opening: 10–5 daily, closed Sun and public holidays. Contact: Curator. Exhibitions: As varied as possible to give visitors a wide range of interest. Sciences represented as well as arts.

Prema Art Centre, Dursley

Applications: Submit ideas with back-up information, (photos or slides if possible). Space: Approx. 150 feet of linear hanging space. The gallery mounts a wide range of exhibitions, including support for local art societies, touring exhibitions and shows of local interest. There are modest facilities (i.e. foyer exhibition space) for young local talent, who could'nt otherwise afford to put on a show.

ILMINSTER
BUTLIN GALLERY, Dillington College, Ilminster, Somerset TA19 9DT. Tel. Ilminster 2427. Opening: 2–5. Contact: Mr Peter Epps. Applications: To the gallery steward. Exhibitions: Paintings, sculpture, photography, crafts, childrens' work. Space: Purpose designed gallery, 100 linear feet of wall space, lighting is recessed behind diffusing panels. Exterior spaces for sculpture etc. Equipment: Most things available. Other arts activities can be shown i.e. dance, poetry, music and mixed media. The gallery is part of a college which runs resident and day courses in all aspects of the arts.

MORETON-IN-MARSH
SOUTHGATE GALLERY, PO Box 8, Moreton-in-Marsh, Glos. GL56 9NH. (Established 1969). Tel. 0608 50051. Opening: By appointment only, except during exhibitions. Contact: John Constable or Nigel Collins. Usually three exhibitions each year, mainly group or mixed shows, mostly of established artist's but all post 1920.

PENZANCE
NEWLYN ORION GALLERIES, Newlyn Art Gallery, New Road, Newlyn, Penzance, Cornwall. Tel. 0736 63715. Opening: 10–5 (10–6 Jul–Aug). Contact: John Halkes, Director. Applications: Write/phone for appointment to Director. Exhibitions: Eclectic range of contemporary visual art, painting, printing, photography, sculpture, film (not much performance or video). Space: Two level gallery. Upper floor access from the street. Arts information in entrance hall. Reception area and good little gallery shop leading to main gallery. 80ft × 40ft. White hessian wall to 9ft. Lofty space augmented daylight. Central staircase descends to lower gallery 40t × 15ft. Passageway through two small exhibition areas—20ft × 12ft and 12ft × 11ft. Garden space leading to wide public green and the shore of Mounts Bay. Equipment: Metal frames for hire; 16mm projector, small offset litho printing machine (A4). Newlyn Orion provides a service to the public and artists. The aim is to stimulate public awareness of contemporary visual art, and to encourage artists whether or not they are well established. Newlyn Orion is an educational charity which receives financial assistance from South West Arts and Cornwall County Council. The small professional staff work actively with artists and members of the public to create a warm and active environment. The staff maintain close links with the regional arts association, the local art schools and Exeter University

extra mural department. Regular poetry readings, occasional music and some lectures.
WOLF AT THE DOOR GALLERY, Bread Street, Penzance, Cornwall. Tel. Penzance 60573. Opening: Mon–Sat 10–5, closed Wed. Contact: Lu Simmons or Anne Sicher. Applications welcome. Best available contemporary fine art and textiles, sculptures, pots, baskets, jewellry, furniture, etc. Space: Two galleries of 500sq ft each. Linear 60ft × 60ft. Track spotlights. 10 one-man/woman shows per year and 2 mixed shows upstairs. Downstairs continuously changing exhibition.

PLYMOUTH
PLYMOUTH ARTS CENTRE, 38 Looe Street, Plymouth. Tel. 0752 660060. Opening: Mon–Fri 10–6, Sat 10–1. Applications: Contact, Rosy Greenlees. Exhibitions: Mainly painting and photography, occasionally weaving and textile work, local artists (the south west) preferred. Space: An attractive room, with daylight from the west, recently sanded floor, track lighting. Equipment: 80 aluminium frames (20" × 24" and 20" × 16") for photography. There is a cinema in the arts centre, which could provide audio/visual equipment.
BARBICAN THEATRE, Castle Street, Plymouth PL1 2NJ. Tel. 0752 267131. Opening: Mon–Sat 10–11. Contact: Margaret Jones. Policy: Young People's Theatre Centre, Work encouraged from young people individuals or groups, and new artists. Space: Approx 67ft (18 1/2 metres) spotlighting.
CITY MUSEUMS AND ART GALLERY, Drake Circus, Plymouth PL4 8AJ. Tel. 0752 264878. Opening: Mon–Fri 10–5.30, Sat 10–5, closed Sundays except during major exhibitions when open 2–5. Contact: Sarah Shalgosky, Exhibitions Organiser. Applications: Submit slides of work, together with C.V. and specific proposal. Exhibitions: Organises small exhibitions of work by local artists and craftspeople, major one-person exhibitions and thematically structured exhibitions of contemporary art. Takes touring exhibitions of historical and contemporary work; painting, sculpture, photography and installations. Space: Four first floor exhibition galleries: 2000sq ft, 1600sq ft, 1400sq ft, 1000sq ft. Access by staircase or lift. One ground floor temporary exhibition gallery: 800sq ft. Wooden floors. Strip and spotlighting. Edwardian building. Education programme. Permanent collection: 18th, 19th and 20th century paintings and prints, notably Newlyn School and Camden Town group. Outstanding collection of 18th and 19th century ceramics. Cottonian collection of some 9000 old master prints and drawings. Also local history, archaeology, ethnography and natural history collections.

PORTSMOUTH
ASPEX GALLERY, Art Space Portsmouth, 27 Brougham Road, Southsea, Hampshire PO5 4PA. Tel. 0705 812121. Contact: The Director. Opening: Tues–Thurs 11–6, Fri & Sat 11–5, Sun 2–5, closed Monday. The gallery space is 55ft × 45ft

with flood and spotlighting. 20% commission on sales.

PORTSMOUTH CITY MUSEUM AND ART GALLERY, Museum Road, Old Portsmouth, Hants PO1 2LJ. Tel. 0705 827261. Opening: 10.30–5.30. Contact: Keeper of Art. Applications: Submit slides, with written biography etc. Space: Two ground floor galleries—104 linear feet and 192 linear feet of wall space. One with natural light, one without, track lighting in both, carpeted. Grassed areas at front and rear are used for outside displays of sculpture. Equipment: Slide projectors and tape recorders, other equipment can be loaned from Polytechnic. The Museum and Art Gallery's own collections consist of British decorative art from the 17th century to 20th century and contemporary crafts and British 20th century prints, drawings, sculpture, paintings from the 30s and by artists with local connections. The exhibition programme attempts to give a varied diet of mainly fine art of work of a national or international importance together with historical shows and other departmental subject matter.

SCREENWORKS GALLERY, Portsmouth Media Trust, The Hornpipe Arts Centre, 143 Kingston Road, Portsmouth PO2 7EB. Tel. 0705 861851. Opening: Tues–Thurs 10.30–4 and Wed–Sat 7.30–9. Contact: Michael Craven. Applications: Advertised in the specialist press. Exhibitions: Exclusively photography and time-based media. Touring shows, one-person shows by nationally recognised and new photographers, local and community exhibitions. Equipment: Video and audio visual equipment, community darkroom and video edit suites, film and photography education programme. Growing photographers slide library of English and Canadian work. Screenworks also programmes the 35mm/16mm Rendez-vous Cinema. Theatre and music is promoted in other prats of the building by The Hornpipe Arts Trust.

ST AUSTELL
MID CORNWALL GALLERIES, Biscovey, Par, Cornwall PL24 2EG. Tel. 0726 81 2131. Opening: Mon–Sat 10–5 throughout the year. Contact: Margaret Gould. Contemporary art and craft. Approx. 8 exhibitions a year showing work by established artists and craftsmen with work by people who are less well-known. Regular group shows and visiting exhibitions. Victorian School coverted to well-lit modern gallery.

ST. IVES
PENWITH GALLERIES, Back Road West, St. Ives, Cornwall. Tel. 0736 795579. Opening: Tues–Sat 10–1, 2.30–5. Exhibitions: Contemporary fine art. Print workshop also.

TAUNTON
BREWHOUSE ARTS CENTRE, Coal Orchard, Taunton, Somerset, TA1 1JL. Contact: Visual Arts Officer.

TETBURY
UPTON LODGE GALLERIES, 20a Long Street, Tetbury, Glos. GL8 8AQ. Tel. 0666 53416. Opening: Mon–Sat 10–6. Contact: Josephine Grant. British paintings and watercolours from 1900 to present day always in stock, with a minor proportion of work by contemporary artists on display offered for sale on commission. Exhibitions are also held in Jun and Nov at Avening House, Avening, Tetbury, where there is scope for exhibiting larger scale work in the setting of a private house from the same period as at Tetbury.

TOTNES
DARTINGTON NEW GALLERY, Dartington, Totnes, Devon. Tel. 0803 863466. Contact: Sarah George.

FINE BRITISH WATERCOLOURS, The Gothic House, Totnes, Devon. Tel. 0803 864219. Opening: Normally Mon–Sat 10–6, closed Tues in summer. Contact: Beverley James Pyke. Distinguished recent work for the connoisseur. Continuous exhibition of selected artists— mainly RWS. (Royal Watercolour Society).

TICKLEMORE GALLERY, No. 1 Ticklemore Court, Ticklemore Street, Totnes, S. Devon. Tel. 0803 866080. Opening: Mon–Sat 9.30–5 (winter), closed Tues. The gallery exhibits traditional paintings in watercolour and oil, all from the West Country. There are also Batiks, ceramics, woodturning and glass. Regular one-man and group shows. The gallery is on two floors, well-lit with natural and spotlight. Near the River Dart, the building is new, and built in a Georgian style. Applications: Submit slides/photographs of work, together with C.V. Exhibitions.

TRURO
THE ROYAL INSTITUTION OF CORNWALL, The County Museum and Art Gallery, River Street, Truro. Tel. Truro 72205. Opening: Daily (Sun and Bank Holidays excepted) Apr–Sept 9–5; 1 Oct–Mar 9–1, 2–5. Contact: Curator, H. L. Douch. Space: Two galleries 67ft × 22ft and 44ft × 22ft. The two galleries are very much part of the museum, designed to house the permanent collection, but there are occasional temporary shows.

WELLS
SIROTA GALLERY, 23 Sadler Street, Wells, Somerset BA5 2RR. Tel. 0749 74553. Opening: Everday except Wed, open Sun 10–5. There is an excellent espresso coffee and patisserie shop included in the gallery space. Work is chosen for exhibition by the proprietors B. and J. M. Sirota. Exclusively contemporary painting and sculpture with some ceramics and prints by established artists and promising newcomers. Send slides and C.V. Artists with work seen only by appointment. Continuous mixed exhibitions with four to five one-man shows per year.

YEOVIL
RIMPTON HOUSE GALLERY, Rimpton House, Rimpton, near Yeovil, Somerset BA22 8AS. Tel. 0935 851108. Contact: Mr & Mrs Bernard Stawt. Applications: By letter, new artists encouraged to apply. Exhibitions: A country house gallery opened in 1985 to show work by professional artists in all media, in a warm and friendly setting. Space: Over 200 linear feet of hanging space in four separate rooms, spotlit. Showing areas set aside for sculpture, glass and ceramics.

CHANNEL ISLANDS

JERSEY
SELECTIVE EYE GALLERY, 50 Don Street, St Helier, Jersey, Channel Islands. Tel. 0534 25281. Contact: Warwick Blench. Applications: Submit high quality photographs or slides and C.V. Exhibitions: Pictures from the Modern British Movement. Contemporary Sculpture and graphic art. This Gallery is keen to contact artists with a view to exhibiting their work.
STUDIO 18 ART GALLERY, 23a Beresford Street, St Helier, Jersey, Channel Islands. Tel. 0534 34920. Opening: 8.30–5.30 Mon–Saturday. Contact: Tony Watton. Applications: Submit slides/photographs of work with selling price, together with C.V. Exhibitions: Contemporary paintings and graphics, frequent one-man and mixed exhibitions by local and international artists, plus a changing selection by various artists always on view. Keen to find artists who are interested in painting Jersey scenes.

NORTHERN IRELAND

ANNAGH MAKERRIG
THE TYRONE GUTHRIE CENTRE, Newbliss, County Monaghan, N.I. Tel: 047 54003. A residential workplace in a country mansion for artists of all disciplines. Fully equipped studios available. Artists from outside Ireland accepted on a fee-paying basis. Further information from Bernard Loughlin at the above address.

ARMAGH
CLOUD CUCKOO GALLERY, 41 Ogle Street, Armagh. Tel. 0861 522685. Open daily except Wed & Sun 9.30–5.30. Gallery space for about 50 small pieces of work.

BELFAST
ART ADVICE GALLERY, 136 Great Victoria Street, Belfast, BT2 7BG. Tel. 0232 324736. Opening: Mon–Fri 10–5.30. Contact: Elaine Hogg. Applications: Submit slides/photographs/C.V. Exhibitions: Contemporary art, mostly local, but welcome touring shows, performance, installation. Regular one-person and group shows—generally sent to our New York gallery for exhibition. Space: modern, well-lit, two floors. Open during exhibition dates only—otherwise by appointment only. Active in promoting art to businesses.
ARTS COUNCIL GALLERY, Bedford House, Bedford Street, Belfast 2. Tel: 321402. Opening: Tues–Sat 10–6. Contact: Kent Russell. Applications: By letter to the Art Committee. Exhibitions: any kind of work. Space: Upper Gallery 50ft × 40ft, with display board facilities. Lower Gallery 50ft × 20ft. Video library and Artists' index in the form of slides and documentation. Book shop and coffee bar. Disabled access.

THE BELL GALLERY, 13 Adelaide Park, Belfast BT9 6FX. Tel. 662998. Opening: Daily 9–6 or by appointment. Contact: Nelson Bell. Applications: Send photographs and previous catalogues. Exhibitions: Established and young Ulster artists, some visiting artists. One-person shows. Space: One large room with two bay windows, one small connecting room, one medium room with two windows, ground floor, good daylight throughout, in a house in university area, plain walls, carpeted floor. A private gallery founded in 1964, aiming to support local artists, educate and cultivate local clients.
TOM CALDWELL GALLERIES, 40/42 & 56 Bradbury Place, Belfast BT7 1RT. Tel. 0232 323226. Contact: Tom Caldwell. Opening: All year, Tues–Fri 11–5. Sat 11–1. Applications: Submit slides/photographs and C.V.'s. Exhibitions: Regular one person shows by nationally recognised artists. Occasional group shows by younger artists.
OCTAGON GALLERY LTD., 1 Lower Crescent, Belfast BT7 1NR. Tel. 0232 246259. Opening: Tues–Sat 11–5. Contact: Director. Applications: Bring in samples of work. Exhibitions: Mainly the work of young and less commercial artists. A young contemporaries show is held each year. Occasionally show established Irish artists or prestigious shows from outside Ireland. Also crafts and prints. Space: Ground floor 30ft × 18ft, leading to smaller room, good lighting. First floor—Crafts room 20ft × 18ft. Equipment: Projectors, tape recorders can be borrowed. The gallery gives lesser-known artists the chance to exhibit; it is not a commercial gallery. Mostly paintings and prints are shown, due to lack of space. The Crafts Room is the only outlet for the work of local craftsmen and designers.

CRAIGAVON

THE PEACOCK GALLERY, Pinebank House Arts and Resource Centre, Tullygally Road, Craigavon, Co Armagh BT65 5BY. Tel. 41082/41033. Opening: Mon–Fri 10–5. Contact: Rosaleen McMullan. Space is one room 8 × 4 metres. Promotes work by local artists and work from further afield.

DERRY/LONDONDERRY

DERRY CITY COUNCIL: ORCHARD GALLERY/FOYLE/ARTS PROJECT, Orchard Street, Derry BT48 6EG. Tel. 0504 269675. Contact: Declan McGonagle. The Orchard Gallery was opened in 1978 by Derry City Council with a subsidy from the Arts Council for Northern Ireland. It is wholly administered by the City Council and over the years has developed a programme of exhibitions and related events such as seminars, workshops, talks, discussions, films, performances which reflect current activity in contemporary art in the world but also in the region and the locality. The Orchard Gallery provides a platform and ongoing support for younger artists as well as exposure for new art and more established figures. An education/mediation team work closely with all artists to develop a parallel programme of events, talks, workshop, films etc which create a context for the particular work on

"The Singing Lesson", Lino Mannocci

Krszyztof Wodiczko projection at the Guildhall, Derry, Northern Ireland

show. A variety of publications and printed material—catalogues, monograph, artist books, posters, cards, pamphlets etc are produced with each exhibition and the Gallery covers all costs to do with each exhibition. An exhibition fee is also paid directly to the artist. While that is standard procedure, each exhibition makes its own demands and more often than not each project's financial and physical requirements are determined by seperate discussion. A series of new projects will come on stream over the next year, including the Foyle Arts Project and an Outreach/Public Art Programme with the idea that the city is the gallery, coming more and more into the foreground. The Foyle Project is housed in a large 19 century school building near the city centre. The development is entirely funded by Deryy City Council and is an important part of an expanding integrated museum and art service. The building has a great variety of spaces fromthose with 16ft ceilings, 22ft × 60ft area, to small cell like spaces in the basement area all of which will be used for performance, theatre, music, visual arts and administration. Space for other projects and voluntary groups in the city will co-exist with visual arts but the building will also be the base for a series of education and neighbourhood/community inititives through the urban and rural council area. Foyle will bring together those things which are normally kept apart, the international and the local/vernacular, the voluntary and the professional. As part of the City Council community services department the Orchard Gallery prides itself on placing the artist at the centre of an international programme with a strong community orientation.

THE GORDON GALLERY, 36 Ferryquay Street, Londonderry. Opening: Mon, Tues, Wed & Fri 11–5.30. Sat 11–1. Closed Thurs. Director: N.A. Gordon. Open to applications. Shows work by better known contemporary Irish artists and British artists. 40% commission.

DONAGHADEE
GEORGIAN GALLERY, Erin Lodge, Donaghadee, Co Down BT21 0BQ. Tel. 0247 882282. Opening: Mon–Sat 10–6. Contact: Director. Applications: In writing or person, with samples of work. Exhibitions: Modern Irish plus British painting and sculpture. Space: Two areas—15ft × 21st and 9ft × 30ft.

EIRE/SOUTHERN IRELAND

CORK

CORK ARTS SOCIETY ·GALLERY, 16 Lavitts Quay, Cork, Ireland. Tel. 021 277749. Opening: Tues–Sat 10.30–6. Contact: Charlo Quain. Applications: Submit samples of original work, slides and photographs with C.V. exhibitions. Two galleries. Ground Floor: Continuous exhibition of work by professional and established artists. First floor suite of galleries: Mainly one man exhibitions, some group shows accepted.

CRAWFORD MUNICIPAL ART GALLERY, Emmet Place, Cork. Tel: 021-273377 and 021-274567. Opening: Mon–Sat 10–5. Contact: Peter Murray, Curator. Permanent collection of 18th and 19th century Irish and English watercolours and oils. Also a large collection of sculpture. Temporary exhibitions programme. Occasional evening lectures and public meetings. Cafe open daily plus Wed, Thurs and Fri evenings.

TRISKEL ARTS CENTRE, Tobin Street, Off South Main Street, Cork. Tel. 021-272022. Opening: Tues–Fri 11–6. Thurs 11–7. Sat 11–5. Contact: Robert McDonald. Applications: submit slides/photographs of work, together with C.V. Exhibitions: Local artists, touring shows, one person shows by nationally recognised artists, exhibitions of craft work, photography and occasionally historical shows. Space: Main Gallery 20 × 50; Artrum Gallery 20 × 20; Cafe: 20 × 20; Foyer Gallery: 20 × 20. Occasional access to adjacent park for sculpture etc. Natural, strip and spot lighting. Equipment: Carousel projector, 16mm film, limited number of frames. Occasional lectures/meetings by artists. Other events: film, music, drama and poetry, and performance art.

WEST CORK ARTS CENTRE, North Street, Skibbereen, Co. Cork, Ireland. Opening: 12.30–5. Mon–Sat. Also open in the evenings, as required, for music, drama classes, poetry readings etc. There is also a thriving Film Society attached. Contact: The Administrator who will submit applications for exhibitions to the management committee. Slides, photographs and C.V.'s would be welcome with applications. Exhibitions: The Summer Members' Exhibition in July/August for 3 weeks. Other exhibitions also on a 3-week rotation throughout the year. Craft exhibitions are held in the summer and coming up to Christmas and an exhibition of children's art is usually held in January. We have touring shows from both the Arts Council of Ireland (Dublin) and the Northern Ireland Arts Council (Belfast) and we have shown many artists of national and international stature since we started. Lighting: Generous natural light and also spots and strip. Space: Approximately 1000 sq ft of floor space, in two separate galleries. A little theatre is planned when further space becomes available and it is also planned to have a coffee room, a reference library, a slide library and projector and a gallery shop. We have ample floor space for sculpture display indoors and we hope to have external space also before too long. We are particularly keen to build a slide library so that we can actively sell our artists. Our financial resources at present do not allow us to build a permanent collection of paintings, sculpture, etc.

93

but slides would give prospective buyers a good idea of what work is done and what kind of art we have available.

CERAMIC ART (Ireland) LTD., Kealkil County Cork, Tel. 353 (0)27 66 123, Central Agency promoting and marketing Irish ceramics. Contact: David Rose.

FERMOY ART GALLERY, 2 Pearse Square, Fermoy, Co. Cork, Ireland. Tel. 025-32345. Opening: Mon–Sat 10–9. Sun 2 p.m.–8. Contact: Peter Gallagher or Stephanie Fouhy. A warm welcoming Gallery comprising two main showing areas and three studios, all very well lit. Art classes each evening Mon–Fri. Exhibitions: A general exhibition by nationally and lesser-known artists at all times but enquiries for one person exhibition welcome. Submit slides and C.V. to Peter Gallagher. Also, exhibitions by Fermoy Art Gallery arranged nationally and abroad, especially United States!

DONEGAL

DONEGAL COUNTY MUSEUM SERVICE, High Road, Letterkenny, Co. Donegal, Ireland. Tel. 074 24613. Opening: Tues–Sat 1 p.m.–6. Contact: Paula M. Harvey. Permanent collection of material evidence and associated information relating to the archaeology, history, folklife, folklore and contemporary Donegal. Temporary exhibitions programme.

DUBLIN

TOM CALDWELL GALLERY, 31 Upper Fitzwilliam Street, Dublin D2, Tel. 688629, Contact: Sara McGuire, Opening: Tues–Fri 11–5. Sat 11–1. Applications: Submit slides/photographs & C.V. Exhibitions: Regular one-person shows by nationally recognised artists. Occasional group shows by younger artists.

DAVIS GALLERY, 11 Capel Street, Dublin 1. Tel. 726969. Opening: Weekdays 11–5.30. Owned and run by artist Gerald Davis. The gallery, opened in 1970 is well-appointed, modern and well-lit. Convenient to central Dublin being in a prime shopping area about 100 meters from the River Liffey. Has shown the work of many well-known Irish artists and craftspersons. Stocks graphics, paintings, sculpture and ceramics. Available for hire for all types of contemporary work.

THE GRAFTON GALLERY, 3 Anne's Lane, South Anne Street, Dublin 2. Opening: Mon–Fri 10–5.30. Sat 10–1. Contact: Mr. C. MacGonigal, Managing Director or Ann O'Neill, Gallery Administrator. Applications: Submit slides/photographs of work, together with C.V. and exhibitions: Lesser-known and new artists, alongside work of more established artists. All media: Regular exhibitions by gallery artists and "Corporate Art" exhibitions and art for offices. Modern building, on two floors, 1500 sq ft. Natural and strip lighting. A privately owned gallery, owned by the directors.

THE NATIONAL GALLERY OF IRELAND, Merrion Square West, Dublin 2. Tel. 615133. Opening: Mon–Sat 10–6. Thurs 10 –9. Sun 2–5.

Admission free. Contact: Marie Bourke Press Officer. Permanent collection of oil paintings and watercolours, drawings, prints, miniatures, pastels and sculpture. All the major European schools represented together with a large Irish collection. Bookshop and Restaurant open during gallery hours. Programme of public lectures. guided tours available on Sundays and by appointment to tour groups.

NATIONAL MUSEUM OF IRELAND, Kildare Street and Merrion Street, Dublin 2, Ireland. Tel. 01-765521. Opening: Tues–Sat 10 –5. Sun 2–5. Contact: Education Officer. Exhibitions: Permanent collection covers Archaeology, Decorative Arts, History, Folklife, Zoology and Geology. Main emphasis on Irish material. Occasional temporary exhibitions of related material. Catalogues, slides and postcards available. Museum shop. Public lecture programme.

PROJECT ARTS CENTRE, 39 East Essex Street, Dublin 2. Tel. Dublin (0001) 712321/713327. Director: Tim O'Neill. Opening: Mon–Fri 11–10. Sat: 12–8. Closed Suns. Applications: Living artists ONLY. Preference for solos rather than group shows. Please send not more than 12 photos/slides, C.V., previous exhibitions if any, brief statement on proposed show. Before 30 November, for exhibition during following March to February. Usual run 2/3 weeks. Preference for 'emerging' artists, or established artists trying new direction. Artists from outside Eire welcome, provided your state has a cultural treaty with the Irish Republic. Project supplies insurance during run, press/promo/Opening, hanging/technicals, staffing, + not more than IR £250 towards poster, materials, etc.. The Artist supplies all other direct costs, inc. materials, framing, publicity, transportation, insurance before and after run. Sales: Standard split 70% Artist/30% Project. Project pays all VAT liability from its 30%. Project is a combined arts centre offering theatre, dance, music and film as well as visual arts. Gallery dimensions approx. 27 ft W × 42 ft L × 14 ft H. Hanging on all 4 walls. Gallery is also box-office/theatre foyer from 7 p.m. to close each evening.

THE GALLERY OF PHOTOGRAPHY, 37/39 Wellington Quay (near Ha'penny Bridge), Dublin 2. Tel. 01-714654. Opening: Every Day Mon–Sat 11–6. Sun 12–6. Contact: John Osman, Director. Monthly exhibitions by Irish and international photographers. Permanent collection of 19th & 20th Century photographs of Irish interest. Comprehensive bookshop and wide ranges of posters and postcards for sale. Framing and photo-restoration services. Space: 1400 sq ft in three rooms. Grant aided by the Irish Arts Council.

THE SOLOMON GALLERY, Powerscourt Townhouse Centre, South William Street, Dublin 2. Tel. 01-794237. Opening: 10–5.30. Mon–Sat. Director: Suzanne MacDougald. Fine Art Gallery. Regular one person and group shows of contemporary paintings and sculpture. Also a permanent display of studio glass and the applied arts. Emphasis on Irish artists, sculpture in particular.

Davis Gallery, Gerald Davis in foreground, Dublin, Eire

Private gallery. 1000 sq ft situated in the former 18th century townhouse of Lord Powerscourt. Exhibitions: Submit slides/photographs of work together with curriculum vitae.

GALWAY

NUN'S ISLAND ARTS CENTRE, Nun's Island, Galway. Tel. 091-65886. Opening: Mon–Sat 10–4. Contact: Elizabeth McAvoy. Contemporary exhibition programme, national and local art. Space: Until additional space is acquired, the space (2000 sq ft) also accomodates music, theatre, literature, dance and lectures.

LETTERKENNY

THE GLEBE GALLERY & ST COLUMB'S, Church Hill, Letterkenny, Co. Donegal. Tel. 074 37071. Times & Dates of Opening: For 1988, 2–10 April, 28 May–2 October. Closed Mondays except Bank Holidays. Hours: 11–6.30. Suns 1–6.30. Admission Charges: £1 Adults, 25p Children, Students, O.A.P.'s. Group rate available. The Collection: St Columb's is an intriguingly decorated and furnished house, given to the Irish Nation by the artist Derek Hill. The collection includes ceramics, glass, Victoriana, wallpapers & textiles by William Morris, over 300 paintings and drawings by many leading 20th century painters, collected principally in the 1950's and 1960's. To create a more formal display area, outbuildings have been converted into a gallery, known as the Glebe Gallery, where both selections from the collection and outside exhibitions are shown. Gallery space modern—with natural and spot lighting—on 2 floors.

LIMERICK

BELLTABLE ARTS CENTRE, 69 O'Connell Street, Limerick, Ireland. Tel. 061 319866. Opening: Mon–Sat 10–9.30 p.m. Contact: Visual Arts Officer. Submit slides or colour photographs of work and C.V. Space: One in theatre foyer and one in restaurant. Lighting: Spot. Exhibitions: Contemporary work by local, national and international artists, individual and group shows. Facilities for lectures, slide shows and 16mm films.

RIVERRUN GALLERY, Honan's Quay, Limerick. Tel. 061 40277. Opening: Mon–Sat 10–5.30. Contact: Brid Dukes. Exclusively contemporary art, monthly exhibitions of established national and international artists, solo and group shows, also some emerging artists. Space modern, gallery well lit, approximately 4000 sq ft with restaurant and poster shop.

LONGFORD

CARROLL GALLERY, Ulster Bank Chambers, Main Street, Longford. Tel. 043 41148. Opening:

Charles Cullen with his mixed media on brown paper, part of the In Dublin series

Mon–Fri 10–5.30 p.m. Weekends by appointment. Contact: Terry Carroll. Gallery specialises in contemporary Irish art, paintings and sculpture. A good selection of work kept permanently in stock also regular group and one man exhibitions. Thematic exhibitions by nationally recognised artists organised.

MONAGHAN
MONAGHAN COUNTY MUSEUM, 1–2 Hill Street, Monaghan. Tel. 047 82928. Opening: 11–1, 2–5. Tues–Sat. Closed Sundays and Public Holidays. Contact: The Curator. Applications: The Curator. Exhibitions: Contemporary and heritage art, touring shows, our own shows etc. Permanent Collections: 18th and 19th century topographical prints and drawings of County Monaghan interest. Works of art of 19th and 20th century date, principally of County Monaghan interest or origin, though not exclusively so. Temporary Exhibitions: Active temporary exhibitions

programme including annual contemporary art show of our origin which takes place in new purpose-designed Art Gallery extension.

WATERFORD
GARTER LANE ARTS CENTRE, 5 O'Connell Street, Waterford. Tel. 051 55038/77153. Opening: Tues–Thurs 12–8. Fri–Sat 12–9. Contact: Exhibition Organiser, Ann O'Regan. Applications: Submission of slides/photographs and C.V. to Exhibition Organiser, touring shows sometimes arranged. Exhibitions: Main Gallery; One person and group shows by contemporary artists painting and sculpture. Side Gallery; Thematic and local interest shows including exhibitions of craftwork and work by local groups. Equipment: Dark room facilities, two artist studios, Information: Permanent collection: Over 200 pieces of Irish art, dating from the 1900's to the present. Other activities include—Meeting facilities for local groups, Adult and childrens art classes.

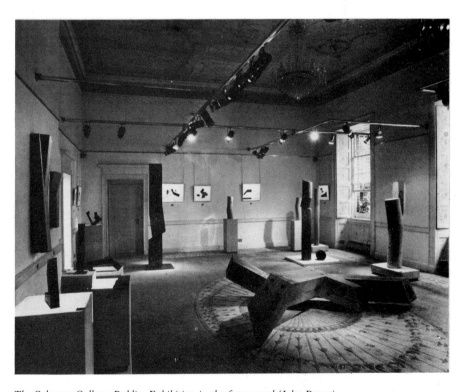

The Solomon Gallery, Dublin. Exhibition in the foreground (John Donat)

97

SCOTLAND

For further details on Glasgow **The Glasgow Arts Guide** by **Alice Bain** will be available Spring 1989.

ALBA magazine (National and International Contemporary Art from Scotland) £1.50 is essential reading matter, available at most art centres and art bookshops.

ABERDEEN

ABERDEEN ART GALLERY & MUSEUMS, Schoolhill, Aberdeen. Tel. 0224 646333. Opening: Mon–Sat 10–5, Thurs 10–8., Sun 2–5. Contact: The Director or the Keeper of Exhibition Services. Applications: By letter, with examples of work. Exhibitions: Historic, documentary, thematic, paintings, sculpture, prints, photographs, installations, A/V, video. About 50 exhibitions are held each year. Space: Several exhibition spaces of varying sizes. Equipment: Slide projectors, film projectors, cassette recorders, compact disc, U-matic and VHS video. 354,000 visitors in 1986—The 8th most visited tourist attraction in Scotland. The major gallery north of Edinburgh.
PEACOCK PRINTMAKERS, 21 Castle Street, Aberdeen. Tel. 0224 639539. Opening: Tues–Sat 9.30–12.30, 1.30 p.m.–5.30. Applications: In writing, with slides. Exhibitions: Mainly prints, some drawings and photographs. Space: 50 linear feet. Equipment: Frames. The gallery is very much a secondary activity to the print workshop which provides open facilities for artists to make prints. The gallery is used to initiate a series of small exhibitions which tour the area.
TOLQUHON GALLERY, Tolquhon, Tarves, Ellon, Aberdeenshire, AB4 0LP. Tel. 065 13 2343. Opening: Mon–Sun 11–5 during exhibitions. Closed Thurs. Contact: Donald Sinclar Ross/Joan Moir Ross. Applications: C.V. with slide or photographic support. Exhibitions: One-man, group and mixed exhibitions of contemporary paintings and prints by mainly Scottish artists both well established and lesser known. Also strong Craft element with changing displays of ceramics, jewellery, glass and wood. Space: Three main exhibition areas in attractive Victorian house set in landscaped grounds where a sculpture park is being developed.

ALLOWAY (AYR)

MACLAURIN ART GALLERY & ROZELLE HOUSE, Rozelle Park, Monument Road, Ayr.

Aberdeen Art Gallery, Scotland

Tel. 0292 45447/43708. Winter Hours (November–March): 11–5. Mon–Sat. Rozelle House Closed. Summer Hours (April–October): 11–5. Mon–Sat, 2–5. Sun. Open on all local and national holidays during period of summer opening. Curator: Mike Bailey BA(Hons) FRMetS. Applications: In person or written with supporting material. Exhibitions: 30–40 exhibitions per year coverng all fine and applied arts including stage design, Crafts and Photography. Space: 5 main galleries within the Maclaurin Art Gallery with 4 spaces within Rozelle House devoted to a temporary exhibition programme. Sophisticated lighting systems. The Maclaurin Art Gallery is built around a cobbled courtyard and is housed in former stables and servants quarters attached to Rozeile Mansion House. The house is situated within attractive parkland close to the birthplace of Robert Burns, the celebrated Scots poet. The galleries are now regarded as one of the key centres for contemporary art in Scotland and serve a wide area of the southwest of the country. Major touring exhibitions are a feature of the temporary exhibitions programme with contributions from the Scottish Arts Council and Arts Council of Great Britain. The gallery gives young artists opportunities to show their work. Both local artists and workers from further afield are encouraged. An important feature of the galleries are the local collections belonging to Kyle and Carrick District Council and the Maclaurin Art Collection of Contemporary Art which are shown in Rozelle House. An Henry Moore bronze (Draped Reclining Figure 1979) is displayed in the gallery courtyard.

ANCRUM
ANCRUM GALLERY, Cross Keys Inn, Ancrum, Nr Jedburgh (on A68) Roxburghshire. Tel. 08353 340. Contact: Dr. Moira Simmons, Exhibitions: Leading contemporary artists including Alberto Morrocco, John Houston, David Donaldson, Brenda Lenaghan, The Earl Haig etc. Opening: Mon–Fri 11–2.30. Sat–Sun 11–6. Closed Tuesday. Space: Two floors.

DUNBAR
THE MACAULAY GALLERY, Stenton, by Dunbar, East Lothian, EH42 1TE. Tel. Stenton (03685) 256. Contact: Angus and Gwenda Macaulay. Exhibitions: Contemporary painting, ceramics and sculpture. Opening: Mon–Sat 12–5. (Closed Wed) Sun 12.30–5. Light lunches are available every day except Wed. Exhibitions change every three weeks. The Gallery is located in attractive countryside approximately three miles off the A1, convenient to Edinburgh.

DUNDEE
CENTRAL ART GALLERY, Albert Square, Dundee, DD1 1DA. Tel. 0382 23141. Opening: Daily Mon–Sat 10–5.30. Contact: Keeper of Art. Applications: To Keeper of Art. Exhibitions: Past and present, fine and decorative arts. About 12 shows per year, which are mostly group. Space:

Five galleries, with from 100 to 200 linear feet of wall space in each. Hanging rails, variety of lighting. Plans for 3 new galleries to be built. Equipment: Slide and film projectors, tape recorders, frames, screens. Permanent collection of Scottish art. Various courses are organised and lunch-hour talks and slide shows are held.
ROSEANGLE GALLERY, 17 Roseangle, Dundee. Tel. 0382 22429. Opening: 11–5 daily during exhibitions. Contact: Mrs Margaret McIntyre. Applications: Submit slides/photographs of work, together with C.V. Exhibitions: Dundee Art Society Members' Exhibitions three times yearly. One-person and group exhibitions, frequently of local artists. Equipment: Two projectors. Space: Main Gallery—850 sq ft, Side Galleries— 200 sq ft, 175 sq ft approx. Natural, strip and spot lighting. Other Activities: Fortnightly lectures and demonstations organised by Dundee Art Society throughout the winter months. Occasional social events organised by Dundee Art Society. Meetings arranged by other organisations. Gallery may be hired for exhibitions or other events. A private gallery, owned by Dundee Art Society, whose permanent collection of pictures is occasionally on view.

EDINBURGH
BACKROOM, Underneath the Arches, 42 London Street, Edinburgh. Tel. 031-556 8329. Opening: Mon–Sat 10.30–5.30. Contact: Michael J. Durnan. Applications: Mainly through calling in to the gallery/shop or by letter. Exhibitions: First time exhibitors, from craft to paintings, group shows of workshops plus group shows organised by the gallery. Space: 15ft square plus hallway wallspace of 6ft, polished wood floor, spotlights. The gallery is more a community gallery/space and encourages first time exhibitors and interesting group shows. Local community is encouraged to visit and comment as much as possible and the aim is to show a wide variety of work—photography, craft, traditional and contemporary art, as well as discussions and, when possible, more experimental shows.
BOURNE FINE ART, 4 Dundas Street, Edinburgh, EH3 6HZ. Tel. 031-557 4050. Opening: 10–6 Mon–Fri 10–1 Sat (Edinburgh). Contact: Stephanie Donaldson (Edinburgh) British Paintings 1800–1950 emphasis on Scottish Artists and subjects including the Colourists, Glasgow Boys, Edinburgh Group. Also Decorative Arts and Scottish Art Nouveau including Furniture. Programme of exhibitions throughout the year. Also Bourne Frames and Restoration.
CALTON GALLERY, 10 Royal Terrace, Edinburgh. Tel. 031-556 1010. Directors: Andrew and Sarah Whitfield. Opening: 10–6 Mon–Fri, 10–1 Sat. Closed Sundays. 3000 sq ft with well lit walls. (No longer for hire—18th & 19th Century works only).
THE CHESSEL GALLERY, Moray House, College of Education, Edinburgh. Gallery space

within a college of education. Major touring and Scottish exhibitions. Opening: Mon–Fri 10–5.

CITY ART CENTRE, 2 Market Street, Edinburgh. Tel. 031-225 2424 ext 6650. Award-winning Art Centre which houses the City of Edinburgh's permanent fine art collection. Extensive temporary exhibition programme caters for major international shows as well as local interest groups. Facilities include four floors, (5 gallery spaces) restaurant, artist studios, lecture room, sales desk. Access for disabled visitors. Lively central Edinburgh venue.

COLLECTIVE GALLERY, 166 High Street, Edinburgh. Tel. 031-220 1260. Lively contemporary art gallery.

THE RICHARD DEMARCO GALLERY, 17-21 Blackfriars Street (off The Royal Mile), Edinburgh EH1 1NB. Tel. 031-557 0707. Opening: Mon–Sat 10–6. Contact: Richard Demarco. Applications: By letter with slides/photographs, or by appointment. Recently moved to a new four storey premises in a building which was once Blackfriars Street Church, its proportion and character, both interior and exterior, resemble Oxford's Museum of Modern Art. Exhibitions: Very wide range of contemporary Scottish, national and international work, including painting, sculpture, photography, installations and performance. The Gallery is essentially international in character, particularly related to creating contacts between both East and West Europe and North America and extending the concept of European Art to include the Celtic world from the Hebrides to the Mediterranean. There are often two or three one-person shows happening at the same time and many young artists have been given their first showing here. Joseph Beuys was first shown in this country by Richard Demarco and his Gallery has been one of the liveliest and most interesting in Britain for many years.

THE DESIGNER GALLERY, 11 Hasties Close, Cowgate. Tel. 031-225 2774. Gallery within a framing shop context, near the 369 Gallery.

EDINBURGH COLLEGE OF ART, Lauriston Place, Edinburgh. Tel. 031-229 9311. Contact: Michael Docherty. Opening: Mon–Fri 10–5, Sat 10–12. Open to applications. Three large exhibitions spaces. Usually a major exhibition venue during the Edinburgh Festival.

THE FINE ART SOCIETY, 12 Great King Street, Edinburgh. Tel. 031-556 0305. Opening: Mon–Fri 9.30–5.30 Sat 10–1. 19th and 20th century British Art with strong Scottish connections. Also occasional contemporary exhibitions and Scottish Furniture.

THE FRUITMARKET GALLERY, 29 Market Street, Edinburgh EH1 1DF. Tel. 031-225 2383. Opening: Tues–Sat 10–5.30 Sun 1.30–5.30 Closed Monday. Extended opening hours during the Edinburgh International Festival. Contact: Mark Francis. Applications: Should be submitted direct to the gallery. Exhibitions: Contemporary art which is both national and international in scope. One person, two person, group and thematic

shows are all covered. The space comprises two galleries 70ft × 30ft The gallery is a converted warehouse building. Walls wood cladding. Lighting, concorde, floor wooden. Basic equipment usually available. A very pleasant spacious gallery which is Edinburgh's main venue for contemporary art. Gallery cafe is housed on the first floor. Also a small magazine and art books/postcards point of sales.

GALERIE MIRAGES, The Lane, 46A Reneburn Place, Stockbridge. Opening: Mon–Sat 1006, Sun 2–5, closed Wed.

GATEWAY GALLERY, 2–4 Abbeymount, Edinburgh. Tel. 031- 661 0982. Opening: Mon–Sat 10–5. Paintings by local artists.

KINGFISHER GALLERY, Northumberland Street, North-West Lane, Edinburgh. Tel. 031-557 5454. Opening: Tues–Sat 10–4.30. Contact: Shand Hutchison. Exclusively contemporary Scottish, British and Foreign Art. Works by established and new artists. Regular one-man and group shows. Space: modernised mews house of two galleries, well lit, on two floors. A private gallery.

GRAEME MURRAY GALLERY, 15 Scotland Street, Edinburgh. Tel. 031-556 6020. Opening: Tues–Sat 11–5. Top Scottish contemporary art shown here.

MALCOLM INNES GALLERY, 67 George Street, Edinburgh. Tel. 031-226 4151. Opening: Mon–Fri 9-6, Sat 10–1. Scottish contemporary art.

THE NETHERBOW, 43 High Street, Edinburgh EH1 1SR. Tel. 031-556 9579. Opening: 10–4, but exhibits on show when there are evening events. Contact: James Day, David Heavenor. Applications: By writing and with a meeting to see work and talk. Exhibitions: About 24 are held each year, 12 in each gallery, mostly one-person shows, coverng painting, sculpture, photography and crafts. Space: Two places, the walls of a ground floor restaurant and a gallery on an upper floor which is less accessible to passing trade. There is also a courtyard available for use. Equipment: Slide projectors and tape recorders. An arts centre funded mainly by the Church of Scotland, which includes a small theatre and a restaurant. Has show mostly relatively unknown artists up till now, but there are plans to develop the gallery.

THE OPEN EYE GALLERY LTD, 75–79 Cumberland Street, Edinburgh EH3 6RD. Tel. 031-557 1020. Directors: Thomas and Pamela Wilson. Opening: Mon–Fri 10–6, Sat 10–4. Contemporary and Fine Arts, Studio Ceramics Framing and Restoration. 17 mainly Contemporary exhibitions per year, contemporary ceramics and sculpture alongside paintings etc. Also deal in Early 20th Century Etchings etc and early studio ceramics to compliment contemporary exhibitions. 1000 sq ft space.

PRESCOTE GALLERY, 5 Northumberland Street, Edinburgh. Tel. 031-557 0080. Newly renovated space at newish address. Contemporary art.

THE PHOTOGRAPHY WORKSHOP, 43 Candlemaker Row, Edinburgh. Tel. 031-556 1230. Contact: Gloria Chalmers and Jane Brettle. 12

100

City Art Centre, Edinburgh (Antonia Reeve)

exhibitions a year offering photographers an opportunity to show their work. Workshops for beginners, schools and more experienced photographers. Also a bookshop, slide resource, darkroom, newletter book library. A relatively new space.

PRINTMAKERS WORKSHOP GALLERY, 23 Union Street, Edinburgh EH1 3LR. Tel. 031-557 2479. Opening: Mon–Sat 10–5.30. Contact: Susan Williams. Gallery acts as an outlet for prints made in its workshop and for work produced by other printmakers in Scotland. Facilities for etching, lithography, silk-screen and photography.

ROYAL SCOTTISH ACADEMY, The Mound, Edinburgh. Major international exhibitions and annual Royal Scottish Academy exhibition open to professional Scottish artists.

SCOTTISH ARTS COUNCIL/SCOTTISH PROVIDENT TRAVELLING GALLERY, Scottish Arts Council, 19 Charlotte Square, Edinburgh EH2 4DF. Tel. 031-226 6051. A custom-built mobile gallery based on a double-decker bus in which displays a changing programme of art exhibitions. It tours throughout the Scottish mainland and islands visiting a wide variety of sites including village squares, town shopping car parks, schools, hospitals and community centres.

THE SCOTTISH GALLERY, 94 George Street, Edinburgh. Tel. 031-225 5955/6. Opening: Mon–Fri 9–5.30, Sat 9.30–1. 1250 sq ft plus mezzanine space of 600 sq ft. Exhibitions by invitation only. Quality contemporary painting, original prints, crafts and jewellery. Restoration, framing & valuation. Chairman: TER Jacobs. Directors: WCM Jackson, B East, G Peploe, P Cormack, DAS Lockhart.

SCOTTISH NATIONAL GALLERY OF MODERN ART, Belford Road, Edinburgh EH4 3DR. Tel. 031-556 8921. Keeper: Richard Calvocoressi. Twelve galleries on ground floor display the permanent collection of International, Scottish and British art of the 20th century. Temporary exhibitions shown in ten galleries on top floor. Outdoor sculpture collection, imminent landscaping of grounds and link with river walkway. Library and print room (appointments only), bookshop, gallery tours, cafe, parking. (Education queries—contact Pat Fitzgerald).

THE SCOTTISH CRAFT CENTRE, 140 Canongate, Edinburgh. Tel. 031-556 8136 and 7370. Opening: Mon–Sat 10–5.30. The best of Scottish craftsmanship by professional craftsmen and women.

STILLS GALLERY, 105 High Street, Edinburgh EH1 1SG. Tel. 031-557 1140. Opening: Tues–Sat 12–6. Contact: Gallery Director. Space: 180 running feet. Exhibitions: Ten exhibitions per year,

The travelling gallery, Scottish Arts Council (Antonia Reeve)

photography only. Stills, founded in 1977, is Scotland's only gallery dedicated exclusively to photography. Funded by the Scottish Arts Council and Edinburgh District Council, its aim is to promote photography as an art and to encourage its understanding as a vital and influential medium in contemporary culture. There is an active education programme, including lectures, workshops and community outreach. there is an expanding library and slide collection.

TALBOT RICE GALLERY, Talbot Rice Gallery, University of Edinburgh, Old College, South Bridge, Edinburgh EH8 9YL. Tel. 031-667 1011 ext 4308. Opening: Mon–Sat 10–5. Contact: Curator, Dr J. D. Macmillan. Applications: By letter to the Curator. Exhibitions: Modern sculpture and paintings, contemporary photographs, photographs from historical archives, architectural drawings, tapestries, group shows, student work, historical collections of paintings. Space: Approx. 350 linear feet of hanging space on 2 floors. Walls are white painted lined ply. Lighting is daylight in main space backed by mercury fluorescent lights mounted in the ceiling. There is also provision for track lighting. Equipment: Slide projectors, frames and movable screens. Policy of gallery is to show contemporary art both Scottish and international, but also to show historical exhibitions from time to time.

369 GALLERY, 233 Cowgate, Edinburgh EH1 1NQ. Tel. 031-225 3013. Andrew Brown, Director. Regular exhibitions of contemporary Scottish art. New studio for gallery artists opened in 1988 upstairs. Dynamic internationally minded director. Usually lively shows by relatively young established colourful artists.

THE TORRANCE GALLERY, 29B Dundas Street, Edinburgh. Tel. 031-556 6366. Opening: Mon–Fri 11–6, Sat 10.30–4. Two gallery spaces, one with prints in stock, the other with temporary contemporary art shows.

WASPS GALLERY, Studios, Patriothall, Hamilton Place, Stockbridge, Edinburgh. Tel. 031-225 1289. Opening: Variable to suit exhibiting artist—most afternoons. Contact: Gerry McGowan. Exhibitions: Contemporary art, mainly tenant artists though not exclusively. Anything considered for unused periods. Space: Large gallery 40ft × 20ft × 16ft high. Additional long corridor plus second space 20ft × 17ft × 16ft high. Strip lighting.

GLASGOW

ANNAN GALLERY, 130 West Campbell Street, Glasgow. Tel. 041-221 5087/8. Opening: Mon–Fri 9–5, Sat 9.30–12.30. Established commercial art gallery. 20th century and some contemporary art.

BARCLAY LENNIE FINE ART, 203 Bath Street, Glasgow. Tel. 041-226 5413. Opening: Mon–Fri 10–5, Sat 10–1. Local contemporary artists.

BLYTHSWOOD GALLERY, 161 West George Street, Glasgow. Tel. 041-226 5529. Opening: Mon–Fri 10–5.30, Sat 10–1. Has shown Glasgow art school graduates work and also contemporary Scottish artists.

BRIGGAIT GALLERY, The Briggait Centre, 72 Clyde Street, Glasgow G1. Tel. 041-552 5127. Opening: Mon–Sat 9.30–5.30, Sun 11–5 (Centre closed Tuesday) Proprietor: J. B. Parker—Art Dealer, Picture Framer—Oils, watercolours & quality prints including limited editions by Sir Wm. Russel Flint, E.R. Sturgeon, David Shepherd, etc on exhibition—Individual or group exhibition can be arranged in the Briggait Centre by contacting centre manager on 041-552 3970.

COMPASS GALLERY, 178 West Regent Street, Glasgow. Tel. 041-221 6370. Opening: Mon–Sat 10.30–5.30. Contact: The Director— Cyril Gerber. Gallery holds continuous exhibitions throughout the year of Scottish and international painters, printmakers, sculptors and ceramic artists—many of whom are young and having their first shows. Other more well-known artists are shown for the first time in the west of Scotland.

CYRIL GERBER FINE ART, 148 West Regent Street, Glasgow. Tel. 041-221 3095. Director: Cyril Gerber. Opening: Mon–Fri 9.30–5.30, Sat 9.30–12.30. 20th century Scottish painting and drawing and contemporary art.

COLLINS EXHIBITION HALL, University of Strathclyde, 22 Richmond Street, Glasgow G1 1XQ. Tel. 041-552 4400 ext 2416. Opening: Mon–Sat 10–5. Contact: Tessa Jackson, Curator. Applications: By letter. Exhibitions: Painting, sculpture (mainly figurative), crafts, historical shows, mostly group. Not installations or performance usually. Space: 400 sq metres, almost a square, walls light beige hessian, tilted ceiling, brown carpet, strip and track lighting. display boards and cases are available. Equipment: Carousel projector, tape recorders, 20 aluminium frames. Audience is two thirds staff and students of the university, where the courses are mostly scientific and technological, so the aim is to provide a wide variety of exhibitions.

FINE ART SOCIETY, 134 Blythswood Street, Glasgow G2. Tel. 041-332 4027. Opening: Mon–Fri 9.30–5.30, Sat 10–1. 19th and 20th century British art. Also occasional exhibitions of contemporary painting and sculpture. Director: Andrew McIntish Patrick. Major interest in top Scottish artists. Two floors of gallery space.

GLASGOW ART GALLERY AND MUSEUM, Kelvingrove, Glasgow G3 8AG. Tel. 041-357 3929. Contact: Alasdair A. Auld–Director, Patricia Bascom–Publications Officer. Headquarters of Glasgow Museums and Art Galleries Department. Major Scottish art gallery and museum. Collections of Italian, French, Flemish and Dutch paintings, also British especially Scottish in particular The Glasgow Boys and Scottish Colourists. Collections of Western European ceramics, glass, silver, jewellery and furniture. A fascinating Glasgow style series of rooms including Charles Rennie Mackintosh furniture. Temporary exhibitions throughout the year. Membership scheme (friends society). Membership section.

Branch museums:

The Scottish Gallery, Edinburgh (Antonia Reeve)

THE BURRELL COLLECTION, Pollok Country Park, 2060 Pollokshaws Road, Glasgow G43. Tel. 041-649 7151. Not to be missed. Designed by Barry Gasson and opened to the public in 1983 it houses the sumptuous, magnificent collection of art, ceramics and artefacts owned by Sir William Burrell, a wealthy Scottish shipowner. 8000 items on show.
HAGGS CASTLE, 100 St Andrews Drive, Glasgow G41. Tel. 041-427 2725.
PEOPLE'S PALACE, Glasgow Green, Glasgow G40. Tel. 041-554 0223. The history of Glasgow. Mural by Ken Currie worth seeing.
POLLOK HOUSE, Pollok Country Park, 2060 Pollokshaws Road, Glasgow G43. Tel. 041-632 0274.
PROVAND'S LORDSHIP, Castle Street, Glasgow G4 0RB. Tel: 041-552 8819.
RUTHERGLEN MUSEUM, King Street, Rutherglen G73 1DU. Tel: 041-637 0837.
GLASGOW ARTS CENTRE, 12 Washington Street, Glasgow G3 8AZ. Tel. 041-221 4526. Aims to provide a wide and varied programme with particular emphasis on providing access to arts activities for citizens of all ages, irrespective of social or educational background. It is part of Strathclyde Regional Council's Education Department and has become one of the country's leading Arts participation resources with classes and workshops in dance, drama, drawing and painting, photography, weaving, music, asian arts and handicapped arts. The programme also includes exhibitions, special projects, outreach work and performances, including regular fortnightly folk concerts. For further details please contact Jacqueline MacKillop, programme co-ordinator at the Centre. The office is open Mon–Fri 8.45-4.45.
GLASGOW PRINT STUDIO, 22 King Street, Glasgow G1 5QP. Tel. 041-552 0704. Contact: John Mackechnie. Magnificent new premises comprising one large exhibition space of 10,500 sq ft with reception area. Exhibitions of painting, printmaking, photography and sculpture. A print workshop that publishes prints by Scottish artists. The workshop is available to non-Scottish artists as well. Scottish and international exhibitions. Useful noticeboard for Scottish art exhibitions and events.
HUNTERIAN ART GALLERY, University of Glasgow, Glasgow G12 8QQ. Tel. 041-330 5431. Opening: Mon–Fri 9.30–5. Sat 9.30–1. New art galler housing major collections of Whistler and Charles Rennie Mackintosh, including a furnished reconstruction of the latter's Glasgow house. Paintings by Chardin, Rembrandt, Stubbs, Pissarro, Carot. Largest print collection in Scotland. Scottish paintings from 18th century to the present and includes paintings by John Bellany, Kate Whiteford, Steven Campbell and other young Scottish artists. Contemporary British art. Sculpture Courtyard. Changing temporary exhibition programme.
LILLIE ART GALLERY, Station Road, Milngavie, Glasgow. Tel. 041-956 2351. Opening:

Tues–Fri 11–5 and 7–9, Sat and Sun 2–5, closed Mondays. Contact: Elizabeth M. Dent. Applications: In writing to Curator. Exhibitions: Scottish and contemporary painting, prints, photography, sculpture, ceramics, jewellery and associated decorative arts. One person, permanent collection and travelling exhibitions. Space: One large 140 linear ft and two smaller galleries. Track lighting, spotlights. One gallery can be blacked out. Permanent collection of 20th century Scottish paintings. Temporary exhibitions are mainly of Scottish artists and subjects of local interest.
MACKINTOSH GALLERY, Glasgow School of Art, Renfrew Street, Glasgow. Tel. 041-. Glasgow Art School is one of Britain's major art schools where many of the Glasgow painters studied. The gallery is in the main Rennie Mackintosh building and has major touring exhibitions as well as Scottish art exhibitions.
MAIN FINE ART, The Studio Gallery, 16 Gibson Street, Kelvinbridge, Glasgow G12 8NX. Tel. 041-334 8858. Opening: Tues–Sat 10–5, Sun 2–5. Exhibitions: A young gallery specialising in Scottish painting that is fresh and contemporary. Space: Situated in a bright, sunny position in Glasgow's West End. Also 5 working studios and classes held in drawing and painting.
McLELLAN GALLERIES, 270 Sauchiehall Street, Glasgow. Tel. 041-332 1132. Available for hire through the Letting Section Glasgow District Council, Halls Department. All publicity and expenses are the responsibility of the hirer. Good central Glasgow venue on busy main street. Current plans are for gallery expansion in time for 1990s Glasgow 'Cultural Capital of Europe' for major exhibitions.
OPEN CIRCLE AT HILLHEAD LIBRARY, 348 Byres Road, Glasgow G12. Tel. 041-339 7223. Opening: Mon, Tues, Thurs & Fri 9.30–8, Sat 9.30–1, 2–5. Contact: Ian Jamieson, 8 Blackburn Street, Glasgow G51 1EL. Tel. 041-427 1865. Open to any applications— forms available from above contact. As a group of practising artists, writers and composers we are interested in supporting the work of all creative people. We exhibit a wide variety of work from one man shows to group exhibitions of Scottish and foreign artists. We have a particular interest in works which cross the disciplinary boundaries of painting, music and writing.
THE SCOTTISH DESIGN CENTRE, 72 St Vincent Street, Glasgow. Tel. 041-221 6121. Opening: Mon–Fri 9.30–5, Sat 9–5. Similar to the London Design Centre. A major outlet and exhibition space on 2 floors for Scottish design.
THIRD EYE CENTRE, 350 Sauchiehall Street, Glasgow G2 3JD. Tel. 041-332 7521. Opening: Tues–Sat 10–5.30, Sun 2–5.30. Contact: Andrew Nairne. Space: Gallery 1—75ft × 24ft, linoleum tiled floor, daylight and spots. Gallery 2—24ft × 24ft, linoleum tiled floor, daylight and spots. A lively arts centre with a visual arts and theatre bias, presenting an ongoing programme of exhibitions of wide-ranging appeal, from contemporary

painting and sculpture to cartoons. Shows touring exhibitions and the work of Scottish artists including photography. Lecture and film programme, information centre for the arts in Scotland, restaurant, bar and good art bookshop. Also a performance art programme organised by Nikki Millican. TRANSMISSION GALLERY, 13/15 Chisholm Street, Glasgow G15 HA. Tel. 041-552 4813. Opening: Tues–Sat, 12–6. Exhibitions Organiser: William Clark. Applications welcome preferably slides, documentation past press release etc. Exhibitions: Transmission gallery is a non-profit making organisation run voluntarily by practising local artists who share a commitment to the accessibility and growth of the visual arts in the west of Scotland. We currently have a membership of forty with a committee of seven who administer the day to day running of the gallery and who plan artistic policy. Transmission was established in 1983 with the aim of supporting the work of young Scottish artists with no extensive exhibition record, the work of the creative artist in Scotland who finds him/herself marginalised in their own country, and work of a more radical nature. The theme of access and experimentation within an artist-controlled context has led to transmission becoming a space for work which might not otherwise be seen in Scotland or represented through the more commerically based gallery system. In its early days, Transmission exhibited the work of many of the now rising stars in Scottish art, has been instrumental in bringing challenging work from south of the border to Scotland, and staged several video installations as well as performance events made specifically for the gallery space, film screenings and Scottish writers' events.

TRON THEATRE BAR GALLERY, 63 Trongate, Glasgow G1 5HB. Tel. 041-552 4267. Contact: Ruari McNeill, Administrator. The gallery is situated in the main bar of the theatre and provides approx. 70ft of hanging space along 3 walls of the bar. Exhibitions are normally hung in the gallery for 4–6 weeks. The majority of exhibitions are organised through Cyril Gerber, Fine Art in Glasgow though we are prepared to consider exhibitions from artists who make direct approaches. Hanging and lighting are somewhat primitive as the primary use of the space is as a Theatre Bar.

90s GALLERY, 12 Otago Street, Glasgow. Tel. 041-339 3158. Opening: Mon–Sat 10–6. Contemporary painting, prints and textiles. Near Glasgow University in the Hillhead area.

Studio—The Drawing Room, the Mackintosh House (Hunterian Art Gallery)

GLENROTHES

CORRIDOR GALLERY, Fife Institute of Physical and Recreational Education, Viewfield Road, Glenrothes, KY6 2RA. Tel. 0592 771700. Opening: 7 Days, 9 a.m–11 p.m. Contact: Peter and Aase Goldsmith. Exhibitions: Photographic, local, national and international photographs.

GREENOCK

McLEAN MUSEUM AND ART GALLERY, 9 Union Street, Greenock. Tel. 0475 23741. Opening: Mon–Sat 10–12, 1–5. Shows touring exhibitions.

HADDINGTON

PETER POTTER GALLERY TRUST, 10 The Sands, off Church Street, Haddington EH41 3EY. Tel. 062-082 2080. Exhibitions— Local Crafts. Lunches served in coffee room overlooking River Tyne. For exhibitions apply: Administrator–Pat Buchanan.

HAWICK

HAWICK MUSEUM and the SCOTT GALLERY, Wilton Lodge Park, Hawick. Tel. 0450 73457. Opening: Mon–Sat 10–5, Sun 2–5. A local history museum offering a fascinating insight into life in and around Hawick. Home of the internationally renowned knitwear industry, there are displays reflecting textile manufacture, domestic life and the history of the area. The Scott Gallery shows the town's collection of 19th and 20th century Scottish paintings, as well as a lively temporary exhibition programme.

INVERNESS

EDEN COURT ART GALLERY, Eden Court Theatre, Bishops Road, Inverness IV3 5SA. Tel. 0463 239841. Opening: Mon–Sat 10.30 a.m.–10 p.m. excluding non-performance days, when 10.30–5.30. Contact: Val Falcon/Nick McClintock. Applications: Taken once a year, during autumn season, for selection of annual programme for following year. Contact for details. Exhibitions: Local and Other Artists, touring exhibitions, one-person and group shows. No free-standing work. Space: Situated in large open-plan foyer area on 2 levels, well lit, 4 walls, total of 150 linear feet. Theatre Programme: Very varied from opera & studio productions to rock & roll, also studio cinema.
INVERNESS MUSEUM AND ART GALLERY, Castle Wynd, Inverness IV2 3ED. Tel. Inverness 237114. Opening: Daily 9–5, closed Sundays. Contact: Catharine Niven, Curator. Applications: By letter and submission of work. Exhibitions: All media, including craftwork. Emphais on Highland Region, but also representative important work from further afield. Space: 43ft × 25ft, neon and track lighting, linoleum floor. Equipment: Slide projector.

IRVINE

HARBOUR ARTS CENTRE, Harbour Street, Irvine KA12 8PZ. Tel. 0294 74059. Opening: Weekdays 2–5, Sat/Sun 2–4, 7–10.30 every evening. Contact: Gallery Director. Space: Contains wired security system and covering insurance. 64 linear feet in main gallery. Equipment: 4 display cabinets, 1 display case. 15% commission. Gallery not suitable for large free-standing sculptures.

KILMARNOCK

DICK INSTITUTE, Kilmarnock & Loudoun District Museums, Dick Institute, kilmarnock, KA1 3BU. Tel. 0563 26401. Opening: 10–8 (Wed & Sat 10–5), closed Sundays. 2 galleries 165 sq metres, natural and controlled tungsten and halogen lighting, air conditions. 50 sq metres—tungsten lighting. Permanent collections include old masters, 19th century European, English, Scottish, 20th century—mainly Scottish. Touring exhibitions and temporary exhibitions by local and other artists include paintings, prints, photography, ceramics, sculpture, textiles. Exhibitions normally by invitation, but applications considered. Apply to the Curator at above address, and include illustrations.

KIRKCALDY

KIRKCALDY MUSEUM AND ART GALLERY, War Memorial Gardens, Kirkcaldy, Fife. Tel. 0552 260732. Opening: Mon–Sat 11-5, Sun 2–5. Contact: Andrea Kerr. Applications: To the Curator, with details of work. Exhibitions: Generally a Scottish, local bias. Anything can be shown apart from large sculpture. Mostly group shows. Space: 7 Galleries, 3 for temporary exhibitions: 2 measuring 34ft × 19ft, 1 measuring 25ft square, track lighting, polished wood floors. Equipment: Slide projectors, tape recorder, video (VHS).

ISLE OF LEWIS

AN LANNTAIR, Town Hall, South Beach, Stornoway, Isle of Lewis, Scotland. Tel. 0851 3307. Opening: Mon–Sat 10–5.50 (closed Wed & Sun). Contact: Roddy Murray, Director. Exhibitions: Monthly programme of contemporary and traditional exhibitions with emphasis on local artists in the summer and touring shows in the winter. The visual arts are supplemented by musical, literary and performing events with an emphasis on traditional Gaelic culture.

ORKNEY

THE PIER ARTS CENTRE, Victoria Street, Stromness, Orkney. Tel. 0856 850209. Opening: Tues–Sat 10.30–12.30 and 1.30–5, Sun 2–5 (summer only), closed Monday. Contact: Erlend Brown. Applications: In writing to the Curator, in the first instance. Exhibitions: The policy is to provide a stimulating programme of varied exhibitions. e.g. one-person shows, mixed exhibitions, touring exhibitions (using all mediums). Exhibitions are planned at least 18 months ahead. Shows

are mounted monthly. Space: Permanent collection occupies two thirds of the warehouse gallery. Also 150 linear feet of temporary exhibition space. White walls, picture rails, carpet and quarry tiles, spotlights. Equipment: Projectors, sculpture stands, frames. Pier Arts Centre is principally a visual arts centre, with permanent collection of 20th century art. The gallery also hosts poetry readings and lectures.

PERTH
FAIRMAIDS HOUSE GALLERY, North Port, Perth. Tel. 0738 25976. This small 17th century building houses continuous exhibitions of established contemporary Scottish artists 'in a small scale' and new young artists. Re-opens May 7th onwards.

PERTH MUSEUM AND ART GALLERY, George Street, Perth. Tel. 0738 32488. Opening: Mon-Sat 10-1, 2-5. Contact: Robin Rodger. Keeper of Fine and Applied Art. Exhibitions: General range of fine and applied art, crafts, etc., historical, contemporary, local interest etc.

PERTH THEATRE GALLERY, 185 High Street, Perth PH1 5UW. Tel. 0738 38123. Opening: Mon-Sat 10 a.m.-11 p.m. Contact: Kenneth McIntosh, Front of House Manager. To Apply: Send C.V. and photographs of work, if possible. Type of Work: Small exhibitions either solo or group, mixed programme of amateur, professional and tours. Any type of exhibition considered, usually three weeks in duration, throughout year. Reasonably well lit space situated in foyer area of Theatre. Restricted to wall mounted exhibits. Booking approx. 12–18 months in advance.

ST ANDREWS
CRAWFORD CENTRE FOR THE ARTS, 93 North Street, Univeristy of St Andrews, Fife. Tel. 0334 76161 ext 591. Arts centre within a university situation artist in residence scheme, touring exhibitions.

STIRLING
MACROBERT ARTS CENTRE GALLERY, University of Stirling, Stirling FK9 4LA. Tel. 0786 73171 ext 2549. Opening: Mon-Sat 11-5, Sun 2-5. Also 30 mins before theatre performances and during intervals. Contact: Roy McEwan, Arts Centre Director. Applications: Write with slides etc. Exhibitions: Wide range— all media, no particular Scottish or contemporary orientation. Space: About 150 linear feet plus 10 screens, in Main Gallery. Foyer/Coffee Bar space approx 300 linear feet. Tungsten halogen floodlamps and spotlights, also dimming system. University grounds available for displaying sculpture outside. Equipment: Most audio-visual equipment can be borrowed. Stock of aluminium frames (30 @ 20" × 30" and 10 @ 10" × 15"). Caters for the university population and the local theatre-going public (the Arts Centre houses two theatres), so the aim is to show exhibitions which appeal to a wide audience.

SMITH ART GALLERY AND MUSEUM, 40 Albert Place, Dumbarton Road, Stirling, FK8 2RE. Tel. 0786 71917. Open all year (Please check gallery opening times). Galleries, shop, theatre, assisted disabled access. Admission free. Contact: Deborah Haase, Curator. Stirling's museum and art gallery features exhibitions from the rich collections, a lively programme of temporary exhibitions and events and of contemporary arts. Major event is the Smith Biennial Exhibition for artists working in Scotland. Details of this and programme details are included in the quarterly SMITH What's On newsletter, available on request.

WICK
LYTH ARTS CENTRE, by Wick KW1 4UD, Highland Region. Tel. 095584/270. Opening: Daily 10–6 from mid-June to mid-Sept. Contact: William M. Wilson. Applications: By letter. Exhibitions: Mostly contemporary Scottish art. Space: Old country school and schoolhouse beautifully converted and offering many small spaces and one 40ft × 20ft lined throughout with cotton/jute twill screens with aged polished redwood floor. Overhead spots about to be replaced by full rig. Building arranged to form a circular tour including main gallery, craft shop, snack bar, permanent collection and tapestry workshop. Gravel terrace 90ft × 60ft specially prepared for sculpture. Equipment: 2 Carousel projectors with sync tape system (Convar) H & H P.A. system with mikes and monitors (part of extensive equipment available for music). Photographic dark room equipment and cameras. A mixed programme of exhibitions and events, including lectures, theatre, dance and music.

WALES

ABERYSTWYTH
ABERYSTWYTH ARTS CENTRE, University College of Wales, Penglais, Aberystwyth, Dyfed SY23 3DE. Tel. 0970 4277. Exhibitions Organiser: Eve Ropek. Opening: Mon–Sat 10–5 and during evening performances. There is an extensive exhibition programme which includes work mainly by contemporary artists, also photography, craft and design. Touring shows are also organised. Monthly 'Ceramic Series' one-person exhibitions of work by contemporary ceramic artists and potters, also studio glass exhibitions. There are three floors: Ceramics Gallery (houses the College Ceramic Collection), Main Gallery, foyer Gallery and Photogallery. (Also concert hall & theatre) Cafe, bookshop and craft shop (Crafts Council approved). Education service-events, courses, talks. The Arts Centre is on the University campus overlooking Cardigan Bay.

ANGLESEY

ORIEL MON, Central Library, Llangefni, Isle of Anglesey, Gwynedd LL77 7RT. Tel. LLangefni 750262 Ext 226/227. Opening: Mon–Fri 10–7, Tues and Wed 10–5, Thurs 10–6. Contact: Elspeth Mitcheson BA, Dip Lib, ALA. Applications in writing. Priority is given to local artists or those with Welsh connections. The Oriel also exhibits photographic and craft work. Space: 600 sq ft, 60 linear feet of wall space, natural light, spotlights and fluorescent lighting.

TEGFRYN ART GALLERY, Cadnant Road, Menai Bridge, Anglesey LL59 5EW. Tel. Menai Bridge 712437. Opening: 10–1 and 2–5. Closed on Mondays. A privately owned gallery opened in 1966, occupying several ground floor rooms of a large Victorian house. Work by N Wales artists and from further afield. A resident mixed exhibition and up to four one-person shows per year.

BANGOR

ORIEL ART GALLERY, Ffordd Gwynedd, Bangor, Gwynedd. Tel. 0248 353368. Opening: Tues–Sat 12–4.30. Contact: Exhibitions Organiser. Space: 3 adjoining exhibition rooms and a corridor gallery. Exhibitions: Painting, prints, drawings, photography and sculpture by contemporary artists, also some craft exhibitions. Founded in 1963 by the University College of North Wales and the Welsh Arts Council. The gallery shows about six temporary exhibitions per year. in the same building as the museum of Welsh antiquities.

BLAENAU FFESTINIOG

ORIEL Y DDRAIG, Blaenau Ffestiniog, Gwynedd. Tel. 0766831777. Opening: Tues–Sat 9.30–5.30. Contact: Pat Clarke or Peter Elliott. Applications: Submit slides of work and C.V. Exhibitions: Changing exhibitions of contemporary work—both group and one person shows, throughout the year. Varying work and media—based on our personal selection. Two print racks are also always on display. Equipment: A picture framing service is available on the premises. Additional information: This is an unsubsidised artist run Gallery.

BUILTH WELLS

WYESIDE ART GALLERY, Wyeside Arts Centre, Castle Street, Builth Wells, Powys LD2 3BN. Tel. Builth Wells (0982) 553668. Contact: Jonathon Morgan. Applications: In person, by post, or by telephone, to the Director, Wyeside Arts Centre. Exhibitions: Almost any kind of two dimensional work, occasionally 3D work. Space: Wallspace 32m × 2.44m, lighting—tracksystem, daylight can be excluded. There are two auditoria with facilities for most art forms including cinema. Local artists are encouraged as well as national ones.

CAERNARFON

ORIEL PENDEITSH, is based in a row of converted cottages directly opposite the main entrance to Caernarfon Castle. It houses a changing programme of exhibitions and also serves as a Visual Arts Information Centre for the area. Contact: Visual Arts Development Officer. Gwynedd County Council, County Offices, Caernarfon, Gwynedd. Tel. Caernarfon 4121.

CARDIFF

ALBANY GALLERY, 74b Albany Road, Cardiff, Tel. 487158. Opening: Daily 10.30–5.30. Closed Wednesdays. Monthly exhibitions by leading Welsh artists oil paintings and watercolours £30–£700.

CHAPTER GALLERY, Chapter Workshops and Centre for the Arts, Market Road, Canton, Cardiff CF6 1QE. Tel. 0222 396061. Opening: Mon–Fri Noon–10, Sat Noon–4 and 6–9. Contact: Stuart Cameron. Applications: In the first instance, send slides or photographs with a proposal for the use of the gallery space. Exhibitions: Contemporary art from Wales and elsewhere (including painting, printmaking, photography, sculpture and installations). Most exhibitions originate at Chapter, although touring shows are also brought in. Space: (1) Unit Gallery—58m hanging length, 3.7m high, white painted chipboard walls, lighting is daylight with tungsten halogen lamps and spots. Four interlinked spaces on the ground floor of the arts centre. (2) Concourse Gallery—part of the restaurant eating area, used for small exhibitions. 12.5m hanging length, 3.05, high, white painted chipboard walls, spotlighting, wooden floors. There is a patio at the rear of the building which is used occasionally for robust sculptures and performance. Equipment: 2 Carousel projectors (plus possible use of the centre's other resources i.e. film projectors). The gallery is part of a multi-discipline arts centre, which has two cinemas, a film workshop, a theatre (showing music, dance, drama etc.), a restaurant, bars and artists' studios and workshops. The gallery's policy is to show a wide range of art-forms by artists from Wales, elsewhere in the UK and from abroad, mostly by professional artists.

HOWARD GARDENS GALLERY, Faculty of Art and Design, S.G.I.H.E., Howard Gardens, Cardiff. Tel. 0222 551111 Ext 5504. Opening: Weekdays 9.30–8.30 (Friday 6.00). Contact: Judy Kelly/Pete Goodridge. Applications: Submit slides/photographs of work plus C.V. Exhibitions: Contemporary national and international art and design—a diverse programme including performances and associated lectures. (Touring shows occasionally arranged.) Facilities: Ground floor custom built Gallery of approx 264.00 m², accommodating 364.00 m² of hanging space. The area is divided by floor/ceiling suspended screens providing a flexible permutation of division. The lighting environment is controlled by vertical blinds and the installation of lighting tracks. A double system of alarms, together with surveillance from porters'

desk and reception desk, provide a 25 hour protection. Permanent collection of signed, limited edition prints by Erte (11 posters, 14 graphic works) may be viewed by arrangement (also available for tour for a limited period from September 1988).

NATIONAL MUSEUM OF WALES, Cathays Park, Cardiff CF1 3NP. Tel. 0222 397951. Opening: Weekdays 10–5; Sundays 2.30–5. Contact: Dr Mark L. Evans—Acting Keeper of Art. Applications: By invitation only. Exhibitions: Painting, drawing and sculpture of the last 100 years, international loan exhibitions, occasionally works by Old Masters. The primary responsibility of the Department of Art of the National Museum of Wales is the display of the extensive permanent collection of painting, sculpture, prints, drawings, watercolours and applied arts from the Renaissance to the present day and the temporary exhibition programme is intended to develop these areas of interest within the very limited space available. A major rebuilding programme to extend display space is currently in progress.

ORIEL, 53 Charles Street, Cardiff CF1 4EH. Tel. 0222 395548/9. Opening: Mon–Fri 9–5.30, Sat 9–5.30. Contact: Joy Goodfellow. Space: Two floors. Oriel is the major Welsh Arts Council gallery, showing mainly contemporary work by artists usually living or working in Wales. Mostly one or two-person shows. There is a comprehensive bookshop stocking a wide range of publications on the visual arts.

CARMARTHEN
CARMARTHEN MUSEUM, Abergwili, Carmarthen, Dyfed SA31 2JG. Tel. 0267 231691. Opening: Mon–Sat 10–4.30. Contact: Chris Delaney or Sally Moss. Admission charge. Collections of local history, culture and environment of the Carmarthen region, including the fine and applied arts. 7 acres of beautiful parkland surround the museum. Lively temporary exhibition programme includes contemporary art. Applications: initially by letter + C.V. to be followed by slides etc., on request.

HENRY THOMAS GALLERY C.C.T.A., Faculty of Art and Design, Job's Well Road, Carmarthen, Dyfed SA31 3HY. Tel. 0267 235855. Opening: Mon–Thurs 10–8, Friday 10–4.30. Contact: Gareth J. Evans Dean. Applications: To the Faculty. Exhibitions: Painting, Sculpture, Printmaking, Photography, Craft and Design. approx. 12 per year. Space: 18m × 6m, with 17 display boards to extend space. Spotlights and natural light.

CLYRO
THE KILVERT GALLERY, Ashbrook House, Clyro via Hereford. Tel. 0497 820831. Opening: Tues–Sun 10–5. Contact: Elizabeth Organ. Permanent exhibition of the work of Border Artists

Chapter Arts Centre (Steve Benbow)

and Artists with connections with the area. One person shows. In addition: Other 20th century and some 19th century paintings, drawings, prints and decorative items. Gallery space in the rooms of the house where the diarist, the Reverend Francis Kilvert lived as Curate from 1865–1862.

CONWY
ROYAL CAMBRIAN ACADEMY OF ART, Plas Mawr, Conwy, Gwynedd. Tel. 0492 633413. Opening: 10–5.30 daily. Open summer exhibition held annually. Gatehouse gallery available for hire fee of £40 per week. Two fine art galleries in addition. Plas Mawr is a large Elizabethan mansion with many interesting features.

CWMBRAN
LLANTARNAM GRANGE ARTS CENTRE, St Davids Road, Cwmbran, Gwent NP44 1PD. Tel. 06333 3321. Opening: Mon–Fri 10–4, Sat 10–2. Contact: Sara Bowie. Application: Submit slides/photographs together with C.V. Exhibitions: Temporary exhibition space, one man, group and touring shows, all media— photography, fine art, crafts, textiles etc. Second gallery space in coffee shop which shows work by local artists and craftspeople. Equipment: frames, plinths and screens available for hire. Carousel projector & screen for lectures and talks. Classes, lectures and workshops by artists and craftspeople are regularly held in the Centre.

FISHGUARD
TALKING POINT/MAN TRAFOD, 6 West Street, Fishguard, Dyfed, SA65 9AE. Tel. 0348 872698. Opening: Tues–Sat 10–5. Contact: Leah Hinks or Myles Pepper. Fine Art and Craft Gallery Established 1983. Crafts Council selected Gallery. Artists and Craftsmen interested in supplying or showing at either of the venues should send photographs/slides and s.a.e.
WEST WALES ART CENTRE, Castle Hill, 16 West Street, Fishguard, Dyfed, SA65 9AE. Tel. 873867. Opening: Mon–Sat 10–5. Contact: Myles Pepper. Contemporary Craft and Art Gallery showing work of both the established and now Music Recitals, Lectures, Accomodation to let. Artists Materials supplied Nationwide at discount rates.

HAVERFORDWEST
LIBRARY HALL, County Library, Dew Street, Haverfordwest, Dyfed, SA61 1SU. Tel. Haverfordwest 2070. Opening: Mon, Wed, Thurs 9.30–5. Tues and Fri 9.30–7. Sat 9.30–1. Contact: Senior Librarian. Exhibitions: Touring and local artists—about 25 shows each year including our own annual Open Art Exhibition in May. Space: Circular carpeted room and foyer with projection room over 1370 sq ft, walls 8ft high with hanging rods, artificial lighting (spots). Equipment: Movable screens— various weights available. Slide + 16mm sound projector with 8ft screen. Exhibition area is also natural entension to library service in

providing accommodation for cultural, education and leisure faciliities for the community.

LLANDUDNO
MOSTYN ART GALLERY, 12 Vaughan Street, Llandudno, Gwynedd LL30 1AB. Tel. 0492 79201. Contact: Jeremy Theophilus. Space: Two galleries with a total of 1150 linear feet fixed wall space with up to an extra 750ft available on temporary walls/screens. Stained wood floor, controllable daylight and tungsten halogen lighting, humidity controlled air conditioning. Craft and Design Shop with continuous displays of stock by contemporary British craftspeople. Exhibitions: temporary exhibitions each lasting 5/6 weeks covering a wide range of contemporary and historical fine and applied arts, with a specific reference to the promotion of Welsh culture.

NEWPORT
NEWPORT MUSEUM AND ART GALLERY, John Frost Square, Newport, Gwent. Tel. 0633 840064. Opening: Mon–fri 10–5.30, Sat 9.30–4. Contact: Roger Cucksey. Permanent collection of early English watercolours plus mainly British 20th century paintings, emphasis on Welsh artists. Temporary exhibitions programme.
WOODSTOCK TOWER GALLERY, Caldicot Castle Museum, Caldicot, Nr. Newport, Gwent NP6 4HU. Tel. Caldicot 420241. Opening: Mon–Fri 11–12.30 and 1.30–5.00, Sat 10–1 and 1.30–5, Sun 1.30–5. Contact: Miss A. Rainsbury–Curator. Applications: By phone or in person in the first instance, then work is seen by the curator. Exhibitions: Oils, watercolours, acrylics, graphics, photography, crafts. Eight exhibitions per year, of one month duration, mainly one person shows. Space: Three tower galleries, one above the other, each approx. 12ft square. Fluorescent lighting. Intended mainly for the use of amateur artists who have not previously exhibited elsewhere.

NEWTOWN
ORIEL 31, Davies Memorial Gallery, The Park, Newtown, Powys SY16 2NZ. Tel. 0686 25041. Opening: Mon–Sat 10–4. Director: Michael Nixon. Crafts Officer: Frankie Liebe. Applications: In writing. Exhibitions: Covers the whole range of the visual arts. Space: 45ft × 36ft. White block boarded walls plus display panels, spotlighting, wooden floor, craft cabinets. The gallery is now operating on a full time basis with twelve exhibitions per year, and is running a selection of evening activities (painting classes, lectures etc) and is gaining a high profile within the local community with audience figures increasing steadily.

PENARTH
TURNER HOUSE, Branch Gallery of National Museum of Wales, Plymouth Road, Penarth, South Glamorgan. Tel. 0222 708870. Opening: Tues–Sat 11–12.45, 2–5, Sun 2–5. Contact: Dr Mark Evans–Acting Keeper of Art, Keeper to be

appointed. Details: As for National Museum of Wales.

PWLLHELI
PLAS GLYN-Y-WEDDW GALLERY, Llanbedrog, Pwllheli, Gwynedd. Tel. 0758 740763. Opening: 10–7 Mon–Sat, 2–6 on Sundays. Contact: Dafydd and Gwyneth ap Tomos. Permanent exhibition of paintings in three large rooms and central hallway. The work is by a wide range of artists and offers an increasing selection of paintings with local connection. The gallery is within an historic Gothic Mansion. There is also a changing series of two-person exhibitions.

ST DAVIDS
PETER'S LANE GALLERY, Peter's Lane, Saint Davids, Dyfed. Tel. 0437 720570. Opening: 9.30 to dusk, Easter to October. Contact: John Rogers. One of the first artist-run galleries in Wales. Gallery occupies two front rooms of a double-fronted house.

SWANSEA
ATTIC GALLERY, 61 Wind Street, Swansea, W. Glamorgan. Tel. Swansea 53387. Opening: Mon–Sat 10–5, open lunchtime. Contact: Brenda Bloxham. Applications: Exhibitions, 3 times a year in gallery. Framing service. Otherwise, the gallery keeps a stock of contemporary work—including lithographs, screenprints and etchings of well known artists.

CERI RICHARDS GALLERY, Taliesin Arts Centre, University College, Singleton Park, Swansea, SA2 8PZ. Tel. 0792 295526. Opening: Mon

Mostyn Art Gallery new craft and design shop (Martin Collins)

11–3, Tues–Fri 11–7, Sat 12–7. Contact: Professor D.Z. Phillips, Ceri Richards Gallery. Occasional one and two-man shows but in the main mixed shows. All shows concentrate on Welsh artists and art in Wales. Pottery, sculpture and ceramics also exhibited within these terms.

THE EXHIBITION ROOM, The Cross, Community Resource Centre, 1 High Street, Pontardawe, Swansea SA8 4HU. Tel. 0792 863955. Opening: Weekdays 10–5, Sat 10–1. Contact: Stephanie McLeod. Applications: In writing to the Leader. Exhibitions: Broad range of arts and crafts, professional and amateur, local and national, individuals and groups. About 20 shows per year. Space: Ground floor 23ft × 13ft, spotlights and windows, rails and hanging rods. The exhibition room is situated in a converted hotel in the centre of Pontardawe, a small valley town. The Centre is intended to stimulate community development in the area. The room has been used for exhibitions since the centre started and a very wide range of exhibitions is put on to stimulate the local people.

GLYNN VIVIAN ART GALLERY AND MUSEUM, Alexandra Road, Swansea SA1 5DZ. Tel. 55006/51738. Opening: Mon–Sat 10.30–5.30. Contact: Mrs. Hilary Woolley. Permanent collection of porcelain and pottery—particularly highly prized Swansea China—glass, tompion clocks and paintings, featuring Welsh artists, notably Ceri Richards. Continuous temporary exhibitions programme. Full education programme.

WELSHPOOL
ORIEL 31, 31 High Street, Welshpool, Powys SY21 7JP. Tel. 0938 2990. Opening: Mon–Sat 11–5. Contact: Walt Warrilow. Applications: Submit slides/photographs of work plus C.V. etc. Exhibitions: 8–10 shows per year by professional artists coverng the whole range of contemporary visual arts. A craft space provides a changing display of ceramics, glass, jewellery etc. Commission is set at a low rate in order to encourage artists whose sole source of income is their art work. There is also a good selection of prints, books and postcards.

WREXHAM
WREXHAM LIBRARY ARTS CENTRE, Rhosddu Road, Wrexham, Clwyd, North Wales. Tel. 0978 261932. Opening: Mon–Fri 9.30–6.45, Sat 9.30–5.30. Contact: Steve Brake. Applications: By letter, with slides. Exhibitions: Main Gallery—The work of living artists and group shows. Foyer—travelling museum exhibitions and small one man and group shows. Space: In the Main Gallery, about 40 linear metres of wall space, lighting fluorescent on dimmers. The Foyer

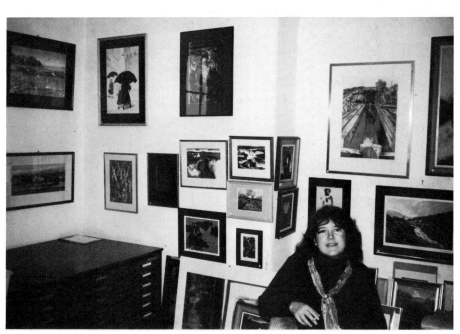

Attic Gallery, Swansea

113

has about 12 linear metres of wall space. Equipment: No frames, but most other 'normal' equipment available. Gallery shows mostly local groups and individual artists, but also the work of major artists from outside the North Wales area.

PERFORMANCE ART

These days, Performance Art finds itself in a stronger, but still marginal position. What the term means is always open to debate, which is one of its strengths. If what comes to mind to the average person is a vision of someone taking their clothes off in an art gallery, then they will be surprised to find the very wide range of approaches to performance that can be seen in Britain today. If the term means nothing to you, then there is a new art form waiting to be discovered by you, that is always stimulating, sometimes shocking, sometimes entertaining, always unpredictable and continually changing direction.

The National Review of Live Art, held annually, has become a focus for new work. There are several 'Platforms' around the country, from which work is selected and the subsequent Review often gains considerable media interest. A greater commitment to the promotion of Performance Art by the Arts Council of Great Britain and the continuing survival of Performance Magazine has added to the sense of a medium that is growing and broadening. Its origins, in this country, are in the tradition of Fine Art, but this now seems to be extending and some of the most interesting work is coming from other roots, in dance, theatre and sometimes cabaret. so the area of Performance Art has become a forum for experimentation in live art, with an even widening repertoire.

Venues for Performance reflect this breadth. There has been increasing interest shown by some of the regional art galleries and museums. For example extensive seasons of live art have been seen in the past year at Wolverhampton Art Gallery, Nottingham's Castle Museum and the Usher Gallery in Lincoln. In London, the ICA and Chisenhale Dance Space have regular seasons, while the Finborough Arms has a twice-weekly late evening slot for experimental work that can fit into a theatre setting. Some organisations actively promote performance work that does not fit into the gallery or studio-theatre setting and are interested in helping artists find more public or less traditional contexts. Babel in Halifax is an example and they have access to vast ex-warehouse space. Projects UK in Newcastle are concerned with all aspects of performance and the Artangel Trust in London promote live and static art which falls into the category of 'interventionist' (see Public Art Section).

While the commercial side of the art world continues to grow stronger in Britain, so that the idea of a painting or sculpture as a commodity is not uncommon, it is reassuring to see performance art also gaining strength. Here there is no chance of commercial gain or indeed anything for sale. What originally attracted artists to performance was the chance to communicate more directly with their audience and to avoid the ins-and-outs of the art world. These ideals remain at the heart of a lively, provocative and still new art form.

Richard Layzell

PERFORMANCE SPACES

LONDON

AIR GALLERY, 6–8 Rosebery Avenue, London EC1 Tel. 01 278 7751. Contact: Sara Selwood. Small basement space.

ARTANGEL TRUST, 133 Oxford Street, London W1. Tel. 01 434 2887. Contact: Roger Took, John Carson. Non-venue based promoter presenting innovative art-work in public spaces.

BATTERSEA ARTS CENTRE, Lavender Hill, London SW11. Tel. 01 223 8413. Contact: Kathryn Standing. Gallery and theatre-studio spaces.

CHISENHALE DANCE SPACE, 64/84 Chisenhale Road, London E3. Tel. 01 981 6617. Primarily promotes new dance, but has a regular programme of performance art in 2 spaces and a gallery, which is organised separately.

DANCE UMBRELLA, Pineapple Kensington, 38-42 Harrington Road, London SW7 3ND. Tel. 01 589 0498. Contact: Val Bourne. Annual festival of new dance work held at a number of venues.

FIGMENT AT THE FINBOROUGH, Finborough Arms, Finborough Road, London SW10. Tel. 01 670 1232. Contact: Colin Watkeys. Regular Friday and Saturday night venue for experimental performance in intimate theatre-space.

ICA THEATRE, 12 Carlton House Terrace, London SW1. Tel. 01 930 0493. Contact: Lois Keidan. Up to 200-seater theatre showing mainly experimental theatre/performance.

ICA GALLERIES, 12 Carlton House Terrace, London Sw1. Tel. 01 930 0493. Contact: Iwona Blaswick. Three gallery spaces occasionally showing performance.

LONDON MUSICIANS COLLECTIVE, 42 Gloucester Avenue, London NW1. Tel. 01 722 0456. New music/performance festival in the autumn. Space available for booking at other times of year.

LIFT, Unit 33, 44 Earlham Street, London WC2. Tel. 01 836 7433/7186. Bi-Annual London International Festival of Theatre.

LONDON VIDEO ARTS, 25 Frith Street, London W1. Tel. 01 734 7410. Video Arts group/promoter. Video library and equipment hire. Occasional video screenings and video/performance presentations at different venues.
OVAL HOUSE, 52–54 Kennington Oval, London SE11 5SW. Tel. 01 735 2786. Contact: Kate Crutchley. Theatre and theatre-studio spaces. A regular programme of new theatre and various workshops in performance skills.
THE PLACE THEATRE, 17 Duke's Road, London WC1. Tel. 01 387 0031. Contact: John Ashford. 250-seater space showing primarily new dance, both national and international. The only purpose-built dance space in London.
RIVERSIDE STUDIOS GALLERY, Crisp Road, London W6. Tel. 01 741 2251. Contact: Greg Hilty.
RIVERSIDE STUDIOS THEATRE, Crisp Road, London W6. Tel. 01 741 2251. New dance and international theatre, occasional performance work.
SERPENTINE GALLERY, Kensington Gardens, London W2 3XA. Tel. 01 402 6075. Contact: Alister Warman. Large Gallery spaces and grounds. Occasional performance art linked to exhibitions.
THE TATE GALLERY, Millbank, London SW1. Tel. 01 831 1313. Contact: Catherine Lacey. Occasional performance art seasons, most recently in the new auditorium.
WATERMANS ARTS CENTRE, 40 High Street, Brentford, Middlesex. Tel. 01 568 3312. Contact: Mick Flood. Visual theatre productions.

NORTHERN ENGLAND
BABEL, 4 World Close, Thornton, Bradford, Yorkshire. Tel. 0422 66723. Performance art group promoting other artists' work in a variety of venues in West Yorkshire. Contact: Paul Bradley.
BLUECOAT GALLERY, School Lane, Liverpool 1. Tel. 051 709 5297. Contact: Bryan Biggs. Occasional performance work in both gallery and theatre spaces.
CARTWRIGHT HALL, Lister Park, Bradford, W. Yorkshire BD9 4NS. Tel. 0274 493313. Contact: Jane Bevan. Large gallery spaces and grounds.
THE CORNERHOUSE, 70 Oxford Street, Manchester M1 5NH. Tel. 061 228 7621. Contact: Bev Bytheway. Large gallery spaces.
THE GREEN ROOM, 48 Princess Street, Manchester Street, Manchester M1 6HR. Tel. 061 236 1676. Contact: Stella Hall. Programme includes new dance, visual theatre, mime, new music and performance art.
HUDDERSFIELD ART GALLERY, Princess Alexandra Walk, Huddersfield, Yorks. Tel. 0484 513808. Contact: Robert Hall. Occasional seasons of performance art.
HULL TIME BASED ARTS, 11 Salisbury Street, Hull HU5 3HA. Tel. 0482 442735. Contact: Dave Ellis, Rob Gawthrop. Non-venue based, artists-run promoter. New music/video/performance/installations/community events.
LAING ART GALLERY, Higham Place, Newcastle upon Tyne. Tel. 091 232 7734. Contact: Mike Collier. Municipal Gallery. Co-promoter of New Work Newcastle performance art festival and exhibition, an annual event.
THE LEADMILL, 6–7 Leadmill Road, Sheffield. S. Yorkshire. Tel. 0742 754500. A mixed programme, which includes visual theatre, dance and performance art, in a large space, which is used as a nightclub in the late evening.
MANCHESTER CITY ART GALLERY, Mosely Street, Manchester M2 3JL. Tel. 061 236 9422. Contact: Julian Spalding. Municipal art gallery.
THE MAPPIN GALLERY, Weston Park, Sheffield S10 2PT. Tel. 0742 26281. Contact: Mike Toobey.
PITT STREET STUDIOS, Off West Street, Sheffield, S. Yorkshire. Tel. 0742 761549. Contact: Sally Cockett. Performance art evenings with established and younger artists.
PROJECTS UK, 69–75 Westgate Road, Newcastle upon Tyne NE1 1SG. Tel. 091 261 4527. Contact: John Bewley, Simon Herbert. Non-venue based major promoter of performance and public art. Annual festival of performance in the spring.
TATE GALLERY LIVERPOOL, Albert Dock, Liverpool. Tel. 051 709 3223. Contact: Richard Francis. Major new art gallery with outside spaces. Opened in 1988 with a performance by Bruce McLean.
USHER GALLERY, Lindum Road, Lincoln. Tel. 0522 27980. Contact: Amanda Wadsley. Large municipal gallery with an interest in performance art.

MIDLANDS
CASTLE MUSEUM, Nottingham NG1 6EL. Tel. 0602 411881. Contact: Michaela Butler. Municipal gallery and museum which occasionally promotes performance art.
IKON GALLERY, 58–72 John Bright Street, Birmingham B1 1BN. Tel. 021 643 0708. Contact: Antonia Payne. Two large gallery spaces.
NORTHAMPTON ARTS CENTRE, Northampton College of Further Education, St Georges Road, Booth Lane South, Northampton NN3 4RF. Tel. 0604 403332. Contact: Ted Little.
THE PERFORMANCE CENTRE, Leicester Polytechnic, Scraptoft Campus, Scraptoft, Leicester LE7 9SU. Tel. 0533 431011 ext 241. Contact: Harriett Dye.

THE PINK ROOM, Unity House, Fennel Street, Loughborough, Leicester LE11 1UQ. Tel: 0509 235386. Contact: Mike O'Donoghue. Cabaret and performance art promoter. Performances held at the Greyhound Hotel, Nottingham Road, Loughborough.

STOKE ON TRENT MUSEUM & ART GALLERY, Bathsheba Street, Hanley, Stoke on Trent, Staffs. Tel. 0782 202173. Large municipal art gallery.

WOLVERHAMPTON ART GALLERY, Lichfield Street, Wolverhampton. Tel. 0902 24549. Contact: Roy Bayfield. Various seasons of performance art in and around Wolverhampton.

EAST ANGLIA

KETTLES YARD GALLERY, Northampton Street, Cambridge. Tel. 0223 352124. Contact: Hilary Gresty. Promoting work inside and outside the gallery.

NORWICH ARTS CENTRE, Reeve's Yard, Norwich. Tel. 0603 660352

SOUTH WEST ENGLAND

ARNOLFINI ARTS CENTRE, 16 Narrow Quay, Bristol BS1 4QA. Tel. 0392 31786. Gallery and theatre spaces.

SPACEX GALLERY, 45 Preston Street, Exeter, Devon. Tel. 0392 31786. Contact: Robin Dobson.

SOUTHERN ENGLAND

BRIGHTON FESTIVAL, Marlborough House, 54 Old Steine, Brighton. Tel. 0273 29801. Contact: Gavin Henderson. Spring/summer arts festival.

GARDNER ARTS CENTRE, University of Sussex, Falmer, Sussex. Tel. 0273 685447. Contact: Nigel Cutting. Gallery space and 400-seater theatre.

JOLIFFE STUDIO, Wyvern Theatre, Theatre Square, Swindon, Wilts. SN1 1QP. Tel. 0793 26161. Contact: Alastair Snow. Performance art, cabaret, community arts promoter in a number of Swindon venues. Outdoor summer festival.

LUTON 33 ARTS CENTRE, 33 Guildford Street, Luton, Beds. Tel. 0582 419584. Contact: Paul Jolly.

MUSEUM OF MODERN ART, Pembroke Street, Oxford, OX1 1BP. Tel. 0865 722733. Contact: Toby Jackson. Large gallery spaces, new dance and performance programme in conjunction with exhibitions.

SOUTHAMPTON ART GALLERY, Civic Centre, Southampton S09 4XF. Tel. 0703 223855. Contact: Andrew Cross.

SOUTH HILL PARK ARTS CENTRE, Bracknell, Berkshire RG12 4PA. Tel. 0344 437272. Contact: Nicola Kennedy. Small gallery, large theatre and grounds.

THE ZAP CLUB, 17 Tichbourne Street, Brighton, E. Sussex. Tel. 0273 727880. Contact: Neil Butler. Regular performance evenings. Arts nightclub with small, but lively performance space.

SCOTLAND

DEMARCO GALLERY, 10 Jeffrey Street, Edinburgh. Tel. 031 557 0707. Contact: Richard Demarco. Large new gallery and performance space. Long tradition of association with performance art and experimental work in general, especially with Scottish, German and Polish artists.

TRANSMISSION, 13–15 Chisholm Street, Trongate, Glasgow G15 HA. Tel. 041 552 4813. Contact: Alan Robertson. Lively new gallery and performance space, also interested in video. Occasionally promotes work in other venues.

THIRD EYE CENTRE, 350 Sauchiehall Street, Glasgow G2 3JD. Tel. 041 332 7251. Contact: Nikki Millican. Gallery and theatre spaces. Nikki Millican organises the National Review of Live Art each year.

IRELAND

LIVING ART SHOW, Room 803, Liberty Hall, Dublin 1. Tel. 0001 740529. Contact: Mimi Behncke Whalley. Annual festival which can include performance.

ORCHARD GALLERY, Orchard Street, Derry, BT48 6EG, Northern Ireland. Tel: 0504 269675. Contact: Declan McGonagle. Gallery spaces and several theatre spaces, some at the newly completed Foyle Arts Centre. A strong commitment to experimental and public art.

PROJECT ARTS CENTRE, Tel. 0001 712321/713327

WALES

CHAPTER ARTS CENTRE, Market Road, Canton, Cardiff. CF5 1QE. Tel. 0222 396061. Contact: Janek Alexander, Stuart Cameron. Gallery and theatre spaces.

SOUTH GLAMORGAN INSTITUTE OF HIGHER EDUCATION, The Space Workshop, Faculty of Art & Design, Howard Gardens, Cardiff. Contact: Anthony Howell.

GWENT COLLEGE OF HIGHER EDUCATION, Caerleon, Gwent. Tel: 0633 59984 Contact: Kieran Lyons.

The Arts Council will consider applications, through the appropriate Regional Arts Association, from *venues* that are interested in booking performance and similar experimental artists, but that lack funds to pay artists' fees or expenses. Your local gallery may not know about this scheme and it could be a way of encouraging them to exhibit your work. Further details from: The Special Applications Assistant, Arts Council of Great Britain, 105 Piccadilly, London W1V 0AU. Tel. 01 629 9495.

There are also two schemes run by the Arts Council for the presentation of artists' film and video, called *Film-makers on Tour* and *Video-Artists on Tour*. Contact the Assistant Film Officer at the Arts Council for details.

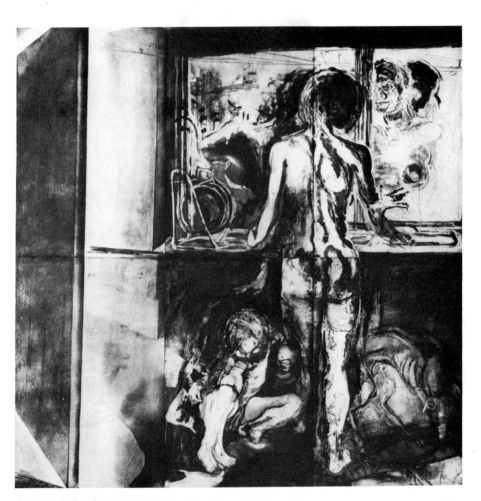

Domestic Still Life, 1981. Beth Fisher (Hunterian Art Gallery, Glasgow)

Chapter 3
SURVIVAL

THE NATIONAL ARTISTS' ASSOCIATION

The NAA was founded in January 1985, after discussion amongst artists that started in the autumn of 1983.

When the NAA was inaugurated, two pledges were made—we would represent all artists equally, democratically: and our policies would be open to input from artists everywhere. In this way we hoped the NAA would be radically different from the existing institutions that control art provision and funding in Britain.

Three years of the NAA's existence have seen—National Conferences in: 1985 Birmingham, London, Bristol, Colchester, Manchester: 1986 Newcastle, Nottingham, London, Milton Keynes, Liverpool: in March 1987, in Birmingham, the 1st NAA National Womens' Conference: followed by conferences in Reading and Brighton.

At these conferences the discussions have been open, frank, and constructive. Workshop sessions have been run by artists and others with experience in various areas of the art world.

As a result of conference decisions, NAA policy includes—an equal opportunities' policy applied to members' representation on the Association's Management Committee. Committee members must also be elected from all parts of the country.

Issued raised at NAA conferences include—art education, artists' placements in schools, copyright, difficulties encountered by disabled artists, insurance of artworks, open exhibitions, policies of funding bodies, public exhibition right payments, racism and sexism in the artworld, social security, taxation. These and other topics have become campaigning issues.

In the past three years the NAA has been involved with the Arts Council and Regional Arts Associations in discussing the future of Exhibition Payment Right (EPR). From January to April 1988, the NAA—commissioned by the Arts Council—ran a series of 12 consultative meetings for artists, craftsworkers, and photographers to discuss Arts Council proposals for EPR. These meetings took place throughout England, and provided an unique forum for public discussion of this important issue.

We have also initiated a series of consultative meetings between artists and the RAA's in the North, North West and Yorkshire. The RAA's have now agreed to fund these meetings, but the initiative came form the NAA.

The NAA represents visual artists on the governing body of the National Campaign for the Arts.

We have set up a Standing Conference with artists' organisations in Ireland and Wales, which meets regularly to co-ordinate policy for artists across the national boundaries. We hope that Scotland will soon also be represented, and that a national representative body for artists in Scotland will come into existence.

Other organisations in England may become subscribing members of the NAA, and individual artists joining the NAA may join the Design and Artists' Copyright Society (DACS) at a discounted rate.

The NAA also offers members participation in an insurance scheme for artworks.

We issue a bi-monthly Bulletin free to all members, and publish reports from the conferences and papers on topics of concern to artists.

We are currently working on:

model artists' contracts

codes of practice for commissions, exhibitions, residencies

the problems faced by women in art education.

Our administration is funded from members' subscriptions— nothing else. Although we have gained grants for conferences and consultative meetings, we have no revenue from grant aid. Our independence is important, but it is paid for with the voluntary, unpaid work of our Management Committee. We are all working artists, and time given to the NAA is precious.

© ROLAND MILLER 1988

NAA Co-Ordinator: Roland Miller, 49 Stainton Road, Sheffield S11 7AX. Tel. 0742 669889.

NAA Membership Enquiries: Karen Antonelli, c/o 45 Rushby Street, Sheffield S4 8GN.

NAA Branches:
BRISTOL: Eddie Chambers, 130 City Road, Bristol BS2 8QY.
EAST ANGLIA: Nigel Kemp, Norwich School of Art, St Georges Street, Norwich NR3 1BB.
LONDON: Liz Clifford, 91A Graham Road, London E8 1PB.
MERSEYSIDE: Peter Corbett, Flat 4, 7 Gambier Terrace, Hope Street, Liverpool L1.
NEWCASTLE (ARTISTS FORUM): David Butler/Susan Jones, c/o PO Box 23, Sunderland SR1 1EJ.
NORTH WEST: Colin Rose, 2 Machpelah, Hebden Bridge, West Yorks, HX7 8AU.
OXFORD: Sarah Eckersley/Helen Ganly, 2 Alma Place, Oxford OX4 1JW.
YORKSHIRE: Shirley Cameron/Roland Miller, 49 Stainton Road, Sheffield S11 7AX.

SUPPLIERS

This list has been compiled with the help of many artists throughout Britain. Note: Addresses are listed according to materials and not regionally, because many artists use addresses from all over the country rather than just in their own area.

PAINTING MATERIALS (see General Section also)

Brodie and Middleton, 68 Drury Lane, London WC2. Tel. 01-836 3280/89. Brushed enamels, paints and pigments.

Leetes, 129 London Road, Southwark, London SE1. Paint, pigments and beeswax.

JT Keep and Sons Ltd., 15 Theobalds Road, London WC1. Tel. 01-242 7578. Enamels, fluorescent paints, paint spray equipment, palettes.

J. W. Bollom and Co., Long Acre, London WC2. A variety of art materials.

A. S. Handover Ltd., Angel Yard, Highgate High Street, London N6. Brushmakers.

Cornelissens, 105 Great Russell Street, London WC1B 3RY. Tel. 01-636 1045. Brushes and pigments.

Dykeshire Ltd., 22 Great Pulteney Street, London W1. Tel. 01-437 5777/8.

George Rowney, 12 Percy Street, London W1. Tel. 01-636 8241. Most art materials.

Winsor and Newton, 52 Rathbone Place, London W1. Tel. 01-636 4237. Most art materials.

Reeves, 178 Kensington High Street, London W8. Most art materials.

Bird and Davis, 52 Rochester Street, London NW1. Tel. 01-485 3797. Stretchers, machinist joiners. Stretchers have to be ordered.

Russell and Chapple Ltd., 23 Monmouth Street, London WC2. Tel. 01-836 7521. Canvas suppliers.

Artex, 115 Kings Cross Road, London WC1. Tel. 01-278 2175. Canvas suppliers.

Charles and Co., 45 Pembridge Road, London W11. Tel. 01-727 6306.

Prog, 32 Thornhill Road, London N1. Tel. 01-607 0357. Aquatex acrylic paint.

Ploton Supplies, 272 Archway Road, London N6 5AA.

Acrylic Paint Co., 28 Thornhill Road, London N1. Tel. 01-607 0357.

Tiranti, 21 Goodge Place, London W1. Tel. 01-636 8565.

Michael Putman, 151 Lavender Hill, London SW11. Brushes made to order.

Aquatec, 28 Thornhill Road, London N1. Tel. 01-607 0357. Acrylic paint.

George Rowney, Bracknell, Berkshire.

George M. Whiley Ltd., Victoria Road, Ruislip, Middlesex. Tel. 01-422 0141. Brushes, gold and silver leaf paint.

Spectrum, Richmond Road, Horsham, Sussex. Tel. Horsham 63799. Acrylics and oils.

Joseph Metcalfes, Leenside Works, Canal Street, Nottingham. Canvas.

Robinsons Ltd., Victoria Street, Nottingham. Art materials.

Rohm and Haas (UK) Ltd., Lenning House, 2 Masons Avenue, Croydon, Surrey. Tel. 01-686 8844. Acrylic media (large quantities).

Thos. Owen Ltd., The Side, Newcastle. Canvas.

Tor Coatings Ltd., 9 Shadon Way, Portobello Industrial Estate, Burtley, Chester le Street, Co Durham. Paints.

Wards, Percy Street, Newcastle.

Thornes, Percy Street, Newcastle.

Binney and Smith (Europe) Ltd., Ampthill Road, Bedford. UK wholesalers for liquitex.

Alec Tiranti, 70 High Street, Theale, Berkshire.

Wm. Wheeldon and Son, Steep Hill, Lincoln. Painting materials, framing etc.

Mellors, West Street, Boston, Lincolnshire. Artists colours, framing etc.

Winsor and Newton Ltd., Wealdstone, Harrow, Middlesex. General art materials.

Billson and Grant Ltd., Clocktower Works, 59 Belgrave Gate, Leicester. Canvas, rope and webbing.

Gadsbys, 22 Mercer Place, Leicester. Acrylic, oils, paper and framing.

Su Barraclough Gallery, 9 Allander Road, Leicester. Liquitex paint.

Cank Street Galleries, 48 Cank Street, Leicester. Liquitex paint.

C.T. Products, Braunstone Gate, Leicester. Canvas.

Textile Manufacturing (Greys) Ltd., 48 George Street, Manchester. Tel. 061-236 3506. Canvas.

Terry Jones, (Stretched Canvas) 3 Weddall Close, York YO2 2EG.

Card'n Art, West End, Gorseinen, Swansea. Acrylic, oils, brushes, paints.

The Craftsman, Killay Shopping Precinct, Killay, Swansea. Paints, canvas, DIY framing.

Art Repro, De la Beche Street, Swansea. Art materials.

Photo supplies, St Helens Road, Swansea. Framing. Handmade paper and other art materials.

Hensons Antiques, 7A Chapel Lane, Headingley, Leeds. Tel. 0532 75194.

Broomhead Publications, 74 Fore Street, Heavitree, Exeter. Tel. 0392 74095. Retail art materials shop.

PAPER

Paperchase, 213 Tottenham Court Road, London W1. Tel. 01-580 8496.

Atlantis Papers, 105 Wapping Lane, London E1. Tel. 01-481 3784.

Sophie Dawson (Papermaker), Vanburgh Castle, Maze Hill, London SE10 8QX.

Clyde Paper Co. Ltd., 26/32 Clifton Street, London EC2. Large quantities of paper.

Falkiner Fine Papers, 76 Southampton Row, London WC1B 4AR. Tel. 01-831 1151. Good variety of handmade papers.

R. K. Burt, 37 Union Street, London SE10. Large quantities, handmade paper.

G. F. Smith, 2 Leathermarket, Weston Street, London SE1.

Berkshire Graphics, Gunn Street, Reading.

Clyde Paper Co. Ltd., Rutherglen, Glasgow, Scotland. large quantities of paper.

Hackitts Ltd., Lillington Road South, Bulwell, Nottingham.

J. E. Wrights Ltd., Huntingdon Street, Nottingham.

Barcham Green and Co. Ltd., Hayle Hill, Maidstone, Kent.

Drawing Office Requisites, Leicester Plan Copying Co., 9-11 Marble Street, Leicester.

G. F. Smith, Lockwood Street, Hull.

Len Tabner, High Barlby, Easington, Saltburn, N. Yorkshire. Tel. 0287 40948.

FRAMING

Blackman Harvey Ltd., 29 Earlham Street, London WC2. 48-hour framing service.

Sebastian D'Orsai, 39 Theobalds Road, London WC1. Tel. 01-405 6663 and 8 Kensington Mall, London W8. Tel. 01-229 3888.

Charles and Co., 45 Pembridge Road, London W11. Tel. 01-727 6306.

Fix-a-Frame, 280 Old Brompton Road, SW5. Tel. 01-370 4189. Open Tuesday to Friday 11.30am-8pm, Saturday 10am-6.30pm.

Frame Express, 1 Queens Road, SW19. Tel. 01-879 3366; 376 Kings Road, SW3. Tel. 01-351 5975. Open Monday to Friday 9am-6pm, Saturday 9am-5.30pm.

Stocks, 174 Clerkenwell Road, EC1. Tel. 01-278 6209. Open Monday to Friday 10am-6pm.

Swallow Art Suppliers, 100-108 Battersea Rise, SW11. Tel. 01-228 0314. Open Monday to Friday 8.30am-6pm, Saturday 9am-5pm.

Crathes Craft Centre, Crathes, near Banchory, Scotland. Tel. 033-044710.

Farley Frames, 6A Balham Road, Edmonton, London N9. Tel. 01-803 0812.

Topics, 232 Railton Road, SE24. Tel. 01-274 7046.

L. M. Frames Ltd., 96-98 Grafton Road, London NW5. Tel. 01-485 2248. Mouldings in different colours.

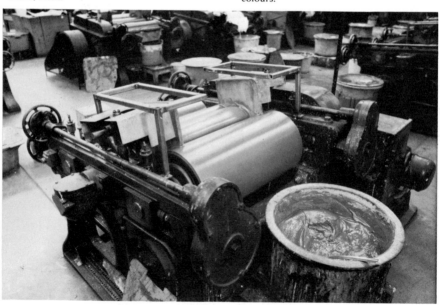

Winsor and Newton, paint production at a factory

Format Frames, 18 Grove Lane, London SE5. Tel. 01-701 8952. Frame kits.

Picture Wise, 11 Tottenham Mews, London W1. Tel. 01-637 4905.

Sancreed Studios, Sancreed, Penzance, Cornwall. Large range of frames.

Pieter van Suddese, 101-103 Doncaster Road, Sandyford, Newcastle upon Tyne. Tel. 091 227826.

James McClure and Son, 1373 Argyle Street, Glasgow, Scotland.

Pitch Pine Products, 23 Mill Dam, South Shields, Tyne and Wear.

City Art, 4 North Court, Glasgow G1. Tel. 041 221 7746.

Gales, Unit 12, Lee Bank House, Holloway Head, Birmingham. Tel. 021 643 6639.

SCULPTURE MATERIALS
METALS

Lazden, 218 Bow Common Lane, London E3. Tel. 01-981 4632. Steel.

Johnson Edwards Ltd., Chain Bridge Road, Blaydon, Newcastle. Ferrous metal bar.

Walter Lakey, Beaumont Fee, Lincoln. Tel. Lincoln 29673. Workshop—specialist in wrought iron, cutting and welding metal.

A. H. Allen, Steel stockholders, Bedford Road, Northampton.

Jamison and Green, 102 Ann Street, Belfast 1. Copper, Steel, aluminium.

TOOLS

Parry and Son (Tools) Ltd., 329 Old Street, London EC1. Tel. 01-739 9422.

Charles Cooper, 23 Hatton Wall, EC1. Tel. 01-278 8167.

Ashley Isles (Edge Tools) Ltd., East Kirkby, Spilsby, Lincs. PE23 4DD. Tel. 07903 372. Very best quality wood carving and turning tools and accessories at reasonable prices. Good mail order service. Highly recommended.

John Hall Tools Ltd., 88 Merton High Street, Merton, London SW19. Tel. 01-542 6644. Tools and machinery—reasonable prices. Also at 23 Churchill Way, Cardiff. Tel. 0222 22242.

Modern Tool and Equipment Co. Ltd., Belfast Road, Lisburn, Co. Antrim. Tel. 08462 5811.

Progress Machinery Ltd., Whitestown Ind. Est., Tallaght, Co. Dublin. Tel. 0001 511433.

Rogers, 47 Walsworth Road, Hitchin, Herts SG4 9SU. Tel. 0462 4177. Full range of woodworking and carving tools, including Japanese imported woodworking tools and technical books. Helpful company. Recommended.

Sarjents Tools, 44-52 Oxford Road, Reading, Berks RG1 7LH. Tel. 0734 586522. Also at 62-64 Fleet Street, Swindon, Wilts SN1 1RD. Plus a branch in Oxford at 150 Cowley Rd, Oxford. Tel 0865 45118. Full range of woodworking tools and metalworking and machinery. Technical books. Recommended.

CLAY

C. H. Brannam Ltd., Litchdon Potteries, Barnstaple, Devon. tel. 0271 3035.

Watts Blake Bearne and Co. Ltd., Park House, Courtenay Park, Newton Abbott, Devon.

English China Clays, St Austell, Cornwall. Not less than ten tons.

Bellman Carter Ltd., 358-374 Grand Drive, Raynes Park, London SW20. Tel. 01-540 1372. Plasters, wax.

E. B. N. Atkins, Stewart Lanes Goods Depot, Saint rule Street, Wandsworth Street, London SW8. Tel. 01-622 1022.

John Myland Ltd., 80 Norwood High Street, London SE27. Tel. 01-670 9161.

Anchor Chemical Co. Ltd., Clayton, Manchester.

Fordanum Co. Ltd., Free Wharf, Brighton Road, Shoreham by Sea, Sussex.

Somerville Agencies Ltd., Meadowside Street, Renfrew, Scotland.

Whitfield and Sons Ltd., 23 Albert Street, Newcastle under Lyme, Staffs.

Deancroft Ceramic Suppliers, Hanley, Stoke on Trent, Staffs.

Potclays Ltd., Brickkiln Lane, Etruria, Stoke on Trent, Staffs.

British Industrial Sand, Etruria Vale, Stoke on Trnet, Staffs.

C. E. Plant, 10 Old Course Road, Cleadon Village, Nr. Sunderland. Clay, plaster, glaze.

GENERAL SCULPTURE ADDRESSES

E. F. Burke & Sons, Unit 12 Newlands End, Laindon North Industrial Area, Basildon. Tel. 026 841 5071. Plaster of Paris.

Hecht Heyworth & Alcan Ltd., 70 Clifton St., London EC2 45P. Tel. 01-626 7820. Ipoxy Resins, Rubbers.

McKechnie Metal Powders, P.O. Box 4, Widnes, Cheshire WA8 0PG. Powdered Metals.

L. Cornelissen & Sons Ltd., 105 Great Russell Street, London WC1B 3RY. Tel. 01-636 1045. Art Colourmen.

Brodie & Middleton Ltd., 68 Chancery Lane, London WC2. Tel. 01-836 3289. Theatrical Suppliers (shellac etc).

Gedge & Co., 88 St John Street, London EC1. Tel. 01-253 6057. French Polish Manufacturer.

Plasterers Merchants, A. Randall, Supremacy House, Hurstwood Road, Golders Green, London NW11 0AR. Scrim, Brushes & Mixing Bowls etc.

John Myland Ltd., 128 Stockwell Road, London SW9. Wood stains, varnishes, shellac, brushes, paints, colours, oils etc.

John Brown, The Bow House, 63 Wood Street, Barnet, Herts. Tel. 01-449 1734. Carving Tools.

T. A. Hutchinson Ltd., 16 St Johns Lane, London EC1. Tel. 01-253 3186. Polishing materials and tools.

Frank Pike, 15 Hatton Wall, London EC1. Tel. 01-405 2688. Craftsmens' tools.

Manuel Lloyd Ltd., Bull Lane, Edmonton, London N18 1SX. Cardboard boxes and tea chests (packing).

Vinotex Ltd., Devonshire House, Carshalton, Surrey, Vinyl-Hotmelt.

Polyservices Ltd., Taylors Rd, Stotfold, Beds. Polystyrene etc.

Robert May, 103 Seven Sisters Rd, London N7. Tel. 01-272 5225. Also Phoenix Display, 117 Seven Sisters Rd, London N7. perspex Display Mounts.

Buck & Ryan, 101 Tottenham Court Rd, London W1. Tel. 01-636 7475. Tools & Ironmongery (silver steel rods).

Charles Cooper, 23 Hatton Wall, London EC1. Tel. 01-278 8167. Tools—Craftsmens'.

Amalgamated Dental Co., 26 Broadwick St, London W1. Dental Investment Wax.

Alec Tiranti, 21 Goodge Place, London W1. Tel. 01-636 8565. Sculpture, enamelling materials.

Aston Farmhouse, Remenham Lane, Henley. Tel. Henley 2603.

Hopkinsons Ltd., Station Road, Nottingham. Metal stockholders.

William Watts Ltd., Arnold Road, Bosford, Nottingham. Large metal stockholders.

British Oxygen, Raynesway, Derby. Welding supplies.

Fosters Welding Supplies, Church Street, Lenton, Nottingham.

Record Ridgway Tools Ltd., Parkway Works, Sheffield, Yorkshire.

The Maininger Foundry Ltd., Bord Close, Basingstoke, Hants. Tel. 0256 24033.

Burleighfield Casting Studios, Loudwater, High Wycombe. Tel. 0494 21341.

British Gypsum, Beacon Hill, Newark, Notts.

China and Ceramic Centre, 231 North Sherwood Street, Nottingham. Clay.

Podmore Ceramics, 105 Minet Road, London SW9. Aalco (Romford) Ltd., North Street, Romford, Essex. Tel. Romford 64161. Aluminium.

Browne and Tawse, St Leonards Street, London E3. Tel. 01-980 4466. Steel.

Poth Hille and Co. Ltd., Wax Manufacturers and Refiners, 37 High Street, Stratford, London E15. Tel. 01-534 7091. Waxes.

Strand Glass and Co. Ltd., 524 High Road, Ilford, Essex. Fibreglass resins.

TIMBER

Moss, 104 King Street, London W6. Hardwoods.

C. F. Anderson and Son Ltd., Islington Green, London W1. Tel. 01-226 1212.

D. and J. Simons and Sons Ltd., 122-128 Hackney Road, London E2. Tel. 01-739 3744. Higgs, Woodley, Reading.

Fitchett and Woollacott, Willow Road, Lenton Lane, Nottingham.

Palmers Timber Yard, Skinner Burn Road, Newcastle. Second-hand joists, floor boards etc.

E. Robson and Co. Ltd., West Side, Tyne Park, South Shields, Tyne and Wear. Wester red cedar for stretchers.

Harlston Heath, Timber Yard, Harlestone, Northampton. Green seasoned, good sizes, cheap offcuts.

Woodlines, 75 Commercial Road, Grantham, Lincolnshire.

Sandell Perkins, various branches throughout London.

E. M. Chambers, 36 Bow Common Lane, London E3. Second-hand wood.

Tyzack and Son Ltd., 341 Old Street, London EC1. Tel. 01-739 8301. Wood and metal working tools.

Buck and Ryan Ltd., 101 Tottenham Court Road, London W1. Tel. 01-636 7475. Machine tools.

STONE

Stone Firms, 10 Pascal Road, London SW8.

Mansfield Quarries, Clipstone Drive, Forest Town, Mansfield.

PLASTICS AND PERSPEX

Central Plastics, 178 Albion Road, Stoke Newington, London N16. Tel. 01-254 5082.

Transatlantic Plastics, 672 Fulham Road, London SW6. Tel. 01-736 2277. Polythene.

R. Denny and Co., 13/15 Netherwood Road, London W14. Tel. 01-503 5152. Perspex suppliers.

Fablon Ltd., Berkeley Square House, Berkeley Square, London W1. Tel. 01-629 8030. Polythene.

Richard Daleman, 325 Latimer road, London W10. Tel. 01-969 7455. Perspex materials.

Tuckers Ltd., 5 Gateside Road, Queens Drive Industrial Estate, Nottingham. Perspex.

G. H. Blore, Perspex Merchants, 48 Honeypot Lane, Stanmore, Middlesex. Tel. 01-952 2391.

A. J. B. Plastics Ltd., Station road, Hook, Near Basingstoke, Hants. Tel. 025672 2706.

PRINTMAKING

Printmakers would be well advised to buy the **Handbook to Printmaking Supplies** published by the Printmakers Council, Clerkenwell Close which covers practically everything that the printmaker should need to know together with appropriate addresses. It is stocked by art bookshops and galleries such as the ICA.

The addresses below are ones recommended by printmakers throughout the UK as being the most useful.

PRINTMAKING SUPPLIERS

Michael Putman, 151 Lavender Hill, London SW11. Tel. 01-228 9087. Etching, litho, engraving and wood block materials. Printing and fine art supplies.

Atlantis, 105 Wapping Lane, London E1. Tel. 01-481 3784. Handmade papers for printmakers.

Mitchell Street Print Studio, 39 Mitchell Street, London EC1. Tel. 01-253 8930. Fine art printing and editioning by arrangement.

L. Cornelissen and Son, 105 Great Russell Street, London WC1. Tel. 01-636 1045. Printing and fine art suppliers.

Hunter Penrose Ltd., 7 Spa Road, London SE16.

T. N. Lawrence and Son, 2 Bleeding Heart Yard, Greville Street, London EC1.

Modbury Engineering, Belsize Mews, 27 Belsize Lane, London NW3. Second-hand relief printing presses.

Lowick House Print Workshop, Lowick, Near Ulverston, Cumbria. Tel. 0229 85698. Editioning, litho, intaglio relief and photo silk screen.

Artspace Studios Bristol, McArthur's Warehouse, Gas Ferry Road, Bristol 1.

Sericol Ltd., Unit C13, Tyne Tunnel Trading Estate, North Shields, Tyne and Wear.

Harry Rochat, Cotswold Lodge, Staplyton Road, Barnet, Herts. Second-hand etching presses.

Serigraphics Silk Screen, Fairfield Avenue, Maesteg, Mid-Glamorgan, (John Gibbs). Tel. 0656 733171.

Bewick and Wilson, 29 Spennithorne Road, Grangefield, Stockton on Tees, Cleveland. Tel. 0642 62768. Etching and litho presses.

Art Equipment, Craven Street, Northampton. Tel. 0604 32447. Etching presses.

Len Tabner, High Barlby, Easington, Saltburn-by-Sea, North Yorkshire. Tel. 02087 40948.

Jim Allen, Print Workshop, 181a Stranmillis Road, Belfast 9. Tel. Belfast 663591. All printmaking materials.

Dryads, Northgates, Leicester. Relief printing materials.

SCREENPRINTING

Sericol, 24 Parsons Green Lane, London SW6. Tel. 01-736 3388.

Selectasine Ltd., 22 Bulstrode Street, London W1.

E. J. Marler, Deer Park Road, London SW19.

PHOTOGRAPHY AND FILM

Process Supplies, 13–19 Mount Pleasant, London WC1. Tel. 01-837 2179. General photo supplies.

Vic Oddens, 5 London Bridge Walk, London SE1. Tel. 01-407 6833. Cameras, film, enlargers etc. Good second-hand selection.

Pelling and Cross, 104 Baker Street, London W1. Tel. 01-487 5411. Professional photo suppliers and also hire photo equipment.

Brunnings, 133 High Holborn, London WC1. Tel. 01-405 0312. Second-hand equipment. Photo dealers.

Keith Johnson Photographic, London W1. Tel. 01-439 8811. Large selection.

Leeds Camera Centre, 16 Brunswick Centre, Bernard Street, London WC1. Tel. 01-837 8030.

Fox Talbot Cameras, 179 Tottenham Court road, London W1. Tel. 01-636 1017. Main Nikon retailers. Good range of quality used equipment.

ETA Labs, 216 Kensington Park Road, London W11. Tel. 01-727 2570. Colour and b/w processors. Reliable and good.

Sky Photographic Services, 2 Ramillies Street, London W1. Tel. 01-434 2266. Also at 111 High Holborn Tel. 01-242 2504. B/w and colour processors. Extra large contact sheets.

FXP, 65 Coburg Rd, London SE5. Tel. 01-703 8232. Photo service for artists.

Buckingham Photographic, 459 Bromley Road, Bromley. Tel. 01-698 4349. Cibachrome and colour processors at reasonable prices.

Art Supplier (Fiona Dunlop)

Atlas Photography, 4 New Burlington Street, London W1. Tel. 01-434 3171. professional photo suppliers.

Tecno, (London, Birmingham, Manchester and Bristol), 326 Euston Road, London NW1. Tel. 01-388 2871. Kensington Tel. 01-602 5311, Holborn Tel. 01-831 9398, City 01-558 4831, Birmingham 021-632 5737, Manchester 061-228 0461, Bristol 0272 214421.

P. & P. F. James Photographic Ltd., 496 Great West Road, Hounslow, Middlesex. Tel. 01-570 3974. Colour processors.

J. R. Freeman Group, 74 Newman Street, London W1. Tel. 01-636 4537. B/w and colour processing and mounting.

The Darkroom, 35 Wellington Street, London WC2. Tel. 01-836 4008. B/w and cibachrome processors. Professional work only.

Rest of Britain

Edinburgh Cameras, 55 Lothian Road and 60 Clark Street, Edinburgh.

Alexanders Photographic Dealers, 58 South Clark Street, Edinburgh.

Hamilton Tait, 141 Bruntsfield Place, Edinburgh.

Lizars, 6 Shandwick Place, Edinburgh 2. Camera suppliers.

Klick Photographic, 229 Mornington Road, Edinburgh 10.

John Goldsworthy Photographic, (Prints from slides), Cairnsmore, Stablecourt, Newton Stewart, Wigtonshire DG8 7BB. Tel. 0671 3840.

Photo Express, 7 Melville Terrace, Edinburgh 9.

Robband Campbell Harper Studios, 11 South Street, David Street, Edinburgh 2.

The Photo Centre, 28/30 Pelham Street, Nottingham.

Independent Filmmakers Association, Midland Group Gallery, Nottingham. Film facilities and equipment.

Ilford Ltd., Norther District Office, Mobberley, Knutsford, Cheshire.

Kodak Ltd., P.O. Box 10, Dallimore Road, Manchester.

Tyne Colour, Wester Approach, South Shields, tyne and Wear. All Kodak, Ilford, Patersons and Ademco products.

Mobile Photo Services, Carliol Square, Newcastle. Cameras, second-hand enlargers and processors.

Bonsers, Bigg Market, Newcastle 1.

Leeds Cameras, Leeds.

Colourworld Ltd., North Shields.

Pelling and Cross, Welsh Back, Bristol.

Hunter Penrose, Bridge Road, Kingswood.

Jessops of Leicester. Tel. 0533 20461.

VIDEO AND FILM

London Video Arts, 23 Frith Street, London WC2. Tel. 01-734 7410. Useful address for video artists. Video library for reference.

Fantasy Factory, 42 Theobalds Road, London WC1. Tel. 01-405 6862. Video editing for 1/2 inch and 3/4 inch tapes.

Hudson and Carter Ltd., Midland Video Systems, 3 Attenborough Lane, Chilwell, Nottingham.

Tyneside Cinema, Pilgrim Street, Newcastle. 8mm video viewing, splicing, editing Umatic.

Amber, The Side Gallery, side, Newcastle. 16mm cutting room.

POTTERY

The Fulham Pottery, 210 New Kings Road, London SW6.

Wengers Ltd., Etruria, Stoke-on-Trent. Tel. 0782 25126.

Podmore Ceramics Ltd., 105 Minet Road, London SW9. Tel. 01-737 3636.

Ferro (GB) Ltd., Wombourne, Wolverhampton, Staffs. Tel. 09077 4144.

Harrison Mayer Ltd., Meir, Stoke, Staffs. Tel. 0782 31611.

Degg Industrial Minerals Ltd., Phoenix Works, Webberley Lane, Longten, Stoke-on-Trent, Staffs. Tel. 0782 316077.

Northern County Pottery Supplies, 29/31 Frederick Street, Laygate, South Shields.

Podmore & Sons Ltd., Shelton, Stoke-on-Trent.

Atlantis, Gullivers Wharf, 105 Wapping Lane, London E1. Tel. 01-481 3784. Wide range of materials.

GENERAL SECTION
London

Yates, 146 Kensington High Street, London W8. Tel. 01-229 4276. Woodyard. Hardboard etc.

Carpenters, 49 Kensington High Street, London W8. Tel. 01-937 6158.

Ryman Conran, 227 Kensington High Street, London W8. Tel. 01-937 1107. Branches throughout London. Stationers, office equipment and general office suppliers.

Instant Print West One, 12 Heddon Street, London W1. Tel. 01-434 2813. Photocopying and printing at reasonable prices.

Winton, 13 Abingdon Road, London W8. Tel. 01-937 2024. Picture glass, hardboard etc.

Cowling and Wilcox, 26/28 Broadwick Street, London W1. Tel. 01-734 9558.

Philip Poole and Co. Ltd., 182 Drury Lane, London WC2. Pens, nibs, inks. Vast variety to choose from.

Rank Zerox, 20 Edgware Road, London W2. Tel. 01-402 7647; HQ Rank Zerox can do colour zerox printing and also at certain Rank Zerox branches.

FXP, 65 Coburg Rd, London SE5. Tel. 01-703 8232. Slide making service for artists.

C. Roberson and Co. Ltd., 71 Parkway, London NW1 7JQ. Tel. 01-485 1163. 'Best art supply shop in London'.

Green and Stone, 259 Kings Road, London SW3. Tel. 01-352 0837. Very popular with central London artists.

Langford and Hill, 10 Warwick Street, London W1. Graphic and fine art supplies.

Rymans Ltd., Office Equipment, 200 Tottenham court Road, London W1. Tel. 01-580 0184.

Paintworks, (General art materials) 93 Kingsland Road, London E2.

124

Keiko Hasegawa, Raku bottle, Oxford Gallery

Walkerprint, (Design & Printing), 46 Newman St. London W1P 4LD. Tel. 01-580 7031.

Oxford Exhibition Service Ltd. (General Art Supplies).

Circus Workshops, 38 Cowley road, Oxford OX4 1HZ. Tel. 0865 242225.

Kilroy Art Supplies, (National Mobile Art Supplies) 1 Thirlmere Drive, St Albans, Herts. Tel. 0727 36071.

ART SERVICES (London)

Fine Art Transport, Tel. 01-948 2220.

Rees Martin Art Services Ltd., 129-131 Coldharbour Lane, London SE5. Tel. 01-274 5555. Transport, packing and storage. 20th century art specialists.

Momart, 6-15 Harfield Road, London E8. Tel. 01-985 4509 or 01-533 0121. Transport, framing, packing, security, export/import.

Dunn Collingwood and Co., 219 Eversleigh Rd, London SW11. Tel. 01-223 7526. Museum and gallery display services used by Cork Street galleries.

Gordon Joy, Tel. 01-981 6419/5956. fine art transport and framing service by friendly artist.

Donald S. Smith, ACME Studio 4, 105 Carpenters Rd, Stratford, London E15 2DU. Tel. 01-519 6434. Caring transport by friendly artist/driver.

REGIONAL

Moorsaws, 6 Cobden Street, Salford, Lancashire. Tel. 061 737 6660. Packing supplies.

Faspak (Containers) Ltd., Unit 6, Longwall Avenue, Queens Drive, Nottingham. Tel. 0602 869391. Cardboard packages.

Baldwins, Salford Street, Aston, Birmingham 6. Packaging.

Russell Scanlon, Wellington House, 15 Wellington Circus, Nottingham. Tel. 0602 470032. Insurers.

Midland Paper Co., Cank Street, Leicester. Polythene off the roll.

Norman Underwood, 11-27 Frees Chorlane, Leicester. Glass.

Central Tape Agency Ltd., Hagden Lane, Watford, Herts. Tel. Watford 39877.

McMordie Bros., 130-134 Ravenhill Terrace, Belfast. Perspex, acrylic sheet.

Celtic Ceramics, Newport, Gwent. Good range of supplies. All pottery materials and equipment.

S. H. Smith and Co., Barker Street, off Portland Road, Shieldfield. Newcastle upon Tyne. Framers, stretchers, mouldings etc.

Craven Art Centre, Coach Street, Skipton, North Yorkshire.

Chandler Craft Shop, Leyburn, North Yorkshire.

Ripton Picture Gallery, Kirkgate, ripon, North Yorkshire.

Millers, 54 Queen Street, Glasgow G1. Tel. 041 221 7985. Canvas, art supplies, graphic supplies.

Millers, 411 George Street, Aberdeen. Tel. 0224 634308.

Millers, 52 Rose Street, North Lane, Edinburgh. Tel. 031 225 4678.

Braithwaite and Dunn, 1st Floor, Victoria Centre, Nottingham.

Newman Abbott Ltd., 7 Helpston Road, Glinton, Peterborough. Cardboard tubes, packaging.

Christopher Maddison, (Furniture maker), Wragby, Lincs. Tel. Wragby 450. Does one-off jobs e.g. light boxes etc.

Milton Keynes Development Corporation, Lloyds Court, Central Milton Keynes. Tel. 0908 679101. Stretchers, darkroom and other facilities for artists in the area.

Museum Easels, 3 & 4 Brookshill Cottages, Harrow Weald, Middlesex.

J. E. Wrights, Huntingdon Street, Nottingham.

Bristol Fine Art, 74 Park Row, Bristol.

F. Keetch Ltd., 48 Bridge Street, Taunton, Somerset.

Drayton Decorations Ltd., 103 Middle Street, Yeovil, Somerset.

Lane and Co., 2 George Street, Bridgewater, Somerset.

STUDIOS

Artists have always had difficulty in finding suitable studio space but in the last ten years several organisations run by artists have helped set up blocks of studio space on short term leases from artists. In London **SPACE Studios** (set up in 1968) and **ACME Housing Association** (set up in 1972) have continued to increase the amount of studio space available to artists living in London. In most cases these properties can only be used for working and not living in. Apart from these two non-profitmaking organisations run by artists, there are many independent studio blocks in London where artists have got together and negotiated their own leases and terms. Some of these studios are listed below.

Outside London—both elsewhere in England, and in Scotland and Wales, similar organisations run by artists and studio blocks have been set up to help artists in these areas. Some of these studio blocks and artist organisations are listed below. Several were set up with the initial help of **ACME** and/or **SPACE** giving advice about drawbacks and disadvantages as well as the advantages. Even in Australia and the USA, **ACME and SPACE** have helped initiate organisations such as Creative Space in Sydney Australia, and the Institute of Art and Urban Resources in New York (Alanna Heiss the Director once worked for **SPACE** Studios in London). Hopefully more of these organisations will be set up to meet the growing demand for studio space.

In Wales the **Association of Artists and Designers** has organised studio space for its members and in Scotland there are several organisations such as **WASPS** (Workshop and Artists' Studio Provision Scotland) in Edinburgh and Glasgow. In English cities such as Liverpool, Portsmouth, Bristol and in

Yorkshire there are other similar artist-run organisations that have come about specifially to provide studio space for artists locally.

If you are thinking of setting up studio space make sure that you are aware of the legal implications and contact the Arts Council of Great Britain who give grants for studio conversions. Regionally each Regional Arts Association should be able to give grants towards studio conversion so contact your local arts association for details or possibly they could give you addresses of organisations in your area that might consider renting you studio space. Whatever you do persevere whether it's keeping on the SPACE waiting list or looking for a warehouse with friends.

<div align="center">

LONDON
</div>

SPACE STUDIOS, 6 and 8 Rosebery Avenue, London EC1. Tel. 01-278 7795.

AIR and SPACE, (Art Services Grants Ltd.), a non-profitmaking charity, comprises SPACE Studios, AIR Gallery.

SPACE was founded in 1968 in response to the need of professional visual artists for low cost studio space. SPACE has begun to meet this need in two principal ways; by providing studios and information on establishing independent studios.

Due to the ever increasing demand and diminishing supply of studios in central London SPACE operates a waiting list system. Although it is impossible to predict accurately the length of time an artist will be on the list before being offered a studio, it can vary from six to twenty months. However, artists who are able to be flexible about the location and condition of a studio are likely to be offered a studio more quickly than those with very specific requirements.

At present **SPACE** leases 22 buildings in the Greater London area, providing studios for 230 artists. The buildings themselves range from listed historic buildings to old schools and warehouse floors, and the studio sizes vary from 159 square feet to 1000 square feet. Since 1968 SPACE has continued to adapt to the economic circumstances and progressed from short-term leases to those of medium term. The outlook on the property market points to SPACE being driven to bid for ever increasing lengths of leases and attempt to acquire suitable freehold buildings. The acquisition of such buildings will give **SPACE** the oppotunity to provide artists with infinitely greater security of working space and ensure that the economic survival of the contemporary artist is a reality of modern society.

Existing **SPACE** *Studio sites*

8 Berry Street, EC1.	Norfolk B.
Belsham Street, Hackney.	Vandy Street EC2.
Bombay Wharf, 59 St Marychurch Street, SE16.	Victor House.
49 Columbia Road, E2.	Winkley Street E2.
8-12 Deptford High Street, SE8.	Block C, Norfolk House, Brookmill Road, SE8.
10 Martello Street, E8.	Old Mill, Lewisham.
Dace Road.	Milborne Street, Hackney.
Britannia Works.	Richmond road, Hackney.
Norfolk A.	6 & 8 Rosebery Avenue, EC1.

Top floor studio, 6 and 8 Rosebery Avenue, EC1. Available to Australian arts institutions to rent for periods of not less than six months at a time. Nominated artist to live and work in a studio. Similar to a bursary scheme. AIR Gallery details under "Gallery Section".

ACME HOUSING ASSOCIATION, 15 Robinson Road, London E2. A registered non-profitmaking charity comprising ACME Housing Association, and related artists activities. Tel. 01-981 6811. **The Showroom Gallery** as above. (David Thorp)

ACME Housing Association was set up in 1972 by a group of artists who realised that in many parts of London there were a considerable number of council-owned houses lying empty and due for eventual but not immediate demolition. As a housing association they could approach the Greater London council direct for this short life property. The properties were often in poor condition but initial expense was offset by the low rents charged. The properties were and still are large enough to allow generous studio space and accommodation which helps the artist and his family by finding him both living and working space.

Artists wishing to be considered for an **ACME** house or studio have to be interviewed first and then if accepted their names are put on a waiting list. At present artists could wait for between six months and a year for a house.

ACME houses some 200 artists and their families at present, and also has studio blocks. The studio blocks provide working space only, not living accommodation. The houses in general provide working and living space for artists and are mainly in the East end of London.

ACME also acts as a consultative and advisory body to other artists in Britain and has been involved initially in advising artists to set up studio blocks elsewhere in England and Wales. At present they have

studio blocks in Bethnal Green, North Shoreditch, Brixton, Camden and Stratford East. Rents are in the region of £2.25 per sq ft per annum, inclusive except for metered electricity. The only studios outside London are in Porthleven, Cornwall. These are available for short-term lets.

The book they publish is called **'Organising your own Exhibition—A guide for Artists'** by Debbie Duffin. It is available in bookshops or may be ordered directly from the ACME office by sending a cheque for £3.40 (made payable to ACME).

The waiting list for studio/living accommodation is closed at present and they will not be accepting any further applications until **September** this year (1988). The waiting list for **studio** space is always open for further applications but they cannot guarantee suitable space becoming available and artists must expect to wait at least two years. As from April 1st 1988 'The Showroom' will no longer be a self-organising gallery available for artists to hire, but will be managed on a selective basis by David Thorp on behalf of ACME.

INDEPENDENT STUDIO BLOCKS (London)

BARBICAN, Old St. Patrick's School, Buxton Street, London E1. 79–89 Lots Road, London SW10. ARTS GROUP, 2 Sycamore Street, London EC1. Tel. 01-253 7394. Fifteen studio spaces. KINGSGATE WORKSHOPS, 110-116 Kingsgate Road, London NW6. Tel. 01-328 7878. Thirty-five studios, £2 per square foot.

Converted warehouses rented commercially at approximately £3 per square foot. Ads for these studios are often in *Time Out* magazine or passed by word of mouth by artists.

NEW CRANE WHARF STUDIOS, 4th Floor, East Warehouse, New Crane Wharf, Garnet Street, London EC1. Tel. 01-488 1819. ERROL STREET STUDIOS, London EC1. Tel. 01-588 5708. Chris Plowman and Tim Mara.

Printmaking studios with facilities for classes for professional printmakers.

STOCKWELL DEPOT, Stockwell, South London. ARTPLACE TRUST, Chisenhale Works, Chisenhale Road, Bow, London E3. Tel. 01-981 4518. £1 per square foot, 38 studios.

Studios for painters and sculptors.

HETLEY ROAD STUDIOS, London W12. Tel. 01-743 1843. Independent studios now, once run by ACME.

LEB DEPOT, 52c Crooms Hill, Greenwich, London SE10. Another independent studio block for artists.

CABLE STREET STUDIOS, Thames House, 566 Cable Street, London E1. 50 studios 150–1000 sq.ft. Rents from £9.50 per week. run by Martin Lilley, Keith Patrick and Michael Daykin.

Space Studios and AIR Gallery offices, London EC1 (Heather Waddell)

ANGEL STUDIOS, 5 Torrens Street, Islington, London N1. Tel. 01-837 1015. Contact: Adrian Hemming.
CHISENHALE STUDIOS, Chisenhale Road, London E3. Tel. 01-981 4518 or 01-980 6447.

ELSEWHERE IN ENGLAND

BRIGHTON OPEN STUDIOS, 166–168 Kings Road Arches, Brighton. James Hudson.
ARTSPACE BRISTOL, Top Floor, McArthur Warehouse, Gasferry Road, Bristol. Tel. 0272 36966.
DARLINGTON ART CENTRE, Vane Terrace, Darlington. Tel. 0325 483271.
START STUDIOS, St Leonards Gate, Lancaster.
HOPE STREET STUDIOS, 32a Hope Street, Liverpool 1. Studios and gallery space.
MERSEYSIDE ART SPACE LTD., Bridewell Studios, Harper Street, Off Prescot Street, Liverpool. Tel. 051 260 6770.
READING FINE ART STUDIO, 3 Regent Street, Reading, Berks.
YORKSHIRE ART SPACE SOCIETY, Washington Works, 86 Eldon Street, Sheffield. Tel. 0742 71769. Supported by ACGB and Yorkshire Arts Association; 4,500 sq ft of studio space for artists. Founded 1977.
ART SPACE PORTSMOUTH, 27 Brongham Road, Southsea, Hants. Tel. 0705 812121.
PENWITH STUDIOS, St. Ives, Cornwall. Tel. 0736 795579.
RED HERRING STUDIOS, 24 North Place, Brighton, East Sussex. BN1 1YF. Tel. 0273 684807.
CULLERCOATS, 57 Percy Park, Tynemouth, Tyne and Wear. (Edwin Easydorchik).
WINCHESTER ASSOCIATION OF WORKING ARTISTS, 4 Staple Gardens, Winchester.
FAR GONE STUDIO, Prince Albert Chambers, 1 Railway Street, Wolverhampton.
LUNESIDE STUDIOS, 2nd Floor, St Georges Works, St Georges Quay, Lancaster LA1 5QJ. Tel. 0524 35396. Artist run studios.
CARLIOL SQUARE STUDIOS, 5th Floor, India House, Carliol Square, Newcastle upon Tyne. Contact: Susan Williams.
SUNDERLAND ARTISTS GROUP, Old Simpson Street School, Simpson Street, Sunderland, Tyne and Wear. Contact: Su Jones.
MIDDLESBROUGH ARTISTS GROUP, 63 Park Lane, Middlesbrough, Cleveland. Contact: Keith Bridgewood.
NOTTINGHAM ARTISTS GROUP (NAG), c/o Hilary Cartmel, 14 Henry Road, West Bridgford, Nottingham NG2 7NA.
CARRINGTON STREET STUDIOS, c/o Christine Fitzpatrick, 38/44 Carrington Street, Nottingham NG1 7FG.
THE PICTURE FACTORY, c/o Colin Bradley, 4 Kings Avenue, Loughborough, Leics.
KNIGHTON LANE GROUP, c/o Ian Carmichael, 146 Queens Road, Leicester LE2 3FS.
THE WORKS, 36–48 Carrington Street, Nottingham.

NUCLEUS, 128 Bevois Valley Rd, Southampton. Tel. 0703 224681. Workshops, classes, gallery for members.
NOTTINGHAM CITY ARTISTS, 42 Canal Street, Nottingham, NG1 7EH. Tel. 0602 587472.
MEADOW LANE STUDIOS, 85 Meadow Lane, Leeds LS11. Tel. 0532 779189. Contact: Jill Coughman.
NEW CUT WORKS, 22 Sydenham Road, Bristol BS6 5SJ. Tel. 0272 232063. Contact: Mike Richards.
PITT STREET ARTISTS, Eagle Letter Works, Mappin St. Sheffield S1 4DT. Contact: Vega Bemejo 0742 581230 or David Ballantyne 0742 333612.
BRISTOL SCULPTURE SHED, McArthurs Yard, Gas Ferry Road, Bristol BS1 6UN. Tel. 0272 290655.
BADA, Arena House Studios, 82/84 Duke St., Liverpool L1 5AA. Tel. 051-709 6996. Contact: John Earwaker.
BLAST LANE STUDIOS, Blast Lane, Sheffield S4 7TA. Tel. 0742 753315.
SAAC, 7 Saint Mary St., Cardiff, CF1 2AT. Tel. 0222 30705 or 709657.
LEEDS ARTSPACE, Stowe House, 5 Bishopsgate Street, Leeds LS1 5DY.
TERRE'S FACTORY, 3rd Floor, Ellesmere Street, Manchester M15 4LZ. Tel. 061-833 9624.
O.H.S.L., The Keep, 571 Oxford Road, Reading, Berks. RG3 1HL.
KIRKLEES ARTSPACE SOCIETY, Eastthorpe Gallery, Huddersfield Road, Mirfield, W. Yorks. WF14 8AT. Tel. 0924 497646.
NEW ART STUDIOS, 2/3 Marys Abbey, Off Capel Street, Dublin 7. Tel. 0001 730 617. Contact: Mary Burke.
CIRENCESTER WORKSHOPS, Brewery Court, Cirencester, glos. Tel. 0285 61566.
ARTSHARE STUDIO, Mouira Street, Loughborough, Leics. LE11 1AU. Contact: The Secretary.
CUBA STUDIOS, 60 Blossom St., Ancoats, Manchester. M4 6AJ. Tel. 061-228 3260. Contact: Phil Rowe.
CARRINGTON STREET STUDIOS, 38–40 Carrington St., Nottingham NG1 7FG.
FOUNDRY STUDIO, Unit 11a, St Mark's Works, Foundry Lane, Leicester.
OPEN HAND/STUDIO LINK, The Keep, 571 Oxford Road, Reading Berks. Contact: Mark Hunt.
READING SPACE STUDIOS, The Stables, Caversham Court, Caversham, Reading, Berks.
MANCHESTER ARTISTS STUDIO ASSOCIATION, 16–18 Granby Row, Manchester 1. Contact: John Gilchrist. Reductions on art materials, annual exhibitions. Tel. 061-236 1078.

D. COTTEE, Cambridge Arts and Leisure Association, 23 Mill Street, Cambridge.

ESSEX CRAFT CENTRE, Maltings Farm, Great Oakley. Tel. 0255 821.

SALLY ANDERSON, Parndon Mill, off Elizabeth Way, Harlow. Tel. 0279 20982.

MICK & JENNY GREEN, Poole Craft Studios, The Lodge, Poole Street, Great Yeldham, Halstead. Tel. 0788 237830.

ALBY CRAFTS LTD., Cromer Road, Alby, Norwich. Tel. 026-376 590.

GUY EADES, Lady Lodge Arts Centre, Orton Goldhay, Peterborough PE2 0JQ. Tel. 0733 237073.

OAKWOOD ARTS CENTRE, Friars Walk, Market Place, Maldon. Tel. 0621 52317.

PITSEA STUDIOS, (Basildon Arts Trust), c/o Basildon District Council, Council Offices, Fodderwick, Basildon SS14 1DR. Tel. 0268 22881. Contact: Ken Cotton (Chairman).

ST. ETHELREDA STUDIO, St. Ethelreda's Church, Duke Street, Norwich.

WALES

ASSOCIATION OF ARTISTS AND DESIGNERS IN WALES, Gaskell Buildings, Collingdon Rd., Cardiff. Vanessa Webb. Available to AADW members only. Also 54b Bute St, Butetown, Cardiff.

CHAPTER ARTS CENTRE, Market Road, Canton, Cardiff. Tel. 0222 396061.

Artist's studio (Heather Waddell)

130

SCOTLAND

SCOTTISH SCULPTURE WORKSHOP, 1 Main Street, Lumsden, Huntly, Aberdeenshire. Tel. Lumsden 372 (Frederick Bushe).

WASPS (Workshop and Artists' Studio Provision Scotland), 22 King Street, Glasgow G1 5QP. Tel. 041-552 0564. WASPS is an independent organisation which receives funding from the Scottish Arts Council for the purpose of assisting artists by providing studios and workshops and studio conversion grants.
Studios and Workshops: WASPS refurbishes to a basic non-equipped standard large studio blocks. These are sublet to artists on a monthly basis at low rents. There are at present 100 studio spaces for artists in Glasgow, Edinburgh and Dundee. A sculpture workshop equipped for use, and offering residential facilities has been established in Aberdeenshire.
New Studio Conversion Grants: Groups of two or more artists who wish to establish and run their own studios can apply for up to £300 per artist towards 75% of decoration and refurbishing costs. The artists are expected to bear all subsequent running costs.
Also WASPS, Patriot Hall, Hamilton Place, Stockbridge, Edinburgh. Tel. 031-225 1289. Studios and exhibition space for tenant artists.
ARTSPACE STUDIOS, 37 Belmont Street, Aberdeen. Tel. 0224 50126.

PRINT STUDIOS

All of these studios have either a membership scheme or access for professional printmakers.

GLASGOW PRINT STUDIO WORKSHOP AND GALLERY, 22 King Street, Glasgow G1 5QP. John Mackechnie.

DUNDEE PRINTMAKERS WORKSHOP, Dudhope Arts Centre, St May Place, Dundee.

KIRK TOWER HOUSE WORKSHOP, Kirkton of Craig, Montrose, Scotland.

EDINBURGH PRINTMAKERS WORKSHOP, 23 Union Street, Edinburgh. Tel. 031-557 2479.

PEACOCK PRINTMAKERS, 21 Castle Street, Aberdeen. Tel. 0224 51539.

ARGUS STUDIOS, Columbia House, Stisted, Braintree, Essex. Tel. 0376 25444.

BURLEIGHFIELD PRINTMAKING STUDIOS, Burleighfield House, Loudwater, High Wycombe, Bucks. Tel. 0494 25068.

ADVANCE GRAPHICS, 75 Tooley Street, London SE1. Tel. 01-407 4554.

NORTHERN PRINT, 5 Charlotte Square, Newcastle-on-Tyne. Tel. 091-227 531.

MITCHELL STREET PRINT STUDIOS, 39 Mitchell Street, London EC1. Tel. 01-253 8930.

LONDON CONTEMPORARY ART, 132 Lots Road, London SW10 0RJ. Tel. 01-351 7696/7. 300 new editions a year.

JANE ANDERSON, Stone lithography, Studio 62a, Southwark Bridge Rd, London SE1. Tel. 01-928 8956. Editioning, short courses, classes, access say in stone lithography.

NORTH LONDON LITHOGRAPHY STUDIO, Offset lithography press. Specialist tuition, editioning. Tel. 01-249 4430 (after 6pm). 3 Aden Grove, Newington Green, London N16 9NP.

MID WALES INTAGLIO, Bridge Street, Corris, Nachynlleth, Powys, Wales.

OLD ST ETCHING CO, 39 Mitchell Street, London EC1. Tel. 01-253 8930.

SOUTH HILL PARK ARTS CENTRE, Bracknell, Berkshire. Tel. 0344 27272.

NORTH STAR STUDIOS, 65 Ditchling Road, Brighton, Sussex. Tel. 0273 601041.

BELFAST PRINT WORKSHOP, 181a Stranvillis Road, Belfast BT9 5AU. Tel. 663591. Contact: Jim Allen, Print Workshop Manager.

BRISTOL PRINTMAKING WORKSHOP, The MacArthur Building, Gas Ferry Road, Bristol 1.

MOORLAND HOUSE PRINTMAKING WORKSHOP, Burrowbridge, Nr Bridgwater, Somerset. Tel. 082 369200.

AADW PRINT WORKSHOP, Tyndall Street, Cardiff, S Glamorgan. Tel. 0222 374049.

CHAPMANSLADE PRINT WORKSHOP, 107 High Street, Chapmanslade, Wiltshire. Tel. 037388 269.

THE GRAPHIC STUDIO, 18 Upper Mount Street, Dublin, Eire. Tel. 0001 766 149.

PRINT WORKSHOP, 36 Mount Pleasant Square, Dublin, Eire.

YORKSHIRE PRINTMAKERS LTD., The Gate House, Globe Mills, Victoria Road, Leeds 11.

BRIDEWELL PRINT WORKSHOP, Bridewell Studios, The Old Police Station, Prescot Street, Liverpool 17. Tel. 051-260 6770.

PADDINGTON PRINTSHOP, 1 Elgin Avenue, London W9 3PR Tel. 01-286 1123. Artists editions, equipment hire, silkscreen, print exhibitions on a carnival theme.

PALM TREE EDITIONS, Mornington Court, 1 Arlington Road, London NW1. Tel. 01-388 3952.

PRINT WORKSHOP, 28 Charlotte Street, London W1. Tel. 01-636 9787.

PRINTERS INK AND ASSOCIATES, 27 Clerkenwell Close, Unit 355, London EC1. Tel. 01-251 1923.

THE ROSENSTIEL ATELIER, 33/35 Markham Street, Chelsea Green, London SW3. Tel. 01-228 8330.

LOWICK HOUSE PRINT WORKSHOP, Lowick Green, Near Ulverston, Cumbria LA12 8AX. Tel. 0229 85698.

STUDIO PRINTS, 199 Queens Crescent, London NW5. Tel. 01-485 4527.

WHITE INK LTD., 2 Shelford Place, London N16. Tel. 01-254 8566.

IAN BRICE, 5th Floor, Warehouse D, Wapping Wall, London E1. Freelance lithographic printing.

OXFORD PRINTMAKERS CO-OPERATIVE, Christadelphian Hall, Tyndale Road, Oxford. Tel. 0865 726472.

PENWITH PRINT WORKSHOP, Back Road West, St Ives, Cornwall. Tel. 0736 795 579.

BRACKEN PRESS, 2 Roscoe Street, Scarborough, N. Yorkshire. Tel. 0723 71708.

CRESCENT ARTS WORKSHOP, The Art Gallery, The Crescent, Scarborough.

CURWEN STUDIO, Midford Place, 114 Tottenham Court road, London W1. Tel. 01-387 2618.

DOG'S EAR STUDIO, F3 Warehouse, New Crane Wharf, Wapping, London E1. Tel. 01-481 9563.

NEW CRANE STUDIO, E4 Warehouse, New Crane Wharf, Garnet Street, London E1. Tel. 01-488 1819.

OMELETTE PRESS, 18 Phipps Street, London EC2.

PALM TREE EDITIONS, The Basement, Mornington Court, 1 Arlington Road, London NW1. Tel. 01-388 3952.

MANCHESTER ETCHING WORKSHOP, 3/5 Union Street, Manchester. Tel. 061-832 5439.

MANCHESTER PRINT WORKSHOP, University of Salford, Meadow Road Building, Salford. Tel. 061-736 5843.

PRINT WORKSHOP, Gainsborough House, 46 Gainsborough Street, Sudbury, Suffolk. Tel. 0787 72958.

PRINT WORKSHOP, Northern Centre for Contemporary Art. 17 Grange Terrace, Stockton Road, Sunderland. Tel. 091-514 1214.

MOAT LANE EDITIONS, Taynton, Gloucester. Tel. 045-279 465.

DOLF REISER, 98 Sumatra Road, London NW6. Tel. 01-435 4768. Open to professional printmakers. Dolf Reiser trained with Hayter in Paris.

PRINT WORKSHOPS WITHIN THE EASTERN REGION

GAINSBOROUGH'S HOUSE PRINT WORKSHOP, Gainsborough Street, Sudbury, Suffolk. Tel. 0787 72958. Contact: Hugh Belsey, Curator. Etching, relief printing, lithography, screen printing. Reciprocal membership with the Minories Print Workshop (see below). Occasional courses.

THE MINORIES, 74 High Street, Colchester, Essex CO1 1UE. Tel. 0206 577067. Contact: Jeremy Theophilus, Director. Etching, screen printing, process photography. Reciprocal membership with Gainsborough's House Print Workshop. Also workshops for photography, film and video.

LUTON COMMUNITY ARTS TRUST, 33 Guildford Street, Luton, Beds. Tel. 0582 419584. Contact: Tim Powell. Screen printing. Also workshops for photography, film and video.

LADY LODGE ARTSCENTRE, Orton Goldhay, Peterborough. Tel. 0733 237073. Contact: Richard Pinkney, Director. Screen printing. Also workshops for photography, textiles, woodwork. Continuous programme of courses.

PRINT STUDIO, Knighton Lane Group (rear of) 68 Knighton Lane, Aylestone, Leicester.

DIGSWELL ARTS TRUST, Digswell House, Monks Rise, Welwyn Garden City, Herts AL8 7NT. Tel. 070 73 21506 (between 10am and 2pm). Contact: Annalisa Columbara, Resident Printmaker. Etching, screenprinting, process photography by arrangement.

PREMISES, Norwich Arts Centre, Reeves Yard, St Benedict's Street, Norwich NR2 4PG. Tel. 0603 60352. Contact: Michael Monaghan, Administrator. Silk screen by arrangement.

THE CHILFORD HALL PRESS, Chilford Hall, Linton, Cambridge. Tel. 0223 892641 or 311511. Contact: Kip Gresham, Artist and Printer. Screenprinting and etching. Private organisation offering printmaking facilities for artists, and publishing and co-publishing services.

FILM AND VIDEO WORKSHOPS

LONDON

ACTIVISION STUDIOS, Unit 20, St James Wharf, All Saints Street, London N1. Tel. 01-833 4488/837 7842. Danny Crilly, Rod Iverson, Karen Knaggs, Francis Martin. Film/video production and distribution. Offers both these facilities to others. Output includes innovative documentaries on 'representation in the media' (*We Ourselves Speak* and *Judge, Jury and Executioner*), Northern Ireland (*Legacy of Tone*), policing strategies (*Tried and Tested*). Also reggae musical *Big, Broad and Massive*. Other productions range from corporate and pop promotions to informational tape/slides. Extra services include video archive and organising screenings.

ALBANY VIDEO, The Albany, Douglas Way, London SE8 4AG. Tel. 01-692 0231. Tony Downmunt.

ANARRES VIDEO, 10a Bradbury Street, London N16. Tel. 01-249 9212. Max Cole. Video production and distribution. Offers these and exhibition facilities to others. Works on industrial and broadcast formats. Campaign and information tapes. In-house editing facilities available.

APHRA VIDEOS, The Diorama, 14 Peto Place, London NW1. Tel. 01-935 5365. Rebecca Maguire. Women's video co-operative producing commissions from women's and community groups. Training for women only in VHS skills and specialised areas like writing and directing.

BLACK AUDIO FILM COLLECTIVE, 89 Ridley Road, London E8 2NH. Tel. 01-254 9527/9536.

Lina Gopaul, Avril Johnson. Film/video production, distribution and exhibition. Offers all these facilities to others. Provides training in 16mm film format and consultancy services in the field of Black film making. Produced *Handsworth Songs* in 1986.

BLACK VISION, 649 High Road, London N17 8AA. Tel. 01-801 8896. Low-band U-Matic recording and editing facilities. Productions include *Taste of Carnival, Reggae Starwars* and *Alan Boesak Speaks.*

CEDDO FILM AND VIDEO WORKSHOP, First Floor, South Tottenham Education and Training Centre, Braemar Road, London N15 5EU. Tel. 01-802 9034. June Reid, Dennis Davis, Ujebe Masokoane. Film/video production, distribution and exhibition. Offers all these facilities to others. Provides training workshops in film and video, organises screenings and discussions and is currently establishing an archive. Productions include *Street Warriors, The People's Account* and *We are the Elephant.*

CINEMA ACTION, 27 Winchester Road, London NW3. Tel. 01-586 2762. Ann Lamche. Film/video production, distribution and exhibition. Offers all these facilities to others. Productions include *Rocking the Boat, So That You Can Live, The Miners' Film, People of Ireland, Film from the Clyde* and *Rocinante.*

CINESTRA PICTURES, Co-op Centre, 11 Mowll Street, London SW9 6BG. Tel. 01-793 0157.

CLIO CO-OP, 91c Mildmay Road, London N1. Tel. 01-249 2551.

CONNECTIONS, Palingswick House, 241 King Street, Hammersmith, London W6 9LP. Tel. 01-741 1766/7. Nicola Moody, Dave Barnard. Film/video production, distribution and exhibition. Offers all these facilities to others. Also runs regular training courses.

CONVERSE PICTURES, Bon Marche Building, 444 Brixton Road, London SW9 8EJ. Tel. 01-274 4000/7335570. Film/video production, distribution and exhibition. Offers production facilities to others. Co-operative which specialises in producing work on equality issues. Also acts as information/contact resource for lesbian and gay film/video makers and photographers.

CO-OPTION WOMEN'S FILM AND VIDEO GROUP, 27 Clemence Street, London E14. Tel. 01-987 3224. Jeanette Iljon.

FACTION FILMS, 28–29 Great Sutton Street, London EC1. Tel. 01-608 0654. Sylvia Stevens. Group of socialist filmmakers with a broad range of interests in film and TV production. film/video

Basil Beattie print, Curwen Gallery, London W1.

production, distribution and exhibition. Offers production facilities to others, having a 6-plate Steenbeck, 16mm edit suite. Titles include *Irish News: British Stories, The Year of the Beaver* and recent production Picturing in Derry.

FILM WORK GROUP, 4th Floor, 79–89 Lots Road, London SW10. Tel. 01-352 0538. Cathy Creed, Nigel Perkins, Clive Myer. Film/video production and distribution. Offers production and post-production facilities to others with special rates for grant-aided and non-profit groups.

FILMS AT WORK, 5th Floor, North Riverside, Metropolitan Wharf, Wapping Wall, London E1. Tel. 01-480 7078.

FOUR CORNERS, 113–115 Roman Road, London, E2 0HU. Tel. 01-981 4243/6111. Maria Roberts, Jayne Knight. Film production and exhibition. Offers both these facilities to others.

FRONTROOM PRODUCTIONS, 79 Wardour Street, London W1E 3TH. Tel. 01-734 4603. Angela Topping. Film production and distribution. Offers production facilities to others. Productions (16mm) include *Acceptable Levels, Intimate Strangers, Ursula and Glenys* and *The Love Child.*

ISLAND ARTS CENTRE, Tiller Road Baths, Isle of Dogs, London E14. Tel. 01-987 7925. Alice Brett.

LAMBETH VIDEO, 245a Coldharbour Lane, London SW9 8RR. Tel. 01-737 5903. Susan Papas. Video production, distribution and exhibition. Offers production and exhibition facilities to others. Also runs training courses, a bursary scheme and produces a local black video magazine.

LATIN AMERICAN INDEPENDENT FILM AND VIDEO MAKERS ASSOCIATION (Casa de la Cultura Latino-Americano), Latin American House, Kingsgate Place, London NW6 4TA. Tel. 01-372 6442. Any Florin.

LONDON FILMMAKERS' CO-OP, 42 Gloucester Avenue, London NW1. Tel. 01-586 4806. Susie Nottingham. Film-video production, distribution and exhibition. Offers all these facilities to others. Accent on experimental and art-based films.

LONDON VIDEO ARTS, 23 Frith Street, London W1V 5TS. Tel. 01-437 2786/734 7410. James Gormley, Atalia Shaw. Video production, distribution and exhibition. Offers all these facilities to others. Offers training courses in video production and post-production.

LUSIA FILMS, 7–9 Earlham Street, London WC2. Tel. 01-240 2350. Marc Karlin, Melanie Chait.

MOONSHINE COMMUNITY ARTS WORKSHOP, 1090 Harrow Road, London NW10 5XQ. Tel. 01-960 0055. Jeff Lee. Offers video production, distribution and exhibition facilities to others. Provides training in production and post-production with U-Matic edit suite and special effects. Works with Brent-based groups and individuals with emphasis on young people and black

community groups producing documentaries and video art.

NEW CINEMA WORKSHOP, Link House, 110 Mansfield Road, Nottingham. Tel. 0602 584891. Jeff Baggott. Offers film/video production and exhibition facilities to others. Also offers training workshops and information to independent film and video makers.

NEWSREEL COLLECTIVE, 4 Denmark Street, London WC2H 8LP. Tel. 01-240 2216. Sylvia Hines. Film/video distribution. offers production facilities to others.

PICTURES OF WOMEN, The Pavement, London SW4. Tel. 01-720 2240.

PIMLICO ARTS AND MEDIA SCHEME, 1–3 Charlwood Street, London SW1Y 2ED. Tel. 01-630 6409. David Drake, James Morris, Jenni Crane, Anne Mitchard. Video production, distribution and exhibition. Offers production facilities to others. Runs production-based courses for unemployed and Videotech—a technical and vocational course for under 25s.

PLATFORM FILMS, 13 Tankerton House, Tankerton Street, London WC1. Tel. 01-278 8394. Chris Reeves. Film/video production and distribution. Work aims to reflect issues within the labour and trade union movement.

RETAKE FILM AND VIDEO COLLECTIVE, 25 Baytham Street, London NW1 0EY. Tel. 01-388 9031/9032. Mahmood Jamal. film/video production, and distribution. Offers both these facilities to others. Productions include *Majdhar, Living in Danger, Environment of Dignity* and *Sanctuary Challenge.* Also holds training courses.

SANKOFA, Unit 5 Cockpit Yard, Northington Street, London WC1. Tel. 01-831 0024. Martina Attile, Maureen Blackwood, Robert Crusz, Isaac Julien, Nadine Marsh-Edwards. Film/video production and distribution. Offers production facilities to others, runs training workshops in film and video. Organises screenings and discussions. Produced *The Passion of Remembrance* in 1986.

STAR PRODUCTIONS, 61 Thistlewaite Road, London E5 0QG. Tel. 01-986 4470. Raj Patel. Film/video production. Offers production and exhibition facilities to others. Specialises in working from an Asian perspective.

THE TELEVISION CO-OPERATIVE, 7 Strath Terrace, London SW11. Tel. 01-323 1285/223 4951. John Underwood.

WEST LONDON MEDIA WORKSHOP, 118 Talbot Road, London W11. Tel. 01-221 1859. Janet Potter, Susannah Lopez, Ka Choi, John Goff. Video production, distribution and exhibition. Offers production facilities to others. WLMW runs a bursary scheme aimed to encourage new makers to debate various cultural/ social issues.

WIDE ANGLE FILM AND PHOTOGRAPHY WORKSHOP, c/o Birmingham Community Association, Jenkins Street, Small Heath, Birmingham B10 0HQ. Tel. 021-772 2889. Hossein Mirshahi, Pauline Walton. Video production and

exhibition. Open-access workshop offering training in video and photography. Offers production facilities.
WOMEN IN SYNC, Units 5 and 6, Wharfdale Products, 47–51 Wharfdale Road, London N1. Tel. 01-278 2215. Rose, Pelin, Sarah, Patricia. Women's video workshop offering production, post-production, screenings, training and advice.
WOMEN'S MEDIA RESOURCE PROJECT (WEFT), 85 Kingsland High Street, London E8 2PB. Tel. 01-241 3155. Offers sound engineering courses, video exhibition equipment and women only screenings.

ABERYSTWYTH
ABERYSTWYTH MEDIA GROUP, The Barn Centre, Alexandra Road, Aberystwyth, Dyfed, Wales. Tel. 0970 4001. Catrin Davies. Film/video production, distribution and exhibition. Offers all these facilities to others. Comprises both Welsh and English speaking members whose work is directly related to media education in rural Wales.

ALVA
ALVA FILMS, Island House, 16 Brook Street, Alva, Clackmannanshire FK12 5JL. Tel. 0259 60936. Russell Fenton, Bill Borrows. Film/video production, distribution and exhibition. Offers all these facilities to others. Work includes BBC and Channel 4 film *Hallaig* and videos. *The Enemy Within* and *The BDBD Zap Video*. In post-production is the film *Tree of Liberty*.

BELFAST
BELFAST FILM WORKSHOP, 37 Queen Street, Belfast BT1 6EA. Tel. 0232 226661. Alastair Herron, Kate McManus. Only film co-operative in Norther Ireland. Film/video production and exhibition. Offers both these facilities to others.
DERRY FILM AND VIDEO, 36 William Street, Derry City, Belfast BT48 6ET. Tel. 0504 260128. Margo Harkin.

BIRMINGHAM
BIRMINGHAM FILM AND VIDEO WORKSHOP, 60 Holt Street, Birmingham B7 4BA. Tel. 021-359 5545/4192/0515. Roger Shannon, Rob Burkitt. Film/video production, distribution and exhibition. Offers production and distribution facilities to others. Recent productions include *Giro*, *Are you being Served Well* and the Channel 4 series *Turn it Up*. New catalogue and handbook available on application.
MACRO FILMS, 364 Soho Road, Handsworth, Birmingham B21 9QL. Tel. 021-523 8272/3. Don Shaw. Video production, distribution and exhibition. Production and distribution facilities offered to others.
2ND SIGHT, The Friends Institute, 220 Moseley Road, Highgate, Birmingham B12 0DG. Tel. 021-440 2985. Dylis Pugh, Glynis Powell, Claire Hodson. Film/video production and exhibition. Offers

both these facilities to others. Aims to facilitate production and provide training and information resources for women.
STUDIO NINE COMMUNITY VIDEO STUDIO, Monyhull Hall Road, Kings Norton, Birmingham B30 3BQ. Tel. 021-444 4750.
TURC VIDEO, 7 Frederick Street, Birmingham B1 3HE. Tel. 021-233 4061. Marian Hall. Video production, distribution and exhibition. Offers all these facilities to others. Works mainly on trade union and minority issues, locally and nationally.
TU/TV, Second City Studios, 855 Bristol Road, Birmingham B29 2CV. Tel. 021-471 2993. Dave Rushton, John Williams.
WOMEN'S AUDIO-VISUAL RESOURCE, (Formerly Women's Film Consortium) Unit 15, Devonshire House, High Street, Digbeth B12 0LP. Tel. 021-773 9306. Produces and exhibits film/video for women's and girls' groups and other groups undertaking anti-sexist and anti-racist work. Arranges screening days.

BLAENGARW
VALLEY AND VALE COMMUNITY ARTS, Blaengarw Working Men's Hall, Blaengarw, Mid-Glamorgan. Tel. 0656 871911. Phil Cope.

BOSTON
BLACKFRIARS ARTS CENTRE, Spain Lane, Boston, Lincolnshire PE21 6HP. Tel. 0205 63108. Tim Diggles. Film/video production and exhibition. Offers exhibition facilities to others. Plans to group together film, video, photography and mixed media arts.

BRACKNELL
THE MEDIA CENTRE, South Hill Park, Bracknell, Berks RG12 4PA. Tel. 0344 427272. Barrie Gibson, Mark Jeffery, Kim Clancy, Bob Gibbs. Video production, distribution and exhibition. Offers all these facilities to others. Publishes independent video magazine. Organises annual National Festival of Independent Video and runs national courses for independent videomakers.

BRIGHTON
BAREFOOT VIDEO, 50 Brunswick Street, West Hove, Sussex BN2 1EL. Tel. 0273 773206. Claire Hunt, Su Braden, Trudi Davies, Kim Longinotto. Film/video production, distribution and exhibition. Offers production and distribution facilities to others. Integrates access to production skills for groups and non-governmental organisations with commissions. Broadcast productions for Channel 4 include *Health or Human Rights... A Happier Old Age?* and *Life on the Line*.
LIGHTHOUSE FILM AND VIDEO, (Formerly Brighton Film and Video Workshop), 19 Regent Street, Brighton BN1 1UL. Tel. 0273 686479. Peter Milner. Film/video productin and exhibition. Offers some training and production facilities to others.

BRISTOL

BRISTOL COMMUNITY VIDEO UNIT, 7-9 Lawford Street, St. Phillips, Bristol BS2 0DH. Tel. 0272 552968. Jayne Cotton.

BRISTOL FILM WORKSHOP, 37-39 Jamaica Street, Bristol BS2 8JP. Tel. 0272 426199. Mike Leggett, Frank Passingham.

FORUM TELEVISION, 108c Stokes Croft, Bristol BS1 3RU. Tel. 0272 40764. David Parker. Co-operative with some emphasis on South West. Film/video production, distribution and exhibition. Offers distribution and exhibition facilities to others. Recent work has involved contemporary and historical issues around work, unemployment and the Labour Movement.

WOMEN IN MOVING PICTURES, Unit 3a, Central Trading Estate, Bath Road, Brislington, Bristol BS4 3EH. Tel. 0272 518682/426706. Pauline Battson, Jane Roberts, Penni Russell. Mainly video production and exhibition. Offers both these facilities to others. Specialises in working with women and people with mental and physical disabilities. Organises distribution for others.

BUILTH WELLS

WYESIDE ARTS CENTRE, 13 Castle Street, Builth Wells, Powys, LD2 3BN. Tel. 0982 552555/553668. Paul Brown. Video production, distribution and exhibition. Offers all facilities to others. runs workshops with local schools.

CAERNARVON

GWEITHDY FFILM A FIDIO CYMUNEDOL SCRIN (COMMUNITY SCREEN FILM AND VIDEO WORKSHOP), 12 Palace Street, Caernarvon, Gwynedd CL55 1AG. Tel. 0286 5055.

CAMBRIDGE

CAMBRIDGE WOMEN'S RESOURCE CENTRE, 7c Station Road, Cambridge CB1 2JB. Tel. 0223 321148. Jane Butcher.

CANTERBURY

FILMSHED, 9 Mill Lane, Canterbury, Kent. Tel. 0227 69415. Tim Reed. Open-access collective for the promotion and production of independent film. Film production and exhibition. Offers exhibition facilities to others; filmmakers on tour and regular screenings of political/workshop films.

CARDIFF

BLACK FILM AND VIDEO WORKSHOP IN WALES, 1st Floor, 4 Dock Chambers, Bute Road, Butetown, Cardiff. Tel. 0222 499835. Charles Thompson.

CHAPTER FILM WORKSHOP, Chapter Arts Centre, Market Road, Canton, Cardiff CF5 1QE. Tel. 0222 396061. Christine Wilks, Carol Salter. Film production, distribution and exhibition. Offers production and exhibition facilities to others. Provides training courses in 16mm, Super live-action and animation film production and holds seminars on media and independent film and video.

CHAPTER VIDEO WORKSHOP, Chapter Arts Centre, Market Road, Canton, Cardiff. CF5 1QE. Tel. 0222 396061. John Drysdale. Video production, distribution and exhibition. Offers production facilities to others. Working with community organisations and trade unions on social, political and cultural issued.

SOUTH WALES WOMEN'S FILM GROUP (GRWP FFILMIAU MENYWOD DE CYMRU), c/o Chapter Arts Centre, Market Road, Canton, Cardiff. Tel. 0222 396061. Sol Jorgenson, Andrea Williams, Helen Catermole. Twenty women actively concerned with issues of representation of women via low-budget film and video production, screenings and discussions. Works in production, distribution and exhibition. Recent screenings include a season of films 'Heroines', at Chapter Cinema.

COLCHESTER

COLCHESTER FILMMAKERS' WORKSHOP, The Minories, 74 High Street, Colchester CO1 1UE. Tel. 0206 560255. Carol Comley. Film/video production and exhibition. Offers both these facilities to others. Provides a wide variety of film and video training opportunities and produces the quarterly community video magazine 'Switch' for North-East Essex.

COVENTRY

CUTTING EDGE VIDEO UNIT, 15 Arches Industrial Estate, Coventry. Tel. 0203 79764.

DONCASTER

DONCASTER FILM GROUP, Walney House, Greengate, Epworth, Doncaster. Tel. 0427 873995. Stewart Hibbert. Film/video production. Offers production facilities to others. Group's main emphasis on productions of a collaborative nature and on training. Setting up VHS/U-Matic edit suite this year.

EDINBURGH

FILM WORKSHOP TRUST, 17 Great King Street, Edinburgh EH3 6QW. Tel. 031-556 2078. David Halliday, Sarah Noble, Graham Maughan. Film/video production and distribution. Offers production facilities to others. Also provides training for community groups in issues such as defence and nuclear power, womens' issues and environmental politics. Titles for Channel 4 include *Site One: Holy Loch* and *Northern Front*.

FILM WORKSHOP TRUST ANIMATION WORKSHOP, c/o Theatre Workshop Arts Centre, 34 Hamilton Place, Edinburgh EH3 5AX. Tel. 031-557 7942. Jessica Langford. Film/video production and distribution. Offers production facilities to others.

VIDEO IN PILTON, 30 Ferry Road Avenue, West Pilton, Edinburgh.

EXETER
EXETER FILM WORKSHOP, c/o Exeter and Devon Arts Centre, Bradninch Place, Gandy Street, Exeter EX4 3LS. Tel. 0392 218928. Joyce McCarthy. Film/video production, distribution and exhibition. Offers all these facilities to others. Holds training courses in film and video productions as well as teaching in schools.

FALMOUTH
FALMOUTH FILM AND VIDEO WORKSHOP, Falmouth Building, Bank House, Bank Close, Falmouth, Cornwall TR11 4AT. Tel. 0326 316104. Lee Berry.

GATESHEAD
SWINGBRIDGE VIDEO, 10a Bridge Street, Gateshead, Tyne and Wear NE8 2BH. Tel. 091-477 6680. Sarah McCarthy, Hugh Kelly, Gev Pringle. Video production, distribution and exhibition. Offers production facilities to others.
TRADE FILMS, 36 Bottle Bank, Gateshead, Tyne and Wear NE8 2AR. Tel. 091-477 5532. Derek Stubbs. Film/video production, distribution and exhibition. Offers production and distribution facilities to others. Workshop comprises two production units. Trade Films (fiction/documentary) and Northern Newsreel (current affairs), together with the Northern Film and Television Archive.

GLASGOW
GLASGOW FILM AND VIDEO WORKSHOP, Dolphin Arts Centre, 7 James Street, Bridgeton, Glasgow. G40 1HY. Tel. 041-554 7449. Graham Barbour.

HULL
HULL TIMES BASED ARTS, c/o 11 Salisbury Street, Hull, North Humberside HU5 3HA. Tel. 0482 447510. Joanna Millett, Rob Gawthrop. Film/video production and exhibition. Offers exhibition facilities to others. Works with experimental film, video, performance and music. Intends to provide equipment, workshop facilities and exhibition space.
OUTREACH COMMUNITY ARTS, (Formerly Hull Film and Video Workshop) Northumberland Avenue, Hull HU2 0LN. Tel. 0482 226420. Tony Hales. film/video production, distribution and exhibition. Offers production and exhibition facilities to others. Holds regular training workshops.

IPSWICH
IPSWICH MEDIA PROJECT, 'Bluebell' Fun Wharf, Deben Road, Woodbridge, Suffolk. Tel. 0394 411406. Lindsay Hall.

LEEDS
LEEDS ANIMATION WORKSHOP, 45 Bayswater Row, Leeds LS8 5LF. Tel. 0532 484997. Janis Goodman. A women's collective working in film production, distribution and exhibition. Offers distribution facilities to others. Productions include *Who Needs Nurseries—We Do, Risky Business, Pretend You'll Survive, give Us a Smile, Council Matters* and *Crops and Robbers.*
VIDEO VERA, PO Box HP5, Leeds LS6 2ED. Tel. 0532 717460. Alison Garthwaite.
YORKSHIRE FILM AND VIDEO CENTRE, Hall Place Studios, 4 Hall Place, Leeds LS9 8JD. Tel. 0532 405553. Alf Bower, Mick Houlder. Open membership resource and training centre on 16mm and video, including studio, film dubbing, rostrum, editing, cameras, sound and lights.

LEICESTER
AVID PRODUCTIONS, Keswick House, 30 Peacock Lane, Leicester LE1 5NF. Tel. 0533 539733.
LEICESTER INDEPENDENT FILM AND VIDEO ASSOCIATION, 11 Newarke Street, Leicester LE1 5SS. Tel. 0533 559711. Laraine Porter, Malcolm Ellis. Film/video production, distribution and exhibition. Offers production and exhibition facilities to others. Holds annual International Super 8 Film Festival on new British and international Super 8 films with workshops and seminars.

LEIGH
MEDIA EDUCATION CENTRE, Leigh College, Railway Road, Leigh WN7 4AH. Tel. 0942 608811 × 241/301. Helen Woodward, Julie Cox, Carol Dahl. Provides video production and exhibition facilities for schools, colleges and local community groups. Facilities include community cinema/small TV studio, teachers resource material and adviser team with technical support.

ISLE OF LEWIS
FRADHARE UR, Rosebank, Church Street, Stornoway, Isle of Lewis. Tel. 0851 81701. Culum MacDhonnaodh.

LLANDRIDROD WELLS
POWYS VIDEO PROJECT, Drama Centre, Tremont Road, Llandridnod Wells, Powys. Tel. 0597 4444.

LIVERPOOL
COMMUNITY PRODUCTIONS, Merseyside Innovation Centre, 131 Mount Pleasant, Liverpool L3 5TF. Tel. 051-708 5767. Clive Pepe.
LIVERPOOL BLACK MEDIA GROUP, 64 Mount Pleasant, Liverpool L3 5SH. Tel. 051-709 2321. Michael Greenidge.
OPEN EYE FILM AND VIDEO, 90–92 Whitechapel, Liverpool L1 6EN. Tel. 051-709 9460.
WITCH (Women's Independent Cinema House) 90–92 Whitechapel, Liverpool L1 6EN. Tel. 051-709 3087. Judy Mason Seal, Ann Carney. Film/video production, distribution and exhibition. Workshops in film, video, photography, animation, sound. Offers advice and some screenings.

LUTON
33 FILM AND VIDEO GROUP, Luton Community Arts Trust, 33 Guildford Street, Luton, Beds.

Tel. 0582 21448. Dermot Byrne, Jean McClements.

MANCHESTER
COUNTER IMAGE, 19 Whitworth Street West, Manchester M1 5WG. Tel. 061-228 3551. Independent arts charity. Film/video production, distribution and exhibition. Offers production and exhibition facilities to independent filmmakers and photographers. Productions include *Fever House* and *Land of Cologne.*
MANCHESTER COMMUNITY TV, 100 Palmerston Street, Ardwick, Manchester. Tel. 061-273 1763. Sue Kimpton.
WORKERS' FILM ASSOCIATION, Media and Cultural Centre, 9 Lucy Street, Manchester M15 4BX. Tel. 061-848 9785. Wowo Wauters, Rosemary Orr.

MIDDLESBOROUGH
SIREN FILM AND VIDEO CO-OP, c/o 10a Albert Road, Middlesbrough, Cleveland. Tel. 0642 221298. Dave Eadington, Sally Constant. Film/video production, distribution and exhibition. Offers production facilities to others. Workers' co-operative producing for community groups and television. Recent titles include *Shipbuilding on Wearside* and *The Afro-West Indian Community in Middlesbrough.*

NEWCASTLE UPON TYNE
AMBER SIDE WORKSHOP, 5 Side, Newcastle-upon-Tyne NE1 3JE. Tel. 091-232 2000. Murray Martin. film/video production, distribution and exhibition. Offers exhibition facilities to others.
CONNEXIONS, Third Floor, 18–20 Dean Street, Newcastle-upon-Tyne NE1 1PG. Tel. 091-261 6581/4163. Clare Segal. Video production and distribution. Offers production facilities to others. Concentrates on producing promotional and training videos for public and voluntary sector. Undertakes straight forward commissions or works alongside client.
MAGINATION MEDIA, 12 Northumberland Avenue, Forest Hall, Newcastle-upon-Tyne NE12 9NR. Tel. 091-266 8044. Annie Lockwood. Women's collective. Video production and distribution. Uses video to promote discussions on issued affecting women.
MIDNIGHT TIME PRODUCTIONS, 46 Salisbury Gardens, Newcastle-upon-Tyne NE2 1HP. Tel. 091-281 3031. Mark Lavender. Grant-aided voluntary organisation. Film/video production, distribution and exhibition. Offers all these facilities to others. Gives amateurs the opportunity to work with film and video professionals.
NEWCASTLE MEDIA WORKSHOPS, 67–75 Westgate Road, Newcastle-upon-Tyne NE1 1SG. Tel. 091-232 2410. Sue Griffiths. Video production, distribution and exhibition. Offers distribution and exhibition facilities to others. Archive and library resources.
OUTLINE ARTS TRUST, 1 Lesbury Road, Heaton, Newcastle-upon-Tyne NE6 5LB. Tel. 091-276

3207. Kate Hancock. A community arts trust using video mostly for very specific and local use.
RESEARCH TRAINING INITIATIVES, 18-20 Dean Street, Newcastle-upon-Tyne NE1 1PG. Tel. 091-261 6581/4163. Bernard Ross. Video production and distribution. Undertakes commissions for training material aimed at community and social workers, local activists, etc. Offer production facilities to others.

NORWICH
EAST ANGLIAN FILM MAKERS, 22–24 Colegate, Norwich NR3 1BQ. Tel. 0603 622313. David Hilton. Grant-aided film workshop, revenue funded by Eastern Arts and Norwich City Council. Film/video distribution, exhibition and some production facilities. Offers periods training courses and production and exhibition facilities to others.

NOTTINGHAM
AUDIO VISUAL ARTS, c/o Nottingham Video Project, 110 Mansfield Road, Nottingham. Tel. 0602 584891. Madelene Holmes, Chris Ledger. Women's media production and training co-operative. Art and education videos include *Short Sharp Shock, Alien Air, Art* and *Industry Tapes, Nature Lessons.*
ISTHMUS PRODUCTIONS, 14–18 St Mary's Gate, Nottingham NG1 1PF. Tel. 0602 585094.
NOTTINGHAM VIDEO PROJECT, 110 Mansfield Road, Nottingham. Tel. 0602 585891. Roger Suckling, Pat Silburn. Offers video production, distribution and exhibition facilities to others. Runs training courses on VHS recording and editing and U-Matic production.

OXFORD
OXFORD FILM MAKERS' WORKSHOP, The Stables, North Place, Headington, Oxford OX3 9HY. Tel. 0865 60074. Annie-Marie Sweeney. Film/video production, distribution and exhibition. Offers production facilities and film training to others.
OXFORD INDEPENDENT VIDEO, Pegasus Theatre, Magdalen Road, Oxford OX4 1RE. Tel. 0865 250150. Maddie Shepherd. Educational and community video project offering facilities to others.

PENZANCE
PENWITH WOMEN'S FILM AND VIDEO WORKSHOP, The Millhouse, Parade Street, Penzance, Cornwall TR18 2RL. Tel. 0736 66499. Helen Wood.

PETERBOROUGH
STUDIO ONE VIDEO, Lady Lodge Arts Centre, Orton Goldhay, Peterborough. Tel. 0733 237073. Clifton Stewart. Video production and exhibition. Offers both these facilities to others. Runs evening workshops for local video enthusiasts.

PLYMOUTH
PLYMOUTH FILM AND VIDEO WORKSHOP, Plymouth Arts Centre, 38 Looe Street, Plymouth. Tel. 0752 660060. Annett Kenp.

PONTYPRIDD
RED FLANNEL FILMS, 3 Ceridwen Terrace, Pontypridd, Mid Glamorgan. Tel. 0443 401743. Clare Richardson, Frances Bowyer, Michele Ryan, Carol White, Caroline Stone. Film/video production, distribution and exhibition. Offers all these facilities to others. Working towards productions with women in the South Wales valleys, through screenings, discussions and oral history projects. Developing an archive and video library.

PORTSMOUTH
PORTSMOUTH FILM AND VIDEO CO-OPERATIVE, The Hornpipe, Kingston Road, Portsmouth. Tel. 0705 861851. Chris Cheshire.
PORTSMOUTH VIDEO WORKSHOP, Portsmouth College of Art and Design, Winston Churchill Avenue, Portsmouth PO1 2DJ. Tel. 0705 826435 × 37. David Baker.

READING
REAL TIME VIDEO, 92a London Road, Reading, Berks. Tel. 0734 475909. Jackie Shaw, Clive Robertson. Process-based community access video workshop. Video production, distribution and exhibition. Offers exhibition facilities to others. Runs courses and workshops, organises screenings and projects.

SCUNTHORPE
PRAXIS FILMS, 24 Dunstall Street, Scunthorpe, South Humberside DN15 6LD. Tel. 0724 856333/047 283 547. John Goddard. Film/video production, distribution and exhibition. Offers all these facilities to others. Covers Eastern England, specialises in rural, sea and oral history concerns. Extensive rural archive.

SHEFFIELD
BANNER FILMS, 11 Swaledale Road, Sheffield S7 2BY. Tel. 0742 556875.
SHEFFIELD FILM CO-OP, Albreda House, Lydgate Lane, Sheffield S10 5FH. Tel. 0742 668857. Chrissie Stansfield. Women's workshop giving a voice to women's views on a wide range of issues. Film/video production and distribution. Also sells and hires productions, which include *Red Skirts on Clydeside, Changing Our Lives, Women of Steel, Let Our Children Grow Tall* and *For a Living Wage.*
SHEFFIELD INDEPENDENT FILM, 173 Howard Road, Walkley, Sheffield S6. Tel. 0742 336429. Colin Pons. A resource base for independent film and video makers in the Sheffield region. funded by Yorkshire Arts Association, BFI, Channel 4 and Sheffield City Council.
SHEFFIELD LIBRARIES COMMUNICATIONS UNIT, Central Library, Surrey Street, Sheffield S1 1XZ. Tel. 0742 734746. Georgia Stone, Andy Stamp. The Unit won the BFI's 1985 Paddy Whannel Award for initiatives in media education. Gaining international recognition for developing practical media techniques, particularly for educationalists. Offers broad training in media and communication skills.
STEEL BANK FILM CO-OP, Albreda House, Lydgate Lane, Sheffield S10 5FH. Tel. 0742 662583. Susie Field, Jessica York, Simon Reynell, Dinah Ward, Noemie Mendelle. Film/video production and distribution. Work includes documentaries, campaign tapes and fiction films such as *Winnie, Please Don't Say We're Wonderful, Learning Lessons* and *Security.*

SUNDERLAND
A19 FILM AND VIDEO, Suite 5, Central Buildings, West Sunniside, Sunderland SR1 1BA. Tel. 0783 655709. Mick Catmul, Nick Oldham, Alan Carter, Sue Kennedy. Video production, distribution and exhibition. Offers production facilities to others. Product reflects local social, economic and historical concerns. Training and advice to schools, community groups and institutions.

SUTTON-IN-ASHFIELD
SUTTON COMMUNITY VIDEO, 28 Lucknow Drive, Sutton-in-Ashfield, Notts NG17 4LS. Tel. 0623 558415. Clem Turff.

SWANSEA
WEST GLAMORGAN VIDEO AND FILM WORKSHOP, 29–31 Pembroke Buildings, Cambrian Place, Swansea SA1 1RQ. Tel. 0792 476441. Paul Taylor. Film/video production, distribution and exhibition. Offers all these facilities to others. Low-band and U-Matic video. Runs training courses. Welsh Arts Council funded.

SWINDON
THE MEDIA ARTS LAB, (Formerly Thamesdown Film and Video), Town Hall Studios, Regent Circus, Swindon SN1 1QF. Tel. 0793 26161 × 3140. Martin Parry. Workshop programme in a public media centre managed by users. Production, distribution and exhibition in film and video. Offers wide range of facilities to public. Involved in filmmakers' visits, education and training. gives production grants. Productions include *On Behalf of the People, Hardcore, Melting into the Countryside, Outsiders, Work It Out* and *Dyslexia Rules OK.*

TELFORD
TELFORD COMMUNITY ARTS, 48 Market Street, Oakengates, Telford, Shropshire TF2 6DU. Tel. 0952 619055. Graham Woodruff. Video production, distribution and exhibition. Offers workshops and training courses.

ULVERSTON
WELFARE STATE INTERNATIONAL, PO Box 9, Ulverston, Cumbria LA12 1AA. Tel. 0229 57146. Mike White, Howard Steel. A consortium

of artists, musicians, technicians and performers. Film/video production, distribution and exhibition. Output includes community feature films and work for television.

WEST BROMWICH
JUBILEE COMMUNITY ARTS, 84 High Street East, West Bromwich, West Midlands. Tel. 021-553 6862. Tony Stanley. Multi-media team working in Sandwell and West Midlands using video, photography, music, drama and visual art. Video production, distribution and exhibition. Offers all these facilities to others.

WOLVERHAMPTON
MEDIA CENTRE, Wolverhampton Art Gallery, Lichfield Street, Wolverhampton WW1 1DU. Tel. 0902 24549.
VOKANI, c/o Wolverhampton Art Gallery, Litchfield Street, Wolverhampton. Tel. 0902 24549. Exhibition, distribution and information network working in Black film and video culture.

WORKSOP
WORKSOP FILMS, c/o Nick Jones, 2 Spring Cottages, Cadhill, Leigh-upon-Mendip, Somerset. Tel. 0373 813067.

WORTHING
WORTHING FILM AND VIDEO WORKSHOP, Connaught Theatre, Union Place, Worthing, West Sussex BN11 1LG. Tel. 0903 200647/35334. Howard Johnson.

WREXHAM
WREXHAM COMMUNITY VIDEO, The Place in the Park, Bellevue Road, Wrexham, Clwyd. Eddie Meek. Video production, distribution and exhibition. Offers production and exhibition facilities to others. Runs short training courses in video production.

YORK
SPROCKETTES (York Film Women's Group), 8 The Crescent, Blossom Street, York. Penny Florence.
YORK FILM WORKSHOP, 8 The Crescent, Blossom Street, York YO2 2AW. Tel. 0904 641394. William Lawrence. Film/video production, a facility also offered to others. runs courses in media studies and film and video training.

PHOTOGRAPHIC WORKSHOPS

LONDON

BLACKFRIARS PHOTOGRAPHY PROJECT, 44 Nelson Square, London SE1. Contacts: Carol Webb, Barbara Hartley. Session fee plus materials. 10–5.30 weekdays plus evening sessions. Classes available.
LONDON NORTH PADDINGTON COMMUNITY DARKROOM, 510 Harrow Road, London W9. Tel. 01-969 7437. Contacts: Ulrike Preuss and Philip Nolmuth. Facilities available to anyone who lives or works in North Paddington. Open 10.30–6 Mon–Fri. Classes given. Part of a large community centre.
HALF MOON PHOTOGRAPHY WORKSHOP, 119–121 Roman Road, London E2. Tel. 01-980 8798. Contact: Richard Harris. Phone for details.

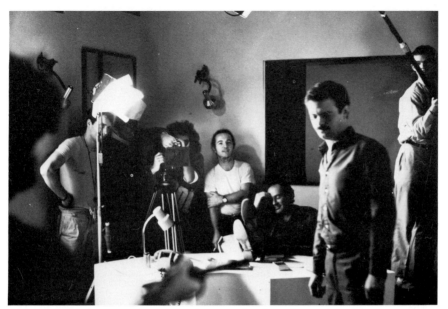

2nd year film students at work on 'State of Siege', Polytechnic of Central London (J. Hunningher)

ELSEWHERE IN THE UK

SOUTH HILL PARK ARTS CENTRE, South Hill Park, Bracknell, Berkshire. Tel. 0344 27272. £5 membership a year. Open 9–11 seven days a week. Classes available. Other film and video facilities available.

BATH CENTRAL CLUB, 6 Lower Boro' Walls, Bath, Avon. Contact: Martin Winson. Facilities open to all. Fee to cover costs and materials. Workshops arranged if needed.

ASTON UNIVERSITY CENTRE FOR THE ARTS, Gosta Green, Birmingham. Tel. 021-359 3979. Contact: Frank Taylor. Session fee for darkroom facilities £4 per term. Gallery also attached. Open seven days a week.

AADW PRINT WORKSHOP, AADW Building, Gaskell Building, Collingdon Road, Cardiff. Tel. Contact: Peter Cole. Open to anyone Session fee. AADW membership. Also print workshop.

PHOTOGRAPHERS PLACE, Bradbourne, Ashbourne, Derbyshire. Tel. 033525 392. Contact: Paul Hill. Session fee £8 per day (£12 including B&B and evening meal). Open 9–5 except for those staying. Workshops £90 per week. Contact Paul Hill for further details of organised courses.

DARLINGTON ARTS CENTRE, Vane Terrace, Darlington. Contact: Richard Grassick. Photographer in residence. Session charge and fee per 3 hour session. Also Arts Centre facilities with gallery, studios, bar etc.

CASTLE CHARE COMMUNITY ARTS CENTRE, Castle Chare, Durham. Tel. 0385 46226.

Contact: Ken Payne. Membership per annum. Open 9–10pm every day. Workshop courses.

BUDDLE ARTS CENTRE, 258b Station Road, Wallsend, Tyne and Wear.

CONSETT PHOTO ARCHIVE, Old Miners Hall, Delves Lane, Consett, County Durham.

CARNEGIE ARTS CENTRE, Finkle Street, Workington, Cumbria.

NORTHUMBERLAND COMMUNITY ARTS, 34 Green Batt, Alnwick, Northumberland.

DERBY COMMUNITY PHOTOGRAPHY, St Kits Community Centre, Stepping Lane, Derby. Lansdowne House, 113 Princess Road East, Leicester.

BREWERY ARTS CENTRE, 122A Highgate, Kendal, Cumbria. Tel. 0539 25133. Contact: David Watt. Facilities available to anyone. Session fee negotiable. Materials available at reduced price.

NEWCASTLE MEDIA WORKSHOP, 67–75 Westgate Rd., Newcastle-on-Tyne. Tel. 091-232 2410. Open Tues-Sat 10–6, Sat 6–10 by arrangement. Membership fee.

SPLIT IMAGE, 17/21 Mumps, Oldham. Tel. 061-620 4063. Contact: Richard Raby, Helen Bridges. Open Mon–Fri 10–5.30. Courses on request. open to groups and individuals.

PLYMOUTH ARTS CENTRE, 38 Looe Street, Plymouth. Tel. 0752 60060. Contact: Bernard Samuels. £5 membership fee a year. Session fee per hour, students half price, non members. Open Mon–Sat 10–9.

ST EDMUNDS ART CENTRE, Bedmin Street, Salisbury. Contact: Peter Mason. Fee per annum. Open Mon–Sat 10–5.30. Two galleries in the art centre.

CRESCENT ARTS WORKSHOP, The Crescent, Scarborough, North Yorkshire. Contact: John Jones. £10 membership a year. Small session fee also. Workshop, lectures etc.

SOUTH YORKSHIRE PHOTOGRAPHY PROJECTS, 173–175 Howard Road, Walkley, Sheffield. Tel. 0742 340369. Contact: Alex Laing. Annual Membership fee plus fee to use photographic facilities. Open Wed–Sun 10–1, 2–5, 5–9.

CEOLFRITH PRINT WORKSHOP, 17 Grange Terrace, Stockton Road, Sunderland. Tel. 091-514

1214. Contact: Norther Centre for Contemporary Art. Membership £15 a year, £8 a quarter, £2 a month. Open Mon–Fri 9.30–6 and Wed 6–9.30.

IMPRESSIONS GALLERY OF PHOTOGRAPHY, 29 Castlegate, York. Tel. 0904 54724. Contact: Val Williams, £10 membership and 50p per session. Open Tues–Sat 10–6, Sundays June–Sept. Discount for materials to members. Good photographic gallery attached.

SNOWDONIA CENTRE OF PHOTOGRAPHY, Glanrafon House, Bryncelyn Road, Talysarn, Gwynedd LL54 6AB. Tel. 0286 881545.

COMMUNITY ARTS PROJECTS IN ENGLAND

GENERAL AND TOURING

ACTION SPACE MOBILE, Hurlfield Campus, East Bank Road, Sheffield S2 2AL. Tel. 0742 643593. Contact: Phil Hyde. Work ranges from performance, large scale structures, foreworks to dance and mime.

AKLOWA, Takeley House, Brewers End, Takeley, Essex CM22 6QJ. Tel. 0279 871062. Contact: Felix Cobbson. Traditional African drumming and dancing, cooking, fabric design. Instructs and tours schools.

CHARIVARI, c/o 16 Felix Road, Felixstowe, Suffolk. Tel. 039-42 74366. Contact: Taffy Thomas.

Puppets, dance workshops, traditional games, songs and entertainment.

EKOME DANCERS, 36 Argyle Road, St. Paul's, Bristol. Tel. 0272 426110. West African dance and drumming, workshops and touring.

FREE FORM, 38a Dalston Lane, Hackney, London E8 3AZ. Tel. 01-249 3394. Contact: Administrator. Touring community arts company.

INTER-ACTION, 15 Wilkin Street, London NW5. Tel. 01-485 0881. Contact: Ed Berman/ David Powell. Arts Centre.

MAJOR MUSTARD, 1 Carless Avenue, Harborne, Birmingham 17. Tel. 021-426 4329.

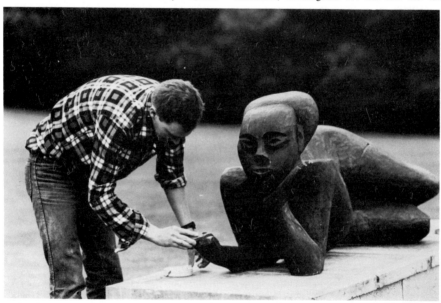

Richard Lawrence with 'Reeling Woman' (Wimbledon art school at Cannizaro Park)

Contact: Mike & Cas Frost. Practical puppetry workshops and performances.
MINORITIES' ARTS ADVISORY SERVICE, Beauchamp Lodge, 2 Warwick Crescent, London W2. Tel. 01-286 1854. Contact: Fay Rodriguez.
NATIONAL ASSOCIATION FOR ASIAN YOUTH, 46 High Street, Southall, Middlesex UB1 3DB. Tel. 01-574 1325. Contact: Ravi Jain. Drama, music, writing and dance workshops.

SHAPE (Network and Affiliated Services)
EASTERN REGION:
Chris Davies, Shape London, 1 Thorpe Close, London W10 5XL. Tel. 01-960 9245.
Lucy Gampbell, Shape East, c/o Eastern Arts, Cherry Hinton Hall, Cambridge. CB1 4DW. Tel. 0223-215355.
Anne Peaker, East Midlands Shape, New Farm, Walton by Kimcote, Lutterworth, Leicestershire. LE17 5RL. Tel. 04555-3882.
Sue Roberts, Artlink for Lincolnshire and Humberside, Humberside Leisure Services, Central Library, Albion Street, Hull. HU1 3TF. Tel. 0482-224040.
Jean Line, Artability (South East), The Old School, Cobden Road, Sevenoaks, Kent. TN13 3UB.
NORTHERN REGION:
Cynth Hopkins & Pat Foster, Shape Up North, 191 Bellevue Rd., Leeds LS3 1HG. Tel. 0532-431005.
Sally Martin, North West Shape, The Green Prefab, Back of Shawgrove School, Cavendish Rd., West Didsbury, Manchester. M20 8JR. Tel. 061-434 9666.
Colin Langton, Northern Shape, Todd's Nook Centre, Monday Crescent, Newcastle-upon-Tyne. NE4 5BD. Tel. 091-226 0701.
SOUTHWEST REGION:
Piers Benn, Southern Artlink, 125 Walton St., Oxford OX2 6AH. tel. 0865 516115.
Pippa Warin, Artshare South West, Exeter and Devon Arts Centre, Bradninch Place, Gandy St., Exeter. EX4 3LS. Tel. 0392 218923.
Lee Corner, Artlink, 17A Hanover St., Newcastle-under-Lyme, Staffs. ST5 1HD. Tel. 0782 614170.
Peter Taylor, Solent Artlink, Hornpipe Community Arts Centre, 143 Kingston Rd., Portsmouth. Tel. 0705 828392.
AFFILIATED SERVICES:
Thursa Sanderson, Artlink Edinburgh & The Lothians, 4 Forth St., Edinburgh. EH1 3LD. Tel. 031-556 6350.
Sheena Moreby, Project Ability, 37 Otago St., Glasgow G12 8JJ. Tel. 041-339 1787.
Bryan Beattie & Fiona Bonar, Scottish Council on Disability Committee on Arts for Scotland, Princes House, 5 Shandwick Place, Edinburgh. EH2 4RG. Tel. 031-229 8632.
Phil Burton, Arts For Disabled People in Wales, "Channel View", Jim Driscoll Way, The Marl, Grangetown, Cardiff. CF1 7NF. Tel 0222 377885.
THE SHELTON TRUST, The Shelton Trust, The Old Tin School, Collyhurst Road, Manchester

M10 7RQ. Tel. 061-202 2037. Contact: Christopher Foster. Community arts advisory service.
STEEL AN' SKIN, 143b Abbey Road, London NW6 4SL. Tel. 01-328 5233. Contact: Peter Blackman. Make ethnic musical instruments, clothes, prints, dance masks.
TARA ARTS GROUP, 35b Garratt Lane, Earlsfield, London SW18 4ES. Tel. 01-871 1458. Contact: Jatinder Verma. Asian theatre company promoting and performing Asian art in English.
TOURING THEATRE OF PNEUMATIC ART, Manchester Arts and Technology Workshop, 3 Murray Street, Ancoats, Manchester 4. Tel. 061-236 2951. Contact: Terry Scales. provides studio workshops and research facilities.
WORKER WRITERS & COMMUNITY PUBLISHERS, 10 Brief Street, London SE5 9RD. Tel. 01-249 4618. Contact: Jane Mace.

EASTERN ARTS
ALF RESCO FUNCTIONS, 214 Cromer road, Beeston Regis Sheringham, Norfolk. Tel. 0263 824966. Contact: Phil Hartigan. Murals.
DIGSWELL ARTS TRUST, Digswell House, Monk's Rise, Welwyn Garden City, Hertfordshire AL8 7NT. Tel. 96 21506. Visual arts.
LADY LODGE ARTS CENTRE, Orton Goldhay, Peterborough. Tel. 0733 234035. Contact: Guy Eades. Visual arts workshops and events.
LUTON COMMUNITY ARTS TRUST, 33 Guildford Street, Luton. Tel. 0582 419584. Contact: Tim Powell. Film, video, photography, drama and craft workshops, music studio, small scale venue.
MASQUE COMMUNITY THEATRE, 3 King's Road, Fakenham, Norfolk. Tel. 0328 4319. Contact: Mike Wilson. Drama.
NUTMEG PUPPET COMPANY, Bulcamp House, Blythburgh, Halesworth, Suffolk. Tel. 050-270 525. Contact: Meg Amsden.
PREMISES, Norwich Arts Centre, Reeves Yard, St Benedict's Street, Norwich NR2 4PG. Tel. 0603 60352. Contact: Michael Monaghan. Arts resource centre.
SPARE PARTS, 23 Crown Street, Leiston, Suffolk. Tel. 0728 830771. Contact: Arlette Biddle. Puppets/Photography.
ST. MARY'S ARTS CENTRE, St. Mary-at-the-Walls. Church Street, Colchester CO1 1NF. Tel. 0206 77301. Contact Michael Prochak.
THE WELLS CENTRE LIMITED, Staithe Street, Wells-next-the-Sea, Norfolk NR23 1AN. Tel. 0328 710130. Contact: Michael Hooton. Arts Resource Centre.

EAST MIDLANDS ARTS
AFRICAN ARTS PROJECT, Derby CRE, 231 Normanton Road, Derby. Tel. 0332 372428. Contact: Anita Lewis. African dance and drumming workshops.
ARTS DEVELOPMENT—NORTHAMPTON DEVELOPMENT CORPORATION, Cliftonville House, Northampton. Tel. 0604 27158/27147. Contact: Clare Higney. Photography and craft

143

workshops, silkscreen, printing, drama, puppetry, circus skills, other arts activities.

BASSETLAW COUNCIL FOR VOLUNTARY SERVICE, The Workshop Centre, The Priory Gatehouse, Cheapside, Worksop. Tel. 0909 6118. Contact: Mike Newstead. Photography, dance/drama workshops, exhibitions, other arts, etc.

CHOPS (Combined Highfield Outreach Playscheme), c/o Highfields Aventure Playground, Mere Road, Leicester. Tel. 0533 51053. Contact: Andrew Legg. Music/educational projects.

CHROMA (Chronicle of Minority Arts), c/o International Community Centre, 61B Mansfield Road, Nottingham. Tel. 0602 49842. Contact: Pat McConnel. Workshops, performances, exhibition of ethnic arts.

COMMUNITY ARTS DEPARTMENT, LEICESTER CITY COUNCIL, New Walk Centre, Welford Place, Leicester. Tel. 0533 549922. Ext. 7345. Contact: Frances Manghan. Summer playschemes, workshops of all types.

CORBY COMMUNITY ARTS, Lincoln Square, Corby, Northants. Tel. 0536 743731. Contact: Mary Allen. printwork, murals, banner-making, bookshop, writing and music workshops, small scale publications, badge making, photography and other visual arts.

DERBY COMMUNITY ARTS PROJECT, St. Augustine's Community Centre, Almond Street, Derby. Tel. 0332 765519. Contact: John Bennett. Pottery workshops, murals, crafts, puppets, photography, drama, video projects.

JUNCTION 28, South Normanton Community Arts Project, New Street Centre, New Street, south Normanton, Derbyshire. Tel. 0773 813343. Contact: Ray Richards. Inflatables, creative writing workshops, printing, drama, photography, silkscreen, carnival and other arts and crafts.

NETHERFIELD COMMUNITY CENTRE, BUN (Brighten Up Netherfield), Ley Street, Netherfield, Nottinghamshire. Tel. 0602 249769. Photography, workshops.

NOTTINGHAM COMMUNITY ART & CRAFTS CENTRE, Gregory Boulevard, Hyson Green, Nottingham. Tel 0602 782463. Contact: Dave Blatchford. Photography, badge making, print work, graphics, pottery, drama, video, playschemes, festivals, woodworking and other arts activities.

ROSEBERY COMMUNITY ARTS PROJECT, 7 Fearon Street, Loughborough, Leicestershire. Tel. 0509 68554. Contact: Kevin Ryan. Drama, woodworking, writers' workshops, murals, small scale publications, exhibitions, printing (developing).

SCARAMOUCH, 6 Chevin Road, Milford, Derbyshire. Tel. 0332 840660. Contact: Chris Timms. Mobile community arts, puppet/drama workshops, arts and crafts, celebratory events, photography, music workshops.

SHOEMAKER/NORTHAMPTON COMMUNITY PRESS, 18 East Priors Court, Northampton. Tel. 0604 413364. Contact: Nigel Gray. Creative writing workshops, literature activities and community publishing.

TOWN & COUNTRY INTERACTION, The Old Rectory, Pear Tree Lane, Woughton on the Green, Milton Keynes. Tel. 0908 678514. Contact: Dick Chamberlain. Drama, music workshops, arts and craft workshops, thematic playscheme workshops, fetes, celebratory events, training schemes, fireshows, school work, media projects, advisory workshops.

118 WORKSHOP, 118 Mansfield Road, Nottingham. Tel. 0602 582369. Resource centre; badge-making, printing, photography, etc.

WOTZIT, 18 Waingrove, Blackthorn, Northampton. Tel. 0604 410882. Contact: Mike Martin. Playschemes, craft activities, fireshows, variety of workshops.

YOUR OWN STUFF COMMUNITY PUBLISHING PROJECT, 13 Mona Road, West Bridgford, Nottingham. Tel. 0602 866015. Contact: David Jackson. Creative writing and community publishing.

GREATER LONDON ARTS ASSOCIATION

ACTION SPACE LONDON EVENTS, 16 Chenies Street, London WC1E 7ET. Tel. 01-631 1353. Contact: Peter Shelton. Community workshops for the mentally handicapped.

AFRICAN DAWN, 29 Waltham Drive, Edgware, Middlesex. Tel. 01-951 3787. Contact: Kwesi Owusu. Music, poetry, drama.

AFRO-CARIBBEAN EDUCATION RESOURCE PROJECT, 275 Kennington Lane, London SE11 5QZ. Tel. 01-582 2772. Contact: Len Garrison. Community-based educational charity, drama, video, publishing.

ALBANY BASEMENT THEATRE, 179 Deptford High Street, London SE8. Tel. 01-691 4562. Contact: Trix Worrell. Drama, dance, music, film, video.

ALBANY COMMUNITY VIDEO, 179 Deptford High Street, London Se8. Tel. 01-692 0231. Contact: Geoff Stowe/Tony Dowmont. Video.

BASEMENT COMMUNITY ARTS WORKSHOP, St George's Town Hall, Cable Street, London E1. Tel. 01-790 4020. Contact: Kate Kelly. Multi-media, printing, publishing, photography, film, video, radio, murals, music, drama.

BRENT BLACK MUSIC CO-OPERATIVE, 86 Hugh Gaitskell House, Butler Road, London NW10. Tel. 01-568 0678. Contact: Leslie Palmer. Music.

CARIBBEAN CULTURAL INTERNATIONAL, Karnak House, 300 Westbourne Park Road, London W11 1EH. Tel. 01-221 6490. Contact: Sebastian Clarke. Music, dance, drama, pottery.

CHAT'S PALACE, 42-44 Brooksby's Walk, London E9. Tel. 01-986 6714. Contact: Alan Rossiter. Multi-media, music, drama, dance, film, video, photography, print, visual arts.

COMMUNITY AND RECREATION ARTS IN BARNET (CRAB), Avenue House, East End Road, Finchley, London N3. Tel. 01-580 6511. Contact: Mary Sarjeant. Photography, murals.

COMMUNITY PROJECTS FOUNDATION, 60 Highbury Grove, London N5 2AG. Tel. 01-226 5375. Contact: N. Vitry.

CRANFORD COMMUNITY ARTS, Cranford Community School, High Street, Cranford, Hounslow TW5 9PD. Tel. 01-897 2001/5. Contact: David Purvis. Multi-media, drama, dance, music, visual arts etc.

DAGARTI COMMUNITY ARTS, 6 Melville House, Sparta Street, Greenwich, London SE10 8dP. Tel. 01-691 6004. Contact: Mario Bayor Diekurroh. Music, dance.

DALSTON CHILDREN'S CENTRE, 9a Sandringham Road, London E8. Tel. 01-254 9661. Publishing, writing, printing, visual arts, photography, drama.

GREENWICH ARTISTS' CO-OPERATIVE, Clockhouse Darkroom Project, Clockhouse Community Centre, Defiance Walk, Woolwich Dockyard Estate, London SE18. Tel. 01-855 7188. Contact: Trish le Gal. Photography.

GREENWICH MURAL WORKSHOP, MacBean Centre, MacBean Street, London SE18. Tel. 01-854 9266/316 7577. Contact: Stephen Lobb. Murals, printing. They also publish a helpful booklet on murals.

HOXTON HALL FRIENDS NEIGHBOURHOOD CENTRE AND THEATRE, 128a Hoxton Street, London N1. Tel. 01-739 5431. Contact: Terence Goodfellow. Multimedia, drama, dance, music, visual arts/crafts.

ISLINGTON BUS CO., Palmer Place, London N7. Tel. 01-609 0226. Contact: Christine Treweek. Multi-media, print, video, audio/sound, photography, publishing, radio, crafts.

LENTHALL ROAD WORKSHOP, 81 Lenthall Road, London E8. Tel. 01-254 3082. Contact: Kathy Andrews. printing, publishing.

LEWISHAM ACADEMY OF MUSIC, 179 Deptford High Street, London SE8. Tel. 01-691 0307. Contact: Jenny Harris. Music.

LOCAL RADIO WORKSHOP, 12 Praed Mews, London W2 1QY. Tel. 01-402 7651. Contact: Peter Edmonds. Radio.

MOONSHINE COMMUNITY ARTS WORKSHOP, Victor Road, London NW10 5XQ. Tel. 01-969 7959. Contact: Ron Groom. Multi-media, music, drama, video, arts and crafts, photography.

NATIONAL ASSOCIATION FOR ASIAN YOUTH, 46 High Street, Southall, Middlesex UB1 3DB. Tel. 01-574 1325. Contact: Ravi Jain. Umbrella organisation, co-ordinating activities of Asian youth groups in Britain plus community arts section.

NEWHAM ARTS COUNCIL, Education Offices, Broadway, Stratford, London E15. Tel. 01-534 4545 ext 421. Contact: Dave Cotton. Multimedia, drama, murals, visual arts, dance, poetry, folk music/crafts, publishing.

NORTH PADDINGTON COMMUNITY DARKROOM, 510 Harrow Road, London W9. Tel. 01-969 7437. Contact: Philip Wolmuth. Photography.

PADDINGTON PRINTSHOP, The Basement, 1 Elgin Avenue, London W9. Tel. 01-286 1123. Contact: John Phillips. Printing, publishing, tape/slide, farm project.

THE POLISH CENTRE, 238-246 King Street, London W6. Tel. 01-741 1940. Contact: Tadek Jarski. Arts centre—various activities.

POSTER FILM COLLECTIVE, 307 Euston Road, London NW1. Tel. 01 388 0182. Contact: J. Mills. Printing, visual arts.

SHOREDITCH COMMUNITY FESTIVAL, Community Wing, Town Hall, 380 Old Street, London EC1. Tel. 01-739 6348. Contact: Jim Ives. Festival—various activities.

SOUTH ISLAND TRUST, Art Store, 3-4 Oval Mansions, Kennington Oval, London SE11. Tel. 01-582 3779. Contact: Owen Kelly. Visual arts/crafts, photography, murals, dance, video.

STAUNCH POETS & PLAYERS, 180 Holland Road, London W14. Tel. 01-603 7559. Contact: Don Kinch. Publishing, writing, drama.

SUGUMUGU SUNDAY, 132a Agar Grove, London NW1 9TY. (Can be contacted at Winchester Project, tel. 01-586 2441). Contact: Lord Eric Carboo. Music, drama, poetry, visual arts.

THEATRO TECHNIS, 26 Crowndale Road, London NW1. Tel. 01-387 6617. Contact: George Eugeniou. Photography, poetry, drama, dance.

TOWER HAMLETS ARTS PROJECT, 178 Whitechapel Road, London E1. Tel. 01-247 0216. Contact: Roger Mills/Alice Brett. Multimedia, bookshop, print, publishing, photography, drama, murals, film, video, visual arts/crafts.

TRINBAGO CARNIVAL CLUB, 62 Park Grove Road, Leytonstone, London E11 4PU. Tel. 01-539 1978. Contact: Lawrence Noel. Carnival.

VINCE HINES FOUNDATION, 150 Townmead Road, Fulham, London SW6 2RA. Tel. 01-731 4438/9. Contact: Vince Hines. Foundation encouraging self-help mainly for Afro-Caribbeans plus community arts activities—music.

WALSWORTH & AYLESBURY COMMUNITY ARTS TRUST, Shop 8, Taplow, Aylesbury Estate, London SE17. Tel. 01-708 1280/1288. Contact: George Dewey/Patricia Allen. Multimedia, printing, photography, drama, music, video, radio.

WANDSWORTH ARTS RESOURCE PROJECT, 248 Lavender Hill, London SW11. Tel. 01-223 4220. Contact: Brian Barnes, Murals, visual arts, printing.

WEST LONDON MEDIA WORKSHOP, 118 Talbot Road, London W10. Tel. 01-221 1859. Contact: Karen Michaelson. Video, photography.

WOMEN'S AIRWAVES, Flat 2, 44 Kensington Gardens Square, London W2. Tel. 01-221 4164 or 01-307 7050 ext 626. Contact: Helen Austerberry. Radio/audio.

LINCOLNSHIRE & HUMBERSIDE ARTS

GRANTHAM PLAY ASSOCIATION, 22 London Road, Grantham, Lincolnshire. Tel. 0476 61061. Murals.

HUMBERSIDE THEATRE, Spring Street, Hull, North Humberside. Tel. 0482 20925. Contact: Jon Marshall. Arts centre—including community work from drama to pottery workshops, large local festival.

OUTREACH COMMUNITY ARTS, Northumberland Avenue, Hull HU2 oLN. Tel. 0482 226420. Contact: Pamela Dellar. Multi-media, drama, music, visual arts, crafts.

also:

FOUNTAINS ROAD PROJECT. Contact: Jeannie Posnett (above address and tel. no.) Multimedia.

MERSEYSIDE ARTS

AWARE (Merseyside Trust), 20 Mirfield Close, Halewood, Liverpool L26 9XP. Tel. 051-728 7884. Contact: Colin Thomas. Mobile photography project undertaking workshops in a variety of youth clubs, community centres etc.

BOOTLE ARTS & ACTION, 290/2 Knowsley Road, Bootle, Merseyside L20 5DE. Tel. 051-933 5168. Originally photographic project, now expending into other forms of visual art; has various touring exhibitions available.

BOOTLE FESTIVAL SOCIETY, c/o Margaret Pinnington, 290 Knowsley Road, Bootle, Merseyside. Contact: Billy Law Jr. Has undertaken one community musical (March 1981) and a one-day festival (August 1981).

BRONTE NEIGHBOURHOOD ORGANISATION, Towbridge Street, Liverpool L3 5LT. Tel. 051-709 36136/7. Contact: William McIntyre. Full-time sculptor working with young people and adults in a purpose built youth and community centre.

CRAWFORD ARTS CENTRE, Mill Lane, Liverpool 15. Tel. 051-722 9091. Contact: Dave Rickus. Arts centre and regional youth service resource providing workshops, performances, exhibitions, screenings etc.

CROSBY RESIDENTS' ASSOCIATION NORTH EAST (CRANE), 16 Broad Hey, Thornton, Merseyside L23 1UQ. Tel. 051-924 5976. Contact: J. Roberts. Visual art, photography workshops, for children and adults in their community centre.

GARSTON ADVENTURE PLAYGROUND, Bowden Road, Garston, Liverpool 19. Tel. 051-494 9524. Contact: Sue Dunne. Festival.

HALEWOOD COMMUNITY CENTRE, James MacColl House, Kenton road, Halewood, Liverpool L26 9TS. Tel. 051-486 2171. Contact: Paul Edwards. Drama and photography workshops, particularly for unemployed teenagers.

LIVERPOOL GINGERBREAD TRUST, 9-11 Fleet Street, Liverpool L1 4AR. Tel. 051-708 7157. Contact: Mrs. G. Helm. Arts, crafts and drama workshops for single parent families.

MERSEYSIDE CARIBBEAN CENTRE, 1 Amberley Street, Liverpool 8. Tel. 051-708 9790. Contact: O. Job. Music and drama workshops, and carnival.

MERSEYSIDE COMMUNITY RELATIONS COUNCIL THEATRE WORKSHOP, 64 Mount Pleasant, Liverpool L3 5SH. Tel. 051-709 0789/6858. Contact: P. J. Somerfield. Drama work with children and young people, mainly from Liverpool's ethnic minorities.

MERSEYSIDE PLAY ACTION COUNCIL, 20 New Bird Street, Liverpool 1. Tel. 051-708 0468. Contact: Jim Kenwright. Vidual and performance art and drama with Liverpool 8 playleaders.

RADIO DOOM, PO Box 18, Southport PR8 1JP. (correspondence); 482 Prescot Road, Liverpool L14 2EH. Tel. 051 228 8894 (workshop). Contact: Dave Key. Mobile project offerng workshops, performances and events in music, radio, film, photography, art & craft, theatre and literature.

RATHBONE PROJECT (LIVERPOOL RATHBONE COMMUNITY ASSOCIATION), 176 High park Street, Liverpool L8 3UQ. Tel. 051-727 2052. Contact: Betty McGorry. film and photography worker within programme of youth and community activities.

RUNCORN VISUAL ARTISTS' ASSOCIATION, c/o Warrington & Runcorn Development Office, Grosvenor House, Runcorn. Tel. 0928 714444. Painting workshops.

SEACOMBE COMMUNITY ASSOCIAITON, Ferry View Road, Wallasey, Liverpool L44 6QR. Tel. 051-630 1725. Contact: P. Collinson. Community drama.

SPEKE ROAD GARDENS COMMUNITY ASSOCIATION, 15 Speke Road Gardens, Garston, Liverpool L19 2PZ. Tel. 051-494 9330. Murals.

ST HELENS PLAY RESOURCE CENTRE, 78 Claughton Street, St Helens WA10 1SN. Tel. 0744 30400. Arts, crafts, drama and photography.

ST MICHAELS AND LARK LANE COMMUNITY ASSOCIATION, The Old Police Station, 80 Lark Lane, Liverpool L17 8UU. Tel. 051-728 7884. Contact: R. Hale. Community festival.

TOWER HILL COMMUNITY ASSOCIATION, Tower Hill Community Centre, Heathfield, Kirkby, Merseyside. Contact: J. Flynn. Community drama.

VAUXHALL NEIGHBOURHOOD COUNCIL, Community Services Centre, Silvester Street, Liverpool L5 8SE. Tel. 051-207 4461. Contact: B. Doyle. Drama workshops and performances within major voluntary community work agency in Liverpool 5.

WINDOWS POETRY PROJECT, 46 Elsinore Heights, Halewood, Liverpool L26 9TE. Tel. 051-486 0818. Two poets funded to provide a programme of workshops, readings and publications.

NORTHERN ARTS

CAPS, c/o East Community Centre, Moor Terrace, Sunderland, Tyne & Wear. Tel. Sunderland 79095. Contact: Dick Ellison. General community arts.

DERWENTSIDE UNEMPLOYED ACTION GROUP, Old Miners Hall, Delves Lane, Consett,

Co. Durham. Tel. Consett 507310. Contact: John Kearney.

ETHNIC ARTS PROJECT, 16 Ashton Way, Whitley Bay, Tyne & Wear. Tel. Whitley Bay 522839. Contact: Marjorie Graham.

HOWGILL CENTRE, Howgill Street, Whitehaven, Cumbria. Tel. 0946 62681. Contact: Bridget Roberts. General community arts work.

NORTH ORMSEBY PROJECT, The Pavilion, Esk Street, North Ormesby, Middlesborough, Celveland. Tel. 0624 242533. Contact: Arthur Battram. General community arts.

NORTHUMBERLAND COMMUNITY ARTS PROJECT, 34 Green Batt, Alnwick, Northumberland. Tel. 0665 603069. Contact: Ian Graigan. General community arts.
also:
Rosemary Lumb, Sanderson House, Bridge Street, Morpeth, Northumberland. Tel. Morpeth 58806.

PETERLEE COMMUNITY ARTS, Peterlee Community Centre, Eden Lane, Peterlee, County Durham. Tel. 0783 860497. Contact: Keith Armstrong. Writing.

SKIN & BONES, The Warehouse, Bell's Court, 109 Pilgrim Street, Newcastle-upon-Tyne. Tel. 091-223276. Contact: Nick Munby. Community theatre.

SOCIAL ARTS TRUST, 45 Victoria Road East, Hebburn, Tyne & Wear. Tel. 0912 832744. Contact: Bernard Ross. Community arts training.

THEM WIFIES, The Warehouse, Bell's Court, 109 Pilgrim Street, Newcastle-upon-Tyne. Tel. 0912 852240. Contact: Judy Seymour. Work with children.

UNCLE ERNIE'S COMMUNITY ARTS, Buddle Arts Centre, 528b Station Road, Wallsend, Tyne & Wear. Tel. 0912 632267. Contact: Tessa Green. General community arts.

VILLAGE ARTS, North Skelton Village Hall, North Skelton, Saltburn, Cleveland. Tel. 0287 52392. Contact: Doff Pollard. General community arts.

SOUTHERN ARTS
ATHENAEUM ARTS CENTRE, High Street, Warminster, Wiltshire BA12 9AE. Tel. 0985 213891. Multimedia.

BLOOMIN ARTS, c/o East Oxford Community Centre, Princes Street, Oxford. Tel. 0865 45735. Contact: Anni Janik/Roger Drury. Dance, photography, craft and drama.

GROUNDWELL FARMERS, Groundwell Farm, Upper Stratton, Swindon, Wiltshire. Tel. 0793 721111. Contact: Roberts Stredder. Multi-media.

MOUNT PLEASANT PHOTOGRAPHY WORKSHOP, Mount Pleasant Middle School, Mount Pleasant Road, Southampton. Contact: Judy Harrison.

OXFORD FILM MAKERS' WORKSHOP, The Stables, Bury Knowles Estate, North Place, Headington, Oxford. Film.

OXFORDSHIRE TOURING, c/o Cowley Road, St Christopher School, Temple Road, Cowley, Oxford. Theatre.

PORTSMOUTH FILM & VIDEO WORKSHOP, John Pound Centre, James Street, Portsmouth. Film and video.

ST EDMUND'S ARTS CENTRE, St Edmund's Arts Centre, Bedwin Street, Salisbury. Tel. 0722 20379. Rural Project: Contact: Chris Foster. Multi-media.

THAMESDOWN COMMUNITY ARTS, Old Town Hall, Regent Circus, Swindon. Contact: Terry Court. Multi-media.

SOUTH EAST ARTS
BAREFOOT VIDEO, 50 Brunswick Street West, Hove, Sussex. BN2 1EL. Tel. 0273 773206.

BRIGHTON COMMUNITY ARTS PROJECT, St Anne's Hall. St George's Road, Kemptown, Brighton. Tel. 0273 697493. Contact: Russ Howarth. Multi-media.

HANGLETON & KNOLL COMMUNITY FESTIVAL, Association Centre, Olive Road, Hove, Brighton. Tel. 0273 738879/728839.

HANOVER COMMUNITY ASSOCIATION, Southover Street, Brighton. Tel. 0273 683931. Contact: Margaret Sharp. Community arts centre.

OCTOPUS TRUST, Whitewood Cottage, Swiffe Lane, Broad Oak, near Heathfield, Sussex. Tel. 04357 495. Contact: Anthony Masters. Drama.

QUEENSPARK BOOKS, 13 West Drive, Brighton. Tel. 0273 682855. Contact: Stephen Yeo. Literature.

SOUTH WEST ARTS
BATH PRINTSHOP, Cleveland House, London Road, Bath. Tel. 0225 20263. Contact: Sue Watkinson. Printing.

BEAFORD CENTRE, Beaford, Winkleigh, Devon EX19 8LU. (correspondence) Tel. 0271 75285 (in process of moving). Contact: Diana Murray. Multi-media.

BRISTOL BROADSIDES, 110 Cheltenham Road, Bristol 6. Tel. 0272 40491. Contact: Ian Bild. Literature.

COLWAY THEATRE TRUST, Colway Manor, Colway Lane, Lyme Regis, Dorset. Tel. 02974 2821. Contact: Ann Jellicoe. Drama.

DAT WEST INDIAN DRAMA GROUP, 7 Windsor Terrace, Bristol 8. Tel. 0272 292763. Contact: Angela Rodaway. Drama.

EMERGING DRAGON, Manor Farmhouse, Wembdon, Bridgwater, Somerset. Tel. 0278 2632. Contact: Danielle Grunberg. Drama.

FAIR EXCHANGE, Marlborough Hall, Kimberley Road, Exeter EX2 4JG. Tel. 0392 32617 (moving shortly). Contact: Kate Dyer. Multi-media.

INKWORKS, 20/22 Hepburn Road, Bristol 2. Tel. 0272 421870. Contact: Alfredo Vasquez. Community arts centre also St Paul's Festival.

PAUL WILSON, 30 Old Tiverton Road, Exeter. Tel. 0392 51529. Contact: Paul Wilson. Music.

SAM RICHARDS & TISH STUBBS, 6 South Street, Totnes, Devon TQ9 5DZ. Tel. 0803 862935. Contact: Sam Richards and Tish Stubbs. Music.

147

SOUTHMEAD COMMUNITY ARTS, Greystoke Avenue, Bristol BS10 6AS. Tel. 0272 505724. Contact: Dave Pole. Multi-media.
WORD & ACTION (LTD), 23 Beaucroft Lane, Colehill, Wimborne, Dorset. Tel. 0202 883197. Contact: R. Gregory. Drama, literature.

WEST MIDLANDS ARTS
AFRO-CARIBBEAN ARTS CENTRE, 2 Clarence Road, Wolverhampton, West Midlands. Contact: Eric Pemberton.
ART LINK CO-ORDINATOR, 12 Homesford Terrace, North Street, Newcastle-under-Lyme, Staffordshire. Tel. 0782 614170. Contact: Lee Corner. Multi-media.
ASIAN ARTS PRODUCTIONS, 97 Dudley Road, Tipton. West Midlands. Tel. 021-557 2217. Contact: Seva Dhalivaal. Asian Drama and dance.
BANNER THEATRE OF ACTUALITY, 173 Lozells Road, Birmingham 19. Tel 021-551 3671. Contact: Barry Clarke. Drama.
BATH PLACE COMMUNITY VENTURE, Bath Place, Leamington Spa, Warwickshire. Tel. 0926 38421. Contact: Richard Sharland. Printing, photography and visual arts.
COMMUNITY LINKS, 12 Nelson Court, Grenville Drive, Warley, West Midlands B66 1JR. Tel. 021-558 4787. Contact: Jim Austin. Photography, video and film.
COVENTRY RESOURCE & INFORMATION SERVICE, Unit 15, The Arches Industrial Estate, Spon End, Coventry CV1 3JQ. Warwickshire. Tel. 0203 77719. Contact: Phil Dunn/Jim Botton. Photography and silkscreen.
THE CULTURAL CENTRE, 328 Hamstead Road, Handsworth, Birmingham B20 2RA. Tel. 021-551 4274. Contact: Bob Ramdhanie. Mixed workshops.
CUT BOAT FOLK LTD, Community Youth Centre, Hockley Port, All Saints Street, Birmingham 18. Tel. 021-551 4837. Contact: Chris Robinson. Playschemes/visual arts.
FOREST COMMUNITY CENTRE, Hawbush Road, Leamore, Walsall, West Midlands. Tel. Bloxwich 76856. Contact: David Calcutt.
FURZEBANK COMMUNITY CENTRE, Willenhall Comprehensive, Furzebank Community Centre, Furzebank Way, Willenhall, West Midlands. Tel. Willenhall 61221. Contact: Martin Stevens, Community Arts Worker.
HANLEY YOUTH PROJECT, Hanley Youth Project, 39 Regent Road, Hanely, Stoke-on-Trent. Tel. Stoke 25434. Contact: Kevin Sauntry.
HOCKLEY FLYOVER ADVENTURE PLAYGROUND, 220 Rotten Park Road, Edgbaston, Birmingham 16. Tel. 021-551 1339. Contact: Paul Pennington Wilson. Playschemes workshops.
JUBILEE COMMUNITY ARTS, Jubilee Centre (Farley Park), Whitehall Road, Greets Green, West Bromwich, West Midlands. Tel. 021-557 1569. Contact: Sylvia King. Multi-media.
MAYPOLE CENTRE, Community Arts Centre, Maypole Centre, Maypole, Birmingham. Contact: Mr Boyle.

MURAL COMPANY, 8b Holly Road, Edgbaston Birmingham B16. Tel. 021-455 8209. Contact: Mark Renn. Visual arts.
NATIONAL PLAYING FIELDS ASSOCIATION, Ward End House, Ward End Park, Washwood Heath Road, Birmingham B8 2HE. Tel. 021-328 5557. Contact: Harry Shier. Arts and craft training workshops.
PENTABUS RURAL THEATRE COMPANY, Old County Primary School, Abberley Avenue, Areley Kings, Stourport-on-Severn, Worcestershire DY13 0LH. Contact: Alun Bond/Jonathan Cross. Multi-media, mainly drama, photography and video.
SALTLEY PRINT & MEDIA WORKSHOP, c/o Saltley Action Centre, 2 Alum Rock Road, Saltley, Birmingham 8. Tel. 021-328 1954. Contact: Julian Dunn/Dave Minto. printing, photography, film and video.
TELFORD COMMUNITY ARTS, 72 Southgate, Sutton Hill, Telford, Shropshire. Tel. 0952 581927. Contact: Cathy Mackerras. Multi-media.
TRINITY ARTS ASSOCIATION (BIRMINGHAM) LTD, 516 Coventry Road, Small Heath, Birmingham 10. Tel. 021-773 7510. Multi-media.
WELD, New Trinity, Wilson Road, Handsworth, Birmingham 19. Tel. 021-554 5068. Contact: Hermin McIntosh. Photography, drama and dance.
WEST MIDLANDS ETHNIC MINORITY ARTS, West Midlands Ethnic Minority Information Service, Holyhead School/Community Centre, Florence Road, Handsworth, Birmingham. Tel. 021-523 7544. Contact: Laxmi Jamdagni.
WEST SMETHWICK COMMUNITY ASSOCIATION, 5 Sandpiper Court, Oldbury Road, Smethwick, Warley, West Midlands. Tel. 021-565 0119. Contact: harry Henderson. Photography, video and film.
WORCESTER ARTS WORKSHOP, 21 Sansome Street, Worcester. Tel. 0905. Contact: Jane Hyteh.
YOUTH PROMOTIONS, 57 Clifton Road, Rugby, Warwickshire. Tel. 0788 73915. Contact: Slim Leo. Ethnic arts training.

NORTH WEST ARTS
COMMONWORD BOOKSHOP, 61 Bloom Street, Manchester M1 3LY. Tel. 061-236 2773. Contact: Ailsa Cox. Writing, publishing.
COMMUNITY ARTS WORKSHOP, The Old Tin School, Collyhurst Road, Collyhurst, Manchester M10 7RQ. Tel. 061-202 2037. Contact: Alan Howarth. Multi-media touring group.
HIGH PEAK COMMUNITY ARTS, c/o Adult Education Centre, Lond Lane, Chapel-en-le-Frith, Derbyshire. Tel. 029-881 2968. Contact: Gerri Moriarty. Multi-media.
HULME COMMUNITY ARTS PROJECT, 1 Clopton Walk, Hulme, Manchester 15. Tel. 061-226 9815. Contact: Fiona Lloyd. Locally based, coverng wide range of arts activities.
LANCASTER COMMUNITY ARTS, YMCA, Buildings, China Street, Lancaster. Tel. 0524 37223. Contact: Steven Smith. Multi-media.

MAAS (NW), 25 Swan Street, Manchester. Tel. 061-834 1786. Contact: Gordon Geekie.
ORDSALL COMMUNITY ARTS, Ordsall Library, Tatton Street, Ordsall, Salford, Manchester. Tel. 061-848 8779. Contact: Jim Smale, Multi-media.
SPLIT IMAGE, 17/21 Mumps, Oldham, Lancashire. Tel. 061-620 4063. Contact: Richard Raby. Photography project.
WORKERS' FILM ASSOCIATION, 9 Lucy Street, manchester 15. Tel. 061-848 9782. Contact: Wowo Wauters. Film, photography and video project.

YORKSHIRE ARTS ASSOCIATION
ARTIVAN, Bank Cottage, 248 Holmebank, Holm Bridge, Huddersfield HD7 1QL. Tel. 048 489 5840. Contact: Brian Cross. Silkscreen, badge-making, etc.
BRADFORD MOBILE WORKSHOP, 3 Hallfield Road, Bradford 1. Tel. 0274 722425. Contact: Paul Malkin. Multi-media.

BRADFORD PLAYSPACE, 40 Marlborough Road, Bradford 8. Tel. 0274 745720. Contact: Mark Fielding. Multi-media.
BRADFORD PRINTSHOP, 127 Thornton Road, Bradford 1. Tel. 0274 722518. Contact: Jules Moore. Workers' co-operative; silkscreen.
CETU, 14 Lord Street, Halifax, West Yorkshire HX1 5AE. Tel. Halifax 57394. Contact: Tony.
COMMON GROUND RESOURCES CENTRE, 87 The Wicker, Sheffield S3 8HT. Tel. 0742 738572. Contact: Colin Grant/Caroline Poland. Photography and silkscreen.
HANDPRINT, 23 Peel Street, Marsden, Huddersfield. Tel. 0484 843879. Printing collective.
JUNCTION 37 BARNSLEY, 156 Sheffield Road, Barnsley. Contact: Peter Deaking. Community arts group.
LEEDS WEST INDIAN CARNIVAL, 4 Ontario Place, Leeds 7. Contact: Ian Charles. Carnival.
MARA YA PILIDANCE GROUP, 234 Kirkstall Lane, Leeds 6. Tel. 0532 741203. Contact: Jan Hambley. Dance.

ARTISTS ORGANISATIONS

ARTISTS ORGANISATIONS—LONDON

SHAPE, 1 Thorpe Close, London W10 5XL. Tel. 01-960 9245. Shape introduces professional visual artists, musicians, actors, dancers and puppeteers to hospitals, prisons, youth centres, day centres and to elderly, mentally and physically handicapped people and to homeless, disturbed adolescents and offenders. See also regional section.
AUDIO ARTS, 6 Briarwood Road, London SW4. Tel. 01-720 9129. Editor Bill Furlong. Sells editions of tapes by known artists whose work is best promoted in this medium.
ACME HOUSING ASSOCIATION, 15 Robinson Road, London E2. Tel. 01-981 6811. Directors Jonathan Harvey and David Panton. A non-profitmaking charity that houses artists mostly in the East end of London. Currently has some 250 houses and three studio blocks. Waiting list after artists have been interviewed.
INTERNATIONAL ASSOCIATION OF ART, 31 Clerkenwell Close, London EC1. Tel. 01-250 1927. £10 membership to professional artists. Card to enable artists to gain reduced entry to galleries in UK and overseas, also discount at certain supply shops, travel agents, books etc.
SPACE STUDIOS, 6 & 8 Rosebery Avenue, London EC1. Tel. 01-278 7795. Sapce Studios was set up in 1966 to help artists find cheap studio space. See Studios section for details. Waiting list and interview for studios. AIR gallery also run below SPACE offices.
THE ARTISTS' UNION, 9 Poland Street, London W1. Tel. 01-720 9595. Active Artists' Union open to all professional artists. Newsletter and latest developments. £10 subscription.
FEDERATION OF BRITISH ARTISTS, 17 Carlton House Terrace, London SW1. Tel. 01-930 6844. Secretary General Carl de Winter. Federation of British art societies including many Royal Art societies. Leases the Mall Galleries where members have the opportunity to submit work for exhibitions. Membership by subscription.
NATIONAL SOCIETY OF PAINTERS, SCULPTORS AND PRINTMAKERS, 17 Carlton House Terrace, London SW1.
NEW ENGLISH ART CLUB, 17 Carlton House Terrace, London SW1.
INDUSTRIAL PAINTERS GROUP, As above. Also: Royal Institute of Oil Painters; Royal Institute of Painters in Watercolour; Royal Society of British Artists; Royal Society of Marine Artists; Royal Society of Miniature Artists; Royal Scoeity of Painters Etchers and Engravers; Royal Society of Portrait Painters; Senefeld Group of Artist Lithographers; Society of Mural Painters; Society of Women Artists; United Society of Artists; Society of Architect Artists.
CHELSEA ART SOCIETY, Chenil Art Galleries, Kings Road, London SW3.
FREE PAINTERS AND SCULPTORS, 15 Buckingham Gate, London SW1.
ART REGISTRATION COMMITTEE, 5 Aysgarth Road, London SE21. John Alexander Sinclair.
ROYAL SOCIETY OF BRITISH SCULPTORS, 108 Old Brompton Road, London SW7.
SOCIETY OF INDUSTRIAL ARTISTS AND DESIGNERS, 12 Carlton House Terrace, London SW1.
SOCIETY OF DESIGNERS AND CRAFTSMEN, 6 Queen Square, London WC1.

ROYAL ACADEMY, Burlington House, Piccadilly, London W1. Membership by election. President Roger de Grey.

FEDERATION OF BRITISH CRAFT SOCIETIES, 43 Earlham Street, London W1. Tel. 01-836 4722.

GREENWICH PRINTMAKERS ASSOCIATION, 7 Turnpin Lane, Greenwich, London SE10. Tel. 01-858 2290.

PRINTMAKERS COUNCIL, 31 Clerkenwell Close, London EC1. Regular bulletin and promotion of printmakers' interests. professional membership. Tel. 01-250 1927.

ARTISTS' GENERAL BENEVOLENT INSTITUTION, Burlington House, Piccadilly, London W1. Tel. 01-744 1194. Artist-run to provide financial assistance to professional artists in old age or in times of misfortune. Also Artists' Orphan Fund.

ARTISTS' LEAGUE OF GREAT BRITAIN, c/o Bankside Gallery, Hopton Street, London SE1. Advice and assistance for the fine art field.

VARS, Visual Artists Rights Society, 108 Old Brompton Road, London SW7. Tel. 01-373 3581.

THE CORPORATE ARTS, 23 Cavaye Place, London SW10 9PT. Tel. 01-370 7427. Director Sarah Hodson. Non-profit. Help artists exhibit work in city offices.

WOMEN ARTISTS SLIDE LIBRARY, Fulham Palace, Bishops Avenue, London SW6 6EA. Tel. 01-731 7618.

DESIGN AND ARTISTS COPYRIGHT SOCIETY, St Marys Clergy House, 2 Whitechurch Lane, London E1 7QR. Tel. 01-247 1650.

SOCIETY OF WOMEN ARTISTS, 16 Carlton House Terrace, London SW1. Tel. 01-930 6844.

ARTISTS SUPPORT PEACE, c/o Norfolk House, Space Studios, Deptford, London SE8.

CAMDEN WOMEN ARTS CO-OP, The Dove CNA Community Centre, 109 Bartholomew Road, London NW5.

ELSEWHERE IN THE UK

ARTISTS AGENCY, Northern Centre for contemporary Art, 17 Grange Terrace, Stockton Road, Sunderland. This is an organisation concerned with the placement of artists in Industry and other Agencies. Tel. 091-510 9318.

CLEVELAND ARTS, PO Box 41, Teesside House, 108a Borough Road, Middlesbrough, Cleveland; an organisation concerned with arts development in Cleveland. Visual Arts Officer: Joanna Morland.

ROYAL GLASGOW INSTITUTE OF FINE ARTS, 12 Sandyford Place, Glasgow G3. President Alan Cuthbert.

ROYAL CUMBRIAN ACADEMY OF ART, Plas Mawr, Conwy.

OXFORD PRINTMAKERS CO-OPERATIVE, Christadelphian Hall, Tyndale Road, Oxford.

WINCHESTER ASSOCIATION OF WORKING ARTISTS, 4 Staple Gardens, Winchester.

YORKSHIRE ART SPACE SOCIETY, 4 Chapel Terrace, Ranmoor, Sheffield.

ASSOCIATION OF ARTISTS AND DESIGNERS IN WALES, Gaskell Buildings, Collingden Road, Cardiff. Tel. Cardiff 487607.

BIRMINGHAM ARTISTS' GROUP, 3 Hermitage Road, Edgbaston, Birmingham. 40 members. Exhibitions, Magazine.

WASPS, 22 King Street, Glasgow G1. Tel. 041-552 0564. See studio section.

Also:

WASPS, Patriot Hall, Hamilton Place, Stockbridge, Edinburgh. Tel. 031-225 1289.

MANCHESTER ARTISTS STUDIO ASSOCIATION, 16-18 Granby Row, Manchester 1.

ARTISTS DIRECTORY, St Annes Hall, 110 St Georges Road, Brighton. Tel. Brighton 697493. Contact: Alan Compton. Register of artists working with the community.

OMEGA '83, Maran Works. Carrington Road. Richmond, Surrey TW10 5AA. Tel. 01-940 9502. Commissions arranged for artists and charity. Invaluable service for architects and interior designers.

ROYAL BIRMINGHAM SOCIETY OF ARTISTS, 69A New Street, Birmingham 2.

ROYAL HIBERNIAN ACADEMY, 15 Ely Place, Dublin.

ROYAL SCOTTISH ACADEMY, The Mound, Edinburgh. President Robin Phillipson.

ROYAL SCOTTISH SOCIETY OF PAINTERS IN WATERCOLOUR, 17 Sandyford Place, Glasgow G3.

ROYAL ULSTER ACADEMY OF PAINTING, SCULPTURE AND ARCHITECTURE, 10 Coolson Park, Lisburn, County Antrim.

ROYAL WEST OF ENGLAND ACADEMY, Queens Road, Clifton, Bristol.

ST IVES SOCIETY OF ARTISTS, Old Mariners Church, Norway Square, St Ives, Cornwall.

SCOTTISH ARTISTS' BENEVOLENT ASSOCIATION, Scottish Society of Women Artists, Netherlea, Old Mill Lane, Edinburgh 16.

GLASGOW GROUP, c/o 7 Station Road, Bearsden, Glasgow. Tel. 041-942 4680. Hold regular annual exhibitions.

GLASGOW ART CLUB, 185 Bath Street, Glasgow G3. Tel. 041-248 5210.

NORWICH ARTISTS GROUP, 10 Launceston Terrace, Newmarket Rd, Norwich, NR2 2JH. Tel. 0603 627204.

2D3D SOUTH, Sue Anderson, 14 Bedwell Close, Rownhams, Southampton, SO1 8FT. Professional painters, printmakers and sculptors.

NORTHERN POTTERS, Isobel Denyer, Wighill House, Wighill, Tadcaster, Yorkshire. Tel. Tadcaster 835632.

CORK ARTISTS COLLECTIVE, 10 Halldene Avenue, Bishopstown, Cork, Eire.

YORKSHIRE CONTEMPORARY ART GROUP, Stowe House, 5 Bishopsgate Street, Leeds, LS1 5DY. Tel. 0532 456421. James Hamilton. Enables artists to show more work in public places or galleries.

YORKSHIRE ARTS CIRCUS, 17 Linden Terrace, Pontefract, West Yorkshire. WF8 4AE. Tel.

0977 793121. Brian Lewis and Rachel Adams. Artist-run and takes proejcts into communities.
THE SOCIETY OF SCOTTISH ARTISTS, 3 Howe Street, Edinburgh EH3 6TE. Tel. 031-557 2342.
ARTISTS IN MIDDLESBOROUGH, 1 Elliot Street, Middlesborough, Cleveland. Tel. 210756.
THE BIRMINGHAM ART TRUST, PO Box 2003, Birmingham B1 1BW.
CAMBRIDGE ARTS FORUM, 26 Arden Road, Cambridge CB4 2UJ. Tel. 0223 322407. Contact: Derek Batty.
DEVON ARTS & CRAFTS GUILD, 52 New Exeter Street, Chudleigh, Devon. Tel. 0626 853606. Contact: Alan Taylor.
MIDLAND POTTERS ASSOCIATION, Contact: Membership Secretary, Stephen Adams. 17 Green Lane, Halesowen, W. Midlands B62 9LP.
NATIONAL ACRYLIC PAINTERS ASSOCIA-TION, 3 Millersdale Close, Eastham, Wirral. L62 8HQ.
SUNDERLAND ARTIST GROUP, Contact: Colin Wilbourne, 4 The Elms, Sunderland, Tyne & Wear.
YORKSHIRE SCULPTORS GROUP, Old School Arts Workshop, Middleham, Nr. Leyburn, N. Yorks. Tel. 0969 23056. Contact: Peter Hibbard.
SHAPE (Network and Affilicated Services).
EASTERN REGION:
Chris Davies, Shape London, 1 Thorpe Close, London W10 5XL. Tel. 01-960 9245.
Lucy Gampbell, Shape East, c/o Eastern Arts, Cherry Hinton Hall, Cambridge. CB1 4DW. Tel. 0223 215355.
Anne Peaker, East Midlands Shape, New Farm, Walton by Kimcote, Lutterworth, Leicestershire. LE17 5RL. Tel. 04555 3882.
Sue Roberts, Artlink for Lincolnshire and Humberside, Humberside Leisure Services, Central Library, Albion Street, Hull. HU1 3TF. Tel. 0482 224040.

Jean Line, Artability (South East), The old School, Cobden Road, Sevenoaks, Kent. TN13 3UB. Tel. 0732 460650.
NORTHERN REGION:
Cynth Hopkins & Pat Foster, Shape Up North, 191 Bellevue Road, Leeds. LS3 1HG. Tel. 0532 431005.
Sally Martin, North West Shape, The Green Prefab, Back of Shawgrove School, Cavendish Road, West Didsbury, Manchester. M20 8JR. Tel. 061-434 9666.
Colin Langton, Northern Shape, Todd's Nook Centre, Monday Crescent, Newcastle-upon-Tyne. NE4 5BD. Tel. 091-226 0701.
SOUTHWEST REGION:
Piers Benn, Southern Artlink, 125 Walton Street, Oxford. OX2 6AH. Tel. 0865 516115.
Pippa Warin, Artshare South West, Exeter and Devon Arts Centre, Bradninch Place, Gandy Street, Exeter. EX4 3LS. Tel. 0392 218923.
Lee Corner, Artlink, 17A Hanover Street, Newcastle-under-Lyme, Staffs. ST5 1HD. Tel. 0782 614170.
Peter Taylor, Solent Artlink, Hornpipe Community Arts Centre, 143 Kingston Road, Portsmouth. Tel. 0705 828392.
AFFILIATED SERVICES:
Thursa Sanderson, Artlink Edinburgh & The Lothians, 4 Forth Street, Edinburgh. EH1 3LD. Tel. 031-556 6350.
Sheena Moreby, Project Ability, 37 Otago Street, Glasgow. G12 8JJ. Tel. 041-339 1787.
Bryan Beattie & Fiona Bonar, Scottish Council on disability Committee on Arts for Scotland, Princes House, 5 Shandwick Place, Edinburgh. EH2 4RG. Tel. 031-229 8632.
Phil Burton, Arts for Disabled People in Wales, "Channel View", Jim Driscoll Way, The marl, Grangetown, Cardiff. CF1 7NF. Tel. 0222 377885.

USEFUL ART ADDRESSES

ARTS COUNCIL OF GREAT BRITAIN, 105 Piccadilly, London W1. Tel. 01-629 9495.
BRITISH COUNCIL, 11 Spring Gardens, London SW1. Tel. 01-930 8466. Fine Art. Dept, 11 Portland Place, London W1. Tel. 01-636 6888.
VISITING ARTS UNIT, 11 Portland Place, London W1. Tel. 01-636 6888.
CENTRAL BUREAU FOR EDUCATIONAL VISITS AND EXCHANGES, Seymour Mews, London W1. Tel. 01-486 5101.
ASSOCIATION OF BUSINESS SPONSORSHIP FOR THE ARTS, 2 Chester Street, Lodnon SW1X 7BB. Tel. 01-235 9781.
GREATER LONDON ARTS ASSOCIATION, 9 White Lion Street, London N1 9PD. Tel. 01-837 8808.
SCOTTISH ARTS COUNCIL, 19 Charlotte Square, Edinburgh. Tel. 031-226 6051.

WELSH ARTS COUNCIL, Holst House, Museum Place, Cardiff. Tel. 0222 394711.
THE ARTS COUNCIL OF NORTHERN IRE-LAND, 181A Stranmillis Place, Belfast. Tel. 0232 663591.
ARTS COUNCIL IN EIRE, 70 Merrion Square, Dublin 2. Tel. Dublin 764695.
BRITISH AMERICAN ARTS ASSOCIATION, 49 Wellington Street, London WC2. Tel. 01-379 7755. Jennifer Williams. Useful organisation for artists travelling to USA and need information prior to departure on scholarships, art schools etc.
ARLIS (Art Libraries Society), c/o Brighton Polytechnic, Brighton BN1 9PH. National society for anyone involved in art libraries.
INTERNATIONAL ASSOCIATION OF ART CRITICS, (President Julie Lawson), 1 Campden

Mansions, Kensington Mall, London W8. Membership open to art critics in the UK. Meets regularly and discusses problems relating to art criticism and arranges appropriate seminars from time to time. AICA also has organisations in many other countries overseas and membership gives art critics reduced entry to exhibitions and other benefits. Members are elected with reference to curriculum vitae or previous experience in the field of art criticism—£20 per annum 1988/89.

CONTEMPORARY ART SOCIETY, 20 John Islip Street, London SW1. Tel. 01-821 5323. Director: Petronilla Spencer-Silver. Acquires works by living artists for gift or loan to public galleries.

COUNCIL FOR NATIONAL ACADEMIC AWARDS, 344–354 Grays Inn Road, London WC1. Tel. 01-278 4411. List courses currently being offered by colleges and polytechnics throughout the UK.

CRAFTS COUNCIL, 12 Waterloo Place, London SW1. Tel. 01-930 4811.

MUSEUMS ASSOCIATION, 87 Charlotte Street, London W1. Tel. 01-636 4600.

NATIONAL ART COLLECTIONS FUND, 20 John Islip Street, London SW1P 4LL. Tel. 01-405 4637. Helps galleries and museums acquire works of art of historical interest. £7 annual subscription.

NATIONAL ASSOCATION OF DECORATIVE AND FINE ARTS SOCIETIES, Room 625, Grand Building, Trafalgar Square, London WC2. Tel. 01-930 1693.

NATIONAL SOCIETY FOR ART EDUCATION, Champness Hall, Drake Street, Rochdale Lancashire. Represents interests of teachers of art and design.

ROYAL SOCIETY OF ARTS, 6-8 John Adam Street, London WC2. Tel. 01-839 2366. Holds occasional art exhibitions, but acts as a link between practical arts and the sciences.

THE SOCIETY OF LONDON ART DEALERS, c/o Secretary, OT Galloway, 41 Norfolk Avenue, Sanderstead, South Croydon. Founded to uphold the good name of the art trade.

SOUTHEBY PARKE BERNET & CO., Fine Art Courses, 34/35 New Bond Street, London W1. Tel. 01-408 1100. Variety of specialised courses open to students.

THE ARTS CLUB, 40 Dover Street, London W1. Tel. 01-499 8581. Exchange arrangements for members to use overseas art clubs and other UK art clubs.

ARTS LINE, 48 Boundary Road, London NW8 0HJ. Tel. 01-625 5666. Information for the disabled on the arts in London. Send sae for list.

MARTIN LILLEY, 220 Thames House, 566 Cable Street, London E1. Tel. 01-791 1659. Photographic service for London based galleries and artists. Location and studio work in 35mm to 5 × 4 formats.

HAMMERSMITH AND FULHAM PICTURE LOAN SCHEME, Arts and Entertainment Section, 181 King Street, London W6. Tel. 01-741 3069.

ARTS CONSORTIUM, 2nd Floor, 66-72 St Johns Road, London SW11. Tel. 01-228 2077. A National Arts Lobby with prominent members of all the arts.

ART GALLERIES ASSOCIATION

GRAVES ART GALLERY, Surrey Street, Sheffield S1 1XZ. Tel. 0742 734781. Contact: Secretary, Julian Spalding.

For the addresses of all Regional Arts Associations see under "Awards" section in Chapter 1.

MISCELLANEOUS

BATH CONTEMPORARY ART FAIR, 1 Pierrepoint Place, Bath, BA1 1JY. Director: Sean Kelly.

LONDON CONTEMPORARY ART FAIR/LA ART FAIR, 11 Manchester Square, London W1M 5AB. Tel. 01-486 1951.

NATIONAL CAMPAIGN FOR THE ARTS, Francis House, Francis Street, London SW1P 1DE. Tel. 01-828 4448.

COUNCIL OF REGIONAL ARTS ASSOCIATIONS, Litton Lodge, 13A Clifton Road, Winchester, Hampshire, SO22 5BP. Tel. 0962 51063.

GULBENKIAN FOUNDATION, 98 Portland Place, London W1N 4ET. Tel. 01-636 5313.

ASSOCIATION FOR BUSINESS SPONSORSHIP OF THE ARTS, 2 Chester Street, London SW1X 7BB. Tel. 01-235 9781.

BRITISH FILM INSTITUTE, 127 Charing Cross Road, London WC2H 0EA. Tel. 01-437 4355.

BUSINESS IN THE COMMUNITY, 227A City Road, London EC1V 1LX. Tel. 01-253 3716.

MARKETING ARTS, 19 Stanhope Gardens, London N6 5TT. Tel. 01-348 8077.

ART AGENCIES

THE ARTANGEL TRUST, 133 Oxford Street, London W1R 1TD. Tel. 01-434 2887. Director: Roger Took. Commissions and supports public art.

ART IN PARTNERSHIP SCOTLAND, 25A SW Thistle Street Lane, Edinburgh EH2 1EW. Tel. 031-225 2042. Robert Breen. Promotes art in public places in Scotland.

ARTSCAPE, 78 Beauchamp Road, Solihull, West Midlands. Tel. 021-704 4772. June Lewis. Promotes art to architects, business landscape designers and other outlets.

ARTISTS AGENCY, 17 Grange Terrace, Stockton Road, Sunderland. Tel. 091-510 9318. Lucy Milton. Promotes art in the north to the public and to businesses.

CITY GALLERY ARTS TRUST, The Great Barn, Parklands, Great Linford, Milton Keynes. Tel. 052-526 617. David Wright. Brings contemporary visual arts to the public.

COMMON GROUND, The London Ecology Centre, 45 Shelton Street, London WC2H 9HJ. Tel. 01-379 3109. Joanna Morland. Brings art to local communities.

PUBLIC ART DEVELOPMENT TRUST, 6–8 Rosebery Avenue, London EC1R 4TD. Tel. 01-

837 6070. Director Lesley Greene. A charity to encourage works of art in public places.
WELSH SCULPTURE TRUST, 6 Cathedral Road, Cardiff. CF1 9XW. Tel. 0222 374102.

Director: Tamara Krikorian. Sculpture in public places.

SURVIVAL

See studio section for practical work survival. Refer to Preparation for an Exhibition for exhibiting details. Refer to Scholarships, Awards and Grants section.

WORK

Trying to find work in the art world is extremely difficult as everyone knows, so below we have listed useful addresses and possible suggestions on a practical basis.

Work in the art world falls into several categories that you might consider:
1. Art administration.
2. Secretarial which could lead to administraton or being a gallery director later on.
3. Art teaching at schools, colleges and studios.
4. Community art, i.e. SHAPE work within the community. See below.
5. Art therapy.
6. Art history teaching.
7. Painting and decorating (horror of horrors, but many artists do it for survival for months and years).
8. Shop work—framers, art materials.
9. Gallery work on different levels.
10. Art magazines.
11. Art criticism.
12. Setting up a gallery, art supply shop, magazine etc. Good relations with your local bank essential.
13. Conservation specialist courses at certain UK centres.
14. Art bookshops.
15. Art organisations.
16. Self employment under various government backed enterprise schemes.

STARTING ON YOUR OWN

In 1981 I set up Art Guide Publications primarily to provide artists and other people in the art world with useful art information, both in Britain and overseas. The "LONDON ART AND ARTISTS GUIDE" was the first book to appear then Paris and New York. Richard Layzell and I who had both been working at ACME gallery and ACME Housing Association for artists respectively, decided that there was a great need for an Artist's Handbook, as we seemed to be carrying around far too much information that other artists could be using, so "THE ARTIST'S DIRECTORY" was started. Initially it was to be published by Angus and Robertson but by the time we had finished it, I had set up ART GUIDE PUBLICATIONS; it eventually came out under the Art Guide imprint in 1982 after I had paid Angus and Robertson back the authors' advance.

Running the publishing company was a completely new experience for me, and if I had known what frightening financial implications were involved I don't honestly think I would ever have continued, but enthusiasm and naivete can do one a good turn sometimes. Between 1981 and 1987 running the company started off well with enthusiasm carrying me along, and the authors were all very helpful, as it was difficult to keep an eye on trying to promote sales and distribution overseas as well as in Britain. At book trade fairs at London and Frankfurt I would summon up courage approaching large distribution companies and often have to face humiliation, but occasionally they would admire your spirit and take the books on. With the help of a Foreign Rights agent I actually managed to sell the French rights of the Paris guide as "Guide de l'artiste à Paris" and this was a great morale boost. However although the press were giving great help with reviews, what came as a complete shock to me was jealousy from a competitor, whose aim was to ruin the company, and make me frightened enough to give up. I mention this as a warning of the dangers also involved in running your own business.

I think it would be fair to say that running the company was a reasonable success, but by 1987 the real problems lay in expansion and the fact that single handed it was virtually impossible to cope both financially with the worries of large loans and without extra help, as the company could not afford extra staff anyway. In August 1987 I put a small advert in "The Bookseller" and received 40 replies from Britain, America and Singapore even. I sold the imprint to A & C Black and now work there part-time to ensure that there were no problems with the takeover, to continue the series and to allow myself more time to do photography and freelance writing. With running the business full-time there was little time for creativity, and this is one of the main considerations, apart from financial affairs, which made me realise it was time to move on. The sale of the company covered the outstanding printers' bills and 3/4 of the bank loans, but I gained the experience of running a business from A to Z when I sold, a six year lifetime's experience but little financial gain.

It is at least gratifying to know that people in the art world in many countries find the guides useful and enjoyable and with renewed funding, apart from the seven books I published, there will soon be another three each year.

Below I am listing various factors that should help when considering starting on your own and also useful addresses to give further advice.

Key Questions to ask yourself
 1. Where do I find the money to start my business?
 2. Should I become a sole trader, partnership or become a limited company?
 3. Should I rent premises or run the business from home?
 4. Should I employ part or full-time staff?
 5. Should I continue with part-time employment?
 6. How do I find a good bank manager, solicitor and accountant?
 7. Are there any organisations that can help me expand and continue?
 8. Have I got adequate insurance for any stock?
 9. Should I concentrate on the UK or overseas as well for sales?
10. How do I find further finance later on?
11. How do I ensure that I am not one of the 4 out of 5 businesses going bust in the first year of business?
12. How do I find adequate press coverage and promotion?

USEFUL ADDRESSES

SMALL FIRMS INFORMATION SERVICE, Department of Industry, Ashdown House, 123 Victoria Street, London SW1. Freefone 2444 or 212 7676 (extremely helpful). You can also dial 100 and ask for **Freephone Enterprise**.

SCOTTISH DEVELOPMENT AGENCY, 102 Telford Road, Edinburgh. Small firms schemes and loans.

LOCAL ENTERPRISE UNIT, Lamont House, Purdy's Lane, Belfast, Northern Ireland.

INVESTORS IN INDUSTRY, (three III) 91 Waterloo Road, London SE1. Tel. 01-928 7822. Loans considered of £5000 upwards. Average loan usually £20,000 or more. Very difficult for small companies to crack this one.

LONDON ENTERPRISE AGENCY (LENTA), 4 Snowhill, London EC1. Tel. 01-236 3000. Training courses, counselling, small business advice. Free leaflets.

WELSH DEVELOPMENT AGENCY, Treforest Industrial Estate, Pontypridd, Mid Glamorgan.

ENTERPRISE NORTH, DUMS, Mill Hill Lane, Durham. Tel. Durham 4191 ext 42.

COSIRA PUBLICATIONS, 141 Castle Street, Salisbury, Wiltshire SP1 3TP. Free advice for small businesses in rural areas.

There is also a GRADUATE ENTERPRISE scheme with branches throughout the UK. Ask your local enterprise agency for details.

USEFUL BOOKS

WORKING FOR YOURSELF, Golzen, Kogan Page publishers £7.95 (ppb)
Part 1: How to operate your business.
Part 2: Opportunities for self-employment/freelance work.
Kogan Page publish a series of other books on running your own from shops to photographic business. Most bookshops stock their helpful books.
KOGAN PAGE, 120 Pentonville Road, London N1 9JN. Tel. 01-278 0433.

USEFUL TIPS (from personal experience)
 1. Always remember your product must be **saleable** for you to survive and for any sponsor or bank to lend you money.
 2. **Money**
 a) **Bank manager**—various business loans available.
 b) **Partner/backer**. Under the Business start up schemes and Enterprise schemes (BES) there are various tax advantages for people wanting to invest over £20,000 a year. Applies to businesses up to 3 years old.
 c) **3 iiis** (see list before) Investors in Industry.
 d) Use your own money or borrow from your family, and if really determined banks will eventually lend you money if sales produce results.
 e) Search for competitions. BBC/TV once ran a competition for small businesses. Prizes were large sums of money and runners up all received free advice from Barclays Bank. The words I remember were "Do you want to be HW cottage industry or HW enterprises" i.e. how ambitious are you?
 3. **Advice**—Essential to have:
 a) **A good bank manager**—always available to give advice on loans, cashflow, export, expansion etc. Problems arise if your kind bank manager moves on! I was given two weeks to find a new bank or repay a £20,000 loan. As luck would have it I found one a day before the deadline.
 b) **Solicitor**—all legalities from becoming a limited company to contracts.

c) **Accountant**—essential for survival when problems arise and they will often save your skin by coming to see the bank manager with you.
4. **Marketing**—Whatever your product you have to consider:
a) Sales in the UK and overseas possibly.
b) Promotion—advertising and free reviews.
c) Extra sales outlets—special offers etc.
5. **Export**—Beware of currency problems and fluctuations. Prices should be flexible.
6. **Financial control**—cashflow all important. Be slow on paying small bills but beware larger ones as they could be the ones that cause you to go bankrupt. VAT registration if you earn more than £22,100. Pay yourself very little at first.
7. **Premises**—Don't waste too much money on luxurious premises. Share premises and the use of photocopier/receptionist/message taker.
8. **Expansion**—Remember Freddie Laker and don't expend too quickly!
9. **Staff**—PAYE is a nightmare if you are a very small company. If you work on your own you can be self-employed by avoiding this and use freelancers.
10. **Invoices**—should state your terms i.e. Terms: Payment in 28 days and possibly give bank details. Overseas accounts often want a postal bank account— (Girobank).
11. Finally bon courage as the French would say— you'll need it! Running a small business will run you through every emotion from laughter, tears, anger, fear, stress and sheer exasperation. Being a Celt that was nothing unusual but for southern temperaments it might be a problem!!!

© Copyright Heather Waddell 1988

There are now Art Guides to **London, Paris, New York, Berlin, Amsterdam, Australia** and under the new ownership in 1989 there will be Art Guides to **Madrid** and **Glasgow** followed by **Milan** and **California**.

USEFUL ADDRESSES FOR WORK IN THE ART WORLD

ARTS COUNCIL OF GREAT BRITAIN, 105 Picadilly, London W1. Tel. 01-629 9495.
ARTS ADMIN COURSES AT CITY UNIVERSITY, supported by the Arts Council.
CITY UNIVERSITY, Arts Dept, Barbican Centre, Frobisher Crescent, Level 12, London EC2Y 8HB. Tel. 01-628 5641/2.
ILEA ARTS CAREERS ADVISORY SERVICE, Central London Careers Office, 145 Charing Cross Road, London WC2. Tel. 01-734 8531. Anne Francis. At present inundated by unemployed artists. Service only open to ex London art school graduates. Ring for an appointment first. ILEA is being disbanded in 1990.
SHAPE (network and affiliated services)
EASTERN REGION:
Chris Davies, Shape London, 1 Thorpe Close, London W10 5XL. Tel. 01-960 9245.
Lucy Gampbell, Shape East, c/o Eastern Arts, Cherry Hinton Hall, Cambridge CB1 4DW. Tel. 0223 215355.
Anne Peaker, East Midlands Shape, New Farm, Walton by Kimcote, Lutterworth, Leicestershire LE17 5RL. Tel. 04555 3882.
Sue Roberts, Artlink for Lincolnshire and Humberside, Humberside Leisure Services, Central Library, Albion Street, Hull HU1 3TF. Tel. 0482 224040.
Jean Line, Artability (South East), The Old School, Cobden Road, Sevenoaks, Kent. TN13 3UB. Tel. 0732 460650.
NORTHERN REGION:
Cynth Hopkins & Pat Foster, Shape Up North, 191 Bellevue Road, Leeds. LS3 1HG. Tel. 0532 431005.
Sally Martin, North West Shape, The Green Prefab, Back of Shawgrove School, Cavendish Road, West Didsbury, Manchester M20 8JR. Tel. 061-434 9666.
Colin Langton, Northern Shape, Todd's Nook Centre, Monday Crescent, Newcastle-upon-Tyne. NE4 5BD. Tel. 091-226 0701.
SOUTHWEST REGION:
Piers Benn, Southern Artlink, 125 Walton Street, Oxford OX2 6AH. Tel. 0865 516115.
Pippa Warin, Artshare South West, Exeter and Devon Arts Centre, Bradninch Place, Gandy Street, Exeter EX4 3LS. Tel. 0392 218923.
Lee Corner, Artlink, 17A Hanover Street, Newcastle-under-Lyme, Staffs ST5 1HD. Tel. 0782 644170.
Peter Taylor, Solent Artlink, Hornpipe Community Arts Centre, 143 Kingston Road, Portsmouth. Tel. 0705 828392.
AFFILIATED SERVICES:
Thursa Sanderson, Artlink Edinburgh & The Lothians, 4 Forth Street, Edinburgh. EH1 3LD. Tel. 031-556 6350.
Sheena Moreby, Project Ability, 37 Otago Street, Glasgow. G12 8JJ. Tel. 041-399 1787.
Bryan Beattie & Fiona Bonar, Scottish Council on Disability Committee on Arts for Scotland, Princess House, 5 Shandwick Place, Edinburgh. EH2 4RG. Tel. 031-229 8632.

Phil Burton, Arts For Disabled People in Wales, "Channel View", Jim Driscoll Way, The Marl, Grangetown, Cardiff. CF1 7NF. Tel. 0222 377885.

Shape introduces professional visual artists along with actors, dancers, musicians, clowns, puppeteers and mime artists to hospitals, day centres, reception centres, youth projects and community centres. They also visit mentally and physically handicapped, disturbed adolescents and elderly people. Contact them if you like working with people and your artwork lends itself to this kind of contact.

MAGAZINES THAT LIST JOBS IN THE ART WORLD ARE LISTED BELOW

ARTISTS NEWSLETTER, PO Box 23, Sunderland, SR1 1EJ. Tyne and Wear. Tel. 091-567 3589.
ART MONTHLY, 36 Great Russell Street, London WC1. Tel. 01-405 7577.
ARTSCRIBE, 41 North Road, London N7 9DP. Tel. 01-609 2339.
TIME OUT, Tower House, Southampton Street, London WC2. Tel. 01-836 4411.
ARTS REVIEW, 69 Faroe Road, London W1X 0EL. Tel. 01-603 7530/8533.

NEWSPAPERS

THE GUARDIAN, 119 Faringdon Road, London EC1. Tel. 01-278 2332. Mondays (creative and media) but also other days for art related jobs. Tuesdays (educational).
THE TIMES, 1 Pennington Street, London E1 9XN. Tel. 01-481 4100.
TIMES EDUCATIONAL SUPPLEMENT, Priory House, St Johns Lane, London E1. Tel. 01-253 3000.
Regionally: Local papers and national art magazines. Also check the **Sunday** papers.

ART TEACHING

If you decide to do an art teacher qualification after art school there are several choices open depending on what level of student or pupil you wish to teach.
GOLDSMITHS COLLEGE, Lewisham Way, London SE14. Tel. 01-692 0211.
MIDDLESEX POLYTECHNIC, Trent Park, Cockfosters, Herts.
UNIVERSITY OF LONDON, 1 Malet Street, London WC1. Art teacher training for secondary and possibilities of college level teaching practice.
GARNETT COLLEGE, Roehampton Lane, London SW15. Teaching qualification for teaching art and art history at further and higher education level. Teaching practice at Foundation level in an art college or FE college. Advantages are that the course offers media studies for video and film-making and teaching practice lets you see other art combined courses rather than just straight life work.
Elsewhere in the UK: Too numerous to list all the teacher training courses that train art teachers but contact your local education authority for addresses of the nearest college.

Art teaching jobs are advertised in the "Times Educational Supplement" and often internally at teacher training colleges. Also in "The Times" and "The Guardian" and in "Time Out" for London, "Glasgow Herald", "The Scotsman" and sometimes in art magazines nationally. Contact art schools and adult education institutes where art evening classes take place, as once you have started teaching art it is easier to find full time jobs.

ART ORGANISATIONS AND GALLERIES

Ask locally at art organisation if they need some part-time help which could lead to more full time work or start as the secretary and work your way up. Galleries often need extra help before exhibitions open. Voluntary work is not necessarily advisable but could help to let you see what the work would be like. Galleries usually need a reliable hard working secretary who is helpful to visitors and willing to learn as he/she goes along. This could help you learn the ropes even if you don't like secretarial work and eventually you could change to administration or set up your own gallery. Contacts is the name of the game really and once you have a job, however menial, you will meet the people who will tell you about the other jobs, sometimes before they come on the market. Take a good secretarial course, an arts administration course or gain some experience as a volunteer before applying for jobs though.

ARTS ADMINISTRATION COURSES

THE CITY UNIVERSITY, Department of Arts Policy and Management, Level 12, Frobisher Crescent Barbican, Silk Street, London EC2Y 8HB. Tel. 01-628 5641/2. Diploma in arts administration, short courses in finance computers, publicity, law and other courses. Supported by the Arts Council. Main art criticism now also available.

ART CRITICISM

Unless you are in the fortunate position to have a secure job as a regular art critic for a newspaper, art criticism is rarely lucrative but often very interesting and satisfying. Usually it is an idea to contact an art magazine before you write a review or article and see if they might be interested unless you don't mind writing it anyway and they might just take it when you ring up. Again perseverance helps and try to find out about more off-beat art magazines and art outlers as the better known magazines are usually well covered.

Another approach is to write to overseas art magazines once you have written and had several items published and send copies of these and a covering letter to an overseas art magazine asking if they need coverage for London. For example France, Italy and Germany rarely cover British and if your languages are good there could be an opening, or else write the articles in English and they will translate them. You do lose money for this however. Typical overseas rates vary but could be £50–£100 for 1000 words plus photos, to £300 for 2000 words plus colour photographs. In London £25 or £10 is usual for an art magazine, so hardly a lucratice career.

As London is well covered, London art critics could contact their home town paper to see if they might be interested in reviews or profiles of exhibitions, artists who are showing in London but come from your home area. Local boy/girl makes good is always a popular angle in local papers.

Art school noticeboards often have jobs listed so check your local art schools. After appropriate experience it is worth joining **AICA** (International Association of Art Critics) See Art Addresses section.

SKILLS
Any skills, especially building skills can be useful, or typing, and you will often have to use these on a temporary basis until you find an appropriate job.

Part-time work. Most serious professional artists find that it is essential to work only part-time so that they can continue their own work, rather than full-time, but obviously this depends on your personal financial situation.

GRANTS, AWARDS, SCHOLARSHIPS, PRIZES

Official awards from the regional arts associations and the Arts Councils in each country.

ARTS COUNCIL OF GREAT BRITAIN
For up to date information contact: Assistant Art Director, Art Department, Arts Council of Great Britain, 105 Piccadilly, London W1V 0AU. Tel. 01-629 9495 (Art); Barry Lane, Photography Officer (Photography); Rodney Wilson, Film Officer (Film/Video).

Art for public places, assisted purchase and artist-in-residence schemes: These schemes are co-ordinated by Rory Coonan. Individual projects are administered by the Regional Arts Assocations with funds provided by the Arts Council. For up to date information contact Rory Coonan.

Studio conversions: Assistance towards conversion of studios in multiple occupation held on secure leases of at least five but preferably ten years or more.

Purchases for the Arts Council Collection: Artists may submit slides or photographs or work for consideration by the purchasing advisory group at any time. For up to date information contact Isobel Johnstone. Curator of the Arts Council Collection, South Bank Centre, London SE1 8XX.

Photography: Assistance towards the equipment of dark-rooms and photography magazines and other publications. No bursaries or awards are currently available. For up to date information contact Barry Lane, Photography Officer.

Publishing: Art magazines, books on art and artists' books. Within the funding currently available priority is given to magazines. For up to date information contact Tania Butler at the South Bank Centre, London SE1 8XX.

Film and video: Funding is available for the production of professional documentary films on all arts subjects. Films are made for the Arts Council, which retains copyright. For up to date information contact Rodney Wilson, Film Officer.

Artists films and videos: Small production awards and bursaries (some less than £1,500); large awards and bursaries (£1,500 and larger); occasional placement bursaries. Also distribution awards; exhibition subsidy and equipment awards. For up to date information contact David Curtis, Assistant Film Officer.

CRAFTS COUNCIL OF GREAT BRITAIN
Awards Officer, David Fry, 12 Waterloo Place, London SW1. Tel. 01-930 4811. Contact the awards officer for details of all craft awards for equipment, maintenance, workshop training and other bursaries. Open to craftsmen and women in England and Wales.

WELSH ARTS COUNCIL
For up to date information, contact The Arts Department (Grants and Loans), Oriel, 53 Charles Street, Cardiff CF1 4ED (0222) 395548. Applicants must be living in Wales or working there for at least nine months of the year, and have their work recorded on the Welsh Art Council's Slide and Information Library.

The following are available:

Interest-free loans with an individual credit limit of £1,000 per artist.

Starter grants with a maximum of £400 per artist (to help in the early stages of art practice).

Special project grants for amounts ranging up to £5,000 (for some major development, possibly with considerable financial implications).

WELSH SCULPTURE TRUST
6 Cathedral Road, Cardiff. Tel. 0222 374102.

SCOTTISH ARTS COUNCIL
AWARDS SECTION: For up to date information contact: Awards Officer, 10 Charlotte Square. Edinburgh EH2 4DF. Tel. 031-226 6051.
Major Bursaries: £700 a month for up to 12 months to buy time/travel, deadline October 1st. Intended for artists who are able to demonstrate a substantial commitment to the visual arts.
Bursaries: £325 a month for up to 12 months to buy time/travel, deadline October 1st.
Awards: Maximum £2,500 towards cost of specific projects—materials, services, mounting exhibitions etc. deadlines October 1st and April 1st.
Small Assistance Grants: Maximum £500 for small projects, applications accepted throughout the year.
Travel Grants: To enable artists to travel/attend conferences (study courses connected with their work). Up to 50% of travel fee, subsistence costs—applications accepted throughout the year.

SCOTTISH DEVELOPMENT AGENCY
Sally Smith SDA, Rosebery House, Haymarket Terrace, Edinburgh EH2. Tel. 031-337 9595. Variety of grants, bursaries and fellowship schemes to craftsmen and women in Scotland. Write to the Crafts Manager for further details.

WASPS (Workshop and Artists Studio Provision) Scotland
Value of up to £300 and not more than 75% of costs. To enable artists to convert studios and workshop spaces for groups of 2 or more who have located suitable premises to convert. Studio must have a least of at least 1 year, or longer preferred. WASPS is an independent organisation grant aided by SAC, 22 King Street, Glasgow. See Artists' Organisations, Chapter 1, for further details.

ARTS COUNCIL, EIRE (Southern Ireland)
Although not part of the United Kingdom the following details may be of use to artists.
BURSARIES AND AWARDS IN VISUAL ARTS 1988
Please note closing dates: Bursaries/Apprenticeships/Dublin Corporation School/Macaulay Fellowship/George Campbell Memorial: WEDNESDAY 13 APRIL 1988
Travel Awards/Collaborative Projects/Grants for materials equipment, documentation: 18 FEBRUARY, 18 MAY, 16 SEPTEMBER, 18 NOVEMBER.

ARTS COUNCIL OF NORTHERN IRELAND
Covers: all art forms under the same committee in Northern Ireland.
POLICY: Awards are organised by individual departments.
SCHEMES: *Major Awards:* Creative artists can apply for two major awards of £5000 each to enable them to concentrate on work for a period of time, deadline gone for 1984: amounts between £100 and £1500 are available to interpretive/creative artists or arts administrators to assist with specific schemes and projects.
Printmakers in residence: Values at £6250 plus rent-free accommodation, designed to buy time for an experienced printmaker for a year.
Alice Berger Hammerschlag Award: Valued at £1000 open to visual artists.
George Campbell Memorial Travel Award: Worth £1000 to visual artists to work in Spain, open to artists in Eire on alternate years.
Tyrone Guthrie Centre: Places available for artists.
Bass Ireland Awards: Individuals and groups can apply for these awards, first £1000, second £400, third £100, applications from creative or interpretive artists.
Contact: Wilma Haines, Arts Council of Northern Ireland, 181a Stranmillis Road, Belfast BT9 5DU. Tel. 0232 381591.

REGIONAL ARTS ASSOCIATIONS
EASTERN ARTS
Covers: Bedfordshire, Cambridgeshire, Essex, Hertfordshire, Norfolk, Suffolk.
SCHEMES: *Support for Visual Artists in Essex/Suffolk:* Run by the Minories Gallery, Colchester and Gainsborough's House, Sudbury, £3000 available, closing dates May 29/September 28. Contact: Diana Pain, The Minories, 74 High Street, Colchester. Tel. 0206 577067 or Hugh Belsay, Gainsborough's House, Gainsborough's Street, Sudbury, Suffolk. Tel. 0787 72958, artists in those areas can still apply for other Eastern Arts schemes.

Grants for Visual Artists: Open to artists, craftspeople and photographers in the areas except Essex and Suffolk (see above), £5500 available, grants for major projects, to buy time, purchase materials/equipment/facilities between £300–£1000, no retrospective grants; applications judged on 'quality of work and need' with possible studio visits; application forms, deadline October 1.

Group projects: Groups of visual artists may be eligible to apply for financial assistance under the schemes for organisations, ask for details.

See the Annual Report for the latest budget.

Payment to artists for exhibiting: Artists showing in public galleries eligible for payment under this nationally-established scheme should get application forms from the gallery, £100 solo exhibition, £50 each two-person exhibition.

Register: Artists are invited to submit slides for inclusion in the register which is often used for selecting work for projects under the works of Art in Public Places schemes, application form available.

Tolly Cobbold Eastern Arts National Exhibition: An open exhibition organised biennially open to artists nationally with a special prize for Eastern region artist.

Contact: Visual Arts Officer, Eastern Arts Association, Cherry Hinton Hall, Cherry Hinton Hall Road, Cambridge CB1 4DW. Tel. 0223 357596.

GREATER LONDON ARTS ASSOCIATION

Covers: London Boroughs & City of London.

FILM & VIDEO SCHEMES: *Production:* Grants are available to individuals, collectives, group to produce independent films and videotapes where the previous work of the applicant demonstrates a reasonable technical/artistic competence, grants are sometimes made for first productions, awards made annually, rarely exceeding £7000, deadline. Deadlines January and August.

Workshop Revenue Grants: Revenue grants vary.

Instructional Courses Schemes: For those wanting to learn how to make films (animation/documentary/experimental) and videotapes.

Exhibitions: Guarantees against loss are offered to London venues with proper film/video projection or playback facilities for programmes which include a reasonable element of independent films.

Contact: Film/Video Officer GLAA, 9 White Lion Street, London N1 9PD. Tel. 01-837 8808.

VISUAL ARTS SCHEMES: *Grants:* Are offered to visual artists working in painting, sculpture, photography, artists' film and video, performance and printmaking to buy time, purchase materials/prepare for exhibition or performance/transport of work/publicity but not framing/lamination costs, towards special projects, installations, documentations, performance art events, deadlines twice a year.

Residencies/Artists in Schools: Proposals considered throughout the year.

Art in Public Places: Proposals considered throughout the year.

Organisations: Grants are available for groups of artists, artists' organisations, local authorities, independent organisations for special projects which have long-term strategic aims but which need short-term funding, artists in residence, public art commissions etc. Grants will not normally exceed 50% of the total cost of a purchase/commission and priority will be given to opportunities afforded by new building projects. Apply for the latest details.

Contact: Alan Haydon (Visual Arts Officer), address as above.

EAST MIDLANDS ARTS

Covers: Derbyshire (except High Peak District) Leicestershire, Northamptonshire, Nottinghamshire and Milton Keynes.

POLICY & SCHEMES: East Midlands Arts maintains an active commitment to supporting the individual artist. This years 87/88 budget for Art, Crafts and Photography is £98,000. Support to individuals amounted to approximately £20,000.

Artists who have completed their studies or otherwise begun professional practice in the past three years are eligible to apply only for the Starter Grant. This is a simple £200 award not tied to any specific requirements of purchase or project. In 1983/84, 22 Starter Grants were awarded to young artists living and working in the East Midlands region.

Established artists who have been working professionally for more than three years are able to apply for Project Grants. These awards can be fore any amount although demand is such that sums in excess of £750 are likely to be awarded very occasionally. The Panel considers Projects in the widest sense and though specific requests attached to exhibitions, particularly those in the region, are given priority, the continuation of working as an artist is considered a valid project.

Open to all artists is the Purchase Scheme whereby the Association will consider matching the costs of purchasing a work for either a public or semi-public site or a public collection in the region. Whilst applications have to come from the organisation, artists can and do initiate such purchases.

The Association has also developed a number of short and long-term residencies in schools, colleges and hospitals. Those which run for six months or longer are advertised nationally. Schools placements are selected by the institution in collaboration with East Midlands Arts and county advisory staff and often involve artists from outside the region. East Midlands Arts has not, as yet, encouraged or developed

schemes which place artists into industrial or commercial settings. Discussions have taken place but it is currently felt that existing schemes would have to be dismantled in order to introduce such placements. Doubt as to the value of such schemes for the artist, rather than the hosts, have also been expressed. However, the Association has an active Business Advisory Group with whom discussions are taking place to explore ways in which a mutually beneficial scheme might be launched and to see whether companies can be persuaded to directly fund such projects.

Like most other publicly funded bodies East Midlands Arts continually reviews schemes and assesses their usefulness, although any changes which are made are introduced gradually!

Contact: David Manley, East Midlands Arts, Mountfields House, Forest Road, Loughborough, Leics. Tel. 0509 218292.

YORKSHIRE ARTS

Cover: North, South, West Yorkshire.

SCHEMES: *Grants & Guarantees:* Available to assist properly constituted organisations and groups with ventures concerned with improving the visual awareness of the community and the regional provision of facilities for the practising craftsperson, support is also available for specific projects by individuals, deadlines April 1/August 1/October 1/December 1/February 1, total budget £9800.

Exhibition & Publications Subsidy: To encourage and assist public art galleries, museums, libraries etc. in mounting contemporary craft exhibitions of national significance, deadlines as above, total budget £2500.

Lectures/Workshops/Demonstations: Fee of £30 per session available where the organisation covers expenses including travel, deadlines as above, total budget £500.

Commissions & Purchases: Up to 50% matching funds available to encourage and enable public and private sector organisations to commission and purchase contemporary craft work, work must be intended for public display, deadlines as above, total budget £500.

Grants to Individuals: Up to £250 can be applied for towards equipment, photographing, publicising, marketing work, preparing for an exhibition or attending a short course, the association will generally meet up to 50% of the costs, deadlines as above, total budget £1200.

Foreign Travel Award: Award of up to £1000 to enable an established craftsperson to travel abroad in order to benefit their work—attend/visit relative craftspeople etc., the award may be divided between applicants, offered annually, total budget £1000.

Fellowship/residencies: The association aids a part-time fellowship based at the Swarthmore Education Centre, Leeds and welcomes proposals for other fellowships or short-term residencies, total budget £2500.

Craftspeople in Schools: Funds are available towards the placement of craftspeople in schools for 15 days on a part-time basis (usually three days a week for five weeks), fee paid by YAA and LEA expected to meet travel/materials expenses, reports on previous projects available, total budget £2500.

Marketing & Promotion: Total budget £1000.

Craftsperson in Industry: The crafts contribution to YAA's Artists in Industry scheme, total budget £1000.

Contact: Crafts Assistant, Yorkshire Arts Association, 4th Floor, Argus Chambers Broadway, Bradford, W Yorkshire BD1 1HH. Tel. 0274 723051. Contact for latest details.

LINCOLNSHIRE AND HUMBERSIDE ARTS

Covers: Lincolnshire and Humberside.

SCHEMES: *Commissions Scheme:* This includes purchase, to provide works of art for public places, offers grant aid to sponsors wiching to commission/purchase work from artists, craftspeople photographers for sites which are accessible to the public.

Visual Arts in the Community

Group Projects & Special Grants: Grants and guarantees against loss may include: minor grant for group studio projects, major grants are sought for capital costs. Grants are made to societies organisations for slide shows/talks/exhibitions/workshops/demonstations.

Residencies: Aimed at projects which have a more direct impact on the public, residencies are usually accompanied by an exhibition, purchase/commission of work.

Contact: Alan Humberstone, Lincolnshire & Humberside Arts, St. Hugh's, 23 Newport, Lincoln. Tel. 0522 33555.

MERSEYSIDE ARTS

Covers: Ellesmere Port, Halton, Knowsley, Liverpool, Sefton, St. Helens, West Lancs and Wirral.

Merseyside Arts overall policy objectives are to support a network of professional arts organisations which serve the needs of artists and the wider community to provide opportunities for the employment of a greater number of workers in the arts. The crafts/photography/visual arts budget was £147,461 in financial year 1987/88.

Contact: Libby Urquhart, Merseyside Arts, Bluecoat Chambers, School Lane, Liverpool L1 3BX. Tel. 051-709 0671.

NORTHERN ARTS
Covers: Cleveland, Co. Durham, Tyne & Wear, Cumbria and Northumberland.

SCHEMES—VISUAL ARTS: *Awards to Artists:* Up to £2000 can be applied for as projects, creating opportunities (exhibition/commission etc. which would attract additional funds) or Helping Young Artists (help with materials/equipment/studio), £12,000 available, students (except those on the part-time BA/MA courses) are ineligible, closing date September 25, application forms.

Northern Artists Bursary: £6000 (of which £1500 is purchase) open to artists not engaged in full-time teaching, exhibition of work aftern twelve months, closing date September 25. (Artists can apply for both award and bursary).

Project Loans Scheme: £10,000 available to artists in the region in interest-free loans from the Visual Arts Development Fund, loans of between £300 to £3000, repayable over three years, made on the basis of artistic quality and the ability to repay, deadlines January 10, April 1, June 25, October 1, application forms.

Support for Artists: Cover a wide category of support to artists making their work public, residencies, purchasing, commissions, murals, grants, studio groups etc. These include placements through the Artists Agency (c/o Northern Centre for Contemporary Art, 17 Grange Terrace, Stockton Road, Sunderland), the Grizedale Forest Sculpture Residency, deadline February 5, 1985), Sculpture North (a scheme coverng Art in the Metro, local authority commissions etc.), Durham Cathedral residency, deadline June/July.

Art Purchase Plan: Northern Arts is establishing an interest free credit scheme to encourage the purchase of artworks.

Travel and Training Scheme: Norther Arts is offering grants of up to £1,000 to any individual currently living in the Northern Region and already working in the field of the arts. Applies across the art forms.

Artists' Slide Index: All artists are expected to lodge slides before an application is processed, index is regularly updated, application forms available.

Contact: Peter Davies, Northern Arts, 10 Osborne Terrace, Newcastle upon Tyne, NE2 1NZ. Tel. 091-281 6334.

POLICY CRAFTS: Total budget £25,000 support to craftspeople.

The Association aims to provide a sympathetic environment for craftspeople, to assist the production of their work and to stimulate their creative development—it also aims to provide opportunities for craftspeople to exhibit and sell their work and is actively working to open up new markets and assist craftspeople in running viable small businesses.

SCHEMES CRAFTS: *Awards:* Grants of up to £1000 for 50% of the costs of equipment or workshop improvements, grants of up to £500 towards an individual or group marketing project, application form, where appropriate, craftspeople are requested to make a piece of work available for public exhibition in exchange for the award, deadline October 1.

Residencies and Placements: These are arranged with other bodies to provide an opportunity for craftspeople to work in a stimulating environment and for the host organisation to benefit from a craftsperson's presence, total budget £15,150, deadlines as advertised.

Artists' Index: Widely used to show crafts capacity, attract commissions and arrange exhibitions, application form, total commissions budget £2500.

Contact: Laurie Short, Northern Arts, address as above.

POLICY PHOTOGRAPHY: Total budget Film/Photography/Video £120,300 of which support to photographers £19,000.

In the region, it is difficult to tease out all the support given to photographers. As well as the obvious schemes listed below, the three established photography centres—The Brewery in Kendal, Newcastle Media Workshop and The Side, both in Newcastle—also give support. The Side through commissions (about £16,000 last year), Newcastle Media Workshop through provision of facilities and the Brewery through small commissions and facilities. The newer centres at Workington, Consett and Darlington also support photographers in various ways. We are trying to develop a network of centres: the main centres are funded on a revenue basis and the smaller, more localised ones on a project basis and the latter are often funded through local authority/MSC and/or community arts. A structure is being developed that is designed to give support to photographers ranging from a beginner (access to workshop facilities and professional advice) to the professional. We are concerned that photographers have the same opportunities for financial rewards as do other professionals working in the arts.

SCHEMES PHOTOGRAPHY: *Production Awards:* Open to photographers living and/or working in the region, awards range from £50–£2000, deadline usually in March, total budget £8000.

Kielder Residency: Usually for one year worth £6000 plus accommodation, open nationally, budget (half year) £3000.

Commissions: This is a one-off grant for an exhibition commission, budget £1000.

Cleveland Artists: Third year of three-year grant to Len Tabner, Chris Killip, Ian MacDonald & Graham Smith (plus £5000 from Visual Arts).
Contact: John Bradshaw, address as above.

NORTH WEST ARTS
Covers: Lancashire (except W Lancs), Cheshire, Greater Manchester and the High Peak District of Derbyshire.
In 1988/89, the Association has the following policy priorities:
1. arts and disabled people;
2. the development of Black and Asian arts;
3. training.

Visual Arts and Photography
Schemes: Total budget for Visual Arts and Photography project funding in 1987/88 is £61,209. All figures below relate to 1987/88 funding.
Exhibition Subsidy: Galleries or groups of artists wishing to organise a contemporary visual arts exhibition in the region can approach North West Arts for grant aid of up to 50% of the costs.
Projects Budget: Projects initiated by non profit making groups or organisations which aim to promote contemporary visual art and encourage public awareness/participation can be considered for grant aid of up to 50% of the costs.
Payments to Artists: This scheme will be revised in 1988/89 and retitled Exhibition Payment Right, providing payment for artists exhibiting their work at publicly funded venues in the region.
Studios and Darkrooms: Support is offered for studio conversion, the establishment of other collective facilities, the purchase of certain equipment for collective use. Up to 50% of the costs can be considered for grant aid, any group applying for assistance must demonstrate a commitment to contact with the public.
Artists in Education: Institutions, groups or individuals wishing to organise short term placements in schools or other community or education centres can apply for up to 50% of the artist's fee.
Performance Art: Contributions to artists fees and expenses are available for performance events at publicly funded venues.
Photography Commissions: Up to 50% of the total costs of a photography commission or residency can be considered for grant aid. In the past these projects have been organised by education and community centres, galleries or industry.
Training: North West Arts organises training events specifically for artists and photographers and can consider applications for small awards towards artists' attendance on training courses.
Environmental Art Projects: Up to 50% of the total costs of the commissioning of Works of Art in Public Places may be considered for grant aid.
Information and Advice: Available on request. Includes lists of exhibition venues and general information relating to the region. The Visual Arts Officer will discuss specific topics such as setting up studios, exhibition opportunities etc with individual artists.
For further information on any of the above schemes please contact Virginia Tandy the Visual Arts Officer or the Assistant at North West Arts, 12 Harter Street, Manchester M1 6HY. Tel. 061-228 3062.
CRAFTS: *Schemes and Projects:* The total budget for Crafts schemes and project funding in 1987/88 is £21,700.
Exhibition Subsidy: Galleries and other venues can apply for exhibition grants/guarantees; funding also available to establish craft collections.
Exhibition Payment Right: Visual Arts scheme (above) also open to craftspeople.
Guilds and Societies: Both professional and amateur craft associations can apply for support for exhibitions and events.
Group Workshops: Both capital and project grants available for the establishment and promotion of formal group workshops/craft centres.
Projects Fund: Organisations and individuals can apply for grants for projects such as open studio days, practical workshops, or any initiative involving the public/local community.
Training: Individuals can apply for grants for advance training, attendance at conferences and so on. North West Arts organises training events specifically for craftspeople.
Crafts in the Community: Schemes in collaboration with schools, museums/art galleries and community groups. Applications from craftspeople interested in participating very welcome.
Environmental Art: As for Visual Arts.
Direct Promotion: The Crafts Register is an index of professional craftspeople, circulated to organisations and interested individuals in the region. "Showcase" as Visual Arts.
Information: Available free on request. Includes lists of craft retain outlets, craft fair contacts, exhibition spaces and general information.
Advisory Support: The Crafts Officer holds surgery sessions one day each month to discuss topics such as marketing, setting up, career development opportunities.

Contact: Lyn Barbour, Crafts Officer, North West Arts, 12 Harter Street, Manchester, M1 6HY. Tel. 061-228 3062.

SOUTHERN ARTS
Covers: Berkshire, Hampshire, Oxfordshire, West Sussex, Wiltshire, Isle of Wight.

POLICY: We are currently reviewing ways in which we can offer support to artists in the region. Over the past year, financial support was offered through purchasing or commissioning work— in the coming year, this approach will be modified so that individual artists nad/or institutions may apply for help in siting works of art in appropriate public locations. The panel will continue to consider applications for grants of up to a maximum of £500 but priority will be given to applications which are orientated towards making contemporary art more available or accessible to the general public. The Art in Public Places will continue to be a priority and it is hoped that more opportunities will be offered to regional artists to participate. Linked with this, we hope to develop an artist in residence programme in conjunction with various centres in the region and to expand the artists in schools scheme. It is not possible, at this stage to give an exact breakdown of the budgets for individual schemes but—the Craft budget is standstill at £26,000, small grants scheme support to craftspeople has increased to £4600, the bursaries scheme has been cut to £3000 and craftspeople in school scheme recieves a standstill of £2200.

SCHEMES: *Major Awards:* A limited number available.

Small Grants: (see above policy for guidelines).

Fellowships/short-term residencies: (details not available).

Artists/Craftspeople in Schools: Support for performance artists, photographic activities and information and advice on marketing/exhibiting work are also available.

Contact: Hugh Adams (Visual Arts), David Kay (Crafts), Southern Arts, 19 Southgate Street, Winchester, Hampshire. Tel. 0962 55099.

SOUTH EAST ARTS
Covers: East Sussex, Kent and Surrey (excluding the areas within the boundary of Greater London).

Grants: Advertised in "The Guardian".

Other Placements: SEA also arranges an occasional fellowship of 1–2 years duration plus a number of shorter-term, one to three weeks, residencies in schools, libraries and adult education centres. Selection is usually made through the Artists' Register, application form available, as is information of the Artists in Schools Scheme, budget £1000 Fine Art, £2000 Photography, £2000 Crafts.

Exhibition Payment: This nationally-established scheme offers £100 for a solo exhibition, £50 each for a two-person show at 14 designated galleries in the region, applications are processed throughout the year, application forms from the galleries. £3000 available for Fine Art and Photography.

Contact: Frances Smith, South East Arts Association, 10 Mount Ephraim, Tunbridge Wells, Kent. TN4 8AF.

SOUTH WEST ARTS
Covers: Avon, Cornwall, Devon, Gloucestershire, Somerset.

POLICY: We are in the process of completely re-thinking our awards scheme as in common with most other RAAs, we have decided that small amounts given to individuals for practical purposes, although no doubt marginally useful, very seldom seem to make any real impact on the recipient's life. After the few hundred pounds is spent on framing, equipment, travel or whatever, the artist is back where she/he started. The same budget will therefore be available for the support of individuals—£9000 in 1984/85 for fine art and photography, but the sum will be divided as follows: 1 residency £3000, 1 bursary £3000, 3 project allocations of £1000 each. It is hoped that matching funds can be attracted and the value of a bursary could be as much as £10,000 by the time everything is counted in. We also hope that in most cases, the money will be given to events with a high public profile, but we realise that this may not be appropriate in all cases. Details are not yet available on the support to craftspeople schemes which will be announced in a later issue.

Contact: South West Arts, Exeter and Devon Arts Centre, Bradninch Place, Gandy Street, Exeter, Devon. Tel. 0392 218188 or Carole Innocent, South West Arts, 35 King Street, Bristol BS1 4DZ. Tel. 0272 49340.

WEST MIDLANDS ARTS
Covers: West Midlands Metropolitan County, Hereford, Worcester, Salop & Warwickshire.

SCHEMES & PROJECTS: Total budget Visual Arts £36,000, Crafts £18,500.

Artists with their Work: Emphasising a far greater interest in what artists do than in what they are with a secondary intention behind the scheme to place greater responsibility, financial and moral, on promoters, hosts, galleries or enablers; the flexible scheme is applied mainly to exhibitions, workshops and seminars, short residencies and commissions and is open to artists and designer-makers, budget £3000 artists, £5500 craftspeople.

Artists in Industry: A number of three-month placements are awarded annually, the aim is to increase and formalise the commitment of the companies to purchase resulting work, budget £12,700 open to national submission.

Midland View: a biennial touring exhibition with prizes totalling £4000 plus purchases, for East and West Midlands artists.

Touring & Education: Channelled through Ikon Touring and Ikon Education, budget £19,000 includes amounts for placements in schools.

Craft in Schools: Budget £3000.

Art in Public Places: £30,000 budget.

Residencies: Policy has been to seek out shorter-term attachments or residencies to produce specific short-term results, these have included one at the Royal Shakespear Theatre, Birmingham City Museums and Art Gallery plus a black artist's residency in Birmingham in conjunction with WMCC, budget £2000.

Special Projects: (visual arts), budget £22,000.

Craft Exhibitions: budget £5,500.

Artists Fees for Exhibition: Budget £5000.

Exhibition Subsidies: Budget £3000.

Information Services: The Artfile slide index covers about 300 artists and craftspeople, budget for this, marketing and collections is £1000.

Contact: West Midlands Arts, 82 Granville Street, Birmingham B1 2LH. Tel. 021-631 3121. Julie Seddon Jones (Visual Arts), Rosalind Merchant (Crafts).

ARTIST IN RESIDENCE SCHEMES
NORTHERN ARTS REGION

Grizedale Forest: Short-term residences for 3–6 months supported by Northern Arts. Workshop and studio provided and basic living accommodation.

Durham Cathedral: artist in residence scheme.

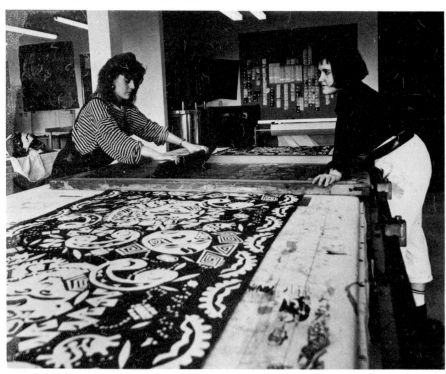

Textiles Workshop, Northbrook

Other Northern Arts schemes include a *Northern Arts bursary,* a photographer in residence, a craft residency, a glass artist in residence, Newcastle Polytechnic craft residency and a craft fellowship. *Contact:* Peter Davies Northern Arts 10 Osborne Terrace, Newcastle on Tyne. Tel. 091-281 6334.

YORKSHIRE ARTS REGION
In Yorkshire the following awards have existed: *Artists in Industry* £1000 for two months, *photographer in residence at Impressions* gallery York, ceramic fellowships, *Sheffield City Art Gallery residencies* £2000 approximately. Contact Yorkshire Arts Award section 4th Floor Argus Chambers, Broadway, Bradford, West Yorkshire BD1 1HH. Tel. 0274 723051.

MERSEYSIDE ARTS REGION
In Merseyside *Liverpool Polytechnic textile residency* is worth £3500 and the *Bridewell Artist in residence* is worth £5000, open to all artists but not photographers. Contact Merseyside Arts Awards section in Bluecoat Chambers, 6 School Lane, Liverpool. Tel. 051-709 0671.

NORTH WEST ARTS REGION
In the North West area; *Photography fellow at Oldham, Preston Fine Art fellowship, Manchester a printmaking, fine art at Crewe and Alsager College of Higher Education, a printmaker in residence at Drumcroon Education Art Centre Wigan, a photography fellowship at Rochdale* as well as a *performance art* one at *Rochdale College of Art and a textile fellowship at Manchester Polytechnic* (the printmaking one is at Manchester Print workshop). Contact: Virginia Tandy, North West Arts, 12 Harter Street, Manchester M1 6HY. Tel. 061-228 3062.

LINCOLNSHIRE AND HUMBERSIDE ARTS REGION
In this region the following are still in operation; *Artescape Trust Fellowship* open to sculptors and painters—more than one position—rent and rates accommodation. Assistance towards cost of exhibition and materials—one year.
 Hull College of Higher Education: 2 year award £5500 and £500 materials. Access to facilities and must give occasional lectures and demonstrations. Contact: Alan Humberstone Lincolnshire and Humberside Arts, St Hughs, Newport, Lincoln LN1 3DN. Tel. 0522 33555.

EAST MIDLANDS ARTS REGION
Contact East Midlands Arts, David Mansley, Mountfields House, Forest Road, Loughborough, Leicestershire. LE11 3HU. Tel. 0509 218292 for the latest awards as policies were under changes at time of going to press. Awards included previously were two hospital artists in residence positions.

WEST MIDLANDS ARTS
Changes have taken place in this region and the Artists in Industry schemes are now given high priority—seven placements under this scheme possibly more. Contact: Julie Seddon-Jones, West Midlands Arts Lloyds Bank Chambers, Market Street, Stafford. Tel. 0785 59231.

EASTERN ARTS REGION
Artists in residence Kettles Yard based at *Cambridge colleges* in rotation £10,000 for an academic year and studio and accommodation provided. Exhibition at the end.
 Norwich College of Art: John Brinkley Fellowships based at the college of art. Three one term fellowships for artists. Opportunity to exhibit in the college gallery at the end of the term.
 Henry Moore Foundation Sculpture Fellowship: £6000 per annum for three years placement. Studio space and help with accommodation. Open to British sculptors of repute. Based at Norwich College of Art Norwich East Anglia.
 Felstead School artist in residence. Two residencies a year to young artists who have recently left college. One year but renewable for a further year. Studio accommodation and small salary. Some teaching required. Contact: Eastern Arts, Cherry Hinton Hall Road, Cambridge CB1 4DW for the latest details. Tel. 0223 357 596.

SOUTH EAST ARTS REGION
Contact Frances Smith, South East Arts, 10 Mount Ephraim, Tunbridge Wells, Kent. Tel. 0892 41666 for the latest details as changes were taking place at time of going to press but several short term residencies will probably be avialable.

SOUTHERN ARTS REGION
South Hill Park artist/printmaker in residence £4000 per annum, a studio and access to facilities in this attractive centre in the country. A second one is also available for £7000 per annum for one year and then renewable. The artist should be involved with the South Hill Park Arts Centre's activities and provide

the centre with a major piece of work. Contact: Hugh Adams, Southern Arts, 19 Southgate Street, Winchester. Tel. 0962 69422 for the latest information.

SOUTH WEST ARTS REGION
Exeter College of Art teaching fellowships—one in painting, one in sculpture and one international fellowship connected with Frankfurt in Germany. In Germany free accommodation materials and studio space and free travel to and from Germany. Part time salaries for all of them about £3000 for 36 weeks.

Cheltenham College of Art Gloucestershire. Artist in residence to carry on work and some teaching.

Bath Academy of Art Honorary fellowship for advanced study. Studio provided and one day's teaching a week for five artists, depending on finances.

Contact: South West Arts, Christine Ross and Valerie Millington, Bradninch Place, Gandy Street, Exeter EX4 3LS. Tel. 0392 218188 £3000 fellowship in fine art and photography, £3000 residency in fine art and photography and three project awards of £1000 in fine art and photography and three for craftsmen and women of £1000 each.

WELSH ARTS COUNCIL REGION
The following are available: *Llanover Hall Arts Centre. Greynog Arts Fellowship* £4500 for 6 months plus studio and accommodation at the University of Wales, *Ceramic Research Award at South Glamorgan Institute of Higher Education* Junior Fellowship in Ceramics also at this institute and Senior Fellowship, *Glynn Vivian Art Gallery* holds a five week residency for £100 a week plus expenses and subsistence to a total value of £1000. Contact: Welsh Arts Council, 53 Charles Street, Cardiff, Wales. Tel. 0222 395548.

South East Wales Art Association also has organised many residencies.

ARTS COUNCIL OF NORTHERN IRELAND
Belfast Print Workshop. Access to studio.

British School in Rome Fellowship. Artists must have been in residence in Northern Ireland for at least two years.

Ulster College Northern Ireland Polytechnic Jordanstown.

Newton Abbey County Antrim—fellowship in fine art. Contact: Arts Council of Northern Ireland, 181A Stranmillis Road, Belfast. Tel. 0232 381591.

SCOTTISH ARTS COUNCIL
For up to date information contact: Awards Officer, 19 Charlotte Square, Edinburgh EH2 4DF. Tel. 031-226 6051.

Major Bursaries: £700 a month for up to 12 months to buy time/travel, deadline October 1st. Intended for artists who are able to demonstrate a substantial commitment to the visual arts.

Bursaries: £325 a month for up to 12 months to buy time/travel, deadline October 1st.

Awards: Maximum £2,500 towards cost of specific projects—materials, services, mounting exhibitions etc, deadlines October 1st and April 1st.

Small Assistance Grants: Maximum £500 for small projects, applications accepted throughout the year.

Travel Grants: To enable artists to travel/attend conferences (study courses) connected with their work. Up to 50% of travel fee, subsistence costs—applications accepted throughout the year.

GREATER LONDON ARTS ASSOCIATION REGION
See previous section for greater details on GLAA.

Photographer in residence Little Ilford School London Borough of Newham.

Grants to artists and photographers £1000 maximum.

Art in Public Places Organisations, schools, local authorities can apply to commission and place art/photography in public places. Picture Loan schemes, residencies and sculpture parks, hospital commission are covered by this scheme. Contact: GLAA, 9 White Lion Street, London N1 9PD. Tel. 01-837 8808. (artists living and working in London boroughs and City of London). See art organisations section for Public Art Agencies.

Whitechapel Art Gallery ILEA sponsored artists in schools schemes in 8 East End locations in London.

ARTS COUNCIL
Five artist in residence awards have included Museum of Modern Art and Wolfson College Oxford; Whitworth Gallery and Manchester University. National Gallery London. Walker Gallery Liverpool. Kettles Yard Cambridge Contact: Arts Council of Great Britain, 105 Piccadilly, London W1V 0AU. Tel. 01-629 9495. London W1.

AWARDS

ANDREW SPROXTON AWARD, The Secretary, Andrew Sproxton Memorial Fund, 17 Colliergate York. Annual award for photographers aged 25 or under. Bursary of £500. Deadline October 1st.

BASS CHARRINGTON ARTS AWARD, Awards Secretary, Arts Council of Northern Ireland, 181A Stranmillis Road, Belfast. 1st prize £1000, 2nd prize £400, 3rd prize £100.
VIDEO BURSARIES, Contact Film Officer, Arts Council of Great Britain, 105 Piccadilly, London W1.
ARTISTS AGENCY, 17 Grange Terrace, Stockton Road, Sunderland SR2 7DF. Tel. 091-5109318. An organisation set up to provide placements, commissions and channel awards to artists, photographers, sculptors, writers and musicians. Supported by Northern Arts the Arts Council of Great Britain and Sunderland Borough Council.
ART AND WORK AWARDS, Wapping Arts Trust, 15 Dock Street, London E1 8JL. Tel. 01-481 1337. Falls into three categories; an art collection sponsored by a company for a corporate building, a work of art commissioned for a specific site and the most outstanding contribution to art in the working environment.
GULBENKIAN AWARD, Calouste Gulbenkian Foundation, 98 Portland Place, London W1N 4ET. Tel. 01-635 5315. Forms available from the Assistant Director. £15,000 available for ten awards for initial research for artists to develop large scale works for specific sites. Subsequently three further awards totalling £45,000 towards final production costs. Projects must take place before October 1989.
PUBLIC ART DEVELOPMENT TRUST, 6-8 Rosebery Avenue, London EC1R 4TD. Encourages works of art in public places.
YORKSHIRE CONTEMPORARY ART GROUP, Stowe House, 5 Bishopsgate, St Leeds LS1 5DY. Helps artists show work in public places and galleries through awards and funding.

PRIZES

Please check for the latest details.
JOHN MOORES, Exhibition Secretary, Walker Art Gallery, Liverpool. Entrance form, labels and handling fee £3. Open to all artists living in the UK. Painting and constructions only. Sending-in dates September. 1st prize £6000, 2nd prize £3000, 3rd prize £2000, 10 prizes of £250. Well worth entering as this exhibition is well publicised and well reviewed nationally.
JOHN LAING ANNUAL PAINTING COMPETITION, Forms from Ms D W Griffin, John Laing Ltd., 14 Regent Street, London SW1. Tel. 01-930 7272 ext 24. Submit up to two paintings. Landscapes and seascapes. Prize of £1,250 or to be chosen for the Laing calendar with appropriate fee.
IMPERIAL TOBACCO PORTRAIT AWARD, Full details from The Competitions Officer, National Portrait Gallery, 2 St Martins Place, London WC2. £4,000 and a further commission of £3,000 is offered. Open to artists aged 18-40. Submit photos of portraits in oil.
HUNTING GROUP ART PRIZES, Forms available from the Secretary of the particular society, 17 Carlton House, Terrace, London SW1. £5,000 for best oil painting, £5,000 for the best watercolour, £15,000 total prizes. Royal Society of Marine Artists. Royal Institute of Oil Painters. Royal Society of Miniature Painters. Sculptors and Engravers. New English Art Club. All artists can enter as well as society members. Tel. 01-930 6844.
TOLLY COBBOLD, c/o Eastern Arts, Cherry Hinton Hall, Cherry Hinton Hall Road, Cambridge CB1 4DW. Prizes of up to £10,000 and possible purchases. Exhibition to include work in all media, but not to exceed 20 feet or project more than 8in. Exhibition will be at the Fitzwilliam, Cambridge and Ipswich, Sheffield and at the ICA London.
INTERNATIONAL ART COMPETITION, Raja Yoga Centre, 98 Tennyson Road, London NW6. To stimulate the creativity of spiritualism. 1st prize £1,000, 2nd £800, 3rd £250.
ROYAL OVERSEAS LEAGUE, Overseas House Park Place, St James Street, London SW1A 1LR. Tel. 01-408 0214 ext 219. Royal Overseas League exhibition £5000 in prizes in 1987. Open to Commonwealth citizens under 35.
TELEVISION SOUTH WEST, In 1984 six prizes of £2000 each donated by National Westminster Bank. In conjunction with South West Arts. Exhibition tours UK. National Open Art Exhibition. In 1987 a very successful series of public art awards nationwide.
BATH FESTIVAL NATIONAL PAINTING COMPETITION for art students. Contact Bath Festival Office, Linley House, 1 Pierrepoint Place, Bath BA1 1JY. Tel. 0225 61659/62231.
LONDON GROUP, Open Exhibition. £1000 plus in prize money. Exhibition in London annually.
LLOYDS BANK AWARDS, c/o Business Art Galleries, 34 Windmill Street, London W1. Tel. 01-323 4700 £3000 made available over 3 years for commissions of 10 original prints for artists under 30.
THE TURNER PRIZE, £10,000 prize for New Art. Run by the Friends of the Tate Gallery, Millbank, London SW1P 4RG. Tel. 01-821 1313/834 2742. Chosen by a jury—greatest contribution to art in Britain in the previous twelve months. First awarded in 1984 due to the generosity of a Patron of New Art. Past winners; Malcolm Morley, Gilbert & George, Richard Deacon.
PRINTMAKERS MINIATURE PRINT EXHIBITION. Contact the Printmakers Council, Clerkenwell Close, London WC1 for further details and other print competitions, prizes.
CLEVELAND DRAWING BIENNALE, Dept 11, Drawing 81, PO Box 52, Middlesbrough, Cleveland. Total of £5,000 and other possibilities of purchase. Supported by ACGB and Northern Arts. Check with ACGB for annual changes for applications from artists.

INTERNATIONAL PRINT BIENNALE, Cartwright Hall, Bradford. Entry fee. Closing date 30th September. Sending-in day 31st December.

MANCHESTER PRIZE, Manchester Prize Office City Art Gallery Mosley Street, Manchester M2 3JL. A new award for art in production. Two prizes available of £5000 and £2000.

SOUTH BANK PICTURE SHOW, Royal Festival Hall London SE1 8XX. The theme is London and there are prizes of £2500, £1500, four at £750 and six at £500. Handling fee of £5 (£1 for students, unemployed and OAPs. Send a large sae to the above address. Exhibition in December.

MARKING TIME, The Museum of London, London Wall, London EC2Y 5HN Prizes of £500, £250 and five prizes of £50. Everyday lives of Londoners. 1987 competition. Check for current details and prizes in 1988 and 1989.

ARTIFACT, 163 Citadel Road, The Hoe, Plymouth, Devon PL1 2HU. Tel. 0752 228727. Director Philip Saunders. for £15 subscription per annum Artifact will send you details about some 140 open art competitions, prizes and shows both in the UK and internationally. A form is completed about your work and then page sheets of information are sent to give all the necessary details in a simple format.

INTERNATIONAL ART COMPETITION, PO Box 401, Tuckahoe, NY10707, USA. Annual competition—deadline May, exhibition August in New York galleries. $3,200 cash prizes, $2800 purchase prizes. Entry by 3 transparencies of work and $9.95 per slide and $7.95 for return of all slides.

ROYAL ACADEMY SUMMER EXHIBITION, Burlington House, Piccadilly, London W1. Tel. 01-734 9052. Many prizes and access to thousands of members of the buying art public.

SCHOLARSHIPS

ELIZABETH GREENSHIELDS FOUNDATION, 1814 Sherbrooke St West, Montreal, Quebec, Canada. 1 year scholarship to an artist from any country. 30 awards.

THE LEVERHULME TRUST, The Secretary, Research Awards Advisory Committee, 15-19 New Fetter Lane, London EC4. Tel. 01-822 6952. Up to 6 studentships overseas (not UK, Europe or USA). £1,000 p.a. + £200 for 1/2 years. Closing date 15th January, interview by March. 1st degree graduates of a UK University or CNAA degree course. Under age of 30 on October 1st of the year of award. Also fellowships and grants for research.

YALE CENTRE FOR BRITISH ART, Box 2120 Yale Station, New Haven, Connecticut 06520. Short term research scholarship in British art at Phd level. Applications by November 1st for following July onwards.

FULBRIGHT AWARDS, USA/UK, Educational Commission, 6 Porter Street, London W1. Tel. 01-486 7697. 1 year + travel. Maintenance. Exchange visitor visa. Closing date 23rd November, interview February. Several scholarships available.

INSTITUTE OF INTERNATIONAL EDUCATION, 809 United Nations Plaza, New York, NY 10017. For further details of possible USA awards.

MACDOWELL COLONY INC., Peterborough, New Hampshire 03458, or MacDowell Colony Inc., 680 Park Avenue, New York, NY 10021. Open to nationals of any country. Resident fellowships to professional painters sculptors film-makers. Use of studio for 3 months.

HARKNESS FELLOWSHIPS, Harkness House, 38 Upper Brook Street, London W1. 20 offered annually for advance study and travel in the USA in various subjects including art. 2 academic years and 3 months travel. Age 21–33. Must have degree or equivalent. Closing date 8th October. (Enclose 10 × 7 envelope + sae with 35p postage) + coverng letter asking for details.

ENGLISH SPEAKING UNION OF COMMONWEALTH, 37 Charles Street, London W1. Tel. 01-629 0104. Ask for details of scholarships to Commonwealth countries.

WINSTON CHURCHILL MEMORIAL TRUST, 15 Queens Gate, London SW7. 100 fellowships for travel and work abroad. Various categories. Entrants can come from any walk of life but must have a good reason for applying for the scholarships. £1,500 average award.

USA/UK EDUCATIONAL COMMISSION, 6 Porter Street, London W1. Tel. 01-486 7697. Run the Fulbright Hays awards as well as other awards.

ABBEY MAJOR AND MINOR AWARDS, 1 Lowther Gardens, Exhibition Road, London SW7.

DAVID MURRAY SCHOLARSHIPS, Royal Academy Schools, Burlington House, London W1. For travel, landscape painting and drawing.

BOISE SCHOLARSHIP, Slade School of Art, University College, Gower Street, London WC1.

USEFUL ADDRESSES FOR INFORMATION OF SCHOLARSHIPS

BRITISH COUNCIL, 10 Spring Gardens, London SW. Scholarships Abroad: £2.50 lists 33 countries with details of all scholarships available in these countries. Apply for details about Hungarian summer schools in art. Tel. 01-930 8466.

BRITISH AMERICAN ARTS ASSOCIATION, 49 Wellington Street, WC2. Tel. 01-379 7755. Directories available for reference listing awards, scholarships in the USA and names of USA art schools, art organisations etc. Phone first to check office hours. Also organises seminars.

CENTRAL BUREAU FOR EDUCATIONAL VISITS AND EXCHANGES, Seymour House, Seymour Mews, London W1. Tel. 01-486 5101. Art teaching bursaries for Europe and elsewhere.

ASSOCIATION OF COMMONWEALTH UNIVERSITIES, 36 Gordon Square, London WC1. Write for details of Commonwealth scholarships.

FRENCH EMBASSY, Cultral Attache, 22 Wilton Crescent, London SW1. Tel. 01-235 8080. Scholarships to post-graduate students in fine art.

ITALIAN INSTITUTE, 39 Belgrave Square, London SW1. Send sae for details of scholarships open to artists and art students.

JAPAN INFORMATION CENTRE, 9 Grosvenor Square, London W1. Scholarships to Japan.

ROYAL NETHERLANDS EMBASSY, 38 Hyde Park Gate, London SW7. Re scholarships to Holland.

GERMAN ACADEMIC EXCHANGE SERVICE, DAAD, 11–15 Arlington Street, London SW1. Tel. 01-493 0614. 15 scholarships to UK artists to study at art academies and other institutions. Up to 32 years old. Closing date March.

THE GREEK EMBASSY, 1A Holland Park, London W11. Closing date March. Scholarships to Greece open to art students and artists. Apply for further details.

CZECHOSLAVAKIA, Academy of Arts, Smetanovo Nabr 2, Prague 1, Czechoslavakia. Exchange scholarship, cost of tuition and certain expenses. Candidate should hold a BA. Closing date end of December.

USA. ACADEMY OF MOTION PICTURES, ARTS AND SCIENCES, Philip Chamberlain, 8449 Wilshire Boulevard, Beverley Hills, California 90211, USA. Student film awards (5) USA $1000. any student who has compiled a film in college or university. Apply after 15th October.

EDWARD ALBEE FOUNDATION. Write to: The Secretary, Edward Albee Foundation, 226 West 47th Street, New York, NY 10036. Twelve talented but needy writers and artists many spend a year at the Barn Montauk in the USA. Free accommodation and evening meal.

AUSTRALIA. Graduate Careers Council of Australia, PO Box 28, Parkville, Victoria 3052. Awards for postgraduate study in Australia. Lists fellowships and scholarships available at universities in Australia.

GRANTS HANDBOOK AND SURVEY OF LEA AWARDS. NUS, 3 Endsleigh Street, London WC1. £1.50 + 30p postage. Lists all UK local authorities. Details of major grant awards.

STUDY ABROAD, UNESCO, Place de Fontenoy 75, Paris 7eme, France. £1.80 Lists international scholarships.

SUMMER STUDY ABROAD, Institute of International Education, 809 United Nations Plaza, New York, NY 10017, USA $2.00. Lists summer study opportunities outside the USA sponsored by US colleges and foreign institutions.

BRITISH FILM INSTITUTE, 42/43 Lower Marsh, London SE1 7RG. Grants value £300–£15,000. Applicant must submit a script, synopsis outlined idea a storyboard. Film experience not necessary/ essential except for feature length proposals.

BRITISH INSTITUTION FUND, Royal Academy, Piccadilly, London W1. Scholarship prizes for painting, sculpture, architecture and printmaking. £100 p.a. and travel scholarships £100.

BROOKLYN MUSEUM ART SCHOOL (Open to nationals of all countries), 187 Eastern Parkway, Brooklyn, NY 11238, USA. Closing date 30th April. Painting, sculpture, ceramics. 25 scholarships annually. Free tuition. Tenable for 1 year. Portfolio of 10 slides and 2 letters of recommendation.

CALIFORNIA COLLEGE OF ARTS AND CRAFTS, Graduate Division, 5212 Broadway, Oakland, CA 94618, USA. 3-8 scholarships annually. Must have BA (Fine Art). Free tuition.

CANADA COUNCIL, Cultural Exchange Section, PO Box 1047, Ottawa, Ontario. (Open to many nationalities). On behalf of the Dept of External Affairs cultural exchanges between cultural organisations and universities. film and video grants and travel grants.

CORCORAN SCHOOL OF ART, NY Avenue and 17th St NW, Washington, DC 20006, USA. Open to US and foreign nationals—fine art students. USA $350–$20250.

COURTAULD INSTITUTE, Ms Robertson, Combe Hay Manor, Bath, Somerset. 12 scholarships annually. Open to students (UK) of art history and architecture. Closing date 31st May.

KODAK LTD, PO Box 66, Kodak House, Station Road, Hemel Hempstead, Herts. 1 award of £2,500 and 2 of £3,500. Open to UK photographers.

PRATT GRAPHICS CENTRE, 831 Broadway, New York, NY 10003. Open to USA and foreign nationals. Opportunity to study at the centre for printmakers from September–July.

NEW ZEALAND. QE11 Arts Council of New Zealand, PO Box 6032, Te Aro, Wellington, New Zealand. Write to the New Zealand Arts Council for details of awards to study in New Zealand.

ROYAL SOCIETY OF ARTS, 8 John Adam Street, Adelphi, London WC2. £75–£1,500. Travel awards for individual designers (industrial).

VIRGINIA CENTRE FOR THE CREATIVE ARTS (USA), at Sweet Briar University, Virginia 24595, USA. Open to artists. $210 per week. 1–3 months per annum.

GRANTS REGISTER, St James Press, 3 Percy Street, London W1. Available for reference at most libraries.

ART SCHOOLS

This section includes information about art schools throughout Britain. Questionnaires were sent round to some 200 art schools throughout Britain and this has enabled us to give additional information to help

artists and art students when choosing a college. When detailed information has not been received from the college the name and address are listed below.

The colleges in this list offer a variety of Foundation, BA (Hons), CNAA, vocational and advanced courses in sculpture, painting, printmaking, graphics, textiles, ceramics, jewellery and silversmithing, furniture, photography, film and television, video, interior and general design, fashion and other relevant courses.

In 1986 the **London Institute** was founded under the rectorship of John McKenzie. Seven schools are members, **Camberwell, Central, Chelsea, St. Martin's, London College of Fashion, The College of Printing** and **The College for the Distributive Traders.** London Institute, 388 Oxford Street, London W1. Tel. 01-491 8533.

ABERDEEN
ROBERT GORDON'S INSTITUTE OF TECHNOLOGY, Gray's School of Art, Garthdee Road, Aberdeen AB9 2QD. Tel. 0224 313247. Courses: CNAA BA/BA(Hons) Fine Art—specialisms Painting, Printmaking and Sculpture. BA/BA(Hons) Design & Craft—specialisms Ceramics, Graphics, Jewellery, Textiles and Surface Decoration. Space: Large open plan and shared individual workspaces. Equipment: Excellent range including new technologies. Materials: Allowance—part of SED grant, good provision of basic materials. College shop service available. Exhibition space: Some general exhibition space. Scholarships, prizes: Several. Exchanges: EEC and USA. Library: Good facilities, specialising in Art and Design—site library—part of Institute Library. Visiting Lecturers: 1/2 day visits from artists and designers on a regular basis. Information available to art students about life after art college.

ABERYSTWYTH
UNIVERSITY COLLEGE OF WALES, Visual Art Department, Llanbadarn Road, Aberystwyth, Dyfed SY23 1HB. Tel. 0970 3339. Courses: BA Honours and Joint Honours in Art with another subject and Joint Honours in Art History. MA in Art History, MA in Studio Studies with Art History, PhD and Postgraduate Diploma in Studio Studies. Undergraduate courses in Art have equal components of Art History and Studio Studies. Studio options in painting, printmaking, photography, book illustration with typography and in ceramic sculpture. Art history mainly 19th–20th century but also include courses in graphic art, photography, art & society etc. Permanent collections of graphic art and photography and studio ceramics together with five specialist galleries. Research interests in the above areas. Vacation grants for all students. University adjacent to the National Library of Wales and set in one of the finest landscapes in Britain.

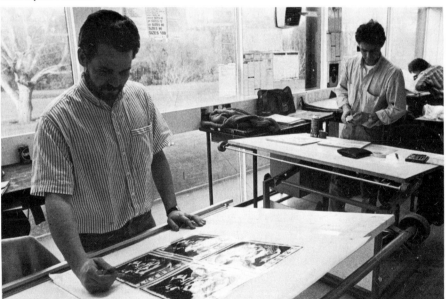

Grays School of Art, Aberdeen, Scotland

BARNSLEY
BARNSLEY COLLEGE OF ART AND DESIGN, Churchfield, Barnsley, S70 2BH. Tel. 0226 285623/ 299869. Courses: BTEC National Diploma in General Art and Design; BTEC National Diploma in Design (Graphic Design); BTEC National Diploma in Design (Surface Pattern Design); YHAFHE Foundation Studies in Art and Design; College Certificate in Painting and Decorating; College Certificate in Signwriting/Advanced Painting and Decorating; TVEI Entertainment Industries. Library: Specialist art library.

BASINGSTOKE
BASINGSTOKE TECHNICAL COLLEGE, Worting Road, Basingstoke, Hampshire. Tel. 0256 54141. Courses: Full-time: BTEC National Diploma in General Art & Design, BTEC First Diploma in Design (Subject to Approval), College Certificate in Creative Clothing. Part-time: Pre Degree Foundation, CGLI (Various), Mixed A levels/GCSE's in a variety of subjects. Space: Studios, workshops and specialist equipment in all fundamental areas of Art & Design.

BATH
BATH COLLEGE OF HIGHER EDUCATION, (incorporating Bath Academy of Art). Newton Park, Bath BA2 9BN. Tel. 0225 873701. Courses: BA Honours Degree courses in Fine Art (painting), Fine Art (sculpture); Graphic Design; Three-Dimensional Design— ceramics; Foundation course in Art and Design. Facilities: Studios, workshops, individual workspaces, materials shop. Studio charges approximately £12 per term. Exchange programme for Graphic Design students.

BEACONSFIELD
NATIONAL SCHOOL OF FILM AND TELEVISION, Beaconsfield Studios, Station Road, Beaconsfield, bucks HP9 1LG. Tel. 049-467 1234. The school offers a three-year, full-time professional course leading to an Associateship (ANFTS) with specialisation in the training of producers, directors, writers, lighting camera operators, editors, animators, art directors, sound recordists, documentary and film composition. Students are encouraged to interchange roles in any practical activity. Facilities include 3 studios, portable video and video-editing, 20 film editing rooms, professional cameras and tape-recorders. The school is funded by a partnership of Government and industry (Film and TV).

BELFAST
RUPERT STANLEY COLLEGE OF FURTHER EDUCATION, Ormeau Embankment, Ravenhill Road, Belfast BT6 8GZ. Tel. 457008/454329/456814/456829. One Year: full-time, Art and Design Foundation Studies. Two Year: full-time, National Diploma in General Art and Design. Two Year: day release course, "Introduction to Graphic Design". Two Year: day release course, "Lens Orientated Media". Part-time: City and Guilds Photography. Each of the full-time courses has its own base studio, with access as required to the specialist photography, printmaking, ceramics, computer-aided design, woodwork and metalwork workshop areas. Three additional art and design studios are used to service other further education requirements. Students over nineteen years of age provide their own materials. All work areas are adequately equipped. Exhibition space is limited normally to foyers and corridors of two main College buildings, but two major exhibitions each year are mounted for a limited period in an Assembly Hall/Gymnasium. One of the two libraries has a specialist art section and slide collection. Close links are maintained with the Faculty of Art and Design at the Ulster University and specialist visiting lecturers are occasionally invited.
 The Gallery Committee of the Board of Governors of the College purchase a work of art by a local artists each year, and the collection is displayed throughout the two main College buildings. No scholarships, prizes or exchanges are currently available, apart from LEA (Education and Library Boards in the case of Northern Ireland) discretionary awards. Many of our full-time and part-time specialist students have traditionally progressed from our normal further education GCSE and GCE 'A' level programme, and the College organises a comprehensive Adult Education programme including classes in painting, photography, ceramics, jewellery, woodwork and art related activities throughout the Belfast area.
UNIVERSITY OF ULSTER AT BELFAST, Faculty of Art and Design, York Street, Belfast BT15 1ED. Tel. 0232 328515. Courses: Certificate in Foundation Studies in Art and Design, HND Design (communication) at Belfast, HND Design (product and graphics) at Magee College, Derry/Londonderry (new course in new facilities). BA(Hons) Courses in Fine Art, Fine Craft Design, Textiles and Fashion Design, Design, Combined Studies in Art and Design. Optional placement (1 year) for all undergraduate courses, leading to additional award 'Diploma of Industrial Studies'. Postgraduate Diplomas in all areas of Faculty's work, MA in Fine Art, MSc in Product Development. All undergraduate courses are unitized, with a degree of student choice and interaction of programmes. Well equipped studies, particularly in Computer applications. Several exhibition spaces in Faculty at Belfast as well as on other sites of University (Magee, Coleraine and Jordanstown). Regular student visits to London and Europe.

BIRMINGHAM

CITY OF BIRMINGHAM POLYTECHNIC, Academic Registry, Perry Barr, Birmingham B42 2SU. Tel. 021-331 5000. Fine Art: BA Honours, full-time. Graphic Design: BA Honours, full-time. Textiles/ Fashion: BA Honours, full-time. Three-Dimensional Design: BA Honours, full-time. Art and Design: DPSE, full-time and part-time. Fine Art: MA, full-time. Graphic Design: MA, full-time. History of Art & Design: Diploma/MA, full-time and part-time.

MATTHEW BOULTON COLLEGE, Sherlock Street, Birmingham B5 7DB. Tel. 021-440 2681. Two and three year full-time courses in printing, design for printing, screen process printing, reprographic techniques and bookbinding.

BOURNVILLE COLLEGE OF ART, Linden Road, Bournville, Birmingham. Tel. 021-472 0953. Fashion: National Certificate in Design. Graphic Design: National Diploma in Design. Technical Illustration: National Diploma in Design and High National Diploma. Three-Dimensional Studies: National Diploma in Design. National Diploma in General Art & Design. Photography: National Diploma in Design.

BLACKPOOL

BLACKPOOL AND FYLDE COLLEGE OF FURTHER & HIGHER EDUCATION, Palatine Road, Blackpool. Tel. 0253 293071. Photographic Technology: National Certificate (part-time). Graphic Design: National and Higher National Diploma in Design. Technical Illustration: National Diploma in Design. Photography: Higher National Diploma in Design. Illustration: Higher National Diploma in Design. Communications: Higher National Certificate in Design (part-time).

BOLTON

BOLTON INSTITUTE OF HIGHER EDUCATION, Department of Art and Design Studies, Great Moor Street, Bolton BL1 1NS. Tel. 0204 28851. Courses: HND Design (graphic design); ND Design Graphics 3D, Fashion Textiles; NWRAC Foundation Course. Facilities: Extensive studio accommodation, computer suite, desk top publishing, and video facilities. John Nicholson Exhibition Gallery. Materials: About 60% of students needs provided.

BRADFORD

BRADFORD AND ILKLEY COMMUNITY COLLEGE, Great Horton Road, Bradford, West Yorkshire BD7 1AY. Tel. 0274 753026. Art and Design: BA, full-time. First Diploma in Design. Graphic Design: National Diploma in Design. Fashion: National Diploma in Design. Textiles: National Diploma in Design. Display: National Diploma in Design. Jewellery: National Diploma in Design. Interior Design: National Diploma in Design. Reprography: National Diploma in Design.

BRIGHTON

BRIGHTON POLYTECHNIC, Moulescoomb, Brighton BN2 4AT. Tel. 0273 693655. Fashion Textiles Design with Administration: BA Honours (sandwich course). Fine Art: BA Honours, full-time. Graphic Design: BA Honours, full-time. History of Design: BA Honours, full-time. Three-Dimensional Design: BA Honours, full-time. Visual and Performing Arts: BA Honours, full-time. Wood, Metal, Ceramics and Plastics: BA Honours, full time. Printmaking: Diploma/MA, part-time.

BRISTOL

BRISTOL POLYTECHNIC, Department of Art & Design, Clanage Road, Bower Ashton, Bristol BS3 2JU. Tel. 0272 660222. FT Courses: BA(Hons) Three-Dimensional Design (ceramics, wood, metal & plastics); BA(Hons) Fashion; FA(Hons) Fine Art; BA(Hons) Graphic Design; Polytechnic Certificate, Foundation Studies. Department of Humanities, Oldbury Court Road, Fishponds, Bristol BS16 2JP. Tel. 0272 655384. FT Course: Diploma in Broadcast Journalism (starting Jan 1989); short courses in audio-visual techniques. Centre for Educational Services, Coldharbour Lane, Bristol BS16 1QY. Tel. 0272 656261. Courses: Summer School Media Courses in photography, video, tape/slides etc. School of Adult Art Studies, Queens Road, Bristol BS8 1PX. Tel. 0272 736259. PT Non-Examination Courses in painting, sculpture, drawing, ceramics, printmaking, enamelling, stained glass, jewellery, textile sculpture, design & making.

BRUNEL TECHNICAL COLLEGE, Ashley Down, Bristol BS7 9BU. Tel. 0272 41241. Department of Printing and Graphic Communication, School of Design. Courses: Two year full-time courses: BTEC National Diploma in Design, Graphic Design, Technical Illustration, Audio Visual Studies, College Diploma in Advanced Design with options in Typographic Design, TV and Computer Graphics, Pictorial/Graphic Systems, Packaging and Point of Sale, Publicity Design. A part-time mode of study is proposed. Space: 12 studios including 3 dark rooms and photographic equipment. Normal studio facilities plus computer graphics; AV and printing machinery/bookbinding support. Materials: students purchase their own. Exhibition space: Main Hall, foyers and corridors. External Awards: Professional entry schemes, National competitions and Industrial bursaries. Library: Extensive general library with sections on Art and Design, Slide and Video collection.

UNIVERSITY OF BRISTOL, Department of Drama, 29 Park Row, Bristol BS1 5LT. Tel. 0272 303030. Postgraduate Certificate in radio, film and television: One year practical course. Facilities include 4-camera colour studio, video editing, Arriflex cameras, film editing, props, etc. Close links with the industry.

BURTON UPON TRENT
BURTON UPON TRENT TECHNICAL COLLEGE, Department of Art, Design and Drama, Ada Chadwick Building, Mill Hill lane, Winshill, Burton upon Trent, Staffordshire DE15 0BA. Tel. 0283 69111. Courses: WMAC Foundation Course in Art and Design, Diploma in Theatre Arts, Diploma in Theatre Studies, Diploma in Design for Print and Publication. Wide range of 'A' level and GCSE courses—photography, film studies, art, graphics, print, ceramics, fashion, theatre design. Specialist short courses: telephone for current information. Space: good range of specialist facilities with relevant equipment.

CAMBRIDGE
CAMBRIDGESHIRE COLLEGE OF ARTS AND TECHNOLOGY, School of Art and Design, East Road, Cambridge CB1 1PT. Tel. 0223 63271. Ext 2267. Courses: BTEC Higher Diploma in Design (illustration). Equipment: Available to all students. Materials: Student contribution £40 at present. Exhibition space foyer and corridors. Travel scholarships per group and individuals. Library: Specialist art section and slide collection.

CANTERBURY
CANTERBURY COLLEGE OF ART AND DESIGN, (a constituent College of the Kent Institute of Art and Design), New Dover Road, Canterbury, Kent CT1 3AN. Tel. 0227 769371. Courses: BA Hons Fine Art; BA and Diploma RIBA Architecture; BTEC National Diploma in Design (fashion/textiles); BTEC National Diploma in Design (graphic design); Foundation Course in Art. Space: Large open plan studio (painting) divided as required; 2 medium sized open plan studios (painting); large sculpture area comprising 4 substantial studios/workshops; outdoor hard standing working space for sculpture; materials store; student work store; staff room; office. Specialist equipment: All types of sculpture equipment available: cutting, welding, foundry, forge, spray booth, vacuum forming, lifting gear etc. These available to fine art students under supervision only. Extensive facilities available for printmaking (silkscreen, litho, etching, relief), photography, typography and computers. Well equipped College workshop for work in wood, metals, plastics and enamelling, jewellery. Audio visual unit (16mm film, sound recording, sound syncronising, 35mm slides). Materials: A sum is incorporated into the student grant to cover materials, books, etc. Materials are available at the College shop at educational discount. The levy system operated by the School of Fine Art enables students to benefit from the School's bulk buying policy. Exhibition space: Permanent gallery (Herbert Read Gallery) about 75 × 33 feet, used for national and international exhibitions as well as the work of students, full-time staff, visiting staff. The College Prize Fund has been built up over the last few years by donations from sponsors, staff, friends of the College etc. Modest prizes for students are available annually. School of Fine Art offers materials subsidy by competition to assist in the expenses of major works. Exchanges: Regular exchange programme developing. Currently includes exchanges with Berlin, Madrid and Trondheim. Library: 33,610 books (including exhibition catalogues), 414 periodicals, 28,242 slides, 907 maps, 690 video cassettes. Architecture Technical Library: 5 books, 5 periodicals, 360 slides. Library's material within fields of art, design and architecture. Also cultural and supporting studies department slide collection of about 50,000 slides. Visiting lecturers: a large number of part-time and visiting lecturer are employed to supplement the full-time staff. Appointments are usually made on a regular basis (1/2 days per week) but one-off visits/lectures, termly visits and block teaching are also arranged. Information on "Life after art school". Advisory and Business and Professional seminars are part of the course programme. Post-graduate student handbook is given to all 3rd year students.

CARDIFF
SOUTH GLAMORGAN INSTITUTE OF HIGHER EDUCATION, Faculty of Art and Design, Howard Gardens, Cardiff CF2 1SP. Tel. 0222 551111. Courses: Fine Art BA Hons, 3 years full-time study specialising in painting, sculpture, printmaking, film, video and performance art, or any combination of these. 45 places available each year. Course Staff: 10. Fellowships: 3. Approximately 50 other artists visit the course each year. City Centre site. Excellent Library. Wide range of technical facilities. Opportunity for International Study in Europe and USA. MA Fine Art, 2 years part-time study.

CARMARTHEN
CARMARTHENSHIRE COLLEGE OF TECHNOLOGY & ART, Carmarthen. Photography: National Diploma in Design. National Diploma in Design. Crafts: Higher National Diploma in Design.

CHISELHURST
RAVENSBOURNE COLLEGE OF DESIGN AND COMMUNICATION, Walden Road, Chislehurst, Kent. BR7 5SN. Tel. 01-468 7071. Courses: Specialist 1 year Foundation Couses in Graphic Design, Fashion Design, Fine Art and Three-Dimensional Design; BTEC National Diploma in Technical Illustration (2 years); College Diploma in Technical Graphics (1 year); BTEC Higher National Diploma in Design (communications)—a course for Programme Operators in television and sound broadcasting' BTEC Higher National Diploma in Engineering—a course for Television Studio Systems Engineering; BA Honours degrees in Fashion Design, Graphic Design, Product Design and Furniture Design. Specialist equipment; fully equipped workshop and studio areas, specialist library slide and media collections, photography and computing resources; well stocked College shop selling materials at below retail cost; Programmes of visits within UK and abroad and visiting practising designers and managers.

COLCHESTER
COLCHESTER INSTITUTE, Sheepen Road, Colchester CO3 3LL. tel. 0206 570271. National Diploma in General Art and Design, National Certificate in Printing, part-time. National Diploma in Clothing. Graphic Design: National and Higher National Diploma in Design. Industrial Design: National and Higher National Diploma in Design.

COLEFORD
ROYAL FOREST OF DEAN COLLEGE, five Acres Campus, Berry Hill, Coleford, Gloucestershire GL16 7JT. Tel. 0594 33416. Course: BTEC National Diploma in Design (craft/ceramics), 2 year full-time course. Space: 4 studios. Excellent equipment in Ceramics. Library: Specialist Art Section. Visiting Professional Craftworkers. Lectures in History of Art/Ceramics. Supporting Studies: Computer Graphics, Visual Studies, Professional Studies.

COVENTRY
COVENTRY POLYTECHNIC, Priory Street, Coventry CV1 5FB. Tel. 0203 24166. Fine Àrt: BA Honours, full-time. Graphic Design: BA Honours, full-time.

CREWE
CREWE & ALSAGER COLLEGE OF HIGHER EDUCATION, Hassall Road, Alsager, Cheshire. ST7 2HL. Tel. 0270 882500. Courses: BA Hons Creative Arts, Visual Arts Element 2 or 3D Studies, Photography, Print Making, Textiles and Ceramics. Open plan mix across disciplines. Forms 1/3 of total courses in years 1 and 2 and may be upto 2/3 in year 3. Facilities: Specialist Studios, Exhibition Spaces—Alsager Gallery and Studio Equipment: generally available. Exchange with USA. Library: Specialist Arts, Photography, Textiles. Integration of art forms encouraged. (Drama, Creative Writing, Music, Dance; one subject to be selected with Visual Arts.)

CROYDON
CROYDON COLLEGE, School of Art & Design, Fairfield, Croydon. Tel. 01-8889271. National Diploma in General Art & Design. National Diploma in Design. Graphic Design: National & Higher National Diploma in Design. Fashion. National Diploma in Design. Ceramics: Higher National Diploma in Design. Theatre Studies: Higher National Diploma in Design.

DERBY
DERBYSHIRE COLLEGE OF HIGHER EDUCATION, Three main sites; Kedleston Road (0332 47181), Mickleover (0332 514911), Green Lane (0332 42182). Art & Design courses at Kedleston Road: BA(Hons) Photographic Studies, MA Photographic Studies (part-time), BTEC HND Design (crafts: studio ceramics), BTEC HND Design (fashion), BTEC HND Design (textile design). At Green Lane: BA(Hons) Photographic Studies (film and video), Post-graduate Diploma Film Studies (part-time), BTEC HND Design (graphic design); One year Foundation Course, Regional Film-Theatre, the Metro Cinema with Exhibition space (GL), Concourse Exhibition area (KR), specialist art library, centre for the study of early film, Faculty Lecture Series, computer aided design facilities in most departments.

DUNDEE
DUNCAN OF JORDANSTONE COLLEGE OF ART, Perth Road, Dundee DD1 4HT. Tel. 0382 23261. Design: BA/BA Honours, full-time. Fine Art: BA/BA Honours, full-time. Public Art & Design: MA, full-time.

EDINBURGH
EDINBURGH COLLEGE OF ART, Lauriston Place, Edinburgh, EH3 9DF. Tel. 031-229 9311. Courses: Degree of BA with Honours in Design, Painting or Sculpture. Four years full-time within the Faculty of Art and Design of Heriot-Watt University. Degree of MA with Honours in Fine Art in

collaboration with the University of Edinburgh. Five years full-time. Facilities: extensive exhibition spaces and equipment. For further information and application details contact the Registrar.
NAPIER COLLEGE–THE POLYTECHNIC OF EDINBURGH, Colinton Road, Edinburgh EH10 5DT. Tel. 031-444 2266. BA Photographic Studies, BSc Industrial Design (Technology), BA Interior Design, HND Communication Studies, HND Journalism Studies, BA Publishing. Variety of display facilities across college sites (6). Prizes for students—no scholarships.

EXETER
EXETER COLLEGE OF ART AND DESIGN, Earl Richards Road North, Exeter EX2 6AS. Tel. 0392/ 273519. BA Hons degree courses in Fine Art, Graphic Design, Three Dimensional Design, Fine Art with a language (with University of Exeter), One Year Publishing and Book Production for Graduates. Well equipped workshops and studios, specialist libraries, courses linked with European colleges, excellent centre for the south west coasts and moors.

FALMOUTH
FALMOUTH SCHOOL OF ART & DESIGN, Woodlane, Falmouth, Cornwall. TR11 4RA. Tel. Falmouth (0326) 211077. Courses: Postgraduate Diploma: Radio Journalism. BA: Fine Art, Scientific & Technical Graphics. HND: Ceramics, Graphic Design, Technical Illustration. OND: General Art & Design, Design, Graphic Design, Technical Illustration. Foundation: South West Regional Diploma in Art & Design. Facilities: Extensive open plan specialist studios and workshops, including high level computer graphics and audio visual provision. Two permanent exhibition spaces. Any Other Information: Falmouth School of Art & Design is a major provider of Art & Design education and will be funded by PCFC from April 1989 onwards. The School which covers the full range of Art & Design activity both in terms of level and subject provision, exists in a pleasant sub-tropical garden environment in the town of Falmouth with a major annexe in nearby Camborne.

FARNHAM
WEST SURREY COLLEGE OF ART & DESIGN, Falkner Road, The Hart, Farnham, Surrey GU9 7DS. Tel. 0252 722441. Fine Art: BA Honours, full-time. Photography, Film, Video and Animation: BA Honours, full-time. Textiles/Fashion: BA Honours, full-time. Three-Dimensional Design: BA Honours, full-time.

GALASHIELS
SCOTTISH COLLEGE OF TEXTILES, Department of Design, Netherdale, Galashiels. Tel. 0896 3351. Courses: BA Honours in Industrial Design (textiles) 4 years, full-time, Post Graduate Diploma in Textile Design one year, full-time. Specialisms in weaving, knitting, printing with student access to equipment and computer-aided design facilities. Materials provided. Exhibitions: Purpose built area plus corridors and foyer. Scholarships, prizes awarded. Exchanges possible with USA. Library, specialist areas.

GLASGOW
GLASGOW SCHOOL OF ART, 167 Renfrew Street, Glasgow G3 6RQ. Tel. 041-332 9797. Courses: BA/BA(Hons) Fine Art, 4 years. First year joint BA/BA(Hons) Design. Second year study in single discipline: Drawing & Painting, Environmental Art, Photography, Printmaking, Sculpture. Combined studies possible in third and fourth years. Historical and Critical studies element throughout the course.
Postgraduate Diploma in Fine Art, 1 year; self-initiated programmes in disciplines listed above. MA Fine Art, 2 years; taught course in disciplines listed above, with common core studies. Space: studies in Mackintosh Building and 4 others. Specialist equipment: access by arrangement. Exhibition space: permanent; available to staff, students and others. Scholarships: travel scholarships, prizes. Large specialist library and slide collection serves the whole School.
BA/BA (Hons) Design, 4 years. First Year joint with BA/BA (Hons) Fine Art. From Second Year onwards, specialist study normally in single discipline: Ceramics, embroidered and woven textiles, graphic design (with sub-specialisms), industrial and interior design (with progressive specialisation in either), printed textiles (and knitting), silversmithing and jewellery. Historical & critical studies element throughout the course. Alternative First Year programme in Industrial & Interior Design, taught with First Year B Architecture students. Postgraduate Diploma in Design, 1 year; self-initiated programmes in disciplines listed above, and Theatre Design.
MA Design, 2 years: taught course—mutlidisciplinary with strong theoretical and philisophical elements. Space: studios in Machintosh Building and 2 others. Specialist equipment: access by arrangement. Exhibition space, Library etc—see above.
B.ENG/M.ENG Product Design—Engineering, 4/5 years. Taught in conjunction with the University of Glasgow. Glasgow School of Art also incorporates the Machintosh School of Architecture. Exchanges: staff and student exchanges with US, EEC countries and Scandinavia.

GLOUCESTER
GLOUCESTERSHIRE COLLEGE OF ARTS & TECHNOLOGY, Oxstalls Lane, Gloucester GL2 9HW. Tel. 0542 426700. Fine Art: BA Honours, full-time. Textiles/Fashion: BA Honours, full-time.

GUILDFORD
GUILDFORD COLLEGE OF TECHNOLOGY, Stoke Park, Guildford, Surrey, GU1 1EZ. Tel. 0483 31251. Printing Department: BTEC National Diploma in Graphic Design (full-time, two years)—2 studios plus printing workshops including digital and phototypesetting, process camera, photographic darkrooms and litho printing. Diploma in Fine Bookbinding and Conservation (full-time, two years)—complete training in forwarding, gold finishing and book conservation, including chemistry, calligraphy and paper restoration by skilled staff in well equiped workshops. Regular visits to lectures, exhibitions and suppliers. Science and Humanities Department: London Board 'A' level Art in drawing and painting—part-time students, one day a week for one year. Currently Tuesdays, Wednesdays and Thursdays. Good painting studio, films, videos, etc.

HALIFAX
PERCIVAL WHITLEY COLLEGE OF FURTHER EDUCATION, Francis Street, Halifax, West Yorkshire, HX1 3UZ. Tel. 0422 58221. Foundation. B.Tec Diploma/Certificate Graphic Design, Pre Foundation Ground Course, Genreal Vocational Design Course.

HARROW
HARROW COLLEGE OF HIGHER EDUCATION, Watford Road, Northwick Park, Harrow, Middlesex HA1 3TP. Tel. 01-864 5422. Fashion: BA Honours, full-time. Graphic Information Design: BA Honours, full-time. Illustration: BA Honours, full-time. Photographic Media Studies: BA part-time. Photography, Film and Video: BA Honours, full-time.

HASTINGS
HASTINGS COLLEGE OF ARTS & TECHNOLOGY, Archery Road, St Leonards on Sea, East Sussex TN38 0HX. tel. 0424 423847. Department of Art & Design: Foundation Studies, P/T Certificate in Art, Design Courses all in purpose converted Grade A listed buildings equipped to high tandards.

HIGH WYCOMBE
BUCKINGHAMSHIRE COLLEGE OF HIGHER EDUCATION, Queen Alexandra Road, High Wycombe, Bucks HP11 2JZ. Tel. HW 22141. Courses offered: MA Degree in Furniture Design and Technology, BA (Hons) Degree in Three-Dimensional Design, with specialisations in: Furniture Design, Interior Design, Silver/Metal Design, Ceramics with Glass. Foundation Art, Higher National BTEC Graphics, Extensive Studio and Workshop provision.

HOUNSLOW
HOUNSLOW BOROUGH COLLEGE, London Road, Isleworth, Middlesex TW7 4HS. Tel. 01-568 0244. BTEC HND Graphic Design & Advertising, BTEC National Diploma in Graphic Design, BTEC National Diplomma in Fashion Design, BTEC National Diploma in Display Design, BTEC National Dimploma in Industrial Design, BTEC National Diploma in General Art & Design. Foundation Course in Art. Specialist Studios and workshops for above, plus Service Studios for Printmaking, Sculpture, Photography, Art Related Studies, Ceramics etc.

HULL
HUMBERSIDE COLLEGE OF HIGHER EDUCATION, Cottingham Road, Hull HU6 7RT. Tel. 0482 41451. Fine Art: BA Honours, full-time. Graphic Design: BA Honours, full-time. Visual Studies: Certificate/Dip HE/BA/BA Honours, part-time. Gallery in entrance hall. Film and video component within the Fine Art course.

IPSWICH
SUFFOLK COLLEGE OF HIGHER & FURTHER EDUCATION, School of Art & Design, Rope Walk, Ipswich IP4 1LT. Courses: Higher National Diploma (BTEC) in Design Communications—options in Film/TV Graphics, Animation, Video Production, Graphic Design, Illustration. Higher National Diploma (BTEC) in 3-D Design— options in TV Set Design, theatre, Scenic Design Interiors, Exhibition and Museum Design. Both 2 years F/T poolable advanced courses. School has fully equipped TV studios, fil editing, dubbing, animation rostrum, cameras, graphic workshops, theatre stage and support studios. Large reference library and supporting art studios programmes. Tel. 0473 55885.

KINGSTON
KINGSTON POLYTECHNIC, Admissions Office, Kingston Hill, Kingston upon Thames KT2 7LB. Tel. 01-549 1366. fine Art: BA Honours, full-time. Graphic Design: BA Honours, full-time. Textiles/Fashion: BA Honours, full-time. Three-Dimensional Design: BA Honours, full-time.

LEEDS
KITSON COLLEGE OF TECHNOLOGY, Calverley Street, Leeds LS1 3HE. Tel. 0532 462978. Diploma in Photography: Two years, full-time. Diploma in Design, Photography and Printing: Two years, full-time. Diploma in printing: Three years, part-time.
JACOB KRAMER COLLEGE, Vernon Street, Leeds LS2 8PH. Tel. 0532 439931. Diploma in Fine Art & Craft: Three years, part-time. Space: 5 studios, open plan. Well-sited small gallery, library, college shop.
LEEDS POLYTECHNIC, Calverley Street, Leeds LS1 3HE. tel. 0532 462903/4. Fine Art: BA Honours, full-time. Graphic Design: BA Honours, full-time. Three-Dimensional Design: BA Honours, full-time. Art History: MA, part-time; Diploma, part-time.
THE DEPARTMENT OF FINE ART, The University, Woodhouse Lane, Leeds LS2 9JT. Tel. 0532 431751 ext 5260. Three BA Single Honours Degrees in: 1) Fine Art (4 years—the practice of art with art history) (UCCA code W150). 2) History of Art (3 years) (UCCA code W400). 3) The History of the Fine and the Decorative Arts (4 years) (UCCA code W450).
 Twelve BA Joint-Honours Degrees in Arts and Language Subjects combined with the History of Art. MA Degree in the Social History of Art (1 year taught course).
 i) Specialist Library with the Department. ii) Large teaching and research collection of slides and other visual material. iii) Computing facilities: Mainframe, PC., Desk-top Publishing, Laserprinting. iv) Painting Studios—mostly individual. v) Printmaking Workshops. vi) Photographic Darkrooms. vii) Film & Video production facilities. viii) Computer Graphics for Video production. ix) Woodworking Workshop. x) Exhibition Space: University Art Gallery, Departmental Foyer Gallery. xi) Fine & Decorative Arts Students study art history alongside Decorative Arts and Museum Studies which are taught by specialists from the local galleries and museums, and benefit from the resources of the City Art Gallery, the Henry Moore Centre for the study of Sculpture and the outstanding collections housed at Temple Newsam House and Lotherton Hall.

LEICESTER
LEICESTER POLYTECHNIC, Admissions, PO Box 143, Leicester LE1 9BH. Tel. 0533 551551. Combined Arts: BA/BA Honours, full-time. Fine Art: BA Honours, full-time. Graphic Design: BA Honours, full-time. History of Art & Design in the Modern Period: BA/BA Honours, full-time. Performing Arts: BA Honours, full-time. Textiles/Fashion: BA Honours, full-time. Three-Dimensional Design: BA Honours, full-time.
SOUTH FIELDS COLLEGE OF FURTHER EDUCATION, School of Printing, Design and Photography, Aylestone Road, Leicester LE2 7LW. Tel. 0533 541818 ext 260. BTEC National Diploma in Graphic Design, BTEC National Diploma in Screen Reprography, BTEC First Diploma in Design with options in Design, Photography, Printing and Printing Administration. Fully equipped Design and Photography studios and processing rooms in addition to a major modern printing workshop facility.

LEIGH
LEIGH COLLEGE, Art & Design Centre, Coniston Street, Leigh WN7 1XN. Tel. 0942 608811. BTEC National Diploma in General Art & Design. Expressive Arts Course. The college has well equipped centres. Centres for The Arts, The Art & Design Centre, The Music Centre, The Drama Centre and The Media Centre, a specialist Art Library and a slide collection. Generally all materials, equipment etc., is provided after the students initial purchase of personal equipment, eg. folio, sketchbooks, etc.

LINCOLN
LINCOLN COLLEGE OF ART, Greestione Centre, Lindum Road, Lincoln. Tel. 0522 23260/8/9. Vocational courses in art and design: Full-time graphic design (4 years). Full-time foundation studies. Preliminary studies—fashion. Part-time printing, photography, pottery, drawing and painting, dress and embroidery. Exhibitions Space: 2 areas 900 and 100 square feet.

LIVERPOOL
LIVERPOOL POLYTECHNIC, Rodney House, 70 Mount Pleasant, Liverpool L3 5UX. Tel. 051-207 3581. Fine Art: BA Honours, full-time. Graphic Design: BA Honours, full-time. Textiles/Fashion: BA Honours, full-time. 4 large Victorian studios. Numerous small individual studios for 3rd year painting students. Scholarships/Prizes: Sculpture competition arranged with local industry. Fine Art–Annual John Moores Scholarship £1,000. Large art library.

LONDON

THE LONDON INSTITUTE, 388 Oxford Street, London W1. Tel. 01-491 8533. The seven following colleges/schools are members.

CAMBERWELL SCHOOL OF ART AND CRAFTS, Peckham Road, London SE5 8UF. Tel. 01-730 0987. BA Hons courses in most departments. Postgraduate courses.

CENTRAL SCHOOL OF ART AND DESIGN, Southampton Row, London WC1B 4AP. Tel. 01-405 1825. BA Hons courses in most departments. Postgraduate courses.

CHELSEA SCHOOL OF ART, (a constituent college of The London Institute), Manresa Road, Chelsea, London SW3 6LS Tel. 01-351 3844. Offers the following courses: MA in Fine Art (specialisms in painting, sculpture, printmaking or alternative media). MA in history of Modern Art (part-time). BA Hons in Fine Art. BA Hons in Graphic Design. HND in Design (textiles). HND in Design (murals). HND in Design (three dimensional): has separate streams in Interior Design and Product Design. Certificate in Interior Decoration (1 year). BTEC National Diploma in General Art & Design (2 year). Foundation Course (1 year). Extra Mural Programme: a large range of courses, daytime and evening, coverng subjects as various as painting, embroidery and television design. Facilities: The School is on four sites in West London. It has probably the best art library in London, an outstanding computer unit dedicated to art and design applications, and its own gallery with a year-round programme of exhibitions. Other information: The School has an unusually high proportion of visiting lecturers, drawn from art and design practice.

LONDON COLLEGE OF FASHION, 20 John Princes Street, London W1. tel. 01-629 9401.

LONDON COLLEGE OF PRINTING, London SE1 6SB. Tel. 01-735 8484.

COLLEGE FOR THE DISTRIBUTIVE TRADES, Department of Display, 107 Charing Cross Road, London WC2. Tel. 01-437 6151.

SAINT MARTINS SCHOOL OF ART, 107 Charing Cross Road, London WC2. tel. 01-437 0611. BA Hons courses in fine art, and postgraduate courses. BA Hons courses in Fine Art, Graphic Design and full-time Foundation course. Postgraduate Diploma in Film and Video (CNAA), Postgraduate Diploma. Part-time course in Graphic Design and Computers (CNAA). Situated on two sites, one on Charing Cross Road and the other in Covent Garden on Long Acre. High proportion of practising artists and designers on the staff.

BYAM SHAW SCHOOL OF ART, 2 Elthorne Road, London N19 4AG. Tel. 01-281 4111. Principal Geri Morgan. Courses: 1 year full-time foundation course; 3 year diploma course; post diploma course and short term studies course. Space: One building. Now in a new North London site. Space is divided up for the art students according to their needs. Photography and printmaking facilities as well as painting and sculpture. Bandsaw and welding equipment available to students. Materials: Shop in the school. Discount prices for students only. Exhibition space: For students only during diploma shows. Scholarships: Jubilee Scholarship (a free place for one year); Ernest Jackson Scholarship (year's free tuition); Award of Merit (free tuition); Prizes: Graham Hamilton Drawing Prize—best drawing £100; James Byam Shaw Painting Prize—£150; Bateson Mason Drawing Prize £100; Peta Katzenellenbogen Prize £50; Chairman's prize £150; Pamela Ovens Prize £250; Principal's Prize £150; Neville Burston Prize (printmaking) £200. Library: Books, magazines, slides for students and staff only. Visiting lectures: Practising artists given termly contracts or invited to give lectures. Information available on "Life after Art School".

CITY OF LONDON POLYTECHNIC, Sir John Cass Faculty of Arts, Central House, 59–63 Whitechapel High Street, London E1 7PF. Tel. 01-283 1030. Courses offered: Silversmithing and Jewellery Department: BA (Hons), full-time and part-time Diploma and Certificate courses, Extended Study programme, Pre-Apprenticeship course; Fine and Applied Art Department: full-time and part-time Foundation, part-time Diploma and Certificate courses; Modular Degree and Diploma Scheme: Major in Design Studies (under validation). Facilities, etc: Small exhibition space, specialist library area.

CORDWAINERS TECHNICAL COLLEGE, 182 Mare Street, Hackney, London E8 3RE. Tel. 01-985 0273. Courses: BTEC National and Higher National Diplomas in Design (footwear) subject to approval and validation' Diploma of the Chartered Society of Designers and College Diploma in Footwear Design. Space: 3 studios, 6 workrooms plus supporting accommodation. Specialised Equipment: Extensive range of Footwear Manufacturing Machinery with programmed availability to all students; Basic hand tool kit essential at approximate cost of £70. Materials: Much provided but reduction likely, students to purchase specialised items, some materials available to approved order, sources of supply information available. Exhibition Space: Temporary in variety of College locations. Available to students, others negotiable. Scholarships, Prizes: Gold/Silver/Bronze Medals, Travelling Scholarships, Industrial bursaries, memorial prizes. Library: Specialist Footwear Design Resource Area—books, magazines, slides and photographs, videos: supportive fashion resources. Exchanges: None at present, proposals considered. Visiting Lecturers: Specialist input from Fashion Designers, design consultants and manufacturers regularly throughout courses. Close links with specialist fashion Colleges of London Institute.

POLYTECHNIC OF CENTRAL LONDON, 309 Regent Street, London W1R 8AL. Tel. 01-580 2020. Courses offered: BA Hons Media Studies, BA Hons Film, Video and Photographic Arts, BSc and BSc

Hons Photographic and Electronic Imaging Sciences, BA Photography (part-time: day and evening release 4 years.). Space: TV studio, control room, post productions facilities, 3 sound studios, sound recording studio, radio studio, photography studios, suite of darkrooms, and a suite of laboratories. Equipment: Available to all students within the faculty. Materials: Each student has an allocation of materials. Exhibition space: The polytechnic has 2 galleries: The Regent Street Gallery, and The Marylebone Road Gallery, they have a flexible system of panels and display cases and are available to students, staff and the public to exhibit their work. Scholarships: None. Prizes: Yearly, within the polytechnic. Exchanges: Frequently with Rochester Institute of Technology. Library: The well-stocked library contains some 9000 volumes on all aspects of communication and holdings of some 200 periodicals in the field. Visiting lecturers: Regular visits by successful members of the media world and artists.

UNIVERSITY OF LONDON GOLDSMITHS' COLLEGE, Department of Communications, New Cross, London SE14 6NW. Tel. 01-692 7171. BA in Communication Studies and Sociology, Diploma in Communications. TV–2 multi camera colour studios with digital effects, character generators and auto cue. U'matic and VHS cameras, recorders and edit suites. Radio–2 sound studios, Uhers, Marantzs and Bell & Howell recorders. Photography— Colour and B/W dark room and printing facilities. Wide range of large format and 35ml cameras. 2 studios. Electronic Graphics— 2 Image Artist computerised paint systems, Chyron VP2 character and graphics generator, video animation system and digital video effects.

HEATHERLEY SCHOOL OF FINE ART, Old Ashburnham School, Upcerne Road, Chelsea, London SW10. Founded 1845. Selective and non-selective courses in painting, sculpture, printmaking and 2D design.

LONDON INTERNATIONAL FILM SCHOOL, 24 Shelton Street, London WC2H 9HP. Tel. 01-836 9642. Two year Diploma course in the Art and Technique of film-making. A practical course recognised by the ACTT and teaching skills necessary for employment in the industry. Facilities include 2 viewing theatres, 2 fully equipped studios, a video rehersal studio and comprehensive editing and sound departments.

MIDDLESEX POLYTECHNIC, Faculty of Art & Design, Cat Hill, Barnet, Herts EN4 8HT. Tel. 01-368 1299. Courses: Foundation Art & Design. Degrees in Fine Art, Graphic Design, Graphic Design (Scientific Illustation, Technical Illustration), Three Dimensional Design, Textiles/Fashion, Jewellery/Ceramics, Interior Design. Opportunities for part-time study are available. Masters Courses in Computing in Design, Interior Design, History of Design. Post Graduate Diploma in Video. Short courses in a wide variety of subjects including computer graphics, computer aided weaving, paintbox systems and desk top publishing. All enquiries to Faculty Office, address and telephone as above.

NORTH EAST LONDON POLYTECHNIC (NELP), Romford Road, London E15 4LZ. Tel. 01-590 7722. Relative courses: BA(Hons) Fine Art: 3 years full-time. BA(Hons) Fashion: Design with Marketing 4 years sandwich. Multi-subject Dip HE 2 years full-time, 3 years part-time. Dip HE and BA/BSc by Independent Study: full-time and part-time, various. For further information and/or course leaflets please contact the Assistant Registrar at the above address.

POLYTECHNIC OF NORTH LONDON, Dept of Environmental Design, Holloway Road, London N7 8DB. Tel. 01-607 2789.

POLYTECHNIC OF THE SOUTH BANK, Division of Arts, 83 New Kent Road, London SE1. No fine art courses. B.Ed for primary teachers with art specialisation in pottery, photography and embroidery. Facilities for all of these available to students.

ROYAL COLLEGE OF ART, Kensington Gore, London SW7 2EU. Tel. 01-584 5020. Courses: Post-graduate courses in the faculties of communication (animation, film, graphics illustration, photography), Humanities (theses, history of design), Design (architecture, industrial, furniture, interior, transport and computer-aided), Applied Design (ceramics, glass, fashion, jewellery, textiles) and Fine Art (painting, sculpture, tapestry, printmaking, visual islamic arts). (2/3 year courses.) Master of Arts (RCA), Master of Design (RCA) PhD (RCA) and Dr (RCA). Space: Painting. Open studios, subdivided. Mixed across the years. Sculpture: Large open plan mixed across the years. changes taking place in all departments with stress on design. Equipment: Machinery for stretchers, structures, frames, mounts etc. Equipment available in other departments for photography, casting etc. Equipment available for students for sculpture. Materials: College shop—discount for students. Allowance to students. Sculpture allowance £200 per annum per student. Not limited to college shop. Exhibition space: Permanent space. Student exhibitions. Annual postgraduate show is the largest in June/July. Gallery at Kensington Gore also shows large exhibitions from outside from time to time. Scholarships and Prizes: Numerous scholarships. See prospectus. Foreign Exchanges: By department. Visiting lecturers: Variety. No information available on "Life after art school".

ROYAL ACADEMY SCHOOLS, Burlington House, London W1. Tel. 01-439 7438. Postgraduate fine art courses only.

SLADE SCHOOL OF FINE ART, University College London, Gower Street, London WC1E 6BT. Tel. 01-387 7050. University of London BA Degree in Fine Art and University of London Higher Diploma in Fine Art.

WILLESDEN COLLEGE OF TECHNOLOGY, Denzil Road, London NW10. Tel. 01-459 0147.

WIMBLEDON SCHOOL OF ART, Merton Hall Road, Wimbledon, SW19 3QA. Tel. 01-540 0231. MA and Postgraduate Diploma in Printmaking (part-time), BA(Hons) Courses in Painting, Sculpture and Theatre Design, DipHE in Theatre Wardrobe and a Foundation Course, all full-time. Pre Foundation classes run by Foundation Department. Facilities for photography, video, film and performance. A purpose built theatre, studios and workshops in the grounds, plus extensive library. Materials at cost. Many professionals as part-time tutors.

LOUGHBOROUGH
LOUGHBOROUGH COLLEGE OF ART & DESIGN, Radmoor, Loughborough, Leics. LE11 3BT. Tel. 0509 261515. Fine Art: BA Honours, full-time and part-time. Textiles/Fashion: BA Honours, full-time and part-time. Three-Dimensional Design: BA Honours, full-time and part-time.

LOUGHTON
LOUGHTON COLLEGE, Art and Design Department, Pyrles Lane, Loughton, Essex. Tel. 01-508 8670. Courses: BTEC First Diploma in Design, BTEC National Diploma in Graphic Design, BTEC National Diploma in General Art and Design, Earac Foundation Studies in Art & Design. Studios to include print-making, 3D Design (wood/metals), Machine Room Ceramics Studio, 3 Graphic Studios, Textile/Fashion Studio, Photographic Section, Fine Art Studio, Drawing Studio.

LOWESTOFT
LOWESTOFT SCHOOL OF ART, St Peters Street, Lowestoft, Suffolk. Tel. 0502 4177/8. First Diploma in Design, National Diploma in Design (graphic design), National Diploma in Design (ceramics), National Diploma in Design (communications), National Diploma in General Art and Design.

LUTON
BARNFIELD COLLEGE, School of Art & Design, New Bedford Road, Luton, Beds LU2 3AX. Tel. 0582 507531. Full-Time Courses: BTEC National Diploma in General Art & Design, BTEC National Diploma in Design (photography), BTEC National Diploma in Design (graphic design), BTEC National Diploma in Design (fashion), BTEC First Diploma in Design. Part-Time Courses: Art & Design Matters, GCE 'A' Level Art, Photography. Space: Specialist Studios and Equipment. Students buy most materials through student purchase scheme. Within Department: Exhibition space: permanent area in Department with display lighting, available to staff, students, outside artists and designers. Library: specialist Art and Design area.

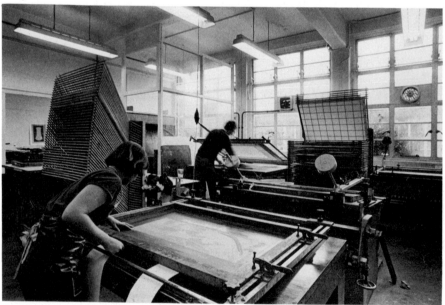

Wimbledon School of Art, Fine Art Department

MAIDENHEAD
BERKSHIRE COLLEGE OF ART & DESIGN, Marlow Road, Maidenhead, Berks. Tel. 0628 24302. Graphic Design: National Diploma in Art & Design and Higher National Diploma. Photography: National Diploma in Design. Fashion: National Diploma in Art & Design and Higher National Diploma. Three Dimensional Studies: National and Higher National Diploma in Art & Design. Jewellery: National Diploma in Art & Design.

MANCHESTER
CENTRAL MANCHESTER COLLEGE, East Manchester Centre, Taylor Street, Gorton, Manchester M18 8DF. Tel. 061-223 1628. National Diploma in Audio Visual Design. Multi-disciplinary, group-based course working between graphics, video, film/animation, sound-recording, photography and tape/slide production. Equipment includes VHS cameras and editing, Bolex camera, sound and lighting equipment.
MANCHESTER POLYTECHNIC, All Saints, Manchester M15 6BH. Tel. 061-228 6171. The Department of Fine Art offers the following courses: MA Fine Art (FT & PT), BA(Hons) Fine Art; there are excellent studios for drawing and painting, a large and well equipped studio/workshop for fine prints, studio/workshop for sculpture (providing facilities for wood, metal, plastics, carving, modelling, moulding), a spray shop and a large foundry for bronze cashing. The Department of Visual Studies is responsible for the following courses and areas of study include: the foundation course, the visual studies component of the BA design course within the Faculty; the visual studies component within the aesthetics domain and core of the DipHE; recreational arts for the community. A variety of other courses are offered by other Departments within the Faculty of Art & Design, for example: General Arts: BA/BA Honours, full-time and part-time. History of Design: BA Honours, full-time. Textiles/Fashion: BA Honours, full-time. Three Dimensional Design: BA Honours, full-time. Graphic Design: MA, full-time and part-time. Textiles/Fashion: MA, full-time and part-time. Three Dimensional Design—Industrial Design (engineering): MA, full-time. Three Dimensional Design—Interior Design: MA, full-time.

MANSFIELD
WEST NOTTINGHAMSHIRE COLLEGE, Derby Road, Mansfield NG18 5BH. Tel. 0623 27191. F/T BTEC Diploma courses in Design, General Art & Design, Graphic Design, Fashion Design, Industrial Design, Photography, City & Guilds Signwork also Media Studies, P/T BTEC Diploma courses in Graphic Design, Fashion Design, Industrial Design, City & Guilds Embroidery, Creative Textiles, Fashion, Ceramics, Toymaking, Soft Furnishing & Upholstery College Diploma—Design Craftsman plus a wide range of 'A' levels in all Art & Craft subjects. Also offered—special day and weekend courses in a variety of subjects. All appropriate facilities of an Art College, the Art & Design Department is ex-Mansfield College of Art. Exhibition space for touring and special displays, available to individual artists. Full range of equipment, plus computer design facilities in most areas. Centre for Art & Design education in Nortinghamshire outside the degree sector.

MIDDLESBROUGH
LONGLANDS COLLEGE OF FURTHER EDUCATION, Douglas Street, Middlesbrough, Cleveland TS12 1BQ. Tel. 0642 248351. Fax, Prestel, Times Network one-to-one. Equipment: 3 Colour-Camera Video Studio with off-line editing, on-line radio. Studio: Photographic Studio/Darkroom etc. Courses: BTEC National Diploma in Design (audio-visual) (2 years full-time). C26 279 Cert. in Video Production: C26 770 Television Studies, C26 779 Radio and Journalism, C26 734 AV Technician's Certificate, C26 744 General Certificate in Photography. Part-time day and evening courses throughout the year.
TEESSIDE POLYTECHNIC, Design Department, Borough Road, Middlesbrough, Cleveland TS1 3BA. Tel. 0642 218121 Ext 4385/9. BA(Hons) Three Dimensional Design—Industrial Design (engineering) and Interior Design. Space: Modern, open plan studios. Equipment: Generally available. Excellent workshop facilities. Materials: No allowance. Students contribute to cost of materials. Exhibition space: Permanent—main foyer. Scholarships, prizes: None. Exchanges: None. Library: Specialist art and design area. Resources library in department. Visiting lecturers: regular weekly lectures and visits by designers and other specialists. Computer Aided Design and animation a speciality of the course.

NEWCASTLE UPON TYNE
NEWCASTLE UPON TYNE POLYTECHNIC, Faculty of Art and Design, Squires Building, Sandyford Road, Newcastle upon Tyne, NE1 8ST. Tel. 091-232 6002. BA(Honours) Graphic Design, full-time. BA(Honours) Media Productions, full-time. BA(Honours) Fine Art, full-time. BA(Honours) Creative Arts, full-time. BA(Honours) Design for Industry, sandwich course. BA(Honours) Fashion, full-time. BA/BA Honours History of Modern Art, Design and Film, full and part-time. BA(Honours) Three Dimensional Design Craftsmanship, full-time. MA Fine Art, part-time. Materials provided freely, but not through a college shop. Art gallery with its own staff. Custom built space with specialist facilities.
NEWCASTLE UPON TYNE COLLEGE OF ARTS AND TECHNOLOGY, Bath Lane, Newcastle upon Tyne. Tel. 091-232 4155. Graphic Design: National Certificate in Design, National and Higher. National

Diploma in Design. Photography: National Diploma in Design. Fashion: National Diploma in Design. Three Dimensinal Design: National Diploma in Design. Spatial Design: Higher National Diploma in Design.

NEWPORT
GWENT COLLEGE OF HIGHER EDUCATION, Faculty of Art & Design, Clarence Place, Newport, Gwent NPT 0UW. Tel. 0633 59984. Fine Art: BA Honours, full-time. Graphic Design: BA Honours, full-time. Documentary Photography: College Diploma. Fashion: College Diploma. Film: College Diploma.

NORTHAMPTON
NENE COLLEGE, School of Art & Design, St George's Ave., Northampton. Tel. 0604 713505. Foundation pre-degree course in Art & Design (1/2 years). Vocational Graphic Design Course (4 years). Vocational Fashion Course (4 years). Vocational Applied Design Course (4 years).

NORTHUMBERLAND
NORTHUMBERLAND COLLEGE OF ARTS 7 TECHNOLOGY, College Road, Ashington, NE63 9RG. Tel. 0670 813248. BTEC HND Design (visual communications). BTEC Nat. Dip. Design (graphic design). BTEC 1st Dip. Design.

NORTHWICH
MID-CHESHIRE COLLEGE OF FURTHER EDUCATION, London Road, Northwich, Cheshire. Tel. 0606 75281. First Diploma in Design. National Diploma in General Art and Design. Graphic Design: national Diploma in Design. Photography: National Diploma in Design. Exhibition Design: National Diploma in Design. Technical illustrations: National Diploma in Design.
NORWICH SCHOOL OF ART, St. George Street, Norwich. NR3 1BB. Tel. 0603 610561. Courses: BA(Hons) Fine Art, BA(Hons) Graphic Design, Foundation Course. Awarding Bodies: Degree Courses— CNAA, Foundation—EARAC. Library: 14,000 volumes, 95 periodicals, 20 study places. Slide Library: 100,000 slides. Welfare: Student counselling service available. Amenities: Norwich Museums, UEA Library and Sainsbury Art Centre, Norwich School of Art Gallery. Accommodation: Very limited student accommodation.

The Fine Art Building, Gwent College, Newport (Peter Morton)

NOTTINGHAM
TRENT POLYTECHNIC, School of Art and Design, Burton Street, Nottingham NG1 4BU. Tel. 0602 418248. Full-time Degree: Fashion, Fine Art, Information Graphics, Photography, Textiles, Creative Arts. Full-time Sandwich: Furniture, Interior, Knitwear. Part-time Master Degree: Fine Art. HND Sandwich: Printing. Full-time/Part-time Textiles: NC/HNC/HND Textiles, Associateship of the Testile Institute. Foundation: Art and Design. Exhibition Space: Permanent Gallery.

NUNEATON
NORTH WARWICKSHIRE COLLEGE OF TECHNOLOGY AND ART, Hinckley Road, Nuneaton, Warwickshire. Tel. 0682 69321. First Diploma in Design. National Diploma in General Art and Design. Graphic Design: National Diploma in Design. Ceramics: National Diploma in Design. Fashion: National Diploma in Design.

OXFORD
RUSKIN SCHOOL OF DRAWING AND FINE ART, Oxford University, 74 High Street, Oxford, OX1 4BG. Tel. 0865 276940. Three year practical course with Art History leading to Bachelor of Fine Art Degree in Painting, Printmaking or Sculpture, or a combination of two of the three.

POOLE (DORSET)
DORSET INSTITUTE OF HIGHER EDUCATION, Wallisdown Road, Wallisdown, Poole BH12 5BB. Tel. 0202 524111. Communication and Media Production: BA Honours, full-time. Photography: Higher National Diploma in Design. Film and Television: Higher National Diploma in Design. Spatial Design: Higher National Diploma in Design. Technical Illustration: Higher National Diploma in Design. Graphic Design: Higher National Diploma in Design. Graphic Design: National Diploma in Design. Photography: National Diploma in Design. Spatial Design: National Diploma in Design. Fashion: National Diploma in Design. Technical Illustration: National Diploma in Design. National Diploma in General Art and Design.

PLYMOUTH
PLYMOUTH COLLEGE OF ART & DESIGN, Tavistock Place, Plymouth, Devon. Tel. 0752 27633. National Diploma in Printing. national Diploma in General Art & Design. Graphic Design: National and Higher National Diploma in Design. Photography: National and Higher National Diploma in Design. Fashion: National Diploma in Design. Display: National Diploma in Design. Crafts: National Diploma in Design.

PORTSMOUTH
PORTSMOUTH COLLEGE OF ART & DESIGN, Winston Churchill Ave., Portsmouth, Hants. Tel. 0705 26435. Higher National Diploma in Design. Technical Illustration: National & Higher National Diploma in Design. Three Dimensional Studies: National Diploma in Design. Communications: National Diploma in Design.

PRESTON
LANCASHIRE POLYTECHNIC, Faculty of Arts, Preston, Lancashire, PR1 2TQ. Tel. 0772 22141. BA(Hons) Fashion (sanddwich), BA(Hons) Fine Art, BA(Hons) Graphic Design (sandwich), HND in Design (Three-dimensional studies in wood, metal, ceramics), Polytechnic Certificate in Foundation Studies (one year course). Accommodation is purpose-built for Art & Design studies. A recently acquired further building will provide scope for anticipated developments within a vigorous Faculty of Arts. Developments in Glass & Fashion Marketing & Promotion are imminent. The Faculty is expanding in terms of access and expertise. The existing good facilities for small-scale production using industrial techniques have been augmented by an impressive range of computer systems. Developments in Information Technology and the application of IT to studies in Art & Design continue to be rapid and exciting.

READING
THE UNIVERSITY OF READING, Department of Fine Art, London Road, Reading RG1 5AQ. Tel. 0734 875234. Courses. Undergraduate: BA in Art, 4 years full-time, short courses for occasional and Junior Year Abroad students, 1 year full-time/part-time. Graduate: MFA, 2 years full-time in the practice of art. Research: M Phil, PhD, 2–4 years full-time/part-time. Among the few British universities in which art is taught, only two compare with Reading in offering a range of degree courses mainly in the practise of art. BA and MFA studies follow an atelier pattern in three areas, namely painting, construction and sculpture; together with technical services which include print, photography, film, video and computer graphics; and with facilities for work in wood, metal, plastics and clay. Nearness to London brings the advantages of ready access to major museums and galleries and contact with many artists whose studios are visited by arrangement. During the Easter vacation a study visit to centres in Europe

takes place which all students are encouraged to attend. The range of staff interests is wide enought to cater for a variety of research topics related to the practise of art. Additional facilities include an art gallery and a journal and slide collection.

RICHMOND UPON THAMES
RICHMOND UPON THAMES COLLEGE, School of Arts, Egerton Road, Twickenham, Middlesex TW2 7SJ. Tel. 01-892 6656-9. Courses: B/TECH General Art & Design. Duration, two years leading to National Diploma in Design, B/TECH Higher National Diploma Graphic Design. Duration, two years, B/TECH National Certificate in Design (photography). Duration, two/three years part-time, B/TECH higher National Certificate in Design (photography). Duration two years part-time, B/TECH National Diploma in Design (photography). Duration three years part-time. Advanced Colour Photography, Basic Video & Visual Techniques. Duration (evening) 32 weeks, B/TECH Natinal Certificate in Design (technical illustration). Duration three years part-time. Facilities: Comprehensive support facilities for design, photography and technical illustration inlcudes printing workshops, colour and monochrome darkrooms, airbrushing studio, audio visual and television studios.

ROTHERHAM
ROTHERHAM COLLEGE OF ARTS & COMMUNITY STUDIES, Eastwood Lane, Rotherham, South Yorks. Tel. 079 61801. First Diploma in Design, National Diploma in General Art & Design. Graphic Design: National Diploma in Design. Fashion/Textiles: National Diploma in Design. Ceramics: National Diploma in Design.

ST ALBANS
HERTFORDSHIRE COLLEGE OF ART & DESIGN, 7 Hatfield Road, St Albans, Hertfordshire AL1 3RS. Tel. 64414. Principal: Colin Hunt. Courses Offered: Ma Art Therapy; CNAA Validated; 2 year part-time, Postgraduate Diploma in Art Therapy; CNAA validated; 2 year part-time and one year full-time, Postgraduate Diploma in Drama Therapy; CNAA validated; 2 year part-time and one year full-time, Advanced Training in Art Therapy and Drama Therapy; 2 year part-time, BTEC National Diploma in Design; 2 year full-time—options within Surface Pattens, Three Dimensional Design and Graphic Design, BTEC Higher National Diploma in Design: Modelmaking; 2 year full-time, Diploma in Professional Studies in Education: Photographys and Related media Studies; CNAA 2 year part-time, BA/BA(Hons) Fine Art; CNAA validated; part-time 4/5 years, Foundation Course—Art; one year full-time—post sixth form level, Part-time courses (day and evening); Ceramics, Drawing and Painting, Photography, Scultpure and Printmaking, Public Lecture Series on aspects of History of Art and Design. Facilities: College is on two sites—Old London Road for BTEC courses and Photography. Other courses at Hatfield Road. Library: Fine Art, Arts Therapies, Design Section, Large Slide Library Studios. Permanent Exhibition Hall, with Exhibitions Officer—available to staff, students and outside artists.

SALFORD
SALFORD COLLEGE OF TECHNOLOGY, Department of Art and Industrial Design, Frederick Road, Salford M6 6PU. Course: Higher National Diploma in Graphic Design; Higher National Diploma in Exhibition and Retail Design; Higher College Diploma (CSD) in Fashion; B/TEC National Diploma in Design; Diploma in Design, Fashion; B/TEC General Art and Design.

SCARBOROUGH
SCARBOROUGH TECHNICAL COLLEGE, Department of Arts and Adult Studies, Lady Edith's Drive, Scarborough, North Yorkshire YO12 5RN. Tel. 0723 372105 Ext 27 or 40. BTEC General Art and Design National Diploma, full-time, 2 years, BTEC National Diploma in Design (graphic design) full-time, 2 years, BTEC National Diploma in Design (fashion) full-time, 2 years, BTEC First Diploma in Design, full-time 1 year, CPVE Art and Design, full-time, 1 year. No facilities, spaces, etc.

SHEFFIELD
SHEFFIELD CITY POLYTECHNIC, Pond Street, Sheffield S1 1WB. Tel. 0742 720911. Fine Art: BA/ BA Honours, part-time, BA Honours, full-time. Three-Dimensional Design: BA Honours, full-time. Film Studies: Diploma/MA, part-time. Film, video and performance art are offered within the fine art course.

SHREWSBURY
SHREWSBURY COLLEGE OF ARTS AND TECHNOLOGY, School of Art, London Road, Shrewsbury, Shropshire, SY2 6PR. Tel. 0743 231544 ext's 290/291. Custom built buildings. Gallery space for travelling exhibitions—foyer and large hall. Courses: One year Foundation Course: validated by WMAC. Normal intake 60 students per year. Areas: Fine Art, Painting, Printmaking, Photography, Video, Sculpture, Visual Communications, Computer Graphics, Three Dimensional Design, Printed Textiles, Woven Textiles, Fashion, Embroidery, Theoretical Art Studies. Course includes visits to London,

municipal galleries and museums and one trip abroad per year. Two year BTEC National Diploma in General Art and Design, intake 24/30 students per year. Two year course in Furniture Design and Construction, City and Guilds of London qualification 555 part two in Hand Made Furniture, Traditional Upholstery, Carcase and Wood Frame Construction and Timber Preparation (first year). At the end of the second year students take Advanced Craft in Furniture Design 555 Part III. Custom built building, studios and facilities excellent. Comprehensive Art Library and slide collection. Gallery space for travelling shows—foyer and large hall.

SOUTHAMPTON
SOUTHAMPTON INSTITUTE OF HIGHER EDUCATION, School of Art & Design, East Park Terrace, Southampton. Tel. 0703 28182. National Diploma in Printing. Graphic Design: National & Higher National Diploma in Design. Fashion: National Certificate in Design, National & Higher National Diploma in Design. Technical Illustration: National Diploma in Design. Crafts: National Diploma in Design.

SOUTHEND-ON-SEA
SOUTHEND SCHOOL OF ART & DESIGN, College of Technology, Carnarvon Road, Southend-on-Sea, Essex, SS2 6LS. Tel. 0702 353931. Courses: Full-time, BTEC National Diploma courses in Graphics, Photography, Fashion, Display and General Art & Design. Regional Diploma in Graphics, Photography, Fashion and Printmaking. Adult Education: Part-time day and evening courses available in a variety of arts and crafts.

SOUTHPORT
SOUTHPORT COLLEGE OF ART & TECHNOLOGY, Mornington Road, Southport, Merseyside. Tel. 0704 42411. First Diploma in Design. National Diploma in General Art & Design. Graphic Design: National Diploma in Design. Photography: National Diploma in Design. Fashion/Textiles: National Diploma in Design.

STEVENAGE
DEPARTMENT OF ART DESIGN & FASHION, Lodge Way, Stevenage SG2 8DB Herts. Tel. 0438 312822. Courses: BTEC National Diploma in Design in Graphic Design, Fashion & Textile Design, 3D Design and Technical Illustration (full-time, 2 years or day release, 3 years). Foundation Art & Design (full-time, 1 year) for BA degree and BTEC HND applications. CPVE (1 year) Art & Design. Spacious campus. Library.

STOCKPORT
STOCKPORT COLLEGE OF TECHNOLOGY, Deptartment of Art and Design, Wellington Road South, Stockport SK1 3UQ. Tel. 061-480 7331. Full-Time: Pre-Diploma, Foundation Art & Design, BTEC Diplomas in Graphic Design, Surface Pattern Design, Photography, General Design, BTEC Higher Diploma in Design (Major options in Advertising and Surface Pattern Design). Specialist Equipment: Available to all students. Excellent computer design/Quantel facilities. Space: Specialist Studios, Workshops and Darkrooms, Lecture Theatres—one of the larger Colleges in the UK with excellent travel/communication links. Materials: Freely available to students, plus LEA Materials grant. Exhibition Space: In Department, with first rate facilities available, Art Gallery adjoining College. Prizes: Special College and Industrial Prizes. Top national awards/prizes/bursaries gained annually by students. Library: Specialist Art & Design section. Regular visits by artists and designers. Very good links with industry and excellent relevant employment placement on completion of course.

STOKE-ON-TRENT
NORTH STAFFORDSHIRE POLYTECHNIC, Faculty of Art and Design, Flaxman Building, College Road, Stoke-on-Trent. Tel. 0782 744531. Courses: BA(Hons) Design with specialisms in 7 areas, Photography, Ceramics, Surface Pattern, Graphics, Product Design, Glass and Audio-Visual Communications, BTEC HND Design (ceramics), MA Design (ceramics), CAD and business studies integral to all courses. BA(Hons) Fine Art with specialisms in Painting, Printmaking and Sculpture, Foundation Studies in Art and Design. BA(Hons) History of Design and the Visual Arts with specialisms in Fashion, Film Studies, Painting and Sculpture, Architecture, Graphics, Glass and Ceramics, DPSE in the History of Art and Design. Exhibition space available. Prizes: awarded annually. Slide Library with archive collection. Overseas and national visits organised by each of the 3 Departments.

STOURBRIDGE
STOURBRIDGE COLLEGE OF TECHNOLOGY AND ART, Hagley Road, Stourbridge, West Midlands DY8 1QU. Tel. 0384 378531. Fine Art: BA Honours, full-time. Three-Dimensional Design: BA Honours, full-time. National Diploma in General Art & Design. Graphic Design: National Diploma in Design & Higher National Diploma in Design.

SUNDERLAND
SUNDERLAND POLYTECHNIC, (for general enquiries): Admissions Office, Edinburgh Building, Chester Road, Sunderland, Tyne & Wear SR1 3SD. Tel. 091 5676191. (for school of art & design): Backhouse Park, Ryhope Road, Sunderland, tyne & Wear. Tel. 091 5141211. Courses offered: BA(Hons) Fine Art (full-time and part-time), BA(Hons) 3D Design (glass and ceramics), HND Visual Design (technical illustrations/model-making), BA Artist/Designer/Craftsman (part-time only), Foundation Studies in Art & Design. Facilities: Fully equipped studios and workshops offering resources for painting, drawing, sculpture, printmaking, photography and precision modelling. Also a purpose built Glass Centre. Exhibition space: Permanent gallery. Art library with slide collection. Any Other Information: Materials allowance available. For Fine Art students: prizes available, a travelling scholarship worth £350 available in the second year of course, study links with the Royal Academy at the Hague. For 3D Design students; study visits to Europe and Scandinavia. Residences at Durham Cathedral, Sunderland Football Club and the Architects Dept. of Newcastle City Council.

SWANSEA
WEST GLAMORGAN INSTITUTE OF HIGHER EDUCATION, Townhill Road, Swansea SA2 0UT. Tel. 0792 203482 Telex. 48435 WGIHE. Courses offered: Higher National Diplomas in Design, Architectural Stained Glass; Technical Illustration; Photography; Ceramics. BTEC National Diplomas in Design, General Art and Design; Technical Illustration; Foundation course in Art and Design. Workshops and Studios for painting, drawing, printmaking, ceramics, photography, glass, illustration, design, 3D, audio visual. BEd(primary) Students intending to become primary teachers may opt to study as their Main Subject a course in Literature and Media Studies. Successful candidates end their course with a fully classified honours degree of the University of Wales and Qualified Teacher Status. The Media Studies component is linked with a study of Literature at the students' own level and also studies for its applications within a primary classroom. In the BA Combined Studies degree, students opt to take two from a selection of five options. One of these (modern english studies) contains a substantial amount of film study. Successful candidates leave the course with a degree validated by the University of Wales.

TAUNTON
SOMERSET COLLEGE OF ARTS & TECHNOLOGY, Wellington Road, Taunton, Somerset. Tel. 0823 83403. National Diploma in General Art & Design. Fashion: National Diploma in Design. Graphic Design: Higher National Diploma in Design. Textiles: Higher National Diploma in Design.

THAME (OXON)
RYCOTEWOOD COLLEGE, Department of Fine Craftsmanship and Design, Priest End, Thame, Oxon OX9 2AF. Tel. 084421 2501. full-time courses, in fine furniture making and design. Summer schools, specialist courses and evening classes. Extensive workshops, studios and machine shops plus exhibition and conference area.

THURROCK
THURROCK TECHNICAL COLLEGE, School of Art & Design, Woodview, Grays, Essex RM16 4YR. Tel. 0375 371621. Courses: Foundation Art Course (1 year), BTEC Diploma in General Art & Design (2 years), Art Bias Course (1 year), General Education through Art & Design course (1 year—run jointly with local VI Form College). Proposed courses commencing September 1988: BTEC Diploma in 3D Design (2 years), BTEC Diploma in Fashion/Textiles (2 years), BTEC Diploma in Art (First Award—1 year). 19 studios, slide collection, part-time study on Foundation Art and Art Bias courses, annual exhibition and fashion show.

TORQUAY
SOUTH DEVON COLLEGE OF ARTS & TECHNOLOGY, School of Art & Design, Newton Road, Torquay, Devon, TQ2 5BY. Tel. 0803 217551. Foundation Studies in Art & Design (one year, Regional Diploma) General Art & Design (two year, BTEC National Diploma) Graphic Design (two year BTEC National Diploma) Interior Design (two year BTEC National Diploma) Pre-Diploma (one year, GCSE etc). A wide range of part-time courses in Art, Design and the Crafts is also offered by the Department of Adult & Community Education. Specialist workshops for photography, printmaking, fashion, textiles, computing, ceramics, sculpture, jewellery & silversmithing. Davies Gallery available for individual and travelling exhibitions.

TOTNES
DARTINGTON COLLEGE OF ARTS, Totnes, Devon TQ9 6EJ. Tel. 0803 862224. Courses: BA Honours Music, BA Honours Theatre, BA Honours Art and Social Context, Arts Access Course. BA Honours Art and Social Contaxt offers students a practical art education combined with a questioning approach to the role and purpose of art, working alongside students studying other arts. Facilities include

pottery, 3D working, video studio, screenprint studio, darkroom, and public gallery. The College is also the Arts Centre for the area.

WAKEFIELD
WAKEFIELD DISTRICT COLLEGE, Margaret Street, Wakefield Sector of Creative and Performing Arts. Tel. Wakefield 370501, Ext 234. Courses offered at Diploma Level on a 1 year or 2 year basis: Foundation Art, General Art and Design: Graphics: Communication and Media; Combined Arts; Drama; Music. Theatre, 4 Exhibitin spaces and Conference facilities.

WATFORD
WATFORD COLLEGE, Department of Art and Graphic Design, Ridge Street, Watford, Herts. Tel. 0923 269816. National and Higher National Diploma in Printing. National Certificate in Printing, part-time. Graphic Design: National & Higher National Diploma in Design. Photography: National Diploma in Design. Communications: National Diploma in Design. Typography: National Diploma in Design.

WIGAN
WIGAN COLLEGE OF TECHNOLOGY, Parson's Walk, Wigan, WN1 1RR. Department of Art and Design. Tel. 0942 494911. Ext 2600. Courses: BTEC First Diploma in Design, BTEC National Diploma in General Art and Design, BTEC National Diploma in Photography and part-time courses in Fashion and Photography. Facilities: A range of specialist equipment including video, page make-up, computer-ised lay planning. Lecture theatre, library and exhibition space, foreign visits, annual student prizes. Department moving into purpose converted building of architectural interest, September 1988.

WINCHESTER
WINCHESTER SCHOOL OF ART, Park Avenue, Winchester, Hants SO23 8DL. Tel. 0962 842500. CNAA BA(Hons) Fine Art (painting, sculpture, printmaking), CNAA BA(Hons) Fine Art as above with specialisms in: European Studies, Public Art, Gallery Administration, Art History & Theory, CNAA BA(Hons) Textiles/Fashion (printed & constructed textiles & fashion), CNAA BA(Hons) Advanced Entry Textiles/Fashion—A Four Ter Course for holders of HND BTEC Courses, CNAA Postgraduate Diploma in History of Art & Design in the Modern period (two years part-time), CNAA Certificate in Art History Credit Course (part-time), Foundation Course in Art & Design. Specialist equipment in Textiles/ Fashion includes advanced computer-related textiles equipment. This is available to all students. Mater-ials: £10–£20 per term depending on the course. All BA and Postgraduate courses in the School place great emphasis on study in Europe. All students visit Italy, Spain and France as part of their course. Fine Art students may spend one term on exchange at University of Barcelona which is funded by the EEC ERASMUS scheme. **The Winchester Gallery**, an independent exhibition space devoted to contemporary art and design, is housed in the School.
KING ALFRED'S COLLEGE, Sparkford Road, Winchester, Hampshire SO22 4NR. Tel. 0962 841515. Art in Education: DPSE, part-time.

WISBECH
ISLE COLLEGE, Ramnoth Road, Wisbech, Cambridgeshire. Tel. 0945 582561. Courses: BTEC national Diploma in Design (graphic design), BTEC National Diploma in Design (technical illustration), BTEC National Diploma in Design (fashion), BTEC National Diploma in Design (display), BTEC National Diploma in General Art & Design. College PRE-BTEC Diploma in Art and Design. Facilities/ Equipment/Exhibition Spaces: Sixteen specialist studios including equipment for Airbrush, Photo-re-touching, CAD, Photography, Screen-printing, Desk-top publishing, Ceramics, Silversmithing/Jewel-lery, Display, Fashion and Knitwear. This college is the sole provider within Cambridgeshire of BTEC National Diploma in Design courses; residential accommodation available to students.

WOLVERHAMPTON
THE POLYTECHNIC, WOLVERHAMPTON, Admissions Unit, Molineux Street, Wolverhampton WV1 1SB. Tel. 0902 313000. Fine Art: BA Honours, full-time. Graphic Design: BA Honours, full-time. Three Dimensional Design: BA Honours, full-time (ceramics/wood, metal and plastics/carpet design and related studies). Two permenent galleries, specialist library, student exchanges with colleges in the USA and France.

WORTHING
NORTHBROOK COLLEGE, Design & Technology, Littlehampton Road, Goring, Worthing. Tel. Worthing 830057. Courses: College Diplomas—Photography Preliminary; BTEC National Diplomas in General Art & Design, Graphic Design, Fashion, Textiles, Theatre Studios, Three Dimensional Studios. Advanced College Diplomas— Audio and Visual Design and Production, Theatre Studios. Southern Regional Council Certificate—Foundation Studios. BTEC Higher National Certificate—Theatre Stu-dios. BTEC Higher National Diplomas in Fashion/Textiles. Facilities: Purpose built new studios and

workshops, TV/Audio studio, editing suite, theatre and appropriate equipment. Materials shop. Exhibition space in corridors and hall. Specialist art section in Library. Visiting lecturers. Year prizes.

WREXHAM

NORTH EAST WALES INSTITUTE OF HIGHER EDUCATION, College of Art, 49 Regent Street, Wrexham, Clwyd. Tel. 0978 56601. National Diploma in Design (graphic design). National Diploma in Design (crafts). First Diploma in Design. National Diploma in Design (audio visual). National Diploma in General Art & Design. Higher National Diploma in Design (crafts). Higher National Diploma in Design (communications). Gallery space. Part of a complex of visual arts with theatre, music and audio visual resources.

YORK

YORK COLLEGE OF ARTS AND TECHNOLOGY, Dept of Art & Design, Dringhouses, York. Tel. 0904 704141. First Diploma in Design. Graphics Design: National & Higher National Diploma in Design. National Diploma in General Art & Design. Fashion: Higher National Certificate in Design and National Diploma in Design. Crafts: National Diploma in Design.

Tricia Gillman, White Walk II, 1984 (Benjamin Rhodes Gallery)

188

Chapter 4
ART AND THE LAW

Although there are many lawyers who would be interested in dealing with legal problems in relation to the art world it is obviously of great help to artists if there is an art organisation that specialises in art legal problems. Artlaw Services in the Strand was set up several years ago to deal specifically with art problems and dealt with a variety of cases since then. Barristers working on a voluntary basis listened to problems and then offered advice about where you stood in relation to the law of the land. Remember that what is law in England and Wales is not necessarily so in Scotland where there is an entirely different legal system. Sadly it went into liquidation in 1983.

Artlaw dealt with many cases of landlord v tenant, artist v gallery, artist v sponsor, artist v VAT (Customs and Excise) and many more varied cases. Prior to the existence of Artlaw many artists were referred to the Artists League of Great Britain where they were offered advice and provided with lawyers who fought their cases and all in return for a small fee to join the art organisation. *Art Monthly* magazine still runs a monthly Artlaw column.

If however an artist feels that consulting a specialist art organisation is not appropriate he will be faced with enormous professional fees to pay if the case is taken to court and also even before he reaches the court. This in most cases is beyond the average artist's means unless of course the artist is commercially successful internationally. The children of the famous American abstract artist Rothko, went to court over large sums of money that they felt that they had been denied and in their case the expensive battle was worth the outlay as they won the case against certain commercial galleries and justice prevailed. In most cases however the artist is talking about fighting cases that could cost him or her half an annual art teacher's salary for example and if the artist is married with children it would be unthinkable to consider such an outlay of money.

DESIGN AND ARTISTS COPYRIGHT SOCIETY LTD., St. Mary's Clergy House, 2 Whitechurch Lane, London E1 1ED. Tel. 01-247 1650. This organisation coordinates SPADEM's copyright collection functions. All artists should be aware of this organisation's role in helping artists. *Visual Artists Copyright Handbook*, Henry Lydiate. Available from DACS at £4.35 (incl. postage), £2.35 for members or £3.35 for students.

ARTISTS LEAGUE OF GREAT BRITAIN, c/o Bankside Gallery, Hopton Street, London SE1. Artlaw sold a booklet giving examples of problems that artists could face such as **Contracts of Sale, commissions, exhibitions, consignment, copyright, VAT, Customs and Excise, Import and Export of work.** These were mostly articles taken from a monthly column written by Henry Lydiate in *Art Monthly* magazine.

ART MONTHLY, 36 Great Russell Street, London WC1.Tel. 01-580 4168. *Art Monthly* still runs a monthly Artlaw column. The magazine can be bought at Dillons Arts shop, 8 Long Acre, London WC2, and at galleries and art bookshops throughout the country or else pay an annual subscription direct to the London Office. £12 per annum or £1.20 per issue.

LAW FOR ARTISTS, or ARTLAW

1. INTRODUCTION

Visual artists are subject to the law of the land, just like every other citizen. The law affects them both as private individuals, and as they set about trying to make a living as practising artists.

As practitioners, artists experience many and varied problems, not just lack of money! The law interprets these problems and may often provide the solution. For instance, after an exhibition the gallery returns a print to the artist, who discovers that it has been damaged. There are several parties involved—gallery, carrier, artist, insurance company—and the law operates to define who is responsible for the damage and how much the aggrieved party can claim and recover.

This specialised application of the law to the working situation o the visual artist is called 'artlaw'. It includes those areas of law relating directly to the visual arts, like contract and copyright. And it also includes less obvious areas like problems with studios and landlords; censorship and obscenity; problems

with executors of a will; entitlement to unemployment and social security benefits; the status of foreign artists in the UK.

Many, but by no means all, of the problems discussed below can be solved by recording agreements and deals *in writing*. This is the most important 'legal' problem experienced by most artists. In reality it is not a legal problem at all, since just about all verbal agreements are legally binding, without written evidence. But there are obvious practical problems about enforcing such contracts. In the words of the late Sam Goldwyn, the M.G.M. magnate, "a verbal contract ain't worth the paper it's written on".

2. SELLING WORK

When an artist sells a work to a buyer, the law will interpret the arrangement they have made in accordance with the statutes and general principles of the law of contract. If they have agreed a particular point, e.g. whether the price includes the frame, then this specific agreement overrides the general law.

But when nothing is said or written the law imposes the following obligations on an artist who sells his/her work by "silent contract":-

(i) to sell the work to the buyer;
(ii) to deliver the work to the buyer;
(iii) to allow the buyer to lose, damage or destroy the work;
(iv) to allow the buyer to reframe the work;
(v) to allow the buyer to restore and conserve the work, without allowing the artist first option to do so and without prior consulation with the artist;
(vi) to pay the buyer the cost of any restoration and conservation necessitated by unreasonable deterioration of the work;
(vii) to allow the buyer to exhibit the work anywhere in the world and under any circumstances;
(viii) to allow the buyer to sell or give the work to any individual or organisation;
(ix) to allow the buyer to prevent anyone seeing the work, including the artist;
(x) to allow the buyer to prevent anyone reproducing the work, including the artist.

The only obligation which the buyer undertakes in this "silent contract" is (i) is to pay the purchase price to the artist—sometime.

Bill of Sale

To circumvent the obvious dangers of such "silent contracts", artists should use a Bill of Sale when selling work. The Bill of Sale should contain the following 10 points.

(1) Name and address of artist;
(2) Name and address of buyer;
(3) Title of work;
(4) Description of work;
(5) Price;
(6) Terms of payment;
(7) Date of sale;
(8) Place of sale;
(9) Who owns copyright;
(10) Signatures of artist and buyer.

Contract of Sale

Appropriate points and clauses can be added to the Bill of Sale, so as to expand it into a full-blown Contract of Sale. These might include terms for the protection of the buyer:-

(i) Warranty by artist that work is original and unique;
(ii) Covenant by artist that edition is limited.Alternatively, they may be terms for the protection of the artist:
(iii) Promise by buyer to preserve the work;
(iv) Promise by buyer to consult the artist if restoration work is necessary;
(v) Promise that artist will be acknowledged as creator;
(vi) Promise to allow artist to borrow the work for exhibition purposes.

There may also be terms for the mutual benefit of both parties.

(vii) To notify each other of change of address;
(viii) Which law governs the agreement.

3. COMMISSIONS

A "commission" is technically a contract for skill and labour. Someone commissioning an artist (the commissioner) purchases the time and expertise of the artist, who produces the work. The commissioner will often pay the cost of materials.

Problems usually arise due to conflict between the artist's freedom to create what he/she wishes and the commissioner's right to know for what he/she is paying. These are, frankly, irreconcilable interests. Most problems can be pre-empted by careful planning on both sides.

The following points should be considered:
(1) Identity of the commissioner;

(2) Dates of commencement/completion of work;
(3) Preliminary designs/sketches;
(4) Description of work;
(5) Scale of fees;
(6) Terms of payment;
(7) Who owns copyright;
(8) Delivery/access to site;
(9) Commissioner's right to terminate contract/reject work;
(10) Which law governs the agreement.

Commission and sale

Most "commissions" are contracts involving the creation of a work by the artist using his skill and labour *and* the subsequent sale of the completed work. It is important to recognise the two legal transactions, combining together in the single arrangement.

In such a case, the commissioner and the artist should consider together the appropriate terms for both the commission and the sale situations. Particular regard should be had to the commissioner's right to reject the completed work. It is a source of much legal contention as to whether this right exists automatically i.e. without being specifically mentioned. The right should be closely defined.

4. SALE OR RETURN

Many painters, printmakers and artist-craftsmen have arrangements with galleries/retail outlets who take work on sale or return. *Consignment* is a more accurate term than 'sale or return' because it makes clear to both sides that the artist does not intend to sell the works to the gallery at any stage, but merely intends to leave them for sale by the gallery as artist's agent or consignee on a commission basis.

In these circumstances a written agreement should be signed by the artist when sending or delivering works to the gallery whose representative should then sign and return it to the artist. The following points should be considered by artist (the consignor) and gallery (the consignee).
(1) Identity of consignee;
(2) List of works;
(3) Retail price of works;
(4) Rate of commission;
(5) Time for payment to artist;
(6) Liability for damage to/loss of works.

A most contentious area is whether the artist is entitled to know to whom work has been sold by the gallery—acting as his agent. Many galleries are reluctant to reveal the names and addresses of buyers to artists, in these circumstances. Artists who wish to know the identities of those who buy their work should bear this in mind from the start.

It is important to distinguish consignment from the situation where the artist parts with work to a gallery which "buys in" the work. The gallery may even take some work on consignment, and "buy in" other work, whether for resale or other purposes. The legal status is very different for each such class of work, and the legal implications, e.g. as to the revelation of identity of buyers, quite far-reaching.

5. EXHIBITIONS

It is important for artists to distinguish between exhibition agreements (where the primary purpose is to show the work) and consignment arrangements (where some or all of the work may nevertheless be on show). An artist will usually conclude an exhibition agreement with a publicly-funded gallery. A consignment deal more often deal with a privately owned profit-making gallery.

Many of the points to be considered jointly by artist and gallery proprietor are sound commonsense. Many are mere administrative detail. But by considering them in advance, both parties can preclude misunderstandings and omissions at the crucial moment. A written record should be made of the following:
(1) Identity of exhibiting gallery;
(2) Exact venue of show and opening hours;
(3) Dates of show and private view;
(4) List of works for exhibition;
(5) Responsibility for collection and delivery of work;
(6) Insurance;
(7) Liability for damage to/loss of works;
(8) Responsibility for hanging/invigilation;
(9) Sales;
(10) Hire fees and commission on sales;
(11) Responsibility for publicity and catalogue.

6. COPYRIGHT

Copyright is the complicated, much-misunderstood right of an artist to protect his/her work. It is, simply stated, the right 'not to have your work copied' i.e. to prevent copying by someone else.

Copyright law, principally contained in the Copyright Act 1956, has developed over 200 years, since its introduction at the behest of William Hogarth for the protection of his work against plagiarism. It is very complicated. The important features are:

(i) Paintings, sculpture, drawing, engravings and photographs all enjoy copyright protection. Copyright arises naturally, there are no formal requirements e.g. registraion or depost of copies. The artistic merits/demerits of the piece are irrelevant.

(ii) Copyright does not protect ideas. It will protect the work itself and any preliminary designs/ sketches, provided that the work is original i.e. not a copy of another copyright work. But a fine art performance piece will not be protected in this way, although any notes belonging to the artist will be.

(iii) The artist owns the copyright from the moment the work is made. He owns the copyright in the work even if he/she is commissioned to produce the work, unless the work is a photograph/ painted or drawn portrait/engraving. In the latter instances, the commissioner owns the copyright. This rule produces anomalous results e.g. an artist commissioned to produce a portrait will own copyright if he/she sculpts a bust, but not if the portrait is painted.

(iv) The employer of an artist owns the copyright in any work produced in the course of that employment. But any of these rules about ownership of copyright can be varied by the artist agreeing with the commissioner/employer to the contrary.

(v) Copyright in artworks lasts for the lifetime of the artist, plus 50 years after his/her death (during which time it is owned by the artist's heirs). The exception to this rule is in the case of photographs, where protection lasts for 50 years from the year in which the photograph is first published. Unpublished photographs are protected indefinitely.

(vi) An artist selling a painting does not thereby automatically sell the copyright along with the work. Copyright remains vested in the artist unless he/she specifically elects to part with it, and this "assignment" is recorded in writing and signed by the artist.

(vii) It is important to distinguish assignment, which is irrevocable, from the grant of permission to reproduce a copyright work e.g. to a publisher. In this situation, the publisher enjoys a "licence" to make copies of the copyright work, upon the agreed terms, and the artist retains the residual copyright. If he/she "asigns" copyright to the publisher, the artist retains nothing.

(viii) The artist's copyright is infringed if the work is copied, e.g. by reproducing/photographing/ publishing it, without express or implied permission. In these circumstances the artist can claim an injunction and/or damages and/or an account of the profits, where the copying has been profitable. The artist cannot persecute the copier, since infringing copyright is a civil, not criminal, offence. (ix) Copyright protection is only given to a citizen/resident of the UK and Eire, or of a county with reciprocal arrangements with the UK under the intrnational copyright conventions. In practice this means the majority of countries in the world, except China. Although no formalities have to be complied with in the UK, it is sensible to put the following information on all your work, the copyright symbol, your name (and address?) and the year of creation e.g. © John Painter 1981. This will ensure that your work is protected overseas, as well.

(x) Under UK law an artist can prevent the attribution of the name of another to his/her work. But he/she cannot insist on acknowledgement or credit as the author of the work unless this has been agreed, for instance with a publisher as part of a "licence" arrangement. The artist in the UK does not enjoy any moral rights (droit moral) or resale rights (droit de suite) at the present time, apart from the limited provision above.

7. PROBLEMS?

John Lennon referred to lawyers as "big and fat, vodka-lunch, shouting males, like trained dogs trained to attack all the time". Not all lawyers conform to this sterotype. Many solicitors are well-equipped to lend a sympathetic and informed ear to an artist facing such problems as outlined above.

<div align="right">

Adrian Barr-Smith
(Previously Director, Artlaw Services Ltd.)

</div>

TAXATION AND ACCOUNTING FOR ARTISTS

1. INCOME TAX

There are two broad areas of taxation of earned income. Schedule D for profits from a profession and Schedule E for income from an employment. For the first tax is payable in two equal instalments on the previous year's profits and for the second tax is deducted under PAYE from the current year's salary. A taxpayer normally has more latitude in claiming expenses against Schedule D earnings than against Shedule E earnings.

Under Schedule D if you can show that you are engaged in a profession with the view to realisation of profits you should prepare an annual account of your professional earnings and expenditure and submit it to your local Inspector of Taxes. If you can agree the figures with him you will then be liable to tax on the net profit, less normal personal allowances, mortgage interest and other allowable deductions. If you make a loss you may claim to have it carried forward against subsequent profits or alternatively to have it deducted from another source of income of the same year.

There are four main areas when you may have to negotiate with the Inspector of Taxes:

(a) Whether certain earnings, such as part time lecture fees are taxable under Schedule D as earned income in your profession as artist or under Schedule E as separate employment.

(b) What expenses may be claimed as allowable deductions from your earnings.

(c) Whether, in a loss making period the losses are available for relief.

(d) Whether certain grants, prizes, bursaries awards etc. are taxable.

You are entitled to argue these points if you disagree with the Inspector and there are certain appeal procedures if you and he cannot reach agreement. It may be advisable to consult an account if you come across these problems.

Official forms that you may receive include:

Tax Returns
These are normally issued shortly after 5th April (the fixed year end) and you are required to enter all sources of income for the previous year and claims for allowances for the subsequent year and then return the form to the Inspector. There are penalties for false declarations.

Notices of Assessment
These are the Inspector's calculations of the tax due. If you consider that the assessment is incorrect you must appeal against it within 30 days. This is particularly important when there is a delay in submitting your accounts, as the Inspector has the power to issue an estimated assessment and this is frequently excessive.

Notices of Coding
These show the allowances to be set off against your salary before tax is charged. If the Inspector does not have all the information he thinks he needs he may issue a Basic Rate (BR) coding which means that tax will be deducted at full standard rate without the benefit of deduction of allowances.

Notices to Pay
These are tax demands and if there is any delay in payment you may be charged with interest.

2. VALUE ADDED TAX (VAT)
If your gross annual freelance income exceeds certain limits (currently £22,100) you are required to register with the Customs and Excise and you will have to charge VAT currently 15% on all your sales, fees, et. You will have to account to Customs and Excise every three months for the VAT you have charged your customers, less VAT you have suffered on your expenses.

3. NATIONAL INSURANCE CONTRIBUTIONS (NIC)
There are three main types of NIC that you may have come across.

Class 1: a proportionate deduction from salaries.

Class 2: a weekly stamp purchased from the Post Office where you are self-employed.

Class 4: a percentage of your annual freelance profits which is assessed and paid at the same time as your income tax.

There are special rules about low earnings, mixed employment and freelance activities etc and in cases of difficulty you should contact your local Social Security Office.

4. ACCOUNTING ARRANGEMENTS
Make sure that you keep bank statements, cheque book stubs, paying in counterfoils, payslips, bills, receipts, invoices, correspondence etc. Buy an analysis book from a stationers and head the columns with each main item of expense. List chronologically the expenses under the relevant headings, using the informaiton that you have retained. Keep a notebook with you and note small cash payments such as fares, postage, magazines, catalogues etc. Make a similar analysis of income.

Expenses that may be claimed include upkeep of studio (proportion of rent, rates, electricity, gas, repairs etc.) telephone (proportion), art materials, frames and framing charges, photography, carriage, postage, stationery, travel (UK) travel (foreign), car expenses (proportion of petrol, oil, repairs, insurance, road fund, licence) submission and hanging fees, subscriptions, exhibiton entrance fees, catalogues, books, journals, commission, cleaning and replacement of clothes etc.

From this information you should be able to provide the Inspector of Taxes with an acceptable summarised set of accounts and negotiate your tax liability. However if you find yourself unable to cope

with this, an accountant would be able to assist you, providing you have retained the basic documentation.

Robert Coward, FCA.

The March 1988 issue of **Artist's newsletter** contains excellent advice on "**Employment Status and Tax**" and also appears in "**Making Ways**" available at £7.95 plus £1 p&p from Artic Producers, PO Box 23, Sunderland SR1 1EJ. Tel. 091-567 3589.

Feeding the Pig, Jock McFadyen

Chapter 5
BUYING AND SELLING ART

BUYING AND COLLECTING PRINTS

No art form is better designed for the collector than the print. The concept of making the same image available to many suggests this purpose. Unlike china or other artifacts, pictures serve no other end than being looked at. Paintings, and the massive literature that surrounds and sustains them, exist in a complex of art historical discussion and connoisseurship which can exclude all but those who have the will and ability to devote a lifetime to study.

The literature of prints, however, is not a matter of theories but of facts. A substantial proportion of it is in the form of the Catalogue Raisonné, which illustrates, dates and describes an artist's oeuvre, being an aid to identification and authentication, rather than subjective judgement.

The past decade has seen a number of books about collecting prints, some of which highlight the pitfalls into which the unsuspecting can fall, but most of which illustrate and describe prints of merit, many of which can be bought on an average salary.

London has printsellers in profusion. The auction houses hold frequent sales of prints, but dealers offer a degree of protection for the collector, incorporated in their markups. Most good dealers guarantee authenticity, which auctioneers do not, and the fact of the multiplicity of the printed image often allows comparison of price.

This is not to suggest that the collecting of prints is simply a matter of investment and value for money. The best and only true criterion for buying a print should be desire and interest. The growth, more especially in America, of art investment schemes negates the basic appeal of collecting: that ordinary people can buy what the like, hang it on their wall and enjoy it. Greater knowledge and growing interest can lead to a satisfying pastime which, if the collector buys wisely, can result in long-term financial gain.

For the beginner, the best thing is to find out what is available. This can be done by reading, rummaging through dealers' stock or museum collections. Dealers publish catalogues, and through consulting these, a potential collector can establish whether the prints which interest him are within his price range.

Most reputable dealers give advice willingly. This is not a matter of altruism, but stems from the fact that a successful printselling business depends upon the cultivation of regular clients and a trusting relationship between dealer and customer. This personal touch is rewarding for both, and should appeal to a collector who wishes to develop his interest.

Most printsellers in London carry a varied stock but have their own specialist area. If you know what you want and it is not their field, they will usually direct you to the right dealer. This, combined with the fact that their premises tend to be less intimidating than picture galleries, will help the beginner of modest means to find what he or she wants.

It is only in recent years that various organisations have sprung up to help offices decorate their corridors, boardrooms, reception areas and generally also making the visual arts more accessible to the public. In the USA and Canada this is and has been very common practice for years but for some reason contemporary art has always remained a mystery to the man in the street. This is partly due to the fact that he is not surrounded by it in his everyday life and partly because contemporary work is given such poor coverage in the national and local press and on television. Hopefully this will change over the next few years and the more the public becomes used to being surrounded by contemporary work the more they will want to buy original artwork for their own homes. Although several artists produce work that is not suitable for the average house, rather for museums and galleries, there are many printmakers, photographers, painters and sculptors who are only too glad to sell work and know that the buyer will look after the work. For the artist this is a matter of concern rarely considered by the buyer and the more the buyer comes into contact with artists the more he will come to understand the artist's world.

A potential buyer of artwork is often uncertain where to find original work at a reasonable price and many gallery directors find it difficult to put themselves in the place of the potential buyer, who is unwilling to admit his ignorance possibly about what he does or does not know about art. This is possibley why **Bond Street** and **Cork Street** galleries for example could frighten off a potential young buyer. Possibly it is advisable to get to know some local galleries in your area and visit the galleries regularly so that you can see what price range you would consider and the kind of work you would like to

buy. Refer to the gallery section at the beginning of this book for galleries in your area. Otherwise you could visit print workshops direct, artists' studios, college degree shows in the summer months where original artwork is reasonably priced and the student is often only too glad to sell work. If you really want good advice then visit your Regional Arts Association (see Chapter 7) and ask to see their slide index of work by local artists, craftsmen and photographers. The slide indexes show work by professional artists not amateurs.

Below is a list of **useful addresses for potential buyers** and conversely for artists eager to sell their work. For example a local print gallery is an ideal place for a potential buyer to visit and also for a local professional artist to sell.

LONDON'S CONTEMPORARY ART FAIR in March/April annually at Olympia has work from some 100 internatinal galleries.

BUSINESS ART GALLERIES, 34 Windmill Street, London W1. Tel. 01-323 4700. A permanent gallery but also acts as an organisation that **helps companies decorate office space**, carries out commissions and sells original contemporary artwork.

THE CORPORATE ARTS, 23 Cavaye Place SW10. Tel. 01-370 7427. Director: Sarah Hodson. A non-profit organisation that seeks to help artists exhibit work in company offices. Interested in professional painters, sculptors, printmakers and photographers.

ART FOR OFFICES, 15 Dock Street, London E1. Tel. 01-481 4259. Run by Andrew Hutchinson and Peter Harris. Sells work to city corporations and offices on a national and multi-national level.

REGIONAL ARTS ASSOCIATIONS, Arts Council of Great Britain, Scottish Arts Council, Welsh Arts Council, Arts Council of Northern Ireland and other similar bodies. See slide registries list for your local office. The public can consult these slide indexes to look at different kinds of artwork before buying.

SCOTTISH DEVELOPMENT AGENCY, and the WELSH DEVELOPMENT AGENCY often encourage local craft work and act as a contact between the public and the artist.

DEGREE SHOWS AT LOCAL ART COLLEGES usually take place in May, June and July. See your local press for details of opening times or phone your local colleges. In this way you will be able to see a variety of work and also help young artists survive at an early stage in their career.

See other sections of this book for useful information. **Chapter 3 Studios section** for groups of artists in your area. Often these groups have exhibitions that you could visit or you could visit the artists in their studios and consider buying work by the artists. **Chapter 2 Galleries section**. Refer to local galleries in your area and see whether they stock the kind of work you might be interested in buying.

Consult this chapter for MEMBERSHIP SCHEMES where you could be invited to gallery private views and gradually find out more about painting, sculpture, photography, printmaking and other art forms. For example the **Photographers gallery** in **London** would be a good place to start if you are

Buying a print (Christian Reinewald)

interested in buying photographs but are not sure where to start. Regionally artists groups such as the **Stills Photography Gallery, Edinburgh**, and the **Glasgow Printmakers Workshop**, and many others have "Friends" of schemes which would enable you to go to local openings and buy work by local professional artists.

PRINT WORKSHOPS, PRINT GALLERIES AND PRINT PUBLISHERS sell original prints by known and not so well known artists. See **Chapter 1 Studios** section for **print workshops**. SOME LONDON GALLERIES THAT OFFER WORK AT ACCESSIBLE PRICES

For regional equivalents consult Chapter 1 Galleries Section

ZELLA 9, 2 Park Walk, London SW10. Tel. 01-351 0588. Opening: Mon–Sat 10–9. Vast selection of prints at reasonable prices. Regular openings. Friendly and helpful.

GRAFFITI, c/o **Blackman Harvey**, 29 Earlham Street, London WC2. Tel. 01-836 1904. Opening: Mon–Fri 10–6. Variety of prints by British artists, also miniature prints.

ART FOR OFFICES, 15 Dock Street, London E1. Tel. 01-481 1337. Useful address for designers, architects and businessmen who wish to either buy or rent artwork. Clients can look at slides of work and then choose to see the originals. 3000sq ft of viewing space.

CADOGAN CONTEMPORARY ART, 108 Draycott Avenue, London SW3. Tel. 01-581 5451. Lively paintings and friendly staff.

CHRISTIES CONTEMPORARY ART, 8 Dover Street, London W1. Tel. 01-499 6701. 100 new editions published a year. Colour brochure available with details of prints for sale. Works by known British printmakers. Also **Berkeley Square Galleries**, 23A Bruton Street, W1.

CURWEN GALLERY, 1 Colville Place, London W1. Tel. 01-636 1459. Prints by known British printmakers.

PHOTOGRAPHERS GALLERY, 5 & 8 Great Newport Street, London WC2. Tel. 01-240 5511. 5 Great Newport Street has a viewing room where staff will help advise and give prices for photographs by British contemporary photographers as well as photos by famous names in the USA and Britain. Wide selection of work and very helpful to buyers at whatever level.

VANESSA DEVEREUX GALLERY, 11 Blenheim Cresent, London W11. Tel. 01-221 6836. Small friendly gallery with work at reasonable prices. Near Portobello Road market. Also another 10 galleries nearby best visited during the **Portobello Contemporary Art Festival** mid April annually.

WADDINGTON GRAPHICS, 4 Cork Street, London W1. Tel. 01-439 1866. If you want to buy a print by a known name such as Joe Tilson, Hockney, Patrick Caulfield, Frink, Hoyland and many other artists. Good place to look at the prints available at main London galleries and get to know work by a variety of artists.

MARLBOROUGH GRAPHICS, 6 Albermarle Street, London W1. Tel. 01-629 5161. Leading contemporary names. Ask to look at drawers of work by a particular artist you are interested in. Consult **Chapter 1 Galleries** section for names of all other possible galleries to visit. Pick up a copy of the monthly **Galleries Magazine** for listings of monthly exhibitions in the central London area. *Time Out Visual Arts* section and *Art Monthly* exhibitions section also list regular exhibitions in london and in some cases regionally, also *Arts Review, Artline.*

PRINT OF THE MONTH CLUB at Angela Flowers Gallery, 11 Tottenham Mews, London W1P 9PJ. Tel. 01-637 3089. Comparable to a book club scheme but for prints. £5 subscription

EDITIONS ALECTO, 27 Kelso Place, London W8. Tel. 01-937 6611. Prints by known British artists.

ANTHONY REYNOLDS, 32A-37 Cowper Street, London EC2. Contemporary artists.

MEMBERSHIP SCHEMES

If you are at all interested in becoming an art buyer, collector, or are just interested in visiting exhibitions regularly it is worthwhile thinking about joining one or several of the **membership schemes** available in your area. Alternatively as a potential buyer many galleries would be interested in considering putting you on their regular **mailing list**. This means that you would be mailed details of private views and dates of exhibitions at specific galleries.

Membership schemes sometimes offer various facilities such as discount on cards, books and materials, visits to galleries and museums elsewhere, visits to artists' studios, invitations to private views and openings and a chance to meet other people interested in art and add to your knowledge about painting, sculpture, performance, video, film and other events in the art world.

LONDON

Information on Friends Organisations throughout the UK can be obtained by writing to The Hon. Secretary, The British Association of Friends of Museums, 66 The Downs, Altrincham, Cheshire. Tel. 061-928 4340. A selection is given below. Check for up to date prices.

FRIENDS OF THE ROYAL ACADEMY, Royal Academy of Arts, Burlington House, Piccadilly, London W1. Tel. 01-439 7438. Benefactors £1,000 or more. Sponsors £500, corporate £100, individual artists Subscribers £45 (includes reduction on art materials at the shop. Friends £24 or £20,

OAPs (museum £17) staff, teachers, and young Friends £17)

FRIENDS OF THE COURTAULD INSTITUTE, 20 Portman Square, London W1. £5 per annum. Students under 26 £3 p.a. Life members £50 or over.

PATRONS OF RIVERSIDE STUDIOS, Crisp Road, Hammersmith, London W6 9RL. Tel. 01-741 2251. (£5–£1,000).

FRIENDS OF THE TATE GALLERY, The Tate Gallery, Millbank, London SW1. Tel. 01-834 2742. Benefactor £1,000 or over. Patron £100 or over annually. Associate £25. Corporate £25. Member £15. Educational £12. Young Friend under 26 £10. Young Friends also organise visits to the theatre and film evenings occasionally. **Patrons of New Art** £250 annually to assist acquisition of works by younger artists.

FRIENDS OF THE V&A, Victoria and Albert Museum, London SW7. Tel. 01-589 4040. Membership £20. Deed of Covenant £15. Educational £12.

FRIENDS OF AIR and SPACE, £10 p.a. membership (2 in same household), £100 patron but more if possible to help the gallery and space studios. Contact: AIR Gallery, 6/8 Rosebery Avenue, London EC1R 4TD.

THE BRITISH MUSEUM SOCIETY, c/o The British Museum, London WC1. Tel. 01-637 9983. Member £8. Aditional lectures and private views £12. Life membership £150 single, £200 husband and wife.

THE INSTITUTE OF CONTEMPORARY ARTS, Nash House, The Mall, London SW1. Tel. 01-930 0493. Member £12 per annum. Associate, or membreship, day membership 60p.

PHOTOGRAPHERS GALLERY, 5 & 8 Great Newport Street, London WC2. Tel. 01-240 5511/12. £15 member (private views), £10 advance mailing only.

CONTEMPORARY ART SOCIETY, c/o The Tate Gallery, Millbank, London SW1. Tel. 01-821 5323. Member £7 p.a.

NATIONAL ART COLLECTIONS FUND, 26 Bloomsbury Way, London WC1. Tel. 01-405 4637. Subscription £10 annually.

FRIENDS OF THE IVEAGH BEQUEST, Kenwood House, Hampstead Lane, London NW3. Tel. 01-348 1286. £3 entry to lectures, £5 to include private views, £1 (under 18).

ELSEWHERE IN THE UK

GLASGOW ART GALLERIES AND MUSEUMS ASSOCIATION, Art Gallery and Museum, Kelvingrove, Glasgow G3. Tel. 041-334 1134.

GLASGOW PRINT STUDIO, 22 King Street, Glasgow. G1 5QP. Tel. 041-552 0704.

STILLS PHOTOGRAPHY GALLERY, 105 High Street, Edinburgh. Tel. 031-557 1140.

FRIENDS OF THE CITY OF EDINBURGH ART CENTRE, Market Street, Edinburgh. Tel. 031-552 7073.

FRIENDS OF THE ROYAL SCOTTISH MUSEUM, 49 Queen Street, Edinburgh. Tel. 031-226 5084.

FRIENDS OF THE TALBOT RICE ARTS CENTRE, University of Edinburgh, Old College, South Bridge, Edinburgh. £2.50 p.a. ordinary, £1 p.a. student, £3 p.a. family, £25 life.

FRIENDS OF ABERDEEN ART GALLERY AND MUSEUMS, Aberdeen Art Gallery, Schoolhill, Aberdeen. Tel. 0224 53517.

TAYSIDE MUSEUMS AND ART SOCIETIES, Central Museum and Art Gallry, Albert Square, Dundee. Tel. 0382 25492.

DUMFERLINE MUSEUMS SOCIETY, Hon. Secretary, 72 James Street, Dunfermline. Tel. 0383 21814.

FRIENDS OF THE MERSEYSIDE COUNTY MUSEUMS AND ART GALLERIES, The Museum, William Brown Stret, Liverpool. Tel. 051-207 0001.

FRIENDS OF KIRKCALDY MUSEUMS, Museum and Art Gallery, War Memorial Grounds, Kirkcaldy, Fife. Tel. 0592 60732.

FRIENDS OF THE HOLBURNE OF MENSTRIE MUSEUM, Great Pulteney Street, Bath. Tel. 0225 6669.

FRIENDS OF THE ULSTER MUSEUM, Ulster Museum, Botanic Gardens, Belfast. Tel. 0232 668251.

FRIENDS OF THE CITY MUSEUMS AND ART GALLERY, City Museums and Art Gallery, Birmingham. Tel. 021-235 2833.

ALDERNEY SOCIETY AND MUSEUMS, Alderney, Channel Islands. Tel. 048-182 2539.

CHICHESTER MUSEUM SOCIETY, Chichester District Museum, 29 Little London, Chichester, West Sussex. Tel. 0243 784683.

AVONCROFT MUSEUM MEMBERS SOCIETY, 33 Old Station Road, Brosmgrove, Worcestershire. Tel. 0527 31363.

FRIENDS OF BOLTON MUSEUM AND ART GALLERY, c/o Gray, Le Mans Crescent, Bolton, Lancashire. Tel. 0204 22311 ext 379.

FRIENDS OF THE LEEDS CITY AND ABBEY HOUSE MUSEUMS, Municipal Buildings, Leeds 1. Tel. 0532 462495.

LEICESTER MUSEUMS ASSOCIATION, The Leicester Museum, 96 New Walk, Leicester. Tel. 0533 712271.

FRIENDS OF LINCOLN MUSEUM AND ART GALLERY, c/o Willimas, 20 Queensway, Lincoln. Tel. 0522 26029.

FRIENDS OF ABBOT HALL, Abbot Hall Art Gallry and Museum, Kendal, Cumbria. Tel. 0539 22464.

BOURNEMOUTH MUSEUM AND ARTS SOCIETY, Art Gallery and Museum, East Cliff, Bournemouth. Tel. 0202 210009.

FRIENDS OF THE ROYAL PAVILION, Art Gallery and Museums of Brighton, Friends Organiser, The Royal Pavilion, Church Street, Brighton. Tel. 0273 603005.

FRIENDS OF THE BRISTOL ART GALLERY, City Museum and Art Gallery, Queens Road, Bristol 8. Tel. 0272 299771.

FRIENDS OF THE FITZWILLIAM MUSEUM, Fitzwilliam Museum, Cambridge. Tel. 0223 69501.

FRIENDS OF EXETER MUSEUM AND ART GALLERY TRUST, c/o The Secretary, Little Hawkridge, Nynet Rowland, Crediton, Devon. Tel. 0392 56724.

FRIENDS OF THE NATIONAL MUSEUM OF WALES, National Museum of Wales, Cathays Park, Cardiff. Tel. 0222 397951.

SLIDE REGISTRIES

Anyone interested in buying artwork should consider looking at one or two of the slide registries available for reference. The visitor can then follow up looking at slides with a studio visit to see the artist's work for himself. Unfortunately the public are often unaware that such registries exist.

There are two kinds of registry. One is for use by for example an organisation such as the Arts Council so that they can refer to work by established British artists and for example show an overseas gallery director work by British artists to save them starting from scratch. These registries are often highly selective. The other kind is also selective but aims to help the artist/craftsman show/sell his work to a wider public. The Regional Arts Associations and the Crafts Council have such registries, although the Crafts Council is again highly selective.

CRAFTS COUNCIL, 12 Waterloo Place, London SW1. Tel. 01-930 4811 £4.95 for an illustrated guide to the works of 350 artist craftsmen and women throughout England and Wales. Selective index. Photos of work, address and details of where further work can be seen by a particular craftsman.

EASTERN ARTS, Cherry Hinton Hill, Cambridge. Tel. 0223 215355. Artists register. Available for consultation whether professionally or privately interested in the visual arts. Open to all professional artists and crafsmen.

SOUTH EAST ARTS, 10 Mount Ephraim, Tunbridge Wells, Kent. Tel. 0892 41666. Artists register. Up-to-date selective register of professional artists, photographers and craftsmen working in the area. Available for consultation by gallery directors, organisers, patrons of the arts etc. Artists can apply twice a year in June an December.

WEST MIDLAND ARTS, 82 Granville Street, Birmingham B1 2LH. Tel. 021-631 3121. Artfile is an index of work by artists, craftsmen and photographers working in the region. 10/20 slides by each artist. Open to all professional artists.

EAST MIDLAND ARTS, Mountfields House, Forest Road, Loughborough. Tel. 0509 218292. Artists register of work by artists, craftsmen and photographers. About 250 on list.

LINCOLNSHIRE AND HUMBERSIDE ARTS, St. Hughs, 23 Newport, Lincoln. Tel. 0522 33555. Register of work by artists, craftsmen and photographers.

SOUTH WEST ARTS, Bradninch Place, Gandy Street, Exeter, Devon. Tel. 0392 218188. Register of work by artists, craftsmen and photographers. South West film directory of work available by SW filmmakers (50p).

NORTHERN ARTS, 10 Osborne Terrace, Newcastle, Tyne and Wear. Tel. 091-281 6334. Register of work by artists, photographers and craftsmen.

SCOTTISH ARTS COUNCIL, 19 Charlotte Square, Edinburgh. Tel. 031-226 6051. Register of work by Scottish artists both living in Scotland and elsewhere in Britain.

THE ARTS COUNCIL OF GREAT BRITAIN, is compiling a selective register of work by known British artists. Not open to artists to apply. Open to the public to use. Now based at the Serpentine Gallery. Contact: Rory Coonan at the Arts Council. Tel. 01-629 9495 for details or to view slides of work.

THE BRITISH COUNCIL, Fine Art Dept, 11 Portland Place, London W1. Tel. 01-636 6888. The library has a selective register of work by British artists. Only available to visitors with a genuine reason to refer to it. Contact the Fine Art Department.

NORTH WEST ARTS, 4th Floor, 12 Harter Street, Manchester. Tel. 061-228 3062. Register of professional artists and slide index.

Chapter 6
SPONSORSHIP AND ART FOR PUBLIC PLACES

SPONSORSHIP

Most art organisations, as registered charities in many cases, have had to think seriously about how they can approach companies and individuals for sponsorship of projects, exhibitions, administration costs and other similar items, at some point. The visual arts, they have soon disovered, are sadly neglected in favour of music, opera and theatre. The British it would seem are a nation of music lovers and theatregoers, not art buyers and art collectors or at least not of contemporary art. There are of course odd exceptions and in these cases it is ofen one individual who has a particular interest in contemporary art, such as Richard Cobbold (Tolly Cobbold exhibition), Alex Bernstein of Granada TV (The Granada Foundation) and Peter Stuyvesant (Peter Stuyvesant Collection).

Advantages for companies entering into sponsorship are many. For example if a major exhibition at the Royal Academy is sponsored, the company can expect publicity from articles in newspapers, television and radio, and of course from posters advertising the event. There are also tax advantages although these are small in comparison with similar tax advantages, for example in the USA and Europe. American art organisations have learned to live with the daily strain that if they want to survive, they have to battle for sponsorship and support from the commercial sector, as well as organisations such as the National Endowment for the Arts. An arts administrator in the USA has to be well trained in approaching companies for sponsorship and has to hassle to be successful. This is acceptable in the USA but totally unacceptable in Britain. In Britain, as many successful art organisations will agree, the personal contact story is the most successful and a gentle word in the company director's ear, by an influential personal friend, will often gain more results that endless letters. Below I have tried to offer some advice step by step for artists, small art organisations and other bodies that have little experience of how to start applying for sponsorship.

The one thing you must bear in mind is that business is built on profit, not benevolence for the arts and that hard as it may seem to you, the artist, anyone considering sponsorship will bear in mind whether the event will give them publicity or possible investment. This explains why contemporary art is a gamble and very few companies are prepared to buy or sponsor contemporary work until the artist has made a name for her/himself. Again in the USA, Australia and Canada for example, possibly as they are younger countries where traditional ideas are not so entrenched, companies are willing to consider sponsoring young artists and new work. Perhaps Britain can learn from this, and the resultant interest in contemporary work by the gerneral public would make a refreshing change to the cultural scene in Britain in general. In Australia recently, during the summer months, Sydney, Adelaide and Perth held art events for children, to encourage their future citizens to take an interest in art and these festivals on a local and international level were sponsored by national and local companies. This attitude surely helps promote culture generally and helps art and artists on several levels rather than a negative attitude where contemporary art is ignored until it is a safe investment.

There are many dangers of sponsorship that organisations need to bear in mind. A gallery can literally be almost taken over by a company wishing to make as much publicity as possible out of an event. Sponsors often tend to sponsor events that are already doing well and really do not need more help and tend to ignore avant garde contemporary work or promotion of exhibitions of narrow appeal. Also the business side to sponsorship is always evident and if artists participate in an exhibition sponsored by a company with political leanings then there could be endless complications that art administrators had never dreamed of.

ASSOCIATION OF BUSINESS SPONSORSHIP FOR THE ARTS, 2 Chester Street, London SW1X 7BB. Tel. 01-235 9781. Formed by a number of leading British companies with the help of a government grant to encourage business organisations to become involved in sponsorship and thereby encourage the growth of arts sponsorhsip. *As such they are not really in a position to help artists or art organisations find funding but they can send you a list of companies that have supported the arts in the past and the companies*

are listed according to which area of the arts they have sponsored. The visual arts I might add are the smallest section.

ASBSA/DAILY TELEGRAPH ANNUAL AWARDS FOR BUSINESS SPONSORS FOR THE ARTS. Companies are nominated for the best support for sponsorship of the arts. Please note that an arts organisation does not benefit directly from this but this is supposed to encourage sponsorship nationally.

THE CORPORATE ARTS, 23 Cavaye Place, London SW10. Director: Sarah Hodson. Helps artists exhibit work in offices. Non-profit.

KALLAWAY ASSOCIATES, 2 Portland Road, London W11. Involved in helping art organisations promote themselves to sponsors. Again the Visual Arts are not their best customers.

It is probably better for a small art organisation or group of artists to organise their own plans for approaching sponsors and they will certainly learn much along the way.

ART FOR OFFICES. Tel. 01-481 1337. See, *Buying Art* for details, Chapter 3.

ART ADVICE, 136 Great Victoria Street, Belfast, Northern Ireland. Tel. 0232 324726. Specialist corporate Art Gallery in Belfast and New York selling work by major Irish artists.

SOME SUGGESTIONS FOR APPROACHING SPONSORS

1. Consult the **Directory of Grantmaking Trusts** at your local library and list all the trusts that seem to have any remote connection with your project. You will be surprised at how many trusts could be possibilities.

2. Contact the **Charities Aid Foundation**, 48 Pembury Road, Tonbridge, Kent. Ask for their checklist of do's and don'ts for people approaching trusts. Compiled by Redford Mullin.

3. Once you hae consulted the latter, compile a letter to sponsors, as short as possible including the areas mentioned below.

(a) Mention the specific area you are involved in. (b) The sum you require and whether it is one off or over several years. (c) Is the sum to cover salaries, equipment or a project or what? Say who you are, what the organisation has done in the past and what you plan to do in the future and give a 3 year cost projection for example. Also mention that you will be sending along someone to see them.

4. Set up an advisory committee with as wide a coverage as possible to meet regularly. This committee should potentially have members who have influential friends in the business or art world. The committee should be able to help with both advice and contacts for sponsorship.

5. If the committee do have any appropriate friends who could approach a director or chairman of one of the companies that you plan to approach so much the better. In many successful cases of sponsorship this approach has proved to be the most fruitful. Any contact however remote can be useful when searching for sponsorship and find out who might be sympathetic to your particular project in advance.

6. Once you have hopefully acquired a personal introduction arrange to send someone round to discuss the project and give very well prepared details of your organisation and what you are seeking. Also offer possible advantages to the sponsor concerned if you feel that this is appropriate.

7. Local sponsors have often proved to be the most helpful. For example of all the art schools mentioned in this handbook many receive sponsorship for scholarships from local companies however small for travel, fees and materials.

NAMES OF ORGANISATIONS
THAT HAVE BEEN INOLVED IN ART SPONSORSHIP RECENTLY

Olivetti (exhibition sponsorship).
Peter Stuyvesant (major art collection).
Esso (British Art Now at the Royal Academy—Exxon in the USA).
Imperial Tobacco (portrait commissions).
Sothebys (ICA events, catalogues, awards).
Marks and Spencer (arts centres).
Tolly Cobbold (exhibition/prizes).
John Moores (exhibition).
Sainsburys (many projects for sculpture, architecture etc).
Alistair McAlpine.
IBM.
BP.
Shell.
Calouste Gulbenkian Foundation (community art, purchases of contemporary art, support of individual artists).
Nuffield Foundation.
The Pilgrim Trust.
The Sainsbury Charitable Fund.
Peter Moores Foundation.
The Wolfson Foundation.
European Educational Research Trust.

The Commonwealth Foundation.
Glaxo Charity Trust.
Strauss Charitable Trust.
Slater Trust Ltd.
Schroder Charity Trust.
Normanby Charitable Trust.
I. J. Lyons Charitable Trust.
Rothschild Charitable Trust (several).
The Rayne Foundation.
Leverhulme Trust Fund (author's note—I owe my art school fees to the generosity of a Leverhulme bursary to an art school).
Consult the **Directory of Grantmaking Trusts** for details on all the above. We have selected trusts that seem to be appropriate to the Visual Arts.
Art suppliers locally and nationally have also been known to support **competitions, scholarships and awards.** See awards section in Chapter 1.

MEDIA SUPPORT FOR THE VISUAL ARTS

The Times (exhibitions).
The Observer (exhibitions).
London Weekend Television (scholarships, bursaries, exhibitions).
Granada (collections, exhibitions etc).
Channel 4 TV
The Independent
Time Out magazine
BBC
Next Retail
Thames TV (exhibitions).
The Sunday Times (exhibitions).
TV South West (public art 3D exhibitions and prizes).
© Heather Waddell

PUBLIC ART

PUBLIC ART DEVELOPMENT TRUST

Without question, the 1980's has witnessed a remarkable upsurge of interest in public art and a corresponding increase in commissioning activity. One of the agencies committed to extending the role of art outside galleries and museums is **Public Art Development Trust (PADT)**, a national charity which initiates and organises commissions.

Working in close collaboration with architects and developers in both the public and private sectors, The Trust's objectives are to promote opportunities for younger artists, help realise the potential for art to enhance the environment and at the same time stimulate public awareness of this capacity for art to contribute positively to our surroundings. Emphasising the relevance of an artwork to its context, the Trust's work is distinguished by a commitment to site-specific commissioning for places which must be 'public'. Supported by Greater London Arts (GLA) for its work with local authorities in London, PADT runs GLA's 'Art in Public Places' progamme and administers a jointly organised slide index.

Clients range from local authorities to private development corporations. The majority of commissions involves more than one client and therefore different sources of funding, the Trust frequently acting as a consultancy bringing together interested parties. One exemplary partnership, for example, involved the collaboration of the **London Borough of Lambeth**, **British Rail** and the **Department of the Environment** in the **Brixton Station Improvement Scheme. Kevin Atherton** was commissioned to cast three local people in bronze, who then literally took up their positions alongside railway passengers on the platforms of the newly refurbished station. This work has attracted much positive publicity and stimulated considerable public debate about the ways in which art can improve the quality of urban developments and provide a focus for regeneration schemes.

Central to PADT's London-based work is the **'Art in Hospitals'** scheme, which is organised by the Trust and jointly funded by GLA and the King Edward's Hospital Fund for London. The aim is to counteract the adverse effects of a depressing environment on both patients and staff, thereby putting into effect the medical profession's comparatively recent acknowledgement that it is important to care for the whole person, not just supply the clinical treatment of an illness.

Projects in hospitals tackled to date have been remarkable for their variety. Brightly coloured tapestries, sculptures, paintings, photographs and murals enhance waiting areas and dreary corridors in a number of hospitals. A sculpture garden with medicinal herbs enlivens what was once a barren and disused courtyard at St. George's Hospital, Tooting; seven large photographic colour panels based on the

lives and mementoes of staff and patients brighten the entrance to a longterm care hospital for the elderly at Colindale in North London.

Wherever possible, strong links are established with the respective community concerned. PADT often organises **exhibitions** and **seminars in schools, hospitals** and **local community centres** to stimulate interest and facilitate a wider understanding and appreciation of any forthcoming commission. School workshops, artists' residencies and artists working on site have all proved effective in fostering receptive and positive attitudes generally towards public art, providing as they do invaluable learning opportunities outside the formal educational framework.

The proper integration of works of art with the built environment is also a key concern. Implicit in this aim is the artist's involvement from the outset with the architectural or landscape design process. Accordingly, PADT urges early collaboration between artists and architects wherever possible in commissions, and has actively promoted the introduction in this country of percent for art legislation. Allocating a certain percentage of all building or refurbishment costs to the commissioning of integrated works of art and craft, the implementation of a **percentage scheme** would represent a positive step towards genuine collaboration in which artists and architects are equal partners.

The Trust has handled a number of projects which provide rare opportunities for younger artists to be introduced to the possibilities of making a living from their work and tackling the demands of a variety of sites.

At the heart of PADT's work is the belief that public art is a valuable resource which can stimulate the vitality and economic prosperity of local communities. Yet every care is taken so that artworks are not foisted upon an unsuspecting public. Usually the Trust organises representative selection committees and exhibitions of artists' proposal for consultation with the relevant community. Against a background of economies and calls for accountability, PADT views such consultation as one means of encouraging more direct public involvement in arts funding. Open competitions are organised wherever feasible to further ensure greater democracy.

In its work for GLA as well as the private sector, PADT aims to provide an efficient service which relieves both client and artist of the administrative burden involved in the commissioning process, and to ensure that a commission is practically as well as aesthetically realised. Drawing from its extensive **artists' slide index**, PADT can assist with the selection of artists in addition to administering and monitoring the legal, contractual and financial aspects of commissions.

The Trust also operates a **general advisory service**, answering queries from artists, the public and other public art agencies across a wide range of issues related to public art.

PUBLIC ART DEVELOPMENT TRUST

6 & 8 ROSEBERY AVENUE LONDON EC1R 4TD TELEPHONE 01-837 6070

COMPLETED COMMISSIONS

St. George's Hospital, Tooting, London—Sculpture Garden. Artist: **Shelagh Wakely**. Title: Five Tables in a Courtyard. Media: Paving, water, medicinal plants. Date: 1983.

London Docklands, Canary Wharf, Isle of Dogs—Environmental Landscape Garden. Artists: **Professor Phillip King** & sculpture students from Royal College of Art. Date: 1984.

St. Stephen's Hospital, Fulham—Mural. Artist: **Faye Carey**. Media: Oil on canvas (8ft×76ft). Date: 1984.

Surbiton Station Booking Hall, Kingston—Murals. Artists: **Graeme Wilson** and **Sue Ridge**. Media: Acrylic on canvas (walls). Emulsion direct on walls (ceiling). Date: 1984.

Queen Mary's Hospital, Sidcup—Tapestries. Artist: **Marta Rogoyska**. Title: Greenhouse I and Greenhouse II. Medium: Tapestry. Date: 1984.

Northwick Park Hospital, Harrow—Mural. Artist: **John Edwards**. Title: Summer Landscape, Harrow. Media: Oil on canvas. Date: 1984.

Bellingham Green, Lewisham, London—Sculpture. Artist: **Hamish Horsley**. Title: Sunstone. Medium: Portland stone. Date: 1985.

Victoria Plaza, Buckingham Gate, London SW1—Tapestries. Artist: **Marta Rogoyska**. Date 1985.

Philip Noel-Baker Peace Garden, Elthorne Park, London—Sculpture. Artist: **Kevin Atherton**. Title: Upon Reflection. Medium: Bronze. Date 1985.

Colindale Hospital, London—Photopiece. Artist: **Hannah Collins**. Medium: Seven photographic prints in light boxes. Title: Shelf/Situation/Shrine. Date: January 1986.

Elthorne Park, Islington, London—Sculpture. Artist: **Emmanuel Jegede**. Title: Adura-Itura—Prayer of Peace. Medium: Bronze. Date: 1986.

London Dental Hosptial—Two paintings. Artist: **Vivien Blackett**. Date: April 1986.

St. George's Hospital, Tooting, London—Sculpture. Artist: **Peter Randall-Page**.

Title: And Wilderness is Paradise Enough. Medium: Grey Welsh slate (dry stone walling technique). Date: 1986.

Brixton BR Station, London—Sculpture. Artist: **Kevin Atherton**. Title: Platforms Piece. Medium: Bronze. Date: June 1986.

West Ham Town Hall—Sculpture. Artist: **Judith Cowan**. Medium: Bronze (fountain in internal courtyard). Date: 1986.

1 Finsbury Avenue, London EC2—Tapestry. Artist: **Marta Rogoyska**. Date: 1986.

Stoke Mandeville BR Station (from Chelsea Flower Show)— Sculpture. Artist: **Sioban Coppinger**. Title: The Gardener and the Truant Lion. Media: Cement and bronze. Date: 1986.

The Economist Plaza, London—Sculptures. Artists: Five students from the **Royal College of Art** working for 6 six weeks in the public view (Simon Noble, Simon Perry, Felicity Powell, Michael Blodget and Eric Matthews). Media: Slate,perspex, fibreglass, metal, electricity. Date: 1986.

Royal Bank of Scotland, Angel, London N1—Sculpture. Artist: **Lee Grandjean**. Title: Angel. Medium: Bronze. Date: September 1986.

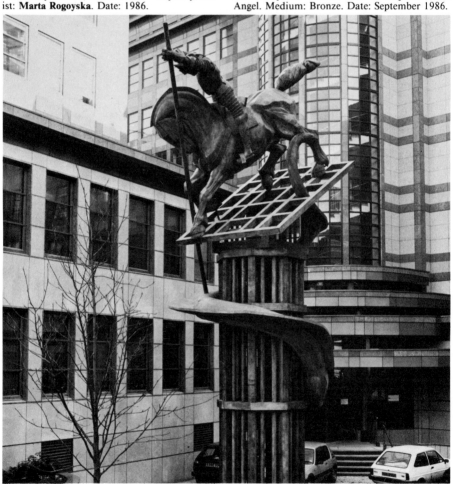

St George and the Dragon by Michael Sandle, Public Art Development Trust (Susan Ormerod)

204

Southern Road Junior School, Plaistow, London—Sculpture. Artist: **Viv Levy**. Medium: Mild steel arch. Date 1987.

Stockley Park, West London—Stained glass. Artist: **Alexander Beleschenko**. Medium: Stained glass—laminate. Date: 1987.

Greycoats plc (61 Queen Street, London EC4)—Tapestry. Artist: **Grace Erickson**. Medium: Tapestry. Date: 1987.

Rosehaugh Greycoats plc (3 Finsbury Avenue EC4)—Two paintings. Artist: **Christine Hatt**. Date: 1987.

Hometon Hospital, London—mixed commissioning programme. Artists: **Andrew Darke** (sculpture), **Bert Irvin** (painting), **Andy Frost** (mixed media work), **Jane Gifford** (painting), **Linda Schwab** (painting), **Esther Barrett** (quilted wall hanging), **Jacqui Murrant** (quilted wall hanging). Date: 1987.

St. Mary's Hospital, Paddington, London—Three tapestries. Artist: **Grace Erickson**. Title: Earth, Sea and Sky. Medium: Tapestry. Date: mid 1987.

Stockley Park, West London—Stained glass. Artist: **Anne Smyth** Medium: Stained glass. Date: mid 1987.

Baltic Wharf, Bristol—Sculptures. Artists: **Vince Woropay, Keir Smith, Stephen Cox**. Media: Bronze, bathstone, red verona marble. Date: 1987.

Thames Walkway, South Bank, London—Sculpture. Artist: **Jane Ackroyd**. Title: Memorial to Civilian Victims of Aerial Bombardment. Medium: Mild steel. Date: 1987.

St. Mary's Hospital, Paddington, London—Environmental design. Artist: **Bridget Riley**. Date: 1987.

Childeric Primary School, London E14—Ceramic. Artist: **Saleem Arif**. Date: 1987.

Harold Wood Hospital, London—Paintings & sculpture. Artists: **Simon Granger, Flick Allen, Suzanne O'Driscoll** (paintings), **Craig Murray-Orr** (sculpture). Date: 1987.

Blue Circle Industries Headquarters, Aldermaston— Sculpture. Artist: **Peter Randall-Page**. Medium: Concrete. Date: 1987.

Unilever plc, St. Bride's House, Blackfriars, London— Sculpture. Artist: **Michael Sandle**. Media: Bronze and steel. Date: 1987.

Albert Square & St. Stephen's Residents' Association— Sculpture. Tradescant Family Trust site adjacent St. Stephen's Church. Artist: **Hilary Cartmel**. Medium: Bathstone. Date: 1987.

Hamilton Associates, Basingstoke—Wall sculpture. Artist: **Liliane Lijn**. Date: 1987.

Fenchurch Street Station, London—Stained glass screen. Artist: **Anne Smyth**. Date: 1987.

Rosehaugh Greycoats plc—Banner. Artist: **John Dugger**. Date 1987.

St. Martin's Property Development Corporation— Sculptures. Artist: **Allen Jones**. Date: 1987.

St. Martin's Property Development Corporation—Kinetic sculpture. Hays Galleria, London Docklands. Artist: **David Kemp**. Title: The Navigators. Date: 1987.

Regalian Properties plc, Free Trade Wharf, London—Mixed commissioning programme. Artists: **Christine Merton** (ceramic work), **Polly Ionides** (sculpture), **Mark Dunhill** (sculpture), **Robert Koenig** (sculpture). Date: September 1987.

PUBLIC ART SECTION

The Artangel Trust, 133 Oxford Street, London W1R 1TD. Tel. 01-434 2887.
The Artangel Trust is a funding and initiating organisation for the visual arts:
 presenting art in public locations
 collaborating with artists and curators to win new audiences 'beyond the museum'
 encouraging artists working in a context of social or political intervention
 supporting public works which are transient, temporary or not gallery-based
Are the arts in Britain flourishing or floundering? Is there some truth to the claim that the visual arts have never had is so good? Or is the full range only partially exposed?
A great number of commercial galleries are showing increasing quantities of contemporary work; more money has been spent by collectors; commercial sponsorship of the arts is said to have risen to over £25m; most major cities and regions boast an art agency promoting contemporary sculpture in public places; and the opening of a new art museum or gallery is not a rare occurence.
But behind this prosperous facade there is **a fundamental shift in the emphasis of cultural production**. Visual artists, sensing the glamour and growing trading impetus around museums and commercial galleries have understandably been attracted to the gains of those associations. Public art agencies have largely been hampered in their aspirations by the preference of their commercial and public sector

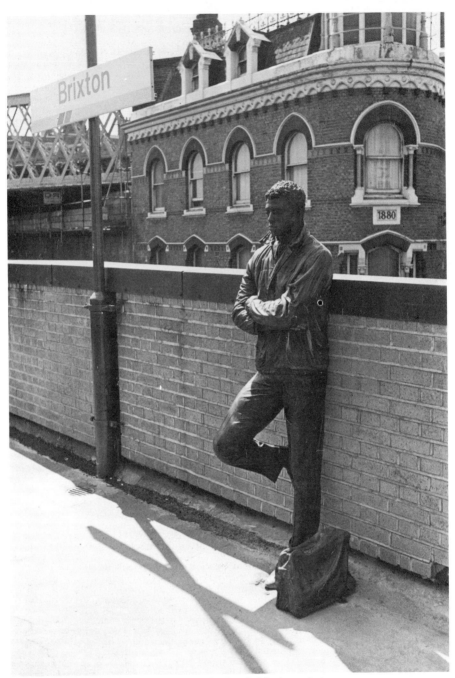

Kevin Atherton's 'Platform Piece' for Brixton Station, Public Art project

funders for conventional kinds of permanent-placement sculpture and museum curators are required to spend increasing amounts of time seeking commercial 'partnership' for major exhibitions or displays.

The present government has urged arts bodies to link arms with the business sector but, understandably, shareholders and multi-national corporations cannot be expected to support activity that carries limited public prestige (without any guarantee of even art-world accolade). Nor is it surprising that these same sources decline in most cases requests to fund cultural activity that seriously and effectively raises contentious issues. **Artists wishing to establish a truy social role for art are thereby denied resources** to develop such a role at a time when viable opportunities within the mainstream for constructive cultural activism and issue-based art are diminishing. Many organisations are aware of this cultural shift. **The Artangel Trust** is one of the few, actively devising and supporting strategies that broaden the confines imposed by this matrialistic trend.

The Trust encourages artwork and projects outside the museum and gallery context, particulary by those artists whose production is not object-based or commodifiable. It supports the development of strong experimental work that has no apparent prestige value and it responds to those artists and producers who have genuine and *viable* strategies to attract and interest wider audiencies.

Artangel does not consider itself a **'community arts'** agency in the generally accepted sense of that term. It does not normally undertake to organise workshops or any major public involvement in the making of work. The Trust supports the value of **'invitational'** activity where the public may participate and feel involved; but it also believes that on other occasions there can be considerable constructive merit in the **'confrontation'** aspect of an artwork or event. The prime concerns are with quality and effectiveness of presentation and with maximising the audience.

Past and future projects include work by: **Conrad Atkinson, Hannah Collins, Godbold & Wood, Andy Goldsworthy, Housewatch, Ian Hunter, Mark Ingham, Barbara Kruger, Les Levine, Tim Head, Jenny Holzer, David Mach, Keith Piper, Kumiko Shimizu, Station House Opera, Boyd Webb, Krzysztof Wodiczko, Lawrence Weiner, Stephen Willats; Julia Wood**; and there have been collaborations with **Interim Art, ICA, Common Ground, AIR Gallery,** and several local Government Authorities, and Regional Arts Associations.

Artangel welcomes proposals for projects from artists, art curators, and producers working in any field or medium, and from interested parties outside the professional arts field with relevant ideas.

These will be considered only where they demonstrably relate to the aims and principles of the Trust and more particularly where they create **significant opportunities for artists to participate in the forum of public debate** on global or local issues.

For further information write to the address above.

MURALS

Over the past few years, murals and public art in general have been flourishing. It's not possible to list mural sites throughout Britain, but there follows a fairly comprehensive list for London and Swindon.

Useful address
Greenwich Murals Workshop, MacBean Centre, MacBean Street, London SE18. Tel. 01-854 9266. Contact: Steve Lobb. See also **Community Arts projects section.**

MURALS IN LONDON

BOROUGH: BRENT
Willesden Stadium, Brent—boundary wall. Title/ Theme: Untitled. Artist: **Hammersmith Mural Arts** Director: Russell Barrett. Year: 1979.

BOROUGH: BROMLEY
Bradford & Bingley, Building Society, 88 High Street, Bromley (Interior). Title/Theme: BROMLEY IN THE REIGN OF GEORGE II (based on Roque's map of 1844). Artist: **Philippa Threfall.** Year: 1973.
Burnt Ash Infants' School, Keedonwood Road, Bromley (Interior). Title/Theme: JUNGLE SCENE. Artist: **Avery Hill students.** Year: 1973/ 1974.

Alexandra Infants' School, Kent House Road, Beckenham. Title/Theme: PIRATES. Artist: **Kentwood schoolboys.** Year: 1977.
Alexandra Infants' School, Kent House Road, Beckenham (Interior). Title/Theme: BOOK-CHARACTERS. Artist: **Kentwood schoolboys.** Year: 1979.
Balgowan Primary School, Balgowan Road, Beckenham. Title/Theme: JUNGLE SCENE. Artist: **Kentwood schoolboys.** Year: 1981.
Park Tavern, St. John's Road, Penge. Title/ Theme: Untitled. Park Tavern with Crystal Palace in background, 100 years ago. Artist: **Orchard Lodge** Regional Resource Centre and The Coal Yard Club (youth group).

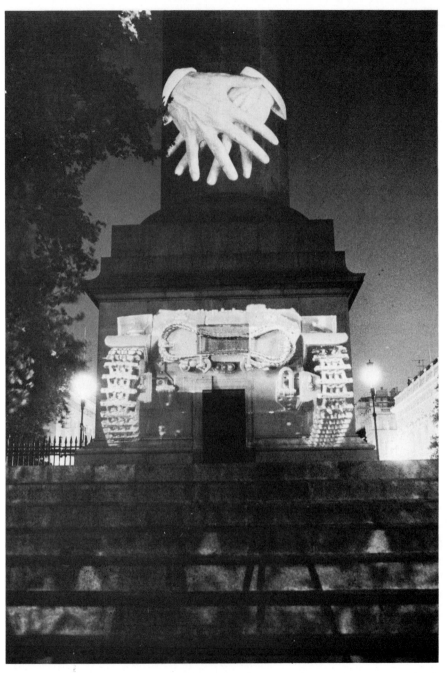

City projections by Krzysztof Wodiczko, The Mall London, ICA and Artangel Trust (Harry Chambers)

BOROUGH: CAMDEN

Blashford Tower Playground, Adelaide Road, London NW3. Title/Theme: Untitled. Blashford Animal Mural (badly weathered). Artist: **Art Workers Co-op.** Year: 1977.

Fleet Community Education Centre, Agincourt Road, London NW3 (Interior and exterior). Title/Theme: Untitled. Artist: **Jane Trevelyan**, Fleet Centre members. Year: 1977 onward.

Abbey Community Centre, Belsize Road, London NW6. Title/Theme: Untitled. Artist: **Art Workers Co-op.** Year: 1978.

Queen's Crescent Community Centre, Queen's Cresent, NW5. Title/Theme: Untitled (bad condition). Artist: **Art Workers Co-op.** Year: 1978.

Old Community Centre, Ferdinand Estate, off Ferdinand Street, London NW1 (Interior and exterior). Title/Theme: Untitled (bad condition. Artist: **Art Workers Co-op.** Year: 1978.

Palmerston Road Adventure Playground, Palmerston Road, off Kilburn High Road, London NW6. Title/Theme: Untitled. Artist: **Karen Gregory & Kimberley Bennett** with **Camden Mural Team** led by **Mike Jones**. Year: 1978.

Old Gloucester Street, London WC1. Title/Theme: THE BIO-SPHERE WORKING WITH THE TECHNO-SPHERE. Artist: **Gilberto Guzman, SantoFe**, New Mexico + local children. Year: 1979.

Kentish Town Health Centre, 2 Bartholomew Road, London NW5. Title/Theme: Untitled. Artist: **Art Workers Co-op, Mike Jones**. Year: 1982.

Camden Town Youth, Sir Wm. Collins Comp. School, Charlton Street, Somers Town NW1.

Main hall & entrance (Interior and exterior). Title/Theme: Untitled. Past and present in Somers Town and people in the school. Artist: **Dave Bangs** with **Karen Gregory & Kimberley Bennett + Camden Mural Team>RO>**. Year: 1982.

Rock & Sole Plaice, Shorts Gardens/Endell Street, Covent Garden WC2. Title/Theme: Untitled. Trompe l'oeil decoration. Artist: Jane Gifford. Year: 1982.

Harwood Community Centre, Forge Place, Ferdinand Street NW2. (Interior). Title/Theme: Untitled. Local people seaside reflection. Artist: **Kim Bennett, John Murray**. Year: 1983.

Mornington Sports Centre, Arlington Road NW1. Title/Theme: Untitled. Sports and abstract shapes. Artist: **Karen Gregory**, Johnny Shapiro. Year: 1983.

Sir Philip Magnus School, Penton Rise, Kings Cross WC1. Title/Theme: PATCHWORK. Artist: **Islington Schools Environmental project**. Year: 1979.

Carlton Centre Bar, Carlton Centre, Princess Road, W. Kilburn NW6 (Interior). Title/Theme: Untitled. Artist: **Art Workers Co-op.** Year: 1980.

Fitzrovia Mural, Tottenham Court Road, (opposite Heals), London NW1. Title/Theme: FITZROVIA. Artist: **Art Workers Co-op.** Year: 1980.

Packenham Youth Club, Kentish Town (Interior and exterior). Title/Theme: Untitled. Artist: **Dave Bangs & Karen Gregory** (+**Dave Vaughan + assistant**). Year: 1980.

Aldenham Youth Club, Highgate Road, Kentish Town NW5 (Interior and exterior). Title/Theme:

Snow sculpture by Andy Goldsworthy on Hampstead Heath, Artangel Trust

209

Untitled. Artist: **Karen Gregory & Kimberley Bennett** with **Dave Vaughan**. Year: 1980.

Parliament Hill Footbridge. Title/Theme: Untitled. Community mural. Artist: **Jane Trevelyan + Mansfield Neighbourhood Assoc.** Year: 1980/1981.

Covent Garden Community Association, Shorts Gardens/Endell Street, Covent Garden WC2. Title/Theme: Untitled. Trompe l'oeil facade with portraits of people in CGCA. Artist: **Jane Gifford + M. Paley**. Year: 1981/1982.

Godwin Court, Crowndale Road NW1. Title/Theme: Untitled. Steam trains from the first to the last. Artist: **Karen Gregory, Kim Bennett, Natalie d'Arbeloff, MSC team**. Year: 1983.

Hamden Community Centre, Ossulston Street NW1 (Interior). Title/Theme: Untitled. Local community—local people in own setting. Artist: **Natalie d'Arbeloff**. Year: 1983/1984.

Calthorpe Project, Grays Inn Road WC1. Title/Theme: Untitled. Landscape. Artist: **Dave Bangs, Gill Johns, Sarah Dewdray, Bruce Currie, Sineid Codd, Brigid de Saulles, Dave Mulholland**. Year: 1984.

Gable End, Phoenix Road, off Pancras Road, Somerstown NW1. Title/Theme: Untitled. History of Somerstown. Artist: **Karen Gregory**. Year: 1984.

St. Mary & St. Pancras Primary School Mural + garden sculptures, Charlton Street NW1. Title/Theme: Untitled. History of women in Somerset. Artist: **Karen Gregory**. Year: 1984.

Brunel Interchange Building, Camden Lock, Camden NW1. Title/Theme: Untitled. Camden—Commercial History. Artist: **Llewellyn Thomas**. Year: 1985.

BOROUGH: CITY

38 Charterhouse Street, Smithfields EC1. Title/Teme: Untitled. Trompe l'oeil butcher's shop. Artist: **Jane Gifford**. Year: 1982.

Museum of London. Archaeological Dig on a Speyhawk development site. The Monument, Fish Street Hill EC3. Title/Theme: THE GREAT FIRE. Artist: **Fee Form Arts Trust**. Year: 1985.

BOROUGH: CROYDON

Purley Oaks Infant School. Title/Theme: Untitled. Artist: **Staff and parents of school**. Year: 1977/1978.

Thornton Heath Library, Brigstock Road, Thornton Heath CR4 7JB. Title/Theme: Untitled. Children's Book Characters. Artist: **Karolyn Minich**, Library staff and children. Year: 1981.

BOROUGH: EALING

Southall Afro-Caribbean & Asian Arts Collective, Unit 16, Charles House, Bridge Road, Southall UB2 4DB (not on permanent display). Title/Theme: SOUTHALL BLACK RESISTANCE. Artist: **Chila Burman, Keith Piper**. Year: 1985.

210

BOROUGH: GREENWICH

40 Floyd Road SE7. Title/Theme: FLOYD ROAD. The Residents of the street preventing its demolition and working together for its rehabilitation. Artist: **GMW and Floyd Road residents**. Year: 1976.

Pound Park Nursery School, Pound Park Road SE7. Title/Theme: Untitled. Water animals, land animals. Artist: **GMW and parents of schoolchildren** Year: 1977.

Macey House, Thames Street, Greenwich SE10. Title/Theme: TOWARDS THE GOOD PLANET. Artist: **GMW with local residents** Year: 1980.

Rathmore Youth Centre, Rathmore Road, Charlton SE7. Title/Theme: CHARLTON PAST, PRESENT & FUTURE. Artist: **GMW with local residents**. Year: 1981.

Stairway, Stirling House, Connaught Estate, Sandy Hill Road, Woolwich SE18. (Interior). Title/Theme: Untitled. People of different cultures. Artist: **GMW with children of Mulgrave School**. Year: 1982.

269 Creek Road SE10. Title/Theme: WIND OF PEACE. The rejection of nuclear weapons by local people of all races. Artist: **Stephen Lobb, Carol Kenna, Chris Cardale, Viv Howard**. Year: 1983.

Macey House, Creek Road, Horseferry Place SE10. Title/Theme: CHANGING THE PICTURE. The people of El Salvador affecting change within their own lives. Artist: **Jane Gifford, Sergio Navarro, Nick Cuttermole, Rosie Skaife, D'Ingerthorpe**. Year: 1985.

BOROUGH: HACKNEY

Caribbean House, Bridport Place N1. Title/Theme: Untitled. Artist: **Free Form Arts Trust** with workers/users of community centre during Shoreditch Festival. Year: 1979.

Evering Road/Benthall Road, London N16. Title/Theme: THE ISLAND. Artist: **Free Form Arts Trust** + local residents. Year: 1980.

Kingsland Road, James Anderson Court, The Harmen Estate, London N1 (gable end mural + garden). Title/Theme: CITY GARDEN. Market gardening. Mural part of landscaping a small plot of land that reflects design of wall. Artist: **Free Form Arts Trust** + local residents) + Brian Walker. Year: 1980/1981.

Towpath of Laburnham Basin: Haggerston, London E2, near Queensbridge. Title/Theme: Untitled. London's Children— + illustrations of canal life and wildlife. Artist: **Free Form Arts Trust** + staff and children of Laburnham Primary School, Hackney Youth Workforce, Canal team: Fional Hamley— local printmaker; Maureen Mossdale and a special tutoring scheme. Year: 1982.

William Patten School, Newington Church Street, London N16. (front boundary wall). Title/Theme: Untitled. Everything good in life, enphasising the different cultures in the school. Artist: **Free Form Arts Trust** + Wm. Patten School children, staff & helpers; Parents/Friends Assoc; Hackney Adult

Education Inst, Alan—schoolkeeper. Year: 1982/1983.

Gayhurst School, off Gayhurst Street E8 (Inside infant school playground). Title/Theme: THE MAP PEOPLE OF LONDON FIELDS. A fantasy of two civilisations in London Fields Park thousands of years ago. One living underground in caves; one living in rainbow river; linking theme of 4 seasons. Artist: **Free Form Arts Trust** as community artist in residence, children, staff, parents & helpers of Gayhurst School. Year: 1982/1983.

Hackney Grove, off Reading Lane E8 (Mural + garden). Title/Theme: Untitled. Plant growth. Artist: **Free Form Arts Trust**, Hackney Grove Garden Group, staff/children of Hackney Free & Parochial School; visitors to the May Festival 1984. Year: 1982/1984.

Milton Gardens, Milton Gardens Estate, London N16. (Bounded by Andrew Marvel House, Browning House). Title/Theme: MILTON GARDENS. Morning, noon and night. Artist: **Free Form Arts Trust**, tenants & children of the estate, workers & children of Shakespeare Walk Adventure Playground, Superstructures; craftsman carpenter—Alex Carr. Year: 1982/1984.

Provost Estate, Murray Grove N1. Title/Theme: Untitled. The Thames river, scenes of life in Lodnon. Artist: **Free Form Arts Trust**, Provost Tenants Association. Year: 1984.

Ridley Road Market, Ridley Road/Kingsland High Street E8. Title/Theme: Untitled. Artist: **Free Form Arts Trust**. Year: 1985.

13 Dalston Lane, Hackney E8. (Opp. Dalston Junction Station). Title/Theme: THE HACKNEY PEACE CARNIVAL MURAL—based on Hackney Peace Carnival, 1983. Artist: **Original design**—Ray Walker, painted by Mike Jones, Anna Walker. Year: 1984/1985.

BOROUGH: HAMMERSMITH

Town House, Goldhawk Road, Shepherds Bush W6. Title/Theme: Untitled. Recording studios. Artist: **Ken White**. Year: (1978 repainted 1984).

Godolphin Road/St. Stephens Avenue, Shepherds Bush. Title/Theme: THE HUT. Artist: **M. J. Worrall, M. J. Harrison**. Year: 1979.

Samuel Lewis Sports, Samuel Lewis Trust Estate, Lisgar Terrace, Hammersmith W14. Title/Theme: Untitled. Artist: **M. Harrison, C. Thorp**. Year: 1982.

Norland Road Estate, (Kingsdale Gardens), Hammersmith W11. (West Cross Route). Title/Theme: Untitled. Garden Terraces. Artist: **M. Harrison, C. Thorp**. Year: 1984.

British Telecom Building, Uxbridge Road/Cunningham Road, London W12. Title/Theme: GLC Peace Mural. Artist: **Paul Butler**. Year: 1984/1985.

BOROUGH: HARINGEY

Umfreville Road, London N4. Title/Theme: RAILWAY FIELDS. Four seasons, developed as a learning resource. Artist: **Free form Arts Trust**, Railway Fields Assoc., children & adults from Railway Fields 1st Playscheme. Year: 1984.

BOROUGH: HOUNSLOW

Brentford Adult Training Centre, Middlesex. Dining Hall (Interior). Title/Theme: FOOD FOR THOUGHT. Artist: **Romarin Grazebrook** and assistants. Year: 1977/1979.

Wood Lane Hostel, Isleworth, Middlesex. Recreation Room (Interior). Title/Theme: GAMES. Artist: **Romarin Grazebrook** and assistant. Year: 1979/1980.

Charlton House, Albany Parade, Brentford, Middlesex. Entrance Hall (Interior). Title/Theme: JIGSAW MURAL. Artist: **Romarin Grazebrook** and L. B. Brent Venture Playgroup. Year: 1980.

Williams, Chemist Shop, Brentwood, Middx. Title/Theme: MAP OF BRENTWOOD. Artist: **Romarin Grazebrook** and L. B. Brent Venture Playgroup. Year: 1980.

Albany Road, Brentford, Middx. (rear of Charlton House. Title/Theme: OLD BRENTFORD. Artist: **Romarin Grazebrook** + local children. Year: 1980/1981.

Spring Grove Adult Education Centre, Charlton House, Brentord High Street, Ealing Road (Interior + exterior). Title/Theme: Untitled. Artist: **Romarin Grazebrook** + local children. Year: 1980/1981.

Brentford Adult Training Centre, Middlesex. Special Care Unit (Interior). Title/Theme: SHAPES & KITES. Artist: **Romarin Grazebrook, Joyce Flanagan** & assistants. Year: 1979/1982.

BOROUGH: ISLINGTON

Hornsey Lane Estate, Playhut, Hornsey Lane Estate N19. (Interior). Artist: **David Bangs** + children of Fishmount Junior School. Year: 1979.

Toffee Park Playground Sports Pitch, Ironmonger Row, Finsbury EC1. Title/Theme: TOFFEE PARK RULES!. Artist: **Dave Bangs**. Year: 1979.

Sir Philip Magnus Shool, Penton Rise, Kings Cross N1. Title/Theme: PATCHWORK. Artist: **ISEP** + staff and pupils. Year: 1979.

Newington Green Primary School, Matthias Road, Stoke Newington N16. Title/Theme: INSECT WALL. Artist: **ISEP** + staff and pupils. Year: 1980.

Elizabeth House Youth Club, Hurlock Street, off Blackstock Road, Finsbury Park N5. (Interior). Artist: **Dave Bangs** CSV, Operation Clean-up Islington, Mural Team. Year: 1981.

Lord Nelson Public House, Copenhagen Street, London N1. Title/Theme: Untitled. Artist: **Dave Bangs** with CSV, Operating Clean-up Islington Team. Year: 1981.

End wall, 119 Mildmay Road/Wolsey Road, London N1. Title/Theme: Untitled. Architecture. Artist: **Carolyne Beale** for AIM. Year: 1981.

Pitt & Scott Ltd., Eden Grove N7. (Visible from BR line only). Title/Theme: THE PITT & SCOTT MURAL. Artist: **Graham Crowley**. Year: 1981.

End wall, 25 Mildmay Park, London N1. Title/Theme: Untitled. Mildmay cyclists & tudor riders. Artist: **Mick Harrison AIM/C. Thorp**. Year: 1981.

Wooden Bridge Adventure Playground, Crouch Hill N4. Title/Theme: Untitled. Fairground. Artist: **Bruce Currie**. Year: 1981.

Tentants' Hall, Barnsbury Estate, off Caledonian Road N1. Title/Theme: GRIMALDI. Artist: **Bruce Currie** and **Sineid Codd**. CSV, Operation Clean-up Islington Mural team. (repaired due to rebuilding. Aug. 1983. Year: 1981.

Charles Lamb Junion School, Popham Road, London N1. (Interior. Title/Theme: UNDERWATER. "The deep sea, rising through the sea and the beach". Artist: **Dave Bangs** with CSV, Operation Clean-up Islington team. Year: 1981/1982.

Martin Luther King Centre + Freightliners Farm, Sheringham Road N7. Title/Theme: 25 YEARS OF MUSIC AND HISTORY. Artist: **Dave Bangs**, **Karen Gregory**, **Kim Bennett**, MSC team. Year: 1981/1982.

Martin Luther King Centre, Sheringham Road N7. Title/Theme: Untitled. Artist: **Dave Bangs** with CSV, Operation Clean-up Islington team. Year: 1981/1982.

Ironmonger Row Youth Centre, Ironmonger Row EC1. (Interior). Title/Theme: FROM PROTEST TO PROGRESS PORTRAIT FOR A GENERATION. Artist: **Des Rochfort**. Year: 1981.

Whittington Hospital, Highgate Hill N19. (Interior-corridor). Title/Theme: WOMEN IN MEDICINE. Artist: **Operation Clean-up Mural Team. Year: 1982.**

Highview Youth Club, Crouch Hill N4. (Interior). Title/Theme: Untitled. Carnival, carribean beach, Kung Fu. Artist: CSV Community Enterprise Project Mural Team. Year: 1982.

Barnsbury Youth & Play Project, 11 Barnsbury Road, London N1. (Interior). Title/Theme: Untitled. Artist: **Dave Bangs** with CSV, Operation Clean-up Islington team. Year: 1982.

Temporary Playground, Graham Street, off City Road, London N1. Title/Theme: Untitled. Artist: **Dave Bangs** with CSV, Operation Clean-up Islington team. Year: 1982.

Holloway Job Centre, Medina Road, London N7. (Interior). Title/Theme: Untitled. Artist: **Carolynne Beale** for SHAPE. Year: 1982.

Islington Green School, Prebend Street, N1. (Interior—3rd floor). Title/Theme: COMMUNICATION. Elements of communication. Artist: **ISEP**, with staff + pupils & students of Middx. Poly. Year: 1982.

Technical Department, Islington Green School, Prehend Street, N1. (Interior). Title/Theme: TECHNOLOGY. Tools, machines and technology. Artist: **ISEP**, with staff & pupils, students of Middx. Poly. Year: 1982.

Islington Green School, Prebend Street N1. (Interior—foyer of arts area). Title/Theme: Untitled. Art activities. Artist: **ISEP** and pupils. Year: 1982.

Islington Green School, Prebend Street N1. (Interior—foyer of biology area). Title/Theme: Untitled. Cell structures. Artist: ISEP staff & pupils. Year: 1982.

Islington Green School, Prebend Street N1. (Interior—maths dept.). Title/Theme: Untitled. Geometry. Artist: **ISEP** pupils. Year: 1982.

Highbury Park, London N5. Title/Theme: WALKING RHYTHM. Artist: **Jim Latter**. Year: 1982.

Lough Road Nursery N1. Title/Theme: Untitled. Nursery rhymes, fantasy. Artist: **Islington Mural Team.** Year: 1982.

Manor Gardens Centre, off Holloway Road, N. (Interior/exterior). Title/Theme: Abstract fantasy. Artist: **Jayne Cominetti**, Brigid De Saulles, **Mark Heksel. Year: 1982/1983.**

Bath Street Health Centre, near Old Street EC1. (Interior). Title/Theme: Untitled. Cartoon characters seaside fantasy. Artist: Mandy McCatin, Maureen Connolly. Year: 1982/1983.

Field End House Daycare Centre, Liverpool Road. (Interior). Title/Theme: Untitled. Landscape cartoon. Artist: **Richard Neshun**. Year: 1982/1983.

Islington Green School, Prebend Street N1. (Interior—music rooms). Title/Theme: Untitled. Music. Artist: **ISEP**/Staff & pupils. Year: 1983.

Islington Green School, Prebend Street N1. (Interior— gymnasium). Title/Theme: Untitled. Physical activity. Artist: **ISEP**/Staff & pupils. Year: 1983.

Islington Green School, Prebend Street N1. (Interior—5/6th floor stairwell). Title/Theme: Untitled. Artist: **David Cashman**. Year: 1983.

Simpson Memorial Library, Hanley Road, Finsbury Park. Title/Theme: GOING TO THE LIBRARY. Artist: **Maureen Connolly**. Year: 1983.

Charles Lamb Junior School, Popham Road N1. Title/Theme: OUTER SPACE. Aritst: **Richard Nesham, Mandy McCartin.** Year: 1983.

Rotherfield Junior School, N1. Title/Theme: Untitled. Alphabet fantasy children's designs. Artist: **Brigid De Saulles, Jayne Cominetti** & children of the school. Year: 1983.

Charten's Neighbourhood, Tenants' Co-operative, Chartens Road N1. Title/Theme: THE TENANTS CO-OP. The Co-operative. Artist: **Dave Bangs**. Year: 1983.

Mitre Pub, Copenhagen Street N1. Title/Theme: THE TOLPUDDLE MARTYRS—150th anniversary. **Dave Bangs**. Year: 1983/1984.

Winton School, Killick Street N1. Title/Theme: EASTERN. Artist: **Islington Mural**. Year: 1983/1984.

237 Pentonville Road, N1. Title/Theme: THE SANKOFA BIRD. Women and Peace. Artist: **London Wall**—Maggie Clyde, **Susan Elliott**, Sonia Martin, **Louise Vines**. Year: 1983/1984.

Archway Tube Station, Highgate Hill, Islington. (Roadway ramp). Artist: **Magnus Irvine**. Year: 1984.

Penton Primary School, Ritchie Street, N1. Title/Theme: Untitled. Mazes. Artist: **ISEP** staff & pupils. Year: 1984.

Rowstock Gardens Tower Blocks, off Holloway Road, N1. (Base of 4 tower blocks). Title/Theme: Untitled. Gardens. Artist: **Len Argent, Jayne**

Cominetti, Mandy McCartin, Maureen Connolly. Year: 1984.
Salvation Army Hostel, Middlesex Street, London EC1. (Interior). Title/Theme: Untitled. Artist: Theresa Witz with homeless men. Year: 1984.
Chequer Centre Adult Education Institute, Chequer Street, EC1. (Interior). Title/Theme: Untitled. Old fashioned interior. Artist: Theresa Witz with men from Salvation Army hostels. Year: 1985.
Blackston Road, Finsbury Park, outside Jack Ashley School, N4. Title/Theme: Evolution Mural. Artist: Magnus Irvine. Year: 1981.
Priory Green Estate, Kings Cross. Title/Theme: Priory Green, Old Laundry Mural, Historic Islington & Joey Grimaldi. Artist: Magnus Irvine. Year: 1983.
Priory Green Estate, Kings Cross. Title/Theme: Priory Green, Playground children's ideas. Artist: Magnus Irvine. Year: 1983.
Play Bus. Title/Theme: Single decker bus, mixed themes. Artist: Magnus Irvine. Year: 1983.
Archway Mall, N5. Title/Theme: Dick Whittington Story. Artist: Magnus Irvine. Year: 1984.
Fortune Street, EC1. Title/Theme: Local places and events. Artist: Magnus Irvine. Year: 1985.

BOROUGH: ROYAL BOROUGH KENSINGTON & CHELSEA

Virgin Mansions, Ladbroke Grove W10. Title/Theme: Virgin Offices. Artist: Ken White. Year: 1981.
Brompton Hospital, Out-patients Department, Fulham Hospital, Fulham Road, SW7. Title/Theme: THE BROMPTON HOSPITAL MURAL. Artist: Graham Crowley. Year: 1982.
Royal Marsden Hospital, Radio Therapy Department, Fulham Road, SW3 6JJ. Artist: Stephen Pusey. Year: 1982.
Cheyne Centre for Spastic Children, 61 Cheyne Walk, SW3. Title/Theme: Street Scene. Artist: Clive Hodgson. Year: 1983.
St. Stephen's Hospital, Entrance Foyer, Fulham Road, SW10. Title/Theme: Trompe l'oeil, History of hospital. Artist: Faye Carey. Organised by Public Arts Development Trust from a National Competition. Year: 1984.
Meanwhile Gardens, 156–158 Kensal Road, W10. Title/Theme: UNITY, EQUALITY & FREEDOM. Artist: Lubaina Himid, Simone Alexander. Year: 1985.

BOROUGH: KINGSTON-UPON-THAMES

Surbiton Station, Victoria Road, Surbiton. Title/Theme: Decorative ceiling. Artist: Sue Ridge. Year: 1984.
Surbiton Station, Victoria Road, Surbiton. Title/Theme: Figurative—local members of the public, station workers. Artist: Graham Willson. Year: 1984.

BOROUGH: LAMBETH

Wiltshire Road, SW9. Title/Theme: COSMIC PICTURE. Artist: Bernard Hanson. Year: 1976.

St. Matthews Meeting Place, Brixton Hill, SW2. (Interior—in cafe and nursery). Artist: Gordon Wilkinson—Brixton Mural Workshop. Year: 1978.
Streatham Place, London SW2. Title/Theme: Untitled. Arches on Angus & Cotton Houses. Artist: Unknown. Year: 1978/1979.
Wix Lane Infants' School, Wix Lane, SW4. Title/Theme: MONSTER MURAL. Monsters. Artist: Jane Gifford & infants. Year: 1979.
Loughborough Youth Club, Loughborough Road, Brixton SW2. (Interior). Title/Theme: Untitled. Artist: Dave Bangs & Karen Gregory. Year: 1979/1980.
Railton Road Youth Club & Methodist Church, Railton Road, Brixton SE24. (Interior). Title/Theme: Untitled. Artist: Karen Gregory & Kimberley Bennett. Year: 1980.
Probation Centre, 351 Croxted Road, SE24. (Interior). Title/Theme: Untitled. Brixton Market. Artist: Oliver Kay. Year: 1980.
Waterloo Station, Westminster Bridge Road, SE1. Title/Theme: Untitled. Portraits. Artist: Murals Unlimited. Year: 1980.
Santley School, Santley Street, SW4. Title/Theme: ZOO ANIMALS. Artist: Kevin Nessling—Medium Wave. Year: 1980.
Santley School Infants', Santley Street, SW4. (Semi-interior). Title/Theme: LEGENDS. Artist: Kevin Nessling—Medium Wave. Year: 1980.
Streatham Wells School, Palace Road, Tulse Hill, SW2. Title/Theme: Untitled. Artist: Paul Pestidge & school children. Year: 1980.
Angell Park Gardens, Angell Road, SW9. Title/Theme: PIANO HAND DANCE. Artist: Robert Wale. Year: 1980.
Stockwell Park Estate, Tenants Hall, Stockwell Park Road, SW9. Title/Theme: Untitled. Artist: Gordon Wilkinson. Year: 1980.
St. Martins Estate, Community Centre, Tulse Hill, SW2 (Interior). Title/Theme DOING THE SMETA SHUFFLE. Artist: M. Harrison. Year: 1980.
Dorset Road Community Centre, Melbury House, off Fentiman Road, SW18. Title/Theme: DORSET ROAD OASIS. Artist: M. Harrison, C. Thorp. Year: 1980.
Somersleyton Road & Coldharbour Lane, SW9. Title/Theme: NUCLEAR DAWN. Artist: Brian Barnes, Dale McCrea and volunteers from the housing association. Year: 1980/1981.
Dorset Road Estate, Community Centre, Fentiman Road, SW8. Title/Theme: Untitled. Artist: Mick Harrison. Year: 1980/1981.
St. Martins Estate Community Centre, Abbots Park, SW2. (Interior). Title/Theme: Untitled. Artist: Mick Harrison. Year: 1980/1981.
Loughborough Estate Community Centre, Loughborough Road/Barrington Road, London. Title/Theme: Untitled. Artist: Gordon Wilkinson. Year: 1980/1981.
Railton Road Method Mission, Railton Road, SE24. (Interior). Title/Theme: Untitled. Artist:

Karen Gregory—Supervised by **Gordon Wilkinson**. Year: 1980.

Tulse Hill Estate, Walkways, SW2. Title/Theme: PICASSO COPIES. Artist: **Andy Harman**. Year: 1981.

Gillian Frazer Centre, Landsdown Way, SW8. Title/Theme: ABSRACT LETTERS & SHAPES. Artist: **Kevin Nessling**. Year: 1981.

Lambeth Children's Play Bus. Title/Theme: BLUNDER BUS. Artist: **Gordon Wilkinson**. Year: 1981.

Play House, 136 Mayall Road, SE24. (Interior). Title/Theme: Untitled. Artist: **Brixton Mural**. Year: 1981/1982.

West Norwood Old Library, I.T. Centre. (Interior). Title/Theme: Untitled. Artist: **Sarah Faulkner**. Year: 1981/1982.

Loughton Road & Barrington Road, SW9. Title/Theme: THE LOUGHBOROUGH MURAL. Artist: **Sarah Faulkner, Gordon Wilkinson**. 1981/1982.

Astoria Cinema, Stockwell Park Walk, Brixton, SW9. Title/Theme: KIDS. Children's faces. Artist: **Stephen Pusey**. Year: 1981/1982.

Angell Day Nursery, Playground Wall, 50 Gresham Road, SW2. Title/Theme: OVERWATER UNDERWATER. Artist: **Brass Tacks Mural Group**. Year: 1982.

Jubilee Hall, Tulse Hill Estate, Brixton. Title/Theme: TULSE HILL JUNGLE. Artist: **M. Harrison, C. Thorp**. Year: 1982.

Brixton Training Centre, Electric Avenue, SW9. (Interior). Title/Theme: Untitled. Artist: **Sarah Faulkner**.

South Western Hospital, Community Psychiatry Dept., Landor Road, SW9. (Interior). Title/Theme: Untitled. Artist: **SHAPE— Alison Harper, Mary Crockett** with patients. Year: 1982.

Sir Wilfred Sheldon, Children's Centre, Prima Road (opp. Oval Tube Station), SW9. Title/Theme: Untitled. Children at the centre. Artist: **Mike Jones**. Year: 1982.

Oasis Karting Project, Priory Grove, SW8. Title/Theme: Untitled. Artist: **Lambeth Community Works Mural Project**. Year: 1982.

Old Loughborough Estate, SW9. Playsite. Title/Theme: Untitled. Artist: **Lambeth Community Works**. Year: 1982.

Play Space, Vauxhall Street, SE11. Title/Theme: Untitled. Artist: **Lambeth Community Works**. Year: 1982.

Stockwell Park Estates, Walkways. Title/Theme: Untitled. Artist: **Lambeth Community Works**. Year: 1982.

Vauxhall Gardens Estate. Playsite. Title/Theme: Untitled. Artist: **Lambeth Community Works**. Year: 1982.

Vauxhall Centre, Walnut Tree Walk, SE11. Title/Theme: ROOTS & SHOOTS. Artist: **Local residents**. Year: 1982.

Tulse Hill Estate, SW2. Title/Theme: NATURE GARDEN. Artist: **Sue Whall**. Year: 1982.

Vassal Road Neighbourhood Centre, Corner Vassall/Brixton Road, SW9. Title/Theme: TROPICAL SUNRISE. Rainbow over town. Artist: **Everton White**. Year: 1982.

Oval House Community Centre, Kennington Oval, SE11. Title/Theme: Untitled. Cafe, theatre, workshops, community interaction. Artist: **Brass Tacks Mural Group**. Year: 1982–1984.

Rushcroft Road/Vining Street, SW2. Title/Theme: WAR AND PEACE (WAR). Artist: **Pauline Harding**. Year: 1983.

Rushcroft Road/Vining Street, SW2. Title/Theme: WAR & PEACE (PEACE). Artist: **Dale McCrea**. Year: 1983.

Maulevere Road, SW2. Title/Theme: MAULEVERE ROAD MURAL. Forest and Brockwell Park. Artist: **Jane Gifford, Ruth Blench, Caroline Thorpe, Mick Harrison, Jonathan Leckie, Toots Silva, Richard Nonan** & children. Year: 1983.

Lytham Road, Ramillies Close, SW2. Title/Theme: BRIXTON WINDMILL. History of the windmill. Artist: **M. Harrison, C. Thorp** & children. Year: 1983.

Vauxhall Railway Station, main concourse. (Interior-vaulted ceiling). Title/Theme: Untitled. Abstract. Artist: **William Pye**. Year: 1984.

Woolworth Store, Coldharbour Lane/Brixton Road, SW2. Title/Theme: GOLDEN GARDEN. Brixton people, leisure activities, fantasy background. Artist: **London Wall**. Year: 1985.

56 Railton Road, Brixton. Title/Theme: THE DREAM, THE RUMOUR & THE POETS SONG. Artist: **Gavin Jantjes, Tom Joseph**. Year: 1985.

BOROUGH: LEWISHAM

Stillness Infants' School, Stillness Road, Brockley Rise, SE23. (Shed wall). Title/Theme: Untitled. Outer space. Artist: **Goldsmiths' College**. Year: 1979.

Rachel MacMillan Nursery, Deptford, SE8. (Nursery wall). Title/Theme: Untitled. Children in the countryside with animals. Artist: **Pam Palmer—Greenwich Mural Workshop**. Year: 1979.

Antony & Hatfield Estate, New Cross Road, SE14. Title/Theme: PILGRIMS. Theme as title. Artist: **South London Murals**. Year: 1979.

Heathside Estate Murals, Sparta Street, Lewisham. (4 gable ends). Title/Theme: Untitled. Artist: **South London Murals, Paul Prestige, Christopher Ryland**. Year: 1980.

Bridge House Meadows, Ilderton Road, SE16. Title/Theme: Untitled. People & children. Artist: **South London Murals**. Year: 1981.

1–13 Douglas Way, Deptford SE8. Title/Theme: Untitled. Olde tyme in Deptford. Artist: **South London Murals**. Year: 1981.

Hatfield Close/Old Kent Road, SE14. Title/Theme: FLOWERS & GARDENS. Artist: **South London Murals**. Year: 1981.

Hatfield Close/Old Kent Road, SE14. Title/Theme: LONDON VIEW OF GREENWICH. Artist: **South London Murals**. Year: 1981.
Sanford Street/Cold Blow Lane, New Cross, SE14. Title/Theme: RIDERS OF THE APOCALYPSE. Artist: **Brian Barnes, Glenn Barnes, Ray Walker, Jane Ray**. Year: 1983.
Crossfield Estate, Deptford, SE8. Title/Theme: Untitled. Artist: **Crossfield tenants**. Year: 1983.
Deptford Church Street/Frankham Street, Deptford, SE8. Title/Theme: THE PINK PALACE. quasi-Baroque facade. Artist: **Mary Maguire, Alex Lech, Paul Prestige** & friends of Crossfield Estate. Year: 1983.
Childeric School, Childeric Road, SE14. Title/Theme: Untitled. Artist: **Saleem Arif**. Year: 1984.
Sanford Street/Cold Blow Lane, SE14. Title/Theme: RIDERS OF THE APOCALYPSE. Artist: **Brian Barnes**. Year: 1984.
Mayesby Tower, Woodpecker Road, Milton Course, New Cross, SE14. Title/Theme: Untitled. Artist: **Wall Street Murals**. Year: 1984.
Playground, Daubenay Tower, Pepys Estate, London, SE8. Title/Theme: Untitled. Jungle scene. Year: 1984.
Docklands Poster, Evelyn Street, SE8. Title/Theme: Untitled. Photo-mural. Artist: **Peter Dunn, Lorraine Leeseon**—Docklands poster project. Year: 1984.

BOROUGH: NEWHAM
Newham District and General Hospital, Woodside Road, E13. (Interior—snack bar waiting room). Title/Theme: THE DANCERS. Artist: **Ray Walker**. Year: 1982.
Newham District and Hospital, Woodside Road, E13. (Interior— snack bar waiting room). Title/Theme: THE MUSICIANS. Artist: **Ray Walker**. Year: 1982.

BOROUGH: SOUTHWARK
Rear of National Theatre, Waterloo Road, SE1. Title/Theme: CALIBAN'S DREAM. (Bad condition). Artist: **Peter Pelz**. Year: 1977.
Vauxhall City Farm, Tyres Street, SE1. Title/Theme: CITY FARM. Artist: **Kevin Nessling**—Medium Wave. Year: 1978.
Concrete fencing of adventure playground, Bethwin Road, SE5. Title/Theme: Untitled. Scenes depicting history of area. Artist: **Free Form Arts Trust**. Year: 1979.
Bethwin Road Adventure Playground, SE15. Title/Theme: AFRKA MURAL. Portraits of everyone in the playground centred around African masks drummers, etc. Artist: **Jane Gifford** & children and playground workers. Year: 1980.
Waterloo Action Centre, Baylis Road, SE1. (Interior). Title/Theme: Untitled. Artist: **Mike Pope & London College of Printing**. Year: 1980.
Campbell Buildings, Baylis Road, SE1. Title/Theme: Untitled. Artist: **Waterloo Murals Group**.
Bethwin Road Adventure Playground, SE15. Title/Theme: KIDS PUB MURAL. A cross-section of the pubs behind the wall with kids. Artist: **Jane Gifford** + children and playground workers. Year: 1981.
Colombo Street, Sports & Social Club, 22 Colombo Street, SE1. (Interior). Title/Theme: Untitled. Artist: **Lynette Lombard**. 1981.
St. Albans Hall, Manor Place, SE17. (Interior). Title/Theme: ST. ALBANS HALL MURAL. Artist: **Christopher Ryland**—South London Murals + Pensioners' group. Year: 1981.
Imperial War Museum, London. Artistic Records. (Interior). Title/Theme: ARMY RECRUITMENT. Artist: **Ray Walker**. Year: 1981.
Addington Street, SE1. Title/Theme: BRITISH RAIL MURAL. Artist: **Carolynne Beale, Kate Morris**. Year: 1981/1982.
Marcus Lipton Youth Club, Minet Road, SE5. (Interior). Title/Theme: Untitled. Artist: **Sarah Faulkner**. Year: 1981/1982.
Maudsley Hospital Nursery Ward, Children's Dept., Camberwell, SE5. (Interior). Title/Theme: CHILDREN'S JUNGLE MURAL. Jungle scene. Aritst: **Liz Ellis** with staff and children. Year: 1983/1984.
Maudlsey Hospital Nursery Ward, Children's Dept., Camberwell, SE5. (Interior—activity games room). Title/Theme: CHILDREN'S CARNIVAL MURAL. Carnival. Artist: **Liz Ellis** with children of the ward. Year: 1984.
Maudsley Hospital Child Psychiatric Unit, Denmark Hill, SE5. (Interior). Title/Theme: Untitled. Artist: **Liz Ellis** with children in the hospital. Year: 1985.
The Dachwyng Family Centre, 2–3 Hordle Promenade East, North Peckham Estate, SE5. (Above Sumner Workshops). Title/Theme: Activities in the family centre. Artist: **Louise Vines**. Year: 1985.

BOROUGH: TOWER HAMLETS
Alpha Grove Community Centre (front of Centre), Alpha Grove, Isle of Dogs. Title/Theme: SKATEBOARDER. Artist: **Free Form Arts Trust, Alpha Grove Youth Club**. Year: 1976.
Mudchute Farm, Pier Street, Isle of Dogs, entrance boundary and car park. Title/Theme: MORNING AT MUDCHUTE portraits of workers and users arriving at the farm. Artist: **Free Form Arts Trust** + workers and users of Mudchute Farm. Year: 1978.
London Hospital Children's Ward, Whitechapel, E1. (Interior). Title/Theme: WINNIE THE POOH. Artist: **Mihele Bacciottini** for **SHAPE**. Year: 1978.
London Buddhist Centre, Globe Road, E2. Title/Theme: THE WIND HORSE spreading the teaching of the Buddha. Artist: **David Featherby**. Year: 1978.
St. George's Town Hall, Cable Street, Tower Hamlets. Title/Theme: THE BATTLE OF CABLE STREET. Artist: **Dave Binnington, Paul Butler, Desmond Rochford, Ray Walker**. Year: 1978/1983.
St. Clement's Hospital, Bow Road, E3. (Interior). Title/Theme: Untitled. Artist: **SHAPE—Rapheal Mergui** with psychiatric patients. Year: 1979.

215

Chicksand Street/Spelman Street, (off Brick Lane), E1. Title/Theme: PROMISED LAND—PLAYGROUND OF THE ABYSS. Artist: **Ray Walker** with some assistance from **THAP**. Year: 1979/1980.

Wapping Youth Club, Tench Street, E1. Title/Theme: Untitled. Town & Country Shops. Artist: **The 'A' Team**. Year: 1979/1980.

Crisp Street Market, Recreation Ground, Will Crooks Estate, Poplar High Street, E14. Title/Theme: THE THAMES RIVER. Artist: **The 'A' Team**. 1979/1980/1981.

Christchurch, Spitalfields, E1. Title/Theme: Untitled. Artist: **Carolynne Beale, Kate Morris**.

Mild End Hospital. Title/Theme: Untitled. Artist: **Community Industry**.

Victoria Park Wall, opposite Cadogan Terrace, E3. Title/Theme: Untitled. Artist: **Community Industry**.

Cotton Street, E14. (Adjacent to Woolmore School). Title/Theme: Untitled. Artist: **Jenni Lomax, Jeanette Sutton**.

London Hospital Outpatients, Whitechapel, E1. (Interior). Title/Theme: Untitled. Artist: **SHAPE—Applied Art Studio**. Year: 1980.

Victoria Park (Housing Trust) Shelters, E2. Title/Theme: Untitled. Landscape. Artist: **Jeanette Sutton**. Year: 1980.

East End Mission, Asian Girls Project, 583 Commercial Road, E1. (Interior). Title/Theme: Untitled. Landscape. Artist: **The 'A' Team**. Year: 1980.

Spitalfields Community Farm, Buxton Street, E1. Title/Theme: Untitled. Children and animals. Artist: **The 'A' Team**. Year: 1980.

Coventry Cross Estate, Gillender Street, E3. Title/Theme: Untitled. Fairground, shops and children playing, underwater scene. Artist: **The 'A' Team**. Year: 1980/1981.

Bethnal Green Adult Education Authority, Bethnal Green Road, E2. Title/Theme: Untitled. Artist: **K. Gregory, Kim Bennett**. Year: 1980/1982.

Burdett Matchbox, Burdett Estate, St. Paul's Way, E14. Title/Theme: Untitled. Abstract. Artist: **The 'A' Team**. Year: 1981.

East End Mission Coffee Bar, 583 Commercial Road, E1. (Interior). Title/Theme: Untitled. Picnic. Artist: **The 'A' Team**. Year: 1981.

Weavers Field Youth Club, Derbyshire Street, E2. Title/Theme: Untitled. Artist: **Mike Jones**. Year: 1981.

Bow Common Lane, Mile End Fields, E3. Title/Theme: THE PEASANTS REVOLT—commemoration of the Peasants Revolt. Wording. Artist: **Mike Jones, A. W. Co-op**. Year: 1981.

Old Ford Mission, Old Ford Road, E3. Title/Theme: OLD FORD MURAL. Animals, Fairy stories, River Thames, Dock scenes. Artist: **David Bratby**. Year: 1981/1982.

Redlands School, Redlands Road, E1. Title/Theme: Untitled. Dickens stories, Jungle scenes, Nursery characters. Artist: **Community Industry**. Year: 1981/1982.

John Scurr School, Tower Hamlets, E2. Title/Theme: Untitled. Athletics, gymnastics, music, chess, stories, John Scurr history. Year: 1981/1982.

Island Baths, Tiller Road, E14. (Interior). Title/Theme: SWIMMERS. Artist: **Will Adams**. Year: 1982.

Oxford House Youth Club, Derbyshire Street, E2. (Interior). Title/Theme: Untitled. Artist: **Will Adams**. Year: 1982.

Bethnal Green AEI, Bethnal Green Road, E2. (Playground). Title/Theme: Untitled. Artist: **Maria Cherslea**. Year: 1982.

Laburnham Basin, Haggerston, E2. Title/Theme: Untitled. Canel-side wild life + self-portraits of participating children. Artist: **Free Form** + **Laburnham Primary School**, local adults. Year: 1982.

Bethnal Green Hospital, Main Corridor, Cambridge Heath Road, London, E2. (Interior). Title/Theme: Untitled. Artist: **SHAPE—Applied Arts Studio**. Year: 1980.

Bow Common Lane, Mile End Fields, E3. Title/Theme: THE PEASANTS REVOLT—commemoration of the Peasants Revolt. Artist: **Ray Walker**. Year: 1981.

Poplar Turkish Baths, East India Dock Road, E14. (Interior). Title/Theme: Untitled. Artist: **Jeanette Sutton**. Year: 1981.

York Hall Turkish Baths, Old Ford Road, E2. (Interior). Title/Theme: Untitled. Artist: **Jeanete Sutton**. Year: 1981.

Blue Gate Fields School, Cable Street, E1. (Interior). Title/Theme: Untitled. Artist: **THAP—Mandy Berry, Denise Jones**. Year: 1981.

Glengall Grove Community Centre, Glengall Grove, E14. Title/Theme: Untitled. Artist: **THAP—Denise Jones, Mandy Berry**.

Bethnal Green Adult Education Centre, Bethnal Green Road, E2. Title/Theme: Untitled. Activities past and present of the Institute. Artist: **Dave Banks, Karen Gregory, Kimberley Bennett, Dennis Holmes** + local youth-centre users. Year: 1981/1982.

Bethnal Green AEI, Bethnal Green Rroad, E2. Title/Theme: Activities past and present of AEI. Artist: **Kim Bennett, Dennis Holmes, Karen Gregory**. Year: 1981.

Old Ford Methodist Church, 533 Old Ford Road, E3. Title/Theme: CROSSING THE RED SEA. Bicyclists crossing a main road. Artist: **David Bratby**. Year: 1981/1982.

London Hospital, General Ward/corridors, Whitechapel, E1. (Interior). Title/Theme: Untitled. Artist: **Applied Arts Studio** (manager: **Michele Bacciottini**) for SHAPE. Year: 1982.

Ensign Club, 59 Cable Street, E1. Title/Theme: SPACE. The planets, space. Artist: **The 'A' Team**. Year: 1982.

Charles Blaber Nursery. Title/Theme: Untitled. Nursery characters. Year: 1982/1983.

Gypsy Horse Far, Eleanor Street, Bow, E3. Title/Theme: GYPSY HORSE FAIR. Artist: **David Bratby**. Year: 1983.

St. Mary's & St. Michael's School, Sutton Street, E1. Title/Theme: O'MEARA'S FARM. Farm animals. Artist: **David Bratby**. Year: 1983.

Basil House Courtyard Mosaic, Henriques Street (off Commercial Road), E1. Title/Theme: THE DREAM OF YADWIGHA. Copy of Henri Rousseau's original painting. Artist: **Patsy Hans**. Year: 1983.

Harbinger Junior School, Harbinger Road, E14. Title/Theme: Untitled. Cutty Sark Pirates, Transport, Fairy Stories. Year: 1983/1984.

St. John's Community Association, Glengall Grove, E13. (Interior). Title/Theme: Untitled. Founding of National Union of Stevedores of Millwall. Artist: **Bernard Canavan**. Year: 1984.

St. Edmunds School, West Ferry Road, E14. Title/Theme: ABC MURAL. The alphabet (a learning aid). Aritst: **Patsy Hans David Bratby**. Year: 1984.

Berner Tenants', Women's Centre, Philchurch Place, off Ellen Street, E1. Title/Theme: Untitled: Tree of life. Artist: **Patsy Hans**. Year: 1984.

Bow North Youth Club, Parnell Road, E3. Title/Theme: Untitled. American skyline + graffiti, London skyline + neon signs—2 murals. Artist: **Jeanette Sutton**. Year: 1984.

Poplar & Berger Community Centre. Title/Theme: Untitled. The Seaside. Artist: **Jeanette Sutton**. Year: 1984.

Redlands School, Redmans Road, E1. Title/Theme: REDMANS ROAD MURAL. Food of different cultures. Artist: **Tower Hamlets' Women's Mural Team**. Year: 1984.

Marion Richardson School, 71 Senrab Street, E1. Title/Theme: Untitled. Dancing, folk stories, landscape, sports, St. Katherine's Dock. Year: 1984.

Avenues Unlimited, 162A Brick Lane, E1. (Interior). Title/Theme: Bangladeshi animals, people, alphabet, houses. Artist: **Local girls** + two project workers. Year: 1984.

Lowood Street, E1. Title/Theme: ACROSS THE BARRIER. Artist: **Shanti Panchal Dushlea Ahmad**. Year: 1985.

BOROUGH: WALTHAM FOREST

Leytonstone House, Green Man roundabout, Leytonstone, E17. (Interior). Title/Theme: Untitled. Artist: **Robert Drew, David Cullen**. Year: 1984.

BOROUGH: WANDSWORTH

Thessaly Road/Wandsworth Road, London SW8. Title/Theme: SEASIDE MURAL. Artist: **Brian Barnes WARP**. Year: 1978/1979.

St. Peter & St. Paul, Plough Road, SW11. Title/Theme: BATTERSEA PUZZLE. Artist: **Christine Thomas WARP**. Year: 1981.

BOROUGH: WESTMINSTER

East Harrow Road, W9. (under Westway, near Royal Oak Tube). Title/Theme: OFFICE WORK. Artist: **David Binnington**. Year: 1977.

North Wall, Harrow Road, W9 (under Westway, near Royal Oak Tube). Title/Theme: THE CONSTRUCTIN WORKERS. Artist: **D. Rochfort**. Year: 1977.

Earlham Street. Frontage of 144 Shaftesbury Avenue, WC2. Title/Theme: Untitled. Artist: **Stephen Pussey**. Year: 1977/1978.

Lisson Grove Underpass, East Side, London. Title/Theme: Untitled. Artist: **Tim Brown/Cockpit Theatre + Arts Workshop**. Year: 1979.

Community House Information Centre, Derry House, Penfold Street, NW8. Title/Theme: Untitled. Artist: **Unknown**. 1979/1980.

Lisson Grove Children's Sports & Recreation Centre, Lisson Grove, Penfold Street, NW8. (Including slide mound). Title/Theme: Untitled. Undersea bubble and creatures based on Paul Klee's drawings. Artist: **David Bangs, Karen Gregory, Kimberley Bennett, Dennis Holmes**. Year: 1980.

Sussex Gardens Children's Playground, Sussex Gardens, Pimlico, W2. Title/Theme: Untitled. Artist: **David Bangs, Karen Gregory, Kimberley Bennett, + Denis Holmes**. Year: 1980.

St. Mary's Church Hall, Paddington. (By the fly-over). Title/Theme: Untitled. Classical sculpture trompe l'oeil niches. Artist: **Quinlan Terry**. Year: 1981.

St. Clement Dane's Junior School, Drury Lane, WC2. Title/Theme: Untitled. Nursery rhymes and stories. Artist: **Jane Gifford**. Year: 1982.

Covent Garden Mural, Covent Garden Piazza, WC2. Title/Theme: Untitled. Trompe l'oeil building. Artist: **Ken White**. Year: 1982.

Jubilee Hall Redevelopment Site, The Piazza, Covent Garden, Southampton Street/Tavistock Street, WC2. Title/Theme: FRUIT AND VEG. Artist: **Free Form Arts Trust** in consultation with the Consortium Traders and other local interests. Year: 1985.

MURALS IN SWINDON

GEORGE AND THE DRAGON
After Uccello, Rodbourne Road, Painted 1975, by young people from a local school. Restored 1985, by **Martin Shipp, Sue Wilkins, Judy Foote, Sarah Faulkner**. Funded by Thamesdown Community Arts (TCA) and Mike Knight Tyres Ltd.

GOLDEN LION BRIDGE
Painted by **Ken White** 1976, Whale Bridge Roundabout. Commissioned by Job Creation Scheme.

KING CLASS LOCOMOTIVE PASSING THROUGH SWINDON RAILWAY WORKS
Henry Street. Painted 1976 by **Terry Court, Ken White**, and members of TCA. Restored 1985 by

Kate Dawson, Jack Wharam, Jo Honeybone, Sarah Faulkner and members of The Probation Day Centre. Funded by Allied Dunbar and Brunel Scaffolding.

PLAYGROUND MURAL. LETHBRIDGE ROAD INFANTS SCHOOL 1979
Painted by **Ken White**, and members of Job Creation Project. (In need of renovation or renewal).

SWINDON PERSONALITIES
Union Street 1979 25ft. Designed by **Ken White** and painted in association with students from Swindon College.

SWINDON JUNCTION RAILWAY STATION 1901
1979 Alexandra Road. Designed and painted by school students, under the direction of **Brian Hamley**. Funded by Urban Aid Improvement Grant.

CAMBRIA BRIDGE
1980 Cambria Bridge Road. 260ft long. Artist: **Ken White**. Commissioned by TCA with funds from the Arts Council.

50 YEARS OF VOLUNTARY EFFORT
Ifley Road. Artist: **Ken White** with assistance from young unemployed people. 1982 Thamesdown Hambro Festival.

SWINDON CELEBRITIES
Pedestrian ramp to lower ground floor. Brunel Centre 1984. Artist: **Ken White**. Commissioned by Traders: Brunel Centre.

OASIS
Oasis Swimming Pool. 1984. Artist: **Ken White**. Commissioned by Thamesdown Borough Council.

WEIGHT LIFTERS
Swindon Body Builders. Ex Rail Works, London Street. 1984. Artist: **Ken White**. Commissioned by Swindon Body Builders.

PLAYGROUND MURAL
Gladstone Street School. 1985. Director: **Alistair Kendry**. Commissioned by Gladstone Street School.

ARKELLS BREWERY
County Road. 1985. Designed and painted by **Sarah Faulkner**. Commissioned by Arkells Brewery to celebrate their existance in Swindon since 1843.

PARADISE ISLAND
Eldene Shopping Centre. 1985. Designed and painted by **Kate Dawson** and **Jack Wharam** and children from Eldene Junion School. Funded by NACRO.

Model for 'Chanting Heads' by Keith Piper, Artangel Trust collaboration

CACTUS HOUSE MURAL
Queens Park. 1985. Artist: **Sarah Faulkner**. Commissioned by Thamesdown Borough Council.

PRINCESS MARGARET HOSPITAL
Art Project. Okus, Swindon 1985/6. Murals and ceiling—works in children's wards. Designed and painted by **Jack Wharam** and **Kate Dawson**. Commissioned by Allied Dunbar, Princess Margaret Hospital, TCA and Manpower Services Commission.

PENHILL NEIGHBOURHOOD CENTRE.
Youth Mural Project. Director: **Jack Wharam** and **Kate Dawson**. 1986. Funded by Wiltshire Social Services.

AMAZON THE SHE-HULK
1986. Subway-Dorcan Way. Dorcan School mural project. Director: **Sarah Faulkner**. Funded by NACRO.

SWINDON STATION
1986. Signal Way. Artist: **Leslie Holland**. With support from Friends of The Earth and Swindon Bike Group.

TOWN HALL STUDIOS MURAL
Entrance foyer. Regents Circus. 1986. Designed and painted by **Jack Wharam** and **Kate Dawson**. Commissioned by Thamesdown Community Arts.

COUNTY SCENE
Cavendish Square. Park South. Artist: **Ken White**. 1987. Funded by Thamesdown Borough Council.

STREET SCENE
The Old Chapel, Regent Street. Designed and printed by SWOP Trainees. Director: **Kevin Fitchett**. Funded by Swindon Work Opportunities Programme.

'NATURE—MOTHER OF THE ARTS'
Dance Studio. Town Hall Studios. Regents Circus. Artist: **Carleton Attwood**. 1979—Fresco.

WALL FLIERS
Dance Studio. Town Hall Studios. Regents Circus. Artist: **Jel Jones**. 1987. Funded by Thamesdown Community Arts.

BIRDS
Princess Margaret Hospital, Okus. Artist: **Mel Jones**. 1987. Funded by Thamesdown Communty Arts.

BEYOND THE NURSERY DOOR
Plus One Centre, Beckhampton Street. Artist: **Simone Alexander**. 1987. Funded by Southern Arts Association, Wiltshire County Council, Thamesdown Community Arts.

WOMAN AND CHILD
Milton Road Health Hydro. Artists: **Andy Rogers, Nick Drew**. 1987. Funded by Thamesdown Borough Council.

SWIMMING POOL MURAL
Wroughton Sports Centre. Inverary Road, Wroughton. Artist: **Chris Moss**. 1987. Funded by Wroughton Sports Centre, Borough of Thamesdown.
Further Information: **Jolliffe Arts Studio**, Wyvern Theatre, Theatre Square, Swindon, Wilts. SN1 1QT.

PUBLIC SCULPTURES

The Yorkshire Sculpture Park, Bretton Hall College, West Bretton, Wakefield, W. Yorks WF4 4LG. Tel. 092-485 261. Contact: Peter Murray. The Sculpture Park has a steadily growing collection of sculpture and also mounts temporary exhibitions.

South Hill Park Arts Centre, Bracknell, Berks. Tel. 0344 27272. The grounds of the Arts Centre contains a permanent collection of outdoor sculpture, including work by Wendy Smith.

Scottish Sculpture Trust, 2 Bank Street, Inverkeithing, Fife. Tel. Inverkeithing 412811. Contact: Barbara Grigor. The Trust displays two permanent exhibitions—'Sculpture in Landscape' at Landmark, Carrbridge, Inverness-shire, and at Glenshee in the mountains of Perthshire. At Glenshee, five sculptures stand on a bare hillside, near the skiing centre. At Landmark eighteen sculptures are placed in a Sculpture park on the edge of a forest. Artists whose works are exhibited are— Denis Barns, Anthony Caro, Hubert Dalwood, JohnFoster, Catherine Gili, Jake Kempsell, Roy Kitchen, Gerald Laing, Andrew Mylius, John Panting, Eduardo Paolozzi, William Pye, Malcolm Robertson, Gavin Scobie and Anthony Smart.

Glenrothes, Fife. A new town halfway between Edinburgh and Dundee, had David Harding as a 'town artist' from1968 onwards. He produced several sculptures on various sites, some in collaboration with other artists and poets. Other artists involved were—Alan Bold, John Gray, Malcolm Robertson, Hugh Graham.

Welsh Sculpture Trust, 6 Cathedral Road, Cardiff. Tel. 0222 374102. (Tamara Krikorian, Director).

Public Art Development Trust, 6–8 Rosebery Avenue, London EC1. Tel. 01-837 6070. Director: Lesley Greene. (see article at the beginning of the Public Art Section).

John McEwen sculpture at Yorkshire Sculpture Park

Chapter 7
THE ROLE OF THE ARTS COUNCIL, THE BRITISH COUNCIL AND THE REGIONAL ARTS ASSOCIATIONS

THE ROLE OF THE BRITISH COUNCIL

The British Council differs from apparently comparable organisations by reason of its function as in effect the cultural aim of the Diplomatic Service. The aim of arts work in the Council has been defined as "to help establish British achievement in the creative and performing arts as an accepted valued part of the cultural life of people of other countries".

The Council was instituted in 1934 with the principal aim of promoting the English language and the image of Britan abroad. It maintains a representation in countries were diplomatic relations exist and works closely with the British embassies in each country. In some countries the representative is also the embassy's cultural attaché, although the Council premises may be independent of the embassy. In countries where appropriate, subsidiary regional offices are established in addition to the main office in the capital.

In London the headquarters building in Spring Garden houses the co-ordinating administrative departments and throughout the UK, generally in university towns, there are local regional offices.

The Council is principally concerned with the teaching of English; with technical training of all kinds, either by sending teachers abroad or by sponsoring foreign students at British universities, art colleges and other educational institutions. It sends specialists to give lectures or tours on invitation from institutions abroad and arranges visits for foreign experts sent here on the recommendation of representatives in their countries.

Arts division departments, based in London, are concerned broadly with exporting British culture, by arranging tours by drama companies, orchestras, music groups or soloists, ballet companies, poets and writers. Fine arts department deals with the visual arts and general exhibitions with technical and didactic exhibitions.

Thus the Council does not exist primarily to help artists, although this is very often a result of its promotional activities. A proportion of fine arts department's exhibition work is concerned with pre-20th century art but there is a growing emphasis on living artists as the security and conservation hazards of handling old master works increase.

The department's **exhibition programme** is planned in response to requests from institutions abroad, generally through the representative but sometimes directly, for specific project. At any given time there is a long queue of proposals, which are considered by the Fine Arts Advisory Committee and incorporated into the programme as budget and staff time allow. If a proposal leaves a measure of selection to the Council, a small committee or a single expert is invited to make an appropriate choice of artists for the event. Broadly speaking the criteria for selection of artists would be their intrinsic merit, as assessment of their potential, their relevance to the particular event and their relevance in an international context.

Exhibitions handled by the Department fall into 3 categories: **loan exhibitions, using work borrowed from institutions** or individuals for a limited period of time; **the official British section of an international event** such as the Venice Biennale; and **circulating exhibitions** which are small permanent travelling exhibitions made up from works bought for the Council's collection. Additionally the department may sometimes make a financial contribution to an institution in Britain or abroad which is organising an exhibition of British art for showing overseas.

Limited help for individuals is available through the **grants to artists scheme**, where artists who have secured a definite invitation to exhibit abroad may apply for a grant towards the expenses of transport or fares. The scheme is administered by a small committee which meets quarterly to consider applications and awards are made on the basis of artistic merit and the suitability of the event in relation to Council policy in the country. A smaller fund is available to help with attendance at professional conferences by delegates who have been invited to make a specific contribution to the meeting, such as a paper or

workshop. Fine arts department is responsible also for manifestations involving performance artists, video, artists' films and crafts.

The Council's collection has been built up over 40 years and now constitutes one of the principal public collections of modern British art. Acquisitions are made from an annual allocation and major purchases are considered by a sub-committee of the Fine Arts Advisory Committee. The collection is functional and almost all purchases are made with a specific purpose in mind, either as constituents of new circulating exhibitions, as supplements to loan exhibitions, or as decoration for Council premises overseas, since these are frequently buildings with public rooms affording good opportunities for the display of works of art. Loans from the collection are made to exhibitions organised by other bodies in Britain and abroad. A catalogue is available, but the store where works not currently in use are kept is not normally accessible to the public, for practical reasons of security.

The Department's **information service** covers a wide range of resources. The Advisory Services Officer deals with enquiries received from aborad relating to British art educational facilities and advice may be sought by artists and administrators on educational institutions overseas. Many enquiries on scholarships, bursaries, fellowships and residencies are however referred to foreign embassies as the Council does not itself administer any awards of this kind. The Advisory Services Officer also deals with recommending suitable specialists for visits abroad as requested by representatives, such as artists to hold workshops, lectures or run summer schools.

Additional information services include a **reference library of publications on British art, a photo-library and slide collection,** all of which are accessible to members of the public who have a particular reason to consult them. Enquirers should write or telphone in advance for an appointment.

Muriel Wilson
Fine Art Department
The British Council
11 Portland Place
London W1.

ARTS COUNCIL OF GREAT BRITAIN

105 Piccadilly, London W1. Tel. 01-629 9495. Information Dept., open 2pm onwards weekdays.

The administration of Arts Council exhibitions, the Arts Council Collection and Art Publications, transferred from 105 Piccadilly, London W1., to the South Bank Centre. All other departments including film and video are still at 105 Piccadilly. Sandy Nairne, Art Director is also at 105 Piccadilly.

The South Bank Centre, Royal Festival Hall, Belvedere Road, London SE1 8XX. The telephone number of the main switchbord at the Royal Festival Hall is 01921 0600. *Telegrams:* Festhall London. *Telex:* 929 226 SBBG. *Fax:* 928 0063.

Joanna Drew	*Director, Hayward & Regional Exhibitions*
Andrew Dempsey	*Assistant Director, Hayward Gallery*
Michael Harrison	*Assistant Director, Regional Exhibitions*
Caroline Collier	*Exhibition Organiser*
Susan Ferleger Brades	*Exhibition Organiser*
Lynne Green	*Exhibition Organiser*
Roger Malbert	*Exhibition Organiser*
Isobel Johnstone	*Curator, Arts Council Collection*
Barbara King	*Bookings Assistant*
Hazel King	*Art Administration*
Pam Griffin	*Art Records*
Jeff Watson	*Overseas Transport*
Joan Asquith	*Art Publicity (Marketing Dept)*
Tania Butler	*Publications (Marketing Dept)*
Helen Luckett	*Art Education*
Julia Peyton-Jones	*Sponsorship*

Aim: "To improve the knowledge, understanding and practice of the arts; and to increase the accessibility of the arts to the public".

Funds for dance, drama, literature, music, opera and the visual arts.

1. The Hayward and Serpentine galleries in London now run from the South Bank Centre, London SE1 8XX.

2. Annual report published each autumn with details of the Council's work and finances.

3. Bi monthly bulletin with Arts Council information.

4. ACGB publications include: Directory of Arts Centres; Festivals in Great Britain; Guide to Awards and Schemes. **The ex Arts Council Shop,** 8 Longacre, London WC2. Tel. 01-836 1359 is now owned by Dillons, but still specialises in arts books.

5. Booklet. The Arts Council of Great Britain—What it does.

6. Major awards and bursaries for artists. See **Awards Chapter 3.**

7. An Eduction Liaison Officer to encourage co-operation between arts organisations and education providers at all levels.

8. Funds for Housing the Arts goes towards the cost of building new theatres, art centres, galleries and concert halls.

9. Grants towards running art organisations.

An example of grants: 4 national companies Covent Garden (Royal Opera and Royal Ballet); National Theatre; English National Opera; Royal Shakespeare Company; 4 symphony orchestras in London and 4 in the regions; 60 regional theatres; 40 small drama companies; 7 national and regional dance organisations; 21 major music and arts festivals; 10 arts centres; 17 galleries that mount exhibitions of art and photography.

10. Administers training schemes for arts administrators, actors, directors, designers and performers. **ACGB Arts Administration courses.** In service and prior to first employment as an administrator.

11. Tours by dance, drama and opera companies and tours of contemporary music and arts films.

12. Specialist panels to choose awards annually.

13. Touring art exhibitions. e.g. The British Art Show chosen by William Packer.

14. Awards to performance artists at certain galleries.

15. Major art exhibitions at the Hayward and the Serpentine.

16. Annual shows open to professional artists to enter for at the Sepentine gallery. Exhibitions during the summer months.

17. Purchases for Arts Council of Great Britain art collection.

18. Selective slide index open to the public at the Serpentine Gallery, London W2. Contact: Alister Warman for details.

SCOTTISH ARTS COUNCIL

19 Charlotte Square, Edinburgh EH2 4DF. Tel. 031-226 6051. Art Director: Lindsay Gordon.

Assistance To Organisations

Organisations may receive contributions towards:

running visual arts programmes or services for the benefit of the public and artists in Scotland.

improving temporary exhibition spaces.

employing artists or commissioning, hiring or buying works of contemporary art for public display.

researching, organising and mounting exhibitions.

hiring exhibitions.

Assistance To Organisations

Individuals can benefit from:

bursaries, to 'buy time' or to travel.

awards, which enable artists to purchase materials and mount exhibitions.

small assistance grants for various projects, including exhibitions, materials and studio conversions.

commissions and assisted purchases, which assist artists by encouraging institutions to commission, purchase or hire contemporary works of art (SAC's contribution will be between 25 and 50 per cent of the costs).

fellowships, residencies and other posts for professional artists.

travel/exchange grants, which enable artists and art administrators to attend conferences and courses outwith Scotland, and which assist similar professionals to come to Scotland.

in-service training grants for those working in visual arts promotion.

Directly Promoted Services

The Art Department carries out the following services:

Collection of Works of Art. Over the last 25 years, SAC has been purchasing works of art from artists living and working in Scotland for use in exhibitions and for rental to publicly-accessible sites. Any organisation, firm, hospital, school, factory, gallery, etc. may hire works for display for periods of one or two years for a nominal charge.

Travelling Gallery. The Council's Travelling Gallery, sponsored by Scottish Provident, takes exhibitions into areas which often have no galleries, visiting schools, factories, hospitals, shopping centres, village squares and local festivals.

Exhibitions. The Council operates a programme of touring exhibitions on a variety of subjects which is available to museums and galleries throughout Scotland.

Scottish Exhibition Bulletin. Published three times a year (together with the Council for Museums and Galleries in Scotland), the bulletin lists all the art exhibitions in Scotland which are available for hire.

Artists' Register. A register of biographical and exhibition details and slides of work of visual artists living and working in Scotland is maintained to assist those seeking information on Scottish contemporary visual arts.

Lecture and Film Hire Schemes. The department publishes lists of lectures and films on the visual arts and operates a booking service for arts clubs in Scotland.

223

Catalogues. The department has published a large number of exhibition catalogues. A full price list is available, which also gives details of posters and postcards.

WELSH ARTS COUNCIL

Museum Place, Cardiff CF1 3NX. Tel. 0222 394711.

North Wales Association for the Arts, 10 Wellfield House, Bangor, Gwynedd. Tel. 0248 353248. Area: Clwyd, Gwynedd, and the District of Montgomery in the County of Powys.

South East Wales Association, Victoria Street, Cwmbran, Gwent. Tel. 063 33 75075. Area: City of Cardiff, Gwent, Mid Glamorgan, Districts of Radnor and Brecknock in the County of Powys.

West Wales Association for the Arts, Dark Gate, Red Street, Carmarthen, Dyfed. Tel. 0267 23 4248. Area: Dyfed, West Glamorgan.

Welsh Arts Council. See Chapter 3 Awards section for details of major awards open to Welsh artists. Supports the Association of Artists and designers in Wales. See "Studios" Chapter 1. Has its own gallery—Oriel gallery in Cardiff— primarily for exhibitions of work of artists in Wales or with Welsh connections. Work by artists throughout Wales. One-off awards also for individual artists. Aid for artists organisations and art galleries. Purchases for Welsh Arts Council collection. Contact: Visual Arts Officer for further details. Register of artists working in Wales and slide index for consultation purposes.

North Wales Association for the Arts. Compiling an index of artists working in North Wales in conjunction with the Mostyn gallery Llandudno.

ARTS COUNCIL OF NORTHERN IRELAND

181A Stranmillis Road, Belfast. Tel. 0232 381591. Committees for art, drama, film, literature, music, traditional arts and community ats. Art director: Brian Ferran.

1. Major awards and bursaries (see Chapter 1 for Awards section).
2. Annual report listing events supported and awards given and other details.
3. Rome Fellowship to study at the British School at Rome.
4. Bass Ireland Arts Award.
5. Community arts—local performances in music and drama—very active in Belfast.
6. Film directions published quarterly.
7. Regional development committee—Young Arts, Youth Drama and Community Arts.
8. Artslink mailing to 7500 subscribers with information about the arts in Northern Ireland.
9. Young Arts has initiated several projects to encourage art activity in shools. Editions of prints available to schools for pupils to look at.
10. Exhibitions in Northern Ireland.
11. Permanent collection. New works acquired by Northern Ireland artists.
12. Print workshop at the above address in Belfast which is run very successfully and professional printmakers can work there.
13. Touring print exhibitions to galleries and arts centres throughout Northern Ireland.
14. Register of Northern Ireland Artists with slides of their work. The public art administrators, gallery owners and other potential buyers can refer to this. Enquire at the above address.

GREATER LONDON ARTS ASSOCIATION

9 White Lion Street, London N1 9TD. Tel. 01-837 8808. Visual Arts Officer: Alan Haydon. Area: Greater London.

1. Awards and bursaries. See Chapter 3 "Awards" section for further details.
2. Runs "Artswork" a free magazine with art news, events, views and other useful information.
3. Contact with local arts organisations, schools, colleges and general contact with London arts events.
4. Supports local festivals and ethnic minorities arts events as well as performance, video, film, photography and other art related events.

LINCOLNSHIRE & HUMBERSIDE ARTS

St. Hugh's, Newport, Lincoln. LN1 3DN. Tel. 0522 33555. Principal Officer, Visual Arts: Alan Humberstone. Area: Lincolnshire and Humberside.

1. Financial support/grant aid schemes.
2. Visual arts slide index and register of regional artists, craftspeople, photographers and individuals working in time based media.
3. Exhibition venues forum.
4. Craft marketing advice.
5. Advice and information services.
6. Art and craft news—bi-monthly newsletter for practitioners.
7. Arts diary—bi-monthly magazine and diary of events.
8. Artsaction—education newsletter.

WEST MIDLAND ARTS

82 Granville Street, Birmingham B1 2LH. Tel. 021-631 3121. Visual Arts Officer: Julie Seddon Jones. Area: Counties of Hereford, Worcester, Metropolitan County of West Midlands, Shropshire, Staffordshire and Warwickshire.

1. Major awards and bursaries (see Chapter 1 for awards section).
2. Diary poster for the areas arts events.
3. Artspost—mailing service for individuals.
4. Monthly bulletin available to all organisations with arts interests.
5. Book on *Artist, Craftsmen and Photographers in the West Midlands*
A very effective way of listing artists in the area. Details of all the artists and photographs in black and white of their work listing address, name, details of where they work and where they have exhibited. A section for each category. 210 artists in all. At the back it also lists galleries in the area, museums, arts centres, craft shops and organisations.
6. Slide index also and artists register with additional names and addresses of those not already in the book mentioned above.
7. Touring exhibitions.
8. Collection of artists work.
9. General advice available about artists in the area.

SOUTH WEST ARTS

Bradninch, Gandy Street, Exeter EX4 3LS. Tel. 0392 218188. Visual Arts Officer: Christine Ross. Area: Avon, Cornwall, Devon, Dorset, Gloucestershire and Somerset.

Music, theatre, visual arts, film and video, literature, dance and community arts. **Leaflets available:** South West Arts At Your Service; Our Grants and Awards; Transport and Subsidy Scheme; How we work; Services to Amateurs.

1. Arts South West. News about the arts in the south west area, available every two months with diary of events. Free of charge to indvduals and organisations.
2. Annual report.
3. South West Review—appears three times a year.
4. Information centre at 23 Southernhay East, Exeter, Devon. Bookshop for art, poetry, fiction and catalogues.
5. Transport subsidy scheme. Parties of 10 or more people travelling to professional arts events by coach or public transport are entitled to a refund of up to half the travel costs, subject to certain conditions being fulfilled.
6. Touring exhibitions in the area.
7. Artists and craftsmen lecture service in the area.
8. See more art schemes.
9. Artist and craftsmen exhibition schemes.
10. A slide index and register of addresses of professional artists and craftsmen and photographers working in the area.
11. Hire of film and video equipment. Cameras, projectors, splicers and screens. Contact the film officer.
12. Specialist advisory service for individuals and organisations throughout the region.
13. **South West Film Directory** which lists films made in the south west region with South West Arts funding and projects in film done in local schools. Useful books at the back.
14. Register of South West Artists.
15. Contact for SHAPE (see Survival section Chapter 3).

YORKSHIRE ARTS ASSOCIATION

Glyde House, Glydegate, Bradford BD5 0BQ. Tel. 0274 723051. Visual Arts Officer: Yvonne Dean. Area: North Yorkshire, South Yorkshire and West Yorkshire.

1. Major awards and bursaries (see Chapter 3 for awards section).
2. Register of artists working in the area. Slide index.
3. Arts diary listing arts events in the area and art news.
4. Touring exhibitions.
5. Festivals and projects.
6. Contact with local arts organisations and schools and colleges in the area.
7. Information and advice available to the public about arts events in the area. Contact the Visual Arts Officer for further information.

SOUTH EAST ARTS ASSOCIATION

10 Mount Ephraim, Tunbridge Wells, Kent. Tel. 0892 41666. Visual Arts Officer: Frances Smith. Area: Kent, Surrey and East Sussex. Music, drama, literature, dance, visual arts.

1. Awards and bursaries. (see Chapter 3 for awards section).

2. Artsdesk a monthly newsletter and diary of events.
3. South East Arts Review—quarterly of creative writing.
4. Touring exhibitions.
5. Encourage sponsorship of galleries, exhibitions and local arts events.
6. Advice on purchase to the public. Art in public places schemes.
7. Register of artists living and working in the area. Slide index that the public can consult and then be advised on how to approach the local artist.
8. Links with local schools and colleges to encourage interest in the various arts.

NORTHERN ARTS
10 Osborne Terrace, Newcastle NE2 1NZ. Tel. 091-281 6334. Visual Arts Officer: Peter Davies. Photography film and video: John Bradshaw. Crafts: Laurie Short. Area: County Durham, Cumbria, Northumberland, Tyne and Wear, Cleveland.
1. Awards and bursaries. (see Chapter 1 for awards section).
2. Touring exhibitions.
3. Sponsorship along with other arts associations of the "Artists Newletter", a practical informative newsletter for artists that lists supply shops, galleries, courses, awards etc. See "Art magazines" (Chapter 1) for details of address, subscription etc.
4. Supports Artist in Residence scheme at Grizedale Forest.
5. Slide index and register of professional artists, craftsmen and photographers working in the area.
6. Information available about galleries, art organisations and arts events in the area.
7. Contact with local schools, colleges to encourage interest in arts events.
8. Support for local art galleries and arts centres such as Northern Centre for Contemporary Art.

EAST MIDLANDS ARTS ASSOCIATION
Mountfields House, Forest Road, Loughborough. Tel. 0509 218292. Visual Arts Officer: David Manley. Area: Borough of Milton Keynes, Derbyshire except Peak District, Leicestershire, Northamptonshire, Nottinghamshire.
1. Awards and bursaries. (see Chapter 3 for awards section).
2. Register of professional artists working in the area and slide index. Open to the public to consult. Contact the Visual Arts Officer for information. Computerised artists' listing service.
3. Regular newsletter with events and news of awards, competitions in the area.
4. Touring exhibitions.
5. Contact with local arts organisations, schools, colleges.

MERSEYSIDE ARTS ASSOCIATION
Bluecoat Chambers, School Lane, Liverpool L1 3BX. Tel. 051-709 0671. Assistant Director (Media): Libby Urqhuart. Visual Arts: Duncan Fraser. Area: Ellesmere Port, Halton, Knowsley, Liverpool, Sefton, St. Helens, West Lancs and Wirral.
1. Touring exhibitions.
2. Register of a artists working in the area.
3. Contact with local organisations.
4. Training.
5. Exhibition fees to artists.

SOUTHERN ARTS
19 Southgate Street, Winchester. Tel. 0962 55099. Visual Arts Officer: Hugh Adams. Area: Berkshire, Hampshire, Isle of Wight, Oxfordshire, West Sussex, Wiltshire and the Bournemouth, Christchurch and Poole areas of Dorset.
1. Awards and bursaries. (see Chapter 3 for awards section).
2. Touring exhibitions.
3. Register of artists working in the area and slide index that can be consulted by the public. Contact the Visual Arts Officer for further details.
4. General advise about arts events in the area.
5. Contact with local schools, colleges and arts organisations.

EASTERN ARTS ASSOCIATION
Cherry Hinton Hall, Cherry Hinton Hall Road, Cambridge CB1 4DW. Tel. 0223 215355. Visual Arts Officer: Jane Heath. Area: Cambridgeshire, Bedfordshire, Essex, Hertfordshire, Norfolk and Suffolk.
1. Awards and bursaries. (see Chapter 3 for awards section).
2. Register of artists and craftsmen and slide index. Open to the public and arts administrators to consult. Advice available about possible purchases. Art in public places scheme.
3. List of art galleries and art centres in the region.

4. Help for artists and craftsmen leaflet outlines various support schemes for individual artists and craftsmen.
5. Touring exhibitions.
6. Contact with local arts organisations, schools, colleges. Artists in the community scheme.

NORTH WEST ARTS
4th Floor, 12 Harter Street, Manchester. Tel. 061-228 3062. Visual Arts Officer: Virginia Tandy. Area: Greater Manchester, High Peak District of Derbyshire, Lancashire and Cheshire.
1. Awards and bursaries (see Chapter 3 for awards details).
2. Register of professional artists working in the area and slide index. Contact the Visual Arts Officer for further information.
3. List of galleries in the nort west arts area.
4. Touring exhibitions.
5. Contact with local arts organisations, schools, colleges.

SOME OTHER APPROPRIATE REGIONAL ARTS ASSOCIATIONS
Bury Metro Arts Association, The Derby Hall, Market Street, Bury. Tel. 061-761 7107.
>**Mid Pennine Associaiton for the Arts**, 20 Hammerton Street, Burnley, Lancashire. Tel. Burnley 29513. Art dance, film, photography, graphics, music, literature and theatre. Compiling a register of artists in the area.
Fylde Arts Association, Grundy Art Gallery, Queen Street, Blackpool. Tel. 0253 22130. Supported by North West Arts. Exists to bring the professional arts to this area (Blackpool, Fylde and Wyre). Blackpool Grundy gallery, Fylde Borough art gallery and Garstang art gallery in Preston.

WALES
NORTH WALES ASSOCIATION FOR THE ARTS
10 Wellfield House, Bangor, Gwynedd LL57 1ER. Tel. 0248 353248. Secretary: D. Llion Williams. Area: Clwyd, Gwynedd and district of Montgomery in the county of Powys.

SOUTH EAST WALES
Victoria Street, Cwmbran, Gwent NP44 3YT. Tel. 063 33 75075. Director: Hugo Perks. Area: South Glamorgan, Mid-Glamorgan, Gwent, districts of Radnor and Brecknock in the county of Powys and the city of Cardiff.

WEST WALES ASSOCIATION FOR THE ARTS
Dark Gate, Red Street, Carmarthen, Dyfed. Tel. 0267 234248. Director: Carwyn Rogers. Area: Dyfed, West Glamorgan.

IRELAND/EIRE
Although not part of Britan, Ireland's arts council's address may be of use to artists.
The Arts Council, Eire, 70 Merrian Square, Dublin 2, Eire. Tel. 0001 611840. Director: Adrian Munnelly.

Head, Hughie O'Donoghue, Charcoal on paper (Fabian CARLSSON gallery)

Chapter 8
INTERNATIONAL SECTION

This section covers useful addresses of galleries, organisations, art schools and general art information for specific countries overseas. It is hoped that artists and the art public in general will find these useful when travelling overseas or planning a visit. In many instances the reader will find that it is necessary to refer to other sections such as **"Grants and Awards"**, **"Useful Address"** and **"Useful Books"** to find out which organisations deal with awards exchanges, grants and details for specific countries.

When travelling to any country it is advisable to enquire if there is a cultural section of the particular country's embassy in your own country and if so to contact them to see if they have specific information that you may require and details about visa requirements in relation to artists. In many cases Cultural Affairs sections have lists of art schools, galleries, Arts Councils and addresses or organisations in their country that deal specifically with cultural visits. This is advisable as in the long run it will make your eventual visit more profitable and worthwhile and enable you to make contact with art counterparts overseas.

In London, **Canada House, New Zealand House, USA Embassy Cultural Affairs, French, Dutch, Italian, Belgian** and **German** embassies are particularly helpful.

INTERNATIONAL ORGANISATIONS

Most of these organisations have offices in London and in many countries overseas.

International Association of Art, Clerkenwell Workshop, 31 Clerkenwell Close, London EC1. Tel. 01-250 1927. UK President: Robert Coward.

The IAA was set up by UNESCO in Paris to enable artists in 60 countries throughout the world to associate with other artists and art organisations overseas, to enable artists to improve and defend their situation internationally. There are national committees in each country and artists meet regularly nationally and every three years representatives meet internationally at IAA congresses where information and ideas are exchanged for the benefit of artists internationally.

At local and national level artists and art organisations can join the IAA and benefits vary according to each country but range from receiving a special card that will allow the artist reduced or free entry to certain overseas galleries and museums, to discount on artists' materials and ability to participate in national and international exhibitions, competitions and exchanges.

The UK committee has recently formed a sub committee which is organising a major national exhibition open to artists, discount to artists on supplies and other similar benefits.

For addresses of overseas IAA committees contact: International Association of Art, 1 Rue Miollis, 75015 Paris, France.

There are IAA commttees in USA, Canada (CAR), Australia, New Zealand, all European countries and in India and certain African countries.

International Association of Art Critics (British section), c/o The President, Julie Lawson, 1 Campden Mansions, The Mall, London W8.

The International Association of Art Critics similarly to the IAA has national committees in many countries throughout the world and international meetings take place every year in different countries.

The aim of this association is to discuss problems relating to art criticism and maintain contact with other closely related art associations. Members are elected by the national committee and confirmed by the Central Office in Paris. There are associations in USA, Canada, France and most European countries and in many other countries throughout the world. Card for press pass to galleries and museums. UK membership £20 per annum (1988/89). The UK section has some 100 art critic members.

Institute of International Education, 809 United Nations Plaza, New York 10017.

Information service on educational exchanges particularly higher education.

USEFUL BOOKS FOR INTERNATIONAL ART TRAVELLERS

Art Diary, PO Box 36, Borgo Trevi 06032 Perugia, Italy. Editor: Giancarlo Politi.

An international art directory $25 (£15) of artists, galleries and organisations in 38 countries. Very useful for artists travelling overseas, especially good on New York and USA and Italy. Pocket size therefore ideal to carry with you. **Photo diary** also now available listing photographers.

The **Art Guide** series now covers: **London, Paris, New York, Amsterdam, Berlin, Australia, Glasgow, Madrid**. All guides are available at £5.95 from most bookshops and art centres or + 75p p&p by post from **Art Guide Publications, A & C Black, PO Box 19, PE19 3SF. Tel. 01-242 0946 for editorial details.**

London Art and Artists Guide, Art Guide Publications, 35 Bedford Row, London WC1. Tel. 01-242 0946. Editor: Heather Waddell.

Price £5.95. 5th edition published 1988. A complete guide to London's art scene, including all 600 galleries, art schools, useful addresses and also a general guide to London restaurants, parks, markets and sport. Pocket guide.

Australian Arts Guide, (3rd edition 1989) Price £5.95 and **New York Art Guide** (2nd edition 1986) Price £5.95. Art Guide Publications. **Berlin** and **Amsterdam** £5.95 each, **Glasgow** and **Madrid** 1989.

Paris Art Guide, Art Guide Publications, 35 Bedford Row, London WC1. Tel. 01-242 0946. Editor: Fiona Dunlop.

Price £5.95. 3rd edition published 1988. A guide to Paris art galleries, organisations and general guide to good cheap eating places, parks, markets.

New York Art Guide, Art Guide Publications, 35 Bedford Row, London WC1. Tel. 01-242 0946. Price £5.95 2nd edition 1986. Pocket guide covering art and tourist information.

Arts Review Yearbook, 69 Faroe Road, London W14. Tel. 01-603 7530/8533.

The London art guide for art dealers and the art public in general. Covers London and elsewhere in Britain. Articles by art critics at the beginning. Published annually in large book format. Price £11 + £2 postage.

Anderson and Archer's SOHO, The essential guide to Art and Life in Lower Manhattan, Simon and Schuster, Rockefeller Center, 1230 Avenue of the Americas, New York 10020.

Available at Stanfords in Covent Garden (London, England) price £4.50. A must for all art travellers visiting New York. A general guide to Soho, the definitve New York art area, with details on art organisations, galleries, art eating places, shops, old Soho buildings.

Art Now, Gallery Guide, Art Now Inc, 144N 14th Street, Kenilworth, New Jersey 07033. Available at most New York galleries. This small magazine lists all exhibitions in New York's 1000 galleries and has clear maps to each area with galleries in it, i.e. uptown galleries, mid town and downtown Soho galleries. Now one for all of the USA available.

Handbook of Printmkaing Supplies, Printmakers Council of Great Britain, 31 Clerkenwell Close, London EC1. Editor: Silvie Turner.

Price £2. Covers all areas of printmaking. A must for British printmakers. It also has addresses of overseas print workshops, supply shops and galleries dealing with prints. 2nd edition out 1980.

USEFUL ART MAGAZINES FOR ART TRAVELLERS

See art magazine section also.

Art Forum, 65 Bleeker Street, New York 10003. Editor: Ingrid Sischy (mostly available at Dillons art shop, Covent Garden, London WC2). London reviewer: Adrian Searle. Available monthly with articles and regular art reviews. Along with Art News and Art in America one of the important USA art magazines. Glossy and in colour.

Art News, PO Box 969, Farmingdale, New York 11737. London correspondent: William Feaver. $5 per issue or $30 for foreign subscribers (10 issues per annum). Covers all USA art news and overseas reviews and art articles and US reviews. Good value. Editor: Milton Esterow.

Arts Magazine, 23 East 26th Street, New York NY 10010. Published ten times a year. $33 USA foreign postage $11. $5 per copy. Wide selection of articles, reviews on contemporary current exhibitions and art historical articles. Glossy with good colour photos.

Art in America, 980 Madison Avenue, New York 10021. Editor: Elizabeth Baker. London correspondent: Suzi Gablik. $4. Annual subscription $34.95 (12 issues). USA art glossy. Reviews, art historical articles and contemporary art.

Flash Art International, PO Box 36, Borgo Trevi, 06032 Perugia, Italy. Editor: Giancarlo Politi. Published in English. Covers art reviews in UK, USA, Australia and Europe. Subscription $30 for 6 issues per annum.

Art International, 77 Rue des Archives, Paris 75003, France. Tel. 48048454. £40 per annum quarterly. Excellent art magazine, now almost in book format. Available at Dillons art shop, Covent Garden.

Studio International, Tower House, Southampton Street, London WC2. Tel. 01-379 6005. UK art glossy when it appears and now more expensive. £5 or sub £20 per annum.

Art Monthly, 36 Great Russell Street, London WC1. Tel. 01-580 4168. Editors: Peter Townsend and Jack Wendler. £1.20 monthly. Good value $40 for USA subscribers. £12 for European subscribers. £12 per annum in the UK. Excellent art news magazine with regular art news and art reviews. national and

international art news and articles. Artlaw section monthly. Australian Art Monthly available now in Australia.

Fuse, 2nd Floor, 31 Dupont Street, Toronto, Canada. Tel. 416 366 4781. Canadian avant garde art magazine. Video and performance and conceptual work covered internationally and nationally.

Vie des Arts, Rue Francois Xavier, Montreal, Québec. Editor: Jean-Claude Leblond. London correspondent: Heather Waddell. 30 French Francs. $25 p.a. overseas subscribers and $18 for Canadian subscribers. 4 issues a year. Canadian art articles and reviews and letters from New York, London, Germany and France in French.

Art and Australia, 653 Pacific Highway, Killapa 2071, NSW Australia. London correspondent: Dr. Ursula Hoff. A$34 within Australia. A$42 for overseas subscribers. Published quarterly. Up to date news on Australian art scene—articles and reviews. Glossy and colour. $8.95 per issue.

Art New Zealand, Art Magazine Press, PO Box 7008, Auckland, New Zealand. Editor: Ross Fraser. $14 (4 issues in NZ) $17 overseas subscribers. New Zealand art glossy and covers art reviews and art articles about NZ artists.

High Performance, 240 South Broadway, 5th Floor, Los Angeles, California 90012. Interested in receiving b/w photos of performances (8 × 10) and 1 page factual history of the event accompanying it. Send to Linda Burnham. Magazine covers performance events in USA and internationally.

City Magazine International. Not an art magazine but covers London, Paris, Berlin, New York, Los Angeles and Tokyo with monthly coverage in French of exhibitions, hotels, shops and places of interest. Articles on fashion in Berlin or London, art events etc. Essential if visiting these cities. 5 Rue Paul-Louis Courier 1211, Paris 75007. Tel. 45 49 9010.

Parkett, Quellenstrasse 27, 8005 Zurich, Switzerland. Tel. 1142 8140. $63 for 4 issues $20 per issue. Glossy art magazine in book form in English and German.

Nike, Postfach 140540, D-8000 Munich 5, Germany. Tel. 089-260 3376. German art magazine with English section for reviews.

Art Almanac, 5/171 Darlinghurst Road, Darlinghurst 2010 NSW Australia. Tel (02) 332 3225. Monthly gallery exhibition listings in Sydney and Melbourne.

Wolken Kratzer, art journal, Meisengasse 28, 6000 Frankfurt Am Main 1. German art magazine. Tel. (069) 280829.

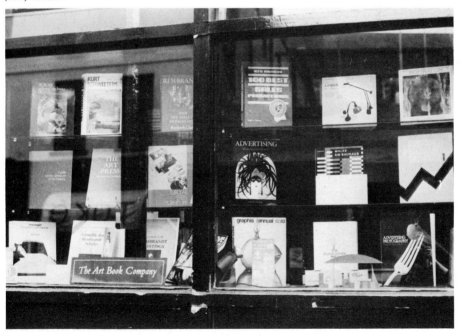

The Art Book Company, Endell Street, Covent Garden

OVERSEAS DIRECTORY

ARGENTINA

Centro de Arte y Comunicacion, Elpidio Gonsalez 4070, Buenos Aires 1407. Tel. 566 8046. Library and showrooms Viamonte 452 Buenos Aires. President: Jorge Glusberg. Gallery consists of two floors each 16 × 20 metres. Documentation center consists of two floors each. CAYC is a non-profit institution. Regular exhibitions of art and video. International and national exhibitions shown at CAYC. Collection includes 400 video tapes, 7,000 photographic prints, 5,000 slides, 150 films and catalogues of all past art exhibitions. Helps circulate travelling art exhibitions throughout Argentina.

Comite Argentino de la Asociacion Internacional de Artes plasticas, Defensa 945, Apo no 7, Buenos Aires. IAA Argentina committee.

AUSTRALIA

See **Australian Arts Guide** (Art Guide Publications) £5.95 for details. (3rd edition 1989 by Roslyn Kean).

Visual Arts Board, Australia Council, Northside Gardens, 168 Walker Street, North Sydney, NSW 2060. Tel. 922 2122. The Visual Arts Board deals with all matters relating to fine artists whereas crafts people would contact another department of th Australia Council. As with the Arts Council in Great Britain the VAB awards grants to artists, funds artist in residence programmes, public galleries acquisitions and helps bring major international exhibitions to Australia. They also have overseas studios for Australian artists in France, Ireland, New York, Exeter (England) and Berlin.

Artbank (Australia), PO Box 3652, Sydney, NSW, Australia. Tel. 298351. Director: Graeme Sturgeon. Artbank is funded by the department of Home Affairs and is a Federal Government agency. It started in 1980 and has acquired works in the fields of painting, sculpture, printmaking, photography, craft and aboriginal art to build up a representative collection of contemporary Australian art. Works can be leased for display in government offices around Australia and abroad.

SYDNEY, NEW SOUTH WALES

Art Gallery of New South Wales, Art Gallery Road, The Domain, Sydney NSW 2000. Tel. 221 2100. Director: Mr. Edmund Capon. Permanent Australian and European art collection. Ideal gallery for visitors to become acquainted with the works of great Australian painters such as the impressionists Tom Roberts, Arthur Streeton and Sydney Long. The gallery consists of two floors both with large exhibition areas. The gallery also exhibits annually the work entered for major art competitions such as the Archibald, Wynne and Sulman prizes. At such exhibitions visitors can see the work of contemporary Australian painters such as Brett Whiteley, Sydney Ball, Tony McGillick and many others. Also Möet Chandon prize in February annually.

The gallery also has an excellent Education Department and talks and lectures are given in the lecture hall. A booklet is available published annually about all competitions open to artists in Australia.

Australian Centre for Photography, 257 Oxford Street, Paddington, Sydney, NsW 2021. Tel. 356 1455. Opening: Wed–Sat 11–6. First started in 1973 and now a flourishing gallery. Work by Australian photographers and exhibitions of work by overseas photographers can be seen here. Two floors of gallery space. The centre is a non-profit organisation and is funded by the Australia Council and the New South Wales Department of Cultural Activities.

Power Institute of Fine Arts, University of Sydney, Broadway, NSW 2006.

MacQuarie Galleries, 204 Clarence Street, Sydney NSW 2000. Tel. (02) 264 9787. Director: Eileen Chanin. One of Sydney's top galleries.

Sydney Film Co-op, St. Peters Lane, Darlinghurst, Sydney. Tel. 313237.

Port Jackson Printing Press, 23 McLaren Street, North Sydney, NSW 2060. Tel. 924181. Director: David Rankin. Opening: Mon–Fri 10–5. Commercial print studio. Publish prints by 20 Australian artists including John Olsen, Arthur Boyd and Clifton Pugh.

Sydney College of the Arts, 58 Allen Street, Glebe, Sydney. Tel. 692 0266. Fairly new art school with growing campus. Lively fine art department.

Alexander Mackie College, The Rocks, 200 Cumberland Street, East Sydney. The older and more established art school in Sydney. Lively art department. Tel. 277 204.

Paddington Video Centre, Paddington Town Hall, Oxford Street, Sydney. Gallery and video access facilities.

Julian Ashton School of Art, 117 George Street, Sydney, NSW 2000.

Watters Gallery, 109 Riley Street, East Sydney. Tel. 331 2555. Lively commercial gallery.

Newcastle College of Art Education, PO Box 84, Waratah, NSW 2298.

Roslyn Oxley Gallery, 13 Macdonald Street, Paddington, NSW 2021. Tel. 331 1919. Lively Australian artists on show here.

The Biennale of Sydney, 100 George Street, Sydney NSW 2000. Tel. 27 3016/3560. Director: Nick Waterlow (1988) next ones 1990, 1992. Major art world event; international and Australian art.

MELBOURNE, VICTORIA
Ewing and Paton Galleries, Melbourne University Union, Parkville 3052, Australia. Tel. 341 6961. Director: Juliana Engberg. Opening: Mon–Fri 10–6, Wed 10–8. Regular exhibitions of work by contemporary Australian artists. Two galleries 32 and 50 metres running length.
Womens Art Register, Carringbush Library, 415 Church Street, Richmond Victoria. Tel. 429 3644.
National Gallery of Victoria, 180 St. Kilda Road, Melbourne. Tel. 618 0222. Opening: Tues–Sun 10–5, closed Mon. Three floors of gallery space housing a permanent collection and a large temporary exhibitions area on the ground floor. Large educational department for talks and lectures. Collection covers European art, Australian art both historical and contemporary and Asian art, also American paintings post 1800.
Victorian College of the Arts, 234 St. Kilda Road, Melbourne, Victoria 3000.
Prahran College of Advanced Education, School of Art and Design, 142 High Street, Prahran, Victoria.
Ballarat College of Advanced Education, Arts Department, Lydiard Street South, Ballarat.
Caulfied Institute of Technology, Department of Art and Design, PO Box 197, Caulfied East.
School of Art, Rroyal Melbourne Institute of Technology, 124 La Trobe Street, Melbourne.
School of Visual Arts, Gippsland Institute of Advanced Education, PO Box 42, Morwell, Victoria 3840.
Art Department, State College of Victoria, PO Box 179, Coburg, Victoria 3058.
Victorian Ministry for the Arts, 9th Floor, 168 Exhibition Street, Melbourne. State Arts Council for Victoria.
City of Mildura Arts Centre, 199 Cureton Avenue, Mildura, Victoria 3500. Tel. (050) 233733. Opening: Mon–Fri 9–4.30, Sat and Sun 2–4.30. Permanent collection of painting and sculpture. Best known for its national Sculpture Triennial when sculptors and performance artists throughout Australia met up. Overseas artists also exhibit here.
The state of Victoria is generally very art conscious and there are several other art schools apart from the above mentioned. Melbourne also has several film co-operatives for film makers, and many commercial galleries of high standing.

QUEENSLAND
Institute of Modern Art, 106 Edward Street, Brisbane 4000. Tel. 229 5985. Opening: Tues–Sat 10–5. Australia's most flexible and innovative exhibition area. Experimental projects by overseas and Australian artists are encouraged by the Director. It has a particularly close link with British artists. Michael Craig Martin, John Danvers and Charles Garrard have all shown work there. Two large gallery spaces running length 21 and 25 meters.
Queensland Art Gallery, South Bank, Brisbane. Tel. 840 733. Opening: Mon–Sat 10–5, Sun 1–5. Main emphasis on Australian art but also European collection. There are also galleries at the University in Brisbane and at the Civic Centre, and several commercial galleries with lively exhibitions such as the **Ray Hughes gallery** in Brisbane, 11 Enoggera Tce. Tel. (07) 369 3757.

SOUTH AUSTRALIA
Contemporary Art Centre, 14 Porter Street, Parkside. Holds exhibitions of work by CAS members regularly at this gallery space. Tel. (08) 272 2682.
Art Gallery fo South Australia, North Terrace, Adelaide. Tel. 223 7200. Opening: Mon–Sat 10–5, Wed 10–9, Sun 1.30–5. Large collection of European and Australian art. There is also a special exhibitions gallery for temporary exhibitions.
Arts Development Branch, Premiers Department, State Government Offices, Victoria Square, Adelaide, SA 5000. State Arts Council equivalent.
The Adelaide Arts Festival, occurs in March every 2 years 1988, 1990 etc.

WESTERN AUSTRALIA
Art Gallery of Western Australia, 47 James Street, Perth. Tel. 328 7233. Director: Frank Ellis. Opening: Mon–Fri 10.30–5, Sat 10.30–5, Sun 1–5. Specialised Aboriginal art collection, historical collection and Australian collection of paintings, drawings, ceramic and sculpture. Also holds temporary exhibitions. Open air sculpture outside the gallery also.
Undercroft Gallery, University of Western Australia, Perth, WA 6009. Tel. 443 3482. Good choice of contemporary Australian art exhibitions. Purchases contemporary Australian art. Ground floor gallery holds temporary exhibitions. Exotic setting.
West Australian Arts Council, 6 Outram, West Perth. Tel. 322 6766. State Arts Council.
Praxis, 33/35 Packenham Street, Freemantle WA 6160. Tel. 09 335 9770. Major alternative space. Artist in residence scheme. Also a magazine.
Gallery 52 & Galerie Dusseldorf are two of the best Perth galleries.

BELGIUM
International Association of Art, Belgian committee, Mr. Walter Vilain, Melkvoestraat 24B, 3500 Hasselt.

BRUSSELS

Ecole nationale supérieure d'architecture et des arts visuels, 21 Abbaye de la Cambre, 1050 Bruxelles. Tel. 648 9619. Principal: R. L. Delevoy. Large art school with lively fine art department and also film and animation department. Keen on the idea of exchange of art students and art teachers. French speaking.

Academie Royale des Beaux Arts, 144 Rue du Midi, Bruxelles. Director: Mr. Claude Lyr. More traditional art school with emphasis on drawing and painting from life.

Atelier de Recherches sur la Communication, 20 Rue Ste Anne, Sablon, Bruxelles. Tel. 02 511 16 57. Director: Françoise van Kessel. An alternative art centre especially interested in music, performance and sound experimental projects. Especially keen to exchange exhibitions with galleries overseas in USA, Canada, UK and the rest of Europe.

Palais des Beaux Arts, 10 Rue Royale, Bruxelles 1000. Tel. 512 0403. Large central Brussels gallery for major art exhibitions.

Pluriel ASBL, 25 Rue des Cygnes, Bruxelles 1050. Tel. 649 0915. Performances, video and concerts.

ANTWERP

International Cultureel Centrum, Meir 50, B2000, Antwerp. Tel. 231 319182. A large art centre with gallery space, restaurant, cinema space for small films and video and performance events.

Nationaal Hoger Instituut en Koninklijke Academe voor Schone Kunsten, 31 Mustaertstraat, Antwerp. Director: Theo Van Looy. Traditional art school. Emphasis on painting, sculpture and printmaking. Antwerp does have a lively young art community though.

Huis Van Nispen, 61 Scheldestraat, 2000 Antwerp. An open studio for artists both professional and amateur. Lifeclass for drawing, etc. Workshop for etching and lithography. No actual tuition but help if needed.

LIEGE

Académie Royale des Beaux-Arts, 21 Rue des Anglais, 4000 Liège. Tel. (041) 22 26 63 and (041) 23 45 54.

La Sanguine ASBL, 7 Place des Franchises, 4000 Liège. Tel. (041) 23 23 60 (between 8–10pm). An open studio offering tuition in drawing, painting and sculpture.

KASTERLEE

Rijkscentrum Frans Masereel, Zaardendijk 20, 2460 Kasterlee, Belgium. Funded by the Ministry for Dutch culture, this print workshop offers facilities for lithography, silkscreen and etching. A stay in the centre is free of charge also free use of materials for printmakers wishing to stay.

BRAZIL

International Association of Art, Associacao Internacional de Artes Plasticas, Rua Noruega 275, Jardim Europa, Sao Paolo SP 01448.

BOLIVIA

International Association of Art, Casilla 5788, La Paz.

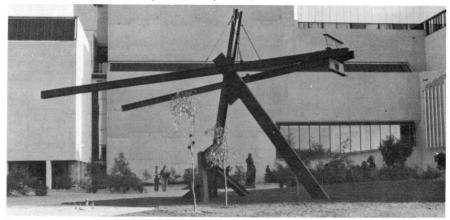

Sculpture Garden, Australian National Gallery (Roslyn Kean)

BULGARIA
International Association of Art, Association des artistes bulgares, Ul Schipka 6, Sofia.

CANADA
See **Visual Arts Handbook** (Visual Arts Ontario, Canada) for detailed addresses. $8.95.
 Canada Council, 255 Albert Street, Ottawa, Ontario. Tel. 613 237 3400. Canada Council awards grants to artists throughout Canada and helps fund non-profit art organisations in Canada. They can advise overseas artists about artist in residence schemes, summer schools etc. as can Canada House in London where Michael Regan can advise artists who best to contact in Canada depending on their specialism.
 Canada House, Trafalgar Square, London SW1. Tel. 01-629 9492. Exhibitions Officer: Michael Regan, Canada House gallery in London holds regular exhibitions of work by Canadian artists and as the exhibitions officer is constantly looking at Canadian work he is in touch with the latest developments on the Canadian art scene.
 Canadian Artists Representation (CAR), Room 44, 221 McDermot Avenue, Winnipeg, Canada. Tel. 204 943 5948. National Representative: Bill lobchuk. Also branches in each state. Canadian Artists Union and also the Canadian committee of the IAA International Association of Art. CAR is very active in Canada and has a large membership right across the country. They have actively changed laws afecting artists studios and taxes on art materials in some instances.
 Parallelogramme, 489 College Street, Toronto. Funded by Canada Council. Parallelogramme is published 6 times a year by ANNPAC the Association of National non profit Artists Centres which represents 25 artist initiated centres of parallel galleries that aim to encourage new art work in all directions. Galleries throughout Canada.

PARALLEL GALLERIES (ANNPAC)

A SPACE
204 Spadina Avenue
1st Floor
Toronto
Ontario M5T 2C2
Tel. 416 364 3227, 364 3228
A.R.C.
658 Queen Street West
Toronto
Ontario M6J 1E5
Tel. 416 947 9169
ART METROPOLE
217 Richmond Street West
2nd Floor
Toronto
Ontario M5V 1W2
Tel. 416 977 1685
ARTCITE
Mackenzie Hall
3277 Sandwich West
Windsor
Ontario N9C 1A9
Tel. 519 252 1539
ARTEXTE
3575 St-Laurent
Salle 303
Montreal
Quebec H2X 2T7
Tel. 514 845 2759
ARTICULE
4060 Boul, St-Laurent
Suite 106
Montreal
Quebec H2W 1Y9
Tel. 514 842 9686
ARTSPACE
The Market Hall
Peterborough Square

PO Box 1748
Peterborough
Ontario K9J 7X6
Tel. 705 748 3883
CENTRE EYE
Photography Gallery
1717–7 Street SW
Calgary
Alberta T2T 2W7
Tel. 403 244 4816
CONTEMPORARY ART GALLERY
555 Hamilton Street
Vancouver B.C. V6B 2R1
Tel. 604 687 1345
THE ED GALLERY
16a Wyndham Street N
Guelph
Ontario N1H 4E5
Tel. 519 837 3571
EYE LEVEL
1585 Barrington
Suite 306
Halifax
Nova Scotia B3J 1Z6
Tel. 902 425 6412
FOREST CITY GALLERY
231 Dundas Street
2nd Floor
London
Ontario N6A 1H1
Tel. 519 434 5875
THE FUNNEL
507 King St East
Toronto
Ontario M5A 1M3
Tel. 416 364 7003
HAMILTON ARTISTS INC
143 James St North

Hamilton
Ontario L8R 2K8
Tel. 416 529 3355
K.A.A.I.
21a Queen Street
Kingston
Ontario K7K 1A1
Tel. 613 548 4883
LANGAGE PLUS
675 Boul. Auger Ouest
Alma
Quebec G8B 2B7
Tel. 418 668 6635
LATITUDE 53
10920–88 Avenue
Edmonton
Alberta T6G OZ1
Tel. 403 439 1985
LE LIEU
629 Rue St Jean
Quebec
Quebec G1R 1P7
Tel. 418 529 9680
MERCER UNION
333 Adelaide St West
5th Floor
Toronto
Ontario M5V 1R5
Tel. 416 977 1412
MUSIC GALLERY
1087 Queen St West
Toronto
Ontario M6J 1H3
Tel. 416 534 6311
NEUTRAL GROUND
No 9–1651 11th Avenue
Regina
Saskatchewan S4P OH5
Tel. 306 522 7166
OBORO
3981 St Laurent
Suite 499
Montreal
Quebec H2W 1Y5
Tel. 514 844 3250
OFF CENTRE CENTRE
118 8th Ave S.E.
3rd Floor
Calgary
Alberta T2G OK6

Tel. 403 233 2399
101
245 1/2 Bank Street
Ottawa
Ontario K2P 1X2
Tel. 613 230 2793
OPEN SPACE
510 Fort Street
Victoria B.C. V8V 1E6
POWERHOUSE
3738 St Dominique Street
Suite 203
Montreal
Quebec H2X 2X9
Tel. 514 844 3489
S.A.W.
55 Byward Market
Ottawa
Ontario K1N 9C3
Tel. 613 238 7648
V/TAPE
489 College Street
5th Floor
Toronto
Ontario M6G 1A5
Tel. 416 925 1961
VIDEO INN
261 Powell Street
Vancouver B.C. V6A 1G3
Tel. 604 688 4336
VIDEO POOL
89 Princess Street
Winnipeg
Manitoba
Tel. 204 949 9134
WESTERN FRONT
303 East 8th Avenue
Vancouver B.C. V5T 1S1
Tel. 604 876 9343
WOMEN IN FOCUS
456 West Broadway
Suite 204
Vancouver B.C. V5Y 1R3
Tel. 604 872 2250
YYZ
116 Spadina Avenue
Toronto
Ontario M5V 2K6
Tel. 416 367 0601

Visual Arts Ontario, 439 Wellington Street West, Toronto. Tel. 416 591 8883. VAO is a federation of art organisations in Ontario comprising some 5,000 members. It runs workshops, colour xerography programme, runs international exhibitions. They produce the useful **Visual Arts Handbook** which is a must for any artist visiting or staying in Canada, editor Hennie Wolff. $8.95 plus postage. Also Toronto Art & Artists guide available from VAO.

DENMARK
IAA, Mrs. Bodil Kaalund, Louisevej 7, 2800 Lyngby.

FEDERAL REPUBLIC OF GERMANY
IAA, Nr. Gerhard Pfennig, 5300 Bonn, Bennauerstrasse 31.
IAA, Mrs. Ursula Ancke, Nationaler Museumstrat der DDR, Wildensteiner Strasse 7, 1157 Berlin.

Kunsterhaus Bethanien GMBH, Mariannenplatz 2, 1B36, Berlin. Tel. 614 9021. Studio space for Berlin artists.
DAAD, German Academic Exchange Service, Steinplatz 2, Postfach 12640 1B12, Berlin. Tel. 310 461. Overseas artists can apply to stay in Berlin on this exchange programme. Artists are given studio and living space if their application is successful. (Film and Visual Arts) 25/30 scholarships awarded annually for one year. There are Kunstlerhaus (art centres) in most German cities such as Hamburg, Stuttgart and Cologne. Refer to Art Diary for endless list of art contacts in Germany.
BERLIN ARTS GUIDE, £5.95 by Irene Blumenfeld Art Guide Publications, 35 Redford Row, London WC1.

FINLAND
Suomen Taiteilijaseura, Ainonkatu 3, 00100 Helsink 10. Tel. 493 919. Maaretta Jaukkuri. Director: Relmo Helno. This Finnish Artists Association is also the IAA representative for Finnish artists. They have one studio house in Helsinki, one in Espoo (an adjoining town) a working and recreation centre for artists some 70km from Helsinki in the village of Samatti as well as a studio house in Florence, Italy and one in Marbella, Spain. They are interested in studio exchanges and exchange exhibitions. They have some 2,000 metres and produce a book with details of their work.

FRANCE
See **Paris Art Guide** (Art Guide Publications) £5.95 for detailed addresses. (3rd edition 1988). The latest edition has been completely revised with new galleries and other art details.
International Association of Art (HQ), 1 Rue Miollis, 75015 Paris.
Centre Culturel Canadien, 5 Rue de Constantine, 75007 Paris. Tel. 551 3573. Director: Gilles Lefevre. Regular exhibitions of work by Canadian artists.
Centre Georges Pompidou, 75191 Cedex 04. Tel. 277 1233. The major modern art centre in Paris with permanent collection and regular changing temporary exhibitions of work by French artists and overseas artists.
Katia Pissarro gallery, 59 Rue de Rivoli, 75001 Paris.
Galerie D'Art International, 12 Rue Jean-Ferrandi, 75006 Paris. Tel. 11 4548 8428.
The **Bastille** area is the "new" art area in Paris. The streets off Blvd St Germain are crowded with small galleries.

GREECE
IAA, National Greek commitee, Kalitechnikon Epimelitirion Ellados, 38 Mitropoleos Street, Athens 126.
National Gallery of Art, 50 Constantinos, Athens. Tel. 711 010.

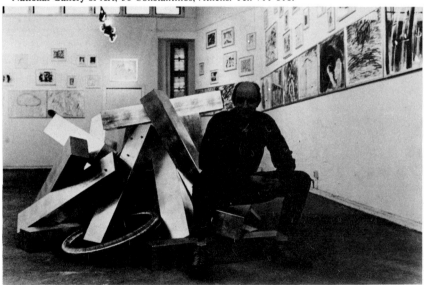

Salome at his Raab Gallery Exhibition, Berlin (Christiane Hartman)

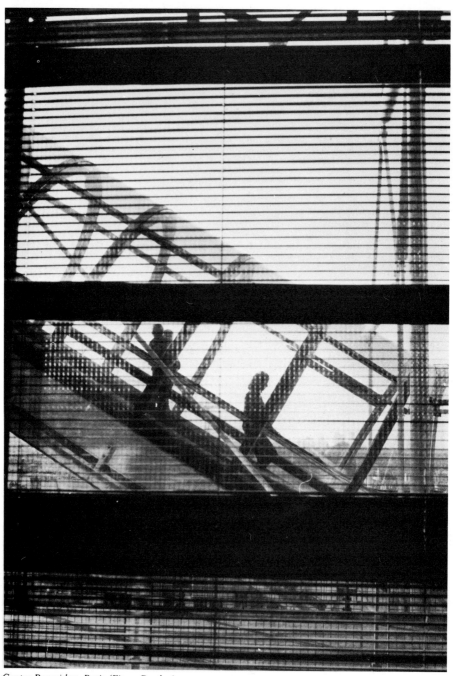

Centre Pompidou, Paris (Fiona Dunlop)

Contemporary Graphics, 9 Haritos Street, Athens. Tel. 732 690.

HOLLAND

BBKB, Bureau Beeldende Kunst Buitenland (Visual Arts Office for Abroad), Oostelijke Handelskade 29, Amsterdam. Tel. 223 501. Dutch equivalent to the British Council. Very helpful to enquiries from overseas artists. Publish "Dutch Art and Architecture Today" monthly.

Nederlandse Kunstichting, Oostelijke Handelskade 29. Tel. 220 414. Dutch Arts Council for affairs within Holland rather than overseas.

BBK, Beroepsvereniging van Beeldenede Kunstenaars, Koggestraat 7, Amsterdam. Tel. 235 456. IAA also at same address. Dutch Artists Union. Has several thousand members so therefore a very active union. Artists in Holland have far greater rights than in most other countries.

Gerrit Rietveld Academie, Frederick Roeskstraat 96, 1076 ED Amsterdam. Tel. 6 0406. Director: R. Van Der Land. Modern art school with wide variety of art departments. Interested in student and art teacher exchanges. Good atmosphere.

Stedelijk Museum, Paulus Potterstraat 13, Amsterdam. Tel. 73 2166. The Stedelijk is the modern art musum in Amsterdam but is also actively involved in educational art programmes and has two studios available to overseas artists. Artists apply to the director for further details.

De Appel, Prinseneiland 7, 1013 LL Amsterdam. Tel. 020 255 651. Installations and avant garde events.

Ateliers 63, Zijlsingel 6, 2013 Haarlem. Tel. 32 1375. Director: Wessrl Couzyn. Art school run along the studio rather than usual art school lines. Known artists visit students regularly.

Nederlandse Filmakademie, Overtoom 301, Amsterdam 1054. Film Academy.

Amsterdam Arts Guide by Dutch artist Christian Reinewald £5.95. (Art Guide Publications).

INDIA

IAA, Mr. Shantanu, The Indian Art Association, 1 Parkview Annexe, Ajmalkhan Park, New Delhi 110005.

ISRAEL

IAA, The Israel Painters and Sculptors Association, 9 Alharizi Street, Tel Aviv.

Barges on an Amsterdam Canal, Holland (Heather Waddell)

ITALY
See **Art Diary** (Giancarlo Politi) for detailed addresses. £15.
IAA, Dr. Mario Penelope, 27 Piazza Firenze, 00186, Rome.
Laboratorio, Via degli Ausoni 3, 00185, Rome. Alternative art space.
Galleria Cavallino, San Marco 1725, 30124 Venice. Tel. 20528. Lively exhibitions, performances, video and film events.
Art Diary, PO Box 36, Borgo Trevi, 06032 Perugia, Italy. Art Diary $25 plus $2 air mail postage. International Art Diary listing 38 countries. Largest sections on Italy. Also photo diary.

JAPAN
IAA, Mr. Heikichi Kurata, Japan Artists Center Building, Ginza 3–10–19, Chuo-ku, Tokyo. The Ginza area in Tonkyo has several hundred galleries.

POLAND
IAA, Zwiazek Polskich Artystow Plastykow, Ul. Foksal 2, 00 366, Warsaw.

SPAIN
Centro de Documentacio d'Art Actual, San Gervasio de Cassolas 31/35 22, Barcelona.
Museo Espanol de Arte Contemporaneo, Avenida Juan de Herras/n, Ciudad Universitaria. Tel. 449 2453. Madrid.
Litografia Artesand, Francia 27, Barcelona 24. Tel. 213 3877. Lithography workshop runby Vicente Aznar.
Madrid Arts Guide (Art Guide Publns) Spring 1989, by Claudia Oliveiro Cesar.

USA
British American Arts Association, 49 Wellington Street, London WC2. Tel. 01-379 7755. Director: Jennifer Williams. Essential to visit this organisation prior to visiting the USA. Reference books for awards galleries, art schools, organisations etc.
National Endowment for the Arts, 1100 Pennsylvania Avenue, NW Washington DC 20506. Tel. 202 682 5400. Director of Visual Arts: Richard Andrews. The National Endowment for the Arts is the USA Arts Council equivalent although per ratio of US population it does not offer as many awards to artists as the UK Arts Council does.

Nanky de Vreeze Gallery, Amsterdam (Christian REINEWALD)

NEW YORK
See **New York Art Guide** (Art Guide Publications) £5.95 for detailed addresses. 2nd edition 1986.
Art schools
Art Students League of New York, 215 West 57th Street, New York 10019.
Cooper Union School of Art, New York 10013.
Pratt Institute, School of Art and Design, Brooklyn, NY 1205 and also 160 Lexington Avenue, NY 10016.
New York Studio School, 8 West 8th Street, NY 10011.
Yale Center for British Art, 180 York Street, New Haven, Connecticut 06520.
Organisations
Institute for Art and Urban Resources, 108 Leonard Street (Clocktower Office), New York 10013. Tel. 212 233 1096. Director: Alanna Heiss. A non profit art organisation that runs studio space for artists in Soho and in Brooklyn. Regular exhibitions of work by USA and overseas artists. They also run an open studio programme for overseas artists to use studio space at the Clocktower.
CAPS (Creative Artists Public Service Programme), 250 West 57th Street, New York 10019. Tel. 212 247 6303. CAPS runs a programme to give financial support to some 100 artists for a specific period. US artists only.
Artists Equity Association of NY Inc., 1780 Broadway, NY 10019. Tel. 212 736 6480. Very established Artists Union. Started in the 30s with many known names.
Galleries
Art Now Gallery Guide available monthly in most NY galleries and lists most New York galleries and current exhibitions. Now one available for all of the USA.
Franklin Furnace, 112 Franklin Street, NY 10013. Franklin Furnace has a unique collection of artists books from all over the USA and overseas. Gallery space for exhibitions, performances and video events. Tel. 925 4671.
The Kitchen, 512 West 19th Street, New York. Tel. 212 225 5793. Opening: Tues–Sat 1–6. Performances in the evening, ring for details and times.
Whitney Museum of American Art, 945 Madison Avenue, New York. Tel. 794 0663.
Whitney Downtown, 48 Old Slip, New York. Tel. 483 0011. Opening: Mon–Fri 12–2.
Galleries that often show work by British Artists
Bernard Jacobson Ltd, 50 West 57th Street, New York. Tel. 582 4695. Tues–Fri 10–6, Sat 10–5.
Terry Dintenfass Inc, 50 West 57th Street, New York. Tel. 581 2268. Tues–Sat 10–5.30.
The Drawing Center, 137 Greene Street, Soho, New York. Tel. 982 5266. Mon–Sat 11–6, Wed–8.
Hirschl & Adler, 21 East 70th Street, New York. Tel. 535 8810.
Rosa Esman Gallery, 70 Greene Street, New York. Tel. 219 3044.
Frank Marino, 489 Broome Street, Soho, New York. Tel. 431 7888. Tues–Sat 12–6.
SOME OTHER USEFUL GALLERIES
Photographic
Light, 724 Fifth Avenue, between 56 and 57th Streets. Tel. 582 6552. Tues–Fri 10–6, Sat 10–5. One of the best New York photographic galleries.
International Centre of Photography, 1130 Fifth Avenue, New York 10028. Tel. 212 860 1777. See New York Times Arts listings for photographic galleries (Fridays) and Sunday New York Times.
Sculpture
The Sculpture Center, 167 East 69th Street, New York 10021. Tel. 2121 737 9870. Sculpture exhibitions throughout uptown and downtown galleries—check Gallery Guide monthly.
American International Sculptors Symposium, 799 Greenwich Street, New York 10014. Tel. 212 242 3374.
Sculpture Space, 12 Gate Street, Utica, New York. Sylvia de Swaan.
Other useful contact addresses
American Council for the Arts, 570 7th Avenue, New York 10018.
National Association of Schools of Art, 11250 Roger Bacon Drive, 5-Reston, Virginia 22090.
Foundation for the Community of Artists, 280 Broadway, Suite 412, New York 10007. Tel. 212 227 3770.
Solomon R. Guggenheim Museum, 1071 Fifth Avenue, New York 10028. Tel. 860 1313. Opening: Wed–Sun 11–5, Tues 11–8.

LOS ANGELES
Los Angeles has seen terrific growth in recent years in contemporary art; The Los Angeles County Museum of Art (LACMA) the Museum of Contemporary Art (MOCA) director Richard Koshalek which as been awarded Count Panza Di Biumo's $11 million art collection, the Armand Hammer Museum of Arts opening in 1990 and other commercial galleries.
Los Angeles Art Fair, (UK address) 11 Manchester Square, London W1M 5AB. Tel. 01-486 1951. Annually in December.

BOSTON
Boston Visual Artists Union Inc., 77 North Washington Street, Boston, Massachusetts 02114. Tel. 227 3076. Exhibitions space, films, performances etc.

CHICAGO
NAME Gallery, 9 West Hubbard, Chicago, Illinois 60610. Tel. 312 467 6550. Artists run alternative space with exhibitions, performance and video events.
Chicago is now America's second largest art centre after New York.

PHILADELPHIA
Foundation for Today's Art, Nexus, 2017 Chancellor Street, Philadelphia, Pennsylvania 19103. Tel. 215 567 3481. A non commercial artist run gallery in the centre of Philadelphia. 2500sq ft of space for exhibitions, performances, events and exchange shows with Canada and USA and video.

WASHINGTON
Washington Project for the Arts, 1227 G Street Northwest, Washington DC 2005. Tel. 202 347 8304. Promotes new and experimental art such as dance, theatre, music, visual arts.
Independent Curators Incorporated, 1740 N Street NW, Washington DC 20036.Tel. 202 872 8200. Offer exhibitions designed to appeal to non art specialists as well as those whose interest is mainly in the visual arts. Exhibitions, performances, video, educational programmes and art publications.

USSR
IAA, Union of Artists of the USSR, Gogolevski Boulevard 10, 121019, Moscow G19.

YUGOSLAVIA
IAA, Savez Likovnih Umetnika Jugoslavije, Mrs Mirjana Kacarevic, Terazije 26/11, 1100 Beograd, Yugoslavia.

NEW ZEALAND
AUCKLAND
Elam School of Fine Art, Auckland University, Auckland. Tel. 31897.
Auckland City Art Gallery, Kitchener Street, Auckland. Tel. 792020. Opening: 10–4.30, Fri 10–8.30.
New Vision Gallery, 8 His Majesty's Arcade, 171 Queen Street,Auckland. Tel. 375 440. Opening: Mon–Thurs 9–5, Sat 10–3. Contemporary New Zealand Work.
New Zealand Society of Sculptors and Painters, Elam Art School, Auckland University, Auckland. Tel. 31897. President: P. Hanly (1980/81).
Peter Webb Galleries Ltd., T&G Building, Corner Elliott and Wellesley Street, Auckland. Tel. 373 090. Opening: Mon–Fri 9–5.30. Contemporary NZ work.

WELLINGTON
Queen Elizabeth II Arts Council of New Zealand, 131–135 Lambton Quay, Wellington. Tel. 730 880. Director: Michael Volkerling. Visual Arts: James Mack.
National Art Gallery of New Zealand, Buckle Stret, Wellington. Tel. 859 703.
Photo Forum Gallery, 26 Harris Street, Wellington.
Galerie Legard, 44 Upland Street, Wellington 5. Tel. 758 798. Opening: Tues–Fri 12–6, Sat 1–3.
Elva Bett Gallery, 147 Cuba Street, Wellington. Tel. 845 511. Mon–Fri 10–5. Major contemporary NZ artists.

CHRISTCHURCH
Ilam School of Fine Art, Ilam University, 108 Ilam Road, Christchurch 4.
Robert McDougall Art Gallery, Botanic Gardens, Christchurch. Tel. 791 660 ext 484. Opening: Sat 10–4.30 and Sun 10–5.30. Large gallery showing contemporary work by New Zealand artists and other visiting exhibitions.
CSA Gallery (Canterbury Society of Artists 1770 members), 66 Gloucester Street, Christchurch. Tel. 67261. Opening weekdays 10–4.30, weekends 2–4.30. Large gallery space both upstairs and downstairs. Variety of exhibitions ranging from one man to group shows, performances, painting, craft etc.

ELSEWHERE
Govett Brewster Art Gallery, Queen Street, New Plymouth. Tel. 85149. Opening 10–5. Permanent home of Len Lye films, painting and sculpture.
Gisborne Museum and Arts Centre, 18–22 Stout Street, Gisborne, Tel. 83832. Opening weekdays 10–4.30, weekends 2–4.
Brooke Gifford Gallery, 112 Manchester Street, Christchurch. Tel. 65288. Opening: Mon–Fri 10.30–5. Contemporary work.

Dunedin Public Art Gallery, Dunedin. Tel. 778 770. Opening: weekdays 10–4.30, weekends 2–5. Major collection of contemporary NZ artists.

Manawatu Art Gallery, 398 Main Street, Palmerston North. Tel. 88188. Opening: 10–4.30, Sat and Sun 1–5, Thurs evening 6–9. Historical NZ artwork.

Rotorua Art Gallery, Tudor Towers, Rotorua. Tel. 85 594. Opening: 10–4, weekends 1–4.30.

Kerikeri Arts Centre Inc., PO Box 127, Bay of Islands. Tel. 79 496.

USEFUL BOOKS

See Art Bookshops (Chapter 1) for your nearest bookshop. The Dillons arts shop is excellent in Covent Garden, London.

FILM AND VIDEO

London Video Arts (catalogue). Price £1.50, plus postage. Available from London Video Arts, 23 Frith Street, London W1.

Directory of Independent Film. Price £1.50, plus postage. Available from Independent Cinema West, 132A Queens Road, Bristol.

London Film Makers Catalogue. Price £1.50, plus postage. Available from London Film Makers Co-operative, 42 Gloucester Avenue, London NW1.

Films on Offer. Price £2.25, plus postage. Available from BFI, 81 Dean Street, London W1.

South West Film Directory. Price 50p. Available from South West Arts, 23 Southernhay East, Exeter, Devon.

Video Distrubution Handbook Price £1.50. Fantasy Factory.

Perspectives on British Avant Garde Film. Price £1.50.

PRINTMAKING

Handbook of Printmaking Supplies. Price £2. Available from Printmakers Council of Great Britain, 31 Clerkenwell Close, London EC1.

Understanding Prints. A contemporary guide. Pat Gilmour. Price £2.95.

A Print Buyer's Handbook. A Delgado. Wolfe Publications.

Prints and Printmaking. Anthony Griffiths. British Museum Publications. Price £5.95.

Prints and the Print Market. A handbook for buyers and collectors. Theodore B. Danson 1977. Thomas T. Crawell and Co. (Expensive but comprehensive for major print collectors).

History of Engraving and Etching. Rosemary Simmons. Studio Vista. £7.95.

Collecting Original Prints.

Practical Guide to Etching, Constable. 10 Orange Street, London WC2. £5.05. Good value as it covers everything step by step.

PHOTOGRAPHY

See Photographic Workshops for addresses of photo galleries and workshops in Britain. Many of these sell photographic books. **The Photographers gallery** in London has a large selection of photographic books, magazines and postcards at 8 Great Newport Street, London WC2, also the **Arts Shop** at 8 Long Acre, London WC2, **Foyles and Zwemmers**, Charing Cross Road, London WC2.

Directory of Independent Photography, Arts Council of Great Britain 105 Piccadilly, London W1V 0AU. Includes museums, galleries, workshops, darkrooms and community projects for the independent i.e. non commercial photography area. £1 inc p&p.

Photography in the Arts, Arts Council of Great Britain as above.

A History of Photography, Cambridge University Press, Shaftesbury Road, Cambridge CB2 2RU. Social and cultural perspectives £25.

GENERAL

The Art of Survival. Some ideas on selling for artists by A. M. Parkin. £2. Write with cheques to A. M. Parkin, 47 Oxenhill Road, Kemsing, Kent. Tel. 09592 4585.

The Directory of Exhibition Spaces, Sue Jones and Neil Hanson. £8.95 (1988). Artic Producers. PO Box 23, Sunderland SR1 1EJ. Tel. 091 567 3589.

Writers and Artists Year Book. Price £5.95. Publishers Adam and Charles Black, 35 Bedford Row, London WC1. Available at most bookshops. Published annually. Excellent for writers but not so for artists, except perhaps commercial artists.

Arts Review Yearbook. Price £11. Publishers Arts Review, 69 Faroe Road, London W14 0EL. Tel. 01-603 7530/8533. Available at most bookshops and at The Royal Academy, Arts Shop.

London Art and Artists Guide. Price £5.95. Publishers Art Guide Publications, 35 Bedford Row, London WC1R 4JH. Tel. 01-242 0946. Availale at Foyles, Arts Council Shop, Royal Academy galleries etc.

Paris Art Guide. Price £5.95. Available as above or direct from the publishers. Also **Australian Arts Guide** £5.95 by Roslyn Kean and **New York Art Guide** £5.95, **Amsterdam Arts Guide** £5.95 and **Berlin Arts Guide** £5.95. Glasgow and Madrid will be published in Spring 1989.

Art Diary. Price $20 (£15). Publishers Giancarl Politi, PO Box 36 Borgo Trevi, 06032 Perugia, Italy. Available from UK distributor. P.I.P. Tel. 388 4060. An international art directory covering 38 countries. Names of artists, art galleries, art organisations etc. Published annaully.

Visual Arts Handbook. Price $8 plus postage. Publishers Visual Arts Ontario, 439 Wellington Street West, Toronto, Canada. Available direct from publisher or at Canadian art bookshops and galleries. Directory for Canadian artists with useful information and advice.

Anderson and Archer's Soho. Publishers Simon and Schuster, Rockefeller Centre, 1230 Avenue of the Americas, New York 10020, USA. A general guide to the galleries and buildings in Soho with useful information. Stanfords, Long Acre, Covent Garden sells maps of New York and **Michelin guide to New York.** The Soho guide is now out of print.

West Midland Directory—Artists craftsmen photographers in the West Midlands. West Midland Arts, Lloyds Bank Chambers, Market Street, Stafford. Price £2. Gloss directory with photographs of work by professional artists in this area and details about the artist and his/her work.

Arts Centres. Every town should have one. John Lane. Price £6.75.

Handling and Packing Works of Art. Francis Pugh. Price £1.

Marketing the Arts. Keith Diggle. Price £2.50.

The Universities, the arts and the public. Price 50p.

The Arts and Personal Growth. Pergamon Press. Price £5.50.

What is Abstract Art? Arts Council of Great Britain publications.

The Phaidon Companion to Art and Artists in the British Isles. Michael Jacobs and Malcolm Warren. £12.95.

Growing up with Art. Price £2.

Director of Arts Centres. (UK) Arts Council of Great Britain.

The Arts Council of Great Britain. Eric W. White. Price £1.

The Arts and the World of Business. Charolotte Georgi. Methuen 2nd edition. £4.90.

The Fine Art of Art Security. Donald Mason. Van Nostrand and Reinhold. Price £6.70.

Festivals in Great Britain. ACGB.

Contemporary British Art—with photographs. Walia and Perry Crooke. Price £9.95.

Thinking about Art. Edward Lucie Smith. Price £1.95.

The Art Galleries of Britain and Ireland. Joan Abse. Price £5.95.

Dictionary of Art and Artists. Peter and Linda Murray.

British Art. Simon Wilson. Tate gallery. Price £10.

Who's Who in Art. Art Trade Press> £10.

The Art and Antique Restorers Handbook. Barrie and Jenkins. Price £4.95.

Art Gallery Guide (Europe). Guide to specific paintings. Mitchell Beazley, £3.95.

Arts Council Publications—list of these available free.

Dutton Paperbacks New York
The New Art
Idea Art
New Ideas in Art Education
Philosphy of Modern Art. Herbert Read. Faber.

The Hidden Order of Art. Anton Ehrenzweigh. Paladin.

Pop as Art. Mario Amaya. Studio Vista.

Towards another Picture. Andrew Brighton and Lynda Morris. Midland Group Nottingham. Price £3. (artists' writings).

Art on the Edge. Harold Rosenberg. Secker and Warburg.

Art and Culture. Clement Greenburg. Thames and Hudson.

The Story of Art. E. H. Gombrich. Phaidon.

Women Artists. Karen Petersen and J. J. Wilson Womens Press. Price £4.95.

An Outline of English Painting. Faber. Price 90p.

Success and Failure of Picasso. John Berger Writers and Readers Co-operative. Price £2.95.

British Art Since 1900. Sir John Rothenstein. Phaidon. Price £5.95.

Performance Live Art 1909 to the Present. Roselee Goldberg. Thames and Hudson. Price £5.95.

Progress in Art. Suzi Gablik. Thames and Hudson. Price £8.50.

Art Within Reach. Published by Art Monthly. Distributed by Thames and Hudson. Price £6.95. Public art coverage.

Open Air Sculpture in Britain. W. J. Strachan. Published by A. Zwemmer. Price £5.95.

A Biographical Dictionary of Artists and **A History of Art** both by Sir Laurence Gowing. Published by MacMillan. Price £35 and £40.

The Art and Architecture of London. Phaidon, by Ann Saunders. Price. £22.50.

Art Museums of the World, Greenwood Press. £135.

Organising your own exhibition: A guide for artists, Debbie Duffin, ACME, 15 Robinson Road, London E2 9LX. £3 plus p&p.

The Green Book, Keith Spencer. The Green Book Pres, 72 Walcot Street, Bath BA1 1XN. £1.75 per issue plus 50p p&p. Annual subscription £9. A visual and literary arts quarterly review.

The Murals Books. Hammersmith and Fulham Amenity Trust, 241 King Street, London W6. £12. A guide to mural painting for artists and community groups.

Making Ways. Artic Producers, PO Box 23, Sunderland SR1 1EJ. £7.95. Covers exhibiting, fund raising, contracts, transporting, copyright and training.

British Art in the Twentieth Century. Royal Academy/Prestel.

Scottish Museums and Galleries Guide. £2.95. Scottish Museums Council, 20/22 Torpichen Street, Edinburgh EH3 8JB.

Depart from Zero. The history of the Gallery London 1973–78. Interviews with John Latham, Rita Donagh, Stephen Willats, Vaughan Grylls with 180 b/w photos. £12. Gallery Trust Publications, Old Loom House, Backchurch Lane, London E1 1LS.

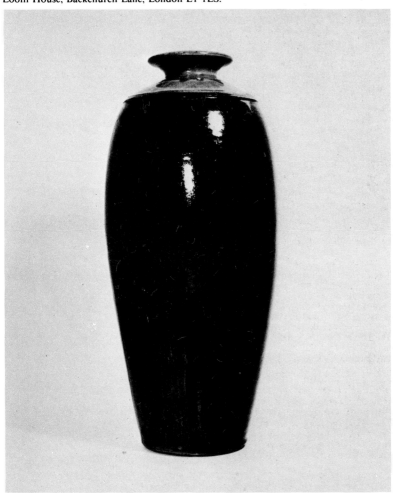

Richard Batterham Stoneware bottle, Oxford Gallery, Oxford.

Frans Masereel. Passionate journey. The Redstone Pres, 21 Colville Terrace, London W11. £10.95. A novel told in woodcuts from the original 1919 edition.

Careers in Art and Design. Kogan Page, 120 Pentonville Road, London N1 9JN. £3.95. Linda Ball 4th updated edition.

Working for yourself in the arts and crafts. Sarah Hosking. £4.95. Kogan Page.

Lucie Rie. Alphabooks. Available from most bookshops. £25. Written by Tony Birks the author of **Art of the Potter** and **Hans Coper**. Excellent colour photos and sympathetic accompanying text by a close friend of Lucie Rie.

Making Art Pay. Bernard Denvir and Howard Gray. Phaidon Press (1988).

New British Painting. Edward Lucie-Smith, Phaidon Press (1988).

ART PUBLISHERS

Art Guide Publications. A & C Black, 35 Bedford Row, London WC1R 4JH. Tel. 01-242 0946.

A & C Black, 35 Bedford Row, London WC1R 4JH. Tel. 01-242 0946.

Arts Council of Great Britain, 105 Piccadilly, London W1V 0AU. Tel. 01-629 9495.

Art Line, 3 Garratt Lane, London SW18. Tel. 01-870 0427.

Artic Producers, PO Box 23, 20 Villiers Street, Sunderland SR1 1EJ. Tel. 091-567 3589.

Audio Arts, 6 Briarwood Road, London SW6.

Academy Editions, 7/8 Holland Street, London WS 4NA. Tel. 01-402 2141.

British Museum Publications, British Museum, London WC1.

Constable, 10 Orange Street, London WC2. Tel. 01-930 0801.

Collets, Denington Estate, Wellingborough, Northamptonshire NN8 2QT. Tel. 0933 224351.

DJ Costello, 43 High Street, Tunbridge Wells, Kent TN1 1XL. Tel. 0892 45355.

Dorling Kindersley, 9 Henrietta Street, London WC2E 8PS. Tel. 01-240 5151.

Richard Drew, 6 Clairmont Gardens, Glasgow G3 7LW. Tel. 041-333 9341.

Ebury Press, 27 Broadwick Street, London W1V 1FR. Tel. 01-439 7144.

Faber and Faber, 3 Queen Street, London WC1. Tel. 01-278 6881.

Hilmarton Manor Press, Calne, Wiltshire SN11 8SB. Tel. 024976 208.

John Murray, 50 Albemarle Street, London W1.

Lund Humphries, Park House, 1 Russell Gardens, London NW11 9NN. Tel. 01-458 6314.

Petersburg Press, 59A Portobello Road, London W11. Tel. 01-229 0105.

Phaidon, 2 St Ebbes, Oxford OX1 1SQ. Tel. 0865 246681.

Secker and Warburg, Michelin House, 81 Fulham Road, London SW3 6RB. Tel. 01-581 9393.

Sothebys Publications, Russell Chambers, London WC2.

Tate Gallery Publications, Millbank, London SW1.

Thames and Hudson, 30–34 Bloomsbury Street, London WC1B 3QP. Tel. 01-636 5488.

Victoria and Albert Museum, Publications, South Kensington, London SW7.

Writers and Readers Co-operative

Weald UK

Yale University Press, 13 Bedford Square, London WC1B 3JF.

All publishers listed above will send catalogues on request to potential buyers. Most books published by the above mentioned publishers are on sale in general and art bookshops but occasionally it is wise to contact the publisher direct.

Kogan Page, 120 Pentonville Road, London N1 9JN publish several practical advice books such as Careers in Art and Design.

If you have any addresses or details to add to this guide book I would be grateful if you could send them on the sheet printed below.

Heather Waddell and Richard Layzell
Artists Directory
Art Guide Publications
A & C Black
35 Bedford Row
London WC1R 4JH

Name of organisation/gallery/restaurant/bookshop/magazine, etc.

...

...

Address ..

...

...

...

Other information ..

...

...

...

...

...

...

Thank you